Dutch Seventeenth-Century Genre Painting

DUTCH SEVENTEENTH-CENTURY GENRE PAINTING

ITS STYLISTIC AND THEMATIC EVOLUTION

Wayne Franits

YALE UNIVERSITY PRESS

NEW HAVEN AND LONDON

Designed by Elizabeth McWilliams

Printed in Singapore

Library of Congress Cataloging-in-Publication Data

Franits, Wayne E.
Dutch seventeenth-century genre painting : its stylistic and thematic
evolution / Wayne E. Franits.— 1st ed.
p. cm.
Includes bibliographical references.
ISBN 0-300-10237-2 (cl : alk. paper)
1. Genre painting, Dutch—17th century. I. Title.
ND1452.N43F73 2004
754'.09492'09032—dc22

2003018897

A catalogue record for this book is available from
The British Library

Frontispiece: Detail of fig. 89.

CONTENTS

ACKNOWLEDGMENTS

The book before you involved the efforts of many people besides those of its author. First and foremost, thanks are owed to Gillian Malpass and her able staff at Yale University Press's London office for their unwavering commitment to this endeavor from its very beginning through its publication. Many other colleagues and friends made contributions of varying sorts, some graciously reading earlier versions of the text, others answering niggling and at times, much to my embarrassment, seemingly simplistic questions concerning Dutch art and culture. Still others provided invaluable assistance in the formidable task of procuring photographs. For this reason, I must acknowledge the following persons (while simultaneously apologizing to those who have been inadvertently omitted here): an anonymous reader, Ronni Baer, Margaret Binns, Ben Bregman, Marten Jan Bok, Celeste Brusati, Jeffrey S. Carnes, Joop van Coevorden, Alan Chong, Rudolf Dekker, Laurinda Dixon, Thomas Döring, Linnéa and Aidan Franits (for their forbearance), Elise Goodman, Emilie Gordenker, Claus Kemmer, Alison Kettering, George Keyes, Jennifer Kilian, Katy Kist, Florence Koorn, Jan Kosten, Walter Liedtke, Frank Macomber, Ekkehard Mai, Stephen Meyer, John Michael Montias, Mireille Mosler, H. Rodney Nevitt, Nadine Orenstein, Gary Radke, Beatrice Rehl, Herman Roodenburg, Eddy Schavemaker, the late Leonard J. Slatkes, Seymour Slive, Eric Jan Sluijter, Eileen Strempel, Peter C. Sutton, Rebecca Tucker, Amanda Winkler, Amy S. Wyngaard, Dennis Weller, Mariët Westermann, Herbert H. Westphalen III, Arthur K. Wheelock, Jr., and Marjorie E. Wieseman.

A great debt is likewise owed to the following art dealers who showed great kindness in permitting me to reproduce photos from their collections and in intervening on my behalf with clients whose pictures appear in the text: Richard Green, Johnny van Haeften, John and Willem Jan Hoogsteder, Jack Kilgore, David Koetser, Otto Naumann, Robert Noortman, and Henry V. Zimet. The auction houses of Christie's and Sotheby's also deserve thanks. Despite the kindness shown by these individuals and institutions, the potential expenditure for illustrating so many images in this book remained downright frightening. Thankfully, funds provided by Dean Cathryn R. Newton of the College of Arts and Sciences of Syracuse University, Bennie R. Ware, the Vice-President for Research and Computing at Syracuse University, and especially the William C. Fleming Educational Trust Fund helped offset these costs.

Dean Newton was also instrumental in encouraging me to take a much-needed sabbatical during the academic year 2001–2 to write the text. And, in this regard, the staff and collections of the following libraries and institutions were indispensible to my completing it: The British Library, E. S. Bird Library at Syracuse University, Koninklijke Bibliotheek, New York Public Library, Rijsbureau voor Kunsthistorische Documentatie, Rijksprentenkabinett, University of Amsterdam, University of Utrecht, and the Witt Library of the Courtauld Institute of Art.

Lastly, this book is affectionately dedicated to Egbert Haverkamp-Begemann, in honor of his eightieth birthday.

Syracuse, N.Y.
December, 2002

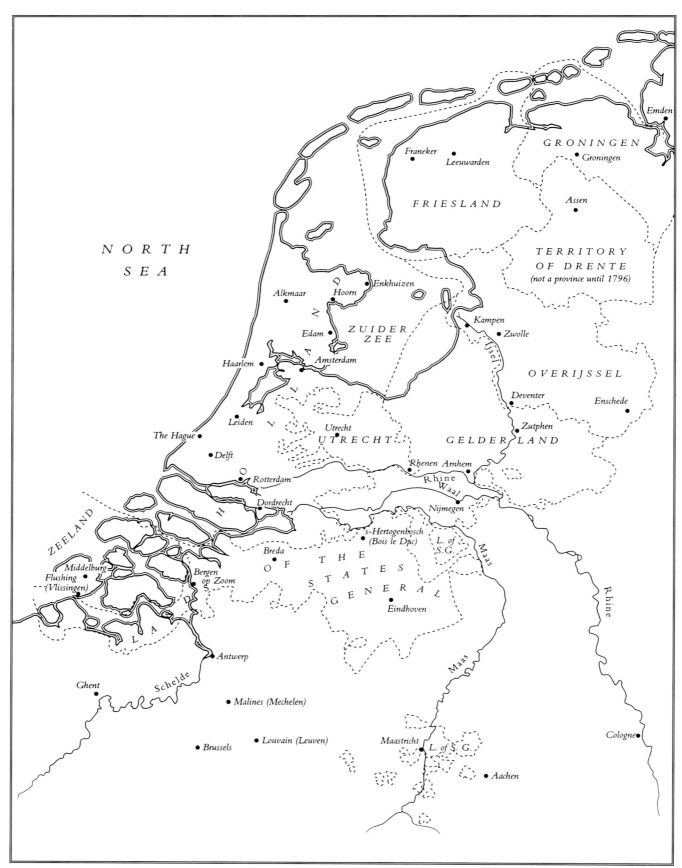

NORTH
SEA

GRONINGEN
• Groningen

Franeker •
Leeuwarden •

FRIESLAND

Assen •

TERRITORY
OF DRENTE
(not a province until 1796)

Alkmaar • Hoorn • • Enkhuizen

ZUIDER
ZEE

Edam •

Kampen •
Zwolle •

OVERIJSSEL

Haarlem • Amsterdam •

Deventer • Enschede •

Leiden •

Zutphen •

Utrecht •
UTRECHT GELDERLAND

The Hague •

• Delft

Rhenen • Arnhem •

Rhine
Waal

• Rotterdam

Nijmegen •

Dordrecht •

's-Hertogenbosch •
(Bois le Duc) L. of
S.G.

ZEELAND

Breda •

OF THE
STATES
GENERAL

Maas

Middelburg •
Flushing •
(Vlissingen)

Bergen
op Zoom •

Eindhoven •

Rhine

• Antwerp

Schelde

Maas

Ghent •

• Malines (Mechelen)

Louvain (Leuven) •

Maastricht •
L. of S.G.

Cologne •

Brussels •

• Aachen

Map of the Republic of the United Netherlands in 1648 showing the seven provinces, Land of the States General, principal rivers, cities and towns.

INTRODUCTION

Dutch seventeenth-century genre paintings, commonly known as scenes of everyday life, encompass a startling variety of subject matter. They range from women working in the home to their moral antipodes, prostitutes, seductively plying their trade among prospective clients; from peasants in ramshackle hovels to the reveries of elegantly attired young people in palatial settings; from attentive children in schoolrooms to their mischievous cousins who wreak havoc during festive occasions.[1] The ability of these seemingly unassuming yet celebrated images to evoke daily existence during the Golden Age of the Netherlands is legendary. Indeed, the great success of recent, international exhibitions of the work of such noted genre painters as Johannes Vermeer, Pieter de Hooch, and Gerrit Dou confirms this.[2] The reasons for the unabated popularity of genre paintings undoubtedly reside in what is today perceived as their typically "Dutch" characteristics. In comparison with the often grandiloquent pictures produced in other European countries during this epoch, they are unassuming but nonetheless illustrate with great charm and conviction the life and times of a long-vanished culture.[3]

However, the most outstanding aspect of these images, namely, their ostensible capacity to proffer unmediated access to the past, is paradoxically the most deceptive. For example, countless genre paintings present costume details that are completely incongruous with what actually existed in the Dutch Republic. This is particularly true of the work of the Utrecht Caravaggisti (see fig. 59) where numerous figures don outlandish garments reminiscent mostly of fashions in centuries preceding the seventeenth. Likewise, genre paintings frequently display architectural settings that may seem entirely plausible but in fact are utterly fantastic (see fig. 83). These examples and many others discussed in this book underscore the tenuous links between what was portrayed in paintings and the reality of contemporary life.

Further complicating our understanding of this art is the restricted range of what it depicts. If by definition genre paintings represent quotidian events, then given the complexity of daily life, the potential subjects for Dutch seventeenth-century artists must have been inexhaustible. In light of the Netherlands' status as one of Europe's preeminent maritime powers, it is, for instance, not unreasonable to presume the existence of many representations of dock workers and other scenes related to this flourishing commerce. Yet virtually none exists.

Dutch genre paintings do indeed present a wide variety of subject matter but the scope of what was portrayed compared with what potentially could be portrayed is quite limited. The marked parameters of suitable subjects for representation attest to the conventionality of this art.[4] The term conventionality, which will appear throughout this book, refers not only to the repetition of specific styles and motifs but especially to the restricted number of themes that artists depicted, ones that were used continually, often over several generations. Therefore some themes were painted with ever-increasing frequency while others just never took root within the limited artistic repertoire. Artists fashioned them in response to personal aesthetic interests, to pictorial traditions, and especially to the demands of the market (see below).

The impact of pictorial traditions is critical for understanding how Dutch genre painters formulated their imagery. As shall be discussed, the visual roots of many seventeenth-century genre paintings lie in the distant past and, in some instances, can be traced back to the art of the late Middle Ages. Two factors explain this phenomenon: first, contemporary audiences had strong affinities for that which was familiar. Consequently, as genre painting gradually became a dominant art form in the Netherlands during the early seventeenth century it was only sensible that artists would turn to the art of the recent past for inspiration. The second factor is a logical extension of the first: painters responded enthusiastically to older art and undoubtedly considered it in continuum with the present because the early modern period as a whole imputed value to artistic conservatism, that is, to working within established modes. Thus, the aesthetic standards of that day were the polar opposite of those of our own postmodern era which places a lofty premium upon creativity and originality.

The assimilation of conventions and pictorial traditions into the production of genre paintings carries far-reaching implications for modern-day perceptions of them. If anything, it should disabuse contemporary viewers of any naive assumption that seventeenth-century Dutch genre paintings are simple "slices of life," that they somehow present direct transcriptions of the mundane experiences of contemporary Netherlanders. To the contrary, these pictures weave clever fictions, ingeniously synthesizing observed fact with a well-established repertory of motifs and styles to create a contrived image that ultimately

transfigures the commonplace.[5] Much of the confusion however is excusable, owing to the stunning verisimilitude of genre paintings. Seventeenth-century viewers responded as well to their remarkably lifelike appearance, even if they were more sensitive to the conventional nature of the imagery. Indeed, contemporary writers routinely marvel at the seeming veracity with which painters captured the surrounding world. Moreover, Dutch art theorists of the era likened the prototypical painting to a "mirror" of nature: like an actual mirror, a painting delightfully yet deceptively renders an appearance, a "semblance of being" that actually does not exist.[6]

Beyond the frequent astonishment recorded by seventeenth-century viewers of genre paintings and beyond the theoretical prescriptions of what constitutes the paradigmatic picture of any sort, detailed contemporary discussions of genre imagery are exceedingly rare. The writings of art theorists occasionally mention genre paintings but not always in a complimentary manner. These theorists were anxious to elevate the social status of painters – artists were not always accorded the respect that they generally enjoy today – and consequently developed a hierarchy of different types or genres of art in order to demonstrate the superiority of some over others. The depiction of those genres most esteemed naturally accrued honor and fame to the artist. For example, Samuel van Hoogstraten, in his *Inleyding tot de hooge schoole der schilderkonst* (Introduction to the Lofty School of Painting) of 1678, assigns history painting (representations of episodes from the Bible, mythology, and actual history) the highest ranking, followed by genre painting, itself ill-defined among "cabinet pieces of every sort," which in turn is positioned above the lowest stratum of art, a wide range of still-life subjects.[7]

That van Hoogstraten does not employ the specific term "genre painting" is hardly surprising. "Genre" was originally a French word meaning "kind" or "type" and only gradually entered the English vocabulary.[8] Its association in French with paintings depicting everyday life (*peintures de genre*) was established in the late eighteenth century by French academic theorists engaged in developing terminology with which to classify art. Within sixty years "genre painting" had become a familiar descriptor in several Western European languages, including English. Seventeenth-century Dutch viewers, lacking any sort of catch-all phrase, resorted to purely descriptive titles to classify genre paintings, including, "gezelschappen" (merry companies) for scenes of young people cavorting (see fig. 20) or "korte-garden" (guardroom pieces) for depictions of soldiers (see fig. 80).[9] Other, to modern ears equally cryptic appellations were invoked as well. Especially fascinating are those employed by the Amsterdam city surgeon and connoisseur, Jan Sysmus, writing in the 1670s. He utilized the terms "jonkertjes" and "juffertjes" (dandies and damsels) to describe the subjects painted by such renowned genre painters as Johannes Vermeer (see fig. 157) and

Gerard ter Borch (see fig. 89).[10] Perhaps the most intriguing designation from that era is "modern", a word employed by art theorists and even notaries to distinguish works of art whose features were distinctly contemporaneous, among them, those with figures in fashionable dress.[11]

Even if the manner in which seventeenth-century audiences identified genre paintings is hardly spirited, there can be little doubt, given the thousands upon thousands of genre paintings produced at that time, that the public harbored great enthusiasm for them. While oft-quoted contemporary traveler's reports concerning the plethora of pictures in the Dutch Republic that supposedly could be seen in such unlikely places as blacksmiths' forges were undoubtedly exaggerated, the remarkably varied prices for genre paintings all but insured their affordability for a significant proportion of the population.[12] In an era in which the average middle-class salary amounted to approximately 500–700 guilders per year, a genre painting of decent quality could be purchased for as little as 10 to 15 guilders and often for less.[13]

However, the clientele for the cheapest works differed markedly from those who purchased genre paintings at an astronomically higher end of the price scale. For example, the Leiden artist Gerrit Dou regularly commanded prices in the 600–1000 guilder range for his panels, a sum sufficient to buy a house in the Dutch Republic. This fact belies longstanding misconceptions that all artists were simple craftsman of modest means who produced unsophisticated pictures for predominantly middle-class audiences.[14] The cost of Dou's paintings and his restricted circles of purely elite patronage enabled him to accrue substantial wealth and thus adopt a lifestyle analogous to those of his wealthy patrons. The celebrated Delft painter Johannes Vermeer likewise enjoyed elite patronage, though in his case in the person of one prominent Delft collector. Despite his frequent financial problems, which were exacerbated by having to provide for a large family, Vermeer too aspired to gentlemanly status, reflective naturally of that of his principal patron. Thus, a number of contemporary notarial documents cite Vermeer as a "seigneur" or "Sr", a title traditionally reserved for men of elevated social standing.[15]

This brief discussion of the cost of genre paintings in the seventeenth century leads to the larger question of the role of the art market, that somewhat nebulous term used to describe those persons or groups who purchased works of art in the Netherlands. The hitherto ingrained scholarly view that artists largely labored independently of the art market has in recent years undergone substantial revision.[16] The market actually functioned as a dynamic system of supply and demand for pictures and was affected equally by artists and consumers. In this sense, the creation of highly conventional genre paintings was impacted by their prospective purchasers: since artists worked for the market, namely, for specific patrons or for an unknown audience

on speculation, they were compelled to produce paintings that catered to the tastes and expectations of that audience. Demand therefore influenced the content of works, inducing some genre painters to specialize in particular subjects known to sell well or, conversely, to jettison those that sold poorly. Some of the best genre painters also experimented with entirely new subjects, thus shifting thematic conventions in the process. Demand also influenced style as artists periodically modified conventions by introducing stylistic innovations to make their works more attractive or even to lower overall production costs.[17]

Artists and art theorists were continually conscious of their actual or potential customers. The painter and theorist Philips Angel, in his *Lof der schilderkonst* (Praise of Painting) of 1642, definitely had prospective buyers in mind when he exhorted painters to impart a "decorative richness" to their works thereby enhancing their marketability:

> How necessary it is for a painter to pay good heed to this can be detected from the stimulating affections it awakens in the breasts of art lovers. One sees this daily in those who enrich their paintings and works with it, drawing the delighted eye of art-lovers eagerly to their works, with the result that paintings sell more readily.[18]

Angel's advice was undoubtedly followed. Neil de Marchi and Hans J. van Miegroet's fascinating study of the art trade between Antwerp and Paris in the middle of the seventeenth century clearly corroborates this.[19] Specifically, de Marchi and van Miegroet explored how art dealers in Antwerp, through their Parisian agents, were able to create niches for Flemish pictures in the French capital despite the predominant French taste for Italian art. Even though the painters supplying the paintings in Antwerp were ultimately working on speculation for buyers whom they had never met, they modified their work at the request of the dealers to make it more appealing and marketable.

De Marchi and van Miegroet discuss one memorable order for works submitted in March 1663 by the Antwerp-born but Parisian-based art dealer Jean-Michel Picart to his Antwerp supplier, Matthijs Musson.[20] Picart requested two major adjustments, both stylistic and thematic, to paintings that would eventually be shipped to him: first, they were to be "suyver geschildert" (cleanly painted), with a high degree of finish – presumably in contrast to what Picart perceived to be typically Flemish, wet-on-wet application of muddy colors.[21] Picart's second stipulation concerned subject matter and its representation: he wanted nothing that was potentially frightening or offensive through its vulgarity or crudity.[22] Thus, his order for twelve images of animals by the famed Flemish painter Jan van Kessel II (1626–1679) specified that they should not include bats or crocodiles, amongst others, but instead innocuous birds and fish.[23] Moreover, Picart requested that Abraham Willemsen (active 1627–72) adjust the faces of figures in his religious paint-

ings to make them less plump – otherwise they would be too peasant-like and indelicate.[24]

De Marchi and van Miegroet's analysis, though concerned primarily with art dealers as intermediaries in the market, nevertheless affords insights into the indirect yet decisive influence of anonymous Parisian audiences upon painters. Surely a similar dynamic was at work between artists and audiences in the Netherlands, regardless of whether the latter were anonymous or composed of identifiable patrons. Who specifically were these audiences? In terms of the types of art discussed in this book, namely, moderately priced to costly genre paintings of uncompromisingly high quality, some patrons were members of the middle class but most stemmed from the upper middle class and especially the social and cultural elite: the aristocracy, regents, patricians, and wealthy merchants.[25]

And where and how did these people go about purchasing pictures? The great flowering of Dutch painting in the seventeenth century, concomitant with a flourishing economy and absence of the traditional patronage of the Catholic Church, not only fostered a wide variety of secular painting specialties (including genre painting, landscape, and still life) but also provided art lovers with many alternatives for purchasing works of art.[26] Customers could negotiate with artists directly either to commission a work or purchase a completed one outright. Moreover, they could visit art dealers who carried a stock of representative paintings. There were dealers who dealt primarily in "high-end" art as well as those who sold more modestly priced paintings by mediocre artists, including copies of works by renowned masters.[27] Still other options were available as representations varying widely in price could be found at fairs, at auctions, and as prizes in lotteries (organized to assist charitable enterprises).[28] The evidence strongly suggests the coexistence of two disparate markets (with some overlap naturally) servicing clientele of differing financial means by providing art of diverse quality and cost through a variety of venues.[29]

After these pictures had been acquired, how were they displayed? This fascinating question has received increased scholarly attention in recent years, most notably in a book published by John Loughman and John Michael Montias.[30] Their comprehensive look at the status and presentation of works of art in seventeenth-century Dutch houses is based primarily upon extensive archival research conducted in the cities of Amsterdam and Dordrecht. The authors arrive at a number of persuasive conclusions, among them, that it is often difficult to distinguish between buyers who purchased paintings as mere decorative accouterments and those whose collections were intended to stimulate intellectual and aesthetic engagement. Furthermore, in the houses of more affluent owners, larger numbers of paintings and often those of the best quality were exhibited in rooms intended for the reception of visitors – the scale and disposition of these rooms, usually in the front of the house, also changed

as the century progressed, a fact which undoubtedly affected the display of art within them. Moreover, the functions of rooms usually had little bearing on the choice of what was exhibited within them (with some exceptions: for example, portraits of ancestors were frequently hung in spaces considered more private and used principally by the family). In fact, the arrangements invariably defy logic from the standpoint of subject matter as genre pictures and those of every other conceivable type were grouped together. They were hung in a manner that typically emphasized symmetricality and especially compatibility in size, color, composition, scale of figures, and so forth. Although these factors suggest a more pronounced interest in decorative display than in content, greater value was clearly placed on certain paintings which were consequently hung over fireplaces, or adorned with gilt frames, or even furnished with protective curtains or encasements.[31]

<p style="text-align:center">★ ★ ★</p>

The interest in seventeenth-century Dutch genre painting continues unabated today. Although the critical fortunes of Rembrandt van Rijn (1606–1669) and other noteworthy Dutch artists of the Golden Age sank precipitously during the eighteenth and early nineteenth centuries, genre painting remained ever popular. And scholarly studies of genre painters had already begun to appear during the late nineteenth and early twentieth centuries, a time in which the field of the history of Dutch art was still in its infancy. In recent decades, historians of Dutch genre painting have shifted somewhat the focus of their attention. In the not too distant past, specialists were beguiled by the seemingly straightforward appearance of genre paintings. Consequently, many earlier publications considered the naturalistic features of these works completely unproblematic; since they supposedly provided unmediated access to contemporary life, questions of their meaning for original audiences were ignored in favor of those pertaining to artistic development, style, and influence.

Around the period of the Second World War scholars slowly began to reassess time-honored perceptions of Dutch paintings.[32] Specialists of that era gradually perceived that the verisimilitude of Dutch genre pictures, their presentation of a plausible reality that had for so long been esteemed, simultaneously served as a conduit for multitudinous ideas and associations. The very first, hesitant steps undertaken by a number of Dutch and German scholars toward the interpretation of Dutch art, namely, the analysis of its potential meanings, proved decisive. A new generation soon followed whose work would exert a profound impact. Many members of this group labored at the University of Utrecht in the Netherlands, whose Institute of Art History soon gained international recognition as a center for interpretive analyses of Dutch painting.

Among the most prominent was Eddy de Jongh who almost single-handedly secured the legitimacy of interpretive studies as a viable and important endeavor within the field. De Jongh, who remains active today, has published numerous essays that have illuminated the meanings of scores of Dutch genre paintings while simultaneously addressing more substantive issues of method and interpretation.[33] His work is clearly indebted to that of the eminent art historian, Erwin Panofsky (1892–1968), specifically to the latter's iconological method.[34] Panofsky argued that three, interrelated strata of meaning or subject matter – the two terms construed as equivalent – are present within a work of art: primary or natural subject matter, consisting of motifs, that is, "pure forms," apprehended as carriers of meaning (pre-iconographical description); secondary or conventional subject matter, that is, combinations of motifs that can be identified as representing particular stories or concepts (iconography); and last, intrinsic content, referring to the underlying contexts that inform the depiction of these particular stories and concepts (iconology proper, or as Panofsky himself defined it, "iconographical interpretation in a deeper sense").[35]

Panofsky's iconological method was constructed with reference to Italian Renaissance art. When confronted with the problem of detecting meaning in the boldly naturalistic, interpretively recalcitrant art of Northern Europe – as Panofsky was in several early studies and in his monumental *Early Netherlandish Painting* (1953) – he attached certain theoretical addenda to his method: hence the development of his well-known theory of "disguised symbolism."[36] For example, in his seminal study of 1934 on Jan van Eyck's celebrated *Arnolfini Portrait* (London, The National Gallery), Panofsky explained the complicated symbolic program of the painting, concluding that within the artist's visually striking pictures:

> Medieval symbolism and modern realism are so perfectly reconciled that the former has become inherent in the latter. The symbolical significance is neither abolished nor does it contradict the naturalistic tendencies; it is so completely absorbed by reality, that reality itself gives rise to a flow of preternatural associations, the direction of which is secretly determined by the vital forces of medieval iconography.[37]

Inspired by Panofsky's hypothesis, de Jongh applied the principle of "disguised symbolism" (with some necessary modifications) to seventeenth-century Dutch art.[38] De Jongh maintains that Dutch paintings were intended to instruct and delight viewers: their sheer visual beauty engages the beholder who is consequently stimulated to uncover their concealed meanings, ones often (but not exclusively) didactic or moral in nature. He therefore contends that the frequently moralizing meanings of

Dutch pictures are conveyed by symbolism that is not immediately apparent but lies hidden beneath their seemingly realistic surfaces.[39] De Jongh further argues that the veiled symbols intrinsic to genre paintings in the form of motifs can be deciphered with the assistance of contemporary prints with inscriptions, popular literature, and emblems.

Of all this source material, de Jongh's use of emblems created the greatest stir, particularly among younger art historians. Their curious reaction was clearly an unexpected and unintentional repercussion of his influential publications. Emblems, which enjoyed enormous popularity throughout early modern Europe, expound upon abstract concepts, objects, and even proverbs through a compelling and entertaining tripartite combination of image (*pictura*), inscription (*inscriptio*), and exegetical text (*subscriptio*). Typical is an emblem by Jacob Cats (1577–1660), one of the most prolific and celebrated Dutch authors of this literary genre. The emblem depicts a man, undoubtedly a suitor, watching a woman sew (fig. 1). In the explanatory text, we learn that this scene and its thought-provoking inscription, *Post Tristia Dulcor* (Sweeter after Sadness), carry amatory overtones:

> Late with my love I did discourse, where as shee
> soweinge sate,
> My grieffes I did complaine, (but marke) shee paide
> mee with her prate.
> Regard, quoth shee, what here I doe, unto it grue
> good heede;
> With needle first a hoole I make, then stopp it with
> the threede.
> Hee that a smale wounde getts, then streight his Armes
> doth cast away
> And calls for plaisters, hee's un fit for Venus fielde, I
> say.
> For love and war therein agree, each hath a prosper-
> ouse howre.
> No sweetnesse can be counted sweete, but first it hath
> bene sowre.[40]

Cats's charming emblem thus transforms the rather mundane activity of sewing into a thought-provoking metaphor of a lover's wounding, an unfortunate yet unavoidable hazard for those who court.

The propensity among Dutch authors such as Cats to produce emblems with attractive illustrations, often replicating objects or events drawn from life, explains their initial allure for exegetes of Dutch art, for ostensible connections could be drawn between them and motifs in paintings. Indeed, in the immediate wake of de Jongh's initial essays, many specialists considered emblems magical keys capable of unlocking the signifying mysteries of Dutch genre painting. This rash view also gave rise to the misleading tendency to regard Dutch paintings as "painted emblems" and the process of interpreting them as "emblematic

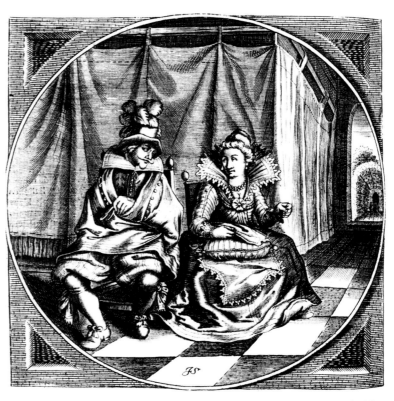

1 Emblem from Jacob Cats, *Proteus ofte minne-beelden verandert in sinnebeelden*, Rotterdam, 1627. Amsterdam, Universiteits-Bibliotheek Amsterdam.

interpretation."[41] Yet emblems seldom function as unadulterated sources for motifs in genre paintings. The greatest value of emblems, just like any other literary texts, lies in the insights they yield into the contemporary notions, superstitions, prejudices, and so on that find analogous expression in painting. After all, art is a purely visual phenomena, governed by its own distinct conventions and traditions. Moreover, meaning in art is initially generated pictorially through the purposeful array and disposition of its motifs, namely, the internal dynamics of its total visual context.[42]

Questions of emblems aside, de Jongh's many contributions to the study of Dutch genre painting have been widely acknowledged. Nevertheless, since the 1980s a growing number of art historians have examined his iconologically based approach with a more critical eye. Interestingly enough, Panofsky's venerable method, which strongly influenced de Jongh's, has simultaneously undergone extensive reassessment.[43] Many of these critics find it difficult to reconcile the realistic look of Dutch art with its purported symbolic program. First and foremost is the problem of how to detect veiled symbols in numerous, meticulously wrought Dutch paintings that so convincingly and

seductively present a coherent impression of reality. In other words, if this symbolism was so well concealed, how could seventeenth-century viewers – let alone modern-day ones – recognize it?[44] In theory, and especially in practice, the presumed presence of hidden symbols is difficult to reconcile with the exquisitely crafted appearance of Dutch paintings. This mode of thought also establishes a problematic and wholly artificial dichotomy between so-called realism and symbolism.

Still other principles of the iconological method have been challenged, among them, its propensity to divorce form or style from content.[45] The iconological interpretation of a work of art typically eschews analysis of the style or form in which it was executed as it focuses upon individual motifs whose aggregate reveals its meaning. In other words, the question of "what" is represented is deemed far more important than that of "how the what" is represented. Within this approach then, style hardly seems to be pertinent and practitioners of this method are often forced to conclude awkwardly that a picture must be meaningless if it does not contain motifs conducive to explication.[46]

It is precisely these inherent shortcomings that have led to a growing dissatisfaction with the iconological method. Therefore, it should come as no surprise that by the 1980s the problem of form or style, or, phrased more generally, the realistic appearance of Dutch paintings, versus their content, became the subject of intense debate. Fundamental in this regard is Svetlana Alpers's stimulating and controversial book, *The Art of Describing* (1983), which almost single-handedly initiated the debate.[47] Alpers took issue with the notion of seeming realism, with the theory that meaning in Dutch art lies hidden beneath the surface. For Alpers, such a view is hopelessly entangled within interpretive strategies developed in relation to Italian – as opposed to Dutch – art. Employing Roland Barthes's concept of the "reality effect,"[48] Alpers calls attention to what she terms "the pictorial mode of Dutch art," its singular capacity to proffer a compelling "perceptual model of knowledge of the world," which ties it to widespread "empirical interests in this age of observation." In essence, Dutch art does not somehow try to capture reality itself on canvas or panel but rather the manner in which reality is perceived, and in doing so, it affords intriguing parallels with scientific developments of this period. In retrospect, *The Art of Describing* stimulated renewed interest in the visual appearance of Dutch painting and how this appearance itself (without recourse to concealed symbols) attests to concomitant cultural phenomena.

Eric Jan Sluijter emerged as another outspoken critic of the iconological status quo. In a major article first published in Dutch in 1988 Sluijter decried the scholarly preoccupation with hidden meanings, sophisticated literary allusions, and didacticism in Dutch art.[49] Although Sluijter does not deny that such phenomena are occasionally present in paintings, his careful analysis of a number of theoretical works written between 1620 and 1670 compelled him to conclude that in general, contemporaries did not consider such types of signification pivotal to art.[50] Dutch art theorists mainly addressed the visual appeal and delight of paintings. In fact, their enthusiasm for the remarkable ability of Dutch art to imitate nature with great precision was shared by many contemporary collectors and connoisseurs.[51]

Peter Hecht also questioned the concepts of disguised symbolism and moralizing meanings in his important exhibition catalogue *De Hollandse fijnschilders* (The Dutch Fine Painters).[52] This catalogue generated further controversy because Hecht strongly downplayed the interpretive possibilities of pictures, arguing that contemporary viewers were likely most attentive to art's virtuosic simulation of reality as opposed to its signifying capabilities. Premises such as these were hotly debated at a symposium organized by the Rijksmuseum in Amsterdam in December of 1989 and in several articles and reviews about the catalogue and Dutch genre painting in general that appeared shortly thereafter.[53]

These reactions to the iconological approach were not, however, purely critical. Sluijter's research, for example, provided avenues of further inquiry that transcended the inherent limitations of iconology as well as those of Alpers's fascinating theories.[54] Specifically, he has explored the ultimately deceptive yet utterly beguiling simulation of the surrounding world in Dutch painting and its effect upon artists, connoisseurs, and even the art market at large. In the last ten to fifteen years, interpretive strategies have grown much more flexible as well as diverse. Traditional methods and interpretations have been supplemented on many different fronts through the assorted approaches of a substantial number of specialists.[55] Today, many scholars of Dutch genre painting acknowledge its multivalency and, equally importantly, its complex interactions with contemporary audiences in shaping seventeenth-century Dutch culture.[56] Moreover, by skillfully incorporating into their research various postmodern, theoretical approaches and insights currently in vogue in other disciplines (especially literary history), these scholars have continued to expand the parameters of investigation to include the broadest possible socio-political, cultural, and critical contexts. In sum, research conducted from a rich variety of methodological perspectives since the Second World War has furnished ample insight into the meanings of genre paintings, meanings that were inconceivable to renowned specialists of earlier generations.

★ ★ ★

The book before you synthesizes much of this scholarly work as it surveys, in eighteen chapters, the thematic and stylistic development of genre painting from its first manifestations in the

seventeenth century to the early eighteenth century. Specifically, the book is divided into three parts, comprising the respective periods, 1609–48, 1648–72, and 1672–1702. Each part begins with a brief overview of Dutch history during the period in question, focusing on a decisive event (or events) and its ramifications for contemporary society and culture.

So, for example, Part II addresses the years 1648–72. The Treaty of Münster (1648) ushered in an extraordinary period of prosperity in the Netherlands, one of explosive economic growth, unprecedented social mobility among the wealthy, and the marked development of notions of civility. Under the influence of these factors, Dutch genre painting achieved an extraordinary level of refinement, both technical and thematic, as a significant number of talented specialists developed new themes, among them, domesticity, and revised established ones, including the depiction of peasants. A diachronic approach to the material then (that is, an assessment of its thematic and stylistic changes over time) is pivotal not only for understanding the development of genre painting through the contributions of individual artists but also how their work was perceived by contemporary audiences.[57]

The ensuing discussions will center on representative works by the leading genre painters of the Golden Age because it was these masters who were at the forefront of artistic developments. In order to facilitate our investigations the book has also been organized, with a few exceptions, by the cities in which they principally labored. As shall be discussed, the fortunes of Dutch cities, locked in heated commercial competition with one another, were invariably linked to the economy. And it is axiomatic that these municipal rivalries affected the vitality of local art markets. Approaching Dutch genre painting by cities consequently amplifies our diachronic approach because the relative economic health or malaise of the town in question exerted a decisive impact on the condition of its art market. As the century progressed certain cities, particularly wealthy and cosmopolitan Amsterdam, attracted large numbers of artists. The lure of robust art markets encouraged painters to leave cities whose economies were languishing in favor of those that were flourishing, a case in point being Haarlem and Amsterdam after 1650. Therefore, the history of genre painting in the Netherlands is, in many respects, enfolded within the rise of certain cities, often at the expense of other ones, as art centers.

These considerations beg the question, long pondered by specialists, of whether we can rightly speak of "schools of painting" within Dutch towns.[58] In other words, does a local tradition of painting exist in a certain city – as opposed to other cities – which displays readily identifiable characteristics? The concept of schools of painting is adopted from the study of the art of Renaissance Italy, a region whose metropolises formed the hubs of independent domains and republics which often lay at great distances from one another.

The geographical circumstances within the Dutch Republic were entirely different. Most of the major towns in the Netherlands – among them, Haarlem, Amsterdam, Utrecht, Rotterdam, Delft, The Hague, and Leiden – are all situated within a circle whose diameter does not exceed forty-five miles. In fact, Haarlem and Amsterdam on one hand, and Delft and The Hague on the other, lay in such close proximity that during the seventeenth century, extensive, horse-drawn barge service between these cities actually enabled the population to "commute" daily between them. Among others, David Beck, a schoolteacher and poet in The Hague who kept a diary during 1624, repeatedly recorded his day trips to Delft to see family members – the distance between these two towns could be traversed in an hour and one half by foot or barge.[59] Artists certainly took advantage of the nearness of these and other cities as well. Moreover there are repeated cases of painters who lived and worked in any number of different towns; Jan Steen is notorious in this respect as he spent various parts of his career in Haarlem, The Hague, Leiden, and Delft (see Chapter 14).

All of these factors complicate the question of schools of painting in the Dutch Republic. Nevertheless, that genre paintings produced in, say, Haarlem, Utrecht, or Leiden have a distinctive look to them is undeniable. This phenomenon may be explained partly by the rather rigorous restrictions within the painters' professional organizations, namely, the guilds of these cities, intended to regulate artistic training as well as the sale of pictures made elsewhere.[60] And artists who moved to a particular town were usually susceptible to local influences. However, as Walter Liedtke has persuasively argued, it is also possible to speak legitimately of regional styles, in other words, of the stylistic qualities found in paintings that stem from broader areas of the Netherlands as opposed to specific cities.[61]

Perhaps it is most helpful to view the question of schools of painting not from the perspective of modern art history but rather from that of seventeenth-century viewers. The latter obviously would not have conceived of the question in the manner in which we do today, yet their perception of art produced in their hometowns is revealing. In contemporary city descriptions, namely, books written in praise of specific towns, there are invariably discussions of native painters. These tomes, which follow a tradition established by Italian Renaissance humanists, were published in increasing numbers in the seventeenth century, a reflection no doubt of the propitious political and economic circumstances of so many towns within the United Provinces (and especially of those in the Province of Holland).[62] With demonstrable pride, the authors extolled their cities' most important painters and occasionally one can even sense their cognizance, however rudimentary, of certain distinguishing stylistic features among pictures executed locally.[63]

The sentiments of these authors of city descriptions find parallels in the collecting habits of many citizens as the latter pri-

marily preferred the work of local artists.[64] The aforementioned study by Montias and Loughman offers a fascinating example of this phenomenon. The authors discuss the inventory of the possessions of the affluent Dordrecht collector Abraham Sam, compiled at his death in 1692. On the basis of the paintings recorded in Sam's "best room" (undoubtedly an impressive space in which visitors were entertained), they conclude that this room, "can be seen as a visual acclamation of his family, his town, and its painters."[65] No doubt Sam's strategies of collecting and display were shared by connoisseurs in other towns.[66]

Yet this book offers far more than a simple stylistic survey of seventeenth-century Dutch genre painting organized by cities and principal artists. To the contrary, questions of style are fully integrated with those of meaning and interpretation. In my opinion, this approach is consistent with seventeenth-century modes of viewing. It also serves to shed light on genre painting's complex functions within the Dutch Republic. Let us now scrutinize these fascinating paintings which despite or perhaps even because of their deceptive appearance, provide a wealth of information about seventeenth-century Dutch culture, its predilections, its prejudices, and indeed its very mind-set.

PART I 1609–1648

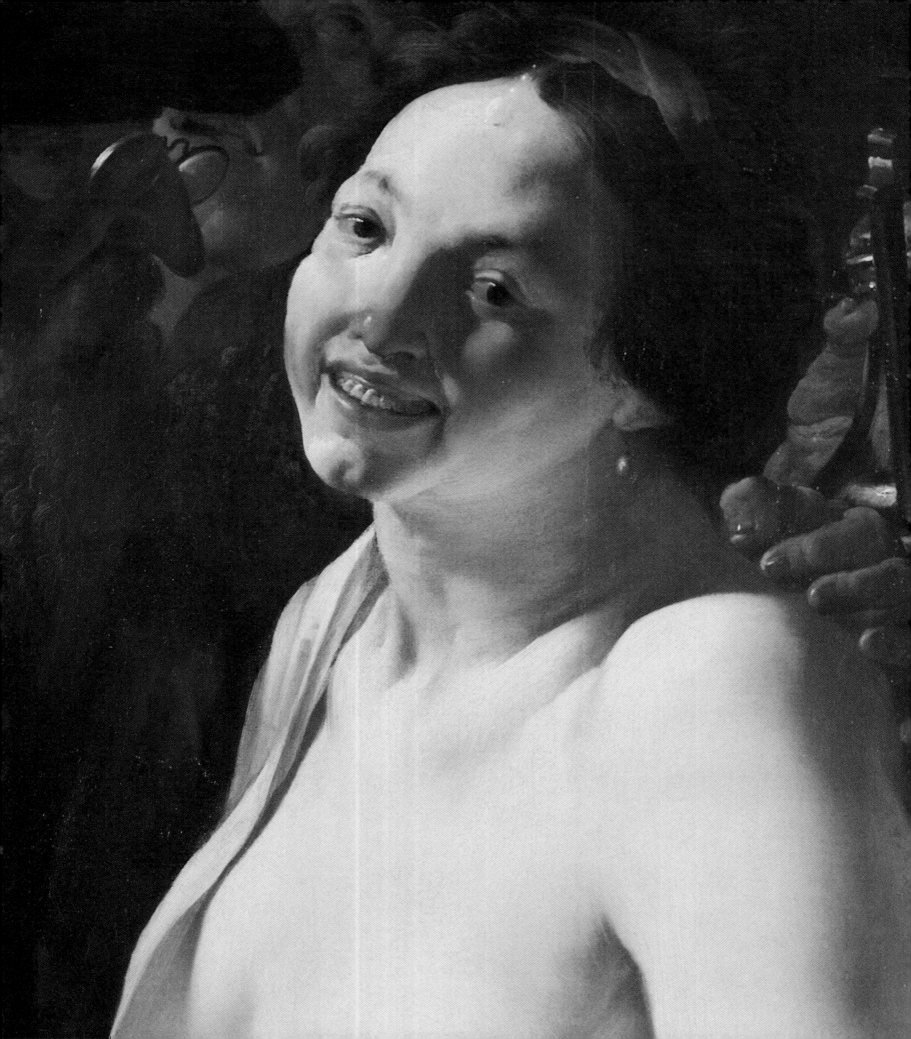

THE DUTCH REPUBLIC, 1609–1648

The Dutch Republic was born of insurrection during the late sixteenth century; therefore, a brief examination of the pivotal events of that period will further our understanding of those that transpired after 1609. Before the insurrection the future nation's territory comprised part of the Low Countries, an area encompassing much of what is modern-day Belgium and the Netherlands. During the 1560s the Low Countries rebelled against its Hapsburg overlord, Philip II of Spain (ruled 1556–98) who had inherited the domain from his father, Charles V (ruled 1519–56).[1] The uprising against Philip occurred in response to a number of interrelated factors, among them, the Spanish king's imposition of harsh taxes to finance his military adventures; his attempts to integrate the region into his other dominions and, in relation to this, his alleged violation of traditional regional privileges; and most explosively, this militantly Catholic monarch's attempt to eradicate in this territory the new Protestant faith in the form of incipient Calvinism.

Philip II sent an army to the Low Countries in 1567 in an effort to crush the rebellion, thereby restoring subservience and Catholicism to his royal possession. Little did Philip know that the ensuing war would continue for decades, extending well beyond his own death. Initially, the Spanish experienced great military success as the king's superior army overran much of the southern and eastern sections of the Low Countries and captured several important cities in its northern and western areas, most notably, Haarlem. Despite the repeated setbacks on the battlefield the Dutch, under the able leadership of the Princes of Orange, doggedly persisted. But only in the 1590s did the fortunes of war change dramatically in their favor.

During this decade, Philip II became increasingly preoccupied with politically unstable France as he attempted to prevent the coronation of a Protestant king there. The diversion of Spanish resources, coupled with the conspicuous improvement of the Dutch army and the strategic skill of its leaders, eventually enabled the seven provinces comprising the northern and western regions of the Low Countries (Holland, Zeeland, Utrecht, Groningen, Overijssel, Gelderland, and Friesland) to wrest their freedom. The southern areas gradually reverted to Spanish control and became known as the Spanish Netherlands or Flanders. A twelve-year truce was inaugurated in 1609 that effectively recognized the de facto independence of the seven provinces, which became known as the Dutch Republic.

The turn of events that led to the separation of the North and South was partly the result of longstanding differences in the social, religious, and economic conditions within the two regions. Simply stated, the South, with its substantially larger numbers of Catholics, urban patriciate, and noblemen, was less forcefully opposed to the Spanish monarch. Furthermore, many of its prominent citizens resented the decisive role that militant Protestants from the North had played in the rebellion. Rather than endanger their possessions and lives, southern elites preferred to negotiate with a king who shared their faith. Moreover, the largely indefensible topography of the South – versus the low-lying North with its natural river barriers – undoubtedly contributed to their trepidation.

Though founded in a period of tremendous tumult, the Dutch Republic, alternatively known as the Netherlands or the United Provinces, rapidly developed into one of Europe's premier powers. Dutch political, social, and religious institutions of the seventeenth century, the Golden Age as it is often called, were not unique, though they were certainly unusual.[2] And while they contributed to the country's astonishing success internationally they were, paradoxically, sources of continual domestic tension. What were some of the general characteristics of seventeenth-century Dutch society?

Over the years many historians have studied the country's complex social organization during the seventeenth century. As a result, traditional views of Dutch society as collectively bourgeois, namely, composed principally of middle-class burghers, demands some modification.[3] The seventeenth-century designation burgher, denoting citizenship for those of appropriate social standing, was remarkably fluid, purely local (as opposed to national, which is only logical given the stiff commercial competition between Dutch cities), and invoked or revoked for politically expedient ends.[4] More significantly, bourgeois, as a contemporary term, referred not so much to members of a specific urban class but rather to a community of persons who manifested desirable behavior, thereby excluding those members of the lower echelons of society in the process.[5] In essence then the population of the Dutch Republic, like that of other European nations, was socially stratified, its "divisions" defined not only by income but especially by such behavioral and communal desiderata as honor, civility, and good breeding.[6]

Scholars have examined the social hierarchy of Dutch society on the basis of such factors as profession, annual income, and

social background.[7] At the very bottom of the social ladder were the unwashed masses – peddlers, beggars, and the peasantry – struggling to eke out a living. Above these impoverished folk were a class of poorly educated persons whose employment as sailors, servants, and the like garnered them less than 300 guilders a year. Next came those earning between 350 and 500 guilders annually – minor bureaucrats, clerks, farmers, small traders, skippers, and so forth. Higher than this group were petty burghers: simple craftsfolk, affluent farmers, keepers of more modest shops, and guild masters whose yearly income reached 500 to 600 guilders. Superior to these were middle burghers – successful merchants, craftspeople, and shopkeepers – who earned between 600 to 1000 guilders per year. The uppermost group, the elite, consisted of members of the nobility, non-noble patrician families and their office-holding counterparts, the regents, wealthy entrepreneurs, and important officials, whose annual incomes exceeded 1000 guilders.[8] As the seventeenth century progressed, constituents of this latter circle became the principal clientele for many of the highest quality genre paintings, pictures traditionally but perhaps too often mistakenly identified with middle-class owners.

It was members of the elite, specifically the regents, who served on the town councils, municipal bodies that governed the heavily urbanized Dutch Republic's cities. This system was only superficially democratic as the regent class was a relatively closed, oligarchic group; invariably, a select number of families dominated politics and nepotistically appointed their kinsmen to key posts. Regents also served the provincial assemblies, called States. Each of the country's seven provinces were overseen by their respective States, which consisted of delegates from the province's major cities in combination with the *ridderschap*, prominent men representing the small towns and nobles the surrounding countryside. If the seven provincial States can be likened to state assemblies in the United States today so can the national governing body, the States General, to the American Congress. In theory, representatives of the seven provinces met as equals in the States General to forge policy collectively. But in reality the Province of Holland dominated national politics.[9] As the country's most populous and affluent province, Holland had effectively led the Revolt. Furthermore, the other six provinces, despite their resentment and frequent resistance, relied upon powerful Holland to maintain the nation's unrivaled economic supremacy.

Overseeing the entire governmental process was a Stadholder (*Stadhouder* in Dutch, literally meaning "city-keeper") a political position unique to the Dutch Republic.[10] During the early sixteenth century, the Holy Roman Emperor (and King of Spain) Charles V had appointed three Stadholders to administer the region. Traditionally then the Stadholders were representatives of the Spanish overlords. However, with the advent of the Revolt and protracted war against Spain, the Stadholders emerged as the

leaders of the nation, particularly in their capacity as commanders of the Dutch military. In fact, the Stadholder William the Silent, who was assassinated in 1584, figured prominently in the initial stages of the struggle and is still revered today in a manner not dissimilar to George Washington in the United States. Throughout the seventeenth century (with the exception of the Stadholderless period of 1650–72), William the Silent's descendants dominated the Stadholderate. William the Silent (in office 1572–84), his son Maurits (in office 1585–1625), his other son Frederik Hendrik (in office 1625–47), Frederik Hendrick's son William II (in office 1647–50), and William II's son, William III (in office 1672–1702) were all Stadholders representing successive generations of the august House of Orange with ancestral possessions in the Netherlands, Germany, and southern France – hence the Stadholders from this illustrious family were also known as the Princes of Orange.[11]

In essence the Stadholder was the highest ranking political representative of each province, charged with supervising political processes (including the appointment of officials) and administering justice. And since the same Stadholder was elected to his position in a majority of the provinces he became a key player in national politics. The Stadholder also served as captain-general of the army, a position that several held with distinction, particularly in times of national crisis. Lastly, the Stadholder was empowered to uphold the Reformed Church, the official public church of the Netherlands. Needless to say, the Stadholders seized many opportunities to expand their powers. In this respect, they were often opposed by the regents, the aforementioned political leaders on the municipal, provincial, and national levels, who stridently advocated each province's sovereignty.

The struggles pitting the Stadholders or Princes of Orange and their supporters (known as Orangists) against the regents and their advocates (called the States Party) were legendary. What made them especially so was the inextricable entwining of religion with their disputes. In general the Princes of Orange were supported by orthodox Calvinists comprising the Reformed Church; although the religious convictions of the Stadholders were typically half-hearted they shrewdly espoused the cause of the orthodox Calvinists when it proved politically expedient to do so. Those who were theologically more liberal (along with members of other religious groups) tended to oppose them. However, it would be simplistic to define the friction between the Orangists and States Party supporters as one of "church conservatives" versus "religiously liberal politicians," for some members of the regency – despite their traditional identification as liberals – were spiritually orthodox and consequently served on church consistories (assemblies of deacons and elders who administered discipline for the Reformed Church) in addition to their work on town councils. When examining political and theological strife in the Dutch Republic it is therefore more accurate to speak of factions, as members of every social strata

potentially held conflicting views – tensions ran "vertically" through Dutch society as opposed to "horizontally." It was the relative strengths and weaknesses of these factions that would dictate the success or failure of the Reformed Church to influence the country's social and cultural life.

Calvinism had played a fundamental part in the Revolt. It had aroused Philip II's ire and was the faith championed by many Dutch militants in their struggle against this dogmatic Catholic despot. Calvinism therefore emerged victorious throughout the land itself as other creeds, principally Catholicism, were suppressed. Moreover, Calvinism was recognized as the official ideology of the State and its church, the Reformed Church, the sole official manifestation of religion.[12] In this sense then, the Reformed Church adopted the role of a public church. But a number of factors prevented the Reformed Church from becoming an "established church," that is, one invested with the imprimatur to regulate mores on every conceivable social and cultural level. Although the Calvinists very slowly became the largest religious group in the country, the population always remained religiously heterogeneous or, phrased differently, multi-confessional. Moreover, unlike official Protestant denominations in other European countries the Reformed Church could not enforce church attendance nor did it enjoy direct representation in any governing body.

The aforementioned city leaders provided another check upon the Reformed Church's influence. They were generally dedicated to the maintenance of peace and order, to tolerance as opposed to the imposition of religious and moral uniformity.[13] The church therefore occupied an ambiguous position as a public institution throughout the Netherlands: it was upheld by civic authorities yet these very same authorities, regardless of their own personal religious convictions, were faced with the vexing reality of having to govern and placate a religiously and morally diverse populace. Far from presenting a theocratically united front, the church and government were frequently at loggerheads in their outlook on public morality. Municipal officials often refused to come to the aid of the Reformed Church in its struggle against perceived turpitude.

The complicated political and theological aspects of Dutch society affected the course of the nation's history virtually from the outset. Already during the first years of the seventeenth century, a notoriously vehement struggle arose between the so-called Remonstrants and Counter-Remonstrants.[14] It all began seemingly innocently enough as a theological dispute between two faculty members at the University of Leiden concerning predestination, the Calvinist doctrine that the Almighty has foreordained mankind's salvation or damnation. The Remonstrants, followers of the theologian Jacobus Arminius (1560–1609) took a more flexible view of predestination, arguing in favor of man's autonomy in choosing whether or not to accept God's gift of salvation. The Counter-Remonstrants adhered to the orthodox

Calvinist teachings of Arminius's adversary, Franciscus Gomarus (1563–1641), who espoused a rigid interpretation of predestination which precluded autonomous choice.

This quarrel rapidly evolved into an epic politico-theological struggle which threatened to tear Dutch society asunder. Living today in a highly secular culture one might consider the intensity of this conflict preposterous, but in order to appreciate its true gravity one must continually recall the degree to which religion and politics were entwined in the Dutch Republic. In this sense, the struggle between the Remonstrants and Counter-Remonstrants was classic. The more elastic or liberal stance of the Remonstrants, given the inherent political tensions outlined above, appealed to many members of the regent class, especially in the Province of Holland. As States Party proponents, many regents asserted the authority of the State over the church as a guarantor of individual liberty in matters of faith.

This view was championed by Holland's leading political and legal administrator, its Advocate, a position held by Johan van Oldenbarnevelt (1547–1619). As Advocate of the most powerful province van Oldenbarnevelt was, in effect, the leader of the entire Republic and in this position was challenged by the principal Stadholder (who succeeded to the title Prince of Orange in 1618), Maurits.[15] Maurits in turn was steadfastly supported by the Counter-Remonstrants, who were mainly Orangists willing to overlook his religious apathy because he opposed many of van Oldenbarnevelt's policies, including the truce of 1609 with the Spanish. In essence then the confrontation between Remonstrants and Counter-Remonstrants involved much more than religion: at its core were fundamental disagreements over Church–State relations, the conduct of the war with the Spanish, and, related to these issues, the relative roles of the Stadholder and the Province of Holland in leading the nation.

Maurits shrewdly recognized the political gains to be made, siding with the Counter-Remonstrants in their opposition to van Oldenbarnevelt as it would ultimately enable him to neutralize Holland's dominant position in national politics. The entire controversy reached its climax in 1618 as van Oldenbarnevelt attempted to engage specially raised troops to quell Counter-Remonstrant unrest in cities in the Provinces of Holland and Utrecht governed primarily by Remonstrant regents. Maurits intervened and disbanded these troops, purged the governments of the Remonstrant towns, and arrested van Oldenbarnevelt and his closest supporters. Ironically, after having spent much of his adult life in the service of his country, van Oldenbarnevelt was beheaded for treason in 1619.

With van Oldenbarnevelt's execution, the Stadholder gained control of the Dutch Republic, thereby subordinating the hitherto preeminent Province of Holland. Maurits also abolished Holland's office of Advocate, replacing it with that of a Pensionary whose more limited powers could not challenge his.[16] Yet despite Maurits's consolidation of power, escalating

domestic and international tensions effectively paralyzed his regime. In 1618 the Thirty Years War erupted in Bohemia. Since the Netherlands was now the mainstay of orthodox Calvinism in Europe Maurits was constrained to support the Bohemian Protestants financially and militarily. Unfortunately Protestant defeats in Bohemia and in Germany would bring the Dutch Republic's implacable enemies, the Catholic Hapsburgs, to the very eastern borders of the country. Meanwhile the twelve-year truce with Spain expired in 1621. Confronted by a potential threat on the eastern frontier, continued politico-theological strife, and the opposition of several provinces to continuing the war, Maurits temporized by making peace overtures to Spain in an attempt to forestall the resumption of hostilities. But after an initial period of uneasy calm, the Spanish resumed their offensive campaigns, targeting several cities on the Dutch border.

The renewal of the war initially had devastating consequences for the Dutch Republic as it stretched financial resources to their limit and severely disrupted the economy. Compounding the problem was Maurits's inability to enlist the full financial and military support of that most indispensable province Holland, which he had humiliated in 1618. The Counter-Remonstrant regents that Maurits had appointed to control Holland's most important cities simply lacked the administrative skills and experience of their ousted predecessors. Moreover these municipal governing bodies experienced deepening political and theological rifts with the gradual resurgence of Remonstrant regents. In sum, the system of rule that Maurits had inaugurated with his coup in 1618, which amplified the Stadholder's powers at the expense of Holland's, was inherently doomed to failure. By the time Maurits died in April 1625 the Dutch Republic found itself in dire military, political, and economic straits.

Upon his death, Maurits's half-brother, the new Prince of Orange, Frederik Hendrik assumed command of the army and eventually the Stadholderate – he first had to be confirmed by each of the seven provinces.[17] Faced with a precarious military situation and the resurgence of Counter-Remonstrantism in domestic politics, Frederik Hendrick proceeded cautiously. He skillfully managed to appease both Remonstrants and Counter-Remonstrants while awaiting an improvement in Dutch military fortunes. Fortunately the huge costs of conducting the sieges of Breda and Bergen-op-Zoom forced the financially strapped Spanish to curtail their campaigns completely, and the eruption of war in Mantua in 1628 further diminished their fighting capabilities in the Netherlands as troops were diverted to northern Italy.

The shift in Spanish strategy and increased backing from the French and English compelled Frederik Hendrik to go on the offensive. However domestic support for his military endeavors was not automatic – the politico-theological factions unique to the Dutch Republic prevented this from ever being so. Frederik Hendrik quarreled over the size of the army and its funding with the resurgent regents of Remonstrant leanings who had gained ascendancy in a number of Dutch cities, principally those in the Stadholder's nemesis, the Province of Holland. These States Party regents were anxious to reassert their province's sovereignty by, among other things, curtailing the war effort to which they had hitherto contributed tremendous amounts of money. They consequently clashed with Frederik Hendrik over their desire to reduce the standing army and its funding, which would severely impede his capacity to wage offensive warfare.

By 1633 circumstances forced Frederik Hendrik to side openly with the Counter-Remonstrants. Even though these Orangists were deeply dissatisfied with Frederik Hendrik's commitment to religious tolerance, they nevertheless supported him strongly as he indefatigably pressed forward with the war effort since for them any compromise with Catholic Spain and the Spanish Netherlands was anathema. In a series of offensives and counteroffensives conducted during the 1630s, Frederik Hendrik's armies battled for control of a number of important cities along the border, among them Breda (which was retaken in 1637), in an effort to secure the frontier as an outer defensive ring for the Republic. In May 1635 France declared war on Spain which essentially committed the United Provinces to a joint invasion of the Southern Netherlands with their new allies. This invasion proved a fiasco militarily and increased political tensions at home.

Negotiations to end the lengthy war with the Spanish began in 1641 in the German cities of Münster and Osnabrück. During these protracted deliberations, which began to make credible progress only after 1644, the Province of Holland became increasing assertive, attempting to influence the terms of any potential treaty. Frederik Hendrik's declining health did not help his position either but he did endeavor to gain some final military triumphs before peace ensued despite Holland's stubborn insistence on decreasing overall military expenditures. The Prince of Orange's death in early 1647 and the cessation of hostilities with the official ratification of the Treaty of Münster in 1648 all but restored Holland's foremost position within the Dutch Republic. But, as is discussed in Chapter 5, this self-assured province's ascendancy and that of States Party advocates throughout the country would initially prove to be only temporary.

★ ★ ★

The period under discussion in this first part of the book, 1609–48, was one in which the de facto independence of the Dutch nation was recognised, serious religious and political strife occurred, and the hiatus in the war with the Spanish ended. Yet in terms of the development of Dutch genre painting these events, however consequential, were overshadowed by the effects

of two additional, related phenomena which were particularly influential in the Provinces of Holland and Zeeland: the flourishing economy and the massive waves of immigration. The aforementioned improvement in the military fortunes of the Dutch which occurred during the 1590s served to stabilize the United Provinces. This factor and others, including Philip ii's ill-advised decision to repeal his embargo on Dutch shipping in the Iberian peninsula; the continued blockade by the Dutch navy of the coast of the Spanish Netherlands; and the reopening of water routes to Germany all contributed to what has been termed the economic miracle of the 1590s.[18]

But most fundamental was the rise of the so-called rich trades and their supporting industries, namely, commerce in spices, sugar, silks, dyestuffs, wine, and the like. Indeed, the Dutch Republic would rapidly develop into the hub for international traffic in such commodities, a predominant position that it would not relinquish until the middle of the eighteenth century. Furthermore as a seafaring nation it would extend its trade during this period to the far reaches of Asia and the Americas through the auspices of the renowned Dutch East India and Dutch West India Companies. The rise of the rich trades and the resultant decline in the traditional Dutch bulk-carrying industries (for example, transporting freight such as grain and timber) had propitious consequences for the country's prosperity and for the very nature of its society and culture. The resumption of hostilities with the Spanish in 1621 generated a recession which would linger into the early 1630s but its most deleterious effects were offset by inland trade with Germany, a strong agricultural sector, and the flourishing textile industries in Haarlem and Leiden (see Chapters 2 and 8).[19]

The long-term success of the rich trades, so critical to making the United Provinces the commercial envy of Europe, was sustained by the vast influx of immigrants from the Southern Netherlands beginning in the late 1570s.[20] Thousands of immigrants fled the growing Spanish reoccupation of their native region by relocating in the North. Their reasons for emigrating varied: although many became refugees because of their religious convictions – as devout Calvinists they were no longer welcome in their re-Catholicized hometowns – still others departed for the Dutch Republic because it offered promising commercial opportunities that did not exist in the economically ravaged South. The majority of these émigrés were successfully absorbed into the Dutch economy because they possessed specialized skills in processing the types of costly goods trafficked by the rich trades. The presence of large numbers of southern immigrants in the Dutch Republic was consequently critical for the transformation of its economy and the explosive growth of its urban centers. These immigrants, who were often affluent, literate, and urbane, likewise wielded great influence on Dutch culture (see further Chapter 2).

The successive waves of immigration also brought many artists to the Netherlands. It has been estimated that some 228 painters emigrated between 1580 and 1630, though not all of these were artists who practiced the art of painting in the creative sense that it is understood today.[21] Nevertheless as a direct result of immigration, the number of bonafide artists active in the Dutch Republic quadrupled during the first two decades of the seventeenth century.[22] The auspicious combination of a surge in the number of master painters and a booming economy – indeed the two phenomena were interdependent – profoundly affected Dutch painting and the art market for years to come. As shall be discussed, the fertile economic and cultural atmosphere of the Netherlands during the first two decades of the seventeenth century provided ideal conditions for artists to introduce numerous thematic and stylistic innovations that served to increase their output and the very marketability of their works. In fact, the demand for pictures of varying quality and cost became so great that one can rightly speak of the Dutch Republic as Europe's first mass market for such luxury consumer goods.[23]

Flemish artists played a pivotal role in the dissemination of both traditional and innovative painting styles and themes within the United Provinces.[24] The authoritative position of these artists is hardly surprising given the celebrated heritage of Flemish art. The cosmopolitan, Flemish city of Antwerp was the indisputable center of painting in Northern Europe during the sixteenth century – by comparison Dutch cities such as Amsterdam, which would prove so consequential for seventeenth-century developments (see Chapters 3 and 12), was a veritable artistic backwater. But it would be reductive to view the relationship between native Dutch artists and their new colleagues as one in which the former slavishly imitated the latter, thereby remaining in a quasi-permanent state of dependency upon superior Flemish masters for inspiration. To the contrary, native artists integrated Flemish paradigms into their own work, and gradually developed, along with their new immigrant colleagues, an art that was distinctively Dutch.

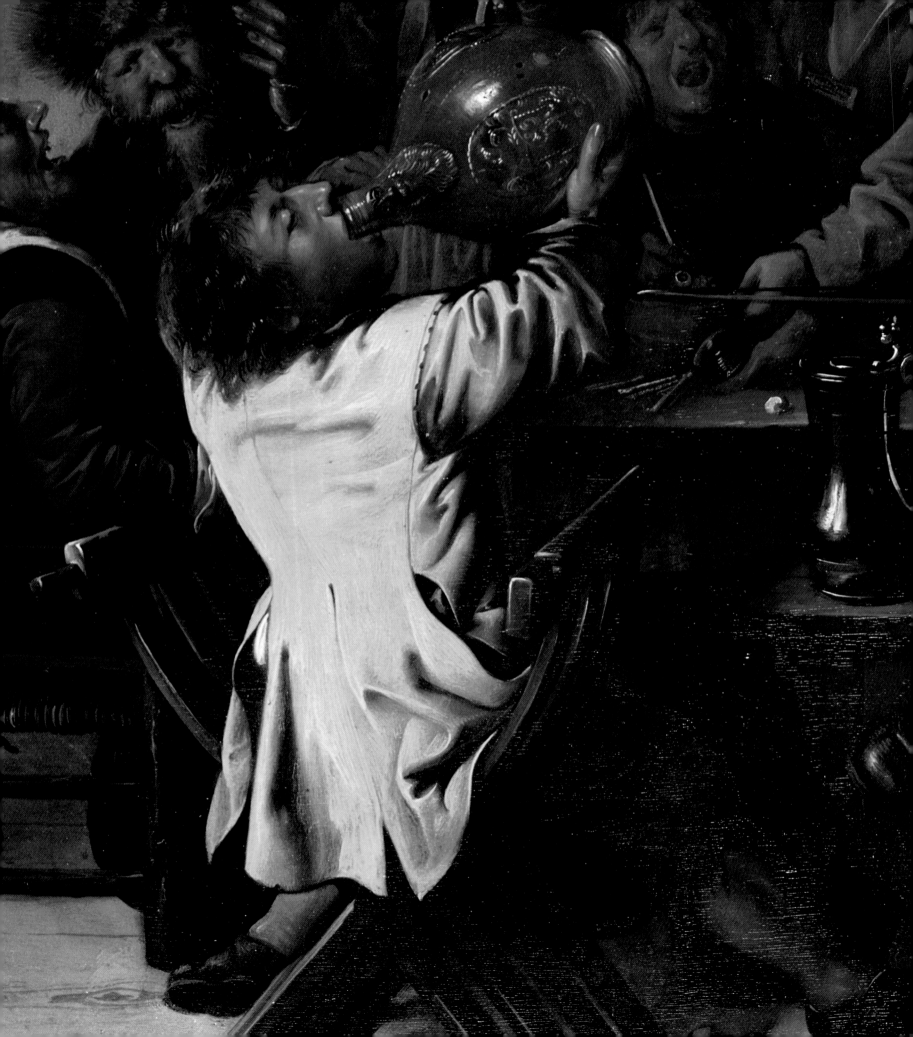

CHAPTER TWO

HAARLEM

During the early decades of the seventeenth century, artists working in the cities of Haarlem and Amsterdam played crucial roles in the evolution of Dutch genre painting. That these specific cities were pivotal for early seventeenth-century developments has much to do with the revival of the Dutch economy and the related phenomenon of immigration outlined in the preceding chapter. Haarlem in particular had been despoiled during the late sixteenth century.[1] It had been sacked by the Spanish army in 1573 after a prolonged and particularly brutal siege. A devastating fire set by Spanish troops in 1576 exacerbated already deplorable conditions there by destroying a huge swath of the city. By the end of the 1570s, Haarlem, though finally free of its foreign occupiers, was languishing economically and its population had sharply declined to roughly 20,000 inhabitants. But this truly dismal situation felicitously changed as the military fortunes of the Dutch Republic improved and propitious conditions were established for the "economic miracle" of the 1590s (see Chapter 1).

Throughout the last two decades of the sixteenth century many of Haarlem's traditional industries were resuscitated. The beer-brewing trade, for example, boomed and by 1623 there were over fifty breweries operating in Haarlem, supplying premium beer to many cities in the Provinces of Holland and Zeeland. Shipbuilding and majolica production likewise flourished. As important as these enterprises were to reviving Haarlem's economy, they paled in comparison with the explosive growth of industries involving the production and processing of wool and flax. The city's many weaving businesses and those that bleached linen (made either from local flax or imported from other cities and countries) employed literally thousands of workers and secured Haarlem's international reputation as a woolen cloth and linen manufacturer.[2] During the late sixteenth century Haarlem also began to produce textiles of even finer quality such as damasks. Skilled weavers and businessmen who immigrated from Flanders where the cloth industry had virtually collapsed owing to the war, were chiefly responsible for establishing this extremely lucrative trade in their adopted city.

With the influx of immigrants and the economic revival, Haarlem's population doubled to approximately 40,000 inhabitants by 1622, as the city reached its economic apogee.[3] However, cost-cutting measures on the part of textile manufac-turers, increased commercial competition from other towns (particularly Amsterdam) in the heavily urbanized Netherlands, and the general recession induced by the renewal of the war with the Spanish after the twelve-year truce would gradually sap Haarlem's entrepreneurial vigor, initiating a slow but steady decline that accelerated in the latter half of the century.

Haarlem's prosperity during its most economically robust decades naturally attracted immigrant artists from the South who astutely recognized the city's market potential.[4] But they were drawn also by Haarlem's renown as an art center. Indeed, the town's artistic past was illustrious; during the late fifteenth century and throughout the sixteenth century the presence of such renowned masters in the city as Geertgen tot Sint Jans (active c. 1475–95) and Maarten van Heemsekerck (1498–1574) had legitimized Haarlem's status as the most important metropolis for art in the Northern Low Countries. And, as shall be discussed, Haarlem retained its reputation in this regard during the earliest years of the Dutch Republic. Around 1584, Karel van Mander (1548–1606; best remembered today for his *Schilderboeck* [Painter's Book] of 1603–4 with its valuable biographies of Netherlandish painters), Cornelis Cornelisz. van Haarlem (1562–1638), and Hendrick Goltzius (1558–1617), founded a short-lived art academy in the city.[5] Unfortunately, little is known about the academy's purpose. Nevertheless, it probably served as a site for artistic study and collaboration. Van Mander, van Haarlem, and Goltzius were all outstanding practitioners of the intricate, virtuosic Mannerist style (fig. 2) and their presence in Haarlem undoubtedly influenced the decision of many Dutch and immigrant Flemish artists to settle there. The auspicious combination then of a booming economy and reputation for art explains the lure of Haarlem for many painters. This likewise accounts for the eightfold increase in the number of artists working in the city between 1605 and 1634.[6] Collectively, these painters enabled Haarlem to become one of the most innovative towns for Dutch genre painting during the early seventeenth century.

As shall be discussed in Chapter 3, Amsterdam also played a leading role in the development of genre painting during these critical years. A mere twelve miles separated it from Haarlem, a scant distance easily traversed by the horse-drawn, passenger barge line established between them in 1631–2.[7] Thus the proximity of the two metropolises greatly facilitated exchanges between their

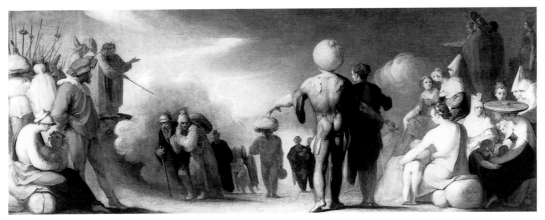

2　Cornelis Cornelisz. van Haarlem, *Crossing of the Red Sea*, 1594 (oil on panel, 42 × 103 cm). Princeton, Princeton University Art Museum, Museum Purchase, Gift of George L. Craig, Jr., Class of 1921, and Mrs. Craig.

leading artists. Nevertheless, Amsterdam would inevitably eclipse Haarlem as a major site of artistic developments.

Esaias van de Velde, Frans Hals, Willem Buytewech, and Dirck Hals

Early seventeenth-century Haarlem was alive with artistic activity, but the presence of the Mannerist painters and their intricate, virtuosic history paintings (that is, representations of biblical, mythological or historical subjects) had scant influence upon the younger generation of genre painters. However, these older artists may have provided some precedents for their younger colleagues in the form of drawings, many of which must have been taken from life, and even an occasional painting (fig. 3), the latter surely ranking among the earliest genre pictures produced in the Dutch Republic. Moreover, Goltzius in particular provided a number of designs for allegorical engravings with pronounced genre-like features.[8] But any potential influences stemming from these sources were undoubtedly filtered through the persistent, seemingly immutable impact of sixteenth-century Flemish art.

This can be seen in the work of Esaias van de Velde (1587–1630) who although born in Amsterdam was the son of Flemish immigrants who had fled Antwerp because of religious persecution in 1585.[9] Van de Velde was initially trained by his father, the artist and art dealer Hans van de Velde (1552–1609), and may have continued his education with the prominent landscape painter and Flemish refugee Gillis van Coninxloo (1544–1607) as well as with David Vinckboons (see Chapter 3), whose genre paintings share many affinities with his. Upon his father's death in 1609, van de Velde moved with his mother to Haarlem and eventually became a member of the city's Guild of St. Luke (the painters' professional trade organization) in 1612. There he enjoyed a brief but distinguished career primarily as a landscapist, producing also a number of important genre paintings. In 1618 he moved to The Hague, undoubtedly drawn by

the employment opportunities in this moneyed city which housed the Prince of Orange's court.

Van de Velde's genre production consists chiefly of the elegant alfresco parties of the type popularized by Vinckboons – whose influence upon van de Velde is therefore beyond dispute, regardless of whether the slightly older artist had actually served as one of his teachers. Yet van de Velde's decision to devote most of his genre art to representations of this theme must have been dictated to some extent by the demands of the art market. It is likely that he played a pivotal role in establishing the theme within the repertoire of Haarlem artists, perceptively anticipating the potential appeal of "garden parties," with their Flemish pictorial lineage, in this prosperous metropolis with a burgeoning immigrant population.[10]

Depictions of outdoor revellers are today most often called "love gardens" or "garden parties."[11] However, an inventory listing of 1627 yields possible insights into how seventeenth-century beholders identified them: in it, a painting by van de Velde is recorded as "a little piece depicting a *plaisance*."[12] This term, of obvious French derivation, had been invoked in the sixteenth century to describe Flemish tapestries representing gardens of love. From this fascinating link in terminology it can be inferred that seventeenth-century audiences perceived a relationship between paintings of garden parties and earlier depictions of related subject matter, one in fact long recognized by art historians.

Van de Velde's earliest dated *Garden Party* was painted in 1614 (fig. 4). Its setting owes much to Vinckboons's work (see fig. 44), with its large arbor and splendid palace – a fantastic edifice with no equivalent in actual Dutch architecture of the period – looming in the distance. However, a neatly cultivated formal garden replaces the lush, bosky settings more typically found in the older artist's work. Moreover, the figures themselves, in comparison with those by Vinckboons, have shed their dainty anonymity, metamorphosing into stocky, somewhat more individualized young citizens of the United Provinces. These figures also act with an air of sophisticated restraint generally absent in

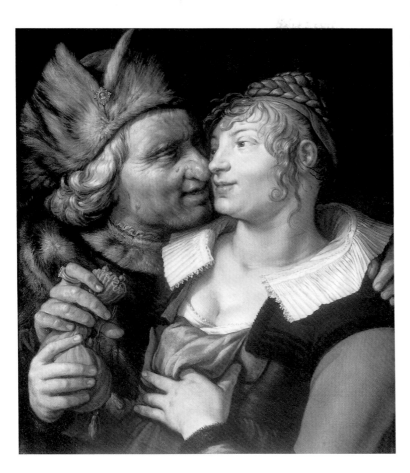

3 (*left*) Hendrick Goltzius, *Unequal Lovers*, 1615 (oil on canvas, 68.5 × 58.5 cm). Private collection.

4 (*below*) Esaias van de Velde, *Garden Party before a Palace*, 1614 (oil on panel, 28.5 × 40 cm). The Hague, Mauritshuis.

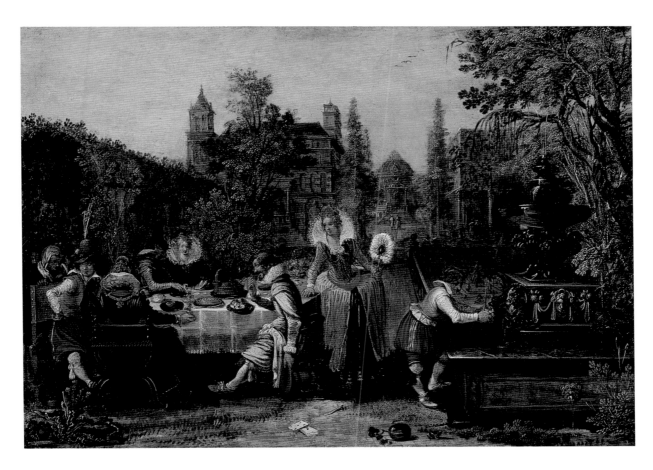

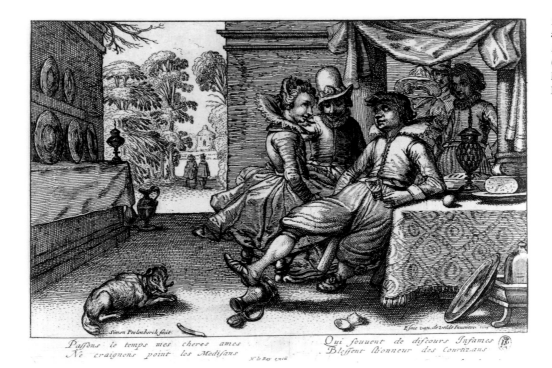

5 Simon Poelenburch after Esaias van de Velde, *Banquet on a Terrace*, 1614 (etching). Rotterdam, Museum Boijmans Van Beuningen.

many earlier depictions of garden parties. In essence van de Velde, like Vinckboons, has taken a highly conventional theme with centuries-old Flemish roots and introduced his own modifications into its representation.[13]

Van de Velde made a further adjustment by including the fascinating motif of an elderly hag who peers over the shoulder of the seated reveller at the far left. This enigmatic crone would have been recognized immediately by seventeenth-century spectators as a procuress. Procuresses figure prominently in contemporary depictions of prostitution, where they guide the affairs of the concubines in their employment (see Chapter 4 and fig. 59). The presence of a procuress here suggests that the activities and identities of the youthful and dashing figures are probably less than wholesome. An etching based on a van de Velde design, likewise dated 1614, corroborates this interpretation as its French inscription playfully repudiates those slanderers who object to the gathering of young men and prostitutes (fig. 5).[14] Thus van de Velde's garden party potentially conveyed negative, admonitory connotations for certain viewers.

While there seems little doubt that some contemporaries viewed this *Garden Party* as an image of reckless dissolution, other pictures of the theme were construed as scenes of innocuous, youthful merriment with the garden an appropriate place to congregate, as so much of the amatory literature suggests. This raises the issue of artistic intention versus audience reception; approaching garden party imagery from the latter standpoint allows us to address more adequately and accurately the complexity of seventeenth-century Dutch culture. Contemporary audiences must have understood representations of this

theme – and for that matter, most genre paintings – on various levels, contingent on a number of governing factors, among them the inherent degree of conventionality within the scene portrayed and, most significantly, the beholder's level of education, social status, depth of religious conviction, and, in relation to the latter, the degree to which he or she conformed to the normative value system.[15]

Contemporary literature confirms the capacity of Dutch art to evoke multivalent associations for its audiences. Several texts provide variations on an amusing anecdote of a peasant and a member of the upper classes who reach strikingly different conclusions about a history painting featuring nudity which they jointly examine. This socially odd couple appear in an illustration from an anonymous miscellany of poems, quips, and songs published in Amsterdam in 1654–5 (fig. 6). Here the peasant interacts with an affluent Walloon, that is, a French-speaking immigrant from the Southern Netherlands, as they peruse a painting of Venus and Adonis.[16] The author of the accompanying verses, David Questiers, exploits current prejudices toward supposedly stupid peasants and haughty immigrants to concoct a witty poem with crude wordplay hinging upon misunderstandings of the painted scene they behold. But most importantly for our purposes, Questiers's doggerel is grounded in the axiom that viewers have inherently different responses to artworks.[17]

To return to van de Velde, more ambitious than his *Garden Party* is his large *Banquet in the Park of a Country House* of 1615 (fig. 7). The artist has represented a small but impressive house in park-like setting with a heavily foliated, arched entrance. Most of the brightly clothed protagonists are depicted to the right,

6 (*right*) Illustration from *Olipodrigo of nieuwe kermis-kost*. Amsterdam, 1654–5. Amsterdam, Universiteits-Bibliotheek Amsterdam.

7 (*below*) Esaias van de Velde, *Banquet in the Park of a Country House*, 1615 (oil on canvas, 80.5 × 128 cm). Private collection.

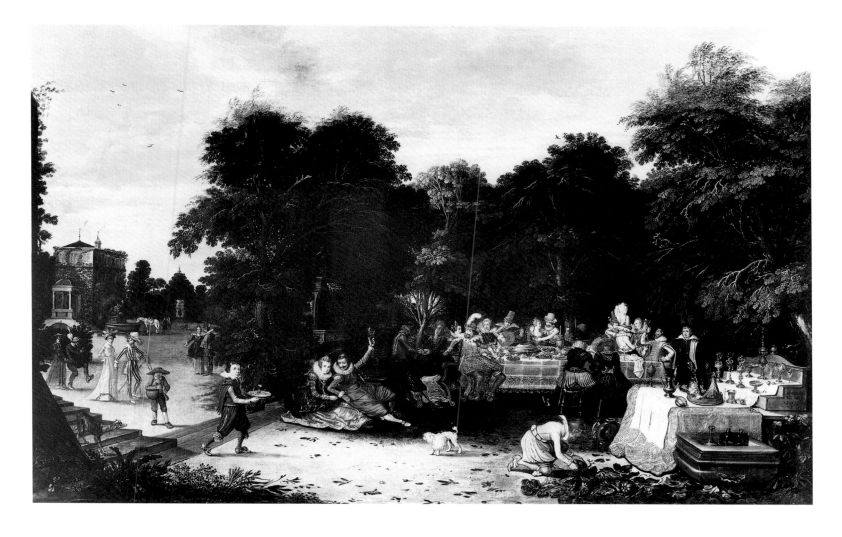

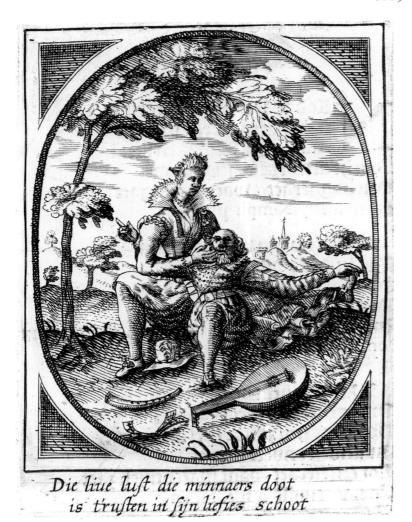

*Die liue luft die minnaers doot
is trusten int sijn liefies schoot*

where they mingle, play music, and toast one another while enjoying a truly epicurean banquet within the semi-enclosed confines of a wooded area. This sylvan setting appears ceaselessly in contemporary art and it is perhaps not coincidental that the woods south of Haarlem were highly praised by none other than van Mander as a site to "refresh the spirit [by] eating, drinking, playing, reading, and singing undauntedly."[18] (Ironically, these very same woods had been decimated during the Spanish siege and replanted in a systematic manner that was anything but "natural."[19]) Unlike the *Garden Party*, this picture emphasizes inoffensive, fashionable pleasures of a type extolled in contemporary songbooks – consider for example, the toasting man in the left foreground leaning against his beloved's lap, a pose that resembles songbook illustrations (fig. 8).[20] The possible connections with amatory literature and the actual leisure practices of Haarlem's citizens aside, what is most striking about van de Velde's imagery is its derivation from the art of Vinckboons and earlier Flemish painters, hence its conventionality. As is demonstrated in Chapter 5, van de Velde gradually altered his approach to genre painting after his move to The Hague in 1618 in an effort to satisfy the tastes of highly sophisticated clientele associated with the court of the Prince of Orange.

Van de Velde had arrived in Haarlem in 1609, the year before Frans Hals (*c.* 1582/3–1666), one of the greatest painters of the Golden Age, enrolled in the local Guild of St. Luke.[21] While still a young child, Hals had emigrated to the North with his parents from their native Antwerp, settling in Haarlem by 1591. A note in the second, posthumous edition of van Mander's aforementioned *Schilderboeck* (1618) informs us that Hals was the author's pupil; this period of training must have occurred before 1603,

8 (*above left*) Illustration from W. I. Stam, *Cupido's lusthof*, Amsterdam, 1613. The Hague, Koniklijke Bibliotheek.

9 (*left*) Frans Hals, *Banquet of the Officers of the St. George Militia Company*, 1616 (oil on canvas, 175 × 324 cm). Haarlem, Frans Hals Museum.

10 Frans Hals, So-Called *Jonker Ramp and His Sweetheart*, 1623 (oil on canvas mounted on panel, 105.4 × 79.2 cm). New York, The Metropolitan Museum of Art, Bequest of Benjamin Althman, 1913 (14.40.602).

the year that van Mander left Haarlem. A true specialist, Hals worked primarily as a portraitist during his lengthy career; nearly eighty percent of his œuvre consists of portraits of varying sorts, including several celebrated depictions of Haarlem's two militia companies (fig. 9). Yet despite his success as a portrait painter Hals was plagued with financial problems throughout his life and, as many documents reveal, he was regularly sued for non-payment of long-overdue bills, for even the most simple goods.[22]

Before he started to focus solely on portraiture, by about 1640, Hals executed a number of impressive genre paintings. The so-called *Jonker Ramp and His Sweetheart* (fig. 10) is characteristic of these and reveals much about his influential style.[23] The picture is dated 1623 and was therefore painted some seven or eight years after the artists's initial forays into genre painting.[24] In contrast to the frequently crowded compositions and bright palette of those earlier works, *Jonker Ramp and His Sweetheart* displays marked clarity and monumentality as two, large-scale figures placed in a diagonal composition dominate the canvas. The primacy of the figures over the setting creates a quite different effect than, say, the diminutive denizens who scurry to and fro within expansive spaces in paintings by van de Velde. This novel compositional approach appears in the work of other artists of Haarlem and Amsterdam at this time as both of these important artistic centers established the formal foundations upon which later genre painters would build.

Hals's color scheme has likewise changed fundamentally; the brilliant if not shrill palette of his earlier genre paintings has been superseded by one composed principally of cooler tonalities in which fine gray tints and silvery blues predominate. That the painting exudes a certain *joie de vivre* is undeniable, an ambience imparted by the joyous expressions of the male and female and by their emphatic gestures. Moreover, the master's extraordinary brushwork plays an important role in establishing the vivacious mien of his paintings. Hals applies paint boldly to his surfaces with swift strokes of his brush. His application is therefore loose. The initial impression it conveys is one of a mass of disconnected brushstrokes, the surfaces of his works optically cohering only at a distance. Evidence of Hals's remarkable technique, which grew more sophisticated as he matured, is best seen in *Jonker Ramp and His Sweetheart* in the faces of the figures, composed of broad, spirited passages of pinks and flesh tones, as well as daring strokes of impasto. This technique enlivens the surface tremendously and in combination with the exuberant countenances of the figures bestows upon them an uncanny vitality.

While the style of Hals's painting is easy to appreciate, its subject matter is more difficult to grasp. The artist has represented a convivial couple whose boisterous demeanors almost suggest intoxication – the male in particular is captured in a moment of rowdy toasting. A sufficient amount of the background has been depicted to deduce that it represents a tavern; Hals has even included the innkeeper who beams at this unruly

11 Title Page from W. D. Hooft, *Heden-daeghsche verlooren soon*, Amsterdam, 1630. The Hague, Koninklijke Bibliotheek.

couple. The setting, the questionable activities of the figures, and the pictorial traditions that underlie the painting have led some scholars to conclude that it actually represents, like Vinckboons's *Garden Party* supposedly does (see fig. 44), the Prodigal Son of the New Testament parable squandering his inheritance through riotous indulgence.[25] With this biblical association in mind, Seymour Slive has linked specific motifs in Hals's depiction (such as the toasting youth and the dog) to the engraved title page of W. D. Hooft's farcical play *Heden-daeghsche verlooren soon* (The Contemporary Prodigal Son), with its depiction of Juliaen (the "prodigal son") carousing with a prostitute while drinking in a tavern (fig. 11).[26] If Hooft's play was moralistic in intent then Hals's painting must be as well: yet Slive astutely observes that the focus on sheer pleasure in the latter undermines any potential didactic intent.

But does Hooft's play truly moralize in a weighty manner? Although the author adopted the biblical parable of the Prodigal Son for the basic plot of his farce, even a casual reading of it reveals differences of such striking magnitude that the didactic purpose of the original tale is completely undermined. H. Perry

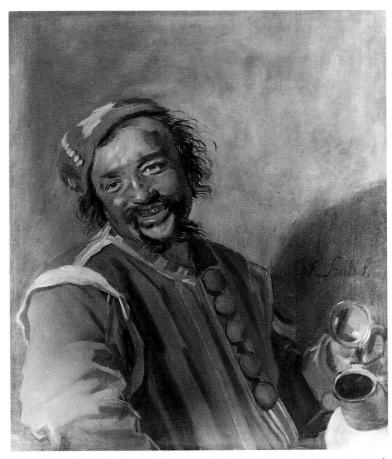

12 Frans Hals, *Peeckelhaering*, late 1620s (oil on canvas, 75 × 61.5 cm). Kassel, Staatliche Kunstsammlungen.

13 Unknown Artist after Frans Hals's *Peeckelhaering*, Frontispiece from *Nugae Venalis*, Amsterdam, 1648. Amsterdam, Universiteits-Bibliotheek Amsterdam.

Chapman perhaps came closest to ascertaining the significance of Hooft's farce when she stated that, "it provided a delightful and entertaining reminder that folly is an inevitable part of man's condition."[27] The play is filled with spicy language, lewd songs, provocative scenarios, and a finale in which Juliaen has returned home simply because he has run out of options. In contrast to his biblical counterpart, he is not sincerely repentant about his errant ways. If parallels can be drawn between this and contemporary paintings such as Hals's, they lie not in the presentation of admonitory messages (as is often assumed) but rather of ribaldry. As demonstrated further in the first part of this book, coarse imagery was quite popular during the early seventeenth century as all segments of the population enjoyed risqué literature, art, and theatrical productions, even the sophisticated owners of paintings by Hals and other artists.[28]

More directly related to the theater is Hals's so-called *Peeckelhaering* (Pickle-Herring) of the late 1620s, which represents a comic character much beloved on the European farcical stage (fig. 12). An engraving of the painting, made later in the century, identifies the figure as Peeckelhaering, and comments on this buffoon's penchant for prodigious consumption of drink, induced by his similarly insatiable appetite for salty herring.[29] Hals enhances the comic aspects of this character by depicting him in a bright red, clownish costume (which displays links to the Italian *commedia dell'arte*) and the figure's grinning expression, uncouthly exposing his malformed teeth, contributes to the humorous effect.[30] Hals has also posed Peeckelhaering at an oblique angle, with his head providing a counter-balance to the sharp diagonal thrust of his body. This device, seen in many of the artist's genre paintings and portraits, serves to accentuate the animation of the figure. Combined with the bold, loose brushwork, the figure's pose and facial expression communicate a degree of ebullience rarely matched in seventeenth-century Dutch art. That contemporaries easily recognized the comic features of this picture is confirmed by its reproduction during Hals's lifetime as the frontispiece to a popular joke book (fig. 13), inscribed "Nugae Venalis" (Jests for Sale), and by its presence in two paintings by Jan Steen (fig. 192).[31]

During the 1620s, his most active decade as a genre painter, Hals also began to depict children individually in representations

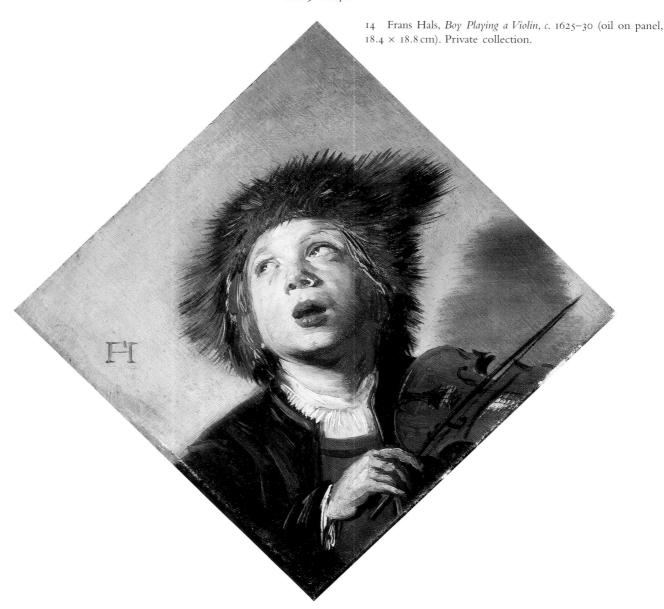

14 Frans Hals, *Boy Playing a Violin*, c. 1625–30 (oil on panel, 18.4 × 18.8 cm). Private collection.

of great innovation and influence. Pictorial precedents for such paintings as the *Boy Playing a Violin* (fig. 14) of around 1625–30 can be found in works by contemporary artists in Utrecht.[32] These painters, with whose art Hals was familiar, specialized in, among other themes, representations of children playing instruments or singing (see Chapter 4 and fig. 67). The Haarlem master adopted the same half-length format and bright light found in depictions of this theme by Utrecht artists, yet his panel lacks the restrained air and comparatively tight paint application that in their portrayals serves to eternalize the children's music-making activities.

The *Boy Playing a Violin* instead pulsates with insinuated motion, created by the wonderful, unstable pose of the youth with his tilted head and distant gaze to the left.[33] But Hals's patently loose brushwork most directly imparts to the painting its overall vivacity. When examined up close – consider the boy's hands and lips – the surface appears to consist of slipshod, chaotic brushstrokes and patches of paint. Yet from a distance, these irregular strokes and daubs resolve themselves into an uncannily coherent impression, suggesting not only form but even texture and an astonishing play of light effects across the panel's surface.[34] Hals's technique gradually became identified with Haarlem painting in general as it influenced innumerable painters in that city, a veritable army of his students and followers attempting to imitate it.[35] Their efforts notwithstanding, these artists were rarely, if ever, able to replicate the renowned master's style completely; it is as if they were able to imitate only the "notes" but not the "music" of Hals's art.

The panel of the *Boy Playing a Violin* is cut in a curious, lozenge shape, a feature it shares with another image of the same size depicting a young girl singing.[36] It is likely that both paintings once formed part of a now-lost series representing the Five Senses. The violin player personifies the sense of hearing while the singing girl, who gazes at a music book, portrays the sense of sight.[37] The Five Senses was a time-honored subject in European art and can be linked ultimately to cosmological concepts dating from antiquity and the Middle Ages. In this world-view (which certainly survived into the seventeenth century despite that era's growing empiricism) the seasons, the elements, the humours, the senses, and so on were all seamlessly interconnected in one divinely ordered, great chain of being. By the late sixteenth century, the Five Senses became a popular subject in graphic art, especially among artists in the Southern Netherlands.[38] Cornelis Cort's engravings after designs by Frans Floris (*c.* 1520–1570), dated 1561, typify the earlier approach to this subject matter as each sense is personified by a female allegorical figure of dignified, classical beauty, accompanied by attributes (fig. 15). The gradual transformation of this traditional iconography toward more naturalistic ends, namely, ones denotative of the everyday world, was already underway in Dutch graphic art shortly before 1600.[39] Nevertheless, Hals's naturalistic depictions of children as personifications of the Five Senses is startling in comparison with their pictorial precedents. Hals's career as a genre painter lasted only two decades. In the end, his activities as a portraitist simply proved too lucrative for him to continue to produce genre paintings. But, his genre pictures, like his art in general, remained influential in Haarlem and beyond.

One of the most talented painters whom Hals inspired was Willem Buytewech (*c.* 1591/2–1624).[40] Buytewech was a native Rotterdamer who moved to Haarlem undoubtedly because of the city's reputation for painting and for its commercial prospects. The young artist arrived there in 1612 (or possibly earlier), enrolling in the Guild of St. Luke that same year. Although his "Haarlem period" lasted only a few years – documents place him back in Rotterdam by late summer, 1617 – Buytewech retained contacts with his erstwhile colleagues after he returned to his native city. Buytewech died in his early thirties, so his career was brief, but he was influential as well as versatile, excelling as a draftsman, an etcher, and a painter. In a book published in 1641 he was called "Geestige Willem" (loosely translatable as "witty William");[41] presumably this was his nickname during his lifetime. *Geestige* in seventeenth-century Dutch conveyed a gamut of meanings but in this context probably referred to Buytewech's artistic creativity, tinged with subtle wit. Buytewech's production as a painter was limited to just a handful of works but in many respects they aptly embody his moniker.

Buytewech's *Garden Party*, painted around 1616–17 (fig. 16), is informed by the very same Flemish pictorial traditions that were

so pivotal for Vinckboons and van de Velde.[42] But the *Garden Party* also demonstrates Buytewech's familiarity with Haarlem painting, specifically with the work of Frans Hals. The figure at the far right, with his debonair costume and self-assured pose, is derived from a sitter in one of Hals's renowned group portraits of Haarlem's militia companies (see fig. 9). Buytewech's bold brushwork applied fairly thinly to the canvas and his choice of sharp, local colors also demonstrate his familiarity with Hals's contemporary work. In fact, a *Garden Party* of circa 1610 (fig. 17), once attributed to Buytewech but now attributed to Hals, has often been identified as an important precedent for the former's picture. Unfortunately, this intriguing and innovative painting, probably the earliest representation by a Haarlem painter of this theme, was destroyed during the Second World War and therefore its attribution to Hals cannot be substantiated.[43]

Buytewech's *Garden Party* displays clear connections with the work of other painters but it simultaneously reveals his own inventiveness. The setting for this gathering of well-heeled, sophisticated youth is rigorously organized and involves architectural elements that display classicizing features. An odd, somewhat capricious motif looms in the background: a church, overgrown with vegetation, which very loosely resembles the long-demolished Church of St. Mary in the distant city of Utrecht.[44] Equally inventive, if not more so, are Buytewech's figures. The extravagantly dressed inhabitants of this canvas, particularly those standing to the right, adopt curiously self-conscious poses that psychologically disconnect them from their neighbors, not dissimilar to what a modern-day viewer might encounter when perusing advertisements in a fashion magazine.

15　Cornelis Cort after Frans Floris, *Hearing*, 1561 (engraving). Amsterdam, Rijksprentenkabinett.

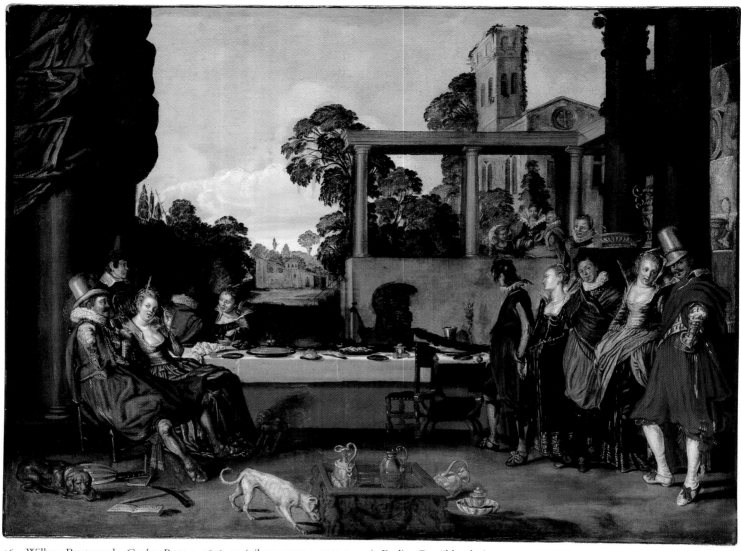

16 Willem Buytewech, *Garden Party*, *c.* 1616–17 (oil on canvas, 71 × 94 cm). Berlin, Gemäldegalerie.

17 Attributed to Frans Hals, *Garden Party*, *c.* 1610 (oil on panel, 65 × 87 cm; destroyed in 1945). Formerly Berlin, Kaiser Friedrich Museum.

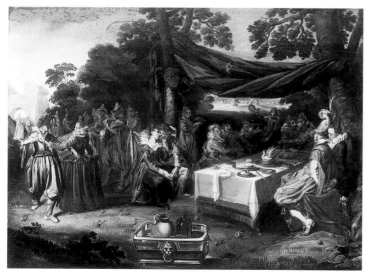

The peculiar demeanor and appearance of these figures has led scholars to hypothesize that Buytewech's art gently satirized the sartorial preoccupations of the youth of his day.[45] The censorious mood thereby created, however playful, is echoed by the modish couple seated at the left. The young woman, with abundant cleavage, gazes coquettishly at her companion. Although this man stares vacuously ahead she has definitely attracted his attention, judging from the fact that his left foot rests against her body. The ultimate intentions of this gesture are comically underscored by the grinning simian who pulls on the salacious female's dress. Monkeys, despite their status as exotic creatures, traditionally functioned in Western European art as embodiments of the base, unchaste instincts of mankind.[46]

The negative, moralizing features of Buytewech's *Garden Party* are thus pronounced, even if they are presented in a somewhat understated and wry manner. Other paintings by the artist employ a similar tone, for example, his *Merry Company* (fig. 18) a work generally dated between 1617 and 1620.[47] As Buytewech's

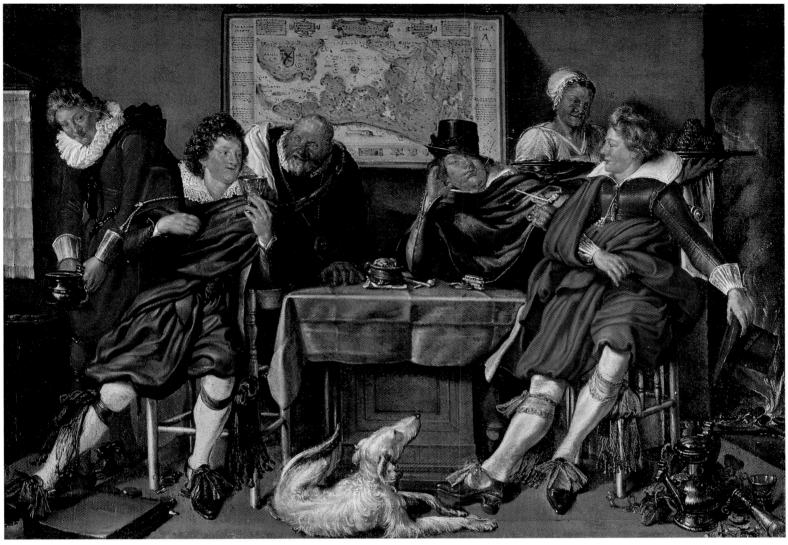

18 Willem Buytewech, *Merry Company*, c. 1617–20 (oil on canvas, 49.3 × 68 cm). Rotterdam, Museum Boijmans Van Beuningen.

career as a painter progressed he evidently lost interest in garden party imagery and began to depict foppish figures in interiors. The results were unprecedented: Buytewech's inventive scenes of elegant companies, however cramped, constitute seminal examples in terms of the indoor setting and subject matter of what would develop into one of the most popular themes in seventeenth-century Dutch genre painting. In this particular painting, four dandies dressed in extravagant costume amuse themselves in a tavern, its constricted space tightly composed of horizontal and vertical elements. A servant girl offers a plate of artichokes to these swank customers while, to her left, an enigmatic figure with a string of sausages tied around his chest leans over the table.

It is difficult to determine whether Buytewech painted the *Merry Company* in Haarlem or upon his return to Rotterdam. However, the picture once again reveals his knowledge of Frans Hals's art for the odd man with the sausage-laden costume is the subject of two Buytewech drawings after works by Hals.[48] The

presence of this unusual character posed no mystery to Buytewech's contemporaries who would have immediately recognized him as the aptly named "Hans Worst," a stock figure in comical theatrical productions of the day who was notorious for his ravenous appetites and foolishness. Perhaps his presence here accentuates the imprudent behavior of the young men in the tavern who drink, smoke, and relieve themselves – the dandy on the far left is about to urinate into a chamber pot.[49]

The incongruities between the dubious activities of these gentlemen and their overly fashionable attire has not gone unnoticed. Buytewech's mockery of these young men is characteristically light-hearted and is paralleled in published plays and related literature. For example, the noted Dutch poet and playwright, Gerbrand Adriaensz. Bredero (1585–1618), satirizes such fashions in his *Spaanschen Brabander* (Spanish Brabanter), a farce performed on the Amsterdam stage in 1617, about the same year that Buytewech painted his *Merry Company*.[50] The title, *Spaanschen Brabander*, refers to the play's principal protagonist, an

impoverished nobleman named Jerolimo who has emigrated to the Dutch Republic from Brabant, a province then entirely in the Southern Netherlands. Bredero possessed an extraordinary literary knack for creating vivid and realistic narratives. In this play, Jerolimo comes to life as an affected fop in fancy costume who speaks in a Brabant dialect, liberally spiced with French words.

Bredero's farce takes place in the Amsterdam of the 1570s, on the eve of the great immigrations that eventually caused the city to undergo severe growth pangs.[51] Although set in an earlier period, the *Spaanschen Brabander* contains sufficient anachronisms and allusions to the contemporary state of affairs to have struck a responsive chord with its audiences. The author's gentle mocking of Jerolimo's apparel and pretentious demeanor playfully exposes some of the underlying tensions that must have existed between the indigenous Dutch population and the steady stream of refugees arriving daily from the South.[52] These immigrants were generally perceived to be more cosmopolitan, if not flashy, than the local inhabitants. Bredero satirizes their behavior from the opening lines of the farce, spoken by Jerolimo: "This city's [Amsterdam] *magnifique*, but what a grubby folk!/ In Brabant we're all quite exquisite/ In dress and bearing – in the Spanish mode –/ Like lesser kings, gods visible on earth."[53] Others took a much more grave stance toward these foreigners and their costly trappings than did Bredero. In a sermon delivered in 1614 the Amsterdam pastor Jacob Trigland squarely placed the blame for morally corrupting tastes upon Flemish immigrants.[54]

While publications critical of improvident clothing and lifestyles in general can be found throughout the century it is fascinating that so much commentary on these issues appeared in texts and graphic art produced around the period of the twelve-year truce (1609–21).[55] The younger generation at this time – Buytewech's generation – was maturing in an era of peace and prosperity, the first in the brief history of the United Provinces. Patriotic fervor consequently ran high; members of those factions who confidently advocated the renewal of the war to vanquish the Spanish were ever vigilant for perceived turpitude among the youthful populace who were suspected of lacking the virtue and single-mindedness of their elders. As the Reformed preacher Willem Teellinck put it, "since the Truce, you [the Dutch] have raised yourselves up in the splendor of your clothing."[56] And in a mocking tone, perhaps closer to that employed in Buytewech's painting, Roemer Visscher lampoons prodigal behavior among the young in his emblem book, *Sinnepoppen* (Meaningful Little Figures) of 1614, a work infused with patriotic overtones. One of the emblems contained therein, inscribed "Ad pompam tantum" (Only fitting for pomp), depicts a young buffoon wearing pantaloons of sufficiently exaggerated breadth to impair his gait (fig. 19). Visscher's commentary criticizes the youth of his day "who show themselves off with plumage on their heads, gold chains around their necks, silken clothes and gilded swords at their sides . . . not [like] the men who demonstrated their devotion in the war . . ."[57]

Despite all these fascinating parallels, Buytewech's painting was probably not created in response to political and social circumstances during the twelve-year truce. Nevertheless, while moralizing commentary on youthful behavior in art was hardly new, Buytewech's work, produced as it was in a period of intense nationalistic rumination, was equally informed by political sentiments, as H. Perry Chapman and H. Rodney Nevitt have argued.[58] The juxtaposition of the young men's lavish "foreign" dress with the unadorned "local" tavern in which they disport themselves is striking. As if to accentuate the contrast Buytewech has depicted a map behind them plainly inscribed "Hollandia,"

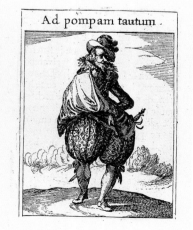

19 (*left*) Emblem from Roemer Visscher, *Sinnepoppen*, Amsterdam, 1614. Amsterdam, Universiteits-Bibliotheek Amsterdam.

20 (*facing page, top*) Dirck Hals, *Merry Company in an Interior*, c. 1624 (oil on panel, 23 × 28 cm). Private collection.

21 (*facing page, center*) Dirck Hals, *Garden Party*, early 1620s (oil on panel, 37 × 55 cm). Amsterdam, Instituut Collectie Nederland.

22 (*facing page, bottom*) Dirck Hals, *Garden Party*, early 1620s (oil on panel, 28 × 45 cm). Present location unknown.

the name of the nation's foremost province, both politically and economically.[59] The air of subtle, amusing burlesque within this interior, itself a remarkably novel setting for a genre painting, along with the nationalistic overtones that it evokes, all betoken Buytewech's creativity, celebrated by his well-deserved sobriquet, "witty William."

Buytewech's influence upon developments in Haarlem genre painting remained strong even after his return to his native Rotterdam in 1617. Nowhere was his impact more keenly felt than in the work of Dirck Hals (1591–1656), the younger brother of Frans Hals.[60] Unlike Frans, Dirck was born in Haarlem. He enjoyed a distinguished career there as a prolific artist and was also active in literary circles. Much of Dirck Hals's work (which, unfortunately, varies markedly in quality) consists of garden parties and merry companies. His first dated pictures were produced in the early 1620s and already reveal his dependency upon Buytewech's compositional and figural prototypes. For example, one of Dirck Hals's early merry companies (fig. 20) displays the same cramped, stage-like space constructed around a large table depicted in Buytewech's interiors. Likewise, the casually posed young man on the left in Dirck Hals's *Garden Party* (fig. 21), from the same period, closely resembles, in mirror image, Buytewech's young, seated dandy at the far right of his *Merry Company* (see fig. 18).[61] The bright, outlandish clothing of the other figures in the *Garden Party* recalls the garments in Buytewech's paintings as well. That this charming painting contains many motifs already encountered is scarcely surprising given the pronounced conventionality of garden-party imagery and indeed, of seventeenth-century Dutch genre painting as a whole.

In Dirck Hals's most fascinating representation of this theme (fig. 22), what initially appears to be simply another elegant gathering of youths has, in fact, much more elaborate subject matter.[62] Hals cleverly incorporated references to the Five Senses here. The well-dressed man playing the lute represents hearing while the sense of smell is personified by the couple at the center of the table who sniff a flower. The pair kissing immediately to their left, who embody touch, are spied upon by the young dandy with the tiny telescope, who personifies sight. Lastly, the couple immediately below this peeping Tom represent the sense of taste as the female holds a glass of wine.[63]

As previously demonstrated, the Five Senses were a time-honored subject in European art. The gradual transformation of traditional Five Senses iconography from allegorical (see fig. 15) to more naturalistic renderings, namely, ones denotative of the everyday world, was already evidenced in Dutch graphic art around 1600. Nevertheless, Hals's representation of the Five Senses, like those by his brother, is startling in comparison with its pictorial precedents. And the innocuous yet playful air of Dirck Hals's representation is perhaps reflective of changing attitudes toward the Five Senses that no longer associated them with deceitful sin, as had older, moralistic views.[64]

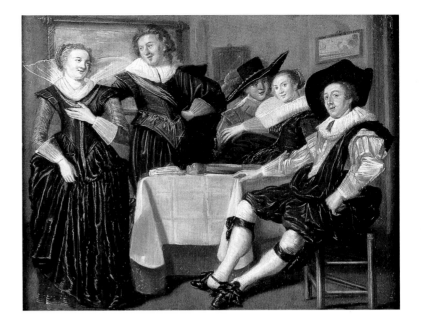

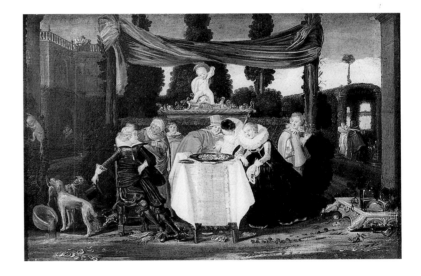

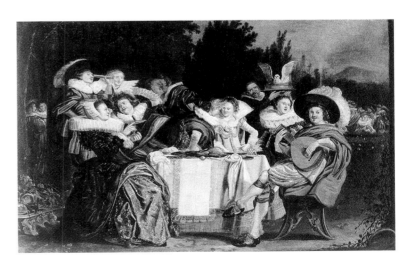

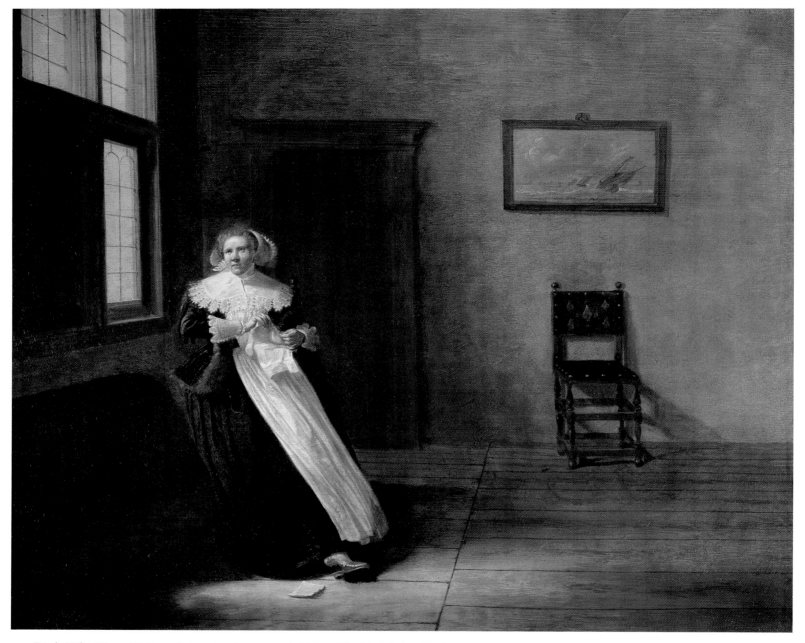

23 Dirck Hals, *Woman Tearing a Letter*, 1631 (45 × 55 cm). Mainz, Mittelrheinisches Landesmuseum.

The pronounced quotidian character of Hals's *Garden Party* testifies to the truly dramatic changes affecting Dutch art during the early seventeenth century. A scant two decades earlier, representations of this sort were uncommon as most artists worked within the prevalent Mannerist mode (see fig. 2). The question of why naturalistic depictions increasingly prevailed in Dutch art in such an astonishingly short time cannot be definitively answered.[65] However, a number of factors undoubtedly contributed to this complex phenomenon, among them, shifting pictorial conventions; the enduring influence of iconographic

traditions in the form of prints; the peaceful conditions as well as the general political atmosphere during the twelve-year truce; the presence of a large immigrant population (which included a sizeable number of artists) and a dynamic economy, both of which fostered the art market.

Contemporaries were most assuredly aware of the profound changes in Dutch painting during these years. Indeed, Dirck Hals's pictures are identified as having "modern figures" in inventories of the estates of several deceased citizens in Haarlem compiled during the 1620s and 1630s.[66] This term was actually

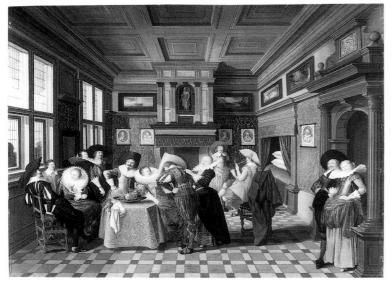

24 Dirck Hals and Dirck van Delen, *An Interior with Ladies and Cavaliers*, 1629 (oil on panel, 73 × 96.5 cm). Dublin, The National Gallery of Ireland.

employed two decades earlier by van Mander in his biography of Vinckboons whom he mentions as having made several landscapes with "modern figures."[67] Nevertheless, that the very same term appears in inventories recorded by notaries who largely lacked van Mander's expertise indicates just how commonplace it had become in a mere twenty years. These disparate sources invoke this term as a descriptor for paintings with contemporary subjects whose figures don modish dress. In comparison with art executed in earlier styles, works by Buytewech, Hals, and members of their generation were acknowledged for their contemporaneous qualities, as these documents clearly attest.

Scholarly assessments of Hals tend with some justification to classify him more as a "follower" than a "leader," to wit, as an artist who ranks somewhat below his supremely talented brother, Frans, and genre painters such as Buytewech. Yet works such as the celebrated *Woman Tearing a Letter* (fig. 23), dated 1631, demonstrate Dirck Hals's occasional ability to scale great artistic heights.[68] Hals had already been painting interior scenes for approximately eight years and within these there is a gradual transition toward depictions with a reduced number of figures and restricted color ranges. The *Woman Tearing a Letter* is extraordinary in this regard. The artist renders an expansive yet plausible space, particularly when compared with the claustrophobic, airless settings of Buytewech's merry-company paintings and of Hals's own earlier work. In the intervening years Hals had collaborated with the architectural painter Dirck van Delen (1604–1671) on a number of paintings of merry companies in palatial interiors whose decorative embellishments and general disposition hark back to Flemish Renaissance prototypes (fig. 24).[69] The depiction of space in these collaborative works was

much more sophisticated than many depicted hitherto in Dutch genre painting. These earlier collaborative ventures undoubtedly inspired the more spacious compositions of Hals's art of the 1630s.[70] His *Woman Tearing a Letter* demonstrates surprising proficiency in this regard as the overall impression of spaciousness and poignancy, given the subject, is imparted by just one figure who comfortably inhabits her sparse surroundings.

Hals's palette is also extremely restricted: seemingly banished are the bright colors omnipresent in genre pictures of the preceding two decades. Replacing them is a limited range of ochers, browns, and olives, applied with fairly broad brushwork, of a type associated with Frans Hals in particular and Haarlem art in general. The novel coloristic effects here, which impart a feeling of atmosphere (both literal and figurative), can be associated with a large-scale shift in stylistic conventions in Dutch genre, landscape, and still-life painting (and even portraiture) during the late 1620s, 1630s and early 1640s. Art historians have identified this phenomenon, in which Haarlem played a significant formative role, as the tonal or, somewhat misleadingly, the monochromatic phase of Dutch painting.

The subject matter of Hals's panel is equally remarkable. It is one of the earliest representations associated with letter reading or writing, a theme that would become one of the most beloved in Dutch genre painting in the second half of the century (see fig. 93).[71] In an age in which a substantial percentage of the European population was illiterate it is surprising to encounter such a subject in art. And it is equally surprising to learn that letter writing – particularly love letter writing – enjoyed a tremendous vogue in the Dutch Republic, though principally among the affluent. This accounts for the frequent appearance of letters in paintings, emblem books, and even in plays, whose complex plots sometimes revolved around the mysterious contents of a missive.[72] Publishers actually capitalized on the popularity of this activity by marketing instruction manuals (principally of French origin) with titles such as *Fatsoenlijke zend-brief-schryver* (The Fashionable Missive-Writer) published in 1651, to assist readers in composing florid letters. For those persons with neither the time nor the requisite epistolary skills, these manuals provided ready prototypes for many different circumstances and situations including romantic pursuits.[73] (And such missives could be dispatched with confidence courtesy of the extensive Dutch postal system.)

Hals's depicts the woman with a somewhat preoccupied expression, possibly peering out of the windows to her right, as she begins to tear a letter in half. Most interestingly, her leaning pose – is she just rising from the chair whose finial is seen behind her left shoulder? – and the rakish angle of her apron echo in reverse the listing ships, close-hauling into the stiff breeze in the seascape on the wall behind her. The formal connection between these two motifs accentuates their metaphorical relationship. In seventeenth-century poetry and emblems,

love was frequently associated with sailing, the ocean, and a host of other maritime metaphors.[74] The oft-cited verses from Jan Harmensz. Krul's *Minne-beelden* (Images of Love) of 1634 make this abundantly clear: "In the boundless sea, full of trackless waves,/ my loving heart sails between hope and fear./ Love is like a sea, the lover like a ship,/ your favour, my love, is the harbour; your rejection a reef."[75] This poem serves as the explanatory text for a delightful image of Cupid sailing a boat (fig. 25), the ensemble inscribed: "Though far away, you are never out of my heart."

The sentiments expressed in this poem may strike the modern reader as bombastic and insincere but they nonetheless illuminate some of the associations evoked by Hals's painting, associations that would have been immediately apparent to any informed, contemporary viewer. Evidently, from her reaction, the woman has received unwanted news, and the presence of the seascape in the otherwise unadorned room comments upon the general nature of the letter and its recipient's mood. One wonders whether in this context the empty chair immediately below the picture refers to an absent lover. While the precise meaning of Hals's panel is ultimately elusive, and perhaps deliberately so, it sheds abundant light on the contemporary mindset vis-à-vis matters of the heart. And, as shall be discussed in Part II of this book, similar genre imagery exploring the passions of the leisured classes reached its peak at a time when the Dutch economy was at its most robust.

Adriaen Brouwer and Adriaen van Ostade

Of all the artists discussed in this volume, Adriaen Brouwer (*c.* 1605/6–1638) is probably the one who fits most comfortably into surveys of both seventeenth-century Dutch and Flemish painting.[76] The reasons are simple: Brouwer, who was likely born in the village of Oudenaarde near the Dutch border in Flanders, spent considerable portions of his career in Haarlem and in

25 Illustration from Jan Harmensz. Krul, *Minnebeelden: toe-ghepast de lievende ionckheyt*, Amsterdam, 1634. Washington D.C., Folger Shakespere Library.

26 Adriaen Brouwer, *Tavern Interior*, *c.* 1625–7 (oil on panel, 34.8 × 26 cm). Rotterdam, Museum Boijmans Van Beuningen.

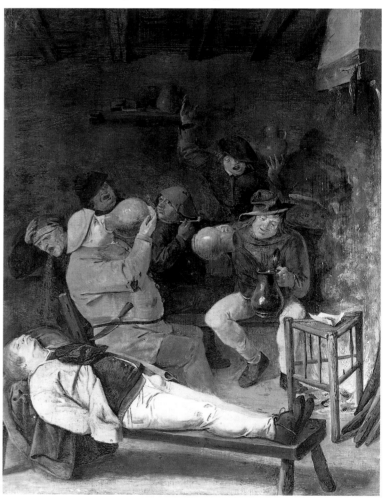

Antwerp. The artist probably moved to the Dutch Republic in the early 1620s. However, the earliest documents place him in Amsterdam in 1625 and in Haarlem only in the following year, 1626. Nevertheless, Brouwer could have been living in Haarlem already in 1625 (if not earlier), given the close proximity of the two cities and the strong affiliations between their resident artists. Brouwer had evidently departed from Haarlem by late 1631, at which time he enrolled in the Guild of St. Luke in Antwerp. Brouwer resided in the latter city, itself the most important center for painting in the Southern Netherlands, until his death in 1638. Unlike the painters previously examined, Brouwer's short life and artistic career were the subject of several seventeenth- and early eighteenth-century biographies.[77] These lively sources are fascinating but can be utterly misleading.

Brouwer's specialty was the representation of peasants; his contributions in this regard to the ongoing development of Dutch genre painting (and Flemish genre painting as well) were considerable. Like Vinckboons before him (see Chapter 3), Brouwer's depictions of peasants ultimately owe their inspiration to Bruegel and other sixteenth-century painters.[78] The enduring impact of older Flemish art upon Brouwer is already apparent in his earliest surviving paintings, which were likely executed in Haarlem around 1625–7. Brouwer's *Tavern Interior* (fig. 26) belongs to this group.[79] There is no documentary evidence to support the claim by the artist's early eighteenth-century biographer, Arnold Houbraken (1660–1719), that Brouwer studied with Haarlem's most renowned master, Frans Hals.[80] If anything, the reddish-pink tones of the *Tavern Interior* (and other, early pictures) as well as the somewhat rudimentary depiction of the interior space betrays his knowledge of the work of such Haarlem painters as van de Velde and Buytewech. But the painting's facture, juxtaposing darker, thinly painted passages (for example, the wall behind the figures) with those more thickly applied in local color augmented by delicately painted accents stylistically separates Brouwer from these masters. Furthermore, Brouwer's representation of an interior, however modest, constitutes one of the earliest examples in Dutch genre painting in which peasants have been placed in such surroundings. This depiction of a new site for peasant activities – hitherto they were principally portrayed outdoors – is but one of Brouwer's many contributions to this subject matter.

The figures in the *Tavern Interior* are comical embodiments of debauchery. Their simple, threadbare clothing identifies them as peasants or related, low-class types as does their dissolute behavior, for peasants are invariably associated in art and literature with base impulses.[81] These men have consumed so much liquor that one vomits while another lies seemingly comatose on a bench in the immediate foreground. As Konrad Renger has argued, the motifs associated with excess – such as the repulsive, corpulent man gulping from an enormous jug – can be associated with Bruegelian representations of *Gluttony*,

the *Fat Kitchen*, and the like.[82] Brouwer's panel, however, is separated from its iconographic ancestors, and, for that matter, the work of his near contemporary, Vinckboons, by the sheer coarseness of his figures and the consequent vulgarity of the depiction.

The *Tavern Interior* is therefore noteworthy for Brouwer's striking modifications to what is in essence patently conventional imagery. Paintings of peasants cannot be considered neutral reportage, as if the artist was somehow recording an actual event (see Chapter 3). Curiously, Brouwer's aforementioned biographers disregarded the conventional aspects of his work – though they were surely aware of them – and happily conflated Brouwer's art with his life, the latter presented principally in the form of fictitious, entertaining yarns about his supposedly roguish experiences.[83] This is already apparent in the earliest biography of Brouwer, published just twenty-three years after his death by Cornelis de Bie (1627–c. 1715) in *Het gulden cabinet vande edele vry schilder-const* (The Golden Cabinet of the Nobly Free Art of Painting) of 1661.[84] For de Bie, Brouwer's art is an extension of his very persona, as these oft-quoted lines declare: "He always scorned the world's vanity./ He was slow in painting and spent money generously./ With pipe in his mouth and in foul taverns,/ There he spent his youth, completely out of money . . . And he lived the life he painted."[85] De Bie portrays Brouwer as a painter who, in pursuit of the fame engendered by his art, scorned the world and its riches; who, like the figures in his pictures, was a denizen of sordid inns; whose "spirited style" was highly esteemed by the greatest artists of his day, among them, Peter Paul Rubens (1577–1640); and who died impecunious because of his prodigal habits.[86] This characterization was generally adopted by Brouwer's later biographers: Joachim von Sandrart (1675), Isaac Bullaert (published posthumously in 1682), and, above all, Houbraken (1718).

Of all the biographies, Houbraken's life of Brouwer is the most comprehensive, and the most embroidered.[87] Houbraken places the painter's origins in Haarlem where he becomes Frans Hals's student after a purely chance encounter in which the great painter espies Brouwer producing craftwork for his own mother. This lands the talented young man in such an abusive relationship with the besotted master that he is forced to flee to Amsterdam. As Houbraken's story unfolds, Brouwer's career and profligate personality are described along similar lines to those related by de Bie some fifty years earlier. Hilarious asides are routinely inserted into the text: on one occasion, after having received, much to his astonishment, 100 ducatons for a painting, Brouwer rolls in the remunerative coinage on his bed and then embarks upon a nine-day journey of reclusive dissipation. Once he resurfaces, Brouwer replies wryly to queries about the money by stating that "he had relieved himself of that ballast." In the end, Brouwer's dissolute ways – Houbraken opines that he had served Venus and Bacchus too zealously – undermine his

physical and financial well-being. He dies destitute but to the good fortune of his memory, an inconsolable Rubens arranges a proper interment in the Carmelite church in Antwerp.

What is perhaps more astonishing than these entertaining biographies themselves is the remarkable after-life that they have enjoyed as later generations scarcely questioned their reliability. As recently as 1982 the catalogue to an exhibition of Brouwer's work (and that of his Flemish compatriot David Teniers the Younger) stated that the former, ". . . lived in a haze of Baroque indulgence, devoted to pleasure and enjoyment, and he loved the easy-going life of the simple folk in the taverns."[88] Perhaps some of the confusion can be forgiven because the scant archival evidence does substantiate certain aspects of the material presented by de Bie amongst others. For example, Brouwer did associate with an Amsterdam innkeeper and art dealer, Barent van Someren; he was placed in prison (probably for political reasons) in Antwerp in 1633; he was admired by Rubens; and he did experience financial problems, having incurred many debts throughout his brief life.[89]

Other evidence, however, underscores Brouwer's good standing in the municipalities in which he lived. For instance, the artist was a member of chambers of rhetoric (amateur literary societies) in both Haarlem and Antwerp. Moreover, in 1627 the playwright Pieter Nootmans dedicated a published play to the "artful and world famous young man Adriaen Brouwer, painter from Haarlem."[90] Brouwer clearly perceived his own status for a notarial document dated 1632 labels him "Signor Adriaen Brouwer."[91] In the seventeenth century, "Signor" was a term invoked for those of elevated social standing.[92] Brouwer's identification (however potentially dubious given his perpetual financial difficulties) with the upper classes likely stemmed from the success of his work among affluent clientele.[93] Rubens, the renowned gentleman artist, for example, owned seventeen of his paintings. Moreover, the 1632 document concerns a picture of a peasant dance owned by Rubens that Brouwer authenticated as having been painted by him only once, thereby implying a flourishing market in copies and forgeries of the painter's most popular compositions.

What was the purpose of these early biographies, given their fundamentally anecdotal, as opposed to factual, accounts of Brouwer's life and career? It is difficult to believe that these authors spun such entertaining yarns about the artist for want of information about him. To the contrary, the portrayal of Brouwer as a prankster whose life accords seamlessly with his art appears to be deliberate. In this regard, H. Perry Chapman's important assessment of Houbraken's biography of Jan Steen (see Chapter 14) is relevant and illuminating.[94] Although Houbraken's account of Steen's life (and those of other artists) has sometimes been dismissed as notorious misinformation, Chapman has demonstrated how the author purposefully crafted anecdotes in order to elucidate supposed contiguities between Steen's life and

art.[95] Houbraken's approach is in line with contemporary practice predicated on the notion that, paradoxically, biography has to be shaped – sometimes in contradiction to hard evidence – in order to evoke the identity of the person in question. And biography is shaped, according to traditions dating back to antiquity, by fashioning anecdotes.

Houbraken was writing in the early eighteenth century, a period in which Franco-Flemish-inspired classicism was dominant in Dutch art and culture; changes in the style of Dutch genre painting, transformations of its imagery, and attendant changes in the taste of its patrons led some critics of Houbraken's generation to consider the subject matter of Steen and similar artists offensive and inappropriate. In light of the similarities between Steen's and Brouwer's œuvres it is no accident that Houbraken portrays both artists as financially pressed yet irrepressibly cheerful men whose comic dispositions and related, intemperate proclivities are fully embodied in their work.[96] Houbraken greatly admired the two artists' work but in his view only ill-bred painters could conceive of the coarse art that they routinely produced.[97] Accordingly, his conception of their lives is ingeniously enlivened by the use of crude language otherwise absent in his biographies of painters whose pictures conform more closely to then-current classical precepts.

Infinitely more pithy, yet more accurate and informative than the fictional tales of de Bie, Houbraken, and others, is the engraving depicting Brouwer in Anthony Van Dyck's (1599–1641) celebrated *Iconography* series, formally published for the first time only in 1645 (after the death of both masters).[98] The eighty engravings in this initial edition of the *Iconography* illustrate eminent men (both living and deceased) of various vocations, including artists. The print of Brouwer (fig. 27), engraved by Schelte à Bolswert (1586–1659) after a lively oil sketch by Van Dyck, depicts the painter as a fashionable, gentleman virtuoso far removed from the boozing jokester known from literary sketches conceived by his later biographers.[99]

And the accompanying Latin inscription speaks volumes about contemporary perceptions of Brouwer and his art: "Adrianus Brauwer, Gryllorum pictor Antverpiae." Anglicized it reads: "Adriaen Brouwer, Antwerp painter of Caprices." Caprice, in English referring to something whimsical, is actually a clumsy translation; the Dutch term *grillen* (or the related word, *grollitjes*) more faithfully captures the nuances of the original Latin. *Gryllorum* was a term invoked by such ancient Roman writers as Pliny the Elder to describe humorous works of art. By Brouwer's day, *gryllorum* had become largely (though not exclusively) associated with humorous and satirical depictions in art and literature of peasants and other social pariahs.[100] This apt designation for Brouwer's art was adopted in the later biographies where it provides the justification for those fantastic tales surveyed above.

As Barry Wind and Hans-Joachim Raupp have shown, Brouwer's biographers viewed him as a modern-day Diogenes,

the ancient cynic philosopher nonpareil.[101] Von Sandrart (1606–1688) made an explicit connection between them in his aforementioned biography of Brouwer published in 1675: "Because of his merry nature, which was inclined to buffoonery and humorous stories in the style of Cynical Diogenes, he was liked by almost everyone."[102] Moreover, many of the biographical anecdotes, in which the painter's unruly and socially abrasive deeds censure the foolishness of those around him, indirectly parallel those told about Diogenes. As de Bie puts it, the artist's discernment was so great that he knew how to "present the absurd folly of this world to one and all under the guise of mocking words and manners."[103] Though the writings of de Bie, von Sandrart and others really describe Brouwer's demeanor and antics, as opposed to his art — even as they routinely conflate the two — the term *gryllorum* does yield insights into the contemporary reception of Brouwer's works.

Following traditional comic theory, satirical art and literature entertain and instruct their audiences by employing subject matter drawn mostly from life, namely, from the lowest echelons of society, presented in a supposedly unvarnished, direct manner.[104] In the introductions and prefaces to their poems, songs, farces, and other printed works, seventeenth-century Dutch authors spilled much ink over the correlation of entertainment and instruction. The pertinence of their arguments for genre painting find support in the writings of Bredero, the author of the farce, *Spaanschen Brabander*, discussed earlier in this chapter. Art historians most often cite Bredero in this regard because he had apparently been trained as a painter. In one frequently quoted passage from the preface to his *Groot liedboeck* (Great Songbook) of 1622, Bredero defends his decision to reproduce the peasant vernacular in his text — elsewhere in the preface he calls his songs and poems "grillige grilletjes" (capricious fancies). The author decided to use a vernacular that is true and apposite to the peasant caste of his characters, a decision justified in language reflective of his interest in painting: "I have followed the saying, common among painters: Those who come closest to real life are the best painters . . . as much as possible I have expressed the pleasantries in the most appealing peasant vernacular."[105]

Many Dutch texts do effectively entertain and instruct, but in other instances authors do little more than pay lip service, claiming edifying intentions for their work by paradoxically presenting figural types and scenarios that the reader knows better than to imitate — ribald farces featuring prostitutes come to mind here.[106] And of course, matters grow immeasurably more complicated when one considers paintings since they generally do not contain texts. Thus contemporary concepts concerning the capacity of the arts to instruct and delight must be balanced by a recognition of the complexity of image reception in the Dutch Republic, or for that matter, in early modern culture in general. Some viewers were responsive to implied didactic content while

ADRIANVS BRAVWER
GRYLLORVM PICTOR ANTVERPIÆ.

27 Boetius Schelte á Bolswert after Anthony Van Dyck, *Adriaen Brouwer*, from the series *Iconography*, Antwerp, 1644 (engraving). Washington D.C., National Gallery of Art, Rosenwald Collection.

others either did not recognize it or dismissed it completely. And while some artists made edifying references conspicuous, others did less so, while still others eschewed them altogether.[107]

Brouwer's renditions of smokers shed much light on these interpretive problems. His *Peasants of Moerdyck* is perhaps his most famous representation of this theme (fig. 28).[108] Executed around 1628–30, shortly before Brouwer departed Haarlem for Antwerp, it evidences a more sophisticated palette in which paint has been densely applied to the figures in predominantly cream and pastel-like colors (which were soon adopted by his followers in Haarlem). These striking effects are balanced by the delicate monochromatic background. The composition is much more cohesive than that of the scattered *Tavern Interior*. Brouwer's color

28 (*right*) Adriaen Brouwer,
Peasants of Moerdyck, c. 1628–30
(oil on panel, 31 × 20 cm).
Private collection.

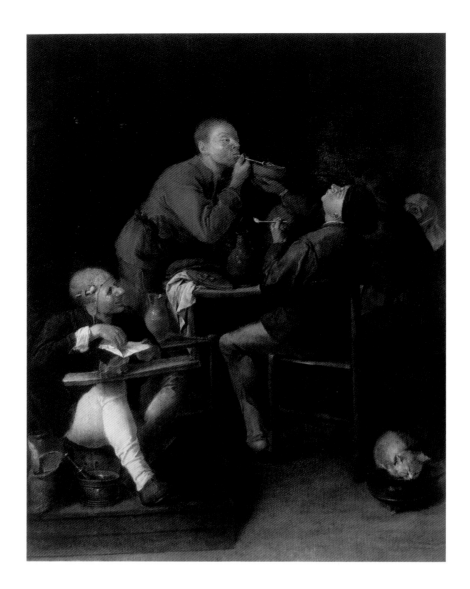

29 (*right*) Illustration from
Johan van Beverwijck, "Schat der
gesontheydt," in *Alle de wercken,
zo in de medicyne als chirurgie van
de heer Joan van Beverwyck,*
Amsterdam, 1656. Collection of
the author.

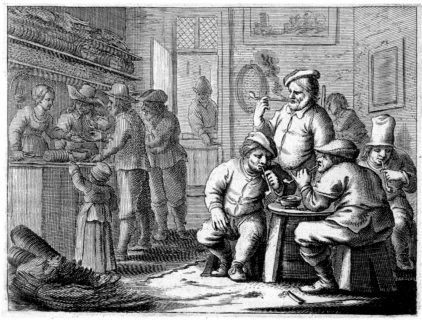

30 (*facing page*) Adriaen
Brouwer, *The Back Operation,
c.* 1635–6 (oil on panel, 34.4 ×
27 cm). Frankfort, Städelsches
Kunstinstitut.

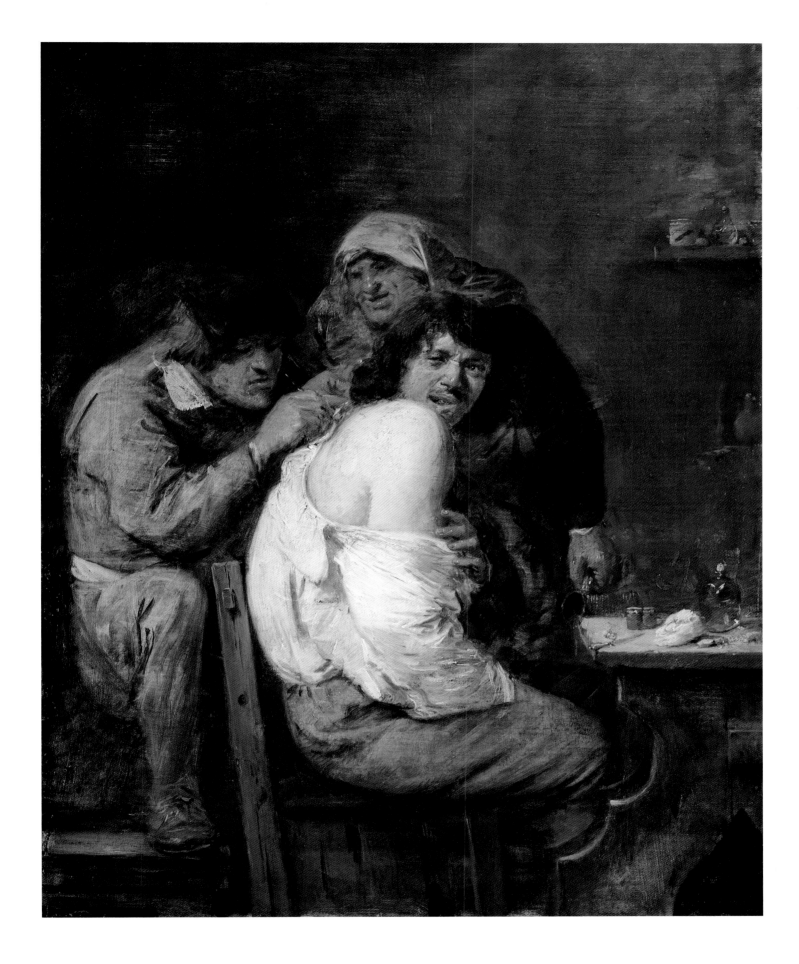

choices visually reinforce the pyramidal design which culminates with a yokel who lights his clay pipe in a glowing brazier.

Tobacco, it must be remembered, was still a novelty when Brouwer's picture was painted, having been imported from the New World only since the late sixteenth century.[109] Judging from the voluminous writings of contemporary herbalists and physicians, the Dutch harbored great ambivalence toward the plant. On one hand, it was thought to possess beneficial, medicinal qualities. Unbelievably from a modern perspective, seventeenth-century medical authorities, whose understanding of etiology was still conditioned by ancient humoral theory, argued that tobacco desiccated the body, consequently inuring it against the plague and a whole gamut of diseases. But on the other hand, medical experts, observing its narcotic or stupefying effects – they were unknowingly diagnosing mild anoxia induced by inhaling acrid tobacco through very short pipe stems – solemnly warned against "tobacco drinking," as they termed it.[110] Therefore tobacco was judged harmful for purely recreational use.

Nevertheless, like other stimulants throughout history tobacco smoking was immensely popular in Europe. And what is most fascinating with respect to Dutch genre painting during the first half of the seventeenth-century is that the abuse of this somewhat dubious habit became associated with the masses, even if they were not the only ones smoking. The identification of tobacco with socially suspect groups, such as peasants, soldiers, and sailors (the last considered its first users) rapidly developed into a literary and pictorial trope, one even employed in supposedly "objective" medical treatises (fig. 29).[111] Actual lower-class diversions undoubtedly helped shape this trope but it is equally reflective, if not more so, of the traditional prejudices of affluent urban dwellers toward their social antipodes.

Thus, the motif of tobacco smoking developed into yet another weapon in the visual arsenal of artists to lampoon the riffraff and corroborate middle- and upper-class owners' supremacy via a decidedly negative form of self-definition.[112] Consequently, it is perhaps most accurate to characterize the moral component of this and related works as broadly ethical and affiliated with social caste as opposed to necessarily didactic per se. In other words, morality does not lie so much in the presentation of behavior that the beholder is admonished to avoid but rather in the presentation of behavior that the viewer smugly recognizes as a distinguishing attribute of his or her social inferiors, behavior that he or she at least theoretically would neither imitate nor condone.[113] It is symptomatic of the ideological components of these images of smokers that they became less popular among art collectors only when attitudes toward the recreational use of tobacco grew more tolerant under the influence of commercial considerations, namely, the burgeoning industries of pipe manufacture and domestic cultivation. Once the stimulant was deemed respectable for urban leisure consumption satirical depictions of lower-class tobacco indulgence grew increasingly passé (although they never disappeared entirely). To my mind, this very fact offers compelling evidence of how peasant themes served primarily to affirm a beholder's social status.

Brouwer was not the only seventeenth-century artist to depict peasants and related plebeian types smoking, but his representations are by far the most sophisticated and influential as he used his almost unrivaled ability to render vivid facial expressions to tremendous humorous effect. Consider the figures in the *Peasants of Moerdyck*, each a physiognomic masterpiece. The man to the right tilts his head backward as he savors the smoke that he blows upward. His standing companion immediately to the left puffs his cheeks and stares vapidly ahead as he lights his pipe from the brazier. And lastly, an ugly man with a bulbous nose grins knowingly as he takes tobacco from a crude pouch.[114] All three figures persuasively (and comically) embody tobacco addiction.

The figures in Brouwer's later pictures, produced after he had settled in Antwerp, are especially animated in gesture and expression, manifesting an unprecedented display of skill matched only by the sophisticated style in which they were painted. *The Back Operation* (fig. 30), generally dated to around 1635–6, is an outstanding representative of Brouwer's late style. The artist has intensified the monochromatic effects of his earlier works, rendering them in a higher key than previously, and he has reduced his composition to just three figures who proportionally occupy a significant area of the interior space. A peasant concentrates intently on his surgical task as he probes or cuts the back of his grimacing patient whose face is contorted with anguish. These figures, along with the observant bumpkin behind them, constitute truly extraordinary renditions of physiognomy. Konrad Renger rightly suspects the possible inspiration here of the Utrecht Caravaggisti, and especially Rembrandt van Rijn (1606–1669), who explored mood and related facial expressions extensively in his etchings and history paintings.[115]

Representations of quack doctors and related medical charlatans have a long history in Netherlandish art. Hieronymous Bosch, for example, working in the late fifteenth century, helped to popularize the theme of the fraudulent "surgeon" who removes a stone from the head of a dim-witted client.[116] Brouwer's work recalls the Boschian tradition despite its rendition of the rare subject of a back operation, as do his more frequent representations of foot operations. But what separates Brouwer's depictions of this sort from those by other artists is his focus upon the effects of the operation, namely the excruciating pain experienced by the patient.[117]

All of Brouwer's paintings of this theme feature peasant practitioners. Although these figures are pure iconographic types (just like the artist's other images of peasants), some indirect links can nevertheless be established between their depiction and actual medical practitioners during the early seventeenth century.[118] In

Brouwer's day university educated physicians concerned themselves largely with theoretical matters and with serious illnesses. Consequently care for more commonplace mishaps such as broken bones was left in the hands of surgeons, men with rudimentary training who often worked simultaneously as barbers in order to make ends meet. In addition there were *vrije meesters*, literally, "free masters," who were largely self-taught and often specialized in a single procedure or care for a particular type of illness or injury. Unlike surgeons and doctors, free masters were not subject to guild regulations intended to oversee education and practice. Naturally, medical training and regulatory control over practitioners was conspicuously absent in rural areas.

It is likely that contemporary viewers of Brouwer's painting would have identified the peasant performing the procedure as a free master. However, in the quintessential Brouwer fashion, the subject exhibits a distinctly comical aura,[119] and the peasants, one of whom inflicts pain on the other, clearly function as satirical types. Brouwer is an enormously sophisticated artist (and was recognized as such in the seventeenth century); his painting therefore communicates satire in other, more elusive ways. Scholars have long noted the bold, loose brushwork of *The Back Operation* and indeed of other pictures from this period of his career. In several places most notably the white shirt of the patient, the brushwork is so free and seemingly spontaneous that the forms are suggested rather than described. Brouwer's broad and sketchy application of paint in this and other late paintings reflects wider developments in art produced in Haarlem by Frans Hals and his circle and, to a much greater extent, contemporary Flemish art. Rubens and Van Dyck were the most important exponents of this broad manner – or rough manner as art theorists termed it at the time – which they routinely employed to execute history paintings and portraits.[120]

Van Dyck in particular imparted tremendous finesse to this technique, placing it in the service of portraiture where it convincingly captured the self-assuredness and graceful air of his elite sitters (fig. 31).[121] Brouwer's brushwork approximates that of Rubens and Van Dyck in its boldness and sophistication but in contrast to these two masters he utilizes it principally to portray uncouth imagery. The deliberate irony (and wit) of this practice of fusing the base with the sophisticated was not lost on contemporaries and in fact helps to explain Rubens's previously noted enthusiasm for Brouwer's art.[122] It is also reflective of the penchant among well-to-do collectors during the first half of the seventeenth century for art with coarse subject matter.

Changing ideologies within Dutch culture in the latter half of the century, and related vagaries of taste, would lead some connoisseurs to consider Brouwer a vulgar artist whose subject matter was offensive and, most remarkably, whose painterly style was equally undignified.[123] As a consequence appreciation of Brouwer's art declined. Yet there is evidence of the once enormous popularity of his paintings not only from their presence

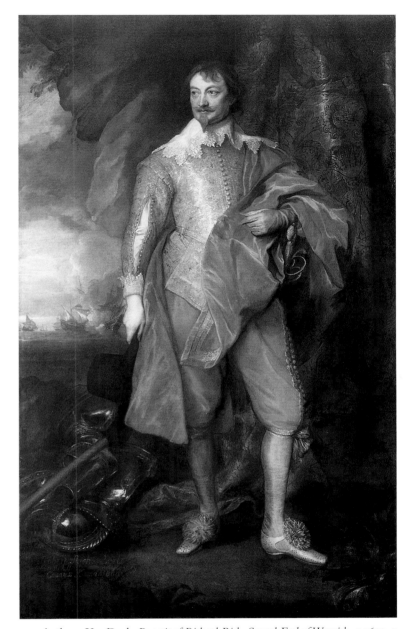

31 Anthony Van Dyck, *Portrait of Richard Rich, Second Earl of Warwick*, c. 1632–5 (oil on canvas, 208 × 128 cm). New York, The Metropolitan Museum of Art, The Jules Bache Collection, 1949 (49.7.26).

in contemporary collections and their reproduction in innumerable prints but especially from his impact upon a sizeable number of masters who specialized in peasant themes. The prolific Adriaen van Ostade (1610–1685) ranks among the artists most thoroughly influenced by Brouwer, at least during his early career.[124] Van Ostade, a life-long resident of Haarlem, enrolled in the city's Guild of St. Luke around 1634. Prior to this act, however, his career remains something of a mystery. Houbraken states that van Ostade and Brouwer were pupils together in Frans

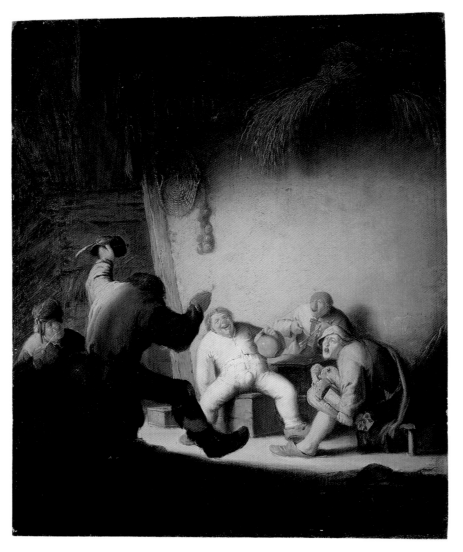

32 (*left*) Adriaen van Ostade, *Peasants Drinking and Making Music in a Barn*, *c.* 1635 (oil on panel, 33.7 × 27.3 cm). Private collection.

33 (*facing page*) Title Page from "Neusboekje," in *Nieuw worckumer almanach*, Leeuwarden, 1718.

Hals's studio.[125] This seems dubious, as previously noted, with respect to Brouwer and equally dubious for van Ostade. Whether they were taught together or not, van Ostade drew heavily upon Brouwer's art, even if his earliest documented activity as a painter dates to 1632, the year after the slightly older master had departed Haarlem.

Like Brouwer, van Ostade depicted caricatured peasants as humorous, raucous embodiments of excess. His *Peasants Drinking and Making Music in a Barn* (fig. 32) of about 1635 typifies van Ostade's early style. In a murky, barn-like hovel, boors in tattered clothing drink and smoke lustily and play simple musical instruments.[126] The palette of cream colors and delicate, pastel blues and pinks is strongly reminiscent of that of Brouwer's pictures from his last years in Haarlem. Yet these colors have been applied with tighter brushwork than that usually employed by Brouwer. And while the monochromatic

overlay of the panel is Brouwer-like, van Ostade's technique of spot-lighting, recalling Rembrandt's renowned chiaroscuro, is much more idiosyncratic.[127]

The subject matter of *Peasants Drinking and Making Music* is, much like its stylistic features, greatly indebted to Brouwer's prototypes. Peasant reveleries were obviously a Brouwer specialty and van Ostade was fully capable of replicating their boisterous vulgarity. Yet Brouwer's extraordinary ability to communicate raucousness through subtle gestures and expressions is absent in van Ostade's work. Indeed, the painting's sordid mood is conveyed by the emphatically clamorous figures, from the ungainly, dancing pipe-smoker in the foreground to the corpulent, jovial bumpkin reclining in the crude chair before him. The principal protagonists here, with their bulbous noses, angular postures, and stupefied expressions, are highly entertaining and throughly explicit portrayals of inebriation.

The motif of the bulbous nose has already been encountered in Brouwer's *Peasants of Moerdyck*. This repugnant physical feature, which so frequently adorns the faces of peasants, must be construed in light of early modern theories of physiognomy. Experts on this subject, such as Hermannus Follinus, citing the authoritative studies of Aristotle and other ancient writers, argued that explicit connections could be made between one's body type and facial features and one's character.[128] Noses of all shapes and sizes were consequently classified according to what they revealed about one's temperament and disposition. Thus bearers of phallically long noses were thought to be promiscuous. And those with large, bulbous noses, of the type common to portrayals of peasants in art, were associated with excessive drinking and smoking. The bearers of immense noses are said to have dipsomaniacal tendencies according to popular "nose books" (fig. 33), a peculiar literary genre of this period which combined succinct verses with crude woodcut illustrations of the nose in question.[129] What probably accounts for the extraordinary popularity of these books was their humorous, often scatological treatment of a subject addressed more earnestly by Follinus and his colleagues.

Many of van Ostade's early pictures can be linked to Brouwer's both in style and subject matter. However, van Ostade was too talented an artist to be slavishly dependent on the older master's models. As noted above, van Ostade's paint application is tighter than that of Brouwer and interiors are dramatically spot-lit. Moreover, his approach to peasant imagery, while lacking the sophisticated innuendo of Brouwer's, still possesses great comic effect. As he matured as an artist he increasingly distanced himself from Brouwer's approach and style and made some truly significant contributions to the depiction of peasants in the decades following the Treaty of Münster (1648).

Jan Miense Molenaer and Judith Leyster

Jan Miense Molenaer and Judith Leyster initially worked within the circle of Frans Hals in Haarlem. After their marriage in 1636 they moved to Amsterdam (where they were able to maintain contact with Haarlem painters because of the proximity of these two major artistic centers). They then purchased property in the village of Heemstede, south of Haarlem, in late 1648. Molenaer (c. 1610–1668) is perhaps the less talented, though definitely the more prolific, of the two.[130] Little is known of his early career; he paid annual dues to Haarlem's reorganized Guild of St. Luke upon the final ratification of its charter by the city in 1634 but may have registered in prior years at a time when the guild was recorded as having been in decline.[131] In any event, Molenaer had begun to sign and date his paintings by 1629.

Molenaer's earliest works reveal his familiarity with Frans Hals's occasional genre paintings, to such an extent that he is sometimes thought to have trained with Haarlem's most celebrated master. Molenaer's *Children Playing with a Cat* provides a case in point (fig. 34).[132] Probably painted around 1627–8 the canvas is reminiscent of Hals's own genre paintings of children (see fig. 14) in its compositional format, palette, and to a lesser extent, paint application.[133] Hals's bravura brushwork is perhaps the most salient and renowned aspect of his art and the most difficult to replicate, judging at least from pictures produced by many artists associated with his circle. Thus the sketchy qualities of Molenaer's facture only approximate that of Hals's work while essentially lacking his deft sophistication. (In fact, in certain respects, Molenaer's technique displays more similarities with that of Frans Hals's brother, Dirck.[134]) Like other early paintings by the artist, *Children Playing with a Cat* also manifests some weaknesses in drawing: the boy's left arm and shoulder are awkwardly composed, particularly in relation to the little cat who consequently protrudes from his shirt in a most peculiar manner. Despite these shortcomings, Molenaer does succeed in capturing the *joie de vivre* that is so often associated with Hals's depictions of children.

Children, represented with or without their parents, gradually developed into an enormously popular subject in Dutch seventeenth-century genre painting.[135] Although pictorial themes involving children would be transformed over the course of the century under the influence of various cultural and economic factors, Haarlem artists can be credited with producing some of the earliest paintings of childhood.[136] The history of childhood has been well-researched during the last fifty years or so. Whereas older theories espousing a grim view in which children were supposedly unappreciated and often neglected have been rightly questioned, revisionist ideas appraising childhood as an entirely halcyon stage of life are likely exaggerated as well.[137] Historical reality probably lies somewhere in between these two opposing perspectives. If anything, Dutch genre paintings of children and related art and literature confirm that childhood as a distinct

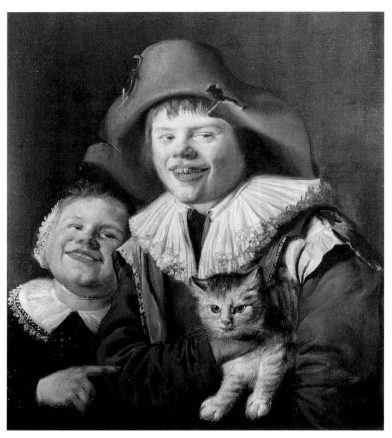

34 Jan Miense Molenaer, *Children Playing with a Cat*, c. 1627–8 (oil on canvas, 66 × 54 cm). Dunkirk, Musée des Beaux-Arts.

phase of life was obviously understood and experienced in early modern Europe in a manner somewhat different than it is today.

The toothy smiles of the two children in Molenaer's painting clearly reveal their delight in playing with the cat, a hapless creature tucked tightly under the arm of the boy. In paintings of children of this type the play element is usually pronounced even in those instances where boys and girls mimic the questionable behavior of their elders.[138] Seventeenth-century commentators looked upon play not as experts do today, as indispensable to the physical and social development of children, but only as an activity to which they were irrepressibly drawn by their very nature.[139] This rather limited understanding of play reflects wider and perhaps equally limited perceptions among adults of childhood as a purely carefree life stage.

Several contemporary prints and emblems of children playing with cats contain inscriptions and explanatory verses that equate the mischievous behavior of child and animal or wax metaphoric on the feline's propensity to cause pain by scratching.[140] But texts and prints with their various and, at times, even contradictory inscriptions pay testimony to the complexity of the contemporary reception of images and the limitations of exploring

meaning from the exclusive standpoint of an artist's intention. Yet Molenaer does provide visual clues, ones that help to narrow the range of interpretive possibilities. The children's tattered clothing, for example, a leitmotif of the artist's representations of this sort, suggests their carefree life as does their gleeful laughter. The copious exhibition of their malformed teeth is deliberate here. Contemporaries regarded excessive laughter with its unsightly display of teeth as a mark of ill-breeding associated with low social groups (such as soldiers and peasants) and youngsters; with characteristic naivety, the latter readily express their exuberance in this manner.[141] Molenaer thus invests the *Children Playing with a Cat* with comic dimensions playing upon notions of childhood as a life stage devoid of encumbrances. His view then is an amusing, but not entirely sympathetic one since compassion is rarely, if ever, present in seventeenth-century art.

Humor is fundamental to Molenaer's œuvre just as it is to so many works by Haarlem's best painters.[142] And as Molenaer's production increased during the 1630s the comic component of his art flourished accordingly. The 1630s were the most significant decade of Molenaer's lengthy career as a painter in terms of sheer output, experimentation, and the resultant, impressive variety of subject matter. *A Painter in His Studio* (fig. 35), signed and dated 1631, illustrates these new impulses in Molenaer's art and his rapid maturity as a painter.[143] This picture and others contemporaneous with it evidence the artist's growing mastery of the representation of figures in interior space as well as his familiarity with the achievements of his fellow Haarlem painters. The room inhabited by the artist and his models is similar in disposition to the one depicted by Molenaer's colleague Dirck Hals in the latter's *Woman Tearing a Letter* (see fig. 23), the floorboards remarkably so.[144] The typical coloristic discordancies of Molenaer's earlier art have been supplanted by a somewhat subdued, tonalist palette with some arresting color accidents, most notably seen in the outfit of the dwarf. The paint has also been applied with more carefully controlled brushwork.

Stylistic changes aside, *A Painter in His Studio* is noteworthy for its subject matter. The theme of the painter at work, while fairly common in painting and the graphic arts in the form of self-portraits, had hitherto been only infrequently rendered in genre painting.[145] Interestingly, most depictions of this theme, which include a number of sub-categories, were painted in Haarlem and Amsterdam; examples can be found in the work of Pieter Codde (see Chapter 3) and also in that of the unjustly neglected artist Hendrick Pot (c. 1580–1657).[146] In contrast to the dignified representations of his associates Molenaer renders the scene humorously. He depicts the unusual moment of a pause in the painter's activities as his group of models seem to take a break from posing – they cleverly reappear on the unfinished canvas tied to a stretcher on the easel at the right. This picture-within-the picture is strikingly witty as it shows an artist surveying the actions of the other three figures, the model who

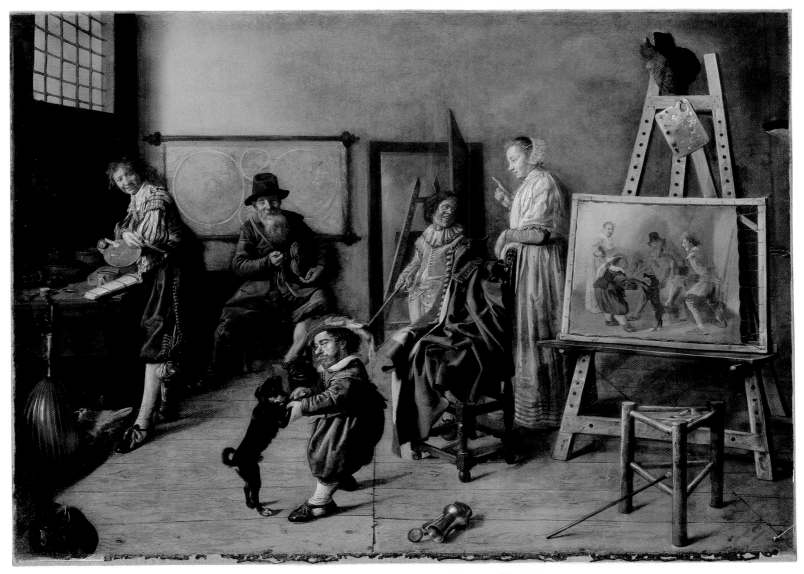

35 Jan Miense Molenaer, *A Painter in His Studio*, 1631 (oil on canvas, 96.5 × 134 cm). Berlin, Gemäldegalerie.

serves as an artist is seen standing with his palette, brushes, and mahlstick just to the left of the chair next to the easel itself.[147]

The artist whom Molenaer depicts as the actual author of the unfinished painting stands at a workbench at the far left, preparing to add new paint with a knife to his palette. He chuckles at the dwarf – a frequent, droll inhabitant of Molenaer's paintings – who dances with a dog to the accompaniment of a hurdy-gurdy played by the old man in the background. This extraordinary depiction of a studio is so plausible in its appearance and accouterments that the distinguished art historian Willem Martin cited it in a memorable article on the life of seventeenth-century Dutch artists published in 1905.[148] In treating the painting as a document of contemporary studio practices Martin did not recognize its comical dimension nor its staged nature and the light

it sheds upon the highly constructed and conventional qualities of Dutch genre paintings.[149] Although Hans-Joachim Raupp's interpretation of the painting as a moralizing meditation upon the Five Senses seems improbably weighty, it is difficult to propose a satisfactory alternative. In the end, one must agree with Dennis Weller's insightful observation that "Molenaer's talent for description and humor tends to obscure any suggestion of possible meaning" in this highly original painting.[150]

It was five years after he completed *A Painter in His Studio*, that Molenaer married the talented Haarlem master Judith Leyster and shortly thereafter they moved to Amsterdam. Although the reasons behind their decision to depart Haarlem are not entirely clear, Molanear's increasing financial problems at this time – in late 1636 his possessions were legally confiscated

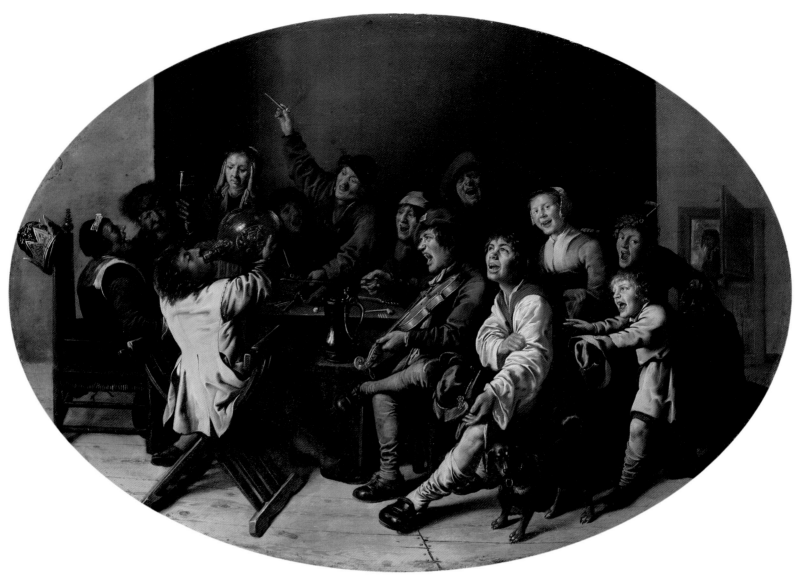

36 Jan Miense Molenaer, *The King Drinks*, c. 1636–7 (oil on panel, 41.5 × 55 cm). Vaduz, The Collection of the Prince of Liechtenstein.

because of debts owed to two creditors – were undoubtedly a contributing factor.[151] They arrived in Amsterdam at an auspicious moment in terms of the art market as this leading metropolis had developed into a keenly competitive artistic center. Molenaer must have appreciated the difficulty of trying to compete with growing numbers of outstanding portraitists and history painters (led by Rembrandt) as he gradually abandoned the practice of these genres in favor of the depiction of low-life imagery and by 1640 was depicting peasants and related base types almost exclusively.

This thematic shift may be considered a response to the art market in Amsterdam. In an effort to capture a niche in that market it is likely that Molenaer chose to focus on peasant imagery because no other artist had emerged to fill the void left by the death some three years earlier of Vinckboons, Amster-

dam's resident painter of such themes.[152] Archival documentation demonstrates Molenaer's connections with one of that wealthy metropolis's most important art dealers, Johannes de Renialme. When an inventory of de Renialme's possessions (including his own stock) was compiled in 1640, twenty of the 101 paintings listed were by Molenaer.[153] Since de Renialme was principally active in the upper end of the art market his sizeable stock of paintings by Molenaer implies a certain predilection among his affluent clientele for the artist's works, even if they did not command high prices.[154] (The comparatively modest costs of Molenaer's pictures are matched by those of works by his fellow genre painters.[155])

The King Drinks (fig. 36), a painting executed around 1636–7, provides an excellent example of the changes in Molenaer's art after his arrival in Amsterdam.[156] He initially retained the con-

trolled brushwork already in evidence in works painted earlier in the decade along with vestiges of the colorful palette that distinguishes his earlier art. However during his Amsterdam period Molenaer typically increased the number of figures that populate his paintings while decreasing their scale vis-à-vis the overall dimensions of the supports. The result was a series of wonderfully clamorous artworks, fully consonant with their subject matter. In this particular instance, Molenaer has not represented peasants per se but rather generic members of an unspecified, low social caste. The indeterminate yet coarse appearance of these figures recalls those of Brouwer and van Ostade which is only logical in light of Molenaer's Haarlem heritage. In fact, long after his move to Amsterdam, Molenaer must have returned regularly to his native town to paint, or so an archival document unearthed long ago declares: in late 1648 Molenaer testified before a notary that he traveled frequently to Haarlem to paint because scaffolding from a construction project on his house restricted the flow of light necessary to paint there.[157]

While the figures in *The King Drinks* recall those of Brouwer and van Ostade – compare the guzzling figure with the one in Brouwer's *Tavern Interior* (fig. 26) – the subject itself, relating to traditional Twelfth Night or Epiphany celebrations is drawn from Flemish art.[158] Painted representations of *The King Drinks* first appeared in Flanders in the late sixteenth century and enjoyed great popularity there during the 1630s and 1640s under the artistic leadership of Jacob Jordaens (1593–1678) and David Teniers the Younger (1610–1690). The latter's pictures of peasants revelling in taverns (fig. 37) recall the protagonists of Molenaer's painting which is certainly no accident given Teniers's considerable reputation in the Dutch Republic.[159]

Twelfth Night or Epiphany falls on 6 January, twelve days after Christmas. In earlier centuries, it was a Catholic holiday that commemorated the adoration of the infant Christ by the three

37 David Teniers the Younger, *The King Drinks*, 1635 (oil on panel, 47.2 × 69.9 cm). Washington D.C., National Gallery of Art, Ailsa Mellon Bruce Fund.

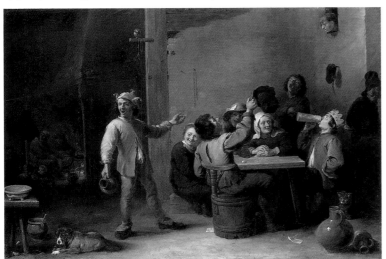

Magi. By Molenaer's time, Twelfth Night had shed much of its religious moorings, having evolved into a traditional celebration forged from earlier church festivities and pagan practices associated with the Germanic winter solstice. Naturally, many dogmatically Calvinist ministers were fiercely opposed to this holiday (and many others) on the grounds of its Catholic (or Papist, as they phrased it) origins and its potential for excessive revelries – one preacher from Leiden, writing in 1607, denounced it as "the first Bacchus feast of the year."[160] Nevertheless, Twelfth Night revelries were widely tolerated and thus provide a particularly instructive example of the typical tensions between leaders of the Reformed Church and secular officials outlined in Chapter 1.

A number of traditional activities were staged during Twelfth Night, including the procession from door to door of singers bearing a paper star illuminated by candlelight, a joyous allusion to the three Magi's original journey to Bethlehem.[161] Domestic celebrations were held involving prodigious quantities of food and drink as well as specific rituals conducted at table. Chief among them was the appointment of a "king" to preside over the merrymaking. This ruler was chosen either by means of a bean-cake – the person whose slice contained the bean was declared king – or by lottery using strips of paper, called *koningsbrieven* or the king's letters. These letters with assigned roles printed upon them were cut from sheets and chosen by lot by all participants who then played their parts at the mock court and in the "king's play" performed that night.[162] (Evidently, the characters in Molenaer's painting have elected the evening's leader by this latter method as various figures have strips of paper attached to their clothing.[163]) The king wore a paper crown decorated with crude images of the Virgin and Child, Joseph, and the three Magi.[164]

Every time the king drank, his acolytes, at the risk of "punishment" for not doing so, were to cheer loudly in unison, "The King drinks!" This ritual is what Molenaer, and, for that matter, Jordaens and Teniers, have depicted in their pictures. The event takes place at an inn, the four chalk marks on the right corner of the table recording the number of rounds previously served. Molenaer, like the other masters, highlights the boisterous atmosphere engendered by excessive drinking – note that the king (himself an iconographic descendent of late medieval images of gluttony) dressed in a bright yellow jacket, guzzles from an enormous jug as everyone else, including the children, yells with such frenzy that one woman covers her ears.[165] The king's paper crown hangs from the finial of a chair occupied by a toothless old hag whose role as "the fool" in this gathering is indicated by the strip of paper affixed to her cap.[166]

The visually contiguous motifs of the king's crown and the fool possibly served to underscore notions of social inversion inherent to celebrations of this type.[167] Persons from every walk of life, from beggars to the Prince of Orange, could theoretically participate in the festivities of this holiday.[168] Thus, a person of

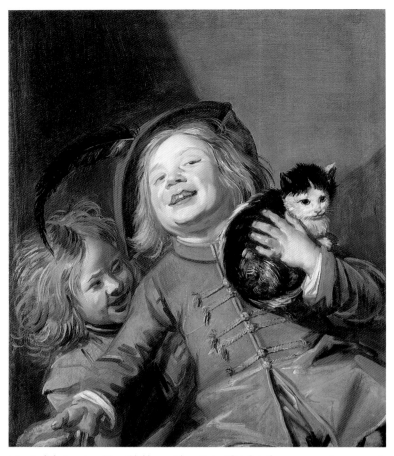

38 Judith Leyster, *Two Children with a Cat*, 16[?29] (oil on canvas, 61 × 52 cm). Private collection.

39 Cornelis Danckerts after Frans Hals, *Two Children with a Cat* (engraving). Amsterdam, Rijksprentenkabinet.

low social status had an opportunity, however temporary, to become the mock symbolic ruler over the evening's proceedings. Fate of course determined this person's appointment, one made purely in fun and, in that sense, momentary social inversions of this type paradoxically served to affirm existing societal hierarchies. Affirmation of rank was also provided by the artist's emphasis upon the excessive carousing of these uncivilized simpletons, behavior presumably far removed from that of the painting's owner. *The King Drinks* thus provides yet another example of how themes in art depicting the lower classes serve to validate the existing social order.[169] Thus Molenaer's panel does not present pure reportage despite the correspondences between it and the actual traditions celebrated on Twelfth Night.

Themes involving the lower echelons of society increasingly preoccupied Molenaer during the last three decades of his career. The artist did paint a small number of outstanding paintings during the 1650s and 1660s but for the most part the overall quality of his late work is unimpressive. In general, Molenaer's art was surpassed by that of his talented wife, Judith Leyster (1609–1660), a native of Haarlem.[170] After having trained with a

still unidentified master – the names of Frans Hals and Frans Pietersz. de Grebber (1573–1643) being most frequently invoked in this regard – Leyster entered the Guild of St. Luke in 1633.[171] There were other female painters in Haarlem at this time, but Leyster was the only woman listed among the roughly thirty male painters in the guild.[172] And equally remarkable, unlike many female artists, Leyster did not come from a family of painters, something that would have facilitated her entry into Haarlem's artistic circles: she was the daughter of a Flemish immigrant who initially worked in the city's burgeoning textile industry but subsequently purchased a brewery in 1618. Archival documents reveal Leyster's competence and pluckiness as she labored in a male-dominated profession. The twenty-six-year-old painter was, for example, already operating an independent workshop with male pupils by 1635, in October of that year bringing a dispute before the Guild of St. Luke concerning the tuition fees of a student who had abruptly left her studio to study with Frans Hals without the guild's permission.[173]

Prior to her dispute with Hals, the two artists must have been on good terms for Leyster served as a witness at the baptism of

40 Judith Leyster *Young Flute Player*, *c.* 1630–35 (oil on canvas, 73 × 62 cm). Stockholm, Nationalmuseum.

his daughter in 1631.[174] There are also distinct connections between Leyster's art and that of Hals, as *Two Children with a Cat* (fig. 38) demonstrates.[175] This painting is dated "16. [possibly 29]" and monogrammed JL, with the two letters entwined and a shooting star springing from the right side. This monogram cleverly refers to Leyster's family name (adopted by her father by 1603), which literally translates to lodestar or leading star.[176] This painting is strongly reminiscent of Hals's depictions of children from this period (see fig. 14) both in its diagonal composition and its exuberance and it relates closely to an engraving (fig. 39) that is signed "f.hals pinxit" (Frans Hals painted). As engravings usually do, it illustrates in reverse the now-lost Hals painting that indicates that Leyster was probably copying the same image that the engraver had seen.[177]

Leyster not only copies the figures; her brushwork is Halsian as well, displaying the pronounced sketchiness identified with that renowned master's facture though the strokes themselves are generally shorter and the paint is applied more thickly. Leyster comes quite close to replicating Hals's bold, seemingly

41 Judith Leyster, *The Proposition*, 1631 (oil on panel, 30.7 × 24.1 cm). The Hague, Mauritshuis.

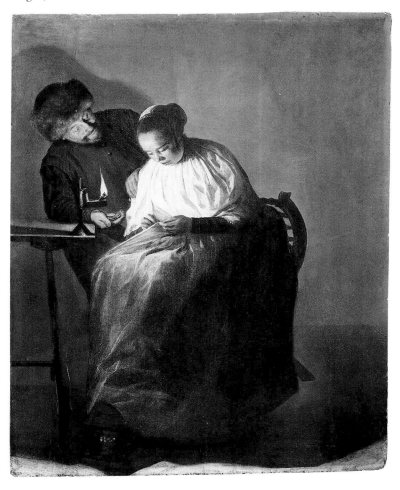

spontaneous execution but invariably, like similar attempts by her fellow Haarlem artists, is unable to imitate it flawlessly.[178] The existence of *Two Children with a Cat* and related adaptations from Hals's work are made all the more intriguing by the fact that Leyster's most Hals-like pictures date to 1629 or thereabouts, in other words, several years before her entry into the guild. For this reason, some scholars argue that Leyster was the famous master's pupil or perhaps worked as an assistant in his studio even if there is no documentary evidence to support these claims.[179]

Leyster's best paintings are complex entities whose pictorial origins are difficult to confine to the inspiration of just one artist, however pivotal he may be to art in Haarlem during this period. One of Leyster's most extraordinary pictures, the *Young Flute Player* of around 1630–35 (fig. 40), has, for instance, been linked to Hals's representations of children playing musical instruments, despite its tighter paint application. Yet the half-length, boyish figure posed before a neutral, unarticulated background bathed in natural light unquestionably recalls paintings by the Utrecht Caravaggisti (see fig. 67).[180] Nevertheless, Leyster's achievement here lies in her creation of an artwork that is more than the simple sum of its disparate parts. One can readily point to paintings by other artists with which she was likely to have been familiar, but the final product is uniquely hers.

The *Young Flute Player* contains a number of interesting details despite its seemingly modest subject matter, including the broken back of the chair upon which the boy sits – or rather slouches, an awkward pose for playing the transverse flute – and the superb rendition of the recorder and violin hanging from the pock-marked wall behind him.[181] The juxtaposition of these two instruments on the wall might not be purely fortuitous: within the ideological world of early modern music (one heavily influenced by ancient concepts), they were considered antipodes. Stringed instruments theoretically belonged to a loftier category associated with Pythgorean harmony whereas wind instruments by comparison were deemed less sophisticated.[182] For this reason the latter are generally depicted in art in the hands of peasants, shepherds, and similar types. Yet there are many exceptions to this iconography – violins, for example, occasionally convey erotic associations while wind instruments sometimes evoke more wholesome notions – and although the boy in Leyster's painting is playing a transverse flute, his earnest expression of great concentration and his distant, upward gaze belie the instrument's base associations.

The flute player's upward glance, while something of a stock expression in Western European art by 1635, nonetheless relates to those found in other representations of musicians, including godly saints and purely secular performers.[183] The theoretical capacity of music to inspire and animate the soul to heights of unadulterated bliss was well known in this era. This theory originated in antiquity with the writings of Pythagoras who argued

that the performance of beautiful earthly music could elevate the human soul to partake of the mystical music of the spheres, namely, the cosmic musical harmonies of the stars and planets rotating en masse. This is not to imply that Leyster's young musician has entered into a celestial realm of lyric concord, but rather that his upward gaze epitomizes inspiration. In sum, the *Young Flute Player* celebrates the pleasures of music-making.

Leyster also excelled at nocturnal scenes. These too were a speciality of Utrecht painters (see fig. 73) and by the early 1620s similar pictures were being executed in Haarlem.[184] Doubtlessly, Leyster was familiar with both Utrecht prototypes and related, Haarlem examples. Leyster's most renowned night scene is *The Proposition*, monogrammed and dated 1631 (fig. 41).[185] By the subtle light of a simple oil lamp, a modestly dressed young woman sews with rapt attention. Her concentration upon her work is so intense that she does not respond to the man to her right who touches her arm, offering a handful of coins. Frima Fox Hofrichter, citing Utrecht precedents for its subject matter (see fig. 59), maintains that this unusual scene represents a sexual proposition, but contrary to the salacious women in these other representations, Leyster's demure female becomes the embarrassed victim, a possible reflection of the artist's viewpoint as a woman.[186] Hofrichter's intriguing analysis does not account for the fact that proposition scenes by Utrecht painters always feature aggressive prostitutes, not meek seamstresses; therefore it is unclear whether the man is soliciting sex. It is also possible that his intention is less vile, namely that he is trying to persuade the woman to court for money, a theme encountered in contemporary graphic art.[187] Furthermore, refusals of advances, whether sexual or monetary, are also found in images by male artists (see fig. 166) so *The Proposition* may not reflect a specifically female viewpoint after all. But many of these images are actually paintings that postdate Leyster's, suggesting she helped to popularize this theme in art, and the woman's unequivocally

wholesome activity of sewing provided an important precedent for later genre paintings depicting domestic virtue.

Each painting by Leyster discussed here has a singular appearance, so much so, that if two were not monogrammed, it may have proved difficult to attribute all three to the same artist. Surely this pays testimony to Leyster's impressive protean abilities. The entire œuvre of this gifted artist was compressed into the period between 1629 and her marriage to Molenaer in 1636. Thereafter, Leyster seems to have painted very little: only one artwork, a silverpoint and watercolor of a tulip, monogrammed and dated 1643, survives from the twenty-four-year period between her marriage and death in 1660. During these years, the lives of Molenaer and Leyster grew increasingly complicated not only by the arrival of children but also by ponderous financial and legal affairs. By the time of her decease, the couple had purchased three houses, in Haarlem, Amsterdam, and the village of Heemstede respectively (and inherited one other); they oversaw the rental of one or possibly two of these properties for investment purposes; had moved repeatedly; were involved in numerous lawsuits; and administered a busy workshop.[188] Leyster's excellent managerial skills were evidently apparent to her husband for in 1657 Molenaer granted her power of attorney to oversee his complex financial concerns. The combination then of motherhood and supervising her husband's numerous business ventures likely hampered Leyster's opportunities to further her own career as an artist, much to our loss today.[189]

As this chapter has made clear, Haarlem played a critical role in the development of genre painting during the first three decades of the seventeenth century. Impelled by waves of immigration and economic expansion, the city became a major site of artistic innovation, led by such talented artists as the Hals brothers, Buytewech, Brouwer, and Leyster. Yet the vicissitudes of time in the form of ever-changing economic and social conditions, would eventually lead to Haarlem's demise as an art center (see Chapter 9).

42 David Vinckboons, *Kermis*, *c*. 1605 (oil on panel, 52 × 91.5 cm). Dresden, Gemäldegalerie Alte Meister, Staatliche Kunstsammlungen.

CHAPTER THREE

AMSTERDAM

During the early decades of the seventeenth century, artists working in both Amsterdam and Haarlem fixed the development of Dutch genre painting. That these two cities were at the center of the revival of the Dutch economy and the destination point for seemingly countless immigrants goes far in explaining their rise to prominence as art centers during the early seventeenth century. The underlying reasons for Amsterdam's imminent artistic primacy once again involve the economy and immigration. Unlike Haarlem, Amsterdam never suffered at the hands of the Spanish army. Although it experienced some turmoil during the Revolt, Amsterdam was infinitely better positioned than Haarlem to reap the rewards of the economic miracle of the 1590s.

It was in that period of pronounced economic expansion that Amsterdam rose to prominence as the Dutch Republic's leading metropolis and Europe's foremost trading center.[1] The city was the hub for international trade and finance, as evidenced by its monopolies over diverse, lucrative foreign markets, for example, French wine, Baltic grain, Brazilian sugar, and Swedish iron and copper; its bulging warehouses that stored a seemingly infinite variety of goods; its well-organized merchant fleets sailing from the city's spacious, secure harbor to the far reaches of the globe; its exchange bank and renowned stock exhange.[2] Indeed, Amsterdam's prosperity and international renown made it one of the most attractive destinations for immigrants from the Southern Netherlands and other European countries as well. These immigrants accounted for the truly exponential growth of the city's population between the early stages of the Revolt and the middle of the seventeenth century.[3] In 1570, for example, Amsterdam had 30,000 denizens; in only thirty years its population would double to some 60,000 inhabitants, of which over fifty percent were Flemish émigrés. By 1620 their number exceeded 100,000 and would nearly double once again by 1660.[4] By any measure, Amsterdam became one of the largest and wealthiest cities in Europe during the seventeenth century.

The tremendous influx of people forced Amsterdam to extend its borders far beyond their antiquated, late medieval limits in several phases beginning in 1585.[5] Initial construction on Amsterdam's signature ring of three canals was begun in 1613 and subsequently expanded in another campaign commencing in 1660. These extensions eventually imparted to the city's topography the distinctive, fan-like shape for which it is known today. Many of the new residential districts were intended for Amsterdam's most affluent citizens, namely, the wealthy merchants and patricians who had most profited from the booming economy. The luxurious residences that these wealthy residents constructed – several on a nearly palatial scale – literally underscored the escalating distance between them and their financial and social inferiors.

Amsterdam's unrivaled prosperity and concomitant cosmopolitan character obviously made it an appealing place for artists to settle. Already during the late sixteenth century, Flemish painters immigrated there, among them Hans Bol (1534–1593) and David Vinckboons, and Dutch painters would continue this trend throughout much of the seventeenth century as they moved to Amsterdam in significant numbers. For example, the foremost painter of the era, Rembrandt, departed his native Leiden in the early 1630s for Amsterdam, undoubtedly enticed by the city's many financial opportunities.

David Vinckboons

David Vinckboons (1576–before 1633) ranks among the earliest painters of Flemish birth to have a significant effect on seventeenth-century Dutch genre painting.[6] Vinckboons immigrated with his family to the North around 1586 and subsequently settled in Amsterdam in 1591 when he was about fifteen years old. He was probably trained exclusively by his father, Philip Vinckboons (c. 1545–1601), who painted watercolor tapestries (marketed as inexpensive alternatives to woven tapestries), a specialty of his native Mechelen in Flanders. David Vinckboons was a multi-talented artist who created drawings as designs for prints, book illustrations (see fig. 46), and even stained-glass windows. His paintings, though less numerous than his drawings, include a variety of religious and mythological subjects. However, of all his manifold work, Vinckboons's genre paintings proved the most influential with a younger generation of masters.

As a painter born in Flanders in the late sixteenth century it was only logical that Vinckboons would be receptive to the profound influence of one of the greatest Flemish artists of that century, Pieter Bruegel the Elder (c. 1525/30–1569). Bruegel's best paintings were almost all in private collections by Vinckboons's day and thus not easily accessible; instead his art was mainly

known from prints and paintings copied from the originals.[7] He was primarily identified with comical representations of peasant life.[8] Vinckboons was responsive to his peasant imagery, especially Bruegel's depictions of peasant fairs and related festivities. This theme was enormously popular during the sixteenth and early seventeenth centuries and was (and still is) generally known by its Dutch title, *Kermis*.

Vinckboons's *Kermis* of around 1605 (fig. 42) is an outstanding representation of this theme, one of many he produced during his three-decade career.[9] The picture shows peasant merrymaking in connection with the feast day of St. George, who is portrayed on the banner hanging from the ramshackle building at the right. This structure and banner were inspired by a print of about 1559 after a now-lost drawing by Bruegel the Elder (fig. 43). Likewise, the focus on excessive peasant revelries in the print is adopted by the younger artist, whose boors urinate, drink, and vomit with wild abandon.

Vinckboons has included an absolute wealth of detail here aided by his tilted composition which causes the space to recede upward rather than backward. This compositional device, commonly termed, "bird's-eye perspective", is ultimately derived from the work of Bruegel the Elder and other Flemish sixteenth-century landscape specialists. Its use enables the artist to reveal a vast panorama of peasant excesses and foibles amidst a bosky setting of highly stylized trees whose foliage is also dependent upon earlier prototypes. The throngs of small-scale figures scurrying to and fro through a dense, sylvan setting are typical of Vinckboons's early work. In the middle foreground, for example, ungainly figures with stooped bodies riotously dance to the music of a bagpipe player. In his brief biography of Vinckboons published in his *Schilderboeck* (Painter's Book) of 1603–4, Karel van Mander praised one of the painter's *kermis* scenes, then in the possession of a prominent Amsterdam collector, for its

"subtle and lively postures."[10] Although the image under discussion here postdates the publication of van Mander's book, the earlier painting to which he refers most assuredly resembled it in the presentation of a seeming myriad of figural types.

In the right background, before a cheering crowd, the artist renders passing horsemen making cruel sport of a greased goose as they attempt to yank the hapless creature off a line to which she has been tethered. This vicious game, called "Tug the Goose" (also known in adaptations involving eels, herrings, and cats) employed either a dead or live animal and was played at fairs and saints' feast-day celebrations – Catholic customs and celebrations were never entirely expunged in the Dutch Republic.[11] Certainly, large numbers of peasants attended these events, but Vinckboons's painting does not simply chronicle seventeenth-century experiences and gatherings. The work owes less to contemporary life than to pictorial traditions that had been popularized some fifty years earlier by Bruegel the Elder. Vinckboons's subject is drawn from the visual repertoire of this renowned, sixteenth-century artist and that of his colleagues, as are such stylistic devices as the bird's-eye perspective, ornamentalized vegetation, bright palette, and stocky, odious figures.

Vinckboons's panel is just one of his approximately dozen representations of this theme. All of these images constitute variations upon one another as many of the same details appear continuously, from those in his earliest depiction of a *kermis*, a drawing dated 1602 (Copenhagen, Statens Museum for Kunst) to those in his latest, a painting dated 1629 (The Hague, Mauritshuis). The incessant repetition of *kermissen* within Vinckboons's œuvre, as well as the constant duplication of motifs from image to image, attests to the conventionality of this theme and, conversely, to its tenuous links with actual social conditions. In essence, Vinckboons perpetuated a theme in art that had already been in existence for decades. However, he did not slavishly imitate the work of his artistic predecessors but cleverly updated it with the inclusion of such details as the figures' more contemporaneous costumes and the Tug the Goose game. Vinckboons must have shrewdly recognized the theme's market potential as he labored in a dynamic and prosperous city, increasingly inhabited with well-to-do immigrants thoroughly familiar with traditional Flemish art. This would explain the existence of so many representations of *kermissen* by Vinckboons and other artists.

With these portrayals Vinckboons was clearly responding to market demands dictated to some extent by the tastes and desires of prospective purchasers. And these buyers were generally members of the upper classes in Amsterdam and other cities. This fact raises the perplexing question of why wealthy urban dwellers would want to pay good money for the privilege of hanging in their homes depictions of ill-bred, country bumpkins. Traditionally it has been argued that the principal purpose of paintings of this sort was didactic, namely, to admonish cosmopolitan viewers about vice in a gentle and

43 Joannes and Lucas van Doetecum after Pieter Bruegel the Elder, *Kermis of St. George*, c. 1559 (engraving). Amsterdam, Rijksprentenkabinett.

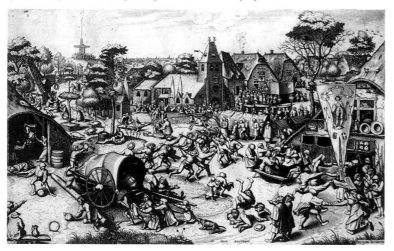

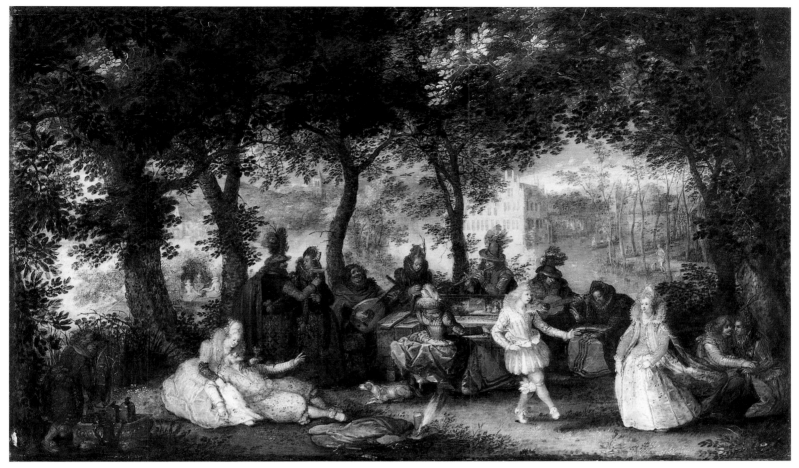

44 David Vinckboons, *Garden Party*, 1610 (oil and tempera on panel, 41 × 68.3 cm). Vienna, Gemäldegalerie der Akademie der bildenden Künste.

inoffensive way by illustrating peasants whose droll behavior appealed to their prejudicial attitudes.[12] This point of view has merit as it is corroborated by some seventeenth-century texts and print inscriptions. But did sophisticated, moneyed spectators invariably gaze at these images of the underclass in order to admonish themselves daily about the depravity of excessive drinking, dancing, and vomiting? Perhaps a more nuanced reading of these images is in order. The conventional nature of these representations attests to their status as constructs of peasant life illustrating unproblematic caricatures of the rural poor fashioned for urban consumption. Essentially these images more closely reflect upper-class biases than the genuine habits and living conditions of the peasantry. Because depictions of peasants present derogatory but comical illustrations of boorish, uncivilized conduct, they also served, in a highly entertaining manner, to affirm affluent connoisseurs' consciousness of their behavioral and social supremacy in a culture characterized by distinct hierarchies of class and rank.[13] In other words, questions of morality hinge not so much upon concepts of sin and damnation but rather upon the secular ethics of urban

elites: these pictures depicted the rabble's supposedly coarse behaviors to which genteel viewers considered themselves insusceptible.

Vinckboons simultaneously catered to refined tastes with an entirely different theme, one depicting the outdoor leisure activities of the upper classes. The painter's representations of the theme of the garden party were just as numerous, conventional, and influential as those of the *kermis*. His *Garden Party* of 1610 (fig. 44), for example, depicts a lush, sylvan setting in which splendidly attired youths enjoy one another's company as they play music, dance, and engage in polite conversation.[14] The delicate, ornamentalized treatment of the foliage extending into the verdant distance offers a pleasurable botanical parallel to the elegant affectations of the revellers. Yet in comparison with the figures in the *Kermis* (see fig. 42), those depicted here have grown in amplitude and in proportion to the overall composition. These stylistic features of the *Garden Party* indicate its transitional status within Vinckboons's artistic development; in his later paintings, the figures nearly dominate the setting. Here, the central focus is the musicians and singers grouped around a large

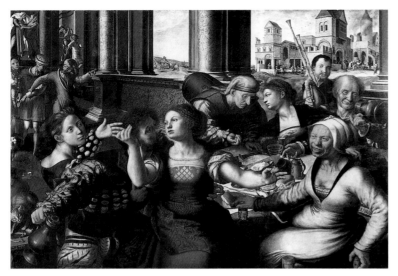

45 Jan van Hemessen, *Parable of the Prodigal Son*, 1536 (oil on panel, 140 × 198 cm). Brussels, Musées Royaux des Beaux-Arts, M.I. 2838.

spinet. Young people also cavort and drink, and in the foreground a young man reclines in the lap of his beloved.

This panel certainly possesses an air of contemporaneity. In fact, on certain albeit indirect levels it can be linked to actual experiences, for young people courted one another in the seventeenth century as they have throughout time, and alfresco gatherings were often recommended for this purpose.[15] The plausible appearance of this image, however, belies the artist's continued dependence on Flemish iconographic traditions for its genesis. The theme of garden parties in Dutch genre painting can be tied to any number of pictorial precedents, including fifteenth-century engravings of gardens of love and sixteenth-century Flemish paintings representing mythological and religious themes in garden settings, most notably that of the Prodigal Son from Christ's parable who squanders his inheritance on prostitutes and drink, a theme of obvious moral condemnation (fig. 45). Despite the influence of such moralizing antecedents, the same didactic impulses do not necessarily inform Vinckboons's painting, for it lacks major motifs, like the Prodigal Son himself or episodes from his parable depicted in the background, that would support such a reading.[16]

To be sure, other representations of this popular theme carried admonitory content, which is easily corroborated by perusing contemporary literature and graphic art. But these paintings, texts (especially those by authors with decidedly Calvinist leanings), and prints must be weighed against others that innocuously celebrate love and courtship within bucolic settings. Curiously, the songbooks held by various figures in the painting (and ever-present in Vinckboons's other depictions of this theme) yield insights into alternative ways in which contemporary audiences may have construed it. Songbooks of the type illustrated here were published in sizeable numbers during the first two

decades of the seventeenth century at precisely the same time that Vinckboons was painting his outdoor merry companies. They were relatively expensive, lavishly illustrated, elegant tomes with songs and poems penned by some of the most talented authors of the period including Pieter Cornelisz. Hooft (1581–1647), Joost van den Vondel (1587–1679), and Gerbrand Adriaensz. Bredero (1585–1618).[17]

As such, songbooks were just one manifestation of the widespread interest in literary paraphernalia associated with love and courtship. To these tomes can be added poetry collections, books of etiquette, and emblem books.[18] Edification was the professed intention of many of these amatory volumes as they advocated caution, self-control, moderation, and reliance upon God's sovereignty during the courtship process.[19] The owners of such books did not simply collect them as luxury items; their use was infinitely more practical as they were toted on excursions – particularly to the country, a locale best thought to hasten courtship, but also to weddings and other festive gatherings, where they facilitated singing and polite discourse about love.[20] Lovers even exchanged them as presents and in some books the buyer could insert the coat of arms of his beloved in a space provided therein.[21]

That Vinckboons himself was actively involved in the production of amatory literature is especially fascinating as he repeatedly provided drawings as prototypes for the engraved illustrations that graced the pages of these books.[22] In fact, one of Vinckboons's creations, initialed in the lower left, DVB inv. (inv. = invenit = designed by), appeared on the title page of several early seventeenth-century songbooks (fig. 46), thus demonstrating just how closely contemporaries could perceive the links between courtship in art and amatory literature.[23] This illustration recalls the *Garden Party* and once again attests to the

46 Title page from *Den nieuwen verbeterden lust-hof*, Amsterdam, 1607. The Hague, Koninklijke Bibliotheek.

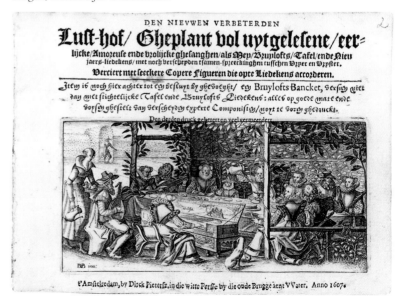

conventionality of this imagery. It too depicts music-making and merriment among splendidly dressed youths in this instance conducted within the refreshing confines of a leafy arbor. If anything, songbooks and related texts militate against the tendency to read didactic overtones into every image of youths indulging themselves in pleasurable activities because such interpretations underestimate the complexity of seventeenth-century Dutch culture.[24] Vinckboons's painting likewise celebrates love (though perhaps with less restraint than in the title page) and must therefore be tied to the contemporary penchant for amatory imagery in all its manifold visual, textual, and even audible forms.[25]

Despite Vinckboons's close adherence to pictorial traditions in his representations of *kermissen* and garden parties he made decisive contributions to the early development of seventeenth-century

Dutch genre painting by modifying and modernizing these themes to some extent. And a slightly younger generation of artists, principally working in nearby Haarlem, responded to his stylistic and thematic innovations and altered them even further.

Pieter Codde and Willem Duyster

Pieter Codde (1599–1678) and Willem Duyster (c. 1599–1635) were the two most prominent genre painters in Amsterdam during the 1620s and 1630s.[26] Both became specialists in this field after some initial forays into portraiture. Their genre paintings, which reveal an intimate knowledge of contemporary artistic developments in Haarlem, comprise an important transitional

47 Pieter Codde, *Dancing Lesson*, 1627 (oil on panel, 39.5 × 53 cm). Paris, Musée du Louvre.

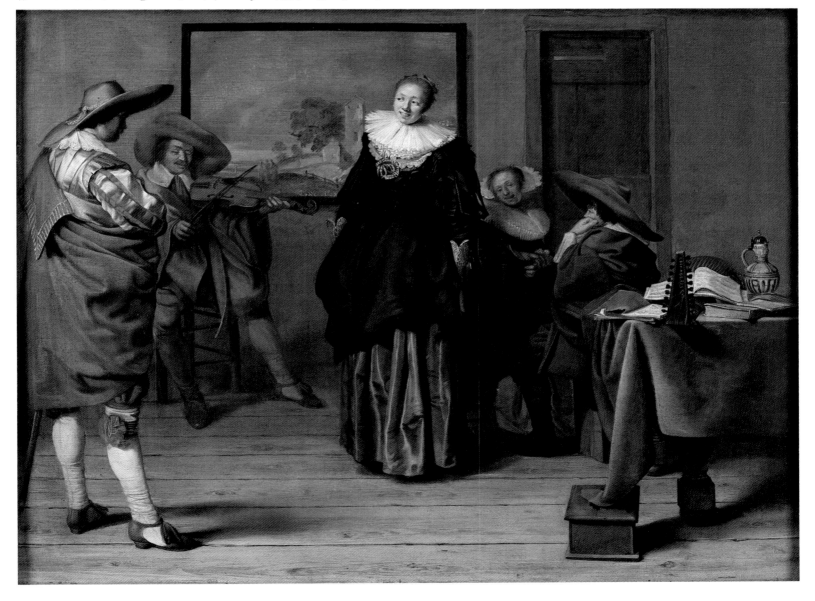

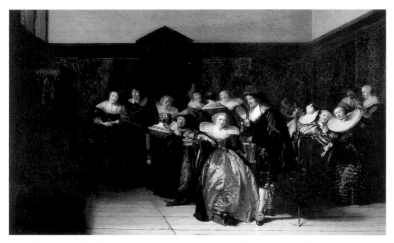

48 Pieter Codde, *Merry Company*, 1631 (oil on panel, 52 × 85 cm). Private collection.

49 Illustration from Gillis Quintijn, *Hollandsche-Liis met de Brabantsche-Bely*, The Hague, 1629. Amsterdam, Universiteits-Bibliotheek Amsterdam.

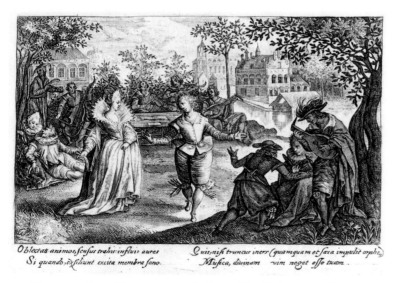

Oblectat animos, sensus trahit: influit aures
Si quando, exsiliunt excita membra sono.

Quis, nisi truncus iners (quamquam et saxa impulit orpheus)
Musica, divinam vim neget esse tuam.

50 Illustration from *Nieuwen ieucht spiegel* . . . , N.p. N.d. (*c.* 1620). The Hague, Koninklijke Bibliotheek.

stage, both thematically and stylistically, between Buytewech's spirited interiors and the graceful images produced by the next generation of genre painters, epitomized by the work of Gerard ter Borch (1617–1681) and Johannes Vermeer (1632–1675). Codde and Duyster matured concurrently as artists and were well-acquainted with one another. Surviving documents reveal some fascinating details – not all of them flattering – concerning their lives and careers. For example, in 1625 Codde and Duyster became embroiled in an altercation that led the former to strike the latter in the face with a tin pitcher![27] That this distressing incident occurred at a gathering held in a country house rented by a professional colleague of the two painters betokens a certain level of camaraderie among members of Amsterdam's artistic community (even if they sometimes fought with one another). The double wedding in 1631 of Duyster to the sister of his fellow genre painter Simon Kick (*c.* 1617–1668) and Kick to Duyster's sister only intensified this communal state of affairs – the two couples eventually lived together in Duyster's house. Duyster's bride was in turn related to the de Brays, a prominent family of artists in Haarlem but, given the proximity of the two cities, he certainly would not have needed this connection to become familiar with painting there. Codde was equally knowledgeable of Haarlem painting and an inventory of Codde's possessions, compiled in 1636 on the occasion of his marital separation, records a sizeable number of paintings by Haarlem artists.[28]

Merry companies and thematic variations upon them rank among Codde's most frequently painted subjects and many of these representations reflect his awareness of Haarlem painting. In fact, the tonalities of Codde's earliest dated genre work, the *Dancing Lesson* of 1627 (fig. 47), are somewhat reminiscent of the art of Frans Hals (see fig. 10), although the former's brushwork (at this early point in his career) is much more precise than that of the latter. These tonalities are enlivened by the warm color accents of the two standing figures' clothing. The woman in the center of this relatively unadorned interior is evidently practicing her dancing to the accompaniment of a violinist as another young man, perhaps her instructor, looks on. The *Dancing Lesson*, with its playful interaction among the sexes, is adapted from paintings of merry companies, which, prior to 1627, were produced in the largest numbers in Haarlem (see fig. 20). But the overall tonal unity of Codde's painting, its more complete integration of the figures into their surroundings, and the absorption of these very same figures in their activities can be considered innovations that would inspire such Haarlem genre painters as Dirck Hals.

Codde eventually depicted dancing in a much more elaborate and elegant manner in a number of musical parties executed during the 1630s (fig. 48).[29] Nevertheless, as a group, these pictures provide fascinating commentary on attitudes toward dancing (as well as other upper-class leisure activities) in the Dutch Republic. Dutch perspectives on dancing were deeply

ambivalent.[30] A succession of Reformed ministers and moralists vociferously condemned the activity for potentially inciting lustful thoughts and deeds. One of them, the fiery Utrecht preacher Gisbertus Voetius, opined in 1644 that the pastime was so inherently laden with temptation that it was even dangerous to watch people dance – one can only imagine what he would have thought of contemporary paintings of dancing.[31]

Conservative anxieties concerning the inherent evils of dance were likewise articulated in Gillis Quintijn's *Hollandsche-Liis met de Brabantsche-Bely* (The Dutch Elizabeth with Bellie of Brabant), published in Haarlem in 1629, a bombastic tome censuring that city's purportedly wayward youth. The illustration that accompanies Quintijn's attack of dancing portrays every Calvinist parent's nightmare (fig. 49): young people dance with such zest – note the youth indelicately hoisting his partner in the foreground – that matters have gotten totally out of hand as couples throw books into a roaring fire and generally comport themselves with frenzied indecency.[32] However much deductive insight Voetius's and Quintijn's admonitory pronouncements yield about contemporary perceptions of genre paintings like the *Dancing Lesson* these men and their like-minded colleagues should not be considered official spokespersons for seventeenth-century Dutch culture.[33] Positive, if not enthusiastic, attitudes toward dancing can be found in other contemporary documents. The highly popular songbooks of the period contain numerous illustrations (fig. 50), poems, and songs celebrating dance as an activity conducive to awakening sweet love.[34] Moreover, in some elite circles, dancing was considered salubrious as it promoted bodily grace and suppleness, requisite physical qualities for those of august social status.[35] For this reason many prominent citizens arranged lessons for their children. Constantijn Huygens (1596–1687), a legendary author and connoisseur in the Dutch Republic, wrote in his diary that his father gave him and his siblings such instruction so that they "would get used to those things that create beauty in appearance and posture and make the gait elegant and unconstrained."[36]

Codde's painting is certainly not documentary but it is fascinating to note in connection with it that dancing schools actually existed in the Netherlands. With this elite perspective in mind, it is illuminating to compare the pose of the young lady in Codde's painting with those of the stooped peasants in David Vinckboons's *Kermis* (see figs. 42 and 51). In relatively relaxed modern society, posture rarely comes into play as a delineator of social status. By contrast, early modern societies featured rigorously demarcated social hierarchies and within in them such phenomena as dress, demeanor, and posture spoke volumes about one's station in life. Codde's woman displays an erect carriage while Vinckboons's peasants sport ungainly poses, which is no mere coincidence. A similar distinction was made in late sixteenth- and seventeenth-century prints, among them Jan Theodor de Bry's pendants of *A Court Dance* and *A Peasant*

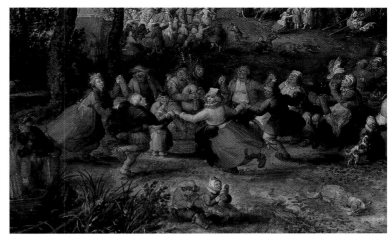

51 Detail of fig. 42.

Dance (figs. 52 and 53).[37] These prints feature suave, courtly dancers and their polar opposites: caricatured peasants who cavort frenetically, stooping their bodies in the most unbecoming positions. The Latin inscription on the *Peasant Dance* interprets these respective prints unequivocally along social lines: "As far as the court is from the farmyard, So remote is the courtier from the peasant; As this wild dance makes clear. But it is all to the good, for it expresses the gulf between different walks of life." Even without the inscription, any seventeenth-century viewer examining these prints along with the two paintings would have implicitly recognized and understood the social commentary provided by the disparate figural poses, even if it eludes us today.

Codde's figures are thoroughly absorbed in their activities, thereby introducing an unprecedented level of intimacy into seventeenth-century Dutch genre painting. This feeling of intimacy is further heightened and refined in the art of Willem Duyster. In retrospect, of the two masters, Duyster possessed greater talent as his work is consistently more novel and visually arresting than that of Codde. Tragically, an outbreak of the plague in Amsterdam in 1635 ended Duyster's career at the relatively young age of thirty-six. (And Codde himself, who lived until 1678, largely abandoned genre painting less than a decade later.) Duyster and Codde were familiar with one another's work; Duyster likewise painted merry company imagery, but he skillfully reduced these frequently complex, multi-figured scenes to their thematic quintessence: a couple engaged in some amorous pastime.

The example par excellence of this type in Duyster's art is his *Duet*, probably executed around 1627 (fig. 54).[38] This painting depicts an affluent couple in an unarticulated interior. An elegantly dressed woman is seated at a table upon which rests an open music book and a lute. A viola da gamba rests against the table with a bow pulled completely through its strings. The woman's male companion, standing at the opposite end of

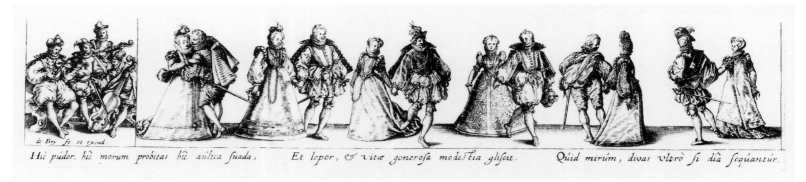

Hìc púdor, hìc morum probitas hìc aulica suada, *Et lepor, & vita generosa modestia glisat.* *Quid mirùm, divas ultrò si dià sequantúr.*

52 Jan Theodor de Bry (attributed to), *A Court Dance* (engraving). Amsterdam, Rijksprentenkabinet.

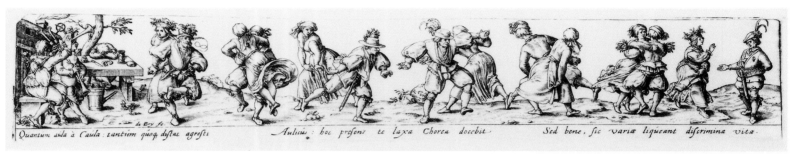

Quantum aula à Caula: tantùm quoq distat agresti *Aulicus: hoc presens te laxa Chorea docebit.* *Sed bene, sic variæ liqueant discrimina vita.*

53 Jan Theodor de Bry (attributed to), *A Peasant Dance* (engraving). Amsterdam, Rijksprentenkabinet.

the table, is thoroughly preoccupied with tuning a lute propped up on the seat in front of him. As many contemporary texts and prints confirm, the consonance of musical instruments properly tuned and played is a metaphor of the harmony between lovers.[39] Perhaps this notion is reinforced visually by the fact that the woman's form echoes the position of the viola da gamba while her ovoid facial features provide a geometrical analogue to the shapes of the two lutes. The introspective, reticent air of Duyster's picture and the peculiar geometricization of the figures anticipates by three decades the qualities extolled today in paintings by the most revered Dutch genre painter of the Golden Age, Johannes Vermeer.

Duyster and Codde's paintings of merry companies, which frequently recycle compositions and motifs, certainly provided important precedents for other artists, but in terms of themes, their greatest contribution to seventeenth-century Dutch genre painting lies in their representation of guardroom interiors. These scenes of soldiers were identified in contemporary documents by the term *kortegaarde*, a bastardization of the French phrase *corps de garde*.[40] The roots of this imagery can be traced to sixteenth-century German prints, and more immediately to martially costumed figures in the art of the Utrecht Caravaggisti (see Chapter 3 and fig. 63),[41] but Codde and Duyster developed and refined it to a significant degree. Under the leadership of these two painters, specific themes emerged, ones that rapidly became con-

ventional. Thus guardroom interiors most often depict soldiers at leisure, examining booty and confronting hostages, or even involved in mundane military tasks.

The earliest guardroom scenes appeared in the middle of the 1620s, during roughly the same period that the war with the Spanish had recommenced after the twelve-year truce.[42] This is certainly not fortuitous as the renewed war effort undoubtedly sparked interest in soldierly subjects. Although much of the fighting during the final two decades of the protracted war occurred along the southern and eastern boundaries of the Netherlands, prospective buyers of these artworks, who largely resided in the Provinces of Holland and Zeeland, had some familiarity with troops, perhaps less from direct experience than from the glut of pamphlets and illustrated broadsides commenting upon the war and its progress.[43]

Duyster's *Card-Playing Soldiers* (fig. 55) offers a telling example of the guardroom interior, as it specifically represents the theme of soldiers engaged in leisure pursuits. Within a darkened, stage-like interior of relaxing soldiers, two brightly illuminated men are playing a card game on top of a drum. The rendition of their clothing and armor is superb, as Duyster introduces delicate, wonderful color harmonies to articulate the satiny sheen of the fabrics. Duyster's supreme skill in rendering textures and stuffs must have been acclaimed by connoisseurs of his day, judging at least from the comments made by the painter and theorist

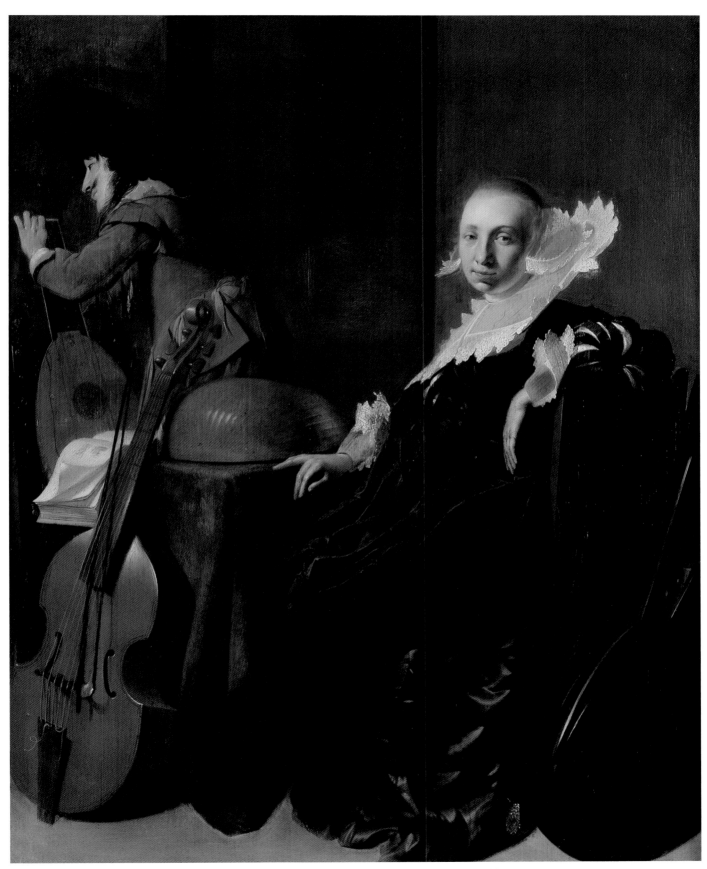

54 Willem Duyster, *The Duet*, *c*. 1627 (oil on panel, 43.4 × 35.9 cm). Berlin, Jagdschloss Grunewald.

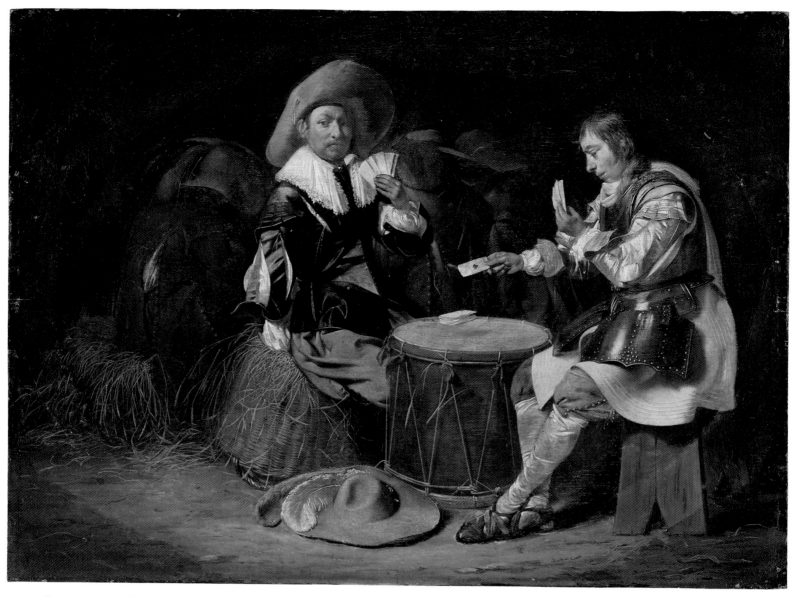

55 Willem Duyster, *Card-Playing Soldiers*, c. 1625–30 (oil on panel, 32 × 43 cm). Munich, Bayerische Staatsgemäldesammlungen, on loan to Schleissheim, Staatsgalerie.

Philips Angel in 1642 in his succinct treatise *Lof der schilder-konst* (Praise of Painting). Angel, writing just seven years after Duyster's death, observed that, "A painter worthy of praise should be able to render this variety [of different fabrics and materials] in the most pleasing way for all eyes with his brushwork, distinguishing between harsh, rough clothiness and smooth, satiny evenness, in which the great, enlightening Duyster, more than anyone else, is most excellent and celebrated."[44]

The lighting and color scheme of the *Card-Playing Soldiers* impart a restrained, quiet aura to the picture which is not dissimilar to that of Duyster's *Duet*. The reticent, dignified mood of this painting is all the more surprising given its subject.

Common foot-soldiers (as opposed to officers) were not highly esteemed in early modern Europe.[45] Like other nations, the Dutch Republic relied heavily upon mostly foreign-born mercenaries to bear the brunt of the fighting. These men, who were poorly paid, were often drawn from the lower echelons of society. Despite their lowly stock they played a pivotal role in the latter phases of the war against Spain. As discussed in Chapter 1, the military campaigns during the last two decades of the conflict consisted of a series of sieges of cities along the southern and eastern borders of the Republic as the Princes of Orange struggled to secure a defensive ring against future incursions. Once a town had been captured from the enemy, a garrison was

established, often on the grounds of commandeered property, to secure its future defense.

Certain aspects of the representation of soldiers in art square with these actual military conditions. Consider, for example, the guardroom setting. Paintings such as Duyster's, while not representing specific guardrooms, nevertheless generally recall the spaces within these garrisons where soldiers would wile away the hours battling nothing more than sheer tedium. Note as well that Duyster's men are playing cards, an activity depicted incessantly within images of this sort. In fact, in Angel's art treatise, he advises painters to include "people seated and throwing dice and playing cards" in guardroom scenes because such details are pleasing to the viewer and attest to the artist's "observation of real, natural things."[46] Angel's breezy identification of soldiers with games of chance probably had some basis in reality, at least if the profusion of contemporary military ordinances prohibiting card playing and like forms of gambling are to be believed.

The figures in Duyster's panel also sport colorful garments. During this period of military history uniforms did not yet exist so soldiers and officers wore their own clothing. Curiously, seventeenth-century Dutch texts, some of which are unmercifully contemptuous of soldiers, are peppered with satirical accounts of troops donned in showy, ostentatious attire of the sort frequently encountered in paintings.[47] Yet in some respects this must have been a literary and visual trope because it is hardly conceivable that unsophisticated, churlish soldiers who earned paltry wages could afford such finery. Furthermore, it is extremely unlikely that off-duty troops would be wearing battle armor of the type worn by the card player to the right in Duyster's painting. Therefore, depictions of soldiers, like seventeenth-century Dutch art in general, cleverly meld fact with substantial amounts of fiction. In this respect, these pictures are reminiscent of those portraying peasants, which is perhaps no mere coincidence since both social groups were the target of upper-class biases. Genre paintings of menial troops are essentially constructs that exaggerate and distort certain aspects of military life, thus articulating the prejudices of wealthy collectors whose contacts with the actual, professional army were relatively minimal.

In the popular imagination then soldiers were associated with a variety of diversions deemed unwholesome for the civilian population. This accounts for innumerable depictions of soldiers gambling as well as for the frequent portrayal of their more deleterious pursuits involving women. In this regard, prostitutes are frequent habitués of guardroom paintings. Pieter Codde's *Guardroom* of about 1635–40 (fig. 56) typifies their presence in representations of this sort.[48] The artist presents a raucous scene of frolicking soldiers in a barracks, identified as such by the rack holding pikes in the left background. Some sleep, others smoke, while a laughing man on the floor pulls a woman down into

his lap as she struggles to maintain her balance. This female seems surprised but unconcerned about her abrupt shift in position; this fact, and the presence of her grinning female companion strongly suggests that both are whores. Once again, despite the highly constructed and conventional nature of this and related art, links with actual conditions are fairly easy to demonstrate. Although cohabitation was anathema in seventeenth-century Dutch society, it was not forbidden in the army.[49] Armies of that day are described as having been accompanied by hordes of women and children. And among these women were considerable numbers of prostitutes, whose pervasiveness continually prompted edicts forbidding their admission to military establishments. So paintings of this sordid aspect of military life must partly reflect the real situation. Yet in accordance with popular notions of ever-roguish soldiery, Codde and other artists undoubtedly included molls to enhance the attractiveness, and ultimately, the marketability of representations of this theme.

The lively, expressive facial features of the figures in the painting – indeed, there are not many instances in seventeenth-century Dutch art in which teeth can be seen – signal changes in Codde's style by the early 1630s.[50] During this decade Codde's compositions were largely constructed along diagonals to enhance the sense of depth, his brushwork grew somewhat looser, and his palette more restricted, exhibiting a predominant use of brown and ocher tints. These developments, particularly the latter two, reveal Codde's continued contacts with painting in nearby Haarlem which played a significant role in shifting the stylistic conventions of Dutch painting of all types toward a tonal or monochromatic aesthetic during the late 1620s, 1630s, and early 1640s.

56 Pieter Codde, *Guardroom*, c. 1635–40 (oil on panel, 36 × 47.5 cm) Göttingen, Kunstsammlung der Universität Göttingen.

57 Willem Duyster, *Soldiers Dividing Booty in a Barn with a Captive Couple* (oil on panel, 32.6 × 43.2 cm). Private collection.

The monochromatic or tonal effects of Codde's paintings are analogous to those present in works by other Amsterdam genre painters produced in that period. Traditionally, this phenomenon has been ascribed, perhaps reductively, solely to changes in taste. But in recent years scholars have proffered more complex explanations for the rise of this tonal phase in Dutch art. John Michael Montias, for example, ties it to economic factors, namely, to innovations in painting techniques developed by artists in an effort to lower their production costs while simultaneously enabling them to penetrate new markets.[51] After all, loosely brushed pictures with restricted color ranges were less labor intensive and were sold more cheaply than highly finished ones with high-keyed hues.[52]

Expanding upon Montias's thesis, Jonathan Israel has tied the changing aesthetic of Dutch art in its monochromatic phase to concomitant historical events, in this case to the economic recession that gripped the Dutch Republic during the 1620s and early 1630s.[53] This recession, whose effects would linger well into the 1640s, affected the art market, forcing changes in the sizes and styles of artworks to make them more affordable for clients with less disposable income. Artists were thus responding to contracting market opportunities and were forced to adjust their techniques accordingly. Perhaps they were also responding to the increasing cost of making works in the older, brighter styles, which principally relied on paints composed of rare substances

imported from great distances whose price increased dramatically during the recession.

Eric Jan Sluijter has further amended these hypotheses, reaffirming the primacy of purely artistic considerations in the execution of tonal art.[54] The origins of the tonal or monochromatic phase can actually be traced to the decade of the twelve-year truce in which there was an influx of inexpensive, rapidly painted, Flemish works of art, imported from Antwerp to satisfy the demand from huge numbers of Flemish émigrés who were accustomed to decorating their homes with such pictures. Dutch painters therefore developed painterly techniques in order to compete with this market for Flemish art, thereby attempting to better Flemish artists, both economically and aesthetically. Yet this does not mean that painterly, tonal art was unsophisticated even if broader segments of the public than ever could afford it. To the contrary, as contemporary sources as well as modern technological research confirm, the brevity of application in these paintings paradoxically involved complex painting techniques whose virtuosic effects must have had great appeal to seventeenth-century cognoscenti (just as they do today).[55] If anything, Sluijter's thesis once again underscores the seemingly ceaseless impact of Flemish art on seventeenth-century Dutch masters.[56]

The newly manifested, tonal characteristics of Codde's art separate it even further from that of Duyster. Duyster never completely adopted the evenly lit, thoroughly tonal art of Codde and his contemporaries as he preferred to interweave harmonious hues with rich, strikingly illuminated color accents within darkened interiors. Additionally, in contrast to Codde's anecdotal and frequently raucous work, Duyster's art continued to exhibit patently reticent, and at times, seemingly melancholic qualities. For example, his portrayals of women in guardroom scenes never include prostitutes; to the contrary, he frequently depicts deplorable situations that involve distressed women as hostages awaiting ransom (fig. 57).[57]

Although Duyster died comparatively young and Codde's career as a genre painter was of relatively short duration, they were both highly influential. Their work, particularly Duyster's, was innovative stylistically and both made significant contributions to the development of new themes in genre painting (guardrooms) and the continued revision of slightly older ones (merry companies). On account of their manifold contributions Codde and Duyster are important transitional figures between the first genre artists of the seventeenth century and those of a younger generation who labored when the specialty was in full flower during the 1650s and 1660s. During that latter era, Amsterdam expanded meteorically as an art center eclipsing Haarlem and, indeed, several other Dutch cities in the process.

CHAPTER FOUR

UTRECHT

Social, economic, and political conditions within the city of Utrecht were quite unusual compared with those of other major urban centers in the Dutch Republic.[1] The city's history was illustrious – it was once the largest metropolis in the Northern Netherlands and, with its bishopric, was the center of Catholicism there. It was also the political hub of the Province of Utrecht. Many noblemen lived within the province, some of whom owned vast tracts of land which afforded them considerable political influence, and substantial numbers kept homes in town. Within the city of Utrecht itself likewise dwelled many members of the lesser provincial nobility or gentry, persons who, incidentally, along with the landed nobility, patronized Utrecht's painters.[2]

For centuries Utrecht had been prone to tensions between this gentry-dominated patriciate and their social subordinates, guild craftsmen. The early seventeenth-century proved no exception as a militia company-led coup in 1610 placed the guilds in power for a few months. Several members of the resurgent local gentry were purged by the Prince of Orange, Maurits, when he restructured the city council in 1618 in an effort to diminish their power. However, this act only partly mollified their guild-based, anti-aristocratic rivals since the Prince added to the council members of the non-noble, urban patriciate. Direct participation in Utrecht's municipal government continued to remain as closed to the influence of the anti-aristocratic faction as it had previously.

The Revolt against the Spanish greatly affected Utrecht, accelerating a decline in municipal influence and prestige that had begun earlier in the sixteenth century. Throughout the lengthy war with the Spanish the city continued to house sizeable numbers of Catholics, particularly among the urban gentry and nobility, and in the middle of the seventeenth century Catholics still comprised thirty to forty percent of Utrecht's population, with sizeable numbers of the elite in particular adhering to this traditional faith.[3] As discussed in Chapter 1, war and politics in the Netherlands were inextricably bound with religion. Thus, the rise of the Dutch Reformed Church in Utrecht during the late sixteenth century cannot really be separated from the constant social and political conflict. With some exceptions, the most militant Calvinists were the very same guild craftsmen engaged in a seemingly unending power struggle with the urban gentry and patriciate, and so, despite their decidedly minority status

through much of the late sixteenth and early seventeenth centuries, the Calvinists played a significant role in local politics.

They were engaged, for example, in an especially vehement struggle over the disposition of properties formerly owned by the Catholic Church but confiscated during the Revolt. The holdings of the Catholic Church in the city were extensive; the largest ecclesiastical proprietorship comprised the five chapter houses owned by enormously wealthy religious confraternities. These chapter houses had for centuries administered the bishopric and their offices were held by members of many of Utrecht's august noble and patrician families. Therefore, routine confiscation of Catholic property of the type occuring in other towns within the United Provinces during this period was simply not possible in Utrecht. Such a move constituted an affront to the city's long-privileged, dominant families and would ultimately redefine political power there. After prolonged controversy it was ruled in 1618 that all new appointees to the chapter house offices must be Protestant; however, these positions would be reserved exclusively for members of the patriciate and provincial nobility.

The impact of social conditions in Utrecht for the local economy cannot be underestimated. Possessing little large-scale industry, it lacked a substantial, affluent mercantile class customarily present in other towns in the Netherlands. Immigration, which had been encouraged in many cities in the neighboring Province of Holland as a potential boon to their economies, was strictly regulated in Utrecht in an effort to protect the interests of local guilds. Between the 1570s and 1620s Utrecht's population increased by approximately fifty percent, relatively modest in comparison with the explosive growth experienced in such cities as Haarlem and Amsterdam, and peaked at some 30,000.[4] Most of the newcomers to Utrecht arrived not from the Southern Netherlands, however, but from the east, namely, from eastern regions of the Republic and Germany. These émigrés did not possess the specialized skills of their Southern counterparts requisite to sustaining the rich trades discussed in Chapter 1. To the contrary, they demonstrated proficiency in vocations that served local and regional markets.

These immigrants prospered in Utrecht because the city functioned as a market for goods and services to the surrounding countryside. And equally importantly, many of them practiced crafts essential for producing luxury goods destined for elite con-

sumption. Economic life in Utrecht was thereby controlled to some extent by the prodigious purchasing power of the town's affluent and influential families. Jan de Vries has rightly called Utrecht's economy "distinctly precapitalist," one dominated by wealthy property owners.[5] The glaring dearth of a dynamic merchant and trading sector within the local economy greatly concerned the municipal authorities but their efforts to rectify this situation were continually thwarted by elites eager to maintain their lucrative sinecures and political power. Over the long run, these singular social and economic circumstances contributed to Utrecht's decline, but during the first decades of the seventeenth century they facilitated a remarkable flowering of painting.

The Revolt and the religious changes it engendered were initially detrimental to artists who saw the patronage of the Catholic Church, a perpetually rich source for commissions, vanish virtually overnight. Fortunately, the general economic miracle of the 1590s which initially reverberated throughout the Dutch Republic; the presence of sizeable numbers of inhabitants with large disposable incomes; and the sheerly serendipitous emergence of a younger generation of gifted painters all contributed to the revitalization of art in Utrecht.[6] By the middle of the 1590s, three talented artists of growing repute were active in the city: Joachim Wtewael (1566–1638) and Paulus Moreelse (1571–1638), both of whom had been born there, and the long-lived Abraham Bloemaert (1566–1651), a native of Gorinchem who had moved to Utrecht as a child.[7] All three specialized in the production of history paintings, working initially in the then fashionable Mannerist style but gradually adopting a more tempered, classicizing approach (fig. 58). These three artists exerted

a great influence on the subsequent generation of masters, including painters who depicted genre themes. Bloemaert and Moreelse in particular were skilled teachers; between them, these two painters trained many of the artists who would enable Utrecht to develop into a leading art center during the first half of the seventeenth century.

The fortunes of painting in Utrecht naturally rose and fell with those of the city's economy. In many respects, art in Utrecht, like the economy there, reached its peak during the first three or four decades of the seventeenth century. As Marten Jan Bok has pointed out there were probably fifty to sixty active masters in Utrecht during its heyday who collectively produced several thousand paintings per year.[8] Their contribution to the local economy then was not insignificant and the presence of this many masters undoubtedly formed the "critical mass" of personnel necessary for Utrecht to develop a distinct artistic identity.[9] Further evidence of the town's flourishing artistic community is provided by the formation in 1611 of a Guild of St. Luke by artists who wished to sever ties with the saddlemakers' guild to which they hitherto belonged. Another secession followed in 1644 with the establishment of a painters' college that left the Guild of St. Luke solely in the hands of sculptors and woodcarvers.[10] Utrecht was also the site of a drawing academy, founded around 1612 and celebrated in Crispijn van de Passe the Younger's drawing treatise of 1643.[11] As the city's economy grew stagnant in the late 1640s so too did its art institutions. Thereafter, Utrecht was relegated to second-class status, eclipsed in every respect by its sister towns in the Province of Holland.

The Utrecht Caravaggisti

An inordinately large percentage of Utrecht's young painters traveled to Italy to supplement their training; indeed that country functioned as a veritable magnet for foreign artists throughout the early modern era.[12] The impressive number of Utrecht artists who traveled there is perhaps a reflection of the ties between this traditionally Catholic city in the Netherlands and Rome, the center of Catholicism. After initial apprenticeships in Utrecht, the town's three most prominent young painters, Dirck van Baburen (c. 1594/5–1624), Hendrick ter Brugghen (1588–1629), and Gerrit van Honthorst (1592–1656) all spent prolonged time in Italy, specifically in Rome. In addition to the famous works of antiquity and the Renaissance that could be studied in abundance, foreign artists arriving in Rome in the early seventeenth century to supplement their training were witness to a true revolution in painting as the Northern Italian artists Annibale Carracci (1560–1609) and Michelangelo Merisi da Caravaggio (1571–1610), along with their numerous followers, transformed Italian art, overturning the well-entrenched Mannerist style.[13] Caravaggio in particular introduced a bold

58 Joachim Wtewael, *The Golden Age*, 1605 (oil on copper, 22.5 × 30.5 cm). New York, The Metropolitan Museum of Art.

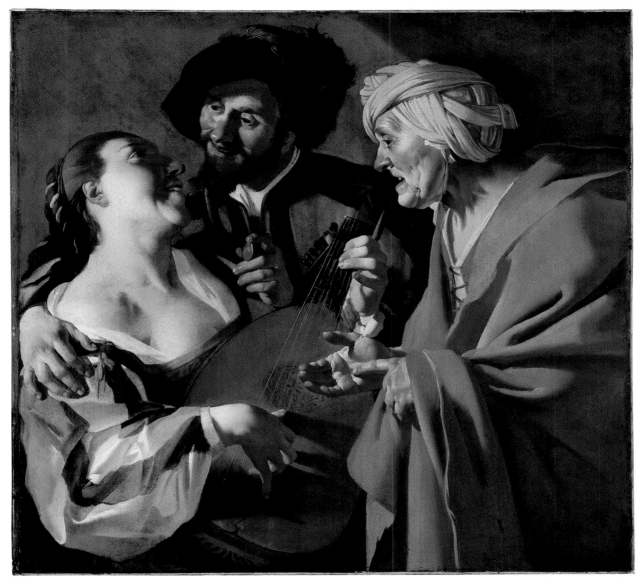

59 Dirck van Baburen, *The Procuress*, 1622 (oil on canvas, 101.5 × 107.6 cm). Boston, Museum of Fine Arts, M. Theresa B. Hopkins Fund, 50.27.21.

naturalism into Italian art and popularized the use of imposing chiaroscuro to enhance the emotional and spiritual impact of his pictures. Caravaggio's genre paintings, though generally devoid of chiaroscuro effects, found special resonance with Northern European artists most likely because the Italian master himself often reinterpreted and "modernized" traditional Netherlandish pictorial themes. To varying degrees, van Baburen, ter Brugghen, and van Honthorst adopted Caravaggio's stylistic and thematic innovations, introducing them to the Netherlands upon their return and thus becoming known (along with their disciples) to posterity as the Utrecht Caravaggisti.

Dirck van Baburen, the youngest of the three, made significant contributions to the subject matter of the Utrecht Car-

avaggisti, and subsequently, to Dutch genre painting in general.[14] He was a pupil of Moreelse in whose studio he perhaps received his first, albeit indirect exposure to elements of Caravaggio's style that were already trickling North during the first decade of the new century.[15] After a four-year apprenticeship with Moreelse, van Baburen departed for Italy shortly after 1611; he would remain there, headquartered in Rome, until roughly the summer of 1620. Caravaggio was already deceased by the time van Baburen arrived in the eternal city. Nevertheless, his Italian-period work attests to his familiarity with the celebrated master's art. Moreover, it is likely that van Baburen was friendly with one of Caravaggio's most influential devotees, the enigmatic Lombard painter Bartolomeo Manfredi (1582–1622). Manfredi and van

60 Caravaggio, *The Cardsharps* (oil on canvas, 94.2 × 130.9 cm). Fort Worth, Kimbell Art Museum.

Baburen were recorded in 1619 as living in the same parish in Rome and the former's interpretations of Caravaggio's art profoundly affected his Dutch colleague as well as other members of the Utrecht Caravaggisti.[16]

Van Baburen's output during his Italian sojourn is comprised almost entirely of religious paintings, some of which were executed for Rome's most prominent churches. It was only upon his return to Utrecht in late 1620 that he began to make genre paintings. That van Baburen managed to introduce a series of stylistic and thematic innovations into the repertoire of Dutch genre painting is all the more remarkable considering his untimely death just four years later. For example, his well-known *Procuress* of 1622 (fig. 59) constitutes an updated, imaginative variation upon a time-honored subject in Netherlandish art: mercenary love.[17] Van Baburen has depicted a lute-playing whore seductively dressed with a nipple exposed as her instrument and bodice crush her breast. This young woman interacts with a client proffering a coin which an old hag, her procuress, inspects while emphatically gesturing as if to demand a larger fee for the prostitute's services.[18]

Representations of prostitution in painting appeared first in sixteenth-century art, largely, though not exclusively, in connection with the New Testament parable of the Prodigal Son who squandered his inheritance on wine and women (see fig. 45).[19] What separates van Baburen's picture from these older precedents are primarily the stylistic innovations that he employs, ones adopted from the work of Caravaggio and his followers. The bold, palpable naturalism of *The Procuress*, the distinctive costumes, the half-length format of the figures who are abruptly truncated at the edges of the canvas, and the raking light that enhances their plasticity are all devices made popular by

Caravaggio in his own genre works (fig. 60). The Caravaggesque elements are pronounced here but are filtered through van Baburen's own aesthetic conceptions involving vigorous brushwork, stylized garments composed of broad, flat planes of color, and expansive figures whose emphatic earthiness easily transcends those by Caravaggio.[20]

What further separates *The Procuress* from many of its precedents is its thoroughly secular subject matter. The overall carousing air of this canvas and related ones has led some scholars to conclude that they constitute an updating of sixteenth-century depictions of the Prodigal Son.[21] Although these paintings descend visually from depictions of the bibical parable, the insistence on identifying them with the older moralizing imagery of the Prodigal Son is misleading primarily because the visual evidence summoned to establish the link is insufficient. In fact, this reasoning has led in the past to the rather awkward argument that it was no longer necessary for artists to include explanatory details in their work that refer back to earlier depictions of the Prodigal Son since these very same references were implicity understood as present. Context determines whether a work represents the Prodigal Son or a brothel. Consequently, one cannot conclude that Dutch seventeenth-century scenes of prostitution carry the same admonitory content as earlier paintings of the Prodigal Son upon the basis of compositional similarities alone or upon minor, somewhat ambiguous iconographic details (like musical instruments and drink), especially in light of the absence of major ones (for example, the Prodigal Son himself or episodes from the parable depicted in the background) that would support such a reading.[22]

While the subject matter and style of these paintings of prostitution – sometimes identified as *bordeeltjes* (little brothels) in contemporary inventories – were forged by van Baburen and his colleagues in response to pictorial traditions along with the creative impetuses of Caravaggio and his followers, the tastes of potential patrons, namely, the affluent citizens of Utrecht and other cities, also played a decisive role in shaping pictorial vocabularies. Since artists worked with a potential or actual audience in mind, their paintings reveal much about the underlying cultural attitudes and interests of the public who bought them. As a result, genre imagery was to some extent determined by the contemporary socio-cultural climate, one that was markedly heterogeneous.

More light can be shed on the reception of brothel imagery by briefly examining the historical circumstances of prostitution in the Dutch Republic. Lotte van de Pol's important studies have explored the sordid realities of prostitution during the seventeenth century.[23] The profession was dominated by poor, single women, many of them migrants, who became prostitutes out of economic desperation. They plied their trade at taverns, inns, and other public places. Small-scale brothels flourished, usually operated by a procuress who retained the services of two or three

women. These prostitutes were often held hostage financially through perpetual debts for room and board, and especially for fashionable clothing (which was de rigueur for the trade).[24] Van de Pol has convincingly refuted the longstanding belief that prostitution was generally tolerated in the Dutch Republic. Municipal authorities clearly made an effort within their limited means to curtail brothels with continual raids by the sheriff or his agents. Their efforts never resulted in the eradication of prostitution but rather in a change in the outer, public form of the trade; brothels simply moved into less conspicuous settings as they became associated with inns, taverns, and music houses.[25] In reality then, prostitution was an odious way to earn livelihood, which, much like today, was characterized by poverty, desperation, violence, and social ostracism.

Our increasingly detailed knowledge of the history of prostitution in the Netherlands confirms the error of assuming that paintings of the profession illustrate its actual practice at that time, as if they somehow document the seamy side of seventeenth-century life. The affinities between depictions of this sort and historical reality are tenuous at best, but the depictions are, nonetheless, clearly tied to contemporary biases such as pervasive notions of innately insatiable and aggressive female sexuality.[26] Stereotypical prostitutes also feature heavily in jest books (popular collections of short anecdotes) and especially farces – indeed, their debauched antics and devious natures account for the generally risqué plots of so many of these humorous, theatrical productions.[27]

Theater was controlled by the elite in major cities within the Dutch Republic.[28] The municipal theater in Amsterdam, for example, had graduated ticket prices, with higher-priced seats and specific "luxury" boxes intended for leading citizens. Moreover, contemporary farces invariably catered to elite tastes by employing complex plots inspired by the writings of the legendary Renaissance author Boccaccio and those of several ancient playwrights. Equally important, farces employed characters whose class or vocations (for example, peasants or prostitutes) were detached from those of the audience, effectively creating a safe, social distance to entertain genteel audiences in a non-offensive manner. Thus the vulgar qualities of so many early seventeenth-century performances testify to a proclivity for comic lewdness among sophisticated theatre-goers, persons of a similar social caste as those who collected costly paintings.

If anything, *The Procuress* and related works of art capitalize upon this interest in ribaldry by sanitizing and embellishing whoredom, transforming it into something titillating by illustrating the seductive and delightful flouting of accepted mores. And the frequent depiction of coins in the hands of clients eager to pay for sexual favors cleverly parallels the "coins" disbursed by a connoisseur for possession of a picture with lascivious trollops.[29] Another representation of this theme by van Baburen is even more lewd and titillating than *The Procuress* as a prostitute

61 Dirck van Baburen, *Loose Company*, 1623 (oil on canvas, 110 × 154 cm). Mainz, Gemäldegalerie.

in diaphanous garb entertains two ruffians in the knowing presence of her keeper (fig. 61).[30] It strains credibility to maintain that affluent viewers recognized the story of the Prodigal Son in these images and consequently scrutinized them daily to admonish themselves about the fate of this biblical character who suffered the consequences of his surrender to carnal temptations.

The vulgarity of van Baburen's representations (and many others like it from this period) bespeaks a predilection for risqué art (and also risqué literature and theater) in the Dutch Republic. The elite buyers of paintings by the Utrecht Caravaggisti were especially interested in ribald art and literature.[31] But the interest in offensive materials permeated Dutch society at all levels, a fact that does not square with lingering, modern constructs of a sober, religiously zealous Calvinist nation. The pervasiveness of such materials naturally evoked impassioned condemnation by leaders of the Reformed Church but it would be a mistake to assume that their denouncements were endorsed by the population at large.[32] Yet as the seventeenth century progressed, sweeping cultural changes within the Dutch Republic would lead to a waning interest among elites in themes of this type and in potentially offensive art in general.

Van Baburen played a significant role in popularizing other themes that were associated with roguish lifestyles. His *Backgammon Players* of around 1622, for example, the earliest painting by a Utrecht artist of the theme of gambling, shows outlandishly dressed, heavily armed men engaged in a dispute over a backgammon game (fig. 62).[33] In the background a wizened procuress drinks, a figure whose presence indicates that the action takes place in a disreputable inn or perhaps a brothel. Just like *The Procuress*, the iconographic roots of this image of gambling can be found in sixteenth-century Netherlandish painting (fig.

62 (*above*) Dirck van Baburen, *The Backgammon Players*, *c*. 1622 (oil on canvas, 105.4 × 128.3 cm). Private collection.

64 (*right*) Crispijn van de Passe the Elder after Dirck van Baburen, *Backgammon Players* (engraving). Amsterdam, Rijksprentenkabinet.

63 (*below*) After Lucas van Leyden, *The Card Players* (oil on panel, 55.2 × 60.9 cm). Washington D.C., National Gallery of Art, Samuel H. Kress Collection.

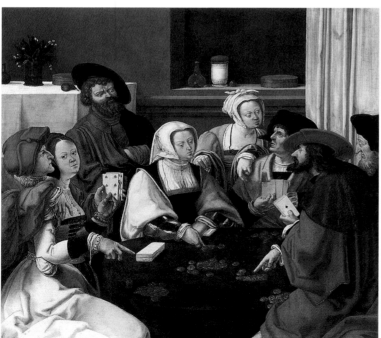

63). However, van Baburen has likewise "modernized" the older representations by imparting a Carvaggesque veneer of colorfully clothed, half-length figures posed before an unarticulated background enlivened by raking light effects. A backgammon board lies on the table in the painting of cardplayers by Caravaggio cited earlier (see fig. 60) but by comparison the Italian's representation is much more benign. Thematically van Baburen's painting perhaps owes more to the intermediacy of Manfredi, whose reinterpretations of Caravaggio's prototypes feature vehement arguments and potential violence between the well-armed gamblers.[34]

Leonard J. Slatkes, the leading authority on the artist, has linked the painting to an engraving by Crispijn van de Passe that closely resembles it (fig. 64).[35] This print carries a Latin inscription, "Irarum Causas Fugito" (Flee from the causes of anger) along with a Dutch one, which in translation reads: "A dicer and gamer is a wretch, he drinks and squanders his money and beats

his wife." The moralizing associations invoked by these inscriptions parallel those found in other engravings and literary texts.[36] For certain audiences then, van Baburen's painting would have served as a reminder of the inherent hazards of games of chance, amusements which, incidentally, were all the rage in the Dutch Republic. (The incredible popularity of gambling at this time probably explains the profusion of texts censuring it.) But this could hardly have been the response of every spectator as the sheer diversity of the populace prevented monolithic responses to pictures.

Paintings such as the *Backgammon Players* and *The Procuress* may have been informed by another literary genre that flourished during this period, namely, picaresque novels.[37] This enormously popular literary genre originated in Spain during the sixteenth century but quickly spread throughout Europe, including the Netherlands where the first picaresque novel, a translation of *Lazarillo de Tormes*, was published in Delft in 1579.[38] Picaresque novels were conceived as lengthy, comic texts revolving around the colorful travels and adventures of soldiers of fortune and other rogues. While conducting their numerous journeys, these ruffians become involved in farcical events and lurid intrigues as they continually pursue profligate activities including thievery, fighting, whoring, and gambling (fig. 65). Particularly noteworthy in picaresque novels is the outlandish clothing that these characters don to impress their peers, apparel usually described in minute detail.[39] By the time Caravaggio and his international school were active, namely, between 1595 and 1630, picaresque novels had developed into something of a pan-European craze, which is perhaps no mere coincidence.[40] Although direct correspondences between specific passages in these novels and paintings cannot be posited, accounts of the disreputable, often bawdy activities of foppishly dressed yet dangerously armed young rogues and soldiers in the former nonetheless closely approximate the general tenor of the latter.[41]

Many of van Baburen's innovations were adopted by Hendrick ter Brugghen with whom he probably shared a workshop.[42] Ter Brugghen, perhaps the most idiosyncratic and talented of the Utrecht Caravaggisti, likewise spent a protracted time in Italy, having traveled there as early as 1604 after concluding his study years with Bloemaert (and possibly another, as yet unidentified master).[43] He remained in Italy, centered in Rome, for nearly ten years, only returning to Utrecht in the autumn of 1614. His stay in Rome overlapped briefly with that of Caravaggio who fled the city after having committed a murder in May 1606. Ter Brugghen was thus the only member of the Utrecht Carvaggisti who may have known Caravaggio. This tantalizing possibility cannot, unfortunately, be confirmed by any ter Brugghen picture from his Italian period for none survives. In fact, his earliest known work, a *Supper at Emmaus* (Toledo, Toledo Museum of Art), if indeed it is authentic, was painted when he was twenty-eight years old. By seventeenth-century standards,

65 Illustration from Mateo Alemán, *Het leven van Gusman d'Alfarache*, Rotterdam, 1655. The Hague, Koninklijke Bibliotheek.

this would have been a relatively late age for an artist to begin practicing his craft. While it is unclear whether ter Brugghen was really a "late starter" there can be no question of his formidable abilities as a painter.

Ter Brugghen enrolled in the Guild of St. Luke in 1616 and continued to produce religious art. However, the return of van Baburen and van Honthorst to Utrecht in 1620 had a significant impact on the future direction of his work. Under their impetus (especially van Baburen's), he began to produce genre paintings, among them his renowned pendants of the *Flute Player* (figs. 66 and 67), dated 1621.[44] During the previous year, 1621, van Baburen had portrayed a young man playing a Jew's harp (Utrecht, Centraal Museum) the earliest representation of a half-length musician by a Utrecht painter.[45] Depictions of musicians, and related ones of ruffians singing or drinking, became immensely popular virtually overnight. Judging from the sizeable number of copies and variations upon paintings of these themes by van Baburen and ter Brugghen, the two young painters conceivably shared a studio until the former's death in 1624.[46] *The Flute Players*, like van Baburen's *Young Man Playing a Jew's Harp*, descends iconographically from late sixteenth-century, Northern Italian precedents as interpreted by Caravaggio and Manfredi.[47] The pendants recall these prototypes in their iconography, half-length compositions, light effects, and unusual attire. Both display however an amplitude of form and sophisticated color combinations that distance them from Italian as well as Utrecht painting – note, for example, the unusual apricot hues of the feather in the hat of the boy turned to the left. Furthermore, the pen-

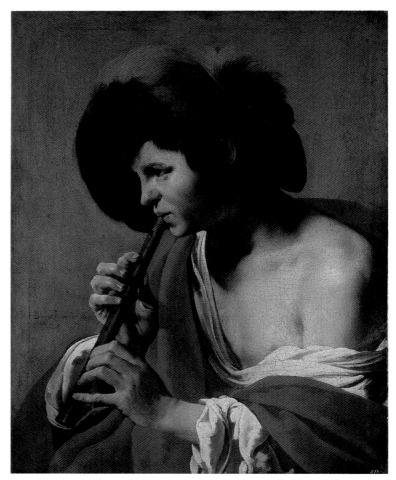

66 Hendrick ter Brugghen, *Flute Player*, 1621 (oil on canvas, 71.3 × 56 cm). Kassel, Gemäldegalerie Alte Meister, Staatliche Kunstsammlungen.

67 Hendrick ter Brugghen, *Flute Player*, 1621 (oil on canvas, 71.5 × 56 cm). Kassel, Gemäldegalerie Alte Meister, Staatliche Kunstsammlungen.

dants exude a novel air of quietude, particularly when compared with the more exuberant musicians and drinkers by van Baburen and van Honthorst (see fig. 77). Indeed, the remarkable restraint of ter Brugghen's figures and the play of sharp, cool light across the one facing to the right anticipate by several decades the achievements of Johannes Vermeer.[48]

Pendants in general are classified as such not merely because of their shared scale and complementary compositions, but because they are invariably linked in subject matter as well and in this regard, ter Brugghen's *Flute Players* prove no exception.[49] Traditionally, the boys' instruments have been identified as flutes.[50] Their instruments actually belong to two different classes of flutes whose identities are clarified by the boys' costumes. The boy facing to the right, sporting an outfit that evokes those worn by German and Swiss mercenaries during the sixteenth century, plays a fife, a military instrument. His companion, dressed in a toga-like costume – one often found in Caravaggio's art – replete with references to antiquity, plays a recorder, an instrument which like his outfit, can be associated with the pastoral. Thus

the instruments and garments of the performers are pictorially expounded in antithetical terms. Similarly antithetical are such purely pictorial features as the cool colors of the painting of the fife player and gaping hole in the upper wall behind him versus the warm colors of the boy with the recorder who performs before a completely undefined background. Unfortunately, the passage of nearly four centuries of time since the completion of these works makes it difficult to ascertain what further ideas they evoked.

Ter Brugghen's *Unequal Couple* (fig. 68) is much simpler to comprehend. This painting, which was altered by the artist and later cropped at the corners, depicts a raucous, almost claustrophobic interior, featuring a bare-chested prostitute clutching the fur garment of a man wearing a mask and pince-nez, both of which make him appear much older than he actually is.[51] This churlish whore smiles at us knowingly, uncouthly exposing her discolored teeth in the process.[52] Her laughter must be understood in terms of widespread contemporary prejudices, bolstered by the theories of "medical experts," concerning the supposedly

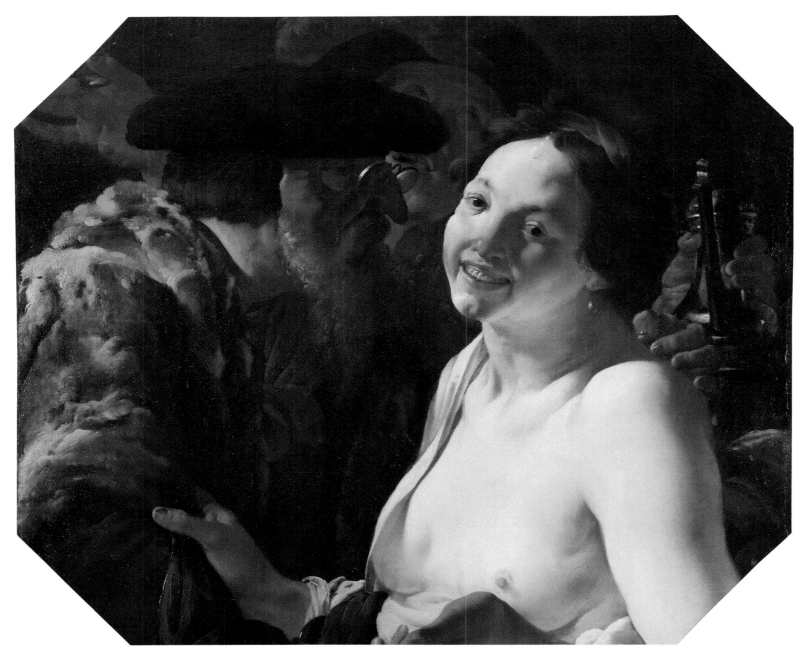

68 Hendrick ter Brugghen, *Unequal Couple, c.* 1623 (oil on canvas, 74.3 × 89.2 cm). Private collection.

debilitated sexual drives of the elderly.[53] The very idea of an enfeebled old man engaging a whore as if he were capable of satisfying himself let alone her sexually was as humorous for seventeenth-century audiences as it is for us today.

Both the subject and compact composition of three half-length figures – a thinly painted man holding a tankard and wineglass is shouting between the principal protagonists – are strongly reminiscent of sixteenth-century Netherlandish paintings and prints of the same theme (fig. 69).[54] Throughout his career, ter Brugghen had an abiding interest in images by his artistic forebears which is hardly surprising given the conventional nature of art during this period. The theme of unequal lovers, which pairs a foolish, lustful old man with a young woman bent on material gain (or vice versa) flourished in Northern European art and literature of the sixteenth and early seventeenth centuries (see fig. 3). It provided viewers and readers with intensely humorous entertainment as well as gentle reminders concerning mankind's innate foolishness. Artists and

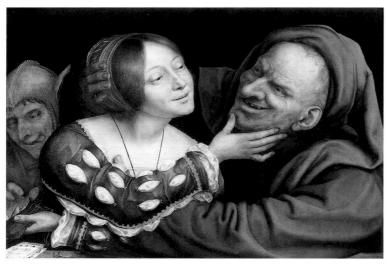

69 Quentin Massys, *Ill-Matched Lovers*, *c.* 1520–25 (oil on panel, 43.2 × 63 cm). Washington D.C., National Gallery of Art.

70 Hendrick ter Brugghen, *Old Man Writing by Candlelight*, *c.* 1626–8 (oil on canvas, 65.8 × 52.7 cm). Northhampton, Mass., Smith College Museum of Art.

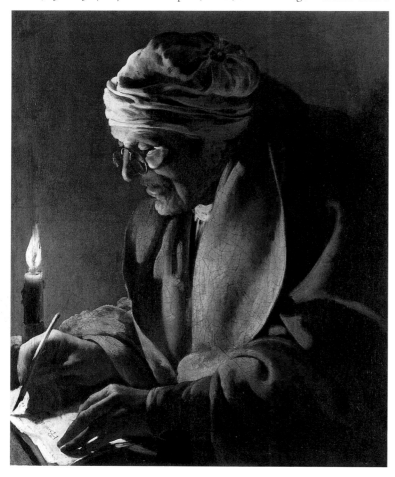

authors alike exaggerated the age disparity between the "sweethearts" to great comic effect, differentiating, for example, between the wrinkled hides of the superannuated suitors and the sheen of their young lovers' skin.[55]

In comparison with these numerous precedents ter Brugghen's representation is highly original with its semi-nude prostitute and counterfeit old man. The artist enhances the man's disguise by depicting him in a heavy fur garment, the chief signifier in Netherlandish art of old age. His spectacles refer not only to the poor eyesight of aged folk but also to the idea of impaired vision as a metaphor of moral blindness and folly.[56] The prostitute's gleeful glance toward the viewer is undoubtedly induced by her cognizance that old men are supposedly impotent. But her expression simultaneously informs the viewer that she recognizes the man's deceit. The spectator recognizes his deception but knows it is compounded by ter Brugghen's skillful concealment of the man's true age. On a certain level then, the viewer colludes with the prostitute. While ter Brugghen's *Unequal Couple* is remarkable for its singular approach to a longstanding, conventional theme, its somewhat shocking vulgarity is wholly consistent with other pictures of this period.

Ter Brugghen also represented an elderly person in a more wholesome context, in his *Old Man Writing by Candlelight* (fig. 70) of around 1626–8.[57] This canvas constitutes an early example of a virtuous image of old age and thus anticipates the veritable flood of representations of this type produced later in the century under the impact of broad cultural change. The conflicting attitudes toward the elderly in Dutch genre painting as a whole are not at all unusual and in fact typify broader European perspectives over many centuries.[58] Following longstanding traditions traceable to antiquity, seventeenth-century authors tended to describe aging itself as a "sickness," its characteristic deterioration of health ineluctably leading to death.[59] Plaintive verses on the sickness of senescence by the most popular Dutch author of the era, Jacob Cats (1577–1660), penned when he himself was an old man, are prototypical:

> Surely old age brings us to Reason,
> Or sends her messengers all through our body;
> She strikes us on our arm, chest, or weak foot
> And teaches us that soon we have to depart from here.[60]

Other writers lack Cats's sensitivity and tact; Adriaen van de Venne tersely observes that the elderly already have one foot in the grave.[61]

Many writers opined that decrepitude caused the elderly to indulge in a veritable legion of vices, including lechery, miserliness, and sloth.[62] In fact, the sheer physical decay of old people provided a pretext for countless authors and artists to ridicule them ruthlessly, turning them into repugnant caricatures with only hazy connections to actual realities. Time and again, the aged are presented as dupes ultimately incapable of enjoying the

vices they so avidly pursue. Yet paradoxically many authors believed that the decline of health in old age actually had beneficial ramifications. For example, it forced elderly people to contemplate death and the hereafter. They were thus thought to possess greater wisdom than their juniors, especially with regard to spiritual matters.[63] As they prepared for their imminent departure for the hereafter, they were expected to bridle their passions. What was at least theoretically difficult for younger people to accomplish was easier for the elderly as they were said to possess, through experience and enlightened reason, temperance, simplicity, and a host of other virtues.[64]

Ter Brugghen's old man studiously writes by glowing candle-light which produces an enchanting reflection through the lens of his pince-nez (a motif which in this context has little to do with foolishness). He wears a nightcap and a dressing gown suggesting that he has arisen quite early in the morning to attend to his work.[65] Diligent males studying at night or in early morning appear in contemporary emblems, including one published in 1607 whose *pictura* contrasts a virtuous, attentive man with his sleepy counterpart, whose torpor has been induced by dissipation (fig. 71).[66] Although there is really no direct connection between the emblem and painting both express analogous ideas centering on virtue and assiduousness.

The *Old Man Writing by Candlelight* descends iconographically from Netherlandish depictions of St. Jerome at work reading or writing in his study, at least one of which, by Aertgen van Leyden (1498–1564) employs similar illumination (Amsterdam, Rijksmuseum).[67] The subtle chiaroscuro effects of ter Brugghen's picture may equally derive from prototypes by Manfredi or other followers of Caravaggio (see the further discussion below). Indeed, his most creative work evidences a compelling mixture of Netherlandish and Caravaggesque elements.[68] Ter Brugghen's paintings of his most mature phase of activity, the late 1620s, are complex in this respect and in their general execution. The *Old Man Writing by Candlelight*, painted during this period, is extraordinarily sophisticated in its color scheme and lively surface handling. The color harmonies here are quintessential ter Brugghen, applied in this phase with increasingly fluid brushwork, from the ochers and reddish browns of the man's clothing to the delicate pink highlights on his cap. Many of the intricate color changes are generated by the play of light over the surface: the artist realized that shadowed areas are not abruptly stripped of color but can be enhanced by lower-value hues of exquisite subtlety. Ter Brugghen's style thus evolved from one in which light served to model form to one that disembodies it in a myriad of tones.

The result of ter Brugghen's stylistic adjustments in his last years are depictions striking for their coloristic splendor and wealth of textures. And these pictorial elements are just as important an agent in communicating meaning in the *Old Man Writing by Candlelight* as the limited number of props accompanying the figure. The very intensity of the writer's studious facial expres-

sion, gloriously delineated by the artist, vividly conveys virtue. Contemporaries surely derived much aesthetic and contemplative pleasure from the skill with which ter Brugghen rendered the withered, gaunt flesh and the light reverberating through his glasses. The old man's wrinkled skin and studious expression instruct one more profoundly about virtuous concepts than any text or complicated visual accessories.

Gerrit van Honthorst survived van Baburen and ter Brugghen by approximately three decades and also surpassed them completely in reputation.[69] Although not well known among the general public today, he was considered one of the Dutch Republic's greatest painters during much of his lifetime. For example, when Rubens visited the Netherlands in 1627, he purposely sought out van Honthorst, at least according to the latter's pupil, the artist and biographer Joachim von Sandrart. Von Sandrart, whose biography of van Honthorst waxes rhapsodic about his erstwhile teacher, also records no fewer than twenty-five students studying with the master, each paying the impressive sum of 100 guilders per year for the privilege of his tutelage.[70]

71 Emblem from Otto van Veen, *Quinti Horatii Flacci emblemata*. Antwerp, 1607. The Hague, Koninklijke Bibliotheek.

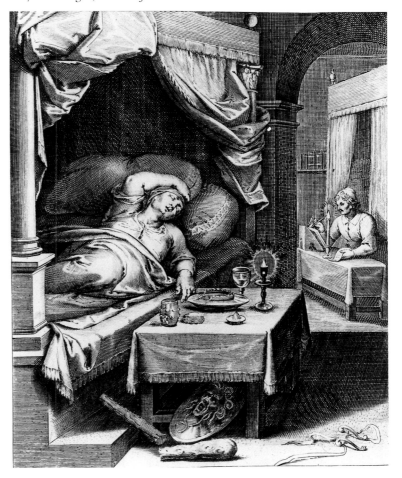

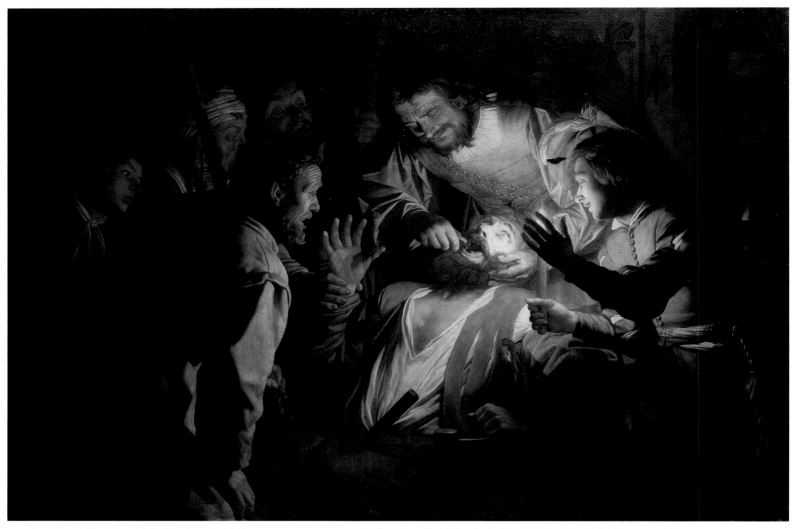

72 Gerrit van Honthorst, *The Dentist*, 1622 (oil on canvas, 147 × 219 cm). Dresden, Gemäldegalerie Alte Meister, Staatliche Kunstsammlungen.

Van Honthorst descended from a family of artists: his grand-father and father, both active in the Guild of St. Luke, painted designs on tapestries and other textiles, his father occasionally being listed as a painter. Perhaps van Honthorst received rudimentary artistic instruction from his father, but at a still unknown date he entered Bloemaert's studio. Like van Baburen and ter Brugghen, van Honthorst also traveled to Italy, in his case sometime between 1610 and 1615. During his protracted stay in Rome he developed an outstanding reputation, making the earlier arrival date seem more probable.

Van Honthorst's impressive output during his Roman period, which consists largely of religious subjects, primarily reveals his exposure to pictures by Caravaggio and Manfredi and to a lesser extent by such older Northern Italian artists as Jacopo Bassano (1510–1592). The Dutch master was principally inspired by Caravaggio's and Manfredi's predominant use of chiaroscuro and

their figural types. By the time of his departure for Utrecht in the spring of 1620, van Honthorst, who was now known by the apt sobriquet, "Gherardo delle Notti" (Gerard of the Nights), enjoyed the patronage of Italy's leading connoisseurs, including the Giustiniani brothers (in whose palace he resided and whose extensive collection of chiaroscuro paintings he must have studied), Cardinal Scipione Borghese, and the Grand Duke of Tuscany. This pattern of executing commissions for members of Europe's most august social and political circles would continue throughout his career.

The Dentist of 1622 (fig. 72), painted roughly eighteen months after his return to the Netherlands, exemplifies van Honthorst's initial style in Utrecht.[71] This canvas shows a "dentist" forcibly extracting the tooth of a grimacing rustic by candlelight while other peasants stare in fascination. In the deep shadows at the far left, a young boy, probably the dentist's accomplice, cuts the

purse strings of an unsuspecting spectator. Van Honthorst adroitly captures the facial expressions of the protagonists, from the authoritative concentration of the dentist and the amused grin of yet another assistant, holding a candle, to the upward, trusting glance of the writing patient and the general apprehension and wonderment of the onlookers.

The Dentist reveals van Honthorst's thorough adaptation of Caravaggesque prototypes as evidenced by the figural types, the clothing of the dentist and his assistant, the composition, and, of course, the bold chiaroscuro effects. In his skillful hands, however, the figures appear more refined, despite their low social status, and the light, now emanating from an artificial source generally absent in the work of Caravaggio and Manfredi, displays golden yellow gradations of decreasing intensity, culminating in the wonderful reflection in the mirror cast by the candle's flame. The light also exquisitely modulates the color intensities, as seen, for example, in the rendering of the patient's sleeve directly below the candle. Shortly before van Honthorst departed Italy the noted physician and aesthete Giulio Mancini (1558–1630), a probable friend of the artist, stated concerning his genre pictures: "his style is very spirited and pleasing in those scenes of merrymaking by night which at the very first encounter make a striking effect."[72] *The Dentist* certainly does not depict merrymaking but it is a nighttime genre scene painted in a style close to canvases produced during the artist's last years in Rome; thus Mancini's remarks are entirely appropriate in this context.

Van Honthorst was obviously not the only Dutch painter to employ elements of Caravaggio's style in his work, but what separates him from van Baburen and ter Brugghen is his compelling combination of naturalistic yet refined figures and artificially illuminated settings (the latter employed much more frequently by the artist than by his two Utrecht colleagues). The resultant, striking effects of his art, to borrow Mancini's words, greatly impressed artists and patrons alike. This accounts for the extraordinary levels of patronage that van Honthorst regularly enjoyed. And *The Dentist* was no exception: it was owned by George Villiers (1592–1628), the first Duke of Buckingham, a nobleman of considerable wealth and prestige at the English court.[73] That an elite collector of Villiers's status would own a painting with such coarse subject matter is fascinating yet consistent with the taste of sophisticates at this relatively early point in the seventeenth century.

The theme of the dentist or tooth-puller in art has Northern European roots that include a famous engraving by Lucas van Leyden (*c.* 1494–1533) dated 1523 (fig. 73).[74] By the late sixteenth century it had been adopted by Northern Italian artists and Caravaggio is also known to have painted a dentist, a depiction with which van Honthorst was surely familiar.[75] The iconography of this conventional theme was fixed with van Leyden's early engraving which already contains all the motifs emphasized in later representations: the ostensibly expert dentist

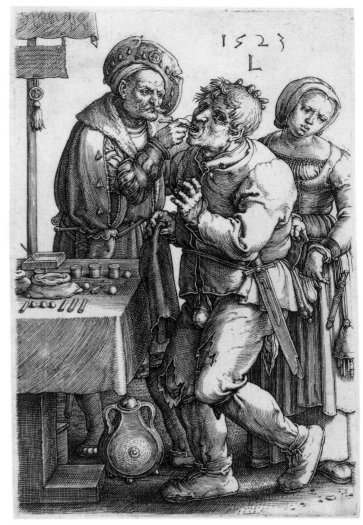

73 Lucas van Leyden, *The Dentist*, 1523 (engraving). Amsterdam, Rijksprentenkabinet.

and the gullible, bumpkin patient who is relieved of his purse by the dentist's accomplice. In early modern Europe, professional dentistry did not exist. The grim business of extracting teeth, the only cure for acute dental problems at that time, was carried out by barber surgeons, wandering tooth-pullers, and assorted charlatans. Therefore, in the popular imagination and in art, extractions were associated with cunning quacks who fleeced unsuspecting sufferers.

Van Honthorst's interpretation of the theme partakes of this pictorial tradition, but he cleverly modifies it to enhance the chicanery of the dentist. The dentist and his assistant are by far the best-dressed figures in the group – even if not fashionably dressed – sporting showy, anachronistic garments of a type worn by Caravaggio's ruffians. The implication of this extravagant clothing is that it has been purchased from the profits made by swindling patients. The dentist himself, who unlike his carica-

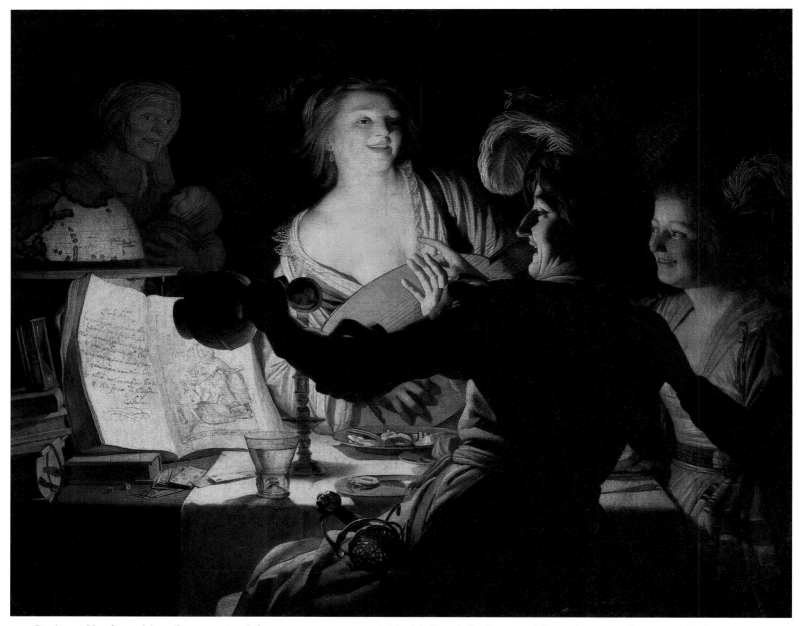

74 Gerrit van Honthorst, *Merry Company*, 1623 (oil on canvas, 123 × 153 cm). Munich, Bayerische Staatsgemäldesammlungen, on loan to Schleissheim, Staatsgalerie.

tured iconographic predecessors is depicted as a competent expert, wears a gold chain across his breast. In the seventeenth century, such chains were dispensed as tokens of esteem to honorable persons. Public servants, military leaders, and even artists were presented with them by grateful political leaders and patrons.[76] In this context, however, it is worn by the dentist to deceive his clients, causing them to regard him as a respectable person. And lastly, the dentist's candle-holding assistant does not rob the suffering victim but, even more insidiously, still another accomplice lurking in the shadows pilfers from the onlookers.

Deceit is central to van Honthorst's picture but it is communicated with the utmost subtlety. And deceit is central to the viewer's experience of the painting as well. For close scrutiny of

its wonderful, deceptively life-like surface, gradually reveals to the beholder the true goals of the dental procedure depicted therein. The viewer is implicated by the machinations of the dentist and additionally by the artifice of van Honthorst in bringing this scene seemingly to life. A clever and aesthetically virtuosic play upon the function and significance of deception thus lies at the heart of *The Dentist* (and many other paintings) which partly explains its appeal to Villiers.[77]

Van Honthorst executed other genre paintings that relate more directly to the subjects portrayed by his fellow Utrecht Caravaggisti. For example, his *Merry Company* of 1623 (fig. 74), a provocative scene of a wanton student in the company of two prostitutes and a procuress carrying an infant, is reminscent

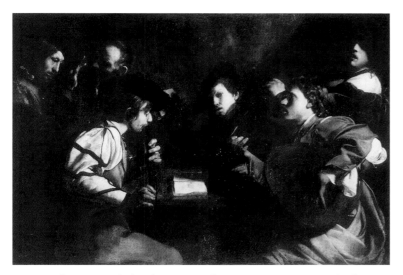

75　Bartolomeo Manfredi, *The Concert* (oil on canvas, 130 × 189.5 cm). Florence, Galleria degli Uffizi.

76　Detail of fig. 74.

of the work of van Baburen (see fig. 61) as well as that of ter Brugghen.[78] But van Honthorst's *Merry Company* is altogether more Italianate, despite its pictorial origins in sixteenth-century Netherlandish art. Its chiaroscuro effects and prominent *repoussoir* figure in silhouette, who serves to establish spatial recession within the relatively compact composition, recall paintings by Manfredi in particular (fig. 75).[79] Yet, as previously mentioned, illumination emanating from an artificial source (such as a candle) is rare in the work of Manfredi and that of his famous mentor, Caravaggio. Moreover, the playful air of van Honthorst's work is generally absent in Manfredi's more somber if not gloomy representations.

A pile of books, an hourglass, and a globe lie on the left side of the table at which the figures are seated. These items are pushed to one side of the table for the young man has completely discarded his studies in favor of debauchery, his propensity to drink made clear by his gaze into a drinking can. The artist has depicted a popular literary and visual trope, a *kannekijker* (a word which can be translated literally as tankard looker), the longstanding embodiment of a person addicted to alcohol.[80]

An immense, open folio on the table silhouettes the youth's tankard (fig. 76). Its pages are brilliantly illuminated by candlelight and thereby linked visually to the equally well-lit, seminude torso of the theorbo-playing prostitute. One of the pages illustrates an older man and a nude child, most likely Cupid, beating a woman who holds a large book. On the opposite page is a Latin poem signed "C. Barlaus," a variation on the name of the famous humanist Caspar Barlaeus (1584–1648). Recently, Marcus Dekiert discovered this poem, titled "Epigram on the painting by the artist Honthorst of Utrecht in which he displayed the life of a lascivious scholar amid the prostitutes," in Barlaeus's *Poemata* published in 1628.[81] Written in elegiac cou-

plets, the verses provide an extremely erudite yet comical gloss on the young man's abandonment of scholarship for pleasure:

> Off with you, dry pages that you are, overly worrisome burdens.
> The learned page ought not to vex youthful heads.
> Thais is my love, my desire, my laughter, my jest,
> A petulant maid with a bit of the god Bacchus mixed in.
> Defeated Pallas sighs while the playful maid with the Patrician name at long last gladdens my obedient heart.
> Thus crazed Circe transforms my honor
> And I through my zeal am a pig, I who was a scholar.[82]

Barlaeus invokes Thais, a famous courtesan in ancient Athens, and the Bromian god, a reference to Bacchus, to suggest that the young man in the painting is seduced by whores and drink.[83] The reference to Circe alludes to the episode from Homer's *Odyssey* in which the enchantress changes some of Ulysses' men into pigs – and in this context, figuratively speaking, the wanton student himself.[84] In effect, women and drink have overwhelmed this youth and even Pallas, or Pallas Athena (the prostrate female in the book illustration) the goddess of wisdom who sighs in defeat. The last line of the couplet contains extremely clever and humorous wordplay as the Latin for "And I through my zeal am a pig" is *studio-sus sum* – equivalent except for spacing and tense of *studiosus eram*, meaning "I was a scholar."

The focus on sex and drink in Barlaeus's couplets once again exemplifies the fondness for comic ribaldry among elites, as does the painting itself, which is hardly surprising given van Honthorst's cosmopolitan clientele. The frolicsome aspects of the *Merry Company* are intimately bound with its eroticism. One of the prostitutes plays a theorbo, tantalizingly concealing a breast

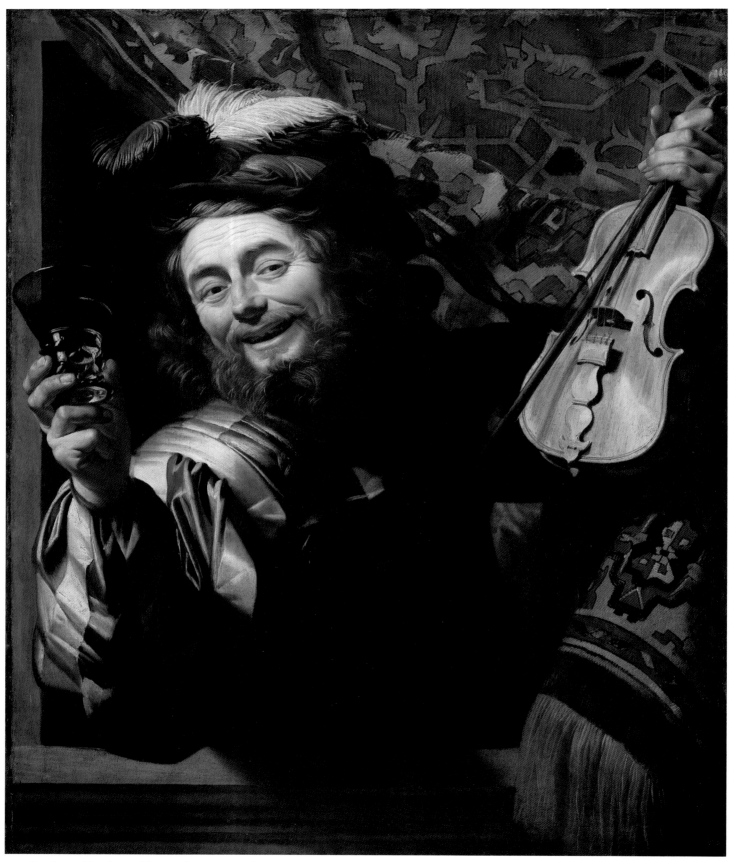

77 Gerrit van Honthorst, *Merry Violinist*, 1623 (oil on canvas, 108 × 89 cm). Amsterdam, Rijksmuseum.

that would otherwise be exposed in her state of dishabille. As Eric Jan Sluijter has repeatedly demonstrated, Dutch artists routinely depicted beguiling temptresses who embody the enticing artistic techniques that engendered them.[85] And surely the sophisticated chiaroscuro effects that cause the woman's form to emerge alluringly from the half-shadows intensify the viewer's enchantment with her. Nighttime scenes in older Netherlandish art were often equated in a moralistic sense with voluptuousness and profligacy, associations possibly evoked by this picture.[86] But the painter's blithe, jocular approach to the subject militates against an exclusively admonitory reading.[87] Even the infant held by the procuress, the illicit fruit of the youth's carnal appetites, is facetiously pointed out by one of the smiling whores.

In essence van Honthorst, in tandem with Barlaeus, has created a splendid representation whose virtuosity and costliness seem almost at odds with its lascivious subject matter. Nevertheless the unexpected combination of such ostensibly contradictory qualities as beauty and vulgarity is fully consonant with elite taste during this period. What for a devout Calvinist viewer would have amounted to a sort of pictorial anathema, and what for ethically inclined beholders may have constituted a trenchant display of shameful activities and behaviors unworthy of imitation, is for sophisticated and discriminating audiences a witty display of the innately dishonorable proclivities of a salacious, fraudulent student of inferior social status.[88]

Van Honthorst was indeed renowned during his lifetime for his chiaroscuro paintings but his œuvre includes other, fascinating images lacking in spectacular light effects. His striking *Merry Violinist* of 1623 (fig. 77), for example, likewise displays his formidable skills as an artist.[89] This painting is comparable with any number of half-length figures of musicians painted by van Baburen and ter Brugghen (see fig. 66) in the early 1620s, yet its iconographic roots are complex as precedents can be found not only in sixteenth-century Netherlandish art but also in the work of Manfredi.[90] What distinguishes van Honthorst's representation from these precedents and those by van Baburen and ter Brugghen is its bold illusionism. The cheerful figure leans over a balustrade, protruding into the viewer's space as his form punctures the picture plane. He sweeps aside the brilliant red carpet whose conspicuous tactility enhances the illusionistic qualities of the canvas.

The man is dressed in the by now familiar, outlandish clothing of a Caravaggesque rogue, his head crowned with an ostrich-feather cap. He clutches his violin and bow in one hand while toasting the audience with the wineglass in the other. Earlier hypotheses identifying him as a member of a chamber of rhetoric (amateur literary societies that flourished in the Dutch Republic at this time) are surely incorrect as are attempts to categorize his distinctive garb as theatrical, of late Burgundian origin. Efforts to link the figure with his wineglass to the sense of taste and thus the picture to a now-lost series of the Five Senses

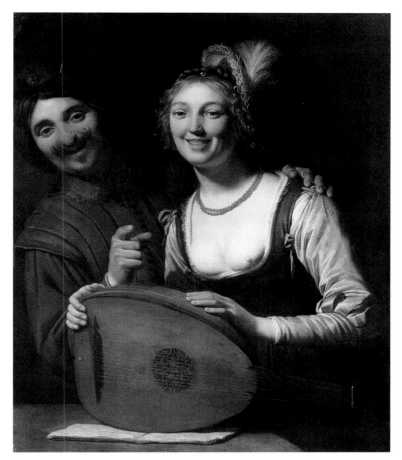

78 Gerrit van Honthorst, *Brothel Scene*, 1628. Present location unknown.

are far more plausible.[91] Yet one must not neglect the potential associations, however general, for contemporary viewers of the *Merry Violinist* with the characters of picaresque novels. The roguish protagonists of those texts are invariably characterized as devotees of dissipation, and are often described, curiously enough, as skilled musicians who use their talents to seduce females.[92]

As van Honthorst matured as an artist, his forms became sharply defined and his chiaroscuro effects increasingly hard. This is particularly true of his last genre paintings, produced during the late 1620s, among them a *Brothel Scene* of 1628 (fig. 78).[93] Here passages of light and shadow are distinctly separated, lacking the softness and subtle interweaving typical of his earlier art. The figural forms here are crisply defined, the outlines of the bodies excessively sharp. This stylistic evolution did not affect the artist's coarse subject matter, however, which continued unabated. In the *Brothel Scene* the man points to the beholders, thereby implicating them in his interactions with a bare-chested prostitute sporting feathers in her hair, an identifying attribute of members of her profession. She touches the rounded belly of the lute below her which is hardly coincidental given the frequent equation in early modern art and literature of the shape

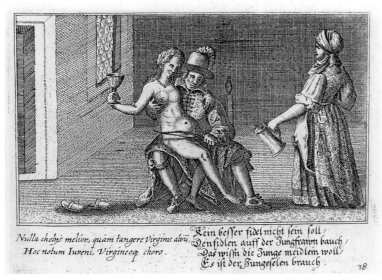

Nulla chelys melior, quàm tangere Virginis aluu.
Hoc notum Iuueni. Virgineoq. choro.

Kein besser fidel nicht sein soll/
Den fidlen auff der Jungfrawn bauch/
Das wissn die Junge meidlein woll/
Es ist der Jungesslen brauch.

38

79 Illustration from Peter Rollos, *Euterpae suboles*, Berlin, 163?. New York, Rare Books Division, The New York Public Library, Astor, Lenox and Tilden Foundations.

and structure of specific musical instruments with the female body (fig. 79).[94]

By 1630 van Honthorst had abandoned genre painting in favor of supplying portraits and large-scale allegorical works in a bland, classicizing style to several European courts. In 1637 he joined the painters' guild in The Hague and purchased a palatial home there where he labored ceaselessly on behalf of the Prince of Orange and his extended retinue. With the new thematic and stylistic directions of van Honthorst's art, coupled with the deaths of van Baburen in 1624 and ter Brugghen in 1629, Utrecht Caravaggism lost much of its initial momentum, its gradual decline largely complete by the middle of the century.

Jacob Duck

Jacob Duck (*c*. 1600–1667) was a prominent artist in Utrecht whose career overlapped the local Caravaggist movement. He was a talented painter and iconographic innovator who scholars unjustly neglected for decades, the first monographic study of his work, by Nanette Salomon, appearing just a few years ago.[95] Duck was originally trained as a goldsmith. At an age (twenty-one) when most fledgling artists were completing their instruction, he began his with the minor Utrecht painter Joost Cornelisz. Droochsloot (1586–1666). He was registered as a master painter with the Guild of St. Luke by 1630 but retained his membership in the goldsmith's guild. Duck spent most of his three-decade career in Utrecht though he did register with the painters' guild in Haarlem in 1636. Later in life Duck spent several years in The Hague but he eventually returned to Utrecht where he died impecunious in 1667.

During much of Duck's early career, the Caravaggist style dominated painting in his native town. Given this situation, and perhaps Duck's own aesthetic proclivities as well as his possible desire to have an impact on the art market in Utrecht, he turned to paradigms established by artists from Amsterdam. During the middle of the 1630s Duck spent significant time in Haarlem (though documentary evidence indicates his continued residency in Utrecht), where he came in contact with the work of the nearby Amsterdam artists Pieter Codde and Willem Duyster, if not the artists themselves.

The relevance of Codde's and Duyster's art for that of Duck's is undeniable. For example, Duck's *Dividing the Spoils* (fig. 80) depicts a scene of soldierly revelry of a type developed by Codde and Duyster (see fig. 55) in the 1620s.[96] Very few pictures by Duck are dated and consequently a precise chronology of his stylistic development is difficult to establish. Nevertheless, *Dividing the Spoils* was probably executed in the middle of the 1630s, a period in which Duck began to depict lofty, cavernous interiors as locales for soldiers' barracks. As was discussed in Chapter 3, the settings depicting guardroom interiors are ficti-tious yet they generally evoke the buildings either constructed or confiscated to garrison soldiers during the protracted war with the Spanish. Duck's barn-like enclosure is no exception but the links with the realities of contemporary soldiering are tenuous at best.

Guardroom imagery, like all themes in seventeenth-century Dutch genre painting, was highly conventional, revolving around a limited range of subjects and motifs – the debt here to the formal and thematic innovations of Codde and Duyster are obvious. The basic, monochrome palette of *Dividing the Spoils* and fairly even lighting are reminiscent of depictions by Codde.[97] These features have been combined with lively accents of rich color applied with great precision to the panel in a manner recalling Duyster's work. Furthermore, the rendering of the satiny fabrics of the women's dresses, in particular, along with the leather and armor of the soldiers' outfits, is analogous to Duyster's famed renditions of similar textures and stuffs. From a thematic standpoint, however, Duck's painting, with its eager military men playfully dividing booty with prostitutes, is perhaps more comparable with raucous depictions by Codde (see fig. 56) than those by Duyster with their sometimes quasi-melancholic qualities.

As Salomon has pointed out, Duck rarely invented new guard-room subjects per se. Rather, his contribution to Dutch genre painting lies in his often singular interpretations of what by the 1630s had rapidly developed into conventional subject matter.[98] *Dividing the Spoils* provides an especially telling example of Duck's talents in this regard as he cleverly combines the themes of booty distribution with hostage-taking, both highlighted by his partition of the pictorial space. Beginning with the lower right side of the panel, a diagonal line comprised of three groups of figures extends into the center middleground. All three

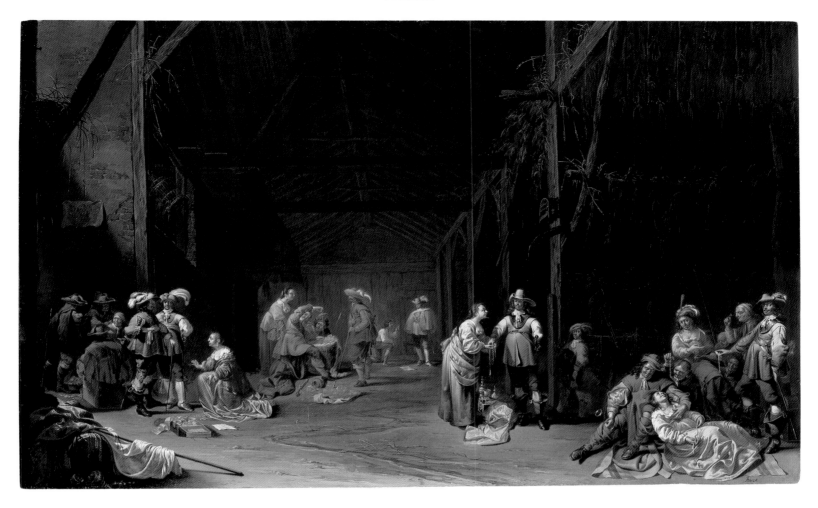

depict soldiers interacting with prostitutes, omnipresent in military encampments of the seventeenth century. The most unruly gathering appears in the lower right corner where among others a drunken soldier fondles a moll clutching a string of pearls.

Duck also includes a female on the left in a much more precarious, defenseless position who is present at the barracks against her will, to wit, the woman in the sumptuous, pinkish-red satin dress and fur-trimmed cape. With her obeisant pose before the two standing officers, she appears to be pleading for her freedom (or perhaps for her very life), conceivably in exchange for the coins, jewelry, and related, luxury articles scattered on the dirt floor beside her. Duck's rendition of this hostage situation lacks the poignancy of those by Duyster (see fig. 57). Much like the presence of the prostitutes in this painting, the depiction of a woman at risk, along with these risky women, clearly heightened the appeal of these pictures by playing upon the fantasies of spectators who had little contact with the actual military. Indeed, *Dividing the Spoils*, and related works, melodramatize and idealize the crass adventures of mercenary soldiers at the margins of society who terrorize respectable yet vulnerable citizens and share looted goods with their licentious cohorts.[99]

80 (*above*) Jacob Duck, *Dividing the Spoils*, c. 1635 (oil on panel, 45.5 × 73.5 cm). Private collection.

81 (*below*) Jacob Duck, *Sleeping Woman and a Cavalier*, c. 1640–45 (oil on panel, 29.5 × 37 cm). Vienna, Gemäldegalerie der Akademie der bildenden Künste.

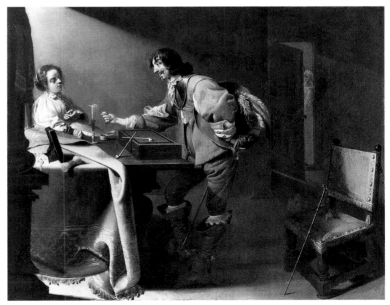

œuvre, often with a degree of nuance absent in paintings by other artists.[101] Sleep was customarily associated with the sin of sloth, one of the seven deadly sins that according to Catholic teaching was the progenitor of other grave transgressions, especially lust. Even though the iconography of these sins was well established in fifteenth- and sixteenth-century art, it is doubtful whether such specific, traditional associations were operative in Duck's painting. To the contrary, the comic, vulgar overtones are paramount.

A snickering officer (identified as such by his military costume), spies upon the sleeping prostitute and makes an obscene gesture which was easily recognizable for contemporary audiences. To make this gesture, then known as "the fig," the thumb is placed between the forefingers in mock imitation of coitus.[102] Later in the century, Godfried Schalcken made an etching of a grinning man in old-fashioned clothing who makes exactly the same gesture (fig. 82). This etching is inscribed *Quam meminisse invat* (Memories Are Such a Delight), an unequivocal reference to his fondest sexual liaisons.[103] That Duck's prostitute is receptive to such overtures, even in her sleep, is suggested by the vagina-like shape of her left hand as it clenches an unidentified object.[104] This motif comically suggests her sexual desire even in a somnolent state, thus fully conforming to contemporary notions of the purportedly insatiable female libido.

The hypothesis that Duck's art was targeted at middle-class audiences is not borne out by the relatively high prices it commanded: his depictions of sleeping figures, for example, regularly sold for 70 to 80 guilders, a sum that would have taken the average middle-class collector in Duck's day nearly two months to earn.[105] How many members of the middle class today could afford to spend the equivalent of two months' salary on a single painting? Surely the not inconsiderable cost of Duck's pictures, the sophisticated techniques that engendered them (ones that grew increasingly refined as Duck matured), and the frequently ribald motifs within them, pay testimony to the tastes of affluent buyers during the third and fourth decades of the seventeenth century.

Painting in Utrecht had been revitalized during the early seventeenth century by a generation of gifted artists who labored for the large numbers of wealthy inhabitants of the city and surrounding region. The work of the Utrecht Caravaggisti during the second and third decades of the century largely accounted for that city's prominent role in the production of genre painting at that time. Jacob Duck made significant contributions to ongoing artistic developments as well by incorporating the features of contemporary genre painting in Haarlem and Amsterdam into his work. However, as Utrecht's economy grew stagnant in the second half of the century so too did its status as an art center, a phenomenon also experienced in other towns of the Dutch Republic at that time.

82 Godfried Schalcken, *Man Making an Obscene Gesture* (etching). Amsterdam, Rijksprentenkabinet.

Duck also specialized in the representation of prostitution, a theme common in the art of the Utrecht Caravaggisti. His depictions, while undoubtedly inspired by the abundant work of his Utrecht colleagues, once again owe a debt to genre paintings produced by Codde and Duyster. Duck's *Sleeping Woman and a Cavalier* (fig. 81), for instance, displays the typical monochromatic palette associated with Codde (and Haarlem artists as well) but in this particular panel the soft, somewhat blurry application of ground colors suggests a date in the early 1640s, as does the restricted number of figures represented.[100] The dramatic, raking light here (also indicative of a later phase in Duck's career) parallels that seen in Caravaggisti pictures (see fig. 59).

This painting represents a brothel: a woman (presumably a procuress) peers through a partly open door at a prostitute, soundly asleep. The drink beside her on the table, or perhaps a client's sexual prowess, has induced her slumber. Other articles generally associated with bordellos lie on the table beside her, namely, clay pipes and a backgammon case. Duck was certainly not the first genre painter to depict a sleeping figure but he nonetheless popularized the motif as it appears throughout his

CHAPTER FIVE

THE HAGUE

The Hague was one of the smallest cities in the Dutch Republic; some seventeenth-century commentators affectionately referred to it as a *dorp* (village).[1] Nevertheless, The Hague's diminutive size was inversely proportional to its significance to the country as a whole: The Hague was the political hub of the Netherlands. It was not only the site of the court of the Stadholder but the States General and the States of Holland convened there. The latter institution partly administered The Hague as the city itself did not enjoy official urban status. Owing to this situation, coupled with its meager size, The Hague might be more accurately termed a township or a borough. Besides the States General and States of Holland, The Hague contained numerous other governmental and judicial offices, including the Court of Justice of Holland and Zeeland. At any given time during the seventeenth century then the town was inundated with military officials, political leaders, baliffs, foreign diplomats, and ambassadors, along with the requisite legions of lawyers, bureaucrats, and petty officials who followed in their wake.[2]

The Hague's role as the administrative and courtly center of the Netherlands affected its growth. In 1570, before the city had assumed most of its political functions, its population stood at roughly 5000 inhabitants. This number, swelled by the influx of Flemish immigrants, doubled by 1600 and by 1627 it had grown to roughly 18,000 inhabitants.[3] During the 1620s The Hague was enlarged to create housing for new residents as well as a harbor for the increasing horse-drawn barge traffic from neighboring cities. Yet two distinct "districts" had already emerged there, the principal one surrounding the court and governmental buildings of the so-called *Binnenhof* (literally, the inner court) where wealthy residents constructed handsome dwellings in its fashionable neighborhoods. The other district encompassed the narrow streets and alleys around the *Grote Kerk* (Great Church) several hundred yards to the southwest of the *Binnenhof*. Many residents of this less affluent district provided goods and services to the government, court, and denizens of the *Binnenhof* quarter.

The Hague had once possessed a thriving cloth industry but the advent of textile production in England and especially in nearby Leiden had led to its complete decline by 1600. Thus by the seventeenth century an alternative, robust market gradually emerged in The Hague for luxury skills and trades capable of supporting the extravagant lifestyles of the ever-increasing numbers of wealthy residents in the city. Such trades as carriage-making, ebony-carving, gilding, goldsmithing, and silk-weaving flourished there at this time. Tax assessments conducted in 1627 reveal that there were proportionally larger numbers of upper-class inhabitants than those of the middle class.[4] Indeed, judging by the average net worth of those citizens who were taxed – in the seventeenth century, taxation presupposed a certain amount of assets – The Hague was the wealthiest city in the Dutch Republic despite its lack of financial institutions and large-scale industry.

Within this prosperous and cosmopolitan atmosphere art was naturally in great demand. The Hague is usually seen as a secondary center for seventeenth-century Dutch painting in comparison with, say, Amsterdam or Leiden, yet several hundred painters labored there during the Golden Age. In 1650 The Hague had the highest ratio of artists in relation to overall population of any city in the country.[5] In addition to selling art on the open market, painters actively pursued patronage from individual citizens, government institutions, and officials from the great courts of the Princes of Orange (especially that of Frederik Hendrik (1584–1647) and his wife, Amalia van Solms (1602–1675)) and the exiled King of Bohemia, Frederick v of the Palatinate (1596–1632), and his English-born Queen, Elizabeth (1596–1662).[6] However, the tastes of these courts were primarily oriented toward foreign art – Frederik Hendrik in particular preferred Flemish painting – so opportunities for local masters were somewhat restricted, most often to portraiture, the predominant type of painting produced in the city.[7] Fortunately native artists found a ready market for their work among lower-level collectors including members of the city's large force of bureaucrats and others of comparatively modest means.

Despite the intense competition between painters, archival documents reveal a kinship among them, many of whom inhabited the same neighborhoods within The Hague.[8] And in 1656, the painters, glass-painters, sculptors, and engravers seceded from the town's Guild of St. Luke to establish the *Confrerie* (Brotherhood), later known as the *Confrerie Pictura* (Brotherhood of Painting).[9] This professional organization was founded in order to protect the artists' mutual interests as they no longer wanted to be associated with the simple craftsmen who belonged to the Guild of St. Luke. This new organization served to affirm their growing financial and social status.

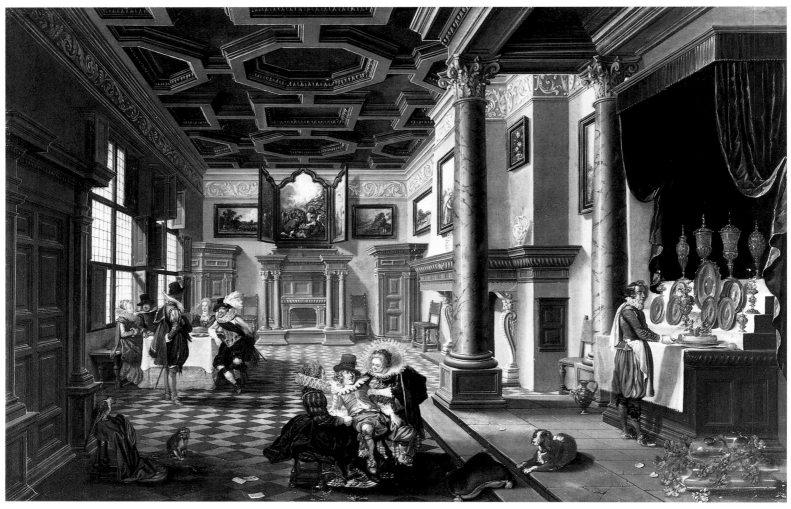

83 Bartholomeus van Bassen and Esaias van de Velde, *Renaissance Interior with Banqueters*, *c.* 1618–20 (oil on panel, 57.5 × 87 cm). Raleigh, North Carolina Museum of Art, Purchased with Funds Given in Honor of Harriet Dubose Kenan Gray by Her Son Thomas S. Kenan III; and from Various Donors by Exchange.

Esaias van de Velde

Esaias van de Velde (whose early career was discussed in Chapter 2) moved to The Hague from Haarlem in 1618, undoubtedly drawn by commercial opportunities in the affluent capital. Once there he adjusted his style and subject matter to appeal to the sophisticated tastes of the resident cognoscenti.[10] Although landscapes continued to predominate his output van de Velde produced some of his most fascinating and elegant genre paintings at this time. Many of these pictures were executed in tandem with the The Hague's leading painter of architectural scenes, Bartholomeus van Bassen (*c.* 1590–1652).

Possibly born in The Hague, van Bassen entered the Guild of St. Luke in nearby Delft in 1613.[11] He undoubtedly took advantage of the close proximity of the two cities to provide works of art for clientele from both, but eventually moved to The Hague and entered the St. Luke's Guild there in 1624. He subsequently enjoyed a distinguished career in that city, both as a painter of architectual scenes and as a practicing architect. In 1639 he was appointed city architect and was also employed by the courts of Frederik Hendrik and Frederick V. Van de Velde was just one of several genre painters with whom van Bassen worked but he was the architectural painter's preferred collaborator during the 1620s.[12]

The most stupendous collaborative efforts between van Bassen and van de Velde were their depictions of sumptuously appointed palace interiors populated by stocky yet suave revellers (fig. 83). The painting reproduced here, a *Renaissance Interior with Banqueters*, typifies their approach. Van de Velde's fashionable figures, whose apparel and coiffeurs suggest a date for the panel of around 1618–20, inhabit a majestic interior replete with ornately carved wainscoting, a coffered ceiling, and two massive marble columns.[13] The painting's probable early date suggests that the two artists began to collaborate before van Bassen moved to The Hague. Regardless of whether the painting was purchased by

someone living in Delft or The Hague (or another city altogether), its luxurious aura and sophisticated yet artificial perspective scheme suggests an owner of lofty taste and distinction. A document from the period testifies to van Bassen and van de Velde's joint efforts as well as to the relatively high prices they commanded for their works. A lottery organized by the Delft glass-engraver Cornelis van Leeuwen in 1626 lists three paintings by the artists valued from 46 to 150 guilders, the latter sum equivalent to roughly three months wages for the average middle-class worker in the Dutch Republic.[14]

Traditionally, it has been argued that van Bassen and van de Velde's paintings of ornate interiors carried moralizing messages for contemporary viewers. This argument is certainly plausible given the frequent appearance of pictures with biblical subjects on the walls in the background, the presence of wine and playing cards, indulgent figures, and fettered apes, creatures long associated with humanity's base instincts.[15] Yet one must also acknowledge additional responses given the status of prospective owners of such works. The intricate perspectival space of the grand room in a *Renaissance Interior with Banqueters* (and similar depictions) was carefully calculated to appeal to affluent connoisseurs of the day as were the ornate, decorative accouterments and dashing figures.[16] And the higher the social and economic position of the owner – recall that van Bassen spent much of his career in the service of the Prince of Orange and exiled King of Bohemia – the less chance that he or she would brook overt reprimands from art. Consequently, Axel Rüger's intriguing observation is equally plausible: such works were "laboriously produced luxury items for a small class of sophisticated patrons who appreciated the tension between the disorder of the subject matter and the orderliness of the perspective construction and the meticulous detail."[17] A *Renaissance Interior with Banqueters* and related collaborative efforts by van Bassen and van de Velde are thus important for what they reveal about elite taste during the early decades of the seventeenth century. Once again the incongruity of well-crafted, expensive works of art containing figures engaged in varying degrees of disreputable behavior is encountered.

These paintings, in terms of the disposition of space, were also significant for future developments in Dutch genre painting. Van Bassen's pictorial construction of a brightly colored, expansive (though airless) box-like interior ultimately evolved from earlier depictions by Antwerp artists, especially those by Hans Vredeman de Vries (1527–1606) and his son, Paul Vredeman de Vries (1567–after 1630).[18] Although this testifies once again to the pervasive Flemish roots of Dutch genre painting, Dutch artists such as van Bassen were not slavishly dependent upon these prototypes but rapidly developed their own variations upon them. As Walter Liedtke has argued, the result was the formation of a conventional, regional style in the southern cities of the Province of Holland and those of the Province of Zeeland, characterized by the distinct and rational recession of well-

defined, interior spaces.[19] This regional style, usually employed in pictures destined for the upper strata of buyers, underlies the definitive interiors created by a younger generation of genre painters, most notably by Pieter de Hooch (1620–1684) and Vermeer.[20]

Adriaen van de Venne

Van de Velde's slightly younger colleague, Adriaen van de Venne (1589–1662), was another noteworthy artist who produced genre paintings in The Hague during the early decades of the seventeenth century. According to de Bie, whose brief biography of van de Venne published in 1661 is the principal source of information concerning the artist's formative years, he was born in 1589 in Delft to parents who had emigrated from the war-ravaged Southern Netherlands.[21] In his youth he studied Latin and received artistic training from two now obscure masters, one of whom, Hieronymous van Diest, specialized in grisailles, which became van de Venne's own preferred technique when he moved to The Hague. Archival documents place the painter's father and brother Jan in the city of Middelburg, in the Province of Zeeland, in 1605 and 1608 respectively. Jan van de Venne established a publishing business in Middelburg and dealt in art as well. His establishment with its accompanying garden became the gathering place for a cultured circle of prominent artists and poets. Adriaen van de Venne participated in the group's activities, as he had likewise resettled in Middelburg, having married there in 1614.

Adriaen van de Venne worked closely with his brother, composing poetry, making political prints, and creating illustrations

84 Illustration from Jacob Cats, *Houwelyck*, Middelburg, 1625. Collection of the author.

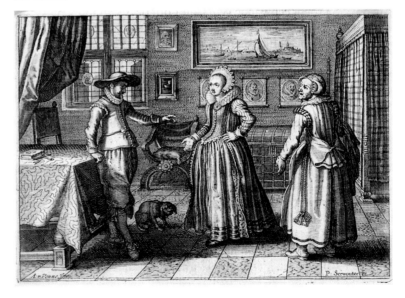

for books published by the shop. In this latter capacity, van de Venne designs were reproduced as engravings in some of the most popular books of the period, thus enhancing his reputation in the process. His illustrations for Jacob Cats's renowned domestic treatise, *Houwelyck* (Marriage), first published in 1625 (and in twenty subsequent editions during the seventeenth century alone), are most extraordinary in this regard (fig. 84).[22] The representation of space in these engravings (demarcated in the example shown here by the floor-tile pattern), the little pictures on the wall, the lively figures, and touches of light and shadow anticipate genre paintings of future decades. They also corroborate van de Venne's stature as a leading exponent of the regional style of South Holland and Zeeland discussed earlier in this chapter.[23]

During his years in Middelburg van de Venne was also quite active as a painter. His paintings from this period display vivid coloring and a wealth of detail and their painstaking brushwork, ornamentalized foliage, strong local colors, and frequent use of a "bird's-eye perspective" link them to works by such contemporary painters as Vinckboons (see Chapter 3) and, ultimately, to Flemish painting, particularly as practiced by Jan Bruegel the Elder (1568–1625), the talented son of Pieter Bruegel the Elder. The subject matter of van de Venne's Middelburg period paintings is varied and includes landscapes, complex allegorical subjects, and portraits of members of the House of Orange.[24]

Adriaen van de Venne can be documented in The Hague that March where he was granted a copyright for Cats's *Houwelyck*. This turned out to be the last publication venture undertaken by his brother, who died in late April or May of 1625. Jan van de Venne's once flourishing printing business subsequently collapsed. His sibling's death probably influenced Adriaen's decision to relocate to The Hague, as did, undoubtedly, his increasing contacts with the Dutch Court and States General for whom he had already been providing paintings and prints for some time. In fact, portrayals of the recently deceased Stadholder, Maurits (1567–1625), lying in state, rank among van de Venne's first works in The Hague.[25] Van de Venne spent the rest of his long life in the capital where he rapidly rose to prominence, regarded highly not only by members of the court and the city's elite but also by his fellow artists. He held, for example, a number of important posts in the Guild of St. Luke and was one of the founding members of the *Confrerie* in 1656. Van de Venne continued to work for the Dutch court, executing portraits, for example, of Frederik Hendrik and his entourage.[26] However, his production in The Hague consisted chiefly of grisailles representing the lower echelons of society.

His depiction of two decrepit musicians, cryptically inscribed *Fray en Leelijck* (Beautiful and Ugly) is a characteristic example of van de Venne's work of this sort (fig. 85). Judging from its small scale and reduced number of figures, it was probably painted in the late 1620s or 1630s.[27] Grisaille is the term used

to describe works of art – or the technique which created them – exhibiting extreme monochrome, in this particular instance, shades of brown.[28] The technique was first employed in late medieval manuscript illumination and was highly popular in fifteenth-century Netherlandish panel paintings where it was most often reserved for the exterior wings of polyptychs.[29] By van de Venne's day, grisaille had developed into a highly sophisticated art form. The virtual absence of color posed a tremendous challange to a painter who instead had to rely purely on skilled and confident brushwork to articulate forms, texture, and atmosphere. Treasured by connoisseurs, grisailles primarily demonstrated artistic virtuosity and were therefore customarily reserved for the depiction of elevated subject matter.[30]

Van de Venne's mastery of these techniques is readily apparent in *Fray en Leelijck*. The picture is composed principally of shades of brown with some subdued bluish tones for the sky and small passages of dark green for the sleeves of the flute player. Grisailles of this period, much like polychrome paintings, manifest either a rather tight application, which yields a smooth facture, or loose brushwork, which, as discussed in relation to Brouwer and Frans Hals, yields lively and varied surface effects.[31] *Fray en Leelijck* belongs to this latter category; despite the seemingly haphazard appearance of the paint application on this panel, it is actually carefully controlled and remarkably diverse, from the strokes and daubs articulating leathery skin to those that render hair and tattered garments.[32]

The owner of this grisaille must surely have savored the intricate painting techniques that engendered it. And much to his or her delight, van de Venne, with remarkable wit, has ironically combined complicated brushwork and bravura effects with the coarse subject matter of a wizened, blind flute-player accompanied by a crone on the hurdy-gurdy, a musical instrument unequivocally associated with the riffraff.[33] This ironic amalgam of the high and low cleverly plays upon the seventeenth-century Dutch term invoked to categorize such images and their technique: contemporary inventories and literary sources employ *grauw* for grisailles, the very same word used colloquially to describe the *grauw*, the unwashed masses.[34] In *Fray en Leelijck*, the inscribed banderole, meaning "the beautiful and the ugly", forcefully echoes the integral irony and cleverness of the representation. This banderole does not record the dialogue between the figures in a manner akin to comic books today. Rather, it is meant for the initiated viewer who will recognize and appreciate homonymic word play that approximates the artist's painting technique in its clever concision. As Mariët Westermann has pointed out, the inscription is intended to be understood on several levels since *fray*, in seventeenth-century Dutch, is a homonym, meaning not only beautiful but also clever, in a deceitful way.[35] Thus, the painting is beautiful but its figures are ugly, or, the music is beautiful but it is made by ugly figures, or alternatively, the painting is beautiful but its ugly figures are cunning.

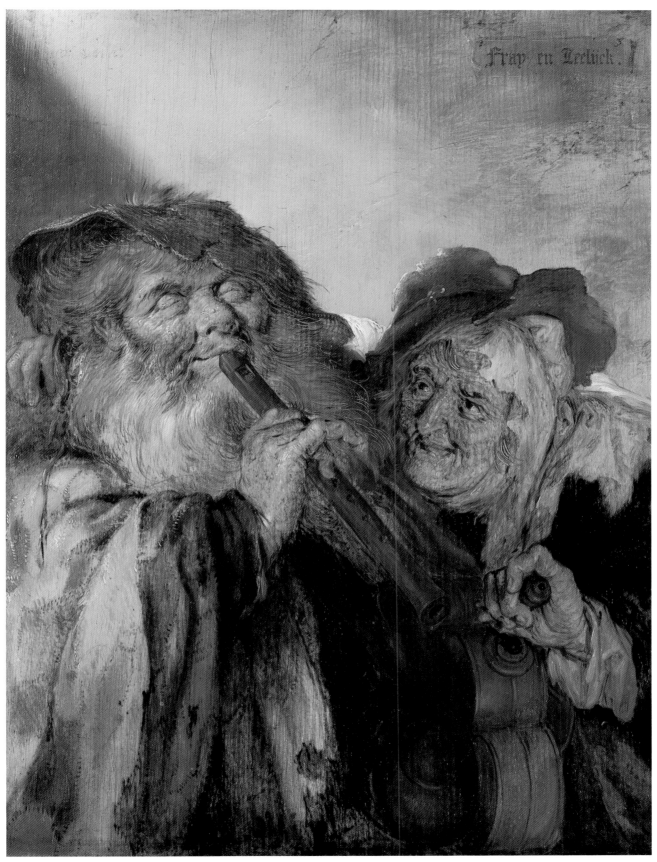

85 Adriaen van de Venne, *Fray en Leelijck*, *c.* 1628–34 (oil on panel, 37.2 × 29.5 cm). Private collection.

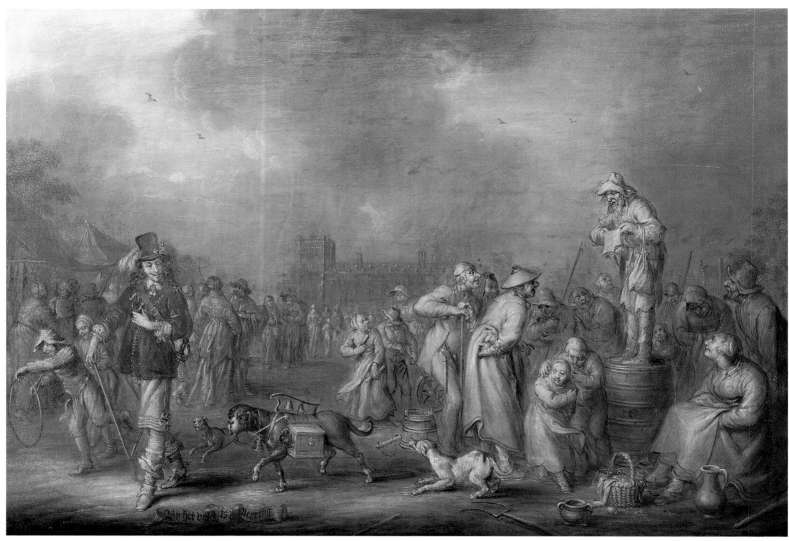

86 Adriaen van de Venne, *Bij het volck is de neering*, 16[5]2 (oil on panel, 46.5 × 65.6 cm). Private collection.

The option of reading *fray* here as ugly or clever affords insights into contemporary perceptions of persons on the margins of society. The theory that beholders construed van de Venne's musicians with compassion confuses modern sensibilities with those of the seventeenth century. In the Dutch Republic, like all early modern European societies, the destitute were classified according to whether they were justly or unjustly poor. The former category included, for example, widows and orphans, the latter, beggars who were considered entirely responsible for their own plight and were thus believed to exploit society deceptively for their own gain.[36] Beggars populate many of van de Venne's grisailles.

The artist must have marketed these pictures initially to genteel collectors in The Hague and other wealthy cities, that is, to prospective buyers who would appreciate the startling and ironic conjunction of base imagery and witty puns with a painting style normally reserved for refined subject matter.[37] According to Westermann, these very same purchasers would have likewise recognized the creative parallels between the artist's stylistically sophisticated renditions of menial subjects and the august literary traditions of paradoxical encomium, namely, elaborate and incisive praise for that which is actually insignificant – Erasmus of Rotterdam's *Praise of Folly* represents an outstanding example of this tradition.[38] Yet van de Venne soon replicated these grisailles in copies of varying levels of quality as surviving examples and the fairly wide range of seventeenth-century valuations attest.[39] Moreover, he recycled figures frequently: the indigent couple in *Fray en Leelijck*, for instance, reappear in other works with different subjects.[40] This suggests that the artist quickly expanded the market for his grisailles

to accommodate both well-to-do buyers and those of lesser financial means.

Van de Venne produced substantial quantities of grisailles throughout the remainder of his career. As the decades progressed, his execution grew more refined and the works larger in format, concomitantly including more figures and a profusion of anecdotal detail.[41] *Bij het volck is de neering* (Where There Are People Money May Be Made), signed and dated 16[5]2, is one of the most ambitious examples of his later grisailles (fig. 86).[42] The brushwork is much tighter here than in his earlier *Fray en Leelijck* and the resultant monochromatic surface is delicate and fully atmospheric. Indeed the moisture-laden clouds rival those produced by landscape artists working in the tonal style.[43]

The panel offers a sweeping view of the renowned, annual May *kermis* in The Hague – the *Binnenhof* complex looms in the distance.[44] However, this is not a documentary image but one swarming with caricatures of ignoble social types meant to entertain a sophisticated, knowledgeable viewer. To the right, clearly separated from some affluent visitors to the *kermis*, is a ballad singer (the seventeenth-century equivalent of a street musician) crooning on a barrel surrounded by paupers and peasants. These figures display ungainly, stooped postures, ones continually associated with boorish types in Dutch genre painting.[45] To the left of this rabble is a man posed and seemingly dressed like a person of high social status. However, his wonderfully devious facial expression, his dog following behind him outfitted with boxes and bells, and especially the inscription *Bij het volck is de neering* strategically placed between his feet and the front paws of his canine companion, alert the viewer to his true identity: a charlatan poised to swindle ignorant customers such as those in the group to his left.

A similar array of miscreants analogous to those seen here and in other pictures are found in van de Venne's own books, most notably his *Tafereel van de belacchende werelt* (Tableau of the Laughable World) of 1635.[46] This tome recounts the experiences of two peasants, Tamme Lubbert and Fijtje Goris, as they attend The Hague's annual May *kermis* (fig. 87). The lively atmosphere of the *kermis* is expertly captured by van de Venne, as the pair, speaking in rhymed dialogue, experience a kaleidoscope of colorful events and characters including a quack practitioner with a German accent who boldly proclaims his ability to cure the infirm.[47] Tamme and Fijtje also encounter what the author describes as lazy, cunning beggars including blind musicians – the literary counterparts of the elderly man in *Fray en Leelijck* – who fabricate "silly lies about the causes of their ill-fated blindness."[48]

Tafereel van de belacchende werelt also evokes the spirit of van de Venne's grisailles in its complex and entertaining linguistic manipulations. These range from the peasants' satirical attacks upon each other, reflective of the customary biases toward bumpkins and peppered with scatological remarks, to the 1750

87 Illustration from Adriaen van de Venne, *Tafereel van de belacchende werelt*, The Hague, 1635. The Hague, Koninklijke Bibliotheek.

glosses in the wide margins of the text that, with a mixture of humor, entertainment, and admonition proffer ceaseless commentary upon Tamme and Fijtje's adventures and conversations.[49] These glosses are presented in epigrammatic form (and are frequently rhymed), thereby recalling the inscriptions on the paintings which is no accident given the close relationship during the early modern period between art and literature, or the sister arts as they are known.[50] Furthermore, both the glosses and inscriptions rely on witty, homonymic word play and irony to amuse and enlighten the reader and viewer. The principal differences between van de Venne's textual glosses and his grisaille inscriptions probably lie in the more thoroughly moralistic tenor of the former. Admonishments are by no means absent from the artist's paintings but in many instances (among them, *Fray en Leelijck*) they seem to possess secondary significance at best.[51] Nevertheless, all of van de Venne's grisailles share the same marvelous display of artistic wit and virtuosity, ironically coupled with coarse subject matter. They consequently furnish further evi-

dence of the paradoxical nature of elite tastes during this period.[52]

With his entertaining and stylish depictions of low subject matter, van de Venne's œuvre represents a high point in genre painting in The Hague during the seventeenth century.[53] Yet already by the latter years of van de Venne's career (he died in 1662) painters from nearby Delft were making inroads into the market for genre paintings in his adopted city. Fortunately for the artistic community in The Hague the gradual contraction of their share of the local market for genre paintings was more than compensated by the expansion of the market for portraiture there and especially in Delft.[54] In the end, the decline of The Hague as a center for genre painting was offset by its reputation for outstanding portraiture.

PART II 1648–1672

THE DUTCH REPUBLIC, 1648–1672

The long conflict between the Dutch and Spanish gradually began to wane during the late 1630s. Shortly thereafter, in 1641, the warring nations entered into protracted negotiations to end the hostilities. Peace finally ensued in 1648 with the official ratification of the Treaty of Münster. This treaty also signaled the initial triumph of the Province of Holland and States Party advocates throughout the Netherlands. Through its legislative body, the States of Holland, the province managed to force decreases in military spending. Furthermore, owing to its premier position in national politics, the Province of Holland dominated the peace negotiations with the Spanish. The Prince of Orange's death in early 1647 and the ratification of the Treaty of Münster the following year all but ensured Holland's and the States Party's preeminence within the Dutch Republic. But at least initially, this self-assured province's ascendancy was tenuous.

Frederik Hendrik's son, William II, assumed the Stadholderate after his father's death in 1647.[1] Like his father, William II also clashed with the Province of Holland over cutbacks in the size of the army and military spending. During 1649–50 this quarrel evolved into a true crisis that brought the country to the brink of civil war. William II cleverly enlisted the support of the other six provinces as well as towns within the Province of Holland that had not profited nearly as much as its port cities from the tremendous economic opportunities brought about by the Treaty of Münster. Moreover, though himself a nominal practitioner of the Reformed faith, William II shrewdly aligned himself with the orthodox Calvinists as a way of bolstering his authority.

What was fundamentally at issue in William II's struggles with the Province of Holland was not so much military matters but sovereignty and, by implication, political control of the country. If Holland could on its own authority impose military spending cuts or even disband the part of the army for which the province had originally paid in compact with the national government (the States General) then the very concept of national unity was threatened. And if Holland – or for that matter any province – possessed this degree of sovereignty then what was to stop her from making independent decisions on other matters vital to the national interest, such as religion? William II clearly realized what was at stake and acted accordingly. In late July 1650, he arrested six of Holland's principal regents in The Hague and, more dramatically, sent 12,000 infantry to the gates of the province's leading city, Amsterdam, which in effect compelled its

intimidated city council to accede to the Prince of Orange's view of what constituted appropriate military expenditures.

Fortunately for Holland and like-minded advocates of state sovereignty, William II died suddenly in November 1650 after having contracted smallpox. Though the Prince of Orange left an heir, William III (1650–1702), who was born that December, his demise ushered in a twenty-two year period in Dutch politics without the leadership of a Stadholder. The States of Holland, anxious to take advantage of William II's unexpected death in order to restore its domination, convened a "Great Assembly" of all its sister provinces in early 1651, ostensibly to determine the future of the country. But the general instability of the lesser provinces and their reliance upon traditionally powerful Holland to maintain the Dutch Republic's preeminent economic and military status, meant the potentially momentous Great Assembly simply served to endorse Holland's (and the States Party's) de facto supremacy.

Despite temporary commercial setbacks caused by trade disputes and a naval war with the English from 1652 to 1654, the Dutch Republic, particularly its provinces with ports, flourished economically in the years immediately following William II's demise. The country was led at this time by Johan de Witt (1625–1672), who served as Pensionary, that is, as a legal advisor and principal administrative officer to the States of Holland.[2] De Witt descended from a prominent Dordrecht regent family and received a law degree from the University of Leiden. An ardent States Party advocate, he was a brilliant and capable leader. In the face of continual foreign pressure and heated domestic disputes running along customary theologico-political lines, de Witt adroitly steered a course promoting the Netherlands' security and its economic vitality while simultaneously championing the regent class's leadership prerogatives.

During the 1660s however, problems mounted for the United Provinces. The restoration of Charles II (ruled 1660–85) to the English throne and especially his appointment as official guardian of his nephew, the young Prince of Orange, William III, after the death of the boy's mother (Charles's sister) Mary in 1661, led to an upsurge in Orangist sentiment that would wax and wane throughout the decade. Moreover, trade disputes and maritime rivalries with England erupted into a second Anglo-Dutch war (1664–7). Nevertheless, de Witt enjoyed the support of many regents and much of the populace if only for the politically and

economically expedient reason that a strong Holland was pivotal to the successful resolution of these threats and problems. It was during this period that de Witt scored one of the States Party's greatest political triumphs: under his aegis, the Perpetual Edict was passed in 1667, abolishing the Stadholderate in the Province of Holland and weakening the power of the Stadholder in other provinces by detaching military responsibilities from the position.

Despite his proven record of masterful diplomacy, de Witt's political control slowly disintegrated under the weight of truly perilous conditions that began to unfold during the closing years of the decade and the very early 1670s. The Dutch became embroiled in disputes with Louis XIV of France (ruled 1643–1715) over the future of the now enervated Spanish Netherlands as well as issues of commerce and colonization. French troops entered the Spanish Netherlands in April 1667. The threat of an armed coalition of the United Provinces, England, and Sweden eventually succeeded in halting France's advancing armies but it exacerbated Louis XIV's animosity toward the Dutch. The French King consequently cultivated alliances with the German states of the lower Rhine bordering the Netherlands and with England, with whom he signed a secret pact in 1670 to take punitive military action against the Dutch Republic.

As potential disaster loomed and as William III fortuitously attained majority, the question of the Prince of Orange's role in the national government, which de Witt had so skillfully deflected during William's boyhood and adolescence, became critical. In light of the grave situation in which the Dutch Republic now found itself, and the heated debates over how to address it, de Witt's position weakened in the face of Orangist challenges to his authority. During the winter of 1672, the States General appointed William III captain and admiral general of the nation's armed forces. Ensuing events would catapult the Prince of Orange to political supremacy at the expense of de Witt, who was brutally murdered by an enraged mob in The Hague.

Although the so-called Stadholderless era ended in calamity the period was largely one of prosperity for the Dutch Republic. The aforementioned ratification of the Treaty of Münster proved one of the most economically auspicious events of the Golden Age. Its salutary impact was felt on all aspects of Dutch life for literally decades to come. Historians have identified the years between the Treaty of Münster and the French invasion of 1672 as one of unprecedented economic expansion, in which Dutch industries and international trade reached their apogee.[3]

The treaty finally halted more than twenty-five years of Spanish efforts to curtail Dutch maritime trade through embargoes and privateering. Likewise, the war's end led to the cessation of Dutch–Spanish hostilities in the New World, and a steep drop in Dutch freight charges and marine insurance rates. These beneficial changes adversely affected Dutch commercial rivals such as the English and, as mentioned, provoked two major naval conflicts. Yet despite the temporary economic setbacks caused by the Anglo-Dutch wars, the post-treaty decades generally engendered tremendous economic growth in the Republic, though mainly in the Province of Holland and its port cities. The Dutch greatly expanded their trade in Spain, the Mediterranean, the Caribbean, the East Indies, and even the Far East. Domestic industries likewise flourished, among them those that produced luxury fabrics, sugar, dyestuffs, tobacco, and diamonds. In most instances, the raw materials for these goods were imported from other countries that readily acknowledged the Netherlanders' superiority in manufacturing processes.

This booming economic atmosphere raised the purchasing power of broad segments of Dutch society, including its already comparatively substantial middle class. And needless to say, regents, patricians, and upper-class merchants of every ideological persuasion grew even wealthier while the disparities between them and poorer folk grew ever more pronounced. Wealth now exerted a decisive impact on the art market in the Dutch Republic on a scale hitherto unseen, with consequences for the economies of each city. In this heavily urbanized nation with keen commercial competition between cities, many artists abandoned those in economic decline for the brighter prospects of those that were booming. As a result, cities such as Utrecht and Haarlem, which were so critical to the formative years of Dutch genre painting, henceforth played a negligible role in its ongoing development. Conversely, metropolises basking in great commercial vitality, Leiden and Amsterdam among them, boomed as centers for the production of genre painting. Amsterdam was particularly influential as it was the largest city in the Dutch Republic and one of tremendous prosperity, luring numerous genre painters during the middle of the seventeenth century with devastating consequences for the artistic vigor of other towns.[4]

For many affluent citizens of the Netherlands the accumulation of spectacular fortunes during these years would gradually translate into the wholesale adaptation of certain aspects of the lifestyles earlier associated almost exclusively with the country's small aristocratic class. This development, commonly termed aristocratization, not only provided opportunities for social advancement but simultaneously enabled elites to extend their distance in this hierarchical society from those groups below them.[5] Although aristocratization was already underway by the end of the sixteenth century it crystallized during the economically heady decades following the Treaty of Münster.[6]

Pivotal to these changes was the so-called civilizing process, a cultural phenomenon, so brilliantly discerned and analyzed by Norbert Elias.[7] Elias actually coined the term "civilizing process" to describe how the upper classes during the early modern period gradually subscribed to evolving codes of manners, gestures, dress, bodily carriage, and so forth, thereby shaping a distinguished and distinctive deportment essential to their self-image in society at large. Thus, in the Dutch Republic, like all hierarchically structured societies of the day, elites utilized

concepts of civility to designate in a broad or narrow sense the special qualities of their own conduct and to emphasize the refinement of that conduct, that is, their "standards," in contradistinction to those of purportedly simpler, socially inferior people. Elite members of society flaunted their supposed supremacy via ever-increasing self-control over, among other things, many aspects of public life including general comportment and even table manners.[8] They also ideologically consolidated their class status by exhibiting cultural superiority in their taste in art, literature, and theater.[9]

Emerging concepts of civility, already in evidence in the sixteenth century, developed appreciably during the second half of the seventeenth, profoundly influencing Dutch society and culture in the process.[10] Dutch theater at the time is particularly noteworthy because it simultaneously sheds further light on the conspicuous stylistic and thematic transformation of genre painting during this period. As discussed in Chapter 4, early seventeenth-century theatrical performances consisted of tragedies, tragicomedies, and highly popular farces, the last striking for their vulgarity. The lascivious nature of many early seventeenth-century farces vexed Reformed ministers and moralists who, ever vigilant for perceived turpitude, vehemently demanded the permanent closing of theaters.[11] Admittedly municipal stages were occasionally shut down through the course of the seventeenth century, although this usually occurred during times of grave national crises, for example, the invasion of the Netherlands by armies of Louis XIV and his allies in 1672. Nevertheless, as the century progressed comic stage productions underwent extraordinary modifications: many adopted more upstanding qualities, purged of their earlier linguistic crudities and reinvigorated with wholesome plots often centering on marriage and related domestic issues.[12] The Treaty of Münster of 1648 can be considered a watershed for this metamorphosis toward progressively refined tastes among affluent and civilized patrons of the theater.

Genre painting experienced analogous changes. Evolving notions of civility and concurrent prosperity affected the upper classes' discrimination in matters artistic and so artists made stylistic adjustments to their work. New themes were also introduced into the repertoire of genre painting and existing ones were altered to render them palatable to a more cultured clientele. Several studies have confirmed that by the middle of the seventeenth century this clientele, composed mainly of elite members of society, had assumed a commanding role in the acquisition of expensive paintings and in the development of significant art collections.[13] (Their social subordinates continued to purchase art, though primarily of a distinctly lower caliber.[14]) During the time period under consideration in this part of the book, genre paintings of uncompromisingly high quality, with their rising prices, rapidly acquired the status of luxury commodities in a prosperous atmosphere ripe for the production and reception of pictorially sophisticated and intrinsically civilized imagery.[15] Thus it was the taste and related collecting habits of the elite in Amsterdam and other cities that insured a ready market for the new types of pictures being produced after 1650 as they responded enthusiastically to the stylistic and thematic changes introduced into Dutch genre painting.

GERARD TER BORCH
AND CASPAR NETSCHER

The art of Gerard ter Borch (1617–1681) most completely embodies the new ideals of civility and refinement that slowly permeated Dutch culture in the decades following the Treaty of Münster.[1] Ter Borch was born in Zwolle, the capital of the Province of Overijssel, a sparsely populated region in the eastern Netherlands.[2] He was trained by his father, Gerard ter Borch the Elder (1582/3–1662), who had earlier relinquished a promising artistic career for a lucrative position in the Zwolle city bureaucracy. Nevertheless, he cultivated his children's artistic skills, offering them practical instruction in drawing. Several of them exhibited talent but none more so than Gerard who by all accounts was a child prodigy.[3]

In 1632, the young ter Borch departed provincial Zwolle for a probable apprenticeship in Amsterdam where he studied with an as yet unidentified artist. He then moved to Haarlem, most likely in 1633, and entered the workshop of the landscapist Pieter Molijn (1595–1661). Ter Borch subsequently enrolled in Haarlem's St. Luke's Guild in 1635, the same year in which he executed his earliest dated painting (Berlin, Gemäldegalerie). His tenure in Haarlem, however, was quite brief, for during the next thirteen years he embarked upon a series of journeys to London, Italy, Spain, France, and lastly, Münster, where he depicted the Spanish and Dutch delegations swearing the oath to ratify the treaty that ended the long war between their respective countries.[4] By late 1648, ter Borch was residing in Amsterdam – he had probably lived there briefly earlier in the decade – but continued to visit his home town and other localities, for example, The Hague, where he executed a portrait commission in 1649. Most interestingly, ter Borch signed a notary document in Delft on 22 April 1653, together with Vermeer, who was merely a fledgling artist at the time.[5]

Ter Borch's pictures of these latter years, namely those dating between the late 1640s and early 1650s, display numerous thematic and stylistic innovations that helped to revitalize genre painting in general. Given the pronounced conventionality of Dutch art, ter Borch's revisions are all the more remarkable.[6] His *Young Woman at Her Toilet* of about 1650 (fig. 88) constitutes an early example of ter Borch's influential, fashionable interior scenes in vertical formats with reduced numbers of full-length figures who dominate the spaces in which they are depicted.

Gesina ter Borch (1631–1690), the artist's half-sister (and an amateur artist and poet in her own right), served as the model for the young woman in this panel who quietly ties her bodice before a mirror placed on a table with silver accouterments.[7] A maid approaches carrying a towel, ewer, and basin to assist her.

The canvas reveals ter Borch's remarkable sensitivity to the rendering of various stuffs and textures, most notably the maiden's rose, satin skirt, reflective no doubt of his familiarity with paintings by Willem Duyster (see fig. 54).[8] The curtained bed, dressing table, and chair are firmly and carefully positioned within the confines of the relatively ill-defined setting. These objects, along with the figures, are bathed in a subtle, natural play of light and shadow and are augmented by the painting's vertical format, one uniformly preferred by genre painters of ter Borch's generation. The light and atmospheric effects here, the superb rendition of various textures, and the serene figures are visually arresting. All of these stylistic facets of ter Borch's picture were further refined and intensified as he matured as a painter, just as his rendition of particular themes grew more subtle and psychologically nuanced. Ter Borch's development should be construed partly as a response to the tastes and demands of his increasingly wealthy and sophisticated clientele during this era of great prosperity.

Ter Borch married in 1654 and settled in Deventer, a town of some 7500 people lying due south of Zwolle.[9] Ter Borch eventually participated in local politics there: in 1666 he was appointed to a life-long position as alderman.[10] Deventer, once an international center of commerce, was well past its prime in the seventeenth century, having not profited from the robust growth of the Dutch economy after the Treaty of Münster. Some minor local industries continued to operate in Deventer but for the most part it had been eclipsed by its sister city to the north, Zwolle.

Ter Borch clearly benefited from the lack of artistic competition in Deventer and quickly established himself as the leading portraitist of the city's elite citizenry. He also executed a significant number of outstanding genre paintings at this time. These works of art were not restricted to local clientele but were marketed and collected in the prosperous cities of the Province of Holland. Archival evidence confirms that paintings by the

88 Gerard ter Borch, *Young Woman at Her Toilet, c.* 1650 (oil on panel, 47.6 × 34.6 cm). New York, The Metropolitan Museum of Art, Gift of J. Pierpont Morgan, 1917 (17.190.10).

touches of ter Borch's earlier art are supplanted here by a more delicate application of paint, as is also seen in related paintings of his artistic maturity. Small, rapid brushstrokes impart lively surface characteristics to the furnishings, figures, and their garments. The garments pulsate with reflections as the master skillfully juxtaposes an entire range of cooler and warmer color values that comprise the fabrics.

A man has entered at the left, dressed in black, a clothing color often mistakenly associated with puritanical sobriety but actually identified during this period with the exact opposite value: formal haute couture.[15] This man, whose features are reputedly those of ter Borch's talented pupil Caspar Netscher, greets the young woman before him by courteously bowing and doffing his hat. The maiden, exquisitely attired in a coral bodice and shimmering, silver satin gown, demurely responds to his greeting in a remarkably graceful and restrained manner. With these two figures ter Borch has expertly captured the complicated choreography of pose and gesture so intrinsic to self-comportment and public display within the hierarchical society of the Dutch Republic.[16]

In a memorable article first published in 1993, Alison Kettering linked *The Suitor's Visit* and numerous other paintings by ter Borch to pervasive Petrarchan notions of love and desire.[17] Sonnets composed by the renowned, late medieval, Italian poet Francesco Petrarca (commonly known as Petrarch; 1304–1374) for his beloved Laura (which became known as the *Canzoniere*) were exceptionally rich in metaphor and enormously influential for early modern European culture.[18] Dutch writers, among them Constantijn Huygens (1596–1687), Pieter Cornelisz. Hooft (1581–1647), and Daniel Heinsius (1580–1655) adapted aspects of Petrarch's style, especially his conceits which were reworked in an ever-changing variety of contexts. By the middle of the century the use of Petrarchan imagery had become highly fashionable in a society preoccupied, if not obsessed, with love as a subject of conversation, poetry, and song. In literary works of all types one continually encounters the conceit of the lamenting lover who pines for unattainable paradigms of female beauty and virtue.

Dutch verse, songbooks, and emblem books, inspired by Petrarchan literature but modified to conform to prevailing mores in the Netherlands, share common motifs, oxymora, antitheses, and the like. The conventionality of their style and imagery is matched by that of their subject matter as they invariably focus on two constants: the lady, who is the ardent object of the lover's affection, and upon the nature of love itself. The lady embodies physical and spiritual perfection – even nature pales by comparison. The typical Petrarchan text first inventories her beautiful, external features with characteristic hyberbole. But the lady's stellar qualities are surpassed by her numerous inner virtues, chief among them, her chastity. She is an object of adoration yet the poet simultaneously laments her deleterious effect upon her love-struck admirers.

artist were owned by several wealthy collectors of note, including Pieter Claesz. van Ruijven, the Delft maecenas of Vermeer.[11] During his years in Amsterdam, ter Borch must have cultivated contacts among connoisseurs in order to facilitate this process because two of his paintings are listed in the 1657 death inventory of one of that city's most prominent art dealers, Johannes de Renialme (*c.* 1600–1657).[12] Ter Borch's reputation as a painter gradually assumed international proportions, as the efforts of Cosimo III de' Medici (1642–1723), the Grand Duke of Tuscany, to acquire copies of his work confirm.[13]

The growing refinement of ter Borch's style after his relocation to Deventer is evident in one of his many paintings that illustrate the theme of courtship, *The Suitor's Visit* of about 1658 (fig. 89).[14] In a darkened interior embellished with gilt leather walls and an ornate marble and carved wooden fireplace, a group of fashionably dressed youths are gathered. The granular, impasto

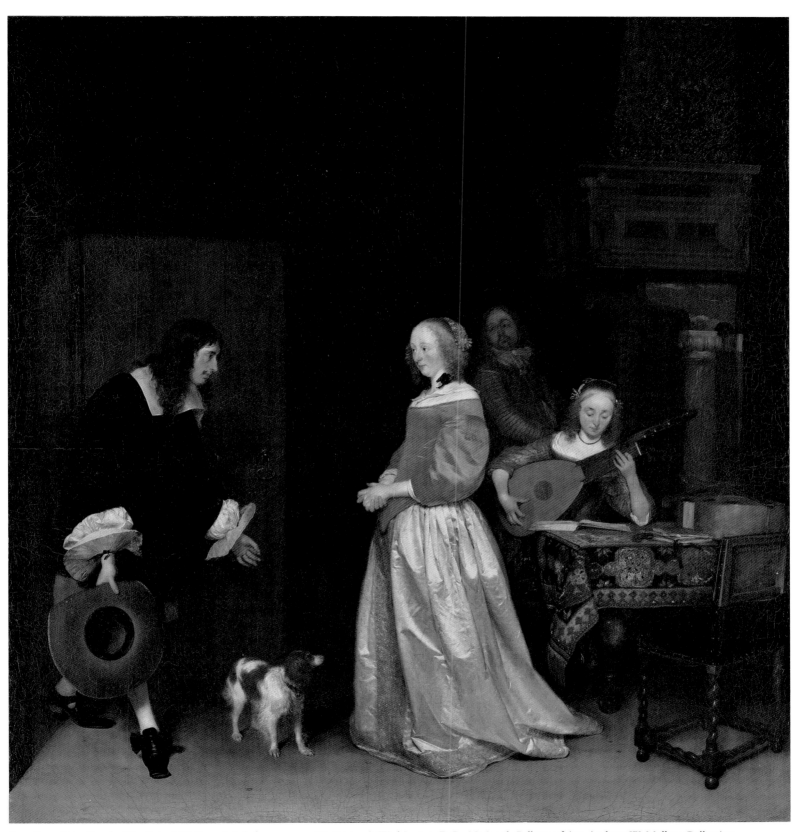

89 Gerard ter Borch, *The Suitor's Visit*, c. 1658 (oil on canvas, 80 × 75 cm). Washington D.C., National Gallery of Art, Andrew W. Mellon Collection.

Emblem books of the period compare distraught suitors, overpowered by love, to mice caught in traps or ominously threatened by cats, to squirrels running futilely on caged wheels, to stags shot by arrows, to insects attracted to burning candles, while the objects of their undying affection are likened to stars in the firmament, to the sun, to the power of the wind, and even to cold-hearted executioners.[19] The classic dilemma, echoed with endless variation, is that of the suitor violently seized by love which unfortunately eludes the insouciant object of his affections. The languishing victim desperately hopes that amorous feelings awaken in this lady, his *dolce nemica*, the source of his painful, unrequited devotion.

Gesina ter Borch was particularly fond of Petrarchan songs and poetry and collected and illustrated such poems and lyrics in three sizeable albums which still survive (fig. 90).[20] Many of her charming illustrations were executed during the period in which she modeled for her half-brother's paintings. The siblings presumably had a close relationship despite the thirteen-year age difference between them; accordingly, one can presuppose their reciprocal convictions in matters of the heart and creativity.

Petrarchan sentiments probably underlay some of the courtship pictures discussed earlier in this book, but in ter Borch's hands they were cleverly adapted with hitherto unseen levels of subtlety and refinement. Unlike the often unassuming depiction of females in earlier merry-company scenes and love gardens (see fig. 44), ter Borch's are noteworthy for their commanding physical presence.[21] In *The Suitor's Visit*, for example, the young lady's erect posture echoes the marble fireplace and the verticality of the canvas. Specifically, the viewer, just like the suitor, concen-

90 Gesina ter Borch, *Gentleman Kneeling Before a Lady* (watercolor from her Poetry Album). Amsterdam, Rijksprentenkabinet.

trates on her luminous gown because its crystalline clarity visually detaches the figure from the gentle penumbra of her surroundings and from the more generalized rendering of her companions. Her finery, delicate skin (in the few places in which it is exposed), and rarefied facial features form the quintessence of Petrarchan beauty and also of virtue, for her expansive apparel envelops her form thereby chastely obscuring it from further scrutiny. Thus this painting exhibits decorous restraint which parallels contemporary ideals of the courting process that allowed young ladies only a limited degree of initiative.[22]

The interactions of the two figures in the foreground are exceedingly subtle if not elusive. Their gestures and gazes of insinuation, supplemented by those of the male and female behind them, present viewers with a myriad of relational possibilities.[23] For example, will the suitor's efforts be successful? Or will the maiden politely refuse his entreaties? And how should the gaze of the man by the fireplace be interpreted: is he surprised by the visit, or jealous, or both? Ter Borch's art is uncanny for its anecdotal subtlety, its psychological innuendo, and tension created by scenes and situations left deliberately ambiguous for the delectation of beholders already captivated by its dazzling pictorial effects. Although not the only artist of his generation to adopt this approach, ter Borch was certainly in the forefront of its development.[24]

Considered en masse, ter Borch's nuanced renditions transcend the often straightforward narratives of many earlier genre paintings, ones so unequivocal and blunt. This discernible shift owes just as much to the changing desires and expectations of discriminating, moneyed collectors, who were most assuredly aware of the older modes of representing specific themes,[25] as it does to the artistic ingenuity of ter Borch and his colleagues. During the 1650s, 1660s, and beyond, genre paintings by the foremost artists were rapidly becoming the exclusive collecting prerogative of the Dutch Republic's upper classes.[26] And the urbane aspirations of these elite buyers necessitated the modification of certain themes and styles to render them palatable to tastes propelled inexorably toward the genteel.

As so many of his paintings attest, ter Borch was in the vanguard of painters inaugurating the seismic stylistic and thematic shifts in Dutch genre painting that occurred in the years following the Treaty of Münster. His *Officer Writing a Letter, with a Trumpeter*, executed around 1658–59, is likewise representative of these changes (fig. 91).[27] Ter Borch has depicted an interior, clearly less sumptuous than that of *The Suitor's Visit*, but well-appointed nonetheless, in which an officer (again probably modeled on Netscher's features) seated at a table composes a letter while a trumpeter, his messenger, awaits its completion.

Unlike many Dutch painters who depicted soldiers, ter Borch was familiar with them from personal experience.[28] His birthplace, Zwolle, and Deventer, where he settled as an adult, both housed garrisons because they were situated along the strategic

91 Gerard ter Borch, *Officer Writing a Letter, with a Trumpeter*, *c.* 1658–9 (oil on canvas, 56.5 × 43.8 cm). Philadelphia, Philadelphia Museum of Art, The William L. Elkins Collection.

92 Gerard ter Borch, *Tric-Trac Players*, *c.* 1640 (oil on panel, 42 × 56 cm). Bremen, Kunsthalle.

defense lines established during the war with the Spanish. Ter Borch's very first drawings, created when he was a child, represent soldiers; so too do many paintings from his early career (fig. 92).[29] These latter depictions, dating from the late 1630s and early 1640s are strongly reminiscent of those by Pieter Codde and Willem Duyster, which is entirely logical in light of his apprenticeship in Haarlem. They share the same oblong composition and guardroom or inn setting swarming with soldiers engaged in games of chance.

By comparison, the *Officer Writing a Letter, with a Trumpeter* is remarkable for its simplicity, restraint, and degree of psychological absorption. Ter Borch has placed the officer and trumpeter in an urban, domestic environment, as opposed to a clamorous guardroom. And the officer, identified as such by his demeanor and outfit, is engaged in letter writing, a leisure activity principally associated with women, love and courtship in Dutch art. The amorous content of the officer's missive in ter Borch's painting is implied by the ace of hearts lying conspicuously on the wooden floor, adjacent to the hunting dog's rear paw. The glint of red reflecting off the officer's cuirass directly over his heart, subtly alludes to the letter's contents as does the canopy bed behind him, a motif that playfully fuses ardor and martialism since it recalls the equipage of soldiers in the field.[30]

A trumpeter waits patiently for his superior to finish the missive.[31] Trumpeters were pivotal figures on the battlefield, announcing formations, charges, and retreats at the behest of their commanders. They also performed important functions unrelated to combat such as arranging prisoner releases and ransoms as well as serving as liaisons between the military and civilians. Discussions of trumpeters in contemporary literature were therefore highly positive, at times even idolizing, and lacked the utter contempt so frequently voiced about ordinary soldiers. Ter Borch's trumpeter acts as the officer's courier for a purely intimate matter as opposed to a military one. His striking silhouette, blue tabard, and long trumpet, suspended on his back by a color-coordinated, decorative sash, offers a stunning sartorial parallel (and curious gender twist) to the young women foregrounded in so many other pictures by ter Borch. His appearance here offers an intriguing parallel to recommendations in contemporary military manuals that trumpeters be comely and handsomely dressed.[32] As Kettering has persuasively proposed, this messenger's prominence in the composition, his finery, and sidelong glance at the viewer make him the painting's true subject and thus the appropriate suitor for the lady who will receive the officer's letter or, by extension, the female viewer. (The painting was possibly owned by Petronella Oortmans-de la Court [1624–1707] the widow of a very wealthy Amsterdam brewer.[33])

As discussed in Chapter 2, the vogue among the upper classes for exchanging letters, particularly those with amorous contents, was widespread. A proliferation of manuals provided practical instruction in the art of missive writing for the diffident and inarticulate. The contents of the epistles for romance printed in these primers are by modern standards hopelessly florid – and seemingly insincere – but they are nonetheless rich repositories of seventeenth-century wisdom on affairs of the heart. Moreover they are couched in Petrarchan language, as the following prototypical letter demonstrates:

> Madam,
> I should not take the Libertie to let you know how extreamly I honour you, if the absolute power of your beauty did not force me to it, Which relating to the violence it useth on my behalf, will easilie (I hope) obtain Pardon for my Presumption. My desire in this is no other but onely to know whether you be pleased I should Everlastinglie bear the Quality, Madam, Of your most humble and most obedient servant, M.[34]

Like *The Suitor's Visit*, ter Borch's *Officer Writing a Letter, with a Trumpeter* was intended for a well-to-do consumer. The soldiers here, turned elegant letter writer, and glamorous courier, have shed the rugged bearing and brutish behavior of their counterparts in genre paintings of the 1630s. They have metamorphosed into genteel fellows consistent with changing audience expectations concerning tasteful art in an era of growing elegance and opulence. Most interestingly, depictions of civilized soldiers appeared on the art market in the years following the end of the war with the Spanish and at precisely the same time that military careers in the officer corps became attractive to patrician members of Dutch society, anxious, in this era of aristocratization, to imitate the aristocracy from whose ranks commanders were traditionally drawn.[35]

Ter Borch also painted a significant number of letter readers and writers of a more conventional nature in that they focus upon females. Depictions of this sort enjoyed immense popularity during this period thanks in part to ter Borch's imaginative reworkings of this pictorial theme. Since letter writing was primarily (though not exclusively) a leisure activity among the well-to-do it is not surprising that paintings of this theme were so prevalent during the decades in which the Dutch economy expanded greatly. Ter Borch's painting *Curiosity*, completed around 1660, features three young women in an ornate interior (fig. 93).[36] One sporting an ermine-trimmed jacket attentively writes a letter as another woman, identifiable as a maid because of her comparatively simple attire, peers inquisitively over her shoulder. Clearly this missive is being written in response to the one with the broken seal lying on the table. To their right stands a young lady of extraordinary beauty and bearing whose position in the picture and gaze toward the beholder are reminiscent of the trumpeter discussed above. Her station and propriety are connoted not only by her luxurious garments but also by her long handkerchief. This accouterment, associated

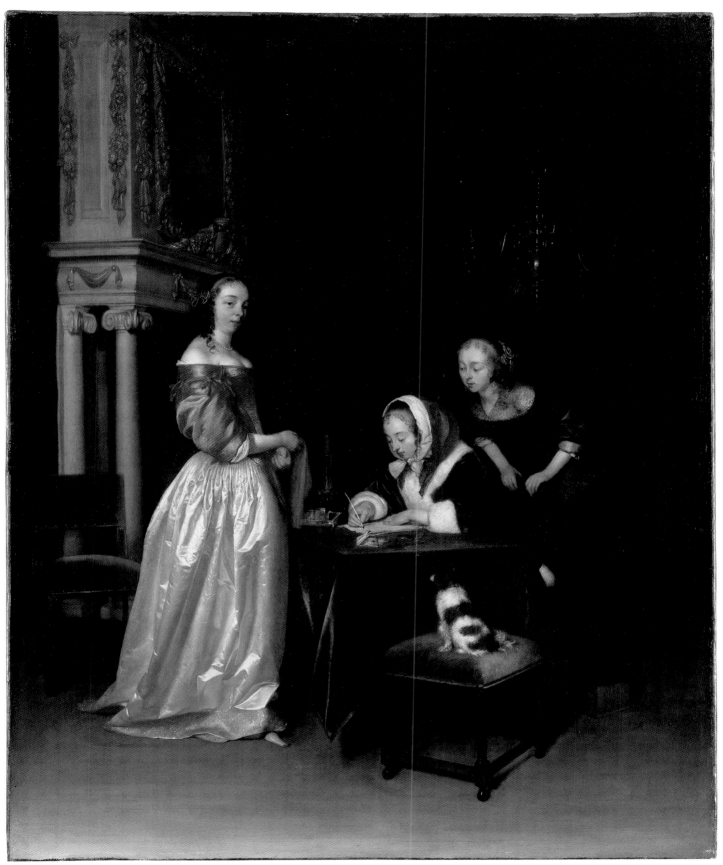

93 Gerard ter Borch, *Curiosity*, *c.* 1660 (oil on canvas, 76.2 × 62.2 cm). New York, The Metropolitan Museum of Art, The Jules Bache Collection, 1949 (49.7.38).

with illness or grief in our culture today, functioned chiefly as a fashionable status symbol for upper-class women in the Dutch Republic.[37] It simultaneously spoke volumes about the bearer's manners since many people still wiped their noses and mouths uncouthly with their fingers in this era of evolving civility.[38]

Earlier representations involving letters, such as the painting by Dirck Hals discussed in Chapter 2 (fig. 23), provided the viewer with motifs deliberately positioned to comment upon the actions of the figures. Thus in Dirck Hals's painting, the little picture of the boats close-hauling in the breeze and the empty chair provide visual cues that augment our understanding of the scene. Ter Borch's *Curiosity*, by contrast, affords the informed viewer the opportunity to speculate upon the narrative implied by the figures and details (especially the mysterious letter) but veiled by the canvas's very aloofness and restraint. In his adroit hands, shimmering satin, epitomized by the apparel of the standing woman, becomes the agent of empathic projection for viewers, allowing them to weave anecdotes of vicarious participation from the luminous imagery before them. Ter Borch's delineation of satin is astonishing and, indeed, has been acclaimed as a singular feature of his art since the early eighteenth century.[39] In this picture the white satin dress's gleaming surface, comprised of tiny strokes of grey and white, contains a profusion of folds and diffuse reflections including those of the colors and general forms of the floorboards and plush, purple velvet tablecloth. These details, symptomatic of heightened observation on the master's part, suggest that he worked directly from a bolt of satin fabric. This thesis is corroborated by the advice of contemporary art theorists who encouraged artists to work directly from the fabric itself to ensure the most convincing and hence spectacular results.[40]

The notion of painting from life was hardly novel but this theoretical exhortation was in practice unwarranted because artists produced highly conventional imagery routinely composed from memory conditioned by repeated experience. But the complexities of rendering satin draped over the human form made it incumbent upon painters to utilize actual samples to ensure its proper replication.[41] The reproduction of satin in a genre painting was a labor-intensive endeavor; in this respect ter Borch's dresses betokened value in a figurative sense as well as a commercial sense for the prospective buyer.[42] The purchaser was thus guaranteed an authentic work of art of uncompromisingly high quality and value whose genesis was contigent upon the use of a costly textile.

Yet the lavish appearance of ter Borch's figures and settings is essentially fictitious despite his probable practice of painting satin from life. Ter Borch, like all seventeenth-century Dutch genre painters, circulated motifs and figures endlessly, creating conventions of form and style in the process. For instance, the dog and inkstand in *Curiosity* are readily found in other works by the artist, as are the costume details and room furnishings.[43] The fur-

nishings themselves are equally fanciful. Despite their plausibility recent research has established that such objects were rarely seen in Dutch homes.[44] The ornate brass chandelier hanging in the right background (and omnipresent in Dutch genre painting), for example, was in reality an extremely costly item most frequently manufactured for churches.[45] And the distinctive dresses worn by women in ter Borch's paintings only loosely conform to actual fashions; the somewhat illusory character of this apparel is intended primarily to constuct female identity and narrative.[46] In essence, the world of ter Borch's paintings is largely contrived, composed of smartly attired characters in luxurious dwellings who serenely ponder the vicissitudes of romance.

But love, as ter Borch represented it, could also be illicit. His *Gallant Military Man* of about 1662–3 (fig. 94) confirms this.[47] A rather corpulent soldier completely lacking the suave disposition of the figures in ter Borch's *Officer Writing a Letter, with a Trumpeter* offers coins to an ostensibly demure young lady. The fancy fireplace recalls the one in *Curiosity* as does the rectangular table with its luxurious covering. A ceramic bowl lies on the table, piled high with unblemished fruit, a metaphor of temptation and desire.[48] The soldier's gesture is impossible to miscontrue: he is soliciting sex. Such overtness is unusual for ter Borch and extends to the soldier's slovenly appearance and stout shape which underscore his profligacy.[49] Furthermore, the artist has once again included a canopy bed with its frolicsome allusion to love and war.

The *Gallant Military Man* can be linked to traditional representations of bordellos. The Utrecht Caravaggisti made decisive contributions to this theme which usually features buxom, insatiable whores and rowdy soldiers or armed thugs as clients (see fig. 59). Yet despite the unmistakable details in ter Borch's painting it differs markedly from earlier depictions of prostitution. The picture exudes quintessential elusiveness and irresolution. How, for instance, should one construe the woman's downward glance, contemplative mien, and somewhat passive pose? They bespeak a certain modesty that seems incongruous with the painting's subject. Moreover, her attire approximates that worn by her honorable sisters in other depictions. It likewise accords with contemporary descriptions of whores in literature whose decorous outfits are said to deceive prospective clients.[50] One might infer that in real life – as opposed to art – prostitutes routinely wore proper clothing. However, since strumpets actually donned tawdry imitations of the garments worn by elites (as recent archival research has revealed), there was likely little confusion over their true identities.[51] The fancy garments of prostitutes in art and literature thus functioned as a trope to entice the viewer or reader.

Yet ter Borch cleverly alludes to the duplicity of the garment's bearer. As Kettering has persuasively argued, ter Borch arrests the flow of the shimmering satin fabric by covering it with the black jacket and compressing it into a small area between

the table cloth and the soldier's huge boots. The satin has been compromised pictorially and, by implication, socially, to cue the informed viewer subtly about the true nature of this young lady's character.[52] The master's concealment of much of the satin can also be considered another discreet way of maintaining some semblance of decorum in a painting whose subject is fundamentally indecorous. Such adjustments on ter Borch's part must be placed within the wider context of taste, patronage, and cultural transformation.

The increasingly refined discrimination of certain elite audiences compelled changes in the manner in which paintings of prostitution (and related libidinous themes) were represented. As a result, these pictorial themes were modified to render them less provocative or rather, more innocuous looking. However, sweeping generalizations should be avoided. While some artists depicted less offensive prostitution scenes others, for example, Frans van Mieris the Elder, enjoyed lucrative careers executing titillating paintings. The vulgarity of their art occasionally rivals that of earlier genre paintings, but in general, such lewd motifs as exposed breasts (see fig. 61) were, in the second half of the century, largely a phenomenon of the past.[53] The underlying reasons for the gradual emergence of less offensive art after 1650 also lie in the ongoing (but never entirely complete) separation of elite culture from popular culture, the latter equated with uncouth, ordinary persons.[54] Earlier in the century elite and popular culture were less decisively demarcated. From this somewhat antiquated milieu with its vestiges of late medieval traditions, slowly arose distinct elite predilections informed by the unfolding civilizing process and inclined to withdraw from anything perceived to be too base.[55]

Ter Borch's most remarkable genre paintings date from the 1650s and early 1660s. Thereafter, he devoted himself principally to painting portraits, mostly of the leading citizens of Deventer (and of other cities as well). Nevertheless, the impact of his genre paintings was enormous, especially among artists of his generation. Ter Borch's reputation was further enhanced by numerous copies of his genre pictures, some of which were made by his students and assistants under his direct supervision.

Caspar Netscher (c. 1635/36–1684) was by far ter Borch's most talented pupil. His early years are shrouded in obscurity.[56] He was probably the son of a painter from Rotterdam though his early biographers claim that he was born in either Heidelberg or Prague. Yet Netscher's name does not appear in the baptismal records in either city for any of the purported years of his birth (usually given as some time in the late 1630s). Netscher's father died by 1642 (the year in which his mother remarried) and eventually he resided in the city of Arnhem in the Province of Gelderland where he seems to have been supported by a certain Dr. Arnold (or Abraham) Tulleken. Netscher initially received training from a local, minor Arnhem artist, but through Tulleken's auspices he entered ter Borch's studio in Deventer around

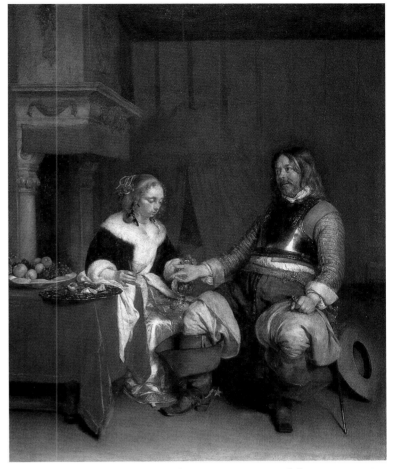

94 Gerard ter Borch, *Gallant Military Man*, c. 1662–3 (oil on canvas, 68 × 55.2 cm). Paris, Musée du Louvre.

1654–5 – Tulleken's brother-in-law was the eminent artist's cousin.

Netscher was undoubtedly taught by ter Borch but in light of his age at that time, eighteen or nineteen years old, he must have already studied elsewhere, hence achieving a relatively advanced level of competence. It is probable that he perfected his skills in the master's workshop and likely worked as an assistant there, judging at least from his copies of ter Borch's works made during this period. The young artist also presumably served as a model for several of his teacher's genre paintings (see fig. 89). Wishing to supplement his education Netscher embarked upon a trip to Italy in 1658 or 1659. However, he traveled only as far south as the French city of Bordeaux, where he married a local woman that fall, and then eventually returned to the Netherlands, a decision that may have been motivated by the worsening conditions for Protestants during the regime of Louis XIV. One eighteenth-century biographer asserts that the artist was encouraged to come home by an official of the Court of Justice of Holland and Zeeland in The Hague.[57] Netscher moved to The Hague in 1662

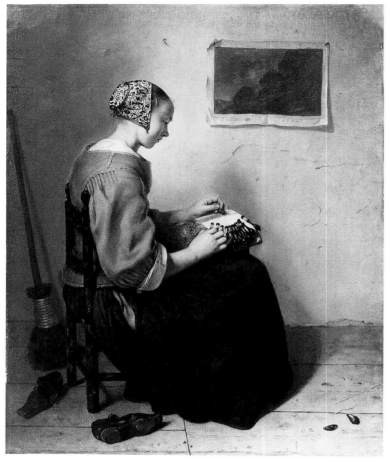

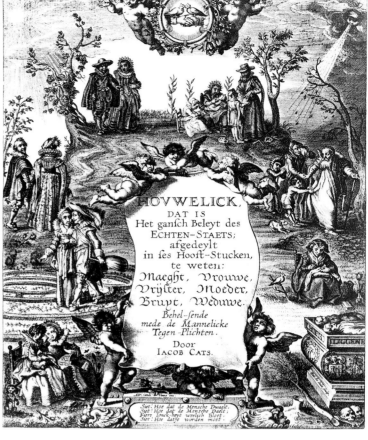

95 Caspar Netscher, *The Lace-Maker*, 1662 (oil on canvas, 34 × 28 cm). London, The Wallace Collection.

96 Frontispiece from Jacob Cats, *Houwelyck*, Middelburg, 1625. Amsterdam, Universiteits-Bibliotheek Amsterdam.

and immediately joined the city's professional organization for painters, the *Confrerie*. He lived the remainder of his short life in The Hague and enjoyed a brief but distinguished career primarily as a portraitist but also as a genre and history painter.

As Marjorie E. Wieseman has observed in her excellent study of the artist, Netscher's career as a genre painter can be divided into three approximate periods: before 1664, 1664–5, and 1666–70.[58] Throughout his career one senses the ongoing influence of ter Borch, but it would be reductive to consider Netscher's paintings slavish imitations of the older painter's work as Netscher was familiar with the achievements of genre painters from a number of cities and, as his progressively elegant renditions attest, equally responsive to contemporary cultural impetuses. Netscher's earliest phase of activity as a genre painter includes guardroom scenes and depictions of domestic subjects set in barns or simple homes.[59] The outstanding picture from this phase is his widely acclaimed *Lace-Maker* of 1662 (fig. 95) in which a young woman makes lace in a spartan interior whose only adornment is a print crudely nailed to the cracked plaster wall.[60]

The woman is clearly young but she is already married, as evidenced by the design on her embroidered cap. Directly below a bird and what might be a heart is the motif of clasped hands, called the *dextrarum iunctio*.[61] This gesture has been associated with the marriage ceremony since antiquity serving as a sacred and legal sign of a couple's marital agreement, a visible, tangible manifestation of their love and unity. In Dutch seventeenth-century art and literature the motif commmonly functions as a signifier of marital concord just as clasping hands did in actual marriage ceremonies of the day.[62] This likely explains its presence as the crowning element (along with doves) to the frontispiece of the most popular domestic treatise in the Netherlands, Jacob Cats's *Houwelyck*, first published in 1625 (fig. 96).

The young woman in Netscher's painting wears sober, modest clothing of a far different type from that which appears in his later paintings. Her activity of lace-making also indicates, if not celebrates, her industriousness and virtue. The woman is completely absorbed in this task, as her intensely focused, ter Borch-like gaze suggests. She is also turned at a slight angle

toward the wall, a position that effectively eliminates any inter-action between subject and viewer. Pose, expression, and attire are deceptively simple if not poetic; indeed, *The Lace-Maker* evokes a mood reminiscent of Vermeer's paintings (see fig. 218), an affinity already noted in the eighteenth century.[63] Netscher's canvas offers a compelling construction of ideal femininity and domesticity, a theme that was painted regularly only after the Treaty of Münster of 1648, which can hardly be a coincidence.

Various objects surround this young housewife: a broom, a pair of shoes, and two mussel shells. Their verisimilitude is stun-ning, particularly that of the mussel shells with their translucent sheen, softly painted so as not to disturb the harmony of the picture. But this demonstration of the artist's skill cannot alone account for the presence of these particular objects in this context, strategically grouped as they are around her. There can be no question that they form part of a deliberate pictorial con-struction, that they have been selected to function as signifiers of appropriate feminine virtues. The broom to her left undoubt-edly refers to the housework and cleaning that every good housewife was expected to perform.[64]

The pair of shoes on the floor, a motif that appears in numerous depictions of domesticity, also conveys virtuous associations. Art historians have written much about the erotic significance of shoes in Dutch seventeenth-century art.[65] However, there is another tradition, one more conducive to the tone of Netscher's representation, in which shoes were under-stood in more wholesome terms. Already in the literature of clas-sical antiquity, specifically in Plutarch's *Conjugalia Praecepta* (Laws of Marriage), shoes, when removed, were invoked as reminders to women that they belong in the home. As the title of Plutarch's little book implies, it is a collection of "laws" which in essence contain the author's observations and advice about marriage. Plutarch expounds his opinions with the aid of metaphorical imagery, an approach that was exceptionally appealing to later writers. Judging from the reprints and its frequent quotation by moralists – including Cats – Plutarch's book must have been well known in the Netherlands during the sixteenth and seventeenth centuries.[66] In one of his laws, Plutarch cites the alleged custom among Egyptian women of discarding shoes in the home, so that they would learn that they must remain there.[67] Several authors of seventeenth-century treatises on marriage quote this law as they exhort women to oversee the daily affairs of the home.[68] Plutarch's account of the Egyptian custom probably inspired the visual arts just as several other of his marriage laws had.[69]

Like the shoes, the two mussel shells lying on the floor to the right of the lace-maker could not have been placed there arbi-trarily. Despite their frequent, erotic meaning in Dutch art,[70] there are several contemporary literary references to mussels and mussel shells as domestic metaphors, drawn from the observa-tion that the creature continually abides in its shell. In his *Tafer-eel van sinne-mal* (Tableau of Foolish Senses; 1623), Adriaen van

97 Caspar Netscher, *Young Girl Holding a Letter*, c. 1665 (oil on canvas, 73.5 × 59.5 cm). Private collection.

de Venne includes the following poem with his delightful illus-tration of a street-vendor of mussels:

> Fresh mussels can be compared to
> The blessed women-folk
> Who speak modestly and virtuously
> And always look after their household
> All wives must regularly bear
> The burden of their "mussel-house."[71]

The conspicuous placement of the broom, shoes, and mussel shells in *The Lace-Maker*, then, is an expedient pictorial device enabling the viewer to savor their detailed naturalism while con-templating their meaning as signs alluding to a host of feminine virtues.

Netscher's most prolific period as a genre painter occurred during 1664–5, when he executed some twenty-six pictures. Collectively they display increasing elegance in their subject matter and style. *Young Girl Holding a Letter* of around 1665 is characteristic for this period (fig. 97): the spartan interior of *The*

98 Albrecht Dürer, *Melencolia I*, 1514 (engraving). New York, The Metropolitan Museum of Art, Harris Brisbane Dick Fund, 1943 (43.106.1).

Lace-Maker has been replaced by one more opulent, replete with canopy bed, chair, and table upon which lie among other objects, a silver candlestick – whose tilted candle echoes the figure's pose – inkwell, red wax (for sealing letters), and stack of paper.[72] But the focus of this engaging painting is the maiden in the salmon-colored bodice and dark blue satin skirt with gold trim who muses upon the contents of the letter in her lap. She is immersed in amorous reverie as she ponders, paper and quill before her, how best to respond to the letter. Thus the picture is yet another example of the popular theme of letters in Dutch genre painting. The very ambiguity of the young woman's expression, compounded by the utter lack of clarifying motifs, shares much with ter Borch's influential representations of this theme (see fig. 93).

The maiden's pose provides the only hint of her state of mind as she contemplates the letter's contents. Specifically, by resting her head upon her hand she makes the time-honored gesture of melancholia known from countless literary and pictorial sources and immortalized in Albrecht Dürer's famous engraving of 1514 (fig. 98).[73] Most representations of female melancholy in seventeenth-century Dutch genre painting focus upon ailing young women attended by quack doctors (see fig. 192). Such pictures comically explore the symptoms and diagnoses for what was termed "erotic melancholy" or lovesickness, a disease thought to be caused by an imbalance of the bodily humors originating in the uterus.[74] However, the *Young Girl Holding a Letter* lacks this obvious medical dimension and is not funny in any respect.

Nevertheless, by early modern medical standards Netscher's woman too is likely experiencing pangs of lovesickness. For Jacques Ferrand, a French cleric, physician, and noted contemporary expert on the malady, love is "a form of dotage, proceeding from an inordinate desire to enjoy the beloved object, accompanied by fear and sorrow." He subsequently surveyed its causes in his treatise on the illness published in 1623, warning of the dangers of "letters and love notes crammed with enticing words that lovers use for pressing and cajoling their ladies and for insinuating themselves into their good graces . . ."[75] Contemporary viewers presumably recognized her melancholic distress as well though their responses to the painting were more likely conditioned by popular notions of love expressed in countless poems, songs, emblems, and art works as opposed to medical texts.[76]

Netscher's production of genre paintings declined noticeably between 1666 and 1670 because portraiture began to dominate his output. In those genre paintings that he did produce during the late 1660s children appear repeatedly. The growing size of Netscher's own family – by 1668 he had five children – might explain this, as Wieseman has plausibly suggested.[77] However, his depictions of children scarcely possess any documentary value. Like all genre paintings, they are conventional images and in this case partake of longstanding pictorial traditions that contributed to the formation of this imagery in the hands of several seventeenth-century Dutch artists. *Two Boys Blowing Bubbles* of around 1670 ranks among Netscher's most engaging paintings of children (fig. 99).[78] The young lad in the background blows a bubble while his older playmate gazes at one floating above, perhaps with the intention of popping it with his beret. Two seashells and a very ornate silver tazza (which expertly reproduces one fabricated by the renowned silversmith Adam van Vianen [1569–1627] in 1618) lie on the ledge before the boys.[79]

In the brief, intervening years between this painting and *The Lace-Maker* Netscher's style had grown quite polished, combining passages of minute detail – for instance, the tazza and shells – with those more broadly painted yet sensitively highlighted by a systematic but subtle application of glazes. His late genre pictures therefore possess an air of splendor and finesse that occasionally rivals those of his great mentor, ter Borch. The resultant level of elegance permeating these images was fully in accord with prevalent social and cultural ideals that preoccupied the lives of his patrons.

99 Caspar Netscher, *Two Boys Blowing Bubbles*, c. 1670 (oil on panel, 31.2 × 24.6 cm). London, The National Gallery.

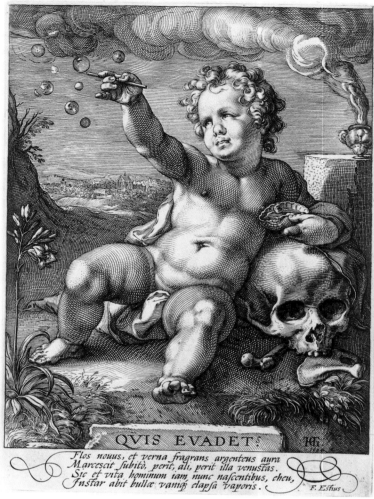

100 Hendrick Goltzius, *Quis Evadet* (engraving).

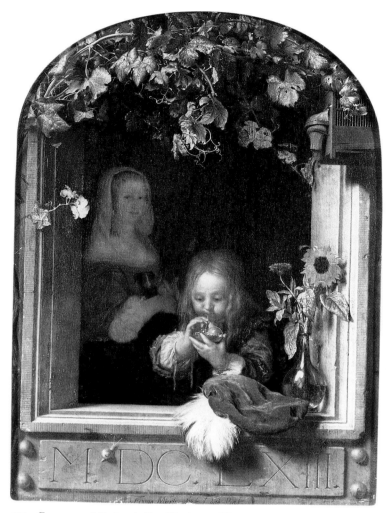

101 Frans van Mieris, *A Boy Blowing Bubbles*, 1663 (oil on panel, 25.5 × 19 cm). The Hague, Mauritshuis.

The motif of bubble blowing in Dutch art is traditionally associated with the Latin expression, "Homo Bulla" (Man is Like a Bubble). This refers to the ephemerality of human existence: like a soap bubble which quickly bursts, life is fleeting. The connection between children blowing bubbles and life's brevity is explicitly made, for example, in a late sixteenth-century engraving by Hendrick Goltzius (1558–1617) with the inscription "Quis Evadet" (Who Escapes It; fig. 100).[80] On one level Netscher's painting is certainly informed by this tradition, but on another level, at least for knowledgable *cognoscenti*, it subverts it. Real bubbles are completely evanescent but bubbles depicted in paintings are permanently fixed to the canvas or panel, forever immutable. Seventeenth-century Dutch art theorists stressed the capacity of painting to immortalize all that is transient in nature, thereby bestowing fame upon the artist and imputing value to his work.[81]

That similar ideas underlie *Two Boys Blowing Bubbles* is highly likely. The artist has depicted two boys in a niche, an imaginary stone enclosure with no equivalent in existing contemporary architecture. The motif of the niche had been popularized by Gerrit Dou (1613–1675) and other members of the Leiden School as a clever means to enhance the illusionistic qualities of a painting and thus delight the viewer by obfuscating the boundaries between the real environment and the painted one, even if the latter is obviously contrived. Netscher was undoubtedly familiar with niche paintings and, in fact, his picture recalls one of a boy blowing bubbles by Dou's preeminent pupil van Mieris (fig. 101).[82]

Such architectural envelopments celebrate the mastery of the painter as they offer a boldly illusionistic setting in which his remarkable ability to replicate nature in all of its diversity is proclaimed. And herein is nature transcended since paintings routinely eternalize her most beautiful yet most transient creations. Consider the two seashells resting on the ledge in Netscher's painting. These exotic items, ones taken for granted in the modern, well-traveled world, were highly valued collectables in early modern Europe. They were cherished items that were de

rigueur for *kunstkammers*, special rooms in which wealthy gentlemen assembled and displayed quasi-scientific, encyclopedic collections consisting of all sorts of ethnographic curiosities.[83] Through his technical skill and wizardry, Netscher has reproduced these expensive, exotic articles of consummate beauty in a setting in which they can never be mislaid or broken. Indeed, his artistry rivals that of nature itself. The same can be said of the man-made object, the silver tazza beside the shells: Netscher has devised a perfect, enduring, painted facsimile of this costly metalwork of extraordinary fabrication.

In sum, *Two Boys Blowing Bubbles* evokes traditional ideas of transience but these are undermined, much to the delight of the astute viewer, by the panel's exquisitely crafted surface which renders the impermanent timeless. As such Netscher's work exemplifies the aims of many genre painters after 1650 whose boldly illusionistic and mimetic work self-consciously promotes their expertise in beguiling the viewer while simultaneously making claims both literal and figurative for the inherent value of their art.[84]

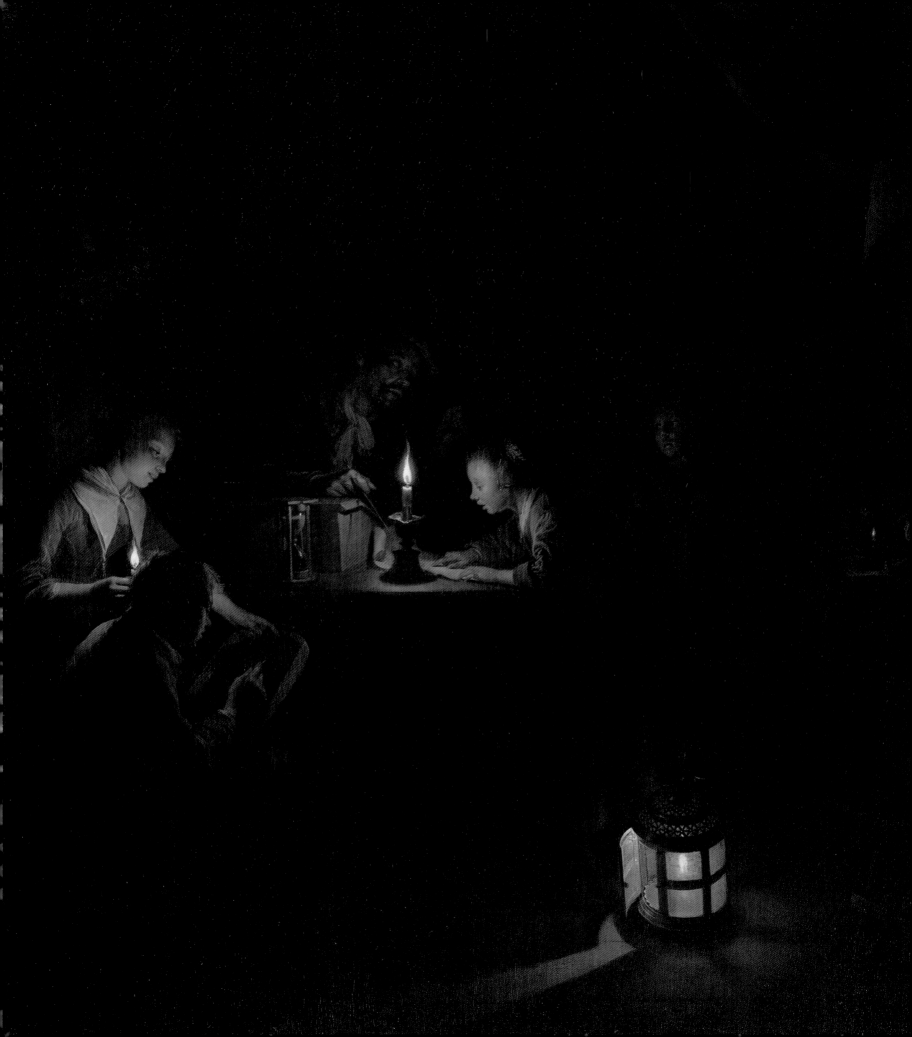

CHAPTER EIGHT

LEIDEN

Like many of the Province of Holland's cities, Leiden reached the peak of its prosperity during the economically robust decades following the Treaty of Münster. Leiden already enjoyed an illustrious history as a textile production center,[1] but this industry grew dramatically during the late sixteenth and early seventeenth centuries with the tremendous influx of refugees from the cloth-producing regions of the war-ravaged Southern Netherlands. At this time Leiden's textile industries produced a variety of cheap fabrics made from coarse wools. Trade in this type of light cloth was lucrative particularly during the twelve-year truce (1609–21), which had opened up markets in the Iberian Peninsula and expanded those in regions bordering the Baltic Sea.

However, what truly established Leiden's international reputation for textile production was its manufacture, beginning in the 1630s, of *laken*, a fine cloth also made from wool with a characteristic smoothness of texture. The technical innovations that facilitated the development of this cloth are not yet completely understood; nevertheless, *lakens* revolutionized the Dutch cloth industry and in Leiden rapidly eclipsed the cheaper fabrics as the main export.[2] Thus more and more laborers were needed to meet the surging demand for the fabric. Further waves of immigration during the 1630s and 1640s provided Leiden with the requisite cloth workers who came not only from the South but also England, France, Germany, and other Dutch cities.

By the middle of the century Leiden's textile enterprises had risen to preeminence in the Netherlands (surpassing those of its main commercial rival, Haarlem) and indeed in Europe as well. *Lakens* were sold in innumerable markets, including Scandinavia, Russia, Germany, Spain, and the Levant. Profits from these sales were, by seventeenth-century standards, astronomical, rising to over nine million guilders in 1654 alone. Judging from such factors as production output and earnings, textile manufacture in general peaked in Leiden during the 1660s. Thereafter, increasing commercial competition with France, war with that country, and political turmoil hastened its slow but steady contraction.

The successive waves of immigration that supported the flourishing textile industries caused the metropolis to grow exponentially.[3] In 1581 Leiden numbered approximately 12,000 inhabitants but by 1622 its population had expanded fourfold. And this impressive growth continued unabated: 67,000 people were living in Leiden in 1665. In order to provide adequate housing for this burgeoning population the city was enlarged three times between 1611 and 1659.

A council of forty elite citizens, drawn from the ranks of the patrician class, controlled politics in Leiden.[4] This small group of regents, representing some of the city's august families, had formed an oligarchy that monopolized the Council of Forty's most important functions and positions. Even in this Stadholderless era, many members of the Council of Forty remained staunchly pro-Orangist, which accounted for Leiden's declining influence in national politics at this time. Still, Leiden remained one of the Province of Holland's largest and most important cities.

Contributing to the town's sophisticated air was undoubtedly its university, the oldest one in the Dutch Republic.[5] William the Silent, Prince of Orange, had established the University of Leiden in 1575 to honor the city's valiant survival of a brutal siege by the Spanish army during the previous two years. The early days of the university were rather modest but it grew rapidly in reputation by, among other things, establishing a distinguished medical school and attracting scholars of international renown, including the humanist Justus Lipsius (1547–1606), the jurist nonpareil Hugo Grotius (1583–1645), and the philologist Joseph Scalinger (1540–1609,) as well as the theologians Jacobus Arminius (1560–1609) and Franciscus Gomarus (1563–1641) who became embroiled in bitter controversy over the biblical doctrine of predestination discussed in Chapter 1. The eventual triumph of Gomarus's orthodox camp had profound political implications for the Dutch Republic; it also explains partly Leiden's pro-Orangist political stance, one typically espoused by conservative Calvinists.

That Leiden's reputation as a center for Dutch genre painting was secured during the years immediately preceding the Treaty of Münster is not at all surprising.[6] As the city rapidly reached the pinnacle of its prosperity the conditions were ripe for art to flourish in the hands of a few talented painters supported by a small circle of affluent, discriminating connoisseurs, a number of whom belonged to the Council of Forty. Yet the low number of potential art patrons in Leiden compared with other cities may be explained by the presence of enormous numbers of textile workers who lacked sufficient means to purchase expensive paintings. Of the major cities of Holland, Leiden had the lowest ratio of painters per thousand inhabitants.[7] Artists were conceivably dissuaded from working there because the city lacked a professional guild through much of the first half of the seventeenth century to protect their economic interests. In 1648, a guild was established whose initial function was solely to

protect its members financially by granting them the exclusive right to buy and sell paintings in the city. Eventually, its functions were expanded so that it more closely resembled the guilds of other cities.[8]

The critical seeds for genre painting's future evolution in Leiden had already been planted by none other than its native son, Rembrandt van Rijn (1609–1669), who spent his early career (1625–c. 1632) in his hometown. Although technically not a genre specialist, he nonetheless exerted a decisive impact on the future course of genre painting by developing certain motifs and stylistic devices that were adopted by a younger generation of painters.

Gerrit Dou

Gerrit Dou (1613–1675), who served as a pivotal intermediary between Rembrandt and younger artists, was arguably Leiden's most significant genre painter.[9] As Rembrandt's first pupil he entered the then nineteen-year-old painter's studio in February 1628 and probably remained there until Rembrandt's departure for Amsterdam around 1632. Prior to his years under the great master's tutelage Dou had been trained by his father and other specialists in glass-engraving, copper-engraving, and glass-painting (namely, the production of windows for churches). Dou must have entered Rembrandt's workshop with proficiency in the rendition of small-scale, meticulous work and combined his earlier talents and training with specific devices and motifs assimilated in the master's atelier, gradually forging a style for which he became internationally acclaimed during his lifetime.

Dou was already executing genre paintings in the early 1630s. However, only during the middle of the 1640s did he begin to amplify the themes and stylistic devices now commonly associated with his genre repertoire.[10] Perhaps inspired by drawings by Rembrandt, Dou popularized what is best described as the "niche painting," which proved enormously influential among genre painters during the late seventeenth century.[11] Paintings of this type feature stone enclosures or window surrounds inhabited by figures whom Dou began to depict with increasing monumentality. The niches served to enhance the overall trompe l'œil effect of Dou's paintings, to foist a delightful visual conceit upon the viewer by toying with the parameters of art and reality. On one level, the enclosure effectively removes the image from our own space, thus monumentalizing it while inducing us to peer into it. But on another level, the extraordinary simulation of real objects within the niche is accentuated by the illusion of their puncturing the picture plane and consequently penetrating our own environment, albeit on a much smaller and enchanting scale than actual things.

Dou's *Violin Player* of 1653 provides a telling example of his use of a niche format in which an arched top enhances the illusion by eliminating what are normally the empty upper corners of a picture (fig. 102).[12] A man, likely identifiable as a painter because of his beret, peers at a birdcage while playing the violin in a stone enclosure, his form casting a faint shadow on its right side.[13] He leans against a sumptuous Turkish carpet draped over a magnificent stone relief of putti playing with a goat. This relief, which Dou used repeatedly in his niche paintings, is based on a frieze by the renowned Flemish sculptor François Duquesnoy (1597–1643), plaster copies of which were known in Leiden at this time.[14] In the background another man smokes a pipe while still another grinds pigment before an easel.

In light of this background scene the subject of this panel can probably be identified as that of an artist playing a musical instrument in his studio, a subject encountered in other genre paintings (and in artists' self-portraits).[15] Generally speaking it illustrates music's ability to stimulate creativity. The contemplative air of the painter/musician is complemented in Dou's representation by the figure grinding pigment behind him, a motif illustrating one of the practical tasks of an artist.[16] Informed viewers would have recognized striking parallels between these two creative arts. Both, for example, rely on principles of harmony, the harmony created by notes in music on one hand, and that created by the interactions of color and proportion on the other.[17] Furthermore, music and painting both entertain by appealing to the senses of sound and sight respectively.[18]

The sensate pleasures offered by the *Violin Player* are amply corroborated by its astounding verisimilitude. Consider the meticulously rendered music book and birdcage, the astonishing illusionism of the violinist's hands, which, with the instrument itself, emphatically break the picture plane.[19] Dou's clever rendition of extrordinarily lifelike motifs that charm and fool the eye is subtly underscored by several motifs in the painting. For example, Peter Hecht has recently observed that the violinist actually directs his playing at the bird in the cage affixed to the left jamb of the niche in an effort to induce the winged creature to chirp. Thus the violinist attempts to deceive the bird into "singing," an act that, by implication, finds parallel in Dou's cogently illusionistic picture which likewise beguiles the viewer.[20]

Equally beguiling is the putto who dons a mask in the "sculpted" relief below the violinist. The mask is a traditional attribute of *Pictura*, the personification of painting. The playful putto brandishes the mask to deceive the goat thereby providing a witty parallel to Dou's deception of those who scrutinize his depiction.[21] And this painted and hence fictitious stone relief is utterly deceptive in that it rivals if not outshines actual sculpture. The *Violin Player* and numerous other works by Dou and his colleagues featuring sculpture refer to *paragone*, the lively, early modern European theoretical debate concerning which of the two arts, painting or sculpture, was superior.[22] Obviously, Dou

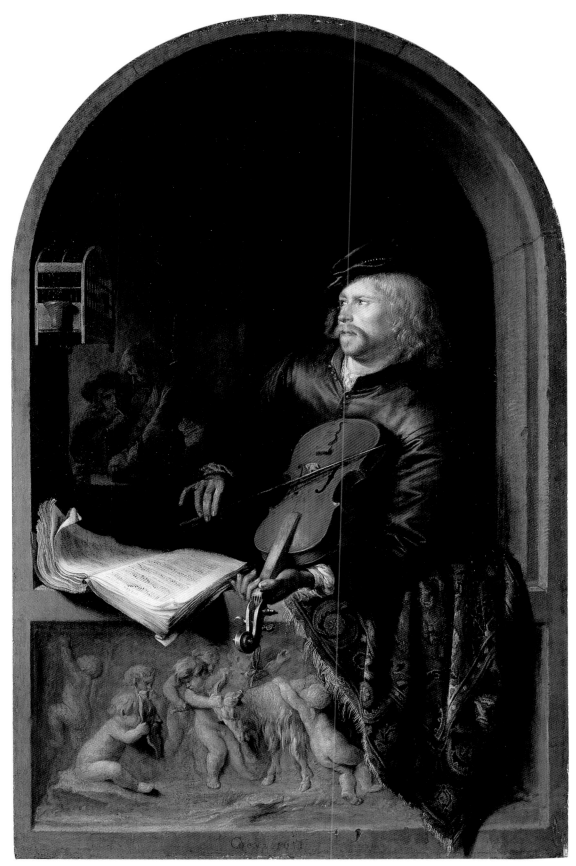

102 Gerrit Dou, *Violin Player*, 1653 (oil on panel, 31.7 × 20.3 cm). Vaduz, The Collection of the Prince of Liechtenstein.

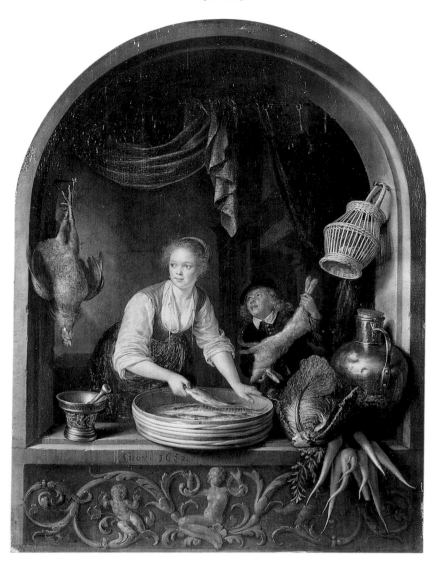

103 Gerrit Dou, *Kitchenmaid with a Boy in a Window*, 1652 (oil on panel, 33 × 23.8 cm). Karlsruhe, Staatliche Kunsthalle.

and his fellow artists championed painting as the superior art, which within the context of the *Violin Player* probably explains the presence of a colorful and tactile carpet hung directly over the comparatively dull, monochromatic relief.[23]

Dou also painted niche pictures whose subject matter was much more suggestive. His depictions of pretty kitchenmaids in niches, such as the one illustrated here (fig. 103), must be understood within the larger context of contemporary biases against female domestics.[24] In farces and jest books, maids humorously and stereotypically embody a plethora of vices, chiefly sloth and lust.[25] A typical example is the popular publication *Zeven duivelen, regerende en vervoerende de hedendaagsche dienst-maagden* (Seven Devils, Ruling and Seducing Contemporary Maidservants), a facetious, misogynistic diatribe examining the purported iniquities of maidservants.[26] In this entertaining text maids are veritable harpies from hell whose ignominious habits roughly correspond to the seven deadly sins.[27] The lengthy chapter on

whorish maids entertainingly elucidates how their lust operates interdependently with other vices such as pride and greed: the lure of the splendid surroundings in which these girls work and their desire to improve their lot incites them to let men "lift up their shifts." Or, when they begin to feel "man-sick" they flaunt their "half-naked bosoms" or tantalizingly "rolled-up sleeves" to expose "the whiteness of their arms" (fig. 104).[28]

Note that Dou's kitchenmaid has rolled-up sleeves and that her blouse is untied thereby providing a casual glimpse of her cleavage. Evidently, stereotypes concerning maidservants were so well entrenched that this pictorial presentation displays striking parallels with the literary one despite the thirty years that separate them.[29] Yet Dou, building upon earlier pictorial prototypes (fig. 105), popularized the depiction of female domestics handling food within the confines of monumental niches.[30] Dou's comely lass is surrounded by various foodstuffs and creatures, many of which seventeenth-century viewers would have recog-

nized as crude metaphors for fornication, genitalia, and so forth.[31] And below the ledge Dou has depicted a calligraphic relief of Venus and putti; as Eric Jan Sluijter has pointed out, wanton women were given nicknames during this period such as "Venus wench," "Venus animal," or "Venus moppet."[32] In sum, genre paintings of sexy maids (see also fig. 225) and the texts they mirror, entertained their audiences by appealing to popular prejudices largely divorced from the social realities of actual mistress–servant relationships in the Dutch Republic.[33]

Many of Dou's niche paintings, regardless of subject matter, primarily articulate the lofty aims and dazzling effects of the art of painting. Figures and objects convey these notions, as do their very placement within the composition. Unlike Gerard ter Borch's genre paintings, which are fundamentally anecdotal, Dou's images are characteristically static if not iconic. Specifically, paintings such as the *Violin Player* present foreground and background motifs deliberately juxtaposed by the degree of clarity with which they have been rendered: the bright, sharply distinct motifs placed immediately in and around the stone enclosure – itself incisively depicted – contrast with the more suggestively painted and dimly lit background elements.[34] And the meaning of these distant motifs, which invariably clarify the foreground scene, can only be teased out by close investigation on the viewer's part.

In his succinct treatise, *Lof der schilder-konst* (Praise of Painting), published in 1642, Philips Angel exalted the art of painting as a manifestation of, among other things, the artist's ability to imitate nature's infinite variety thus providing pleasure for the art lover.[35] Dou's work completely embodies Angel's views and thus explains the author's occasional references to the artist to substantiate his arguments. Angel praises Dou, for example, for the "meticulous looseness" of his brush; this undoubtedly refers

to his precise yet delicate manner of application in which the comparative tightness of the brushstrokes is deftly adjusted to the requirements of the motif being depicted. Naturally, in the hands of less skillful painters a precise technique (termed "neat" at the time) could all too easily yield to stiff, contrived results.[36]

Other contemporaries of the painter extolled his seemingly miraculous ability to render objects and textures with tremendous fidelity regardless of scale. For example, Jan Orlers, a member of Leiden's Council of Forty and owner of a large art collection, touted Dou in the 1641 edition of his *Beschrijvinge der stadt Leyden* (Description of the City of Leiden) as an "outstanding master, especially in [the rendering of] small, subtle, and curious things," adding that everyone must be "astonished" by his pictures because of their "neatness and curiosity."[37] (By the word "curiosity," Orlers probably meant the enchanting wealth of detail that embellishes the typical Dou painting.[38]) Likewise, a newspaper advertisement of 1665 announcing an exhibition of Dou's works described them as "most admirably painted and wonderfully finished."[39] The frequently laudatory comments in these sources concerning the smooth, precise surfaces (and related qualities) of Dou's paintings – and, for that matter, those of his pupils – suggests that contemporaries recognized a certain stylistic cohesiveness among Leiden genre painters under his aegis.[40] Later generations of connoisseurs labeled Dou and his pupils *Leidse fijnschilders*, or Leiden fine painters, in response to these very same formal qualities.[41]

Dou had the good fortune to locate several important and wealthy patrons, among them, Pieter Spiering and Johan de Bye. In his *Praise of Painting*, Angel reports that Spiering paid the master the then lavish sum of 500 Carolus guilders per year for the simple right of first refusal of his works.[42] De Bye owned twenty-seven of Dou's paintings which he exhibited in Leiden

104 (*right*) Illustration from *Zeven duivelen, regerende en vervoerende de hedendaagsche dienst-maagden*, Amsterdam, 1682. The Hague, Koninklijke Bibliotheek.

105 (*far right*) Pieter Feddes, *Kitchen Scene*, 1619 (drawing, 23.4 × 29.0 cm). Düsseldorf, Museum Kunst Palast, Sammlung der Kunstakademie.

in 1665, marking one of the earliest instances in the history of art of a "one-man show."[43] Dou's stable relationship with these affluent clients granted him the liberty to work laboriously for extended periods of time on truly magnificent paintings, ones for which he charged enormous prices. In an era in which the typical painting sold for approximately 15 to 30 guilders (and often less) Dou regularly commanded prices in the range of 600 to 1000 guilders.[44] The latter sum was nearly twice the amount of the average, annual middle-class salary in the Dutch Republic and was indeed sufficient to purchase a modest house at that time.[45]

Because Dou charged huge amounts for his work his clientele were generally restricted to elite buyers of great affluence. Included among these prospective patrons were some fellow citizens of Leiden but many resided in other locales – in fact, Dou was one of the few seventeenth-century Dutch genre painters to enjoy the patronage of foreign courts, including that of Queen Christina of Sweden (ruled 1632–54), Charles II of England (ruled 1660–85), and Cosimo III de' Medici (1642–1723), the Grand Duke of Tuscany.[46] In an era of spectacular economic and cultural development genre paintings by the foremost masters were swiftly becoming luxury items as elites took a prominent role in collecting them.[47] By comparison, the cost of genre paintings by leading artists during the early seventeenth century varied sufficiently to make some of them affordable for members of the middle class. As the decades progressed, middle-class collectors were increasingly priced out of the market, a fact not sufficiently appreciated today. The much greater cost of paintings and the higher social standing of those collecting them, in turn, necessitated changes in what themes were represented and, equally important, how they were represented.

Certainly, the restricted yet secure market for his pictures afforded Dou opportunities to experiment with subject matter. But one should not necesarily conclude that the subjects of his works interested his patrons less than the style in which they were painted.[48] To the contrary, Dou must have been sensitive to changing tastes among the Dutch Republic's elites – a class to which the artist belonged – and presumably would not have labored intensively to produce paintings whose subjects may be considered offensive by his patrons; after all "right of first refusal" by definition allows the purchaser to reject an artwork. Surely, in the interests of income and reputation it would have been disadvantageous for Dou to have paintings rejected on grounds that their subject matter was unappealing or downright distasteful.[49]

It is worthwhile to recognize what Ronni Baer has termed "the uncanny congruency of medium and message [which is] fundamental to an understanding of the appeal of the artist's paintings."[50] Dou's thematic innovations in genre painting were numerous, including the introduction of a number of novel subjects and the development of variations upon other, more established ones.[51] Especially noteworthy are the contributions that

he made to the emerging theme in Dutch genre painting of domesticity. Although such images only began to be produced in significant numbers after the Treaty of Münster, the concept itself, obviously, was not suddenly invented at this time. Many of the then current familial notions had actually originated during the preceding century if not earlier.[52] Literature focusing upon the topics of marriage and the family was already in print by the early 1520s, often in the form of published sermons. However, what began initially as a small trickle of publications would culminate in the exhaustive domestic conduct books that appeared towards the end of the sixteenth century, and well into the seventeenth.[53] As the decades progressed the concept of domesticity must have become pervasive as literally hundreds of Dutch paintings of domestic themes, the majority of which post-date 1650, attest.

Dou's *Young Mother* of 1658 (fig. 106) constitutes an outstanding example of his rendition of domestic themes while simultaneously demonstrating the scope of the painter's contemporary fame.[54] This painting was begun earlier in the decade, possibly as a commission in honor of a wedding – technical examination has revealed that the last number in the date (seen in the coat-of-arms in the window) was altered from a 3 to an 8.[55] The exact circumstances of this earlier commission are not entirely known. The panel was probably kept in Dou's studio which proved auspicious as it became part of the politically motivated "Dutch gift," a group of artworks (and a yacht) presented in 1660 by the States General to the newly crowned king, Charles II, in honor of his restoration to the British throne.[56] The *Young Mother* remained in England for some thirty years where it never ceased to amaze visitors to court. One of them, the connoisseur John Evelyn, who saw the painting in December 1660, commented in his diary that it was "painted . . . so finely as hardly to be distinguish'd from enamail."[57]

The exquisitely crafted surface of this work, its painstaking depiction of numerous objects scattered about the cavernous interior, invites the beholder's close inspection. Its brilliant surface, created by the superimposition of up to twelve layers of paint,[58] likewise offers enjoyment of its bold, almost palpable mimetic effects as well as intellectual engagement of the strategically positioned motifs depicted therein. In essence, Dou confronts the viewer with an utter cornucopia of motifs that are striking for their conventionality because they appear in seemingly countless domestic paintings. All refer to the exemplary woman's tasks and the scope and limitations of her obligations, which, according to seventeenth-century concepts of marriage and domesticity, lay exclusively in the home. For example, the cooking utensils and abundant comestibles advert to the housewife's important duty of preparing food for her family. The discarded shoe and possibly the lantern function as reminders of the woman's place at home.[59] Her needlework and her role as a mother – her eldest daughter tends to the infant in the cradle

beside her – obviously evince virtuous associations as well. The left background of this interior contains items that do not properly belong to the sphere of females, among them, a large bookcase with a globe and large conch on its top shelf. There is also a man's cloak and sword hanging from a peg on the column directly in front of the bookcase. These items probably serve as attributes of the masculine realm in contradistinction to those pertaining to the feminine realm.[60]

Despite the picture's astounding lifelikeness one should not assume that the *Young Mother* and related paintings of domestic themes offer straightforward glimpses of home life in the Dutch Republic. To the contrary, like all genre paintings, they weave very clever fictions. The cavernous interior in Dou's painting speaks volumes about this: it is entirely fanciful – no seventeenth-century viewer would have confused it with the actual spaces of a Dutch home – and should perhaps be thought of as a "reality effect" rather than "reality."[61] It is one heavily dependent upon pictorial conventions employed to delight audiences yet simultaneously to articulate their collective cultural experiences (and biases). Dou's painting therefore operates as a trope, presenting – like the literature it mirrors – a paradigmatic construct of what contemporaries considered virtuous behavior among housewives and maids.

The naturalistic effects of the *Young Mother* appear to be more advanced than, say, those rendered in tonal paintings of the 1630s (see fig. 47) which must have seemed almost rudimentary by comparison.[62] Nevertheless, it would be erroneous to conclude that Dutch seventeenth-century genre painting developed rectilinearly in the direction of ever more faithful representations of the surrounding world. It is much more accurate to view genre painting's development through the course of the century as incessantly shifting from one predominant set of pictorial conventions to another – and the prevailing conventions of the 1650s and 1660s promoted astonishing mimetic effects.[63]

By this stage in Dou's career his style had become increasingly refined. The expansive interior of the *Young Mother*, with its imposing space and luxurious chandelier, clearly pays testimony to this. But the overall air of refinement is also exuded by its very surface, namely, its assured, exacting execution, the use of saturated colors, and the generally brighter tonalities.[64] The subject and style of the *Young Mother* are seamless and meant to cater to the growing elite penchant for bright, polished pictures of intrinsically wholesome subjects. As demonstrated repeatedly, the post-1650 period was one of great affluence and, related to this, of an increasing awareness of civility, that self-conscious cultivation of grace and status expressed by, among other things, one's taste in art. Fashionable representations of domesticity must have become enormously appealing and therefore provide ample information about buyer taste in a prosperous atmosphere ripe for the production and reception of such images.[65] It was the taste and related collecting habits of the elite,

106 Gerrit Dou, *The Young Mother*, 1658 (oil on panel, 73.5 × 55.5 cm). The Hague, Mauritshuis.

then, that insured a ready market for the new types of artwork being produced after 1650 as they responded enthusiastically to the thematic and stylistic changes being introduced into Dutch genre painting.

Dou's style and imagery are incipient representatives of "the elegant modern manner," a mode of art with which the arch-classicist Gerard de Lairesse (1640–1711) associated the painter some fifty years later in his treatise *The Art of Painting*.[66] According to de Lairesse, paintings in the elegant modern manner eschew "low and unbecoming subjects for ornament, especially for people of fashion, whose conceptions ought to surpass the vulgar."[67] And as a closer reading of other passages in his treatise confirms, a bright, polished painting style was deemed more agreeable, sophisticated, and civil.[68] The thematic and stylistic values that de Lairesse championed in art were undoubtedly linked to the values of the elite class to which he belonged; thus "people of fashion," as he phrased it, were unquestionably people who were sophisticated and civil.[69] The same holds true *mutatis*

mutandis for Dou's art and the audiences of the painter's slightly older generation.

However, at this comparatively early stage in the relationship between art and civility Dou's polished, bright manner was occasionally employed for more questionable subject matter. Dou's previously mentioned patron de Bye, for example, owned and displayed at his exhibition of the artist's work in 1665 a number of nudes and amorous, seductive subjects.[70] At a later, more sophisticated stage in the civilizing process, namely, the era in which de Lairesse was writing, some connoisseurs considered Dou's depiction of erotic imagery offensive. Arnold Houbraken (1660–1719), for instance, in his biography of the artist, published in 1718, laments that Dou did not use "his brush for the representation of more dignified and praiseworthy things."[71]

Dou also revitalized the use of artificial illumination in night scenes, a device popularized years earlier by the Utrecht Carvaggisti (see fig. 74).[72] Many of Dou's pictures of this type date to the late 1650s and especially the 1660s, the final, full decade of his activity in which his artistic powers reached their climax. The so-called *Night School* (fig. 107), one of a group of paintings of educational themes dating to the early to mid-1660s, exemplifies his skillful manipulation of artificial light sources.[73] A teacher (himself an iconographic descendant of sixteenth-century engravings of *Grammatica*, the personification of grammar) instructs a small group of students in reading and writing beside his desk while still others practice their writing in the distance. Compared with the mischievous children that populate so many early seventeenth-century genre paintings (see fig. 34), those depicted here are paragons of propriety and diligence. The scene is exquisitely illumined by three candles and a large lantern. The resultant visual effects are stunning; Dou's painstaking style enables him to render full and half-shadows with extraordinary subtlety and verisimilitude.

For contemporary viewers the painting was certainly not construed as an illustration of a real school but rather an abstract representation of educational ideas cloaked in the artist's compelling illusionism.[74] In seventeenth-century Dutch literature, candles, along with other sources of illumination, were frequently tied to the concepts of reason and understanding, honed through education.[75] As one author, Theodore Rodenburgh, phrased it, those who lacked diligent study habits were "lanterns without light."[76] Rodenburgh's comments appeared in one of the period's best-known grammar books, *Grammatica ofte leez-leerlings steunsel* (Grammar or a Support for Reading Pupils), published by Richard Dafforne in 1627.[77] The young students in Dou's painting acquire the light of wisdom and understanding through their assiduous practice of reading and writing. Prints and emblematic *picturae* similarly feature figures studying by candle-light as metaphors of vigilance and studiousness (see fig. 71).

A billowing, velvety curtain is depicted at the top of the painting, pulled back to reveal Dou's uncanny simulation of an artificially illumined interior just as real curtains were drawn aside to reveal the paintings they protected, having been placed over them to protect against dust and dirt.[78] Art historians have long connected curtains of this type with Pliny the Elder's legendary tale of the competition between the ancient Greek painters Zeuxis and Parrhasius (fig. 108).[79] According to Pliny, the two painters entered into a contest of artistic skill. Zeuxis painted grapes with such lifelikeness that they deceived birds who attempted to eat them. When Zeuxis asked Parrhasius to open the curtain on his painting to unveil its subject the former was bested because the skillful illusion of the latter's painted curtain had completely deceived him: Zeuxis did not realize that the curtain was actually the painting's subject.

Pliny's story was well known in the seventeenth century. The Leiden poet Dirck Traudenius, for instance, writing in 1662, exalted Dou as the Dutch Parrhasius whose masterfully illusionistic paintings were capable of deceiving Zeuxis anew.[80] Moreover, for contemporary Dutch theorists, the story provided the quintessence of painting's definitive goal: consummate illusionism. The anecdotes recounted by such theorists and biographers as Karel van Mander (1548–1606), Samuel van Hoogstraten (1627–1678), and Joachim von Sandrart (1606–1688) about the prodigious illusionistic talents of Netherlandish and German artists who routinely beguile viewers are essentially variants of Pliny's renowned tale.[81] Hans Vredeman de Vries (1527–?1606), for example, painted "for Gillis Hofman, on a site opposite a gateway . . . a large perspective looking like a vista in a garden. Later some German nobleman as well as the Prince of Orange were deceived by this, thinking it to be a real building with a view."[82] Likewise, von Sandrart relates how a painting by Sebastian Stoskopff (1597–1657) depicting a print affixed to a board with wax seals totally fooled – and naturally delighted – the Holy Roman Emperor, Ferdinand III, who tried to remove the print from its "mount."[83] As Celeste Brusati has perceptively observed, "Whether true or not, these stories helped ideologically to underscore a belief in the capacity of deceptive pictures to subvert established hierarchies and to allow artists to trade imitative skill for social and economic gain."[84]

That the artist's social and economic gain of which Brusati speaks is achieved in the service of elite patrons and audiences is especially fascinating, for fundamental to all of these stories is how these pictorial deceptions are foisted upon persons of great affluence or august social status.[85] Often overlooked in acknowledging Dou's conspicuous display of illusionistic mastery in such motifs as the curtain in the *Night School* is their capacity to boost the marketability of his art by astounding elite audiences – and most assuredly, anyone who would behold his paintings. The result of Dou's efforts imputed honor and distinction to him, qualities intrinsic to his elite circle of patronage. Dou's portrait of himself as an elegant gentleman (fig. 109), painted at approximately the same time as the *Night School*, demonstrates just how

107 (*above*) Gerrit Dou, *The Night School*, *c*. 1660–65 (oil on panel, 53 × 40.3 cm). Amsterdam, Rijksmuseum.

108 (*right*) Emblem from Joost van den Vondel, *Den gulden winckel der konstlievende Nederlanders*, Amsterdam, 1613. Amsterdam, Universiteits-Bibliotheek Amsterdam.

109 Gerrit Dou, *Self-Portrait*, 1663 (oil on panel, 54.7 × 39.4 cm). Kansas City, Missouri, The Nelson Atkins Museum of Art (Purchase: Nelson Trust) 32–77.

pupils."[88] There are many fascinating parallels between van Mieris's and Dou's careers. Like Dou, van Mieris descended from a family of craftsmen who executed finely wrought work, though in the latter's case, gold and silversmithing. Van Mieris received some initial instruction in this metier but by approximately 1649 he had embarked upon a five-year training period with three artists, including two lengthy terms with Dou.

Van Mieris's earliest works reveal Dou's decisive influence upon him.[89] But already by the end of the 1650s van Mieris had produced an assortment of truly outstanding paintings in which he achieved a definitive style. The *Inn Scene* of 1658 (fig. 110) belongs to this latter group.[90] This painting depicts a busty young maid (identifiable as a Catholic because of the cross worn around her neck) pouring a drink for a soldier who pulls her green apron to bring her closer to him. An inebriated man slumbers behind the maid while a couple converse in the background. Any suspicions about the disreputable surroundings in this panel are readily confirmed by the somewhat shocking detail of the fornicating dogs, a ribald motif of the type more frequently encountered in genre paintings earlier in the seventeenth century.

Despite the progressive interest in increasingly wholesome imagery among patrons and painters after 1650, van Mieris forged an enormously successful career as a painter of erotic subject matter whose presentation of titillating themes and motifs sometimes lacks subtlety, a quality that occasionally separates his art from that of several other prominent *fijnschilders*.[91] The *Inn Scene* can therefore be construed as a luminous updating, in the *fijnschilder* mode, of the theme of prostitution featuring a whore and her client, a soldier, the latter considered a habitué of brothels following longstanding literary and pictorial traditions.[92]

The *Inn Scene* bears a superficial similarity to Dou's art in its abundance of meticulously rendered details. However, closer scrutiny betrays significant differences. For example, Dou's brushwork, though generally "neat" (as contemporaries described it) and exact, is actually quite varied as he combines broader brushstrokes (especially for the facial features of his figures) with tighter ones to define forms and textures. By comparison, van Mieris's brushwork is more uniformly precise to such an extent that all evidence of the artist's hand virtually disappears. Moreover, van Mieris's pictures are infused with light reflections and subtle gradations of atmosphere to a degree far exceeding those by Dou. The soldier's gleaming metal cuirass offers a telling example of van Mieris's virtuosity in handling light; its surface is radiant as it contains a myriad of reflections all rendered with painstaking accuracy. The sparkling appearance of this motif extends to the man's striated sleeves and the prostitute's skirt. These motifs are also fascinating from a coloristic perspective. Van Mieris's palette is singular in this regard, particularly in the color combinations composing the costumes of the figures.

Taking his cue from Dou but quickly surpassing him, van Mieris raised genre painting to an extraordinary level of tech-

closely these elite qualities concurred with his own social standing.[86] Although several early seventeenth-century genre painters accrued tremendous wealth and status through their work it is only with Dou's generation that such artists begin to portray themselves frequently as gentlemen, a reflection no doubt of the changing economic and cultural milieu in which they labored.[87]

Frans van Mieris the Elder and Pieter van Slingelant

Over the course of his lengthy career Dou taught a sizeable number of students, which is hardly surprising given his contemporary renown. Indeed, many members of the next generation of *fijnschilders* passed through his atelier. However, one student surpassed all others: Frans van Mieris the Elder (1635–1681) whom Dou purportedly called "the prince of his

110 Frans van Mieris, *Inn Scene*, 1658 (oil on panel, 42.8 × 33.3 cm). The Hague, Mauritshuis.

nical refinement by 1660. Consequently, younger painters responded principally to his technical innovations, as opposed to Dou's, whose influence was more restricted to innovative subject matter and compositional schemes. Van Mieris's striking pictorial achievements fully accord with the contemporary theory of *aemulatio* or emulation whereby young artists were encouraged to extract the most appealing details from the art of their teachers and illustrious forebears in order to create works that ultimately surpass all prototypes.[93]

The matchless splendor and consummate illusionism of van Mieris's art was likewise celebrated by his contemporaries, who invoked much of the same encomium used to describe Dou's work – for example, van Mieris too was compared to Parrhasius.[94] Likewise, the younger artist enjoyed patronage among the Dutch elite (including clients whom he shared with Dou) and international clientele among Europe's preeminent nobility.

Cosimo III de' Medici, the Grand Duke of Tuscany (who actually visited the artist's studio and Dou's in 1669), can be counted among his patrons, as can Archduke Leopold Wilhelm of Vienna (1614–1662).[95] Like Dou, van Mieris commanded high prices for his paintings which placed them well beyond the financial reach of the middle class. Archduke Leopold Wilhelm probably paid 1000 guilders for *The Cloth Shop* (fig. 111) and subsequently offered the painter an annual salary of 2500 guilders to become his court painter in Vienna (an offer which the painter declined).[96]

The Cloth Shop, signed and dated 1660, ostensibly represents a shop interior, a subject rarely seen in Dutch art.[97] However, this is a store whose sumptuous adornment is far removed from real shops of the time.[98] Amidst the dazzling array of fabric bolts a smirking officer gently strokes the chin of the slightly disheveled female clerk while he touches a cloth swatch on the table

111 Frans van Mieris, *The Cloth Shop*, 1660 (oil on panel, 55 × 43 cm). Vienna, Kunsthistorisches Museum.

between them. Behind the couple, in the back of the shop, a craggy-faced old man dressed in heavy clothing observes them with resentment and points to the mantel above on which hangs a painting of the Old Testmament tale of Adam and Eve mourning the body of their slain son, Abel.

The sumptuous banner lying on the Persian carpet on the right-foreground table is folded in such a way as to make its Latin inscription partly legible. It reads: "Comparat[ur?] cui vult." This can be translated into English very loosely as either "Purchased for the one who wants it" or "There are comparisons for those who want them."[99] (The meaning hinges on the word, *comparat* a conjugation of the verb, *comparare* which denotes to purchase or to compare.) Within the context of the narrative the inscription is both purposeful and clever for *comparare* is precisely what the cavalier is doing: he compares the textures of the silken cloth with the delicate skin of the clerk. And judging from her enticing appearance he can probably purchase both the fabric and its seller. This Lothario's sexual advances are watched by the old man with envy most likely because his debilitated physical condition prevents him from engaging in similar activities.[100] The painting on the marble mantelpiece above the elderly man probably illuminates his mental state because Abel was murdered by his insanely jealous brother Cain.[101]

But the inscription also invites the viewer of the painting to compare and purchase. One is compelled to inspect van Mieris's amazingly meticulous rendition of diverse textures and surfaces, ranging from the assorted fabrics and the female's soft skin, to the weathered hide of the aged man and the airy feathers of the officer's hat, contrasted by the hard, reflective brass of the chandelier directly above it.[102] The artist's skill in delineating such textures and stuffs is matched by his expertise in capturing convincing atmospheric effects within the confines of the shop. The sheer visual enchantment of *The Cloth Shop*, a superb example of van Mieris's artistry, causes the beholder to long to purchase it and, in a further demonstration of the artist's cleverness, inspire mock envy of the Archduke's ownership of it. Although the exact circumstances of the commission are not known, van Mieris undoubtedly made every effort to impress his illustrious patron with a painting that showcased his talents. And judging from the Archduke's offer to van Mieris to become his court painter, he clearly succeeded. Compared with ter Borch's reserved genre pictures, with which the painter was undoubtedly familiar, van Mieris's are rather transparent in meaning. Yet in this instance meaning is communicated with phenomenal wit.

Van Mieris's style was also placed at the service of less overtly alluring themes, including those portraying female beauty, itself a popular *topos* in seventeenth-century Dutch culture. Female beauty is on display in the *Young Woman Standing Before a Mirror* (fig. 112). With its deep chiaroscuro, comparatively darker palette, and somewhat stylized figure, this painting dates to around 1670.[103] It depicts a young woman who stares at a mirror – her

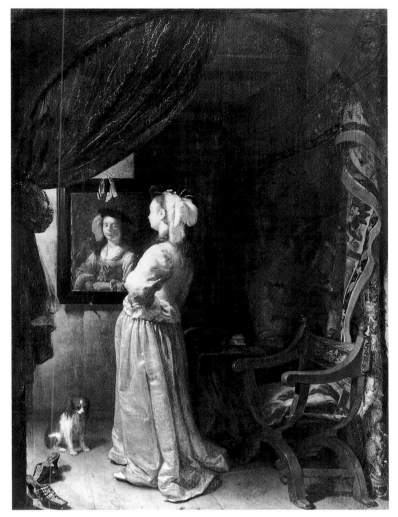

112 Frans van Mieris, *Young Woman Standing Before a Mirror*, c. 1670 (oil on panel, 43 × 31.5 cm). Munich, Alte Pinakothek.

reflection confronts the viewer directly – in a well-appointed though somewhat nondescript interior, complete with a dog and discarded green shoes. The theme of a woman posed before a mirror is age-old; once again van Mieris renewed and revised a traditional theme, though this time through the intermediacy of ter Borch (see fig. 88) and his teacher, Dou.[104] In this context, the conspicuous combination of the motifs of the woman, her cap sporting enormous feathers, the dog, the discarded shoes, and mirror suggest that van Mieris has rendered a prostitute.[105] Yet in this instance (as opposed to the *Inn Scene*) the subject has been treated with tremendous subtlety if not understatement on a par with the art of ter Borch and consonant with the increasingly cultured and civilized tastes of a growing number of patrons during the second half of the century.

The subtlety and sophistication of the *Young Woman Standing Before a Mirror* extends beyond the discreet rendition of the subject to the very style in which it is painted.[106] This beautiful

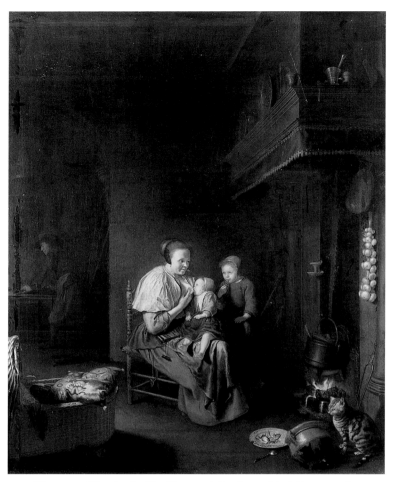

113 Pieter van Slingelandt, *The Carpenter's Family*, c. 1665 (oil on panel, 42.9 × 35.4 cm). Windsor, The Royal Collection.

female gazes directly into the eyes of the spectator through her reflected glance in a mirror. Art theorists of the day likened the prototypical painting to a "mirror" of nature: like an actual mirror, a painting delightfully yet deceptively renders an appearance, a "semblance of being" which actually does not exist. The consummate, mirror-like illusion beheld here is one of a woman whose beauty is cleverly meant to elicit the viewer's desire for her as well as for the artwork – the two are fundamentally inseparable. Hence the viewer (who is presumably male) is seduced by the woman's glance and resplendent form, engendered by the seductive painting technique which created them.

The capacity of painted representations of ravishing females to elicit longing (and temptation) in beholders was frequently acknowledged in theoretical writings and related literature of the period.[107] As the painter and author Adriaen van de Venne phrased it: "The eye desires, man yearns/ And I long all the more for this reason:/ Because I see an image that has neither body nor speech,/ Movement nor feeling, and is but semblance . . . The eye is never satisfied, desire is never satiated,/ As long as

one remains involved with art and love."[108] Van de Venne penned these verses nearly fifty years before van Mieris painted the *Young Woman Standing Before a Mirror*, so had in mind art of a strikingly different type in technique and appearance. Yet van Mieris's remarkable picture would have most assuredly affected him with equal intensity if not more so.

Pieter van Slingelandt (1640–1691) was another significant artist to emerge from Dou's studio. In fact, van Slingelandt was the only other painter associated with Dou (besides van Mieris) who was commended in contemporary literary sources. For example, the French connoisseur Balthasar de Monconys, who visited the studios of Dou, van Mieris, and van Slingelandt in Leiden in 1663, called the young artist, a "good painter who works in the manner of Dou and van Mieris."[109] Strong affinities between the work of Dou, van Mieris, and van Slingelandt were also noted by Simon van Leeuwen in his *Korte besgryving van . . . Leyden* (Brief Description of . . . Leiden), published in 1672. Van Leeuwen regarded the art of van Mieris and van Slingelandt as an extension of Dou's, declaring that the two younger masters might even better their teacher.[110]

It was during the 1660s, the decade immediately following his tenure in Dou's studio – he presumably studied with the master during the late 1650s – that van Slingelandt produced his best work. *The Carpenter's Family* (fig. 113), for example, reveals the indelible mark of his teacher, so much so that it has occasionally been attributed to Dou himself.[111] Like Dou, and undoubtedly inspired by him (and by the impetus of the art market), van Slingelandt painted numerous images of domestic virtue which feature meticulously painted interiors filled with a profusion of household motifs. Van Slingelandt's use of chiaroscuro and the general disposition of space are analogous as well – observe the dimly lit figure of the father in the background of *The Carpenter's Family* which recalls the maids cooking in the background of Dou's *Young Mother* (see fig. 106).

Van Slingelandt's representation exudes an aura of tranquility as it illustrates the diligent performance of spousal and parental duties which, according to contemporary domestic treatises, ensure harmony and peace within the family. But the seemingly derivative nature of this and other paintings by van Slingelandt should not be construed negatively. Although modern culture places a high premium on originality in art, this criterion does not altogether apply to art of the early modern period. As is clear from the sources quoted above, van Slingelandt was an artist of considerable repute, and the indisputable origins of his subject matter and style in the art of Dou (and van Mieris) was consistent with seventeenth-century conceptions of artistic training and inspiration.

Van Slingelandt also executed pictures tinged with eroticism. Many of these reveal his responsiveness to the art of van Mieris. For example, van Slingelandt's *Lady with a Pet Dog* of 1672 (fig. 114) was inspired by van Mieris's *Teasing the Pet* (fig. 115), painted

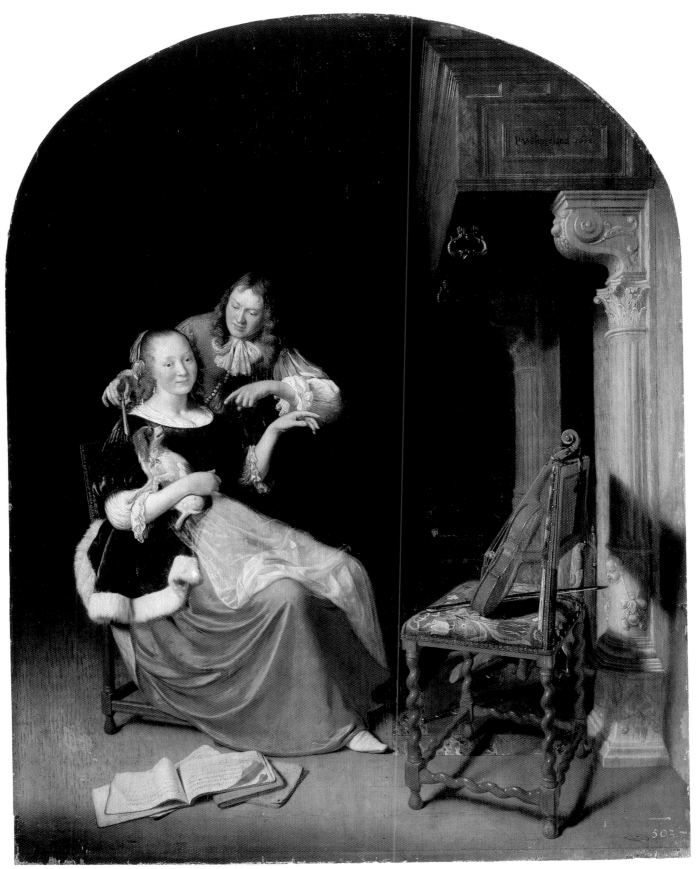

114 Pieter van Slingelandt, *Lady with a Pet Dog*, 1672 (oil on panel, 39.5 × 30.5 cm). Dresden, Gemäldegalerie Alte Meister, Staatliche Kunstsammlungen.

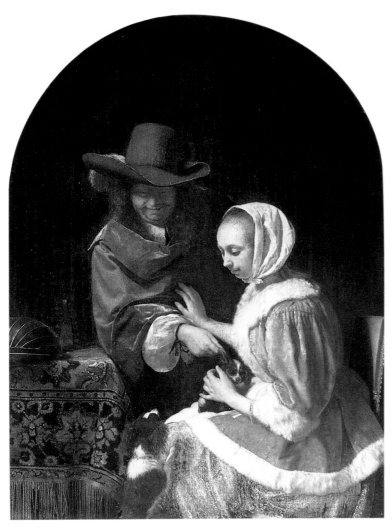

115 Frans van Mieris, *Teasing the Pet*, 1660 (oil on panel, 27.5 × 20 cm). The Hague, Mauritshuis.

twelve years earlier.[112] In a dark yet opulent interior (note the ornate fireplace), a duet has been interrupted by a dashing young man who uses a recorder, a time-honored phallic symbol, to tease the little dog in his lady's lap.[113] The panel exudes a playful air of erotic tension not dissimilar to that found in paintings by van Mieris. The dandy is about to poke the lapdog with his instrument: does he do so to distract his companion so that he can peer at her cleavage, or is he simply staring at the dog? The ambiguity of his glance is probably purposeful and meant to implicate contemporary viewers, in effect forcing them too to gaze upon the woman's décolletage. The beholders' implication and the deliberate vagueness of the narrative of the scene are furthered heightened by the woman, who looks directly at the viewer while half-heartedly deflecting her suitor.[114]

Both the *Lady with a Pet Dog* and *Teasing the Pet* of 1660 properly belong to the illustrious lineage of courtship imagery in Dutch art (see Chapters 3 and 7) but its specific subject, a suitor

pulling on the ear of a puppy in his beloved's lap as she attempts to push him away, is van Mieris's own invention. The suitors' action in both images, though frisky, is one motivated by jealousy as they attempt to displace the animal as the principal focus of the women's affection. The conceit of the envious admirer who competes with a lapdog for his lady's favor is found in several songs and love poems of the period: "Fortunate little dog, your prosperous lot is envied:/ Fortunate little dog, that so often enjoyed Celestyne's lap,/ And, to my regret, was caressed by her so softly."[115] This poem, penned by Joannes Blasius in 1663, is quintessentially Petrarchan in conception. Pervasive Petrarchan sentiments animated the cultural phenomenon of courtship in the Netherlands, as was already discussed in connection with ter Borch. By the 1660s such sentiments had become highly fashionable in a society preoccupied, if not obsessed, with love as a subject of conversation, poetry, and song. And many genre painters cleverly adapted these sentiments to their own work. In the case of van Mieris and van Slingelandt they were infused with eroticism generally of a frolicsome nature as opposed to a crude one (*pace* van Mieris's copulating canines; fig. 110) in keeping with the increasingly cultivated tastes of prospective patrons.

The *Lady with a Pet Dog* resounds with the same splendid visual effects as *Teasing the Pet* though van Slingelandt's picture displays a stiffer and harder surface appearance. Van Slingelandt's overly intense concentration on specific details such as the songbooks and the beautiful chair in the lower right corner imparts an additive quality to the panel as a whole thereby detracting from its narrative aspects. The fact that the figures are somewhat awkwardly rendered and seemingly detached from one another does not help matters either. By contrast van Mieris's depiction is much more subtle, both in style and in its narrative features. Despite these typical shortcomings the *Lady with a Pet Dog* has the same extraordinary attention to detail and textures as well as the astonishing luminosity and atmospheric subtlety. The refined facture of this picture clearly amplifies its sophisticated subject matter. The focus on the urbane yet playful rituals of courtship in this painting and others like it indicates that they were destined for an elite clientele who, motivated by shared, civilized values and sizeable disposable incomes, purchased large quantities of related amatory literature, including songbooks and emblem books. Furthermore, as part of the overall aristocratization process many regents and patricians purchased country properties; it was to these bucolic locales that they would regularly retire to discourse politely on love and courtship with which they were well acquainted from literature, art, and presumably, life.

Quirijn van Brekelenkam

The final painter to be discussed in this chapter is Quirijn van Brekelenkam (after 1622–?1669).[116] The work of this prolific

artist is much more modest in appearance than that of Dou, van Mieris, and van Slingelandt. It was also significantly less expensive and, consequently, yields insights into the market for art after the Treaty of Münster among buyers of lesser means. Van Brekelenkam's paintings display strong affinities with those by Dou, particularly in terms of subject matter, but it is unlikely that he studied with him; in fact, his teacher has never been identified. Van Brekelenkam's earliest paintings date to the late 1640s and early 1650s and illustrate themes that had been previously popularized by Dou. For example, his *Old Woman at Table* of 1654 (fig. 116), which depicts an elderly woman eating stew from an earthenware pot in a ramshackle interior, is unquestionably related to Dou's *Old Woman Eating Porridge* (fig. 117) painted some twenty years earlier.[117] The similarities extend beyond the setting and the wizened features of the aged figure to the fairly tight execution, meticulous detail, and to certain aspects of the palette with its brown and ocher hues in combination with warm gray.

Van Brekelenkam's pictures of virtuous elderly women, which he produced in large numbers, probably sold for about 8 to 12 guilders each, far less than the immense sums netted by Dou and van Mieris.[118] Thus, the artist's clientele consisted principally of collectors of more modest means.[119] Nevertheless, the repetitive subject matter of van Brekelenkam's art and the large quantity of it in the inventories of Leiden's collectors confirm his reputation in the city. The incessant repetition of particular themes in his work once again affirms the marked conventionality and limited repertoire of seventeenth-century Dutch genre painting.

Despite the often derivative nature and unassuming look of van Brekelenkam's art the painter produced some truly innovative subjects during his approximately two-decade career. For example, van Brekelenkam was the first painter to depict tailors (notwithstanding the existence of some earlier drawings and prints of these artisans), a subject he represented no fewer than thirteen times between 1653 and 1664.[120] That these images are largely variants upon one another suggests that the artist had cornered a certain niche in the market for such subjects. In turn, other painters, among them Pieter van Slingelandt, responded to van Brekelenkam's pictures and the general demand for this and related subject matter.[121]

117 (*right*) Gerrit Dou, *Old Woman Eating Porridge*, *c.* 1632–7 (oil on panel, 51.5 × 41 cm). Private collection.

116 (*below*) Quiringh van Brekelenkam, *Old Woman at Table*, 1654 (oil on panel, 57 × 68 cm). Bayerische Staatsgemäldesammlungen, on loan to Bayreuth, Staatsgalerie im Neuen Schloss Bayreuth.

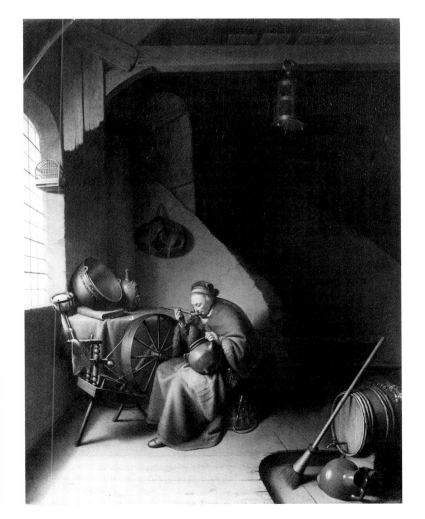

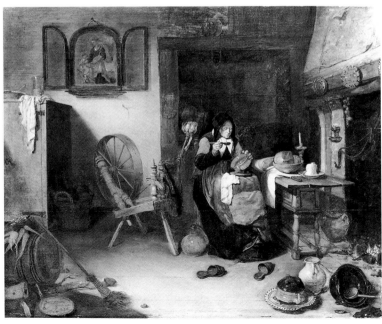

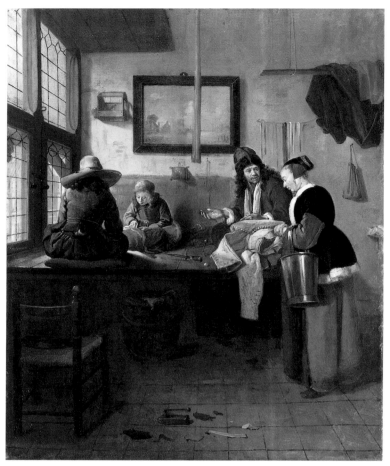

118　Quiringh van Brekelenkam, *The Tailor's Workshop*, 1661 (oil on canvas, 66 × 53 cm). Amsterdam, Rijksmuseum.

The *Tailor's Workshop* of 1661 (fig. 118) constitutes a characteristic example of van Brekelenkam's approach to the subject. A tailor converses about a gentleman's jacket with a respectably dressed housewife holding a shopping pail while his two young assistants (or apprentices perhaps) attend to their work. The ground floor of a domestic dwelling serves as the tailor's shop, as it would have in actuality. The depiction of the corner of a room with large windows on one side is reminiscent of the spatial construction of contemporary paintings by such artists as Nicolaes Maes and Pieter de Hooch (see fig. 147), with whose work van Brekelenkam was surely familiar. His paintings of tailors extol the virtues of simple industriousness. Slothful figures are never encountered within them but always diligent laborers in plain garb working in orderly, plain interiors. The popularity van Brekelenkam's paintings of tailors may have resided also in their capacity to evoke associations, however oblique, with Leiden's flourishing textile industry.[122] Representations such as these belie the idea that only artists earning substantial sums through firmly established patronage networks had the financial liberty to pursue thematic innovations in their work. To the contrary, even artists whose paintings were intended for the lower echelons of the market occasionally took financial risks by introducing novel subject matter.

The *Tailor's Workshop* also signals certain stylistic changes in van Brekelenkam's art as he entered his final years of activity. The vertical format of this canvas, its spatial arrangement, and more open brushwork attest to these changes. At this time, van Brekelenkam also turned to representations of courtship and related themes and consequently introduced a hitherto unseen level of elegance and finesse into his work. The *Gallant Conversation* of around 1663 (fig. 119) shares the general spatial disposition of the *Tailor's Workshop* but the furnishings are more elaborate as is fitting for its subject: polite conversation between a smartly dressed couple. The interactions of the figures in this picture (and related ones by the master) owe much to the art of ter Borch, the foremost contemporary Dutch painter of courtship themes. The presence of a musical instrument and wine, time-honored motifs of love, suggest that the young pair converse about amorous matters. And consider as well the presence of a large, rocky landscape on the wall behind them. This landscape, with its traveler ascending a steep and arduous path, possibly comments upon the nature of the couple's relationship and love's travail in general.

There are, then, close connections between dalliance and gentility in these paintings – indeed, modern viewers have no trouble recognizing this given the plethora of sophisticated fashions, ornate furniture, and amorous motifs within them. Yet some details of seventeenth-century Dutch genre paintings of courtship that triggered responses from contemporary beholders elude modern-day viewers entirely. In van Brekelenkam's panel, this is true of the young lady holding the wineglass.[123]

Early modern social codes were enormously complicated; in the hierarchically structured societies of that period, one's rank and station in life were certainly predicated upon wealth, dress, and residence, but they were also demarcated by the potentially more subtle actions of gesture and posture. The woman in the painting holds the wineglass by delicately grasping its foot between her thumb and index finger, a courteous act reflective of good breeding and high social standing. Such motifs are frequently encountered in Dutch genre paintings executed after the middle of the century undoubtedly because of rapidly developing notions of civility at that time. Her manner of holding the glass was codified some fifty years later by de Lairesse in his treatise *The Art of Painting*.[124]

De Lairesse actually illustrates different ways in which glasses can be held (fig. 120) in the context of his discourse on how to represent figures in painting appropriately, namely, according to their station – he specifically distinguishes between "people of fashion" and "ordinary people." The accompanying engraving serves to demonstrate "different handlings of the same things in

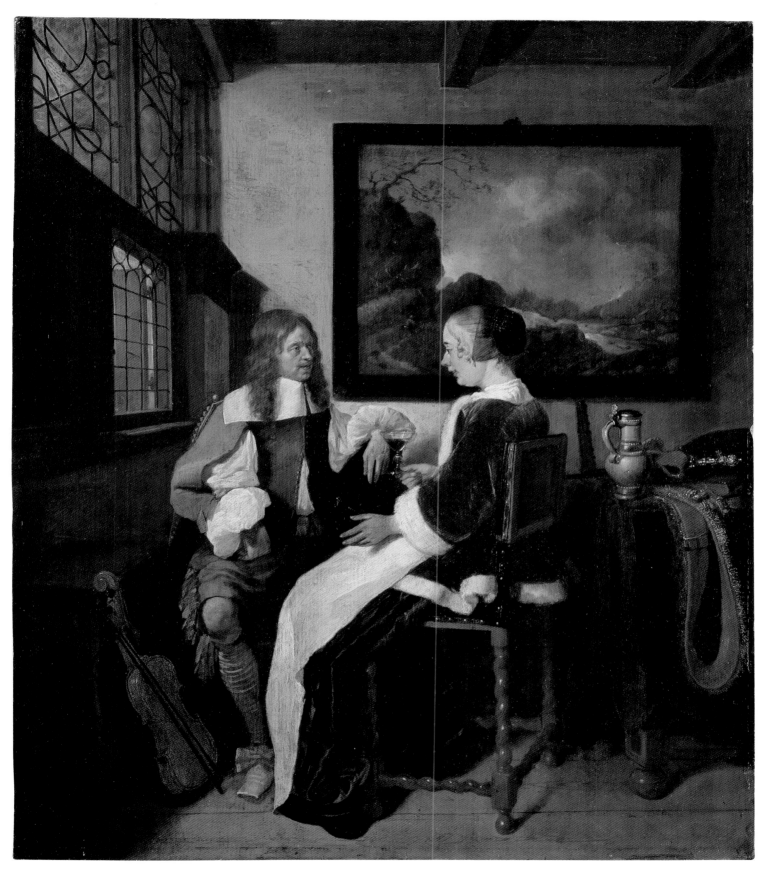

119 Quiringh van Brekelenkam, *The Gallant Conversation, c.* 1663 (oil on panel, 41.3 × 35.2 cm). New York, The Metropolitan Museum of Art, The Friedsam Collection, Bequest of Michael Friedsam, 1931 (32.100.19).

120 Illustration from Gerard de Lairesse, *The Art of Painting*, London, 1778. Collection of the author.

persons of different conditions." Number 5 approximates what can be seen in van Brekelenkam's painting; de Lairesse regards this as the most urbane way of holding a glass because it is

associated with princely behavior. Undoubtedly, contemporary viewers of the *Gallant Conversation* would have interpreted the motif of the woman with the glass in a like manner.

The *Gallant Conversation* and related works by van Brekelenkam bespeak the same wholesome, civilized values as costly pictures by the *fijnschilders* and ter Borch destined for socially elevated clientele. With these paintings van Brekelenkam successfully identified a market among less affluent clients who desired art replete with associations centered around savoir-faire and civility. This market was generated by the "trickle-down effect" of elite ideals as persons of lower social status often (though not always) aspire to the lifestyles and values of their superiors.[125] This co-optation of civilized values by non-elites continually impelled elites themselves to redefine the parameters of what constitutes civilized behavior as a strategy to exclude perceived social inferiors.[126] The result was the exceedingly evolved concepts of civility that permeated Dutch culture at the end of the century.

In sum, genre painting in the prosperous city of Leiden boldly emerged during the decades following the Treaty of Münster. Growing affluence and shifting tastes enabled artists such as Dou and van Mieris who practiced the *fijnschilder* style to acquire tremendous prestige (and wealth) both in the Dutch Republic and abroad. Yet other, prolific masters such as van Brekelenkam were successful in capturing a local market with art of more modest appearance and cost. Clearly, the demand for genre painting in Leiden was great during this period (as it was in many Dutch cities) and adroit artists worked tirelessly to meet it. The results of their labors solidified Leiden's prominence as an artistic center during the Golden Age and continue to enrich us today.

HAARLEM

Haarlem had reached its economic peak by 1650.[1] The city had flourished during the first half of the seventeenth century owing to its thriving enterprises of beer-brewing and especially wool and linen production. Unfortunately, the tremendous growth in the Dutch economy between 1648 and 1672, which chiefly benefited the port cities of the Province of Holland, generally bypassed Haarlem. Moreover, its impressive textile industry began to show signs of malaise. This was mainly triggered by heated competition in wool manufacture with other Dutch cities, most notably Leiden, and with other nations. In response, Haarlem's entrepreneurs shifted production to the countryside, specifically to the southeastern regions of the Netherlands where operating costs were significantly cheaper. In doing so, they followed the practices of their colleagues in the linen business. The city's renowned bleaching industry continued unabated; however, bleached linens were increasingly manufactured outside the Dutch Republic. Likewise, beer-brewers began to face increasing competition from Germany, which eventually precipitated a steep drop in the number of breweries active in Haarlem. Despite the rise of the silk industry in the city at this time, Haarlem experienced stagnation after the middle of the century followed by a marked decline in its economic vitality after 1670.

The most dramatic effect of the reverses to Haarlem's economy can be seen in her population statistics as numerous residents left to seek their fortunes elsewhere. As noted in Chapter 2, the city's population doubled between the 1580s and 1622, to approximately 40,000 inhabitants. This number stood at 54,000 in 1670 only to diminish by some 20,000 by 1707. A noticeable decrease in the number of houses in Haarlem between 1665 and 1680 suggests that the population already began to decline there during the late 1660s.[2] An ambitious endeavor by the city fathers to enlarge the municipality to accommodate an anticipated flood of Protestant refugees from France owing to mounting troubles with that nation was eventually halted for the expected numbers failed to materialize.[3] A larger city was entirely unnecessary since Haarlem was no longer capable of retaining its own citizens let alone attracting immigrants. Concomitant with the decrease in the town's population was a decline in individual income as tax statistics corroborate.[4]

Despite Haarlem's stagnated economy and consequent population woes during this period its wealthiest citizens participated in the widespread trend among the Dutch Republic's elite toward more lavish yet refined lifestyles, albeit on a lesser scale than their peers in such towns as Amsterdam and The Hague.[5] The desire among these persons for more civilized and sophisticated genre paintings was met by a dwindling number of important masters who continued to live in Haarlem.[6]

Adriaen van Ostade

In contrast to his uproarious image of riot and inebriation in *Peasants Drinking and Making Music in a Barn* (see fig. 32), painted early in his career, van Ostade's *Peasant Family in a Cottage* of 1661 evidences a number of important stylistic and thematic changes (fig. 121).[7] In this painting the palette has become considerably cooler – for example, the bright pastel blues of the earlier painting have been replaced with a blue of a much lower intensity that approximates slate gray. The application of paint is slightly smoother and tighter. There is also greater attention to detail and not merely in the picturesque proliferation of objects scattered throughout the room. Van Ostade has meticulously depicted individual figures and motifs such as the wicker basket beside the mother playing with her child. The energetic composition of the earlier painting has been exchanged for one more carefully controlled and the murky, dramatically spot-lit interior has been replaced by one more evenly lit and expansive. Moreover, the frenzied scene of peasants drinking has been superseded by one of utter domestic tranquility. This peasant family is sober, tender, and loving. The only significant action occurring in this peaceful image is that of the two children at play.

Even van Ostade's later representations of peasants in taverns differ substantially from those made during his early career. Consider, for instance, his *Peasants in an Inn* (fig. 122) of 1662.[8] The placid demeanor of the peasants is once again remarkable, all the more so because they appear in a setting that had previously served as a pretext to portray rowdy dissipation. Here, a group of yokels sit amicably together, presumably having listened to a companion just play the violin. Even the blue-capped peasant toasting does so in a relatively restrained manner. The *Peasants in an Inn* is analogous stylistically to the *Peasant Family in a Cottage*. It manifests the same shift toward cooler tonalities in the artist's palette likewise applied more smoothly and tightly. A

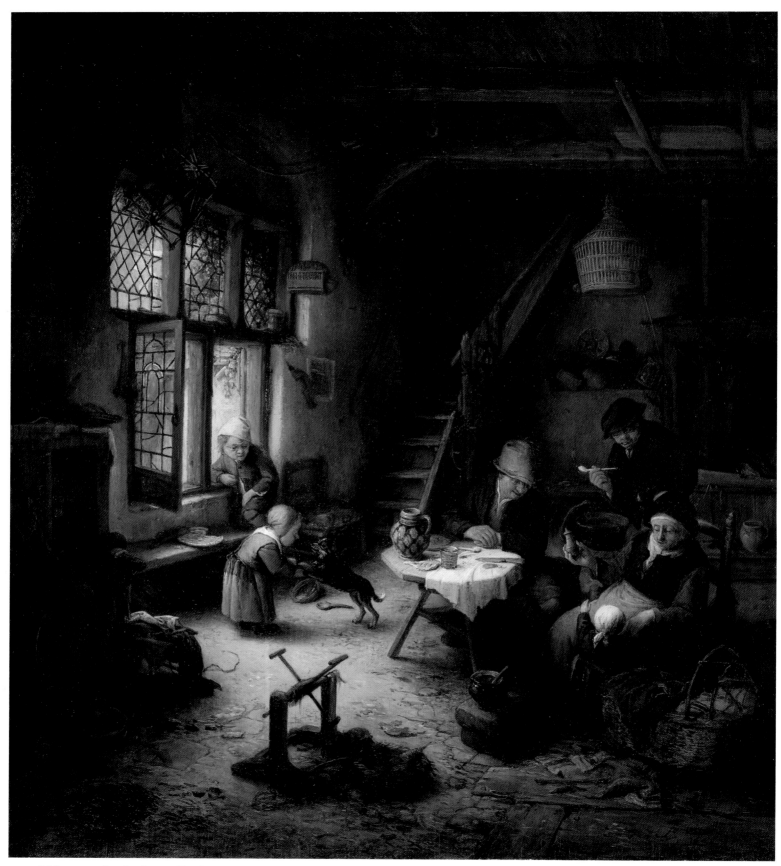

121 Adriaen van Ostade, *Peasant Family in a Cottage*, 1661 (oil on panel, 34.9 × 31.1 cm). Private collection.

plethora of painted details similarly litter the spacious chamber in which the scene occurs.

The transformation from an early image of rowdy, drunken peasants to two later ones of dignified, well-behaved peasants is not unique to these three paintings. Naturally there are exceptions, but modifications to van Ostade's manner of rendering boors were as profound as they were permanent – something long recognized by art historians.[9] Although there is no modern monograph on Adriaen van Ostade's paintings a scholarly consensus nonetheless exists that the artist began to modify his style during the 1640s.[10] But many specialists have found these modifications baffling. For example, the renowned, early twentieth-century art historian Wilhelm von Bode regarded van Ostade's images as nothing more than direct transcriptions of reality, a commonly held view of Dutch art at that time. Consequently, von Bode believed that these pictures more or less documented the evolution of the social development of the peasantry from poverty to prosperity.[11] Yet if this were true, rustics in the Dutch Republic must have become prosperous virtually overnight since van Ostade recast his representations of them within a relatively short period.[12] Obviously, scholars no longer consider Dutch paintings transcriptions of seventeenth-century life. Nevertheless, Hessel Miedema, writing in 1977, wondered whether the novel, placid mood of depictions produced around the middle of the century mirrored fresh, contemporary perceptions of peasants.[13]

Still others have argued that these new, seemingly unprecedented representations should be tied to textual traditions extolling the usefulness of peasants in providing food for society or to the joy of their carefree existence unencumbered by the concerns of urban dwellers.[14] The literary construct of the happy, productive peasant is indeed longstanding but apart from calendar miniatures in medieval illuminated manuscripts, sixteenth-century prints that continue this cosmological tradition, and a few other scattered examples, an equally viable pictorial tradition does not exist.[15] Furthermore, it would be exceptional if the sweeping metamorphosis in van Ostade's art could be explained purely as the result of the abrupt, unexpected influence of a different literary tradition.

Interpreting these paintings as illustrations of joyful, light-hearted peasants is not categorically incorrect; indeed, inscriptions on some of van Ostade's prints of similar imagery confirm this. For instance, the Latin inscription on the fifth state of *The Breakfast* of around 1650 (fig. 123) presents a free variation on one of the elegies of the Roman poet Tibullus, which reads as follows: "We spend time for an untroubled table. After a lengthy wait, a fair day comes." The inscription interprets the scene in a sympathetic, positive light, celebrating the peasants' respite from toil.[16] The fact that it is in Latin reminds us that van Ostade's prints, with their proliferation of picturesque detail, were usually intended for educated audiences. However, this inscription, and those on other prints, only indicates one possible manner

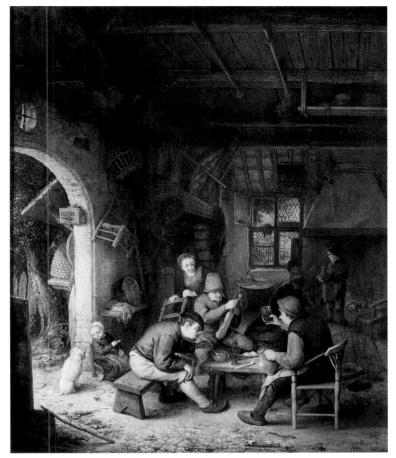

122 Adriaen van Ostade, *Peasants in an Inn*, 1662 (oil on panel, 47.5 × 39 cm). The Hague, Mauritshuis.

123 Adriaen van Ostade, *The Breakfast*, c. 1650 (etching). Collection of Dr and Mrs S. William Pelletier, Athens, Ga.

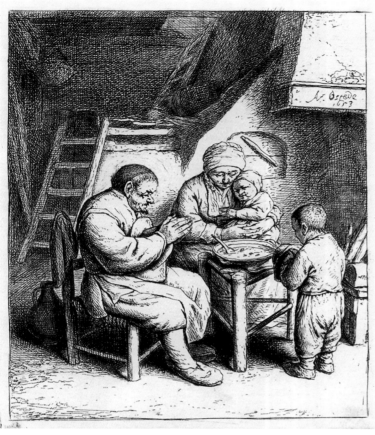

124 Adriaen van Ostade, *Grace*, 1653 (etching). Collection of Dr and Mrs S. William Pelletier, Athens, Ga.

1648. In fact, some of his etchings rank among the earliest representations of particular domestic subjects. For example, the artist's touching print of 1653 of a poor family saying grace anticipates paintings of this subject by genre painters of the late 1650s and 1660s (fig. 124).[17] Conversely, the development of the theme of domesticated peasants in his own paintings and prints was partly inspired by his colleagues' paintings of domesticity.

Still other factors likely affected van Ostade's thematic innovations, foremost among them his patrons, who probably desired portrayals of well-behaved peasants because they deemed earlier ones undignified. Yet one cannot infer that affluent collectors suddenly liked peasants or were even sympathetic to their social status, for sympathy with persons of a low class or those in dire straits is largely a modern sentiment. Rather, by 1650, notions of civility were becoming so well entrenched that certain patrons sought to demonstrate superlative taste and, consequently, good breeding and social distinction, by purchasing and displaying depictions of less raucous subjects such as peasants acting responsibly and sedately within domestic settings. By comparison, older paintings of boisterous peasants, where the frenzied action often occurs in barn-like hovels, must have struck some buyers as brutish and tasteless.[18]

The bumpkins' commendable behavior in van Ostade's later paintings is also manifested by their more erect stances and by the heightened attention paid to their physiognomic features. The painter made them appear much more "human" than their earlier cousins who were illustrated with distorted postures in either total anonymity or with their turgid features only partially exposed. Peasants thus metamorphose from churlish, bestial types to well-mannered humans.[19] Most importantly though, the transformation of peasants in art does not necessarily signal transformations in actual life, for invariably, such pictures primarily articulate the concerns and interests of affluent, urban dwellers. The changing reception of low-life imagery among patrons can therefore be charted as follows: through much of the first half of the century, condescending images of animalistic, unruly peasants affirmed superior social status while providing an endless source of entertainment. Thereafter, under the burgeoning influence of civility, van Ostade contributed to the introduction of a more tempered rendition, probably reflecting as well as shaping the progressively genteel sensibilities of the urban audiences to whom he marketed his work. Such collectors now deemed earlier paintings uncouth and consequently preferred more agreeable portrayals of boors.[20] In essence then, van Ostade's increasingly refined style linked him with broader developments within Dutch art and culture during this period.

In a provocative hypothesis first expounded in 1977 Lyckle de Vries posited that the work of van Ostade and many of his contemporary colleagues, including ter Borch, betrays marked attention to style over content, a phenomenon that he termed *iconographische slijtage* (iconographic erosion).[21] According to de

in which seventeenth-century viewers could have understood van Ostade's peasant representations – it is difficult to imagine that van Ostade's imagery can be reduced or distilled to just one meaning, a meaning moreover that is tied so directly to texts, a meaning that neither takes satisfactory account of the potential audiences for his pictures nor of the pictures themselves, that is, of the style in which they are conceived.

In the late 1640s, Dutch genre painting began to undergo sweeping changes. As the preceding chapters have shown, artists such as Dou and ter Borch executed genre paintings of unprecedented refinement. By comparison with these delicately illuminated, exquisitely crafted works of great narrative subtlety early seventeenth-century interiors must have seemed old-fashioned. Adriaen van Ostade was certainly responsive to new technical achievements as the pictorial devices that he utilized in his paintings from this period corroborate: smoother, tighter brushwork, a proliferation of meticulously rendered detail, and more intricate and sophisticated light effects.

Adriaen van Ostade also played a role (though one not yet completely understood) in the development of new themes, such as domesticity, which emerged after the Treaty of Münster in

Vries, as the seventeenth century progressed, the symbolic, inherently moralizing content of Dutch genre painting gradually diminished in the face of its growing aestheticization. Thus by the middle of the century the wholesale exhaustion of iconographic traditions and ensuing decrease in demand for didactic art fostered new representational and stylistic approaches that asserted the primacy of the aesthetic, formal aspects of paintings. Presumably symptomatic of iconographic erosion would be the gradual supplanting of admonitory images of unruly peasants by those depicting boors neutrally as peaceful denizens of an idyllic countryside.[22]

De Vries astutely recognized the evolving appearance of Dutch genre painting as the century proceeded and its relationship to altered interests and expectations among patrons and artists. However, his theory is predicated on the assumption that early seventeenth-century Dutch genre paintings were predominantly moralizing because they were supposedly inspired by emblems.[23] As Part I of this book repeatedly demonstrated, paintings evoked multivalent associations for diverse audiences as opposed to ones exclusively didactic for a homogeneous audience. Equally problematic is the implication of iconographic erosion that aestheticization, namely the pronounced elegance and refinement of later genre paintings, renders content extraneous because it rests on the dubious supposition that the formal qualities of pictures are completely meaningless.[24]

In sum, genre paintings produced after 1650 lost none of their capacity to signify. Artists of this period did indeed revitalize iconographic traditions but the adjustments they made to existing themes owe more to shifting conventions than to the supposed enervation of these traditions. Moreover, in this period of unprecedented wealth and cultural progression an ever-widening circle of sophisticated and affluent clientele helped inspire the unprecedented development of new themes concentrating on gentility (ter Borch) and rectitude (Dou), the latter even extending, oddly enough, to representations of peasants (van Ostade).

Cornelis Bega

By early modern standards of longevity van Ostade lived until the ripe old age of seventy-five, remaining active until the very last years of his life. Several members of the next generation of Haarlem painters passed through his studio, most notably Cornelis Bega (c. 1631/32–1664).[25] Arnold Houbraken's biography of Bega, written in the early eighteenth century, provides the only evidence that the young artist studied with van Ostade. Houbraken actually opines that Bega was the master's best student.[26] Judging from Bega's remarkable work Houbraken's opinion must surely be correct. The painter stemmed from a prosperous family with illustrious artistic roots: his father was a

gold and silversmith and his maternal grandfather was the celebrated Mannerist artist Cornelis Cornelisz. van Haarlem (1562–1638), who had helped solidify Haarlem's reputation as an important art center during the early seventeenth century (see fig. 2).[27] Bega most likely studied with van Ostade between 1650 and 1653, yet given his age (eighteen) and family circumstances, he was probably already a somewhat competent artist when he entered van Ostade's studio. His experiences in the older painter's atelier abruptly ended in the spring of 1653 when Bega embarked upon a seventeen-month tour through Germany, Switzerland, and France accompanied by his colleague Vincent Laurensz. van der Vinne (1628–1702) and by another friend.[28]

Bega returned to Haarlem in the late summer of 1654 and immediately enrolled in the city's Guild of St. Luke. His earliest pictures and graphic work – Bega was a superb draughtsman whose initial drawings were superior to his paintings – date to the early 1650s and reveal the influence of van Ostade both in subject and in style.[29] His paintings of this period are fairly loosely composed, recalling the chaotic mood of van Ostade's crowded peasant scenes of the 1630s. Bega's career was cut short as he died tragically of the plague in 1664, but his maturation into an accomplished painter was rapid. By the late 1650s, he was executing masterful and innovative paintings. Like van Ostade, Bega was primarily a painter of peasants and related, low-life characters. His depictions of boors, executed during a period in which the thematic possibilities for their rendition had greatly expanded, run the gamut from virtuous to risqué.[30] Despite the general constraints of this subject matter Bega, by seventeenth-century standards, produced some highly original art.

His *Young Mother* of roughly 1659–60 is unusual in its portrayal of a woman confronted or perhaps exploited by a besotted man (fig. 125).[31] This subject, which Bega painted repeatedly around 1660, has iconographic roots in depictions of drunken females and, more significantly, in those representing women as victims or hostages of soldiers.[32] The latter category was a specialty of Pieter Codde and Willem Duyster, Amsterdam artists with distinct connections to Haarlem. Duyster in particular provided an important precedent (see fig. 57) for Bega's rendition of various textures and stuffs, most notably the nursing mother's gray apron and the brilliant white blanket of her child. In the years between his earliest work and the *Young Mother* Bega had assimilated a variety of different pictorial styles and approaches including, among others, the late, classically tempered paintings of his famous grandfather, van Haarlem, the art of the so-called Haarlem classicists such as Pieter de Grebber (1600–c. 1652/54), and the work of the Flemish painter David Teniers the Younger (1610–1690) whose influential depictions of peasants (see fig. 37) were avidly collected in the Dutch Republic.[33] Bega subsequently fashioned relatively tranquil representations with figures on a hitherto unseen, large scale, delineated with

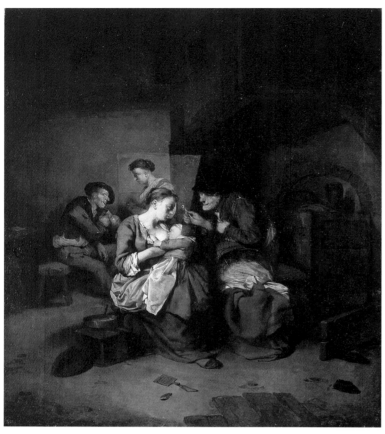

125 Cornelis Bega, *Young Mother*, *c.* 1659–60 (oil on panel, 41 × 35.6 cm). Capetown, Michaelis Collection.

smoother, tighter brushstrokes and a brighter palette. In other words, Bega began to make paintings whose stylistic features were *au courant*.

Yet Bega's new, modish manner of execution was often placed at the service of coarse subject matter. The *Young Mother* illustrates general dissipation, from the pipe-smoking miscreant to his drunken colleague in the background with the beer tankard.[34] And the young woman herself, with her sluggish, inebriated gaze and pallid countenance highlighted by dark, sunken eye sockets, epitomizes addiction. The expressive subtlety of this woman's stupor and that of her fiendish counterpart are compelling and provide further evidence of the artist's formidable talent. But feelings of sympathy for the mother and child should not be projected onto seventeenth-century audiences, for representations of the lower classes were never meant to elicit compassion for the downtrodden. To the contrary, in a society with distinct hierarchies the hapless status of the unwashed masses was regarded as divinely ordained. Moreover, their destructive behaviors were deemed intrinsic to their very being since according to contemporary estimations peasants and other base folk ranked only slightly above the level of brute beasts.[35]

Bega's thematic repertoire also included representations of quack scientists, especially alchemists, a subject he depicted at least four times.[36] The most outstanding version, an *Alchemist* signed and dated 1663, is currently in the collection of the J. Paul Getty Museum in Los Angeles (fig. 126).[37] In a cluttered, shabby interior, a bearded alchemist in tattered clothing concentrates intensely as he is about to place a red, powdery substance on his scales. He is surrounded by the detritus of his profession: books (including one on chiromancy) and papers, cryptic substances, bottles, strangely shaped jars, and chipped earthenware abound. Bega has depicted these items with astonishing mimetic fidelity which rivals the art of Dou and Frans van Mieris the Elder. This is no coincidence given his deepening familiarity with their work during the last years of his career. Every chink, imperfection, and reflection in the implements scattered about the room has been deftly captured. Bega has even expertly rendered the dust lying on the discarded clay vessels in the foreground.

Alchemy was first practiced in Europe during the Middle Ages.[38] Part science, and part materialist philosophy, it was based upon the theory of transmutation, to wit, that all matter in nature was mutable and hence interchangeable. Transmutation was in turn grounded in Aristotelian notions of the four elements – earth, air, water, and fire – which were considered, like atoms and molecules today, fundamental constituents of the universe. Alchemists conducted complex (and downright dangerous) experiments in which they strove to create a substance whose elemental properties were in such perfect equilibrium that they constituted a quintessential "fifth element." This newly created matter, called the philosopher's stone, could then be utilized to transmute other, theoretically unbalanced substances into equally pure matter. This endeavor had medicinal and especially metallurgical applications as alchemists strove to transmute metals into their supposedly purest form: gold. Alchemy has long been discredited as a psuedo-science. Nevertheless, in the seventeenth century, many scientists did not simply dabble in alchemy as is sometimes stated; to the contrary, they practiced it with utmost earnestness. In this era in which science was in an embryonic stage of development, alchemy's laboratory precepts provided the foundation for what eventually became the discipline of chemistry.

Representations of alchemy in art and literature, based as they are upon tropes, diverged widely from these realities, however, as is so often the case. By the sixteenth century, for example, the alchemist's ceaseless attempts to create the philosopher's stone became the fodder for many humorous representations in which his preposterous and unavailing activities served as fitting metaphors for human folly in general. The Flemish artist Pieter Bruegel the Elder, whose imagery proved so consequential for seventeenth-century Dutch genre painters, provided a design for an engraving that comically illustrated the vain pursuits of the

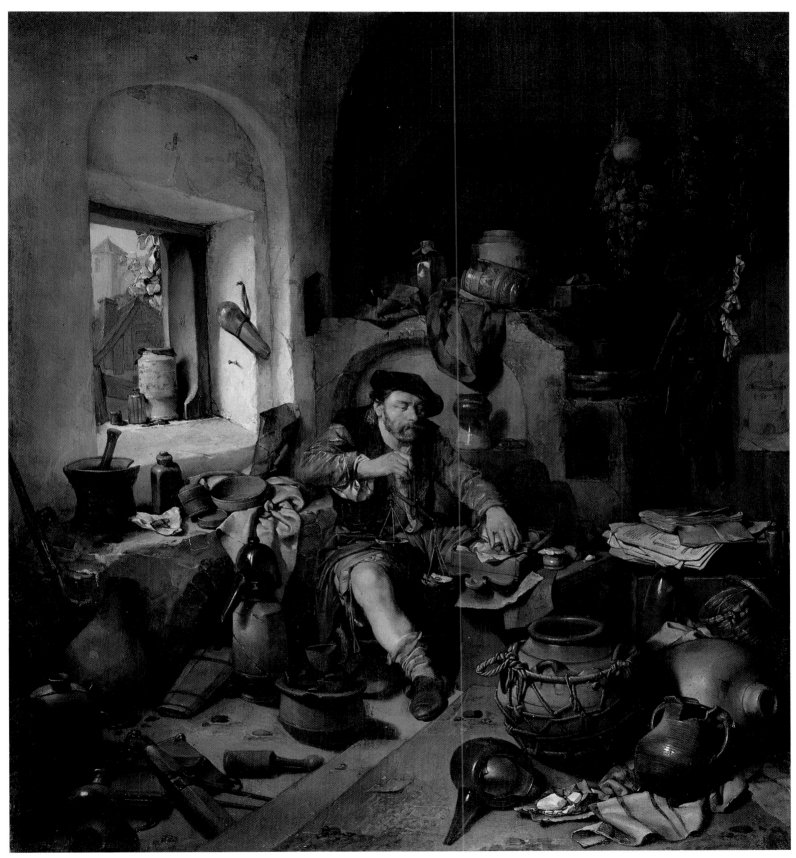

126 Cornelis Bega, *Alchemist*, 1663 (oil on panel, 35.6 × 31.8 cm). Los Angeles, The J. Paul Getty Museum.

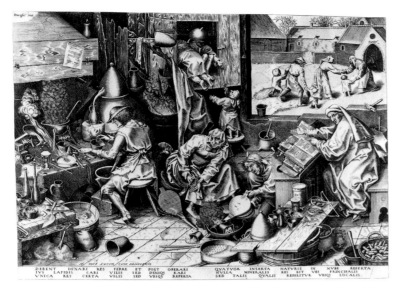

127 Philips Galle after Pieter Bruegel the Elder, *The Alchemist, c.* 1558 (engraving). New York, The Metropolitan Museum of Art, Harris Brisbane Dick Fund, 1926 (26.72.29).

alchemist and its calamitous repercussions for his impoverished family (fig. 127).[39] The print includes a scholar who gestures broadly at the frenzied scene before him while pointing at a book inscribed "Alghe Mist" a clever pun on the term for practitioners of alchemy as well as the words *al ghemist*, meaning everything is ruined or foul.

This homonymic word play was adopted by numerous seventeenth-century Dutch authors who mercilessly lampooned the profession.[40] Comically derisive images of alchemists were also made by Dutch genre painters, among them Jan Steen, who lived in Haarlem between 1660 and 1670, and Bega's teacher, van Ostade.[41] Bega's *Alchemist* also partakes of this tradition though in quite subtle ways. The serious attitude of the artist's fastidious alchemist belies the foolishness of his quest. But his unkempt appearance and the vast pile of debris that surrounds him – the tangible evidence of past experiments gone awry – underscores his futile efforts. Furthermore, the hat, ruff collar, and cloak, hanging beside a Hieronymous Bosch-like drawing of an alchemical apparatus on the wooden partition, are the time-honored attire of charlatans.[42] Thus, like a quack the alchemist deceives others about his discoveries but really dupes himself in pursuing what is ultimately unattainable.[43]

Representations of quacks aside, the appeal of Bega's paintings undoubtedly lay in the striking combination of his frequently coarse subject matter clothed in an elegant style. The arresting visual effects of his pictures intensified during the last period of his brief career between roughly 1660/61 and 1664, as his *Alchemist* of 1663 attests. The *Duet* is signed and dated the same year, 1663, which was Bega's most productive one as an artist (fig. 128).[44] It offers a telling example of the seeming incon-

gruities of content and style in his œuvre. A young woman strums her lute in an expansive, stone interior, her fingering depicted with such accuracy that Mary Ann Scott, in her study of the artist, posited Bega's probable familiarity with string instruments.[45] A male accompanist, whose crude facial features contrast pointedly with the more delicate ones of his companion, sings and plays the violin beside her.[46] His plain outfit consisting of a dark brown shirt and roughly stitched leather jerkin (and headband!) likewise differs from his friend's elegant attire. The lutenist is literally enveloped in huge swathes of satin drapery which flow implausibly in every direction from her form. This multi-colored fabric, based on extensive drapery studies by the artist,[47] is reminiscent of those painted by ter Borch and especially Dou and his fellow *fijnschilders* from whose work Bega repeatedly drew inspiration during his final years of activity. Indeed his smooth application, composed of a myriad of tiny, overlapping brushstrokes, is exceedingly close to Dou's.[48]

The lavish fabrics are complemented by the expensive instruments: in addition to the violin and lute, a bass violin rests against the bench in the foreground while a shawm, the ancestor of the oboe, lies just above it. Costly music books are also heaped beside the figures. The murky, grayish-brown background of this ambiguous, lapidary setting also contains a large ewer and expansive curtain whose knots and folds echo the fabric encasing the lutenist. The emphasis here is upon luxury with possible allusions to antiquity; therefore, similar works by the artist and his circle have been associated with abstruse allegories of music and hearing.[49] Whether the *Duet* evokes similar associations remains an open question.

Once again, the juxtaposition of plebeian types with expensive accouterments depicted in a polished, bright style is peculiar yet stunning. Scott speculates that Bega's comfortable economic circumstances account for his unusual depictions: his financial freedom supposedly liberated him from the pressures of having to earn a living by selling his work thus allowing him to experiment with subject matter.[50] This theory imputes too much creative license to Bega, entangling him in concepts of art and originality more germane to centuries beyond his own. Although little is known about contemporary collectors of Bega's work, some were quite affluent, among them, the painter Jan Miense Molenaer.[51] Moreover a representation of a female peasant by Bega valued at the respectable sum of 54 guilders, was owned by the art dealer Gerrit van Uylenburgh who specialized in costly pictures.[52] Thus Bega's work was generally marketed to an elite clientele.

It is precisely this target audience then that accounts for the singular appearance of Bega's paintings. Far from producing works of art on a whim without concern for their eventual sale, as Scott proposes, Bega's art was carefully calculated to appeal to elite tastes. Perhaps inspired by the combination of sophisticated style and coarse themes in the work of Brouwer (his teacher's

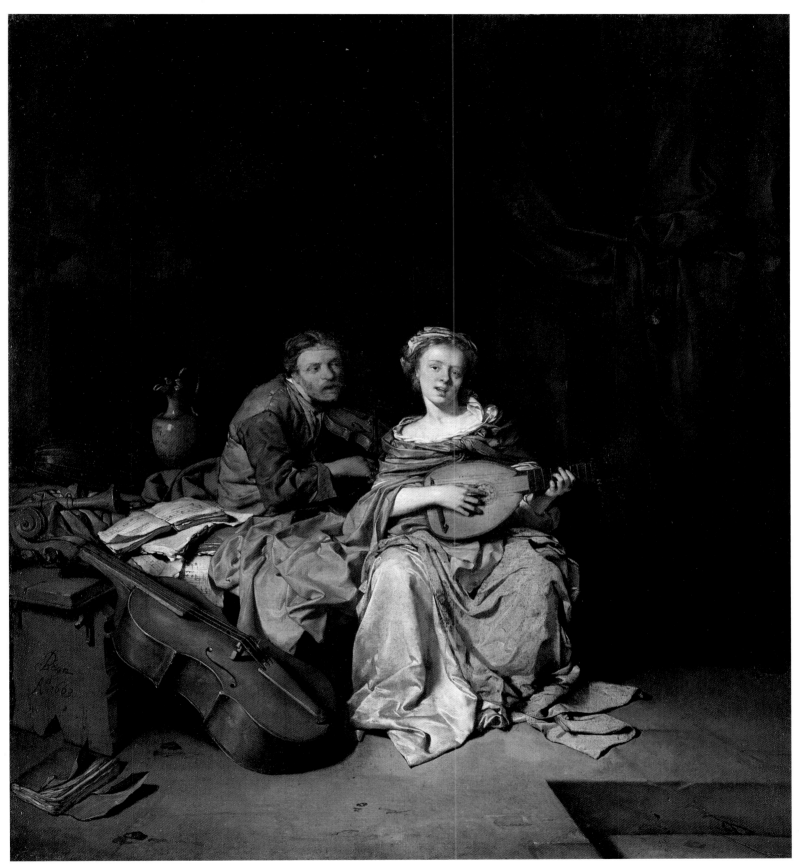

128 Cornelis Bega, *Duet*, 1663 (oil on panel, 45 × 41 cm). Stockholm, National Museum.

own master), and in particular the witty and ironic commercial success that master had enjoyed by fusing base imagery with sophisticated painting techniques (in Brouwer's case, though, loose brushwork was then fashionable),[53] Bega adopted a similar approach but modified it to suit the proclivities of collectors of his generation who generally preferred bright pictures with smooth, tight application and lustrous textural effects. Bega's highly successful career, however brief, simultaneously testifies to the continual recasting of peasant types in art motivated not by a desire to admonish elites but to conform to current tastes informed by notions of civility and *savoir-vivre*.

By the time of van Ostade's death in 1685, economically debilitated Haarlem had lost of much of its vitality as a center for progressive painting of any sort. Skilled artists continued to live and work there but in drastically reduced numbers versus the early decades of the seventeenth century.

CHAPTER TEN

DORDRECHT

Dordrecht is the oldest incorporated city in the Netherlands, having been granted a charter by William I, Count of Holland, in 1220.[1] Thus by the seventeenth century, Dordrecht was already some 400 years old. Fortuitously seated on a delta formed by the confluence of the Maas and Waal Rivers at the mouth of the Rhine River, Dordrecht had enjoyed an illustrious history as a trading center. During the Middle Ages it had completely dominated the Northern Low Countries economically. However, over the centuries, other thriving port cities in the region began to eclipse Dordrecht. Antwerp, for example, usurped Dordrecht's prominent role in trade during the sixteenth century only to be superseded itself by Amsterdam and Rotterdam in the seventeenth. Accordingly, during the heyday of the Dutch Republic Dordrecht ranked a distant third behind Amsterdam and Rotterdam among Dutch ports engaged in inland trade. Moreover, its role in lucrative overseas shipping, so vital to the Netherlands' extraordinary economic success during the postwar decades, was sharply curtailed.

The town's diminished economic circumstances are reflected in its population statistics. With its growing inability to compete commercially Dordrecht never attracted the enormous waves of immigrants that flooded other cities in the Provinces of Holland and Zeeland during the late sixteenth and early seventeenth centuries. As a result, between 1600 and 1700 its population rose only some forty-five percent, from 15,000 to 22,000 by the century's end.[2] By comparison, Amsterdam experienced a 200 percent increase in the number of inhabitants (from 65,000 to 200,000) and Rotterdam a 270 percent rise (13,000 to 48,000) during the same period.[3] Nevertheless, Dordrecht remained prosperous, well-served by trade along the Rhine and Maas Rivers in such goods as timber, wine, and iron ore. Additionally, the city was a site for salt-refining and for ship construction and repair.

Despite Dordrecht's lessened economic circumstances it continued to exert a notable impact upon provincial and national politics. The city had a celebrated history and was home to many regent and aristocratic families of lofty status and imposing lineage. Traditionally, the Pensionary of Dordrecht, that is, the legal advisor and principal administrative officer, wielded great influence in representing the city at the States of Holland, the governing body of the most powerful province in the Dutch Republic. Furthermore, several of Dordrecht's pensionaries were appointed to the position of Pensionary of the States of Holland, including Jacob Cats and Johan de Witt. Consequently, the interests of Dordrecht were actively promoted at the highest political and legal levels.

Dordrecht was also a bastion of Calvinist orthodoxy during the seventeenth century. The city had hosted the Synod of Dordrecht in 1618–19, an international gathering of the leaders of the Calvinist Church.[4] It was this Synod which definitively ruled in favor of the Counter-Remonstrants in their theological controversy with the Remonstrants concerning the doctrine of predestination. Compared with other towns in the Dutch Republic a huge percentage of the population of Dordrecht adhered to the teachings of the Reformed Church,[5] yet the near homogeneous religious conditions did not prevent discord between church leaders and town officials. In the years immediately following the Synod of Dordrecht relations between church representatives and the ruling elite began to deteriorate. The Reformed Church's governing body in Dordrecht, the classis, ultimately succeeded in instituting a public form of Protestant piety there most notably by abolishing open worship by Catholics. But its efforts to influence public morality by curtailing the city's flourishing culture of popular amusements, among them, taverns, gambling, the celebration of traditional, religious feast days, and the like, were continually stymied by civic authorities. The attempt by Calvinist leaders in Dordrecht to regulate communal mores on seemingly every conceivable level was a dismal failure, an outcome replayed all over the country.

Moreover, as so often happened in the Dutch Republic, local religious and politic struggles – which were usually interwined – had national ramifications, for Dordrecht's regents were generally anti-Orangist in sentiment, especially during the Stadholderless period when one of their own, Johan de Witt, effectively oversaw the nation. The regents were opposed by the city's church officials, traditional supporters of the Stadholder, as well as by many members of Dordrecht's guilds who were likewise staunchly Calvinist.[6] The prominence of the town's elites in the political arena naturally extended to the cultural one. As stated above, many stemmed from families with illustrious lineages. And while the prosperity of Dordrecht could not match that of Amsterdam and Rotterdam there was ample capital among her distinguished families to support the arts.

Collectively, Dordrecht's elite formed the largest body of patronage for the city's artists.[7] These members of the upper classes were keen to commission portraits, substantial numbers of which appear in contemporary inventories.[8] Landscapes and history paintings were also avidly collected, though the latter mostly during the first half of the seventeenth century. Genre paintings lagged behind in popularity among the elite. According to John Loughman, who has made a statistical study of the types of paintings in Dordrecht collections, the average percentage of genre paintings within them peaked during the 1660s at 10.4 percent,[9] the heightened interest prompted, perhaps, by the extraordinary levels of technical and visual refinement genre painting had reached and its popularity amongst the well-to-do. Samuel van Hoogstraten and, especially, Nicolaes Maes, Dordrecht natives who were former pupils of Rembrandt, may also have stimulated interest in genre painting.

Samuel van Hoogstraten

Samuel van Hoogstraten (1627–1678) was the son of Mennonite parents who had emigrated to Dordrecht from Antwerp.[10] He descended from a family of silversmiths. His father, Dirck van Hoogstraten (1596–1640), became a painter and registered with the Guild of St. Luke in Dordrecht in 1624 and, four years later, with the Guild of St. Luke in The Hague where Samuel spent part of his childhood. Van Hoogstraten himself declared that his father was his first master; presumably he had learned the rudiments of painting and engraving from him.[11] Shortly after his father's death, which occurred in December 1640, the young artist entered Rembrandt's studio in Amsterdam where he remained for several years. Archival documents place him in Dordrecht again in 1648 (but he certainly could have returned somewhat earlier).

Although it is not known whether van Hoogstraten received any formal schooling, he was a man of tremendous learning, a polyglot, and author of numerous literary works including a comprehensive treatise on art, the *Inleyding tot de hooge schoole der schilderkonst* (Introduction to the Lofty School of Painting), published in the year of his death, 1678.[12] Van Hoogstraten's activities as an artist and writer were intimately bound to his pronounced social ambitions: he was active in cultured, literary circles in Dordrecht and energetically cultivated potential patrons at courts in the United Provinces and abroad.[13] To this end, he departed in 1651 for Vienna and employment at the court of the Holy Roman Emperor Ferdinand III (ruled 1637–57). Van Hoogstraten's pupil and early eighteenth-century biographer, Arnold Houbraken, relates that Ferdinand III presented the artist with a gold chain and medallion in recognition of his skill at having confounded him with complex, trompe l'œil, still-life paintings – the medallion subsequently appeared in a number of van Hoogstraten's pictures.[14]

During his five-year tenure in Vienna, van Hoogstraten traveled with the court to Germany and embarked upon a trip of his own to Italy. He returned to Dordrecht in 1656, a celebrated artist and one of considerable financial means who, like many elites of his day, pursued the trappings of an aristocratic lifestyle. (Even before his departure for Vienna, he displayed a coat-of-arms and adopted the noble custom of carrying a sword, thereby estranging himself from his kin, the abstemious, pacifist, Mennonite community in Dordrecht.[15]) Despite his commercial and social success in his native city van Hoogstraten once again embarked upon a prolonged journey abroad, this time to London where he resided from 1662 to 1667, no doubt lured, as a letter he wrote from England to a friend implies, by the potential patronage of the recently restored Charles II and his court.[16] Upon his return to the Netherlands, van Hoogstraten settled in The Hague where he made portraits of the leading members of Dutch society. He purchased a home in Dordrecht in the autumn of 1671 but probably did not resettle there permanently until late 1673.[17]

Van Hoogstraten produced all types of pictures during his career but concentrated on portraits and history paintings. His genre paintings thus comprise a much smaller percentage of his output. *The Slippers* (fig. 129), which was once incorrectly attributed to Pieter de Hooch, marks an early foray on van Hoogstraten's part into the field of genre painting.[18] This interior scene must have been painted in the late 1650s because a pastiche of Gerard ter Borch's renowned *Paternal Admonition* of around 1655 (fig. 130) hangs on the background wall.[19] Moreover, the perspectival disposition of *The Slippers* with its progressive view through a series of vestibule-like spaces – a *doorsien* (literally, see through) in contemporary art-theoretical terminology – reveals the artist's familiarity with Nicolaes Maes's equally ambitious interiors painted as early as 1655.[20]

With *The Slippers* van Hoogstraten was clearly responding to contemporary developments in genre painting, as the presence of the ter Borch pastiche literally demonstrates. Furthermore, many of the items viewed through the doorway such as the footwear – hence the popular title of the canvas – empty chair, and candlestick with its extinguished candle askew, are conventional, recurring in many genre images at this time. Similarly, the high-key tonalities, skillful delineation of different textures, and bold use of light and shadow correspond to the stylistic devices employed by artists of van Hoogstraten's generation. But what makes *The Slippers* so unusual is the conspicuous absence of human figures. (In this respect, it highlights some of the problems discussed in the Introduction concerning the definition of what constitutes a genre painting.)

Van Hoogstraten possibly excluded protagonists from this painting in order to heighten its ambiguity in clever ways. The loose copy of ter Borch's *Parental Admonition* in the background sets the tone for the entire representation. The original painting by ter Borch is noteworthy for the deliberate vagueness of its

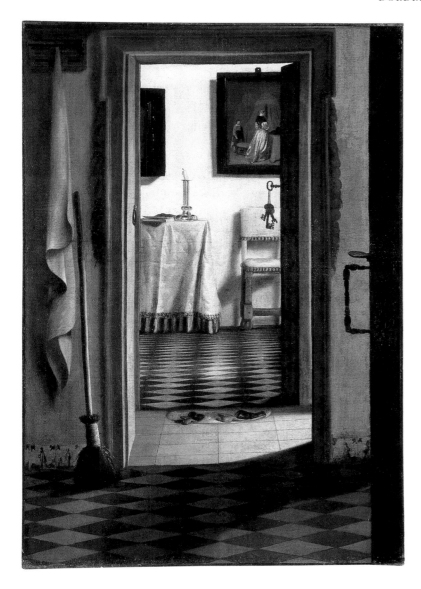

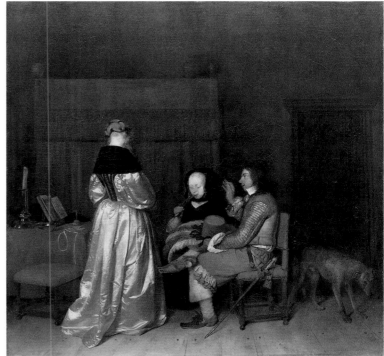

130 (*above*) Gerard ter Borch, *The Paternal Admonition*, c. 1655 (oil on canvas, 71 × 73 cm). Amsterdam, Rijksmuseum.

129 (*left*) Samuel van Hoogstraten, *The Slippers* (oil on canvas, 100 × 71 cm). Paris, Musée du Louvre.

subject matter, a feature intrinsic to most of his mature work. The anecdotal subtlety of ter Borch's art, its psychological innuendo created by scenes left deliberately unresolved for the delectation of beholders already captivated by dazzling pictorial effects have already been noted. The *Parental Admonition* in particular has been heralded for precisely these qualities. For example, Alison Kettering, in one of her superb studies of the artist, wisely emphasized its open-endedness which potentially allowed one viewer to construe it as a brothel scene while another might have interpreted it as an innocuous rendition of courtship.[21]

The objects strategically placed at salient points in van Hoogstraten's canvas function in an analogous manner. For contemporary Dutch literature, proverbs, and prints yield positive as well as negative (erotic) connotations for the keys suspended from the lock in the door, the slippers, the candlestick and candle, and even the broom.[22] Nevertheless, the individual beholder must determine the specific associations applicable to

the painting. And this beholder is implicated by the artist's masterful use of perspective which optically positions him or her at the threshold of this mysterious interior, as Celeste Brusati has so perceptively observed.[23] Van Hoogstraten was thus inspired not merely by one of ter Borch's paintings but by his very approach to subject matter. Discriminating connoisseurs of his day presumably would have recognized this. *The Slippers* is an unusual painting but its clever spatial construction did inspire several other genre specialists.[24]

Van Hoogstraten's most concentrated period of genre painting production occurred only during the last years of his career, around 1670–71. These later pictures exhibit limited subject matter focusing primarily upon domestic themes. Especially fascinating are his pendants of *Two Women by a Cradle*, dated 1670, and the *Doctor's Visit* (figs. 131 and 132).[25] In the *Doctor's Visit* a taciturn physician examines a flask containing the urine of an ailing young woman while another man (her husband?) looks

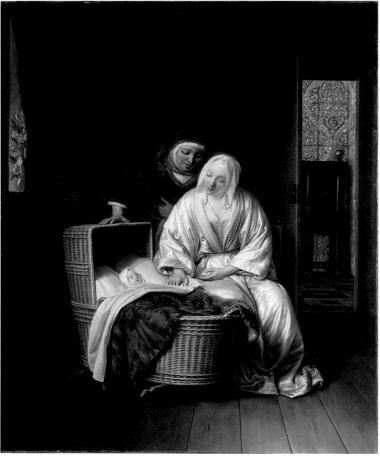

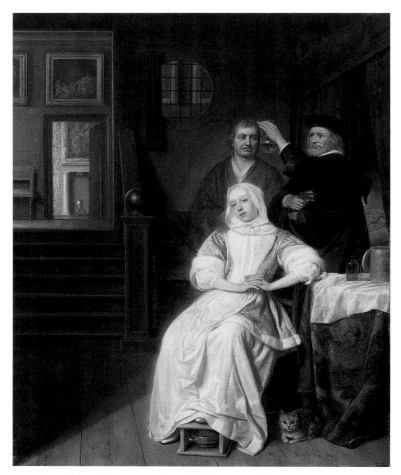

131 Samuel van Hoogstraten, *Two Women by a Cradle*, 1670 (oil on canvas, 66 × 54.5 cm). Springfield, Museum of Fine Arts, James Philip Gray Collection.

132 Samuel van Hoogstraten, *Doctor's Visit*, c. 1670 (oil on canvas, 69.5 × 55 cm). Amsterdam, Rijksmuseum.

on. This event takes place in a well-appointed house; the recession of space through two rooms in the background allows the viewer to scrutinize some very interesting paintings hanging on the walls and a sliver of a brilliantly illuminated gilt-leather wall-hanging. A more expansive, equally well-lit wall-hanging also appears in the *Two Women by a Cradle*, a canvas representing a mother and her companion affectionately gazing at an infant resting in a wicker cradle.

The inclusion of gilt-leather wall-hangings (an expensive decorative accouterment at this time), costly paintings, and sumptuous fabrics enhances the aura of opulence exuded by these pendants. And surely van Hoogstraten's meticulous application of paint and bright palette contributes to it as well. The paint application and silky sheen of the women's skin in both pendants recall the genre paintings of Caspar Netscher (see fig. 97). Netscher, who lived in The Hague, composed his last and most refined genre paintings during van Hoogstraten's sojourn there.[26] Most interestingly, the pendants are first mentioned in the estate inventory of Elisabeth Françoise Pauw, compiled in 1760.[27] Pauw

was the granddaughter of Maarten Pauw (1616–1680), a wealthy regent who lived in The Hague where he served as Receiver General for the States of Holland and West-Friesland. Van Hoogstraten made portraits of Pauw and his family in 1671, just a year after he completed the pendants.[28] The pendants were thus possibly owned first by Pauw. Even if this is not absolutely certain clearly the luxurious appearance of these two genre paintings would have appealed to a patron of Pauw's social status,[29] as would the placid, restrained imagery in this era of heightened civility; indeed, the solemn ambience of the *Doctor's Visit* contrasts strongly with other, boisterously humorous representations of this theme (see fig. 192).

Pendants in general are classified as such not merely because of their shared scale and complementary compositions: their subject matter is also linked.[30] Yet the thematic connection between van Hoogstraten's pendants has never been fully explained, owing perhaps to confusion concerning the true subject of the *Doctor's Visit* – some commentators have surmised that it depicts a doctor diagnosing the woman's pregnancy.[31]

However, as the illuminating studies of Laurinda S. Dixon and Einar Petterson have convincingly demonstrated, lovesick females in representations of this theme (see also fig. 193) usually suffer from the exact opposite "condition": they are not pregnant.[32] Specifically, they are afflicted by what contemporary medical experts called *furor uterinis* (uterine fits) or hysteria. The collective medical wisdom of the ancients, which remained strongly influential in the seventeenth century, held that the uterus coveted semen insatiably. If it were not accommodated, that is, if the distressed sufferer did not become pregnant, the uterus wreaked physiological and emotional havoc; it was thought to wander restively through the body causing excruciating pain as it constricted vital organs!

Beyond the infirm woman's pallid features and interlocked fingers (a gesture of mental anguish), both emotionally symptomatic of hysteria, additional motifs in van Hoogstraten's painting clarify both the nature and cause of her malady.[33] The cat, with the mouse between its paws, lying on the floor beside her, was traditionally associated with the aggressive female libido and was considered by many authorities the most promiscuous of all creatures.[34] In poems and songs infused with Petrarchan sentiments males are sometimes likened to hapless mice caught by cats.[35] The mouse in the painting has little to do with Petrarchan notions of love but it may imply the focus of the feline's desire, and, by allusion, the female's powerful sexual drive. At the very least the cat in this painting, within the greater context of seventeenth-century medical lore, implies the cause of its owner's illness: an unbridled uterus craving for intercourse which will furnish a definitive cure.

The *Doctor's Visit* also includes two intriguing paintings in the distant chambers. One represents Venus and her acolytes which complements the nudes woven into the elaborate covering on the table upon which the ailing young woman rests her elbow. The unequivocal erotic associations of these motifs clearly refer to her yearnings, or more accurately, the yearnings of her agitated womb. Over a mantel in the far back room, is a cropped detail of Raphael's *School of Athens* (Rome, The Vatican) a Renaissance fresco just as renowned in the seventeenth century as it is today.[36] Cognoscenti of van Hoogstraten's day erroneously believed that Raphael's presentation of the great philsophers of antiquity was a religious image. Its presence in the *Doctor's Visit* was possibly meant to allude to a second cure for *furor uterinus*: prayer and scripture reading which were thought to have a palliative effect on the womb.[37]

To describe van Hoogstraten's fascinating pendants according to the rather crude medical parlance of his day, if the *Doctor's Visit* represents the uterus inflamed then the *Two Women by a Cradle* represents the uterus restored through pregnancy and childbirth. For the peaceful atmosphere and tender emotions expressed in the latter picture proffer the salubrious effects of motherhood. The theme of mothers with their infant children

was not van Hoogstraten's invention but his numerous depictions rank among the most wholesome and touching. And their fashionable figures and decor rendered in a polished bright style bind them seamlessly to broader developments in contemporary genre painting. Brusati proposed that van Hoogstraten's depictions of this theme, which often display objects associated with birthing rituals in the Dutch Republic, served as decor in lying-in rooms to celebrate the arrival of a new child.[38] Whether her fascinating hypothesis applies to these pendants cannot be determined despite their tantalizing connections to the Pauw family.

Van Hoogstraten did not paint a significant quantity of genre paintings. Nevertheless, the few that survive from his hand were fascinating and, in some instances, influential.

Nicolaes Maes

Nicolaes Maes (1634–1693) was Dordrecht's most important genre painter in the years immediately following the Treaty of Münster. He was born in Dordrecht in 1634, the son of a successful merchant.[39] After studying briefly with an unidentified master the fledgling artist entered Rembrandt's studio probably in the late 1640s.[40] Following an approximately four-year stay in the famous master's atelier Maes returned to Dordrecht where he married in December of 1653. Initially he worked as a genre painter producing some forty paintings of this type between 1654 and 1659, but Maes also began to paint portraits during this period, perhaps motivated by commercial prospects following the death in 1652 of Dordrecht's leading portrait painter, Jacob Gerritsz. Cuyp (1594–1652).[41] By the decade's end, Maes was painting portraits exclusively. The overwhelming success of his fashionable portrayals of the city's well-to-do citizens induced him to move to prosperous Amsterdam in 1673 where potential earnings were infinitely greater. Maes died there in 1693 having become a portraitist of considerable acclaim and wealth.

Although Maes's activities as a genre painter were unfortunately compressed into a roughly six-year phase early in his long artistic career, his pictures were nonetheless innovative and decisive for the work of his colleagues in Dordrecht and in other cities. The artist's earliest genre work clearly reveals his familiarity with Rembrandt's paintings and drawings. For example, the warm brown and vermilion tonalities of his *Young Lace-Maker Beside a Cradle with an Old Woman Looking out the Window* of 1654 (fig. 133) recall a number of Rembrandt's compositions from the 1640s, particularly his representations of the *Holy Family* (fig. 134).[42] Further parallels lie in the rather grainy paint application (with some heavy passages of impasto) and such tender motifs as the sweetly dozing infant in the wicker cradle. Essentially, Maes has adapted for a genre context stylistic devices regularly employed by his teacher for history paintings.

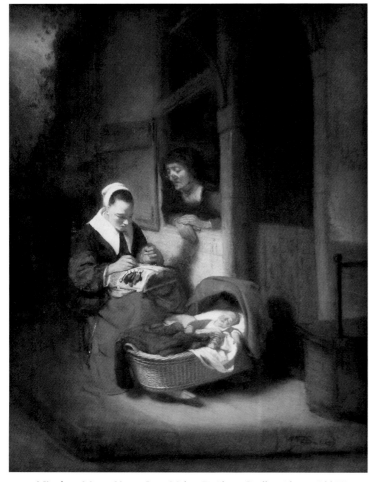

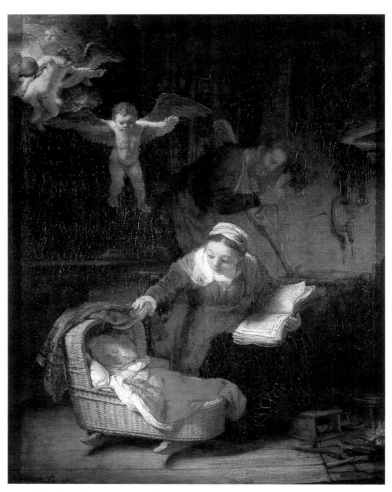

133 Nicolaes Maes, *Young Lace-Maker Beside a Cradle with an Old Woman Looking out the Window*, 1654 (oil on panel, 71.3 × 54.3 cm). Worms, Stiftung Kunsthaus Heylhof.

134 Rembrandt van Rijn, *The Holy Family with Angels*, 1645 (oil on canvas, 117 × 91 cm). St. Petersburg, Hermitage.

The most fascinating Rembrandtesque device in the *Young Lace-Maker* is the expressive use of light. In a peculiarly evocative manner, the light adopts a preternatural dimension investing this genre painting with a spiritual mien akin to Rembrandt's Holy Families. Bright light bathes the features of the lace-maker and baby mysteriously purifying them and transforming their radiant forms (and that of the elderly woman) into icons of moral perfection.[43] The combination of attentive lace-making and childcare here bespeak an image thoroughly imbued with domestic rectitude. The presence of the elderly woman peering from the window sill at the younger female's praiseworthy activities implies the passing of domestic skills and virtues from one generation to the next (and eventually perhaps to still another, implied by the sleeping child). This relatively early panel by the twenty-one-year-old Maes places him in the forefront of those masters painting images of domestic virtue after the Treaty of Münster. Indeed, during his brief career as a genre painter Maes created a disproportionally large amount of domestic images and related ones of virtuous elderly women.

In Maes's hands the latter theme frequently emphasizes fervent religiosity as is seen, for example, in his *Old Woman Saying Grace* (fig. 135), a painting likely executed around 1656.[44] The reddish-orange glow of the palette of this canvas and its subtle yet expressive chiaroscuro effects once again reflect Maes's intimate knowledge of the work of Rembrandt.[45] However, its comparatively meticulous facture – note the woman's remarkably wizened flesh and the resplendent delineation of the articles on the ledge above her – as opposed to the granular, pastose surface of the *Young Lace-Maker* provides evidence of Maes's effort to transcend the work of his teacher.

Here an aged woman prays ardently before her simple Lenten-like repast consisting of salmon – a common species in Dordrecht's surrounding waters – soup, bread, and cheese; the serene gaze on her wrinkled face bespeaks the intensity of her supplications as do her weathered hands, folded earnestly in prayer. This woman's fervid spirituality must be perceived in relation to her advanced age and the objects on the ledge referring to *vanitas*. Through motifs like the hourglass and Bible as well as

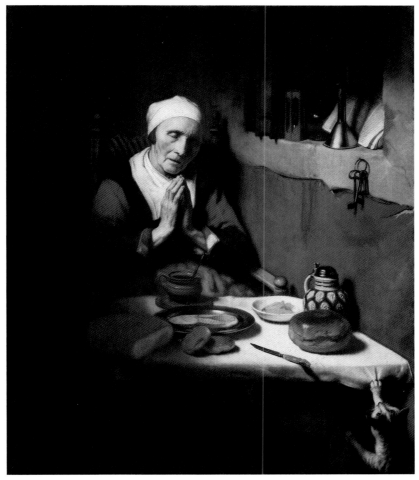

135 Nicolaes Maes, *Old Woman Saying Grace*, *c.* 1656 (oil on canvas, 134 × 113 cm). Amsterdam, Rijksmuseum.

the compelling naturalism of the painted surface, this canvas gently encourages the viewer to live humbly and piously in view of life's brevity. The cat pulling on the tablecloth imparts a witty touch of deviousness in an otherwise tranquil, sacrosanct scene.[46]

Genre paintings of the elderly were still something of a novelty in the middle of the century. Prior to this time old people had been portrayed by the Utrecht Caravaggisti (see fig. 70) and by Rembrandt (in a number of touching etchings and drawings surely known to Maes) and his erstwhile pupil Gerrit Dou (see fig. 117). Collectively these works of art partake of time-honored pictorial traditions; they share, for example, many details with engravings of aged men who personify winter in series of prints in the late sixteenth and early seventeenth centuries, linking the ages of man to the four seasons (fig. 136).[47]

The print reproduced here, an engraving by Johannes Sadeler (after a design by Hans Bol) dated 1580, illustrates the traditional association of old age with winter, including references to mortality for during that season many living things lie dormant or have already died. In the foreground, a venerable man wearing thick, fur-lined clothing sits by a fire on a little hill surrounded by provisions that will presumably tide him over during the winter months – note his gesture of prayer and the beam of light extending from heaven to the simple meal on the table beside him. The accompanying inscription informs us that this man, a personification of winter, is thankful for his food and drink since they are his just recompense for having toiled his entire life in preparation for his last years. The man's thick garments, like those rendered by Maes and other seventeenth-century Dutch genre painters, therefore function as an attribute of senescence, alluding to frail health and, ultimately, to life's impermanence.[48]

The ties between late sixteenth-century engravings of old age and seventeenth-century Dutch paintings of the subject once again attest to the highly conventional nature of both. Like other themes in Dutch art, the very conventionality of portrayals of the elderly reflected (and even shaped) the expectations of audiences who desired to see a limited number of subjects rendered in a specific manner. Hence, the conventions themselves, whether stylistic or iconographic, possessed an intrinsic level of

significance. The focus in these paintings of the elderly on the concept of vanity (embodied in the figures themselves) and on virtues like piety and humility parallels the ideas expounded in contemporary Dutch literature where they are purposefully presented as models of spiritual ardor and wisdom and as evidence for ephemerality. Nevertheless, such concepts are inextricably tied to the mimetic qualities of the paintings. For example, the very intensity of the facial expression of Maes's old woman, carefully delineated in all of its shriveled detail, vividly conveys associations of vanity and virtue. Therefore pictorial style is just as important an agent in communicating meaning as the props continually accompanying the old woman. Viewers must have derived considerable pleasure from the skill with which Maes and other artists rendered the withered, gaunt flesh, and hoary heads of these elderly figures.

Judging from the significant numbers of paintings of senescent types dating to after 1650, the market for them must have been considerable. Within a period of four years, Maes himself executed at least ten paintings of old women, most of whom appear within virtuous contexts.[49] But Maes simultaneously represented subjects illustrating assorted vices. While the latter are fewer in number than those with wholesome themes, his depictions of human foibles rank among the most imaginative genre paintings created during the seventeenth century. Maes's *Idle Servant* of 1655, one of his best known works of this type, demonstrates the breadth of his talent (fig. 137).[50] Here, a woman wearing a luxurious jacket with ermine trim – a garment which surely identifies her as the mistress of the house – gazes at the viewer while gesturing toward her plainly dressed, slumbering maid. Judging from the empty chair in the upper room behind her she has left the dinner party and descended the stairs to expose her servant's idleness. A prowling cat behind this soporific female steals a plucked chicken. Consequently, the guests gath-

ered around a table in the backroom unwittingly wait in vain for their meal.[51]

Earlier studies of this painting have rightly linked the scullery maid's somnolent state and pose – her hand supporting her head – to traditional images of sloth (fig. 138).[52] Thus, on one level, the *Idle Servant* is manifestly conventional.[53] Yet, on another level, it is quite innovative for like all talented artists Maes modifies conventional motifs and settings, enriching them in the process. In sixteenth-century prints (such as the one illustrated here) sloth is usually depicted in an allegorical, abstract setting. Earlier seventeenth-century representations of this vice enhance the general context in which it appears but none compares with the *Idle Servant* in its *mise-en-scène* and lively narrative.[54]

Various motifs account for the anecdotal efficacy of the picture. The mistress's demonstrative gesture is perhaps the most cogent among them: like an actor on stage, she turns aside to address the viewer by signaling her maid's indolence with a gesture analogous to those employed in contemporary oratory to persuade the hearer of evidence and hence of an argument's veracity.[55] Maes's rendition of space in the *Idle Servant* is equally compelling. The seemingly awkward, tipped perspective of the foreground, effectively flattened for effortless comprehension, is compensated by the masterful recession of space culminating in the chamber at the top of the stairs where the guests await their meal.

Maes's complex spatial constructions are often said to have been inspired by van Hoogstraten's paintings. However, the older artist was still residing in Vienna when the *Idle Servant* was painted in 1655. Therefore creative impulses vis-à-vis space and perspective probably flowed at least initially in the opposite direction, from Maes to van Hoogstraten upon the latter's return to his native town in 1656, the year in which the two painters finally enjoyed their first sustained professional contact.[56] Moreover, the work of other artists demonstrates a mutual interest in comparable concerns, most notably that by the enigmatic Isaac Koedijck (1617/18–before 1668) whose complicated renditions of space anticipate Maes's own by several years.[57] Painters throughout the southern regions of the Province of Holland had been preoccupied with problems of space and perspective for decades. Rather than attempt to identify a specific source for Maes's efforts it is perhaps more reasonable to perceive them within the context of a broader, regional style within South Holland and Zeeland, as Walter Liedtke has convincingly argued.[58]

The upper room in the *Idle Servant* with its unattended guests amplifies the housewife's discovery below. Like this housewife's gesture the subdivision of the space with its *doorsien* functions as a rhetorical device to provide additional commentary upon the consequences of the maid's shiftless inactivity.[59] The unserved visitors not only allude to the servant's torpor, so too do the plundering feline, the cookware, and other utensils carelessly strewn across the floor in this messy kitchen. This pile of dirty vessels is the reprehensible result of the maid's neglect of duty.

137 (*above*) Nicolaes Maes, *Idle Servant*, 1655 (oil on panel, 70 × 53.3 cm). London, The National Gallery.

136 (*facing page*) Johannes Sadeler after Hans Bol, *Winter*, 1580 (engraving). Amsterdam, Rijksprentenkabinet.

138 (*left*) Hieronymous Wierix after Philips Galle, *Acedia* (engraving). New York, The Metropolitan Museum of Art, Harris Brisbane Dick Fund, 1953 (53.601.19(59)).

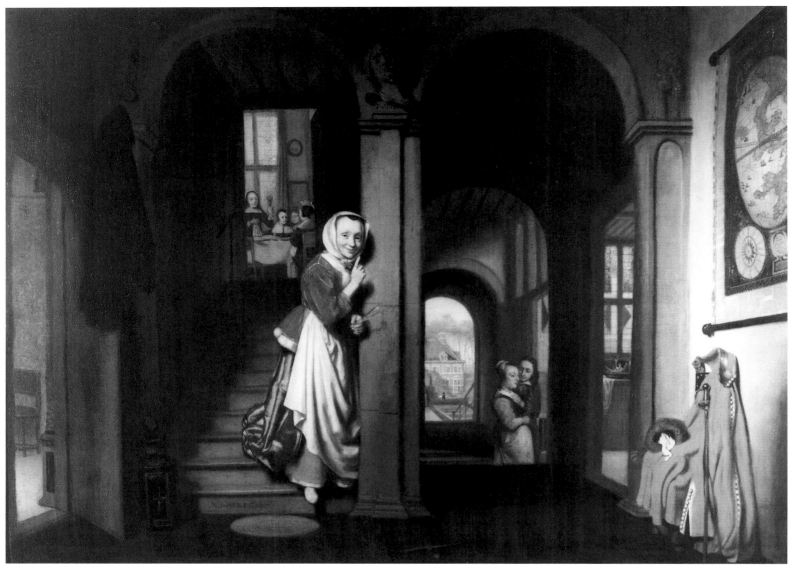

139 Nicolaes Maes, *Eavesdropper*, 1657 (oil on canvas, 92.5 × 122 cm). The Netherlands Institute of Cultural Heritage on loan to Dordrecht, Dordrechts Museum.

The motif of the cat stealing the poultry makes the same point. A proverb by Johan de Brune (1588–1658) is quite fitting in this context for it states that "a kitchen maid must have one eye on the pan and the other on the cat," a responsibility that has not been discharged by the lethargic, young servant.[60]

Still, the slumberer's infraction and its consequences do not impute grave moral implications to the panel. If anything, the housewife's indulgent grin (reflective of the artist's skill at articulating lively facial expressions) underscores its light-hearted, satirical air. Maes's derisive presentation of servants' offenses both here and in his famous series of paintings of eavesdroppers (discussed below) must be understood within the larger context of contemporary biases against female domestics. In plays, literature, and prints, maids humorously embody a plethora of vices,[61] as

seen in the facetious, misogynistic text *Zeven duivelen, regerende en vervoerende de hedendaagsche dienst-maagden* (Seven Devils, Ruling and Seducing Contemporary Maidservants) discussed in Chapter 8.[62] In the chapter devoted to sloth we learn that maids are addicted to sleep, so much so that they neglect their duties. The anonymous author also relates an anecdote about a maid who so loved to snooze that while her master and mistress were still in bed she would not arise and go to work as she was obliged to do but would hire "a poor wench" who lived nearby to do the scrubbing. For these irresponsible servants idleness also had its benefits: their neglect of duty kept their hands soft and white ennabling them to pass for daughters of quality![63] Such texts and the paintings they mirror are pure fiction meant to entertain readers and viewers by appealing to popular prejudices

largely divorced from the social realities of actual mistress–servant relationships in the Dutch Republic.[64]

In its subject matter and architectonic qualities the *Idle Servant* recalls Maes's acclaimed paintings of eavesdroppers. Each of the six variants of this theme were painted between 1655 and 1657. Their nearly concurrent execution and affinities in subject and style have led scholars to consider them a group with analogous meanings. The oft-discussed *Eavesdropper* of 1657 is the final and by far most intricate of the six (fig. 139).[65] In an interior of great complexity, a young woman – another housewife, identified as such by her elegant garments – is poised at the bottom of a staircase, eavesdropping upon the dalliances of her maid and a suitor.[66] The ambitious rendering of space – indeed, the spatial constitution of many earlier Dutch genre paintings pales by comparison – the brighter tonalities, and more distinct outlines in this picture all signal the stylistic features of Maes's last genre paintings.

The youthful mistress is strongly reminiscent of her counterpart in the *Idle Servant*: she too smirks at the viewer while making a distinct hand gesture. Only in this painting, and the other five portrayals of eavesdroppers (see fig. 141), the gesture is easily recognizable as one enjoining silence.[67] It has a long history in Western culture and the visual arts. In late antiquity, for example, the evangelists and other major religious personages are shown making it, a reflection no doubt of the linking of silence and virtue by ancient cultures.[68] More chronologically contiguous to Maes's depiction are a number of artworks depicting figures putting their index fingers to their lips. Among the most intruiging are prints of satyrs making the gesture as they espy sleeping nudes or embracing couples (fig. 140).[69] The parallels with the *Eavesdropper* are fascinating in that both protagonists gleefully invoke silence as they discover erotic dalliance. In this sense, the gesture in Maes's painting extends beyond pure censure to one of conspiracy or collusion between the figure making it and the viewer.[70]

The maid and her lover are the focus of the housewife's curiosity. The paramour is most likely a soldier, judging from the cap, cloak, and sword discarded on the chair below the map on the right wall. (Soldiers, as swaggering embodiments of excess, are stereotypically imaged in all sorts of prodigal circumstances.) The combination of military apparel and map then may not be mere coincidence as the latter sometimes refer in genre paintings to worldliness and temptation.[71] The couple frolic at the base of a staircase before the entrance of still another room. Within that room we once again encounter a cat stealing poultry. This motif literally illustrates the maid's neglect of duty just as it did in the *Idle Servant*; in both pictures, the assembled guests in the upper room will never receive their dinner. However, cats purloining fowl also provided seventeenth-century authors with a ready metaphor for the dangers of seduction, a meaning certainly appropriate in this context.[72]

From its position atop the pilaster where the two prominent arches meet, a bust of Juno, the ancient Roman goddess and protectress of the household and state, presides over the furtive goings-on in this enchanting dwelling.[73] Juno's head tilts in the opposite direction of the eavesdropping mistress beneath her. Antithetical as well is her serious countenance indicative of a measure of propriety deficient in the amused woman below.[74] The mistress's comparatively youthful appearance, wineglass, and festive attire further undercut her authority. From a moral perspective the *Eavesdropper* appears to lack weighty reproach, suppressed largely by comic innuendo. In this respect, the canvas parallels contemporary stage productions featuring caricatured housewives and domestics, as several scholars have noted.[75]

The motifs of the map, soldier's equipage, and mischievous feline in the *Eavesdropper* are conventional, yet what sets this representation apart is the setting, an interior of striking complexity that marks the pinnacle of Maes's spatial displays.[76] Modern-day art lovers unfamiliar with Dutch architecture of the Golden Age are liable to confuse the dwelling depicted here with an actual one. However, this is not an architecturally accurate rendition of a domicile – something rarely encountered in genre painting – but rather a fanciful one, whose pronounced width (augmented by ancillary chambers to the left and right) would be unusual by seventeenth-century Dutch standards.[77] If anything, the disposition of this interior and the large garden distinctly visible behind the trysting maid loosely recall the mansions constructed by elites during the late seventeenth century in urban centers and particularly in the countryside.[78]

This fictitious space is placed entirely at the service of narrative as the house is bifurcated into diagrammatic "zones" inhab-

140 Werner van Valckert, *Sleeping Venus Surprised by Satyrs*, 1612 (etching). Amsterdam, Rijksprentenkabinet.

141 Nicolaes Maes, *An Eavesdropper with a Woman Scolding*, 1655 (oil on panel, 46.4 × 72.1 cm). London, Mansion House, The Harold Samuel Collection.

ited by the principal figures and vignettes. These zones are peculiarly flattened to make them easier to apprehend despite Maes's obvious facility in creating depth through his expert use of the *doorsien*.[79] The mistress is pivotally positioned near the base of the staircase, a transitional area between the festive upper chamber of toasting guests and the lower one with the cavorting maid. That her descent is arrested is ingeniously suggested by the motif of her foot dangling off the end of the lowest step. She leans forward (like a statue breaking out of a niche, as Martha Hollander has so wonderfully phrased it) to listen to the unsavory encounter of the couple on the lower staircase.[80] And the viewer is implicated directly by her grinning gaze and con-spiratorial gesture but also more obliquely by the space directly in front of her.

The open nature of this area, which contains such accouterments as clothing and an unlit lantern, indicates that it is the vestibule of the house, known in Maes's day as the *voorhuis*.[81] The viewer is thus placed in a privileged position because, unlike the guests who do not see the couple below, and the eavesdropper who only hears them, the viewer is witness to all of the proceedings. Potential audience engagement is playfully heightened in another version of this theme, *An Eavesdropper with a Woman Scolding* of 1655, in which the tables are turned: a maid enjoins silence as her mistress shouts at someone in a distant room (fig. 141).[82] The recipient of the housewife's harangue is hidden from view behind the stiff, bluish-green curtain that covers much of the right foreground of the painting. This trompe-l'œil device, already encountered in the art of Dou (see fig. 107), certainly vaunts the artists's illusionistic skills. But the bold illusionism likewise plays cleverly upon the viewer's inquisitiveness as it tempts him or her to pull the curtain aside to reveal the unfortunate target of the shrewish mistress's wrath.

The *Eavesdropper* constitutes yet another example of masterful genre painting created after 1650 in which setting, pose, gesture, and even color – note the seemingly cadenced use of vermilion leading from the mistress to the cape to the maid – conspire to intrigue, delight, and convey narrative with a hitherto unprecedented level of sophistication and wit. That Maes's genre pictures had reached such supreme stylistic and thematic heights while he was still at a relatively early stage in his career makes his decision to turn to portraiture regrettable. Nevertheless his work, as well as that of van Hoogstraten, helped to establish a tradition for local genre painting in Dordrecht and was also significant for their colleagues in other cities.

CHAPTER ELEVEN

DELFT

After Dordrecht and Haarlem respectively, Delft was the third oldest city in the Netherlands, having been granted a charter by the Count of Holland, William II, in 1246.[1] During the late Middle Ages it ranked among the most important cities in the Northern Low Countries and in its capacity as capital of Delfland (a region extending roughly from The Hague to Rotterdam) its economy profited greatly. During the early stages of the war with the Spanish, the city served as the seat of the fledgling Dutch government and it was at his headquarters in the *Prinsenhof* (Prince's Court) in Delft in 1584 that the Prince of Orange, William the Silent, was assassinated. William the Silent's son and successor, Maurits, later moved the capital and court to The Hague.

The relocation of the capital from Delft to The Hague was a harbinger of the former's declining influence during the seventeenth century in other social and economic arenas. The city's traditional industries of beer-brewing and textile manufacture, for example, experienced severe contractions during this period. In 1600 there were eighty-two breweries in Delft, but intense commercial competition in this lucrative business with Rotterdam and Haarlem eventually forced the closing of a large number of them and by 1667 only fifteen remained in operation. The dwindling prospects of the brewing industry compelled the city fathers to intensify their efforts to bolster the flagging textile industry. Thus various ventures were undertaken – many involving immigrants from the Southern Netherlands – to reinvigorate cloth production in Delft. In the end, with the exception of tapestry manufacture at which it excelled, Delft was simply unable to compete with Haarlem and nearby Leiden.

Fortunately, several other enterprises partly offset the grave economic situation. Principal among them was the manufacture of faience which had already begun in the city in the late sixteenth century and was sustained and expanded to some extent by the influx of immigrants in the early seventeenth. Ironically, what proved a boon for this business was the importation, by the Dutch East India Company (which had a chamber in Delft), of Chinese porcelain. Delft's artisans responded much more successfully to this commercial competition than did their colleagues in the beer-brewing and textile trades, and as a result, the quality of their own faience was greatly refined. When civil war erupted in China in the 1640s, sharply curtailing imports from that country, Delft was fortuitously well-positioned to meet the great demand for Chinese porcelain with worthy imitations of this much-desired, oriental luxury item. Between 1655 and 1670, the number of potteries in Delft doubled as this industry entered its most dynamic phase of production, employing a considerable percentage of the population.[2] Notwithstanding stiff competition from other European countries which incited a conspicuous drop in faience manufacture in Delft during the eighteenth century, Delftware, as the product is called, remains famous today, routinely coveted by tourists visiting the Netherlands.

The flourishing faience industry could not completely offset Delft's economic slump though, which began around the middle of the seventeenth century but accelerated greatly after 1680. In sum, its modest size – its population peaked at 25,000 inhabitants in 1665[3] – compared with that of rapidly growing cities with large ports (for example, Amsterdam and Rotterdam), and its contracting economy, exacerbated by falling property values in the surrounding countryside comprising Delfland, stifled Delft's development just as it had that of many other smaller towns in the United Provinces. Delft had the sheer topographical misfortune of lying close to the booming manufacturing centers of Leiden and Rotterdam (and also The Hague, the most affluent town in the country) and its vitality was slowly but surely sapped during the second half of the seventeenth century by commercial rivalries with these thriving urban centers.

General economic problems aside Delft still had its share of wealthy citizens. Many of them stemmed from venerable families who had amassed great fortunes through prudent investments in the Dutch East India and West India Companies and in the rich trades in general. And the growing economic malaise in Delft only accelerated this sort of investing among elites who under the simultaneous influence of aristocratization increasingly withdrew from local industrial ventures. Just like the scenario recurring endlessly in other towns, leading members of Delft society completely dominated municipal life by controlling local government as members of the oligarchic Council of Forty. Likewise, this group was frequently at loggerheads with ministers of the Reformed Church. Delft is sometimes described as a religiously conservative community dominated by Calvinism.[4] Yet the great diversity of faiths practiced in Delft, which, incidentally, housed several thousand Catholics, and the tolerant attitude of civic leaders in matters moral, religious, and political – many were anti-Orangist – militates against this view.[5]

Remarkably, within this progessively sluggish economic milieu arose one of the most important "schools" of genre painting in the Dutch Republic. During the first half of the century a number of noteworthy genre painters had been active in Delft, most notably, Anthonie Palamedesz. (1601–1673) and Jacob van Velsen (c. 1597–1656).[6] But their earlier presence in the city does not entirely account for the seemingly spontaneous blossoming of genre painting there during the 1650s, a decade in which Carel Fabritius (1650) and Pieter de Hooch (1652, 1654) arrived in Delft and Johannes Vermeer made his first genre paintings.

That Fabritius, de Hooch, and Vermeer, along with a host of other masters, could produce unquestionably innovative and splendid art in a city past its economic prime is something of a paradox. However, many of Delft's best artists worked there but subsequently died or left the city years before its fiscal circumstances truly worsened. Moreover, Delft painters did not limit themselves to the local market: they sold pictures in other towns, especially The Hague where they actively encroached upon the market there for genre paintings. The proximity of these two cities facilitated the sale of paintings by artists from both despite the best efforts of their respective guilds to restrict traffic in art by outsiders.[7] Curiously, in the decades following the Treaty of Münster, portraiture in Delft, which comprised such an important part of its artistic output before 1650, was largely ceded to specialists from The Hague; conversely, Delft's genre painters made substantial inroads in The Hague (and other cities), competing with the dwindling number of specialists there.[8] And, of course, the role of elite patrons, relatively inured to economic downturns in general, in fostering the arts on a local level should be acknowledged.

Carel Fabritius

Carel Fabritius (1622–1654), whose extremely promising career ended abruptly with his tragic death at the age of thirty-two, is a truly enigmatic figure.[9] Fabritius was born in 1622 to a schoolmaster (and amateur painter) and his wife in Midden-Beemster, a village lying some eighteen miles north of Amsterdam. A document written in 1641 identifies Fabritius not as a painter but as a carpenter. In September of that year he married and moved to Amsterdam. At that time he probably entered the workshop of the renowned Rembrandt, presumably after having learned the rudiments of painting from his father. Our knowledge of Fabritius's presence in the famed master's studio comes not from an archival source but from Samuel van Hoogstraten's comment in his *Inleyding tot de hooge schoole der schilderkonst* (Introduction to the Lofty School of Painting) that Fabritius was his fellow pupil.[10] Fabritius's scant paintings provide further evidence of his apprenticeship with Rembrandt. How a carpenter with virtually no professional training was able to join Rembrandt's atelier at

the pinnacle of the latter's career will probably always remain a mystery.

By the late summer of 1643 Fabritius's wife was dead, as were the two young children whom she had bore. He was recorded as living once again in Midden-Beemster. The next significant document bearing Fabritius's name appears seven years later announcing his second marriage; it states that the betrothed couple, both widowed, were currently residing in Delft. Fabritius's move to Delft by 1650, therefore, probably occurred for personal as well as professional reasons.

What is baffling, though, is the paucity of paintings by Fabritius dating between his departure from Rembrandt's studio in 1643 and 1652, when he finally registered with the Delft Guild of St. Luke – one wonders whether he resumed his earlier trade as a carpenter.[11] Fabritius's modest production increased after he enrolled with the guild. His pictures from this later period, which vary in subject matter, are stunning and reveal a young artist of tremendous talent. Tragically, his potentially distinguished career ended with the explosion on 12 October 1654 of one of the municipal arsenals in Delft, imprudently established within the city limits years earlier by the States General and States of Holland for safekeeping for the Dutch army. The catastrophic explosion, which was heard many miles away, leveled a substantial portion of the town and claimed hundreds of victims including Fabritius and, if contemporary accounts are accurate, a pupil and client upon whose portrait he was working at that very moment.[12]

Of the approximately one dozen surviving, autographed works by Fabritius only one, *The Sentry*, signed and dated 1654, can be classified as a genre painting (fig. 142).[13] The subject of this canvas, a soldier attending to his musket beside a city gate with a portcullis, is highly unusual but related indirectly to earlier depictions of soldiers by Codde, Duck, and the aforementioned Delft painter Palamedesz. The man's somewhat slovenly appearance and slumped pose has suggested to some scholars that he is asleep. However, the careful positioning of the young man's hands reveal his attentiveness to the workings of his gun as he clears its firing hole with a pricker, a devise that soldiers kept on their cartridge belts.[14] Even if this young trooper is diligently cleaning his weapon his depiction differs markedly from those in contemporary manuals on firearms who always stand conscientiously erect as they care for their muskets.[15]

The motifs that flank the sentry are even more puzzling. The city gate to his right contains a relief of St. Anthony, a highly venerated saint in medieval and early modern Europe who was invoked against various illnesses.[16] Despite the Reformed Church's abhorrence of sainthood and other supposedly superstitious practices of Catholicism, St. Anthony continued to be revered thus providing yet another example of the inability of Calvinists in the Dutch Republic to eradicate Catholic traditions altogether. In particular, the saint was sometimes venerated by

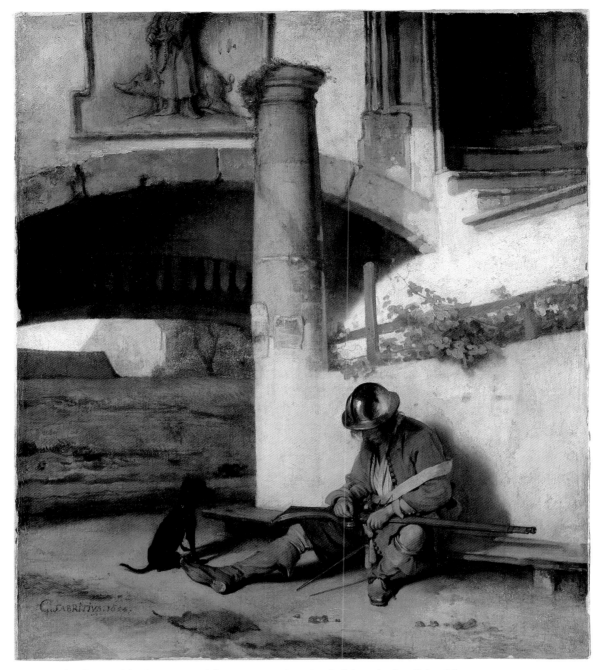

142 Carel Fabritius, *The Sentry*, 1654 (oil on canvas, 68 × 58 cm). Schwerin, Staatliches Museum.

militia companies.[17] These municipal organizations of citizen soldiers, whose membership generally included a town's most affluent citizens, were found in every Dutch city.[18] They were rarely, if ever, engaged in combat for armies were then comprised chiefly of mercenary soldiers. Instead, the official functions of these companies were often ceremonial and confined to local concerns, especially keeping the nightly watch at the gated entrances to fortified cities. Still, it is uncertain whether St. Anthony's presence in the relief over the gate identifies the sentry as a militia-company member. Fabritius's scene is a daytime one and watch over a city's entrances during the day was provided by paid guardsmen, as opposed to militia companies.[19]

The motifs of the column and dog beside the sentry complicate matters further. Columns are traditional symbols of fortitude, namely strength of character (fig. 143).[20] The black dog, a multivalent beast in Dutch art, possibly conveys notions of fidelity and perspicacity in this context, reinforced perhaps by the creature's alert stance. Admittedly, it is difficult to reconcile

143 Crispijn van de Passe the Elder, *Fortitude* (engraving). Amsterdam, Rijksprentenkabinet.

Pieter de Hooch

If the life and career of Fabritius epitomize tremendous promise grievously cut short, then that of Pieter de Hooch (1629–1684) epitomizes promise fulfilled, for de Hooch played a fundamental role in the development of genre painting in Delft after 1650.[22] Unfortunately, only meager details about his life are known. He was born in Rotterdam in 1629, to a father who was a brick-layer by trade and a mother who worked as a midwife. His working-class parents must have recognized his incipient artistic talent and consequently arranged professional training. Arnold Houbraken, writing in the early eighteenth century, informs us that de Hooch studied with Nicolaes Berchem (1620–1683), a renowned Haarlem landscapist.[23] By 1652, the young artist was living in Delft; an archival document, dated 5 August of that year, reveals his presence there at the signing of a will together with the painter Hendrick van der Burch (1627–after 1666), who eventually became his brother-in-law.

The following May de Hooch was recorded as painter and servant to the Delft linen merchant Justus de la Grange.[24] De la Grange was also an art collector and owned eleven paintings by the artist. It is unclear whether de Hooch worked for de la Grange as an indentured artist, to wit, handing over part or all of his paintings in exchange for room and board or some comparable benefit, or whether he was employed as an actual servant. As a relatively new resident of Delft perhaps the young painter needed to support himself by another occupation, a not uncommon practice among artists in the Netherlands at this time. De Hooch subsequently returned to his native Rotterdam only to relocate in Delft once again at the time of his marriage in May 1654. He enrolled in the city's Guild of St. Luke the following year but, apparently beset with financial problems, he was unable to pay the entire 12-guilder admission fee required of painters born outside of the city.

De Hooch's first known paintings, none of which are dated, were executed during the early 1650s. He made numerous pictures of soldiers at this time, among them, the *Tric-Trac Players* (fig. 144).[25] In terms of setting and figural emphasis, this panel owes something to precedents by Gerbrandt van den Eeckhout (see fig. 164) and especially the tavern interiors of Ludolf de Jongh (see fig. 178), who like de Hooch was a native Rotterdamer though thirteen years his senior.[26] Boisterous guardroom images were of course painted decades earlier by Codde and Duyster – in fact, the monochrome palette of the *Tric-Trac Players* recalls these earlier works. But de Hooch's, van den Eeckhout's, and also ter Borch's (see fig. 94) representations of soldiers, with their restrained, proportionally larger figures in structured settings, collectively attest to the transformation of this theme in the hands of this younger generation of artists.

As the decade progressed, de Hooch's production of martial subjects was gradually supplanted by representations of mothers, children, and servants. Concomitantly, his palette and depiction

the positive associations of these motifs with the unkempt, slouched soldier. And, as discussed previously, soldiers generally possessed dubious reputations, particularly in Dutch literature and art. Therefore *The Sentry*, much like its creator, remains enigmatic.

However abstruse its subject, the canvas unequivocally displays Fabritius's masterful use of light contrasts, architectonic shapes, and thin, fluid application of relatively subdued tones of paint. The result is an image with an astounding physical presence, a subtle orchestration of beiges, browns, and grays in which lighter passages alternate with darker ones to render a convincing impression of space and its recession. The contrast between the swarthy form of the soldier and the sun-drenched wall behind him is startling and anticipates the pictorial qualities of Vermeer's genre paintings of the early 1660s. Yet it would be erroneous to consider Fabritius, in spite of his formidable skills, the principal catalyst for future developments in Delft genre painting. His work, with its limited yet exquisite tonalities and its pronounced attention to spatial recession displays affinities, for example, with that by the town's outstanding painters of church interiors, artists who also contributed decisively to what Axel Rüger has termed "the common artistic language prevalent in mid-century Delft."[21] The premature death of Fabritius unfortunately deprived his colleagues of any further potential contributions on his part to Delft painting.

of space became more sophisticated. What must have made de Hooch's paintings of domesticity so appealing was their compelling perspective and spatial complexity as well as their impressive daylight effects and sympathetic figures. A *Mother and Child with a Maid Sweeping* of about 1655–7 (fig. 145) is a telling example of the artist's domestic imagery that anticipates his masterful works of mothers and children painted between 1658 and 1660.[27] In this interior composed of loosely brushed, warm colors a mother holds a toddler wearing a pudding cap – a cap made from rolled cloth to protect a child's head – while her maid sweeps the unadorned yet cozy room.

Idle brooms often appear in the immediate vicinity of women in Dutch genre painting (see fig. 95) but their actual use in sweeping floors was only infrequently represented. A rarefied atmosphere of intimacy and sanctity pervades images of women sweeping such as this one suggesting that the activity may convey associations extending well beyond those of mere domestic duty.[28] Seventeenth-century writers frequently associated the broom with spiritual and moral purity. For example, in the frontispiece to Petrus Wittewrongel's influential, domestic conduct book *Oeconomia Christiana* (Christian Economy; fig. 146), published in several editions contemporaneous with de Hooch's

painting, a maid wields a broom in a purely symbolic manner as she vigilantly sweeps away objects of vice, among them playing cards, that can undermine the spiritual and moral well-being of the family to her right. A passage from a book by one of Wittewrongel's Pietist colleagues, Simon Oomius, provides a literary parallel to this scene. According to Oomius, discipline in the home, that is, spiritual and moral assiduousness, is the broom that cleans it, preparing it to receive God's presence.[29] Similar wholesome associations but doubtlessly less specific ones were possibly evoked by the motif of the servant sweeping the already immaculate floor in de Hooch's painting.

Domestic imagery only began to be produced with great frequency after the Treaty of Münster in 1648, a period of tremendous affluence and, related to this, increased awareness of civility, that self-conscious cultivation of grace and status expressed by, among other things, a person's taste in art. Codes of civility also emphasized self-control over many aspects of public life including general comportment and table manners. The refinement of these communal or public aspects of behavior led to the relegation of many overtly indecorous acts to the hitherto scarcely extant private sphere, for instance, care for the body and its natural functions.[30] At this time, the concept of privacy was also

144 Pieter de Hooch, *Tric-Trac Players*, early 1652–5 (oil on panel, 45 × 33.5 cm). Dublin, The National Gallery of Ireland.

145 Pieter de Hooch, *Mother and Child with a Maid Sweeping*, c. 1655–7 (oil on panel, 43 × 32 cm). Private collection.

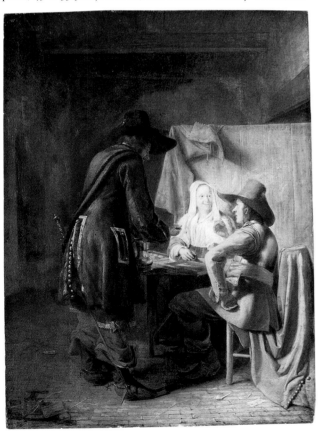

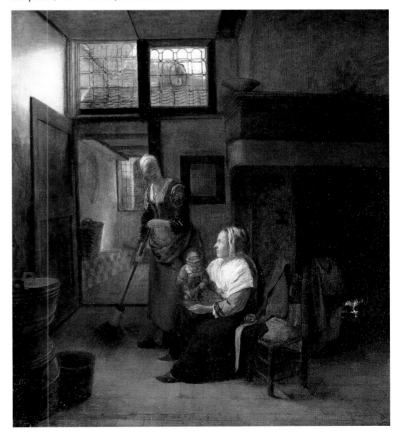

146 Frontispiece from Petrus Wittewrongel, *Oeconomia Christiana ofte Christelicke huys-houdinghe*, Amsterdam, 1661. Amsterdam, Universiteits-Bibliotheek Amsterdam.

Mother and Child with a Maid Sweeping and similar pictures by de Hooch and his colleagues are reflective of — and perhaps even constitutive of — these emerging requirements.[33] In an era in which notions of privacy were still actively in flux it is fascinating that paintings by de Hooch and other artists feature figures cloistered in intimate spaces. The complex interiors of de Hooch's domestic subjects, with their patent view into another chamber, are inhabited exclusively by females (with the exception of young children of both sexes); in these quixotic milieux, adult males are virtually non-existent. Housewives and/or mothers and maids are most commonly portrayed. Thus, de Hooch's peaceful, gendered spaces accommodate female family members and their domestics seemingly captured in reclusive moments, secluded from the hustle and bustle of the world only implied by views through windows, open doors, and vestibules.[34] And that world was one that signified the domain of men from which women were theoretically excluded.

During de Hooch's very last years in Delft — he moved to Amsterdam in 1660 or 1661 — he produced some of his most visually arresting genre paintings. *A Woman Nursing an Infant with a Child and a Dog* executed around 1658–60 (fig. 147), for example, has been called "one of de Hooch's purest celebrations of the beauty of motherhood and domesticity."[35] In this tranquil interior a mother tenderly breastfeeds her infant. Her solicitous rectitude is imitated by the older child to her right in a charming and clever way. In an action that parallels that of her mother, the girl feeds the family dog from a dinner pot.[36] Breastfeeding mothers are found in Dutch genre painting for the first time in substantial numbers only in art by de Hooch's generation and so provide yet another example of the wholesome imagery pervasive in the second half of the century.

In an era in which wet nurses often suckled children, doctors and moralists alike advocated maternal breastfeeding for its specific physical and psychological advantages to both mother and child. Breastmilk was thought to be blood that had whitened in the breast, the indispensible liquid that had hitherto nourished the infant in utero. Furthermore, a child was believed to imbibe the personality of the woman who nursed it, as prevailing medical opinion held that behavioral traits were conveyed to children through breastmilk.[37] If the wet nurse were of questionable character — as many were said to be — a feeding child would literally acquire her disposition, losing whatever respectable behavioral traits it had at birth. Despite these warnings the practice of hiring wet nurses was fairly common given the notoriously unsanitary conditions, poor care, and frequently difficult deliveries that characterized seventeenth-century obstetrics. Therefore, paintings of the theme of breastfeeding, like others of domestic virtue, are completely paradigmatic and visually analogous to specific, literary prescriptions concerning maternal duties.

The virtuous mien of *A Woman Nursing* is enhanced and complemented by the style in which it is rendered. By the late 1650s

evolving in a complicated, dialectical interaction with notions of the public.[31] As a result of the growing influence of civility in the public sphere, the private realm in all of its manifestations from the base to the sublime was undergoing dramatic evolution. An intrinsic component of this evolution was an increasing valuation of domesticity, which focuses on behaviors that are both appropriate and desirable in the private sphere of the home. In this sense, it is difficult to dissociate contemporary notions of domesticity from those of civility and privacy.

Curiously, the tremendous demand for paintings of domesticity coincided with changing patterns of house construction. As several scholars have noted, during the second half of the seventeenth century there was increasing differentiation of the rooms composing a domicile.[32] Now designated for specific purposes rather than the more communal arrangements typifying earlier homes, dining rooms, bedrooms, and the like promulgated the growing desire to separate private and public spaces and hence satisfied incipient needs for privacy. In certain respects, a

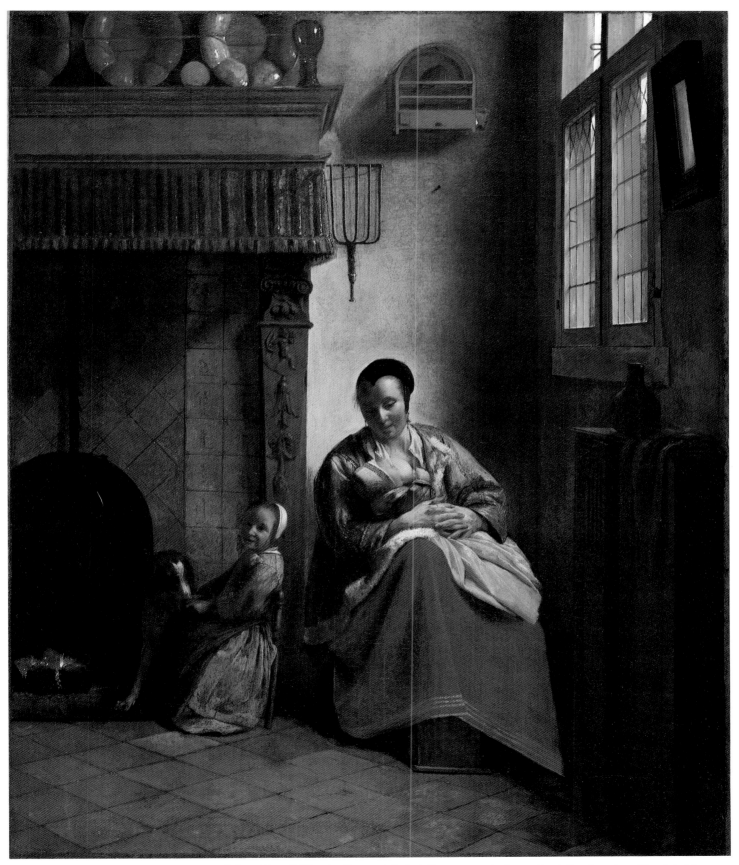

147 Pieter de Hooch, *A Woman Nursing an Infant with a Child and a Dog, c.* 1658–60 (oil on canvas, 67.8 × 55.6 cm). San Francisco, Fine Arts Museums of San Francisco, Palace of the Legion of Honor, inv. no. 61-44-37. Gift of the Samuel H. Kress Foundation, 1961.

de Hooch's paint application had grown tighter, his figures volumetric, and the natural effects of light and shadow, notwithstanding the overly bright palette of unmixed hues, more convincing and dramatic. The interior space depicted here is not as complex as the one in a *Mother and Child with a Maid Sweeping* because it lacks a *doorsien*. Nevertheless, it evidences de Hooch's complete command of linear perspective; by comparison the earlier picture with its awkwardly plunging recession (partly concealed by strategically placed elements) seems hesitant and somewhat inept. Space recedes in a convincing way in *A Woman Nursing*, articulated by the worn, terracotta floor tiles and the wall at the right, punctuated by a cabinet, mirror, and luminous, curtained windows.

Over the years, scholars have repeatedly discussed de Hooch's rendition of space and perspective. Some specialists link it specifically to developments in Dordrecht, namely, to van Hoogstraten's and Maes's comparable depictions of interiors.[38] Presumably, developments in that city became known in Delft through the agency of Carel Fabritius, who like Maes, and simultaneous with van Hoogstraten, had been a pupil in Rembrandt's atelier. However, the more emphatically ordered appearance of de Hooch's works and their naturalistic lighting has led other scholars, by contrast, to stress the supposedly singular nature of de Hooch's art.[39] In light of the highly problematic nature of these hypotheses it is perhaps best to construe the perspectival features of de Hooch's art as a regional as opposed to purely local phenomenon as Walter Liedtke has repeatedly argued.[40]

Liedtke classifies de Hooch's genre interiors as the "South Holland" type, one not only seen in the work of artists in Dordrecht, who were previously thought to have been de Hooch's immediate models, but also in his native Rotterdam, in Leiden, and even in distant Antwerp where the roots of this

regional style lay. And it continued to be practiced by such Flemish painters contemporary with de Hooch as Gonzales Coques (1614/18–1684; fig. 148), whose work testifies to the persistent Flemish influence on seventeenth-century Dutch genre painting. Clearly, de Hooch did not slavishly imitate these prototypes but transformed them. In essence, he synthesized the South Holland approach to perspective and interior space construction with the naturalism and figural emphasis characteristic of works by ter Borch, van den Eeckhout, and other painters from Haarlem and Amsterdam.[41] Yet in light of the distinctive appearance of de Hooch's canvases, the whole, in terms of influences, is definitely more than the sum of its parts.

Judging from the large percentage of domestic themes in de Hooch's œuvre, and his frequent recycling of specific subjects and settings,[42] he clearly sought to capitalize on the ready market for these new types of paintings. In fact, such paintings helped to secure his reputation in his own day and in ours as well. In this respect de Hooch is most frequently identified with paintings of courtyards which he single-handedly developed and popularized during his relatively brief tenure in Delft. Courtyards were of course an intrinsic feature of Dutch domestic architecture and were constructed either within the middle of a house or at its very back.[43] They thus provided light and additional, transitional spaces for homes customarily built on long, narrow lots within Dutch cities. De Hooch's obvious familiarity with courtyards does not mean that his paintings of them transcribe real ones, despite his habit of including readily identifiable structures in the background. Like all Dutch genre paintings they are ultimately contrived, a skillful mixture of direct observation, artistry, invention, and convention.

Prototypical is his *Courtyard of a House in Delft*, monogrammed and dated 1658, a seminal year in de Hooch's artistic career (fig. 149).[44] This prized canvas, long heralded as one of the artist's best pictures, portrays a maid, identified as such by her simple clothing, who holds an earthenware dish as she descends a small set of stairs with a young girl. They enter a brilliantly illuminated courtyard whose tawny, floor bricks and weathered masonry are soaked in light. A woman (perhaps the servant's mistress) lingers in the adjacent vestibule – another example of de Hooch's trademark *doorsien* – the delicate shadows of her form playing upon the highly polished, stone floor.

A seeming myriad of textures are suffused with light, ranging from the broom and wooden bucket in the foreground to the rotted wooden planks adjacent to the steps; from the smooth surface of the gleaming orange window shutter to the delicately rendered foliage above the young maid and her charge. Liedtke rightly considers de Hooch's considerble attention to painterly effects here an attempt to appeal to cognoscenti,[45] and these discriminating viewers would have likewise appreciated the pronounced architectonic features of the courtyard, heightened by

148 Gonzales Coques, *The Duet* (oil on panel, 39 × 57 cm). Brussels, Musées Royaux des Beaux-Arts, M.I. 3971.

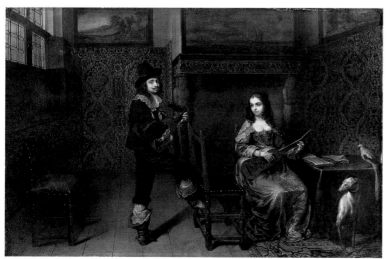

149 Pieter de Hooch,
*Courtyard of a House in
Delft*, 1658 (oil on canvas,
73.5 × 60 cm). London,
The National Gallery.

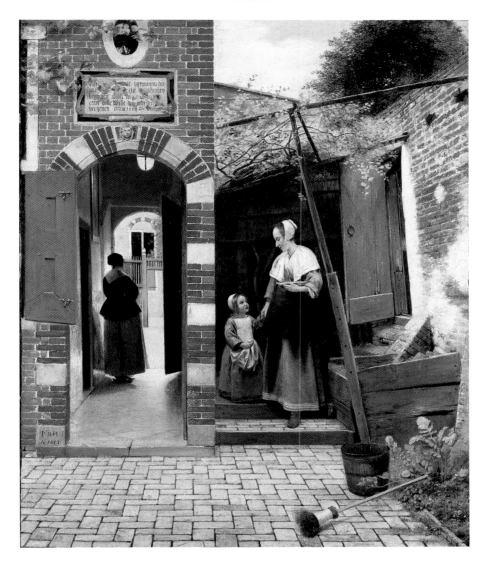

the illumination and his confident application of linear perspective. Contemporary connoisseurs repeatedly commented upon these aspects of genre painting in Delft, an important point discussed later in regard to Vermeer. In any event, de Hooch, like Vermeer, took a surprisingly practical approach to the problem of spatial construction. Close examination of the surfaces of several of his paintings has revealed pinholes, indicating that he stuck a pin with a string tied to it into the canvas at the intended vanishing point.[46] He then coated the string with chalk and snapped it (much like a carpenter would working on a project today) on the prepared ground of the canvas to establish the orthogonals. Only after the architectonic setting had been painted were the figures finally added.

Peter C. Sutton, the leading authority on the painter, has observed how the subjects of de Hooch's paintings are skillfully wedded to the sophisticated perspectival configurations in which they appear.[47] In this sense, de Hooch's orderly yet ostensibly

natural spatial designs echo if not enhance the tranquil domestic scenes within them. This is certainly true of *A Courtyard of a House in Delft*. The disposition of space vis-à-vis the figures of the maid and child in this image cleverly and subtly echo the inscription on the tablet over the entrance to the vestibule. This inscribed tablet closely resembles an early seventeenth-century one commemorating the long-destroyed Augustinian Monastery of St. Hieronymous in Delft, affixed in de Hooch's day to a garden wall in the fashionable neighborhood erected over the complex's remains – the tablet still exists (fig. 150).[48] Foliage partially obscures the tablet in the painting but several scholars have made the following translation based on the original inscription: "This is St. Jerome's vale, if you wish to repair to patience and meekness. For we must first descend if we wish to be raised."[49] The reader is thus advised to be humble in life if he or she wants to rise in spirit and in standing. The maid below seems to embody this counsel and her

descent down the steps may possess further significance inasmuch as the inscription advises one to descend first if one wishes to rise.[50]

Virtuous servants recur incessantly in de Hooch's domestic imagery and that of his colleagues. In fact, well-behaved servants in genre painting far outnumber representations of their mischievous sisters of the type encountered in works by Maes (see fig. 137). "Type" is key here for all of these images are fictitious, akin to descriptions in contemporary literature of ideal master–servant relationships and reflective of the tastes of genteel collectors who desired inoffensive pictures in this progressively civilized era. In recent years, social historians have studied servanthood in the Dutch Republic; their conclusions corroborate the discrepancies between these pictorial and literary tropes and actual conditions.[51]

Dutch domestics, the vast majority of whom were women, were hired contractually for only brief periods of time in a rather small percentage of homes. Disputes over wages seem to have been the norm and maids were sometimes involved in paternity suits against their employers and hence often accused of ensnaring male members of the household in an effort to attain financial security. Servants also appear frequently in the criminal records of cities such as Amsterdam. Contemporary servant ordinances also confirm this view. The authorities used municipal laws governing master–servant hiring procedures and relationships to control the market for servants and, equally importantly, to control their behavior. The ordinances included lengthy enumerations of virtuous and unseemly behavior. From her study of such seventeenth- and eighteenth-century ordinances, Marlies Jongejan concluded that, "The ideal servant was obedient and served his or her master for many years to come in 'all diligence and faithfulness.' The extensive legislation makes one suspect that practice was not in agreement with this ideal."[52]

By the end of de Hooch's stay in Delft, his career had risen to great heights. From his somewhat maladroit beginnings as a painter of soldiers de Hooch emerged as a talented genre painter

150 Tablet Commemorating the Hieronymusdael Cloister in Delft. Delft, Gemeente Musea, Stedelijk Museum Het Prinsenhof.

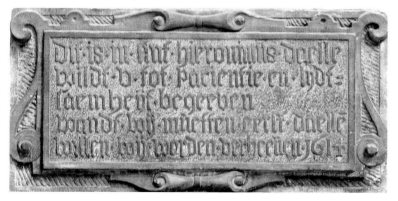

of domestic themes (and merry companies; see Chapter 12) whose extraordinary delineation of perspective, light, textures, and stuffs appealed to sophisticated buyers in Delft, The Hague – where he registered with the local guild in 1660 – and other cities. No doubt lured by potential commercial opportunities, de Hooch (like a number of other painters from Delft) moved to Amsterdam in 1660 or early 1661 where his style evolved further.

Johannes Vermeer

Johannes Vermeer (1632–1675) was unquestionably the most talented genre painter in Delft during the entire seventeenth century. In fact, Vermeer can rightfully claim a place among the greatest Dutch masters of the Golden Age. He was acclaimed in his lifetime only to sink gradually into semi-oblivion during the eighteenth century and, finally, was recompensed by his rediscovery and seeming deification in the nineteenth and twentieth centuries.[53] As numerous publications and the spectacular success of the exhibitions held in Washington D.C. and The Hague during 1995–6, and New York and London in 2001 attest, the art of Vermeer continues to fascinate art historians and laypersons alike.[54] Vermeer is clearly worthy of the praise bestowed upon him by scholars, the public, novel writers, poets, and even an opera composer.[55] But it is axiomatic that like all historical personalities, he is "time-bound," firmly ensconced within the historical circumstances of his age. The ubiquitous conventionality of Dutch seventeenth-century genre painting and the constraints of the art market consequently affected Vermeer's work thoroughly – and one must acknowledge these factors in order to demystify his art.

Vermeer was the second and youngest child of Digna Baltens (c. 1595–1670) and Reynier Jansz. Vermeer (alias Vos; c.1591–1652), both Reformed Protestants. His father was trained in Amsterdam to weave caffa, a fine, patterned fabric of satin or silk. Upon his return to Delft he probably sought employment in the weakened textile industry which the city fathers were attempting to revitalize. Eventually, Reynier Jansz. Vermeer became an innkeeper and picture dealer; he registered for the latter profession with the Guild of St. Luke in Delft in 1631. His activities as an art dealer necessarily provided him with many contacts among local painters and collectors.[56] The young Vermeer's career choice must have been affected by these circumstances. Presumably, the painter began to train sometime around 1645–7. In this regard, the identity of his teacher or teachers has long been debated.

Vermeer's admission as a master painter to the Guild of St. Luke on 29 December 1653 sheds further light on this problem. According to guild regulations, any painter who enrolled as a master had to have served at least six years as an apprentice with a recognized artist (or artists), either in Delft or elsewhere.[57]

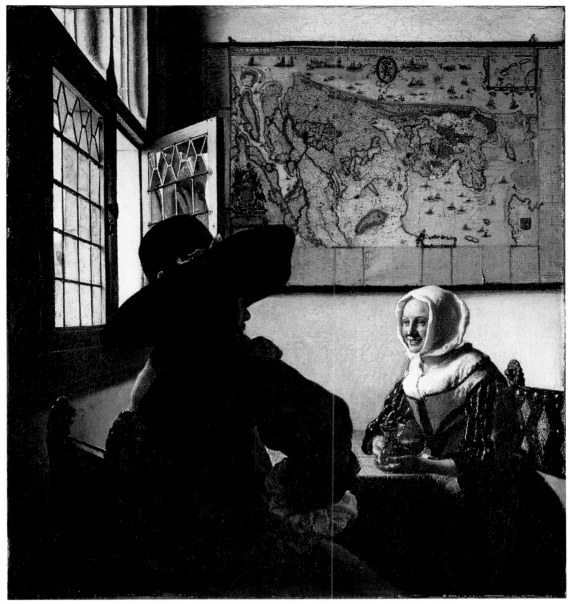

151 Johannes Vermeer, *An Officer and Laughing Girl*, c. 1658 (oil on canvas, 50.5 × 46 cm). New York, The Frick Collection.

Equipped with this knowledge, scholars have thus turned to Vermeer's immediate artistic milieu to try to identify his teacher. Vermeer is described as the artist who trod masterfully in the path of "the Phoenix," Fabritius, in one version of a poem by Arnold Bon published in Dirck van Bleyswijck's *Beschryvinge der Stadt Delft* (Description of the City of Delft; 1667).[58] The poem alludes to the explosion of one of Delft's arsenals in 1654 that claimed Fabritius's life. On the basis of this poem it was once argued that Fabritius was Vermeer's teacher even though Bon merely implied that Vermeer succeeded Fabritius as the foremost painter in Delft. Despite some similarities in their styles Fabri-

tius could not have served as Vermeer's teacher since the former only enrolled in the Guild of St. Luke in October 1652, in other words, approximately one year before Vermeer.[59]

John Michael Montias has hypothesized that Vermeer, after spending the first four years of his apprenticeship in Delft, concluded his training in Amsterdam or Utrecht or possibly both cities in succession.[60] The influence of painters from these cities on Vermeer's early work has long been noted. Montias's archival discovery that the prominent Utrecht artist Abraham Bloemaert was a distant relative of Vermeer's wife (whom he married in April 1653) further supports his hypothesis.[61]

152 Illustration of a Camera Obscura from J. Zahn, *Oculus artificialis teledioptricus*, 2nd edn., Nuremberg, 1702. The Hague, Koninklijke Bibliotheek.

Vermeer's enrollment in the guild granted him the right to sell his work in the town as well as pictures by other artists, as his father had done before him (he eventually engaged in this occupation), and to take on pupils. Vermeer's first surviving paintings date to shortly after this event. During this early stage of his career (around 1655–7) the young artist experimented with various techniques and subjects. Most of his works from this period are history paintings, illustrating episodes from the Bible, mythology, or classical and modern history. Clearly, Vermeer initially aspired to become a history painter for reasons undoubtedly tied to the general esteem in which history painting was held by seventeenth-century art theorists.[62]

Vermeer's first, unequivocal genre paintings date only to his so-called middle period, approximately 1657–67. *An Officer and Laughing Girl*, executed in about 1658 (fig. 151), and his other pictures of this period reflect the painter's response to the innovative formal and thematic developments that had begun to emerge.[63] In Vermeer's paintings one encounters the tempered, civilized themes featuring elegantly attired figures engaged in a wide variety of genteel activities that were becoming popular. The concurrent stylistic changes in the work of the younger generation of artists – such as Gerrit Dou (see Chapter 8), ter Borch, and de Hooch who remained sensitive to the renderings of textures and stuffs but also focused on the subtle, natural play of light and shadow on figures and objects firmly positioned within carefully constructed spaces – was also something with which Vermeer was certainly familiar.

Even though ter Borch lived in Deventer, Vermeer was acquainted with him as the two artists jointly signed a notary document in Delft in April 1653.[64] It was, however, the stimulus of his fellow Delft painter de Hooch that must have kindled

Vermeer's growing interest in the placement of figures within architectonic, light-filled spaces. De Hooch had already perfected the compositional schema evidenced in *An Officer and Laughing Girl*, namely, the depiction of the corner of a fairly spacious room illuminated by a window or windows positioned along one side of the canvas [see fig. 147]. However, in contrast to de Hooch's figures those by Vermeer are proportionally larger and are placed closer to the foreground. (Moreover, the strongly silhouetted officer is reminiscent of *repoussoir* figures found in the work of the Utrecht Caravaggisti (see fig. 74) which is perhaps no mere coincidence.) And also, like de Hooch, but much more intensely, Vermeer paid scrupulous attention to the brilliant naturalistic effects of light within his interiors and carefully manipulated these effects for expressive purposes.[65] *An Officer and Laughing Girl* is considerably accomplished in this respect: the superb rendition of sunlight and shadow within this radiant interior reveals Vermeer's great technical mastery and a rarely matched intensity of vision.

The distortions in size and scale between the soldier in the foreground and the woman seated in the middleground, along with the unfocused appearance of such motifs as the lion-headed chair finial, her hands, and the wineglass she is holding, provide the earliest indications of Vermeer's interest in optical devices.[66] That Vermeer had some interest in such devices in relation to his art is undeniable; but the degree to which he actually employed them while working is difficult to determine. Several decades ago, scholars argued that Vermeer utilized the camera obscura directly in the execution of his paintings. Their hypotheses have been challenged but in recent years a controversial book by Philip Steadman and a much-publicized symposium on optics and Western painting led by the artist David Hockney has rekindled the debate.[67]

The camera obscura was invented in the Renaissance as a perspective aid for artists, mathematicians, scientists, and generally interested amateurs.[68] In essence this contraption is a precursor of a modern camera. In its earliest and most elemental form, it was simply a darkened chamber with an extremely small opening in one of its walls. Rays of light pass through this small opening and project an image with uncanny fidelity (though inverted and reversed) on the back wall. By Vermeer's day the camera obscura had become more widely available in a mobile form as a transportable box (fig. 152). The image cast was sharpened and intensified by a converging lens placed in the hole through which the rays of light passed. Additionally, it was now projected onto a screen composed of frosted or ground glass, oil paper, or some similarly translucent material. To early modern Europeans, not jaded as modern viewers are by television, movies, and computer games, the image must have been absolutely startling even if a substantial part of its perimeter was blurred on account of the crude lens with its very limited depth of field.[69] This was especially true for projections of metallic

objects or those with hard surfaces: their peripheries would be literally dissolved into broken contours of light called halations. A further drawback of the device was its reduction of the scale of items but not the amount of color or light that reflected off them so color accents and light contrasts subsequently gained in intensity.

Although there was general enthusiasm among contemporary Delft artists such as de Hooch and Fabritius for complex perspective as well as optical phenomena which may have stimulated Vermeer's interest in the camera obscura,[70] but there is no proof that Vermeer either traced or copied his compositions directly from the projected image of the camera obscura (an image that could be righted with a mirror built into the box). So how then did the apparatus affect his work? The enchanting ocular effects produced by it no doubt stimulated his aesthetic interest to such an extent that he often replicated them in his art but without needing direct recourse to the device. Vermeer thus modified these effects and often, surprisingly, exaggerated them to suit his artistic vision. Moreover, as Mariët Westermann has insightfully observed, "The very modernity of the camera must have played a role in his decision to play up the signs of its creative presence in his practice."[71]

This is especially true of Vermeer's famous *pointillés*, little dots of impasto applied to the surfaces of his pictures in order to imitate the halations inherent to the peripheries of gleaming objects projected by the contraption. Although Vermeer likely used *pointillés* initially to duplicate what commonly could be seen through the camera obscura he soon realized their independent aesthetic potential. For instance, he could not have observed them on the bread depicted in a slightly later canvas, *The Milkmaid* (of about 1659–60; fig. 153) because the contraption will only cause halations on projected things that reflect light (such as metal or polished wood).[72] In *The Milkmaid* the *pointillés* bestow an extraordinary tactility to the chunks of bread; these multitudinous paint dots seem to exist independently of the forms they describe.

This visual evidence militates against the theory that Vermeer employed the camera obscura directly in the genesis of his paintings. An illuminating essay by Jean-Luc Delsaute further confirms this: on the basis of his careful reading of contemporary art-theory books and treatises on the camera obscura Delsaute determined that the apparatus was used directly to create paintings only during the eighteenth century.[73] Like all seventeenth-century Dutch masters Vermeer worked from established stylistic

153 Johannes Vermeer, *The Milkmaid*, c. 1659–60 (oil on canvas, 45.5 × 41 cm). Amsterdam, Rijksmuseum.

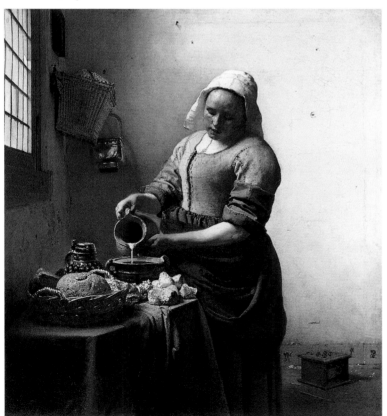

154 Johannes Vermeer, *The Girl with the Wine Glass*, 1662–5 (oil on canvas, 77.5 × 66.7 cm). Braunschweig, Herzog Anton Ulrich-Museum.

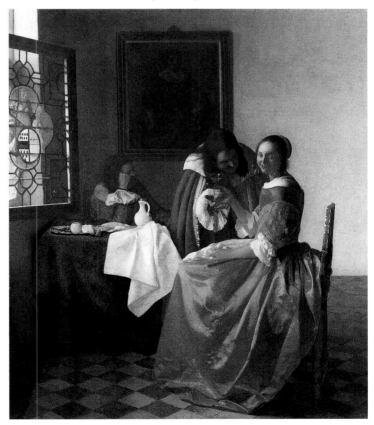

and thematic conventions. It was his particular genius to absorb them completely and refashion them into ostensibly straightforward if not unique-looking works, seemingly devoid of artistic influences. To the untrained eye the extraordinary appearance of these pictures can only be explained via the intervention of a camera obscura but nevertheless Vermeer's amazing pictorial feats were not at all contingent upon direct use of this contraption in the generative process.[74]

During the 1660s, the most significant decade of his career, Vermeer continued to modify his style. He introduced unprecedented levels of refinement in such paintings as *The Girl with the Wine Glass* (fig. 154) and the so-called "pearl pictures," a group of paintings, usually dated between 1662 and 1665, depicting his favorite subject, women, that share a common motif of pearls and a luminous, silvery tonality, among them, the *Young Woman with a Water Pitcher* (fig. 156).[75] At this stage in his development Vermeer no longer relied on pasty modeling with thick impasto and consequently his use of *pointillés* became less obtrusive. As a result, the paintings' surfaces are much smoother, displaying less tactility. Light becomes a dominating device as it defines space and forms, imparting a wonderfully radiant sheen to Vermeer's work.

In order to achieve this effect, the artist deliberately utilized the underpaint as an interactive agent with the paint layers above. In the *Young Woman with a Water Pitcher*, for example, he applied a darker tone over the light ocher ground layer followed by a thin glaze to delineate shadowed yellows, such as those on the right side of the girl's jacket. In the lower right a layer of reddish-brown has been applied over this ground in order to enhance the reddish glow of the astonishing reflections on the brass basin while it simultaneously serves as the base color for the tablecloth.[76]

Vermeer's stylistic shift toward greater refinement is best explained as a response to contemporary artistic developments among the Leiden *fijnschilders*. In particular, the exceptional polish and sophistication now apparent in Vermeer's art is analogous to that encountered in the works of such Leiden artists as Frans van Mieris the Elder (see fig. 111).[77] The refined style of Vermeer's paintings of the early 1660s is matched by their subject matter for the artist continually adjusted his style to correspond to pictorial content. Much like the work of ter Borch, whose sophisticated paintings of courtship and society likewise influenced Vermeer, the meanings of the latter's pictures tend to be elusive and deliberately so.[78]

The Girl with the Wine Glass, for example, is replete with references to civility and politesse. The leering gaze of the man encouraging his exquisitely attired companion to drink is reminiscent of pictures by van Mieris (see fig. 183). Is his action here one of attempted seduction by plying his unsuspecting victim with alcohol? In smiling, this maiden displays her teeth, an act which for Vermeer's contemporaries betokened childishness.[79] Does her facial expression, awkward body language, and grasping of the glass at the man's urging indicate that she is a

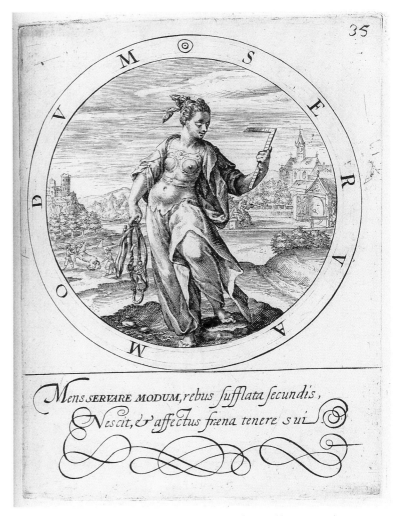

155 Emblem from Gabriel Rollenhagen, *Nucleus emblematum Selectissimorum*, Arnhem and Utrecht, 1611–13. New York, Rare Books Division, The New York Public Library, Astor, Lenox and Tilden Foundations.

guileless ingénue being taught manners by a dissolute mentor?[80] Seventeenth-century viewers would have recognized the savoir-faire with which the young woman delicately holds – or is learning to hold – the wineglass. This manner of grasping a glass was later codified by Gerard de Lairesse in *The Art of Painting* as the most elegant way to hold a glass.[81]

Unfortunately, other details in *The Girl with the Wine Glass* do not entirely clarify the main scene. What is the significance of the dozing man in the background?[82] And how do the portrait of the man, dressed in fashions of the 1630s, and the coat-of-arms in the window relate to the action?[83] In the latter motif, a female figure holds what is probably a bridle and thus functions as a personification of temperance, one found in contemporary prints and emblem books (fig. 155). If this coat-of-arms signifies temperance then it cleverly comments upon the male protagonists' debauchery or perhaps upon the grinning female

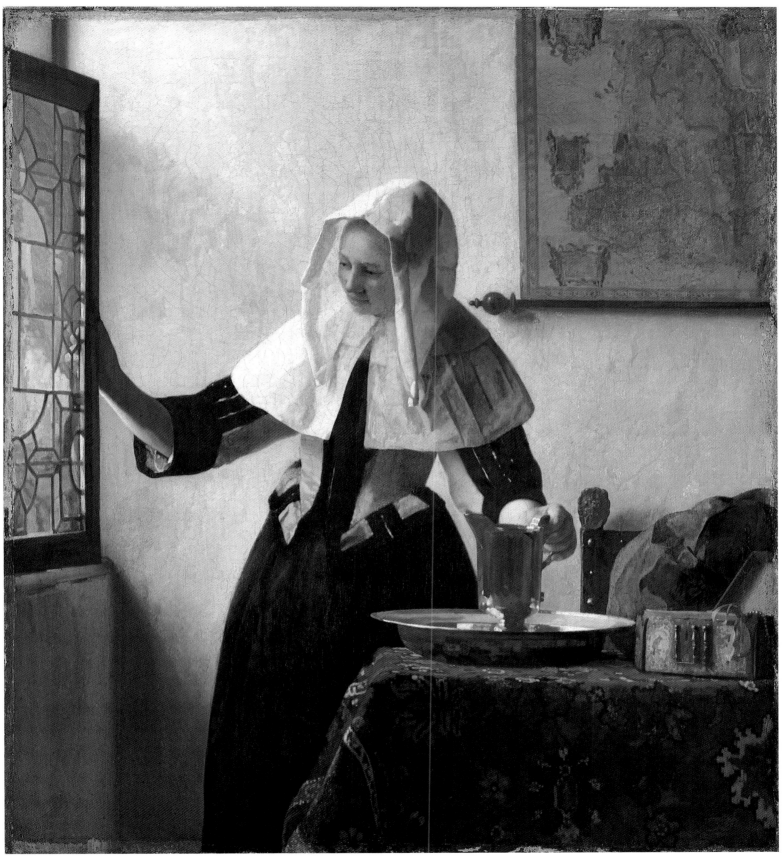

156 Johannes Vermeer, *Young Woman with a Water Pitcher*, 1662–5 (oil on canvas, 45.7 × 40.6 cm). New York, The Metropolitan Museum of Art, Marquand Collection, Gift of Harry G. Marquand, 1889.

who is about to imbibe – after all, there is a visual connection between the personification's coral skirt and hers.[84]

Vermeer's pearl pictures are even more enigmatic. For example, the presence of a basin and ewer, jewelry box, and head and shoulder coverings suggests that the maiden in the *Young Woman with a Water Pitcher* is at her morning toilet.[85] Yet compared with paintings by ter Borch and van Mieris of this theme (see figs. 88 and 112), Vermeer's conspicuously lacks a broader narrative context and additional accouterments, most notably a mirror, which would make the subject of the painting more easily identifiable. Instead, it communicates an air of reticence and introspection, qualities with which modern-day beholders readily identify. The ewer and basin provide some insight into the picture's original meaning for they were time-honored symbols of purity and innocence.[86] But these concepts are more perfectly embodied in the effulgent female herself whose resplendent, inviolate form is forever arrested in an ostensibly inconsequential moment in time.[87] She assumes the moral authority of a traditional personification without actually being one, as H. Perry Chapman has astutely observed. Equally perceptive is Chapman's characterization of Vermeer's representations of women in the home as ideational, that is, supremely concerned with ideals and related abstract concepts.[88] And fully integrated with the ideational is the beautiful, the artist's superb delineation of quintessential, female pulchritude, the depiction of which contemporary art theorists exalted as one of painting's highest goals.[89]

Vermeer's urbane and often cryptic images of beautiful women who court, primp themselves, write letters (see fig. 217), make music (see fig. 157), and engage in domestic tasks (see fig. 218) virtuosically articulate the civilized values of elite culture. This is a culture to which the artist himself aspired judging at least from the trappings with which he adorned himself after his marriage into a well-to-do family in 1653. These included his adoption of the upper-class title "seigneur" and his membership in Delft's militia company, for participation in these municipal organizations of citizen soldiers presupposed a certain level of affluence and social standing.[90] Vermeer's paintings were thus made for elite audiences because their subject matter and style were consonant with the increasingly cultured and genteel tastes of those of lofty social rank.[91] Furthermore, their production was labor intensive, often involving costly paints, and as a result were quite expensive by seventeenth-century standards; a French visitor to Delft in 1663 was told by the owner of one of Vermeer's single-figure paintings that he had paid 600 guilders for it, a sum higher than many Dutchmen earned in a year.[92]

Fortunately, much is now known about Vermeer's patrons. Strong circumstantial evidence suggests that he had a maecenas who possibly enjoyed first right of refusal to purchase his paintings: the moneyed Delft citizen Pieter Claesz. van Ruijven (1624–1674).[93] In many ways van Ruijven typified the elite of

his day. He stemmed from a prominent Delft family – his father was a brewer – and although his profession is not known he accrued substantial wealth through inheritances (possibly from his wife's family) and judicious investments. And like many members of the upper classes in this era of aristocratization, van Ruijven paid a truly astronomical sum (16,000 guilders) for a noble title and domain in 1669. As a member of Delft's elite van Ruijven was doubtlessly a man of sophisticated taste and distinction. He was also a discriminating connoisseur who assembled an impressive art collection, at the core of which were some twenty paintings by Vermeer, probably acquired as soon as they were finished (including *The Girl with the Wine Glass* and *An Officer and Laughing Girl*). Collecting art evidently "ran in the family": van Ruijven's cousin was Dou's important patron Pieter Spiering.

Van Ruijven loaned Vermeer and his wife 200 guilders in 1657. According to Montias, who has written extensively on Vermeer's patrons, this loan, given the amount and its short duration, was conceivably an advance toward the purchase of one or more paintings. On 19 October 1665, van Ruijven and his wife, Maria de Knuijt (d. 1681) signed their last will and testament. One of the most fascinating parts of this document is the arrangements made for the guardianship of their surviving child or children if both parents predeceased them: the guardian was to dispose of works of art that would be found in the house according to the stipulations made in a certain book marked "A" (unfortunately now lost), upon which was written "Dispositions of my *Schilderkonst* (works of art) and other matters." Vermeer possibly enjoyed more than a professional association with the couple. In 1665 de Knuijt had her own, separate section of the couple's last will and testament drafted in case her husband and child or children predeceased her. In it, de Knuijt bequeathed 500 guilders to the painter, the only non-relative to be singled out for a special bequest. This is a rare if not unique example of a seventeenth-century Dutch patron bequeathing money to an artist.

The bulk of the van Ruijven and de Knuijt estate – including their art collection – was eventually inherited by their son-in-law, Jacob Abrahamsz. Dissius (1653–1695) after his wife, their daughter Magdelena, died childless 1682.[94] In May 1696, seven months after his death, Dissius's collection, with twenty-one paintings by Vermeer (at least twenty of which were first owned by van Ruijven and de Knuijt) was auctioned.[95] This sale is well-documented which explains the once widely held view that Dissius had been Vermeer's patron. However, he was just twenty-two years old and destitute when Vermeer died; Dissius undoubtedly had inherited his Vermeer paintings via his wife's parents.

Vermeer's circle of buyers and devotees, drawn largely from the upper echelons of society, extended beyond van Ruijven and de Knuijt. For example, two other Delft patricians, Gerard van Berckel (1679–1759) and Nicolaes van Assendelft (1630–1692), are likely to have owned paintings by Vermeer.[96] The artist's work

also appears occasionally in collections in other Dutch cities – a "face by Vermeer" was listed in the death inventory (composed in August 1664) of Johannes Larson, an English sculptor who lived in The Hague where he worked for both the Dutch and English courts.[97] Moreover, in a list of "present day painters" and their subjects, compiled by the Amsterdam surgeon Jan Sysmus between the years 1669 and 1678, Vermeer is associated with themes of "little dandies and castles."[98]

Montias has published excerpts from the fascinating diary of Pieter Teding van Berckhout (1643–1713), scion of a distinguished family in The Hague, who was active in cultured circles in his home town and in Delft.[99] Van Berckhout traveled to Delft by boat on 14 May 1669 and visited Vermeer, whom he called "un excellent peijntre" (an excellent painter) who showed him "quelques curiositez de sa maijn" (some curiosities made by his own hand). Approximately five weeks later, van Berckhout returned to Delft and once again sought out Vermeer. This time he called the artist "un celebre peijntre" (a famous painter) and related that Vermeer "me monstra quelques eschantillons de son art dont la partie la plus extraordinaijre et la plus curieuse consiste dans la perspective" (showed me some examples of his art, the most extraordinary and most curious aspect of which consists in the perspective). Van Berckhout's obvious admiration for the rendering of perspective in Vermeer's pictures is fascinating; one wonders what paintings in particular he had seen.[100] Van Bleyswijck, in his previously mentioned *Beschryvinge der Stadt Delft*, also commends the excellent use of perspective in local painting with reference to works by Fabritius.[101] Perspective was probably recognized as a salient feature of Delft art along with its exceptional craftsmanship and sophisticated subject matter, the latter often presented with decorous reserve.[102] Even though many of Delft's best artists had died or departed the city by the 1660s there is sufficient stylistic and thematic cohesion detectable in genre paintings produced there before that date to speak of a "Delft School" in the loosest sense of that term.[103]

During his middle period Vermeer also executed two genre paintings with comparatively deep spatial recessions: *The Music Lesson* (London, Collection of Her Majesty the Queen) and *The Concert* (fig. 157).[104] The latter painting, dated to around 1665–6, depicts a trio completely absorbed in their music-making: an officer soldier strums a lute while a young woman wearing a dazzling outfit plays the harpsichord. Together they accompany another woman who sings. These three figures are actually depicted on a smaller scale than that of the room's perspective in order to exploit the volumetric qualities of the entire scene. The spatial disposition of *The Concert* reveals other inconsistencies that suggest an intuitively created perspective system here for a picture that could not have possibly been composed exclusively with the aid of a camera obscura, notwithstanding the tantalizingly blurred appearance of the cittern, carpet, and sheet music on the foreground table.

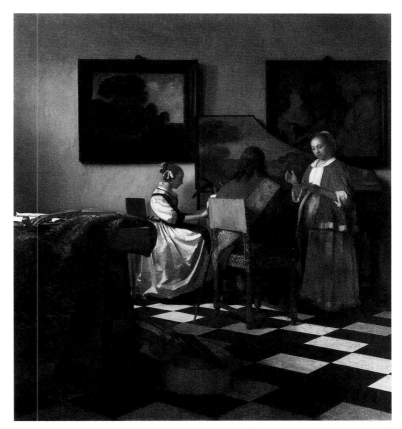

157 Johannes Vermeer, *The Concert*, c. 1665–6 (oil on canvas, 72.5 × 64.7 cm). Boston, Isabella Stewart Gardner Museum.

Like many seventeenth-century Dutch paintings, *The Concert* is no longer in optimal condition; many of the delicate glazes employed by Vermeer to achieve his signature luminosity have been abraded.[105] The singer's splendid costume, for example, was once a vibrant blue, created with a thinly painted layer of expensive ultramarine, thereby echoing the sky in the landscape on the lid of the harpsichord (which is also abraded). Despite its surface losses, the canvas is still sufficiently preserved to disclose the artist's ever-evolving style. *The Concert* and other works of the late 1660s evidence Vermeer's diminishing propensity to replicate the textures of diverse motifs which he had hitherto done with uncanny accuracy. Textures are no longer described in any detail but "suggested" by patterns of color on objects. And equally fundamental to their articulation is the play of light upon them.

One feature of Vermeer's art that remains immutable however is the general ambiguity of his subject matter. *The Concert* contains two paintings on the wall behind the figures as well as the previously mentioned landscape on the harpsichord lid. Elise Goodman has persuasively associated the landscapes with widespread notions comparing love, female beauty, and nature.[106] The other little picture is a copy of Dirck van Baburen's *Procuress* (see fig. 59) then owned by Vermeer's wealthy

mother-in-law Maria Thins (*c.* 1593–1680) in whose house he resided. Does this theme of mercenary love complement the music-makers iconographically or is it intended to contrast their actions, in other words, to pit vice against virtue?[107] Gregor Weber's application of the principles of early modern rhetoric to the function of paintings-within-paintings is illuminating in this respect.[108] Weber posits that pictures on the wall within Dutch genre paintings serve to amplify their possible meanings, providing the viewers, much like a speaker engaged in debate, with material upon which to base his or her judgments. But this material never leads to monolithic conclusions; to the contrary, it is open-ended and multivalent. Thus the elusiveness of the *The Concert* is an intentional feature meant to delight viewers already enthralled by its dazzling visual effects.

The presence of van Baburen's *Procuress* in *The Concert* and in a later painting of a woman at a virginal (London, The National Gallery) raises the question of Vermeer's use of settings and props for his canvases. Despite his near constant manipulation of formal elements for expressive purposes the rooms in his paintings are striking in their occasional resemblance to one another.[109] This has led to several, unsuccessful attempts to identify the spaces depicted in the paintings with those that actually existed in his mother-in-law's house.[110] Vermeer also resorted to an impressive array of "studio props" in addition to identifiable paintings, among them, costumes, musical instruments, furniture, and wall coverings, including maps that are generally rendered with great fidelity.[111]

While many of these items are listed in an inventory of the deceased artist's moveable goods drafted in 1676[112] Vermeer's continual alteration of their appearance along with the rooms in which they are depicted must be acknowledged. From this standpoint the variations from painting to painting are seemingly inexhaustible: the famous chairs with lion-headed finials are often shown with different upholstery, the patterns of tiles on the floors change, the pictures on the walls vary in scale and have different frames, the placement of windows are modified with respect to the back walls, and so forth. Vermeer's ceaseless modifications of existing objects and spaces in his work once again underscore his habit of structuring his paintings to maximize their potential to evoke ambience.

By the late 1660s Vermeer was at the pinnacle of his career. Clearly, he had become a well-respected member of Delft's artistic community and in this capacity enjoyed the esteem and patronage of elite collectors (particularly van Ruijven) in that city and beyond, even if his laborious technique limited his production. In 1662, and again in 1670, Vermeer's colleagues elected him one of the headmen of the Guild of St. Luke. He was the youngest artist to be chosen for the post since the guild was reorganized in 1611, a reflection certainly of the esteem of his counterparts (in spite of the fact that many other possible candidates had either died or already left the city).[113] In sum, Vermeer epitomized the so-called Delft School at a time when its most illustrious years were, like the renowned master's career and life, rapidly coming to an end.

AMSTERDAM

Between the years 1648 and 1672 Amsterdam reached its economic and political zenith.[1] During the twenty-two-year Stadholderless era, States Party advocates of the Province of Holland, mainly regents who administered this province's many urban centers, controlled national politics under the leadership of the Pensionary, Johan de Witt (1625–1672). And Amsterdam itself, with its enormous wealth, prestige, and growing population (swelled by immigration to approach 200,000 during the 1660s) dominated politics within Holland.[2] Thus it is no exaggeration to claim unparalleled influence on a national as well as international level for Amsterdam's regents at this time.

These regents shrewdly wielded power not as an end unto itself but as a means to enhance Amsterdam's prosperity and dominance within the nation at large.[3] For Amsterdam continued to serve as a veritable entrepôt for international trade. Its envious position was only enhanced by the cessation of hostilities with Spain, which thoroughly energized the United Province's economy at the expense of those of its nemeses, particularly Great Britain. Ships from Amsterdam's harbor (and those of her sister ports) greatly expanded trade in Spain, the Mediterranean, the Caribbean, the East Indies, and the Far East, and Amsterdam's local industries likewise prospered, among them silk manufacture, sugar-refining, and the processing of tobacco and diamonds. Curiously, Amsterdam also profited greatly from the industries of its domestic, commercial rivals. It exercised, for example, a virtual hegemony over the textile industry and its principal manufacturing centers in Leiden and Haarlem by serving as the importer of the requisite raw materials and as the exporter of the finished products.[4]

In essence Amsterdam's economic preeminence led to its cultural preeminence in the Netherlands insofar as the city functioned as a trendsetter on a wide variety of fronts, including architecture, the decorative arts, literature, and fashion.[5] Amsterdam's unprecedented affluence also allowed it to expend huge sums on municipal projects. Indeed, its expenditures in this arena peaked during the 1660s, which is no mere coincidence given the economic and political situation.[6] At this time a number of imposing public structures were completed such as the new, majestic Town Hall (completed in 1665), a building whose richly sculpted pediments glorified the city's dominion over the seas.

In a second wave of dramatic municipal expansion during this decade, the ring of three concentric canals was extended to the Amstel River.[7] Within these new, fashionable districts, many monumental residences were built for elite habitation. The luxurious homes constructed for wealthy residents and the accouterments chosen to decorate them underscored the escalating distance between their owners and financial and social inferiors. Members of the upper classes lavishly embellished their new residences with expensive furniture, imported ceramics, and works of art.[8] Genre paintings by Amsterdam artists and similar pictures imported from such cities as Leiden, capture and even exaggerate the luxurious atmosphere of these residences and therefore function as commodities in the same respect as the resplendent objects they so frequently depict.

Amsterdam's immense population included innumerable citizens of non-elite social status who likewise possessed sufficient discretionary income (albeit on a lesser scale) to tap the vast markets for luxury goods. The economic historian Jan de Vries has demonstrated how new forms of luxury consumption (and attitudes toward such consumption) accompanied economic development in European urban centers during the early modern period, especially in cities within the booming Dutch Republic.[9] He argues that new forms of luxury took their place beside traditional, "old luxury" ones. The focus of "new luxury" was upon costly goods and services intended for comfort and enjoyment; it generally lacked old luxury's associations with personal decadence and dangerous profligacy among elites. (However, these two forms of luxury remained in flux during the seventeenth century.) Most importantly, new luxury gradually engendered a nascent consumer culture in which a broad segment of society participated. It therefore potentially eroded established social hierarchies by eliminating the exclusivity of specific products. But these hierarchies were to some extent sustained by the range of cost and quality of the products in question. The price and quality of genre paintings certainly fluctuated greatly but the ones under consideration in this book were on the whole intended for affluent purchasers.

Jacob van Loo and Gerbrand van den Eeckhout

Genre painting had flourished in Amsterdam for decades, initially in the skillful hands of David Vinckboons, followed by Willem Duyster and Pieter Codde. Around 1650, the younger

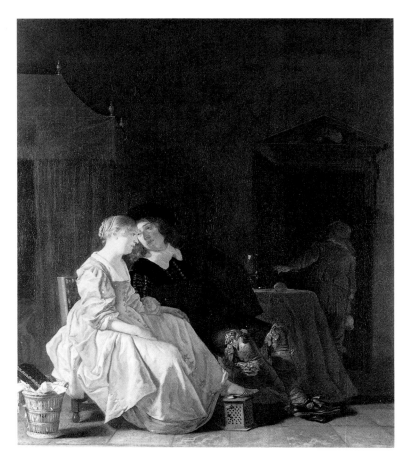

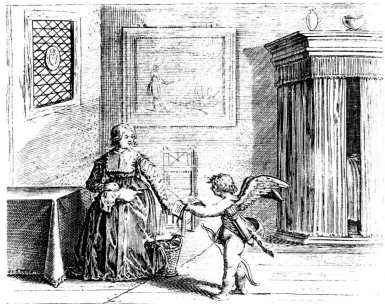

159 (*above*) Emblem from Jan Harmensz. Krul, *Pampiere wereld*, Amsterdam, 1644. Amsterdam, Universiteits-Bibliotheek Amsterdam.

158 (*left*) Jacob van Loo, *Wooing*, c. 1650 (oil on canvas, 73.3 × 66.8 cm). The Hague, Mauritshuis.

masters Jacob van Loo and Gerbrand van den Eeckhout introduced a series of stylistic innovations that permanently altered the subject matter and style of genre painting in the city. Van Loo (*c.* 1614–1670) was actually born in Flanders; after possibly receiving training from his father, who was said to be a painter (though no works by him survive), he emigrated to Amsterdam, having settled there by 1642 if not somewhat earlier.[10] Van Loo quickly established himself as one of Amsterdam's best painters, practicing a variety of genres, including portraiture and history painting. Tragically, in October 1660 van Loo murdered a man in a scuffle at a tavern and was forced to flee the country. Thereafter he settled in Paris where he became a member of the Royal Academy of Painting and Sculpture and enjoyed a distinguished career until his death in 1670. His artistic legacy endured however in the hands of his progeny who rank among the leading French masters of the eighteenth century.

Many of van Loo's genre paintings were produced during the late 1640s and early 1650s. *Wooing*, of around 1650 (fig. 158), is prototypical; the vertical format of this canvas, and more significantly, its concentration on two figures gently enveloped in subtle shadows that play upon the exquisite textures of their clothing, evidence its innovative nature.[11] The nuance of gesture and facial expression here, the soft luminosity and general air of refinement anticipate ter Borch's courtship pictures. This is not

to imply that van Loo's art somehow served as a catalyst for ter Borch but rather that both artists exemplify the resourceful adaptations of traditional subject matter by a younger generation of genre painters. The work of both masters also testifies to changing expectations and tastes among increasingly wealthy and civilized buyers who desired more sophisticated renderings of established imagery.

Van Loo's painting constitutes an elegant and intimate updating of earlier depictions of courtship (see fig. 24). He focuses on the gentle supplications of the elegant young man, which probably explains why this work has long carried the title *Wooing*. Judging from this suitor's attentive gaze and gesture, he seems to entreat his beloved. The evocation of emotion, specifically that of longing on the part of the young man confronted with the ostensibly inattentive focus of his affections, is thoroughly Petrarchan.[12] Other details in the painting confirm this reading. A basket filled with fabric and a sewing cushion to the side of the maiden are motifs that may convey particular notions in this context. A common conceit in amatory poems, songs, and emblemata (fig. 159) infused with Petrarchan sentiments is that of the enervated lover who is so overwhelmed with desire that he or she can no longer perform daily tasks effectively.[13]

The footwarmer upon which the young lady rests her foot is another motif with possible significance in this context. It has

160(*above*) Emblem from Roemer Visscher, *Sinnepoppen*, Amsterdam, 1614. Amsterdam, Universiteits-Bibliotheek Amsterdam.

161 (*right*) Jacob van Loo, *Brothel Scene*, *c.* 1650 (oil on canvas 76.2 × 63.5 cm). Private collection.

been related to a frequently cited, and often misunderstood, emblem by Roemer Visscher (1547–1620) whose *pictura* also shows a footwarmer (fig. 160). The *inscriptio* calls the warmer a *mignon des dames* (a favorite of women). In the *subscriptio*, Visscher initially notes how women are fond of the contraption, particularly in wintry weather, but he quickly arrives at the real subject at hand, to wit, proper courting strategies:

> He who aspires to win second place in [the ladies'] esteem [first place belongs to the footwarmer of course] must embark upon serving them with sweet, witty and amusing talk, avoiding all boorishness and vulgarity, without reprimanding their cackling and chattering and never mocking their fussy and showy clothes; but praising them for everything they do and propose, then he will be praised in their company as a perfect courtier.[14]

This could be a rare instance in which an emblem functions as a true *clavis interpretandi* for a motif in a painting.[15] The fact that the emblem discusses proper courting tactics enhances our understanding of the painting since other motifs within it – the seashell, the needlework that has been placed aside, as well as the youthfulness of the figures, their satin garments, restrained gestures, and demeanors – all contribute to its display of courtship and *civilité*.

Among van Loo's limited output of genre paintings are those whose subject matter is more suspect.[16] An interior scene, for example, datable to roughly 1650 depicts two couples interacting in an expansive interior (fig. 161). The man and woman in the right foreground are engaged in some sort of intimate exchange while their companions in the middleground play cards – the female gambler gazes confidently at the viewer. Behind the card players lurks an elderly woman who in this context can only be a procuress. Van Loo has thus depicted a brothel. Yet consistent with the new approaches to subject matter in this post-war period, strong sexuality of a type encountered in earlier representations of this theme (see fig. 61) has been sublimated and rendered innocuous. Moreover, this canvas employs the same upright composition, sophisticated chiaroscuro effects, and fashionably dressed figures as *Wooing* and paintings by ter Borch and other masters.

Van Loo's work heralds future developments in Dutch genre painting even if his career as a genre painter was of comparatively short duration. The same can be said of the work of Gerbrand van den Eeckhout (1621–1674).[17] Van den Eeckhout, a native Amsterdammer and son of a well-to-do goldsmith, was trained by Rembrandt, whose studio he probably entered in the late 1630s. A life-long bachelor, van den Eeckhout cultivated contacts within influential political and literary circles in Ams-

162 Gerbrand van den Eeckhout, *Party on a Terrace*, 1652 (oil on canvas, 53.5 × 64 cm). Worcester, Worcester Art Museum.

terdam, serving for example as a tax appraiser for paintings and exchanging verses with prominent poets (and on at least one occasion published a poem).[18] Like van Loo, he specialized primarily in history paintings and portraiture.

Most of van den Eeckhout's genre paintings date to the early 1650s, when he depicted several images of elegant courtship. A good example is his *Party on a Terrace* of 1652, which shows young people congregating on a classical portico before a park-like setting containing a statue of Cupid (fig. 162).[19] This setting, the relaxed poses of the figures, their sartorial splendor, and even

the artist's vibrant palette, doubtlessly inspired by Flemish art, all convey an atmosphere of affluence and nonchalance.[20] However elegant, the painting essentially constitutes a "modernization" of the love-garden theme popularized in Dutch genre painting by Vinckboons, Esaias van de Velde (1587–1630), and other artists of that older generation (see fig. 44).

Conventional motifs familiar from earlier representations are present: a lute, songbooks, wine, a servant, and, obviously, court-ing couples, though the last now appear more natural-looking and proportionally occupy greater space within the canvas. The

females in this picture have nearly identical hairdos, garments, and facial features and are especially beautiful and chic; their modish dresses, crowned by exceptionally wide, layered, lace collars, complement their idealized features. These women are quintessential, Petrarchan beauties who have become the objects of their ardent suitors' attentions. Their beauty and refinement echo that of the garden setting behind them – no mere coincidence since it was a common literary conceit of the period to compare feminine beauty with nature.[21] The modish hats of the men serve as their principal identifying feature. The individuality of all of these figures is subordinated to the overall courtship ritual in which they are engaged, one in which pose, attire, and setting smack of gallantry, polite conversation, and haute couture.

Although the mood of van den Eeckhout's scene is somewhat restrained, the couples are actively involved in the courting process. In the foreground a man importunes his beloved, the sincerity and urgency of his overtures underscored by his hand held over his heart. She holds a fan, a motif that must have been replete with associations for contemporaries given its frequent inclusion in scenes of courtship.[22] It is impossible to determine its full significance here but it is clear that her suitor's companions have been more fortunate, especially the one to the left with his arm around the waist of a maiden holding a songbook. Popular Petrarchan conceits involving languishing lovers and insouciant ladies would have stimulated contemporary viewers to project their own feelings and experiences into the sophisticated narratives of courtship fashioned by van den Eeckhout and other members of his generation.

Party on a Terrace closely resembles another painting by the artist of the same subject (fig. 163).[23] Once again, van den Eeckhout has depicted a party of well-dressed youths gathered on a columned terrace before a wooded grove. In the background, a man gestures to his heart as he woos a fashionably dressed young woman holding a fan. In front of this couple is a man with his arm around the chair of his lady; he gently touches her shoulder as they sing from an oblong songbook.[24] The man in the foreground is clearly the focus of attention in this painting by virtue of his position within the composition and the light that softly illuminates his resplendent form. He sits in a chair beside a large hunting dog, before a servant and a table with music books upon it. This young man stares wistfully at the couple singing the duet, his melancholic distress indicated by his head resting on his hand.[25] In this context, his melancholy ensues from unrequited love – in fact, his gesture appears in other paintings of courtship where the plaintive suitor is likewise set apart from a couple to underscore his despondency and rejection.[26] This man, along with his counterparts in other pictures, embodies the classic spurned suitor whose laments are commonplace in amatory poetry and song of the period.[27]

Van den Eeckhout also painted several guardroom interiors, a theme developed by Codde and Duyster and subsequently

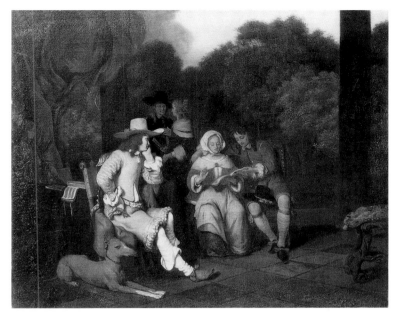

163 Gerbrand van den Eeckhout, *Party on a Terrace*, c. 1652 (oil on canvas, 50.5 × 62.5 cm). New York, The Metropolitan Museum of Art, Bequest of Annie C. Kane 1926 (26.260.8).

164 Gerbrand van den Eeckhout, *Tric-Trac Players*, 1653 (oil on canvas, 43.8 × 37.8 cm). Private collection.

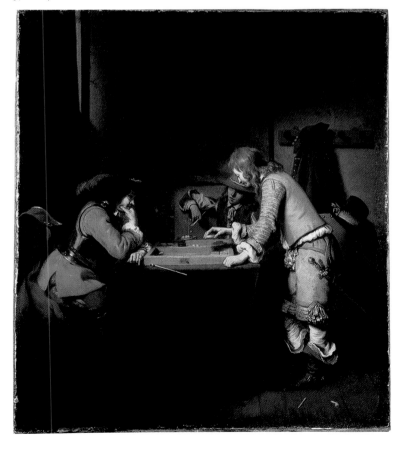

adopted by ter Borch for some of his very first genre pictures (see Chapters 3 and 6, respectively).[28] His *Tric-Trac Players* of 1653 (fig. 164) presents officers cleansed of the rugged bearing and brutish behavior of their counterparts who populated genre paintings from the 1630s (see fig. 56). In literature and the visual arts, soldiers were traditionally associated with games of chance; therefore the painting, like its pictorial predecessors, presents an unadulterated topos. Nevertheless, these men play tric-trac in a gentlemanly manner. The restrained comportment of the soldiers and their colorful clothing, the intimacy of their surroundings, the upright composition, and engaging chiaroscuro effects once again bespeak a novel mode of rendering conventional subject matter. Van den Eeckhout's pictures of civilized soldiers emerge quite early in this evolutionary process yet can be construed partly as a response to the tastes and demands of a progressively wealthy and sophisticated clientele in an era of growing prosperity. However, with the triumphant conclusion of the war with Spain, the demand for depictions of guardrooms diminished considerably.[29]

Gabriel Metsu and Pieter de Hooch

The careers of Gabriel Metsu and Pieter de Hooch were symptomatic of an increasing trend among genre painters during the second half of the century; namely, to relocate to the grand metropolis of Amsterdam where commercial prospects must have appeared limitless. Metsu (1629–1667) was born in Leiden two months after the death of his Flemish immigrant father, who also was a painter.[30] Little is known of Metsu's early career; his teacher, for example, has not yet been identified. Evidently he was precocious as his earliest painting, dated 1645 (St. Petersburg, Hermitage), was executed when he was fifteen or sixteen years old. His precocity is confirmed by the appearance of his name in two documents signed by a group of artists in 1644 and 1648 attempting to establish a provisional guild in Leiden (see Chapter 8). By 1650 or 1651 Metsu had left his native town only to return in 1654. His interim years may have been spent in Utrecht since the art of that city inspired his initial works.

During Metsu's brief Leiden period (to 1657) he produced a disproportionate number of history paintings as well as fairly broadly painted genre pictures on a large scale with figures whose expansive forms and gestures are reminiscent of the work of such Utrecht masters as Nicolaes Knüpfer (*c.* 1603–1655) and Jan Baptist Weenix (1621–?1660/61).[31] Archival evidence places Metsu in Amsterdam by 1657, the city in which he spent the remainder of his relatively short life. Genre paintings dominated his output in Amsterdam, revealing a somewhat protean artist who absorbed the styles and themes of the leading genre painters of his generation and forged them into something distinctive.

The Hunter's Gift (fig. 166) likely dates from Metsu's early years in Amsterdam, judging at least from its fluent, liquid-like paint application and startling juxtapositions of red and green (in the curtain, tablecloth, and the female's dress).[32] Its subject, a young woman sewing who entertains a hunter proffering a dead partridge, constitutes a male–female confrontation that lies at the heart of much of Metsu's imagery throughout his career. Cleverly, the artist has even introduced a contrast between the protagonists' dogs: the lady's lapdog poised on the table stares at the stocky spaniel standing faithfully by its master's side.

Clearly, the little statue of Cupid perched on the linen chest behind the hunter and seamstress emphasizes the amorous nature of his offer, but the lustful underpinnings of the hunter's gesture would have been readily apparent to seventeenth-century viewers even if they elude modern audiences. In a classic article, Eddy de Jongh convincingly explained the erotic significance of the man's proposal by citing several contemporary prints and texts in which birds refer to lasciviousness and the Dutch verb *vogelen* (to bird – the rough equivalent of "to screw" in modern English) to sexual intercourse.[33] An engraving by Gillis van Breen (active *c.* 1595–*c.* 1622) of an aged, lecherous man selling birds – one of his hands is in his breeches – suggests this by wittily punning on *vogelen* (fig. 165). Its inscription, a dialogue between the man and his female customer, informs us that the dead bird on top of the basket by his feet has already been sold "To a faire ale-wife whom I bird ['ick vogel', the present tense of *vogelen*] all year round."[34] Thus by offering the bird to the young woman, Metsu's hunter is actually propositioning her.[35]

165 Gillis van Breen after Nicolaes Clock, *Poultry Seller* (engraving). Amsterdam, Rijksprentenkabinet.

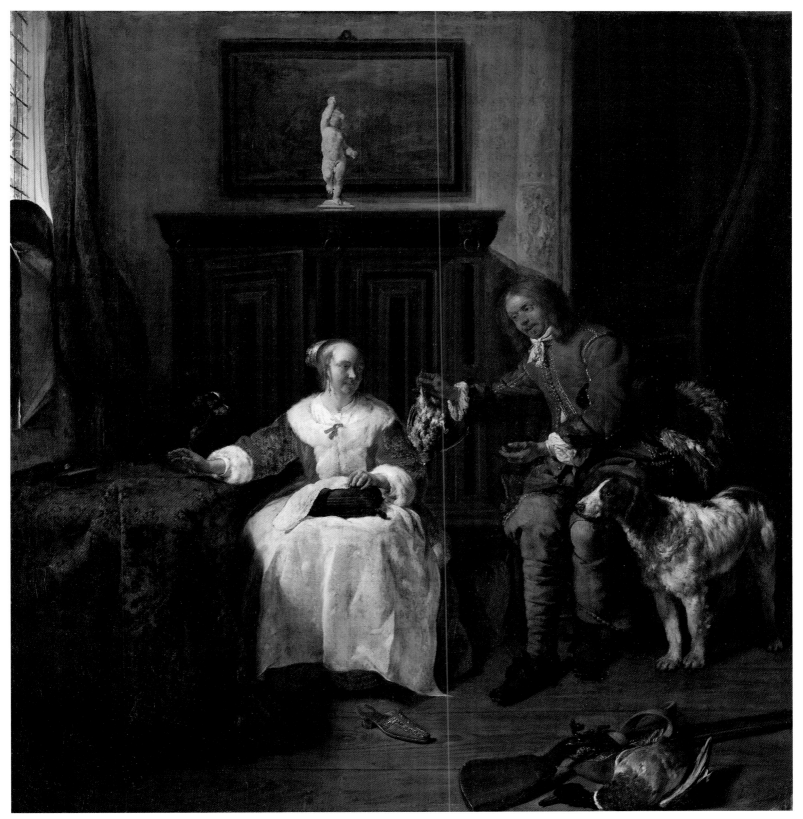

166　Gabriel Metsu, *The Hunter's Gift, c.* 1658–60 (oil on canvas, 51 × 48 cm). Amsterdam, The City of Amsterdam, on loan to Amsterdam, Rijksmuseum.

Less convincing, however, is de Jongh's hypothesis that the motifs of the woman's shoes and sewing have sexual meanings as well, which in effect implies that she welcomes her suitor's lewd advances. This reading seems inconsistent with the woman's virtuous demeanor and action. Later studies of *The Hunter's Gift* have focused on the woman's action of reaching for the book on the table, one said to underscore her "moral dilemma" of whether to accept the hunter's proposal.[36] In this sense, Metsu's picture relates thematically to Leyster's innovative *Proposition* of 1631 (see fig. 41) and more immediately to several contemporaneous paintings by ter Borch in which women respond to males (see fig. 89). However, the figures in *The Hunter's Gift* seem histrionic by comparison with their very reserved counterparts in Leyster's and especially ter Borch's paintings. Indeed, the inherent drama of Metsu's genre pictures distances them from those by his contemporaries who tended to render narrative in more subdued terms.

Metsu's seamstress may be more decisive than has been hitherto recognized because she reaches for a book whose proportions imply religious or devotional contents. Regardless of this book's precise content, her gesture seems less one of hesitancy than of resolution and resistance. (Is this why the statuette of Cupid directly above her head appears to be "fleeing"?) Her sewing, a motif widely associated with domesticity, suggests this, as do her shoes lying prominently in the foreground, a motif that can sometimes convey virtuous notions (see fig. 95).[37] An interesting parallel to this scene is found in the frontispiece to one of the books from *Pegasides pleyn* (Pegaside's Square), a late sixteenth-century tome by the Brussels humanist Johan Baptist Houwaert (1533–1599) that was republished several times in the Dutch Republic (fig. 167).[38] *Pegasides pleyn* consists of a series of

long poems divided into sixteen books providing extensive discourse on female life stages (from adolesence to widowhood); according to the author, its purpose was to teach young people, especially women, to lead honorable and virtuous lives.

The illustration in question prefaces the second book, entitled "The Crown of Virtuous Maidens." A man enters the room holding a chain, his companion following with a large trunk. They approach three women, one of whom immediately reaches for a book. The accompanying poem exhorts maidens to be virtuous and withstand all potential admirers who would enslave them. Although Houwaert's book should not be considered "a source" for *The Hunter's Gift* – the former's allegorical trappings are completely foreign to the latter – the poem could very well be describing Metsu's painting and the frontispiece is strikingly similar as well: note the sewing basket and maiden reaching for a book to resist the man's advances.

At the onset of the 1660s Metsu turned for inspiration to the art of the *fijnschilders* from his native Leiden. His *Hunter in a Niche* of 1661, for example, reveals his knowledge of developments there (fig. 169). The brushwork has become tighter and the picture has been painted on panel – a support that Metsu increasingly employed during this period – as opposed to canvas because the former enhanced the meticulousness of his technique. Metsu obviously adopted Dou's trademark, niche format (see fig. 102) for this painting (and several others). Arthur K. Wheelock's hypothesis that Metsu was responding to the market for Dou's paintings in Amsterdam is undoubtedly correct.[39] One needs only to recollect that exquisite, expensive paintings by Dou and other Leiden *fijnschilders* were eagerly desired by wealthy collectors throughout the Dutch Republic and Europe at large. In this particular instance, Metsu's technique approximates that of van Mieris, as does the virtuosic signature and date, cleverly "chiseled" in stone (see fig. 101).[40]

The hunter seated within the enclosure appears to be toasting after a successful expedition, the results of which lie before him along with sporting equipage. Although he gazes at us, the position of his body in general and hand in particular suggests that he is interacting with a female in a companion painting. In fact, the probable pendant to the *Hunter in a Niche* is a *Lady Seated in a Window* (fig. 168) which is almost identical in size and has a complementary composition.[41] In this context, the hunter should not be construed in the same erotic terms as his counterpart in *The Hunter's Gift*. Rather, the tone here is virtuous; the sportsman is surrounded by motifs apposite to the male realm and his hunting trophy illustrates the age-old mandate that men provide sustenance for their families.[42]

The female too is encompassed by motifs connoting, like her very persona, virtue. She is about to peel an apple, an activity associated with food preparation, a quintessential task of women. Note as well the book on the ledge, a tome indicating piety, and also the grapevine and birdcage hanging in the space behind

167 Illustration from Johan Baptist Houwaert, *Pegasides pleyn*, Rotterdam, 1622–3. Amsterdam, Universiteits-Bibliotheek Amsterdam.

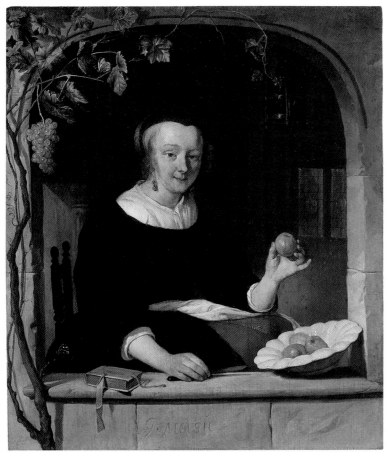

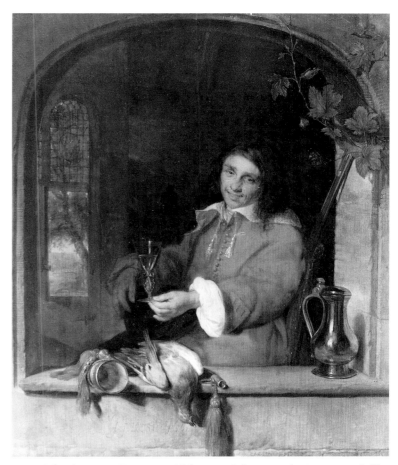

168 Gabriel Metsu, *Lady Seated in a Window*, c. 1661 (oil on panel, 27 × 22 cm). New York, The Metropolitan Museum of Art, The Jack and Belle Linsky Collection, 1982 (1982.60.32).

169 Gabriel Metsu, *Hunter in a Niche*, 1661 (oil on panel, 28 × 22.8 cm). The Hague, Mauritshuis.

her.[43] The grapevine creeps up the left jamb of the enclosure, extending beyond the center of its arch. Since antiquity, grapevines and similar plants that "climb" by using tendrils have symbolized love, fidelity, and marriage because of their ability to cling securely to many different surfaces, including walls.[44] The birdcage in the room signifies domesticity, as it does in contemporary literature. For example, the popular moralist Jacob Cats cites a French proverb criticizing a woman who wanders about gossiping, remarking that she should be like a bird in its cage, in other words, that she should remain at home, a metaphor adopted by many other contemporary writers.[45]

The wholesome notions evoked by these pendants are present in many other paintings by Metsu, who labored in an era of heightened civility and wealth. In this respect one of his most intriguing images is the *Visit to the Nursery*, also dated 1661 (fig. 170).[46] This painting represents the seventeenth-century ritual of the lying-in visit in which female callers would celebrate a new arrival.[47] (Endemic to childbirth in this era of woefully inadequate obstetrical care were high mortality rates for both mother and infant, so a

felicitous outcome provided just cause for jubilation.) Metsu depicts a well-to-do woman who has entered a sumptuous chamber where she is greeted by the new parents. The father gestures deferentially while a maid dutifully fetches a chair for this esteemed visitor. The man's courteous pose recalls that of the suitor in ter Borch's *Suitor's Visit* (see fig. 89) which is no mere coincidence since Metsu was repeatedly inspired by that master's art during the 1660s. And the representation of space, with figures firmly planted within the confines of the large room, is reminiscent of works by de Hooch who had recently moved to Amsterdam.[48]

What makes this painting especially interesting is its provenance: strong, circumstantial evidence suggests that it was first owned, if not directly commissioned by the wealthy Amsterdam regent Jacob Jansz. Hinloopen (1626–1666). Metsu was employed by Hinloopen on at least one other occasion, having made a portrait of his entire family around 1662–3 (Berlin, Gemäldegalerie).[49] While the *Visit to the Nursery* was in Hinloopen's possession the renowned author Jan Vos (1610–1667), who penned verses for the regent on several occasions, dedicated a poem to

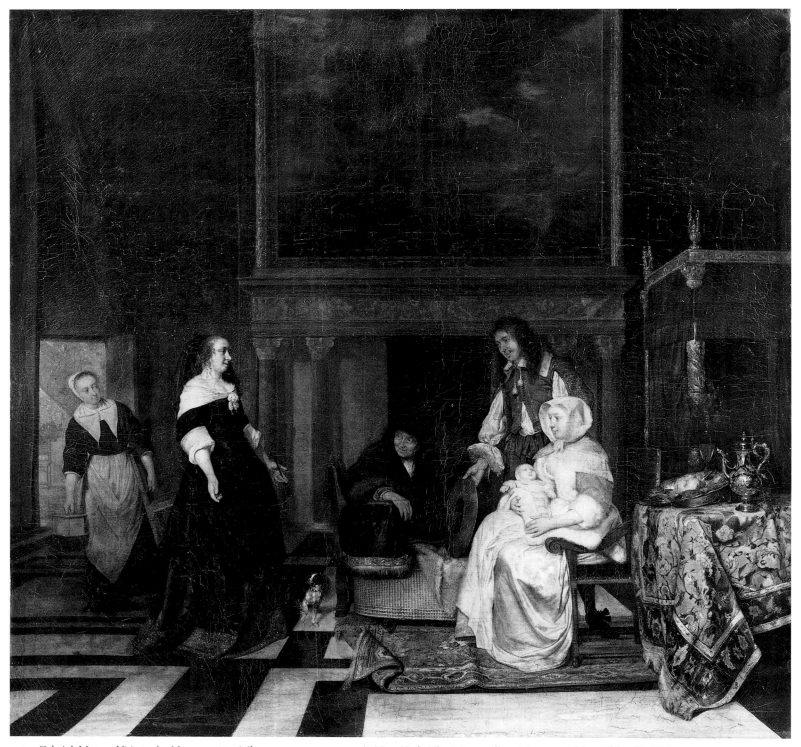

170 Gabriel Metsu, *Visit to the Nursery*, 1661 (oil on canvas, 75 × 79 cm). New York, The Metropolitan Museum of Art, Gift of J. P. Morgan, 1917.

it. In what constitutes a rare example of a contemporary ode to a genre painting, Vos extolls the canvas's beauty and its convincing narrative, ingeniously commenting that its astonishing lifelikeness allows men – that is, male viewers – to participate in the lying-in visit, thereby transgressing established social mores.[50]

Vos describes the *Visit to the Nursery* as hanging "in the reception hall of the honorable alderman, Mr. Jacob Jansz. Hinloopen." Reception halls or rooms, which were present in domiciles of the affluent more frequently after 1650, were typically reserved for entertaining visitors. They were thus well-

appointed and often featured the most outstanding paintings in a family's collection.[51] The decor of Hinloopen's reception room must have been luxurious but it would have paled in comparison with what is seen in Metsu's fanciful painting. In addition to a gilded bed and elaborate, silver service, Metsu includes an ornate, tiled floor and marble mantelpiece in a room of unrealistically large proportions. Indeed, the lavish surroundings serve as an ideal environment for his genteel figures to enact the ritual of the lying-in visit with all of its attendant, complicated etiquette.

Several scholars have pointed out the room's relation to either the Burgomaster's Cabinet or Council Chamber in the new, magnificent Town Hall in Amsterdam (today, the Royal Palace) which was nearing completion in 1661. Unfortunately, the abraded and darkened surface of the *Visit to the Nursery* prevents precise identification of the chamber (which may not be possible to do even if the painting were in pristine condition); suffice it to say that the marble floor and mantelpiece replicate what was seen in the Town Hall on a regular basis by the likes of Hinloopen. But the picture artfully melds fact and fiction: the large painting over the mantelpiece, for example, of a vessel tossed to and fro by a stormy sea was certainly not hanging in the actual Town Hall. Rather, its presence is meant to allude to the newborn's tribulations during its journey through life.[52] Implausibilities aside, it is fascinating that a representative of one of Amsterdam's elite, governing families owned a genre painting whose setting approximates that of a room in the Town Hall, a structure he regularly frequented. Hung in the reception room of Hinloopen's home, the *Visit to the Nursery* thus alluded to his powerful role in local politics.[53]

The emphasis on gentility and opulence intensified in Metsu's works during the final years of his career as did his painstaking technique which became harder and drier. Such works as *A Woman Writing Music* of about 1663 (fig. 171) present a rarefied view of the leisure life of moneyed urbanites.[54] In this panel, a woman gazes serenely as if lost in thought as she composes music, poised to record the notes played by her lute-strumming confidant behind the table. A man, perhaps an admirer, peers over her shoulder as she works, not unlike the inquisitive housemaid in ter Borch's *Curiosity* (see fig. 93). (Stylistically speaking, this panel fuses ter Borchian themes and figural types with a crisp application reminiscent of Dou's work.) The room, though more intimate in scale than that of the *Visit to the Nursery*, is also extravagantly decorated, from its wooden table bedecked with an expensive Turkish carpet to the eye-catching mantelpiece that once again mimics a real one in the Amsterdam Town Hall. The painting above the mantelpiece is likewise a seascape with a storm-tossed boat. However, within this visual context, this conventional motif, one often encountered in earlier images of love and courtship (see fig. 23), can refer only to love's vicissitudes.[55]

The heightened luxury of Metsu's late paintings is matched by those made by de Hooch after he resettled in Amsterdam in 1660 or early 1661. In fact, de Hooch's Amsterdam-period inte-

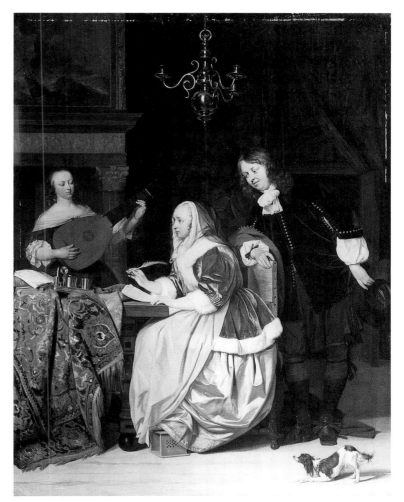

171 Gabriel Metsu, *A Woman Writing Music*, c. 1663 (oil on panel, 58.5 × 44 cm). The Hague, Mauritshuis.

riors are often striking when compared with the more modest surroundings depicted during his Delft years.[56] In response to the demands of potential patrons, de Hooch's style shifted in a manner somewhat analogous to Metsu's: in yet another example of the influence of the Leiden *fijnschilders* upon a Dutch genre painter, de Hooch's paint application becomes more precise, his tonalities cooler, his lighting effects more exaggerated, and his figures more fashionable.[57]

De Hooch's *Linen Chest* of 1663 (fig. 172), depicting an exquisite interior with a marble floor and embellished architectural detail, is a characteristic work of his early years in Amsterdam.[58] A mistress and her maid are shown placing linen – an expensive ware in its own right at this time – into a large, costly chest made of oak and inlaid ebony. Subject and style are inextricably bound as the execution of *The Linen Chest*, like de Hooch's other Amsterdam-period paintings, is much finer and its surface more reflective than those composed in Delft.[59] De Hooch placed his newly wrought style at the service of diverse themes including merry companies, letter readers, and card

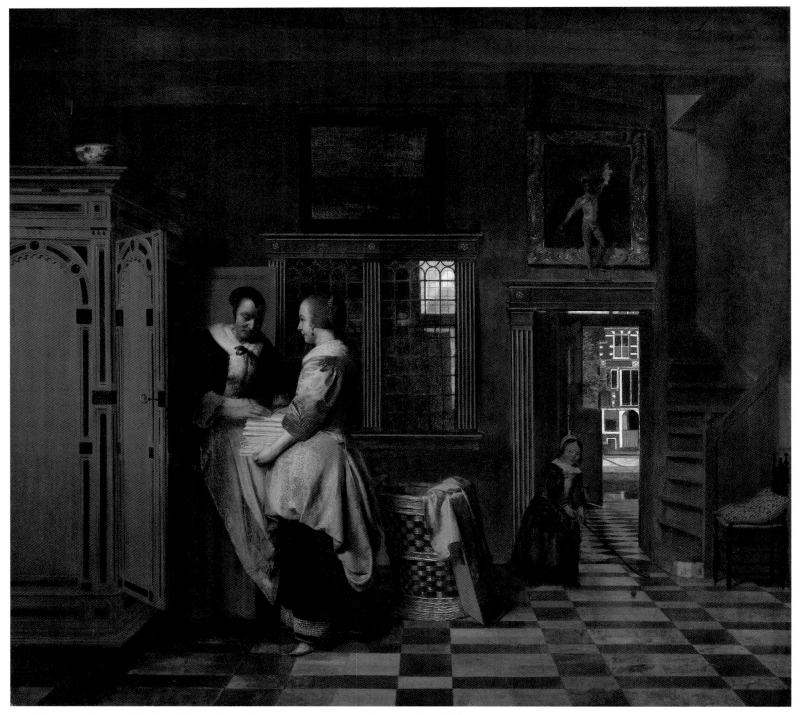

172 Pieter de Hooch, *The Linen Chest*, 1663 (oil on canvas, 72 × 77.5 cm). Amsterdam, Rijksmuseum.

players (fig. 173), all of which were generally imbued with what was for him a hitherto unparalleled degree of splendor and refinement.

The presence of marble floors, ornate fireplaces, chandeliers, and other decorative items in pictures by de Hooch, Metsu, Dou, ter Borch, and a host of other masters active after 1650 should be tied directly to the surge of prosperity in the Dutch Repub-lic.[60] C. Willemijn Fock has recently called attention to the implausible nature of such trappings in seventeenth-century Dutch genre interiors.[61] Marble floors, for example, were uncommon in homes during this period, even as they were more frequently present in public buildings (such as the Amsterdam

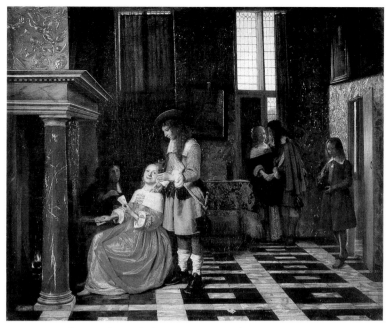

173 Pieter de Hooch, *Card Players*, c. 1663–5 (oil on canvas, 67 × 77 cm). Paris, Musée du Louvre.

cific, for it was elites who dominated the market for them. Taste is perhaps best understood in this context as Pierre Bourdieu has expounded it in his now classic study, *Distinction: A Social Critique of the Judgement of Taste*.[67] Essentially, Bourdieu perceives taste (and consumption) as a social signifier, one that serves both to affirm and legitimize social differences. The upper classes naturally determine the dominant taste and utilize it strategically to distinguish themselves from their social inferiors. Nevertheless, persons of lower status may attempt to imitate the refined penchants of their superiors, though mostly through products of lesser cost and comparatively inferior quality.[68] Although Bourdieu's exhaustive analysis focuses upon post-Second World War France, many of his persuasive observations are applicable to early modern societies whose social hierarchies were much more conspicuous than those of any modern-day country.[69]

If one considers specific themes and styles in Dutch art as expressions of taste and as mechanisms to affirm social status then the acts of purchasing and displaying paintings can be linked to the concepts of civility, all the more so when the paintings in question represent domestic themes.[70] As already discussed, taste was bound up with civility as elite members of society ideologically consolidated their class status by projecting a sense of cultural superiority by their civilized conduct and by their discriminating choices in art, literature, and theater.[71] Artists therefore painted distinctive themes in specific styles to gratify and simultaneously to convey elite values centering around discrimination, sophistication, and refinement.

Domestic imagery can also be construed along the lines of what cultural historians have termed "appropriation." Among others, Roger Chartier has argued that elite culture largely constituted itself by appropriating beliefs, texts, objects, and so on that did not properly belong to it.[72] In Chapter 8 the pervasiveness of domestic ideals during the early modern period as fostered by numerous treatises was demonstrated. In effect, paintings of the home by Dou, de Hooch, Metsu, and others appropriate a widespread domestic concept and consequently transform it into a commodity (both literally and figuratively) for elite consumption.

The domestic imagery of numerous artists active at this critical period is perhaps best understood as the product of a "dialogic relationship" between themselves and their audiences. This term denotes how artists, as they work, take into account the market as it is embodied in the desires (either actual or projected) and expectations of real or potential buyers. Although it is worthwhile to investigate pictures in relation to taste and the market one must continually recognize the painter's primary role in introducing new subjects and styles. Furthermore, it is the most creative artists who introduce the most intriguing changes into their work as shown by the rise of domestic imagery in Dutch art after 1650.

Town Hall). As archival data confirms, in those unusual instances in which marble floors graced the homes of the well-to-do they were often limited to the *voorhuis* (vestibule) because elite homeowners preferred wooden flooring for their living spaces.[62] Likewise, brass chandeliers, seemingly omnipresent in genre paintings, were in reality extremely expensive articles most frequently made for churches.

Fock rightly calls attention to what in essence are highly fictitious details, but her hypothesis that artists included such motifs merely to demonstrate their mimetic skills in rendering different textures and surfaces demands modification.[63] For marble floors, chandeliers, Turkish carpets, and similarly costly items were included also to connote status and sophistication as part of an ongoing effort among painters to make their work as attractive as possible to prospective purchasers.[64] Conversely, one can also posit a certain expectation among art collectors to see such presentations of lavish decor in their purchases. On a certain level then, these genre paintings serve to fulfill the decorative desires if not the fantasies of buyers; these images even possess the same luxury commodity status as some of the actual decorative items on display in the houses of the moneyed.[65] In this sense, genre paintings not only reflected contemporary taste but simultaneously helped to shape it in a prosperous atmosphere ripe for the production and reception of pictorially sophisticated, intrinsically civilized imagery.[66]

Dutch genre paintings of uncompromisingly high quality speak volumes about contemporary taste, elite taste to be spe-

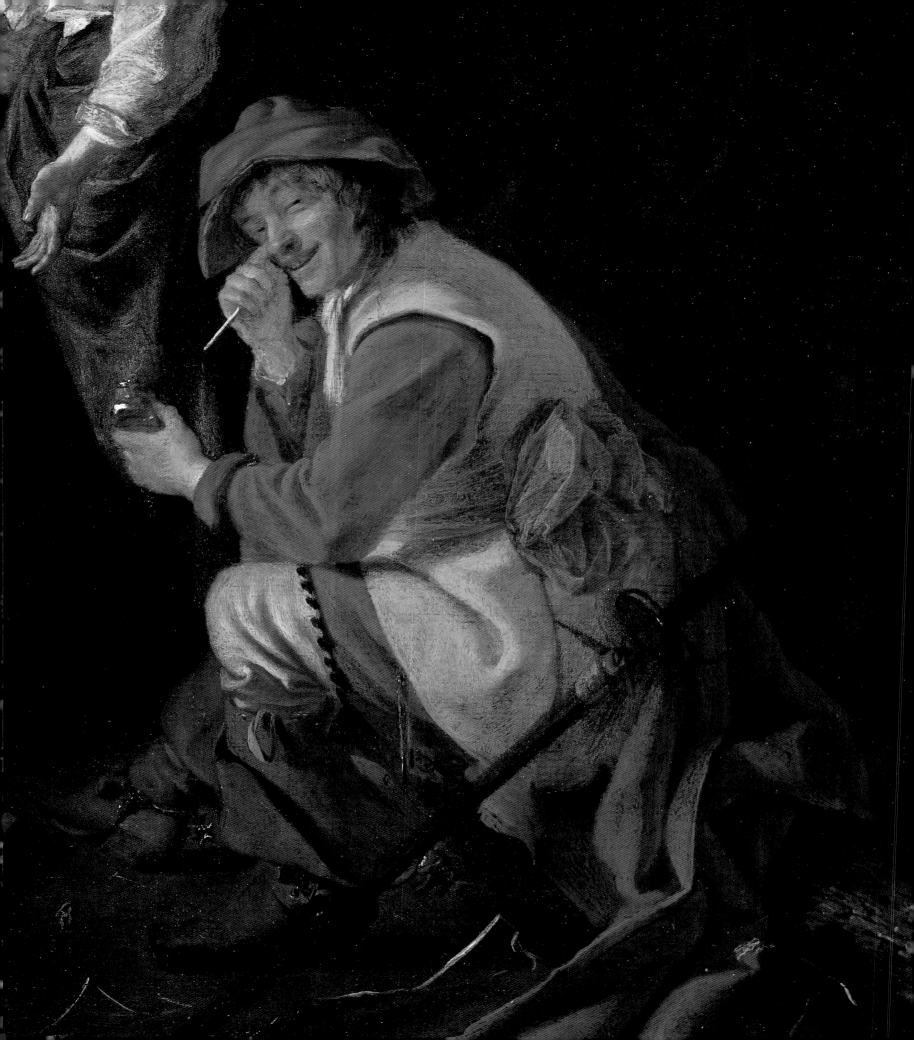

CHAPTER THIRTEEN

ROTTERDAM

Rotterdam's development into a major economic center parallels the rise of a number of other cities in the Province of Holland whose histories were surveyed in previous chapters.[1] Like its sister towns, Rotterdam benefited greatly from the economic miracle of the 1590s and, concomitant with this, the huge surge in immigration. By 1622, Rotterdam numbered nearly 20,000 residents, a modest number compared with Amsterdam but a fourfold increase over its mid-sixteenth-century population nonetheless, and the city would continue to grow at a steady pace, reaching 40,000 denizens by 1665.[2] The dramatic population growth during the early seventeenth century forced Rotterdam's expansion and many of its most prosperous citizens moved into the newly established districts.

Indeed, Rotterdam had many affluent inhabitants. A wealth-tax assessment conducted in 1654 – taxation in this period presupposed a certain level of assets – reveals that at least 130 families possessed personal assets exceeding 40,000 guilders, a truly impressive sum equal to roughly sixty-five years' wages for a simple craftsman![3] Wealth was accrued in Rotterdam during this period by a variety of means. The city had long operated as an important site for herring fishing and processing – in fact, in earlier centuries, Rotterdam had been a sleepy, fishing village. To this vital, traditional enterprise were added beer-brewing, a major local industry that by the middle of the century was servicing most of the Province of Holland; textile production, though on a much smaller scale than Leiden and Haarlem; a merchants' exchange, the oldest in the Netherlands; and, naturally, given its impressive port (which was enlarged in 1609–10), shipping, in all sorts of products, particularly those connected to the rich trades gathered from and distributed to many international locales. Rotterdam had active East India Company and West India Company chambers, and after 1630 developed a thriving trade in French wine. The collective success of the town's commercial ventures enabled it to assume the role of the Dutch Republic's leading mercantile center after Amsterdam. And much like Amsterdam, its civic leaders harbored flexible theological views – the city had a large, Remonstrant community – and many were ardent States Party advocates.

In the sixteenth century Rotterdam had been a cultural backwater, but its economic ascent in the seventeenth had ramifications for the art market there, which rapidly evolved in size and scope. Approximately ninety painters worked in the city between the 1590s and 1630 (including Willem Buytewech, a native Rotterdamer who returned to his hometown in 1617 after an extended stay in Haarlem) increasing to about 120 at the height of Rotterdam's artistic prominence between 1630 and 1670, serving local collectors and those living in other cities.[4] The city's proximity to the Southern Netherlands virtually guaranteed the relocation of Flemish painters there who helped swell the numbers of resident artists. Moreover, the influence of such Flemish masters as Adriaen Brouwer and David Teniers the Younger would be keenly felt. In the decades preceding the Treaty of Münster Rotterdam developed a reputation for peasant imagery painted in the circle of the so-called "Dutch Teniers Group," including, among others, Pieter de Bloot (1601–1658) and Cornelis Saftleven (1607–1681),[5] and peasant themes remained popular even during the second half of the century when high-life genre painting emerged.

Hendrick Sorgh

Hendrick Sorgh (c. 1609/11–1670) was born in Rotterdam sometime between 1609 and 1611.[6] His father, Maerten Claesz. Rochusse or Rokes, operated a market barge on the Rotterdam–Dordrecht barge line, earning the sobriquet "Sorgh" (literally "care" or "solicitude" in English) because of his circumspect manner of handling cargo. The young Sorgh also worked in the shipping profession even after he had already embarked upon his career as a painter. He continued to be called a market shipper to the very end of his life although archival documents suggest that in later years the painter probably had employees who handled the daily operations of the business. According to Houbraken, Sorgh was trained by Buytewech and Teniers, claims which are difficult to substantiate.[7] Since Sorgh was only a young teenager when Buytewech died any possible instruction he would have received from him was minimal; and while archival documents imply Sorgh's absence from Rotterdam during 1630–33, study years with Teniers in Antwerp cannot be established. Besides, Teniers only joined the Antwerp Guild of St. Luke in 1633 and, consequently, could not have trained artists before that date.

The earliest dated painting by Sorgh was executed in 1641, in his first decade of sustained activity as an artist. Sorgh's *Barn Inte-*

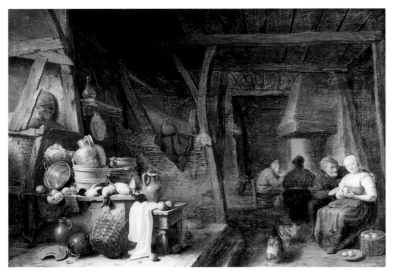

174 Hendrick Sorgh, *Barn Interior with Amorous Couple, c.* 1640 (oil on panel, 46.5 × 68 cm). Rotterdam, Museum Boijmans Van Beuningen.

175 Hendrick Sorgh, *Kitchen Interior,* 1643 (oil on panel, 46.3 × 38 cm). Warsaw, National Museum.

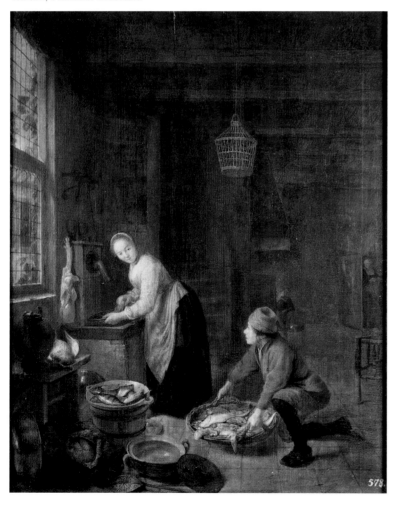

rior with Amorous Couple likewise belongs to this period (fig. 174).[8] In its subject, this thinly painted, monochromatic panel relates to the artist's earliest pictures, barn and stable interiors of the 1630s, but its more structured space anticipates his stylistic maturation.[9] Sorgh depicts an impressive accumulation of still-life elements on the left side of the painting and, neatly separated by a wooden post, four peasants on its right. In the immediate foreground an old peasant ogles a stocky, young female peeling apples, his arm draped around her shoulder. The *Barn Interior* displays affinities with a painting by Teniers (Karlsruhe, Staatliche Kunsthalle) but is perhaps more closely linked to the work of Saftleven, de Bloot, and other Rotterdam masters who effectively made this theme a local specialty.[10] The scrofulous peasants in the foreground also recall Brouwer's types, a similarity with Brouwer's work that calls into question the aforementioned appellation, the Dutch Teniers group. Brouwer (and, possibly, his Haarlem disciple Adriaen van Ostade) seems to have been a more pivotal figure for Rotterdam painters than Teniers. Yet despite Brouwer's and, to a lesser extent, Teniers's important prototypes, Rotterdam artists developed their own, distinct style.[11]

As the 1640s progressed Sorgh's production gradually shifted toward more elevated subjects in more respectable settings with concurrent stylistic modifications: his figures grew proportionally larger and his brushwork tighter. Presumably these changes were largely a response to transformations occurring in genre painting as a whole along with patrons' expectations during this period. Comparatively early, yet prototypical of the new direction of Sorgh's art is his *Kitchen Interior* of 1643 (fig. 175).[12] It depicts a maid cleaning fish at a sink who watches a young fish-vendor place a large, flat basket on the tile floor. The domestic subject, its setting (particularly the spiral staircase behind the maid), and Sorgh's relatively smooth, meticulous application of paint for the figures (the brushed background is more loose) recalls contemporary genre painting from the nearby town of Leiden under the auspices of Gerrit Dou. But the upright composition of this work is unusual for this date (1643) and its subject, a vendor selling his stock in a domestic interior, anticipates by at least a decade themes represented frequently by Quirijn van Brekelenkam and Jacob Ochtervelt.

With the advent of the 1650s Sorgh's repertoire of genre subjects expanded to include some truly striking imagery. At this time, for example, he began to depict fish markets and vegetable markets; roughly a dozen are known today, all painted between around 1650 and 1665. With its lighter tonalities and firmly modeled figures, in contrast to his earlier, monochromatic paintings with looser brushwork, Sorgh's *Fish Market* of 1654 exhibits the stylistic changes engendered by the development of this theme and others in his œuvre (fig. 176).[13] A young female is shown paying a market woman for fish. The setting includes a vending hall, a roofed structure housing stalls which was common to contemporary Dutch markets, and an abundant

display of fish, fishermen, and, of course, surrounding buildings and a harbor. The pendant to this work, a *Vegetable Market* (Kassel, Gemäldegalerie), includes *mutatis mutandis* many of the same motifs. Although the settings in both pendants cannot be identified with any specificity surely Sorgh's own experiences as a market bargeman, through which he must have gained an intimate knowledge of Rotterdam's markets and their wares, provided inspiration for his representations of this theme.

Personal recollections aside, Sorgh's depictions of markets were highly conventional, recycling specific motifs and settings repeatedly, and the ostensibly novel appearance of these works of art belies their relationship to longstanding pictorial traditions. In the hands of such painters as Pieter Aertsen (*c.* 1507/8–1575) and his nephew Joachim Beuckelaer (*c.* 1534–*c.* 1574), market scenes developed into a specialty in sixteenth-century Antwerp.[14] The frequent combination in these pictures of a profusion of comestibles with biblical vignettes in their backgrounds imparted an ethical dimension to them. In the early seventeenth century, Flemish painters continued to represent markets, as did some Dutch artists, but these were generally devoid of the religious motifs. However, the interest in market imagery in the Dutch Republic during those years was largely relegated to the graphic arts, especially to illustrations found in city descriptions, a literary genre discussed in the Introduction. During the 1650s depictions of the market in Dutch art began to undergo a revival, stimulated in part by the concurrent rise in cityscape painting.[15] That Sorgh played a pivotal role in this revival is undeniable.

The associations evoked by the *Fish Market* and related images must have centered around the interdependent notions of civic pride – even if the specific market represented cannot be identified – and prosperity. Indeed, the city descriptions, including those dedicated to Rotterdam, extoll markets ceaselessly, in effect presenting them as visual embodiments of the spectacular commercial success and resultant wealth of the city in question and the nation at large.[16] Interestingly, such paintings of markets attracted the attention of elite collectors early on. In fact, Sorgh's pendants were once in the collection of Willem Vincent, Baron van Wyttenhorst (d. 1674), a distinguished, Catholic aristocrat and connoisseur who owned two adjacent houses in the city of Utrecht as well as Nijenrode Castle in the surrounding countryside.[17] Van Wyttenhorst and his wife, Wilhelmina van Bronckhorst (d. 1669), assembled an extraordinary art collection whose contents were itemized in an unusually detailed inventory that the nobleman compiled between 1651 and 1659. Among their vast cache of paintings – which included sixteenth-century paintings and no fewer than fifty-four works by the history painter Cornelis Poelenburch (*c.* 1594/95–1667) – are listed these two market scenes by Sorgh, for which they paid 100 and 109 guilders, respectively.[18]

Sorgh's earnings from the sale of these pendants to van Wyttenhorst amounted to 209 guilders, a sum equivalent to

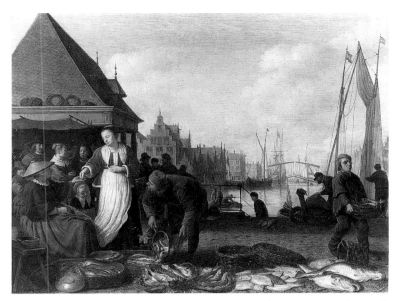

176 Hendrick Sorgh, *Fish Market*, 1654 (oil on panel, 30.4 × 40.2 cm). Kassel, Gemäldegalerie Alte Meister, Staatliche Kunstsammlungen.

roughly four months' salary for the typical, middle-class wage earner in the Dutch Republic. Once again, evidence of the contemporary cost of such genre paintings contradicts the traditional assumption that they were intended primarily for middle-class audiences. Judging from this transaction Sorgh's income as a painter must have been respectable and to this must be added his earnings as a market bargeman (though, as was stated above, he engaged employees to handle the daily operations of this business). The painter evidently enjoyed the esteem of Rotterdam's civic authories who appointed him to two municipal posts (one of which was a sinecure) in the late 1650s. Moreover, an archival document implies that he fraternized with the city's aldermen.[19] Collectively, this confirms Sorgh's status among Rotterdam's elite. It may also explain his abiding interest as the years progressed in wholesome, genteel themes catering to the tastes of his peers.[20]

The Lute Player of 1661 exemplifies Sorgh's approach to fashionable imagery in his later years (fig. 177).[21] He depicts a young dandy with a double-necked lute serenading the unimpressed recipient of his affections in a gated veranda before an urban setting. The open, fanciful setting and its costly furnishings are loosely reminiscent of Gerbrand van den Eeckhout's courtship scenes (see fig. 163) but the physical amplitude of the figures, the meticulous finish, the bright, even lighting, and superb delineation of textures separates Sorgh's panel from those by the Amsterdam artist. *The Lute Player* is obviously replete with references to love and courtship. Playing musical instruments was long considered indispensible to fostering eros (see fig. 44) and in this sense, Sorgh's foppish, lute player is entirely conventional.[22]

Directly over the head of the unperturbed female the painter has also cleverly included a small picture of Ovid's star-crossed

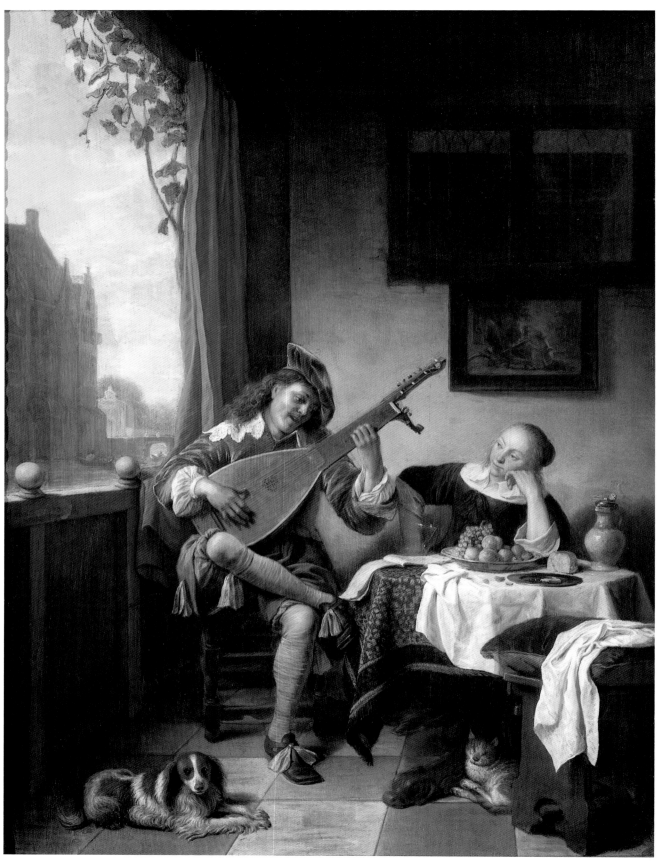

177 Hendrick Sorgh, *The Lute Player*, 1661 (oil on panel, 51.5 × 38.5 cm). Amsterdam, Rijksmuseum.

lovers, Pyramus and Thisbe, who both committed suicide under mistaken circumstances.[23] Their tragic story had tremendous appeal in early modern Europe not only among artists but also authors, among them, William Shakespeare (1564–1616) who imparted to it a parodic twist.[24] Other writers followed Shakespeare's comic approach to the tale including the Dutch playwright Matthijs Gramsbergen who incorporated it into a farce published in Amsterdam in 1650.[25] In Gramsbergen's farce, colorful characters perform a play about Pyramus and Thisbe for a duke. Pyramus in particular is presented as an insincere, comic seducer who at one point exclaims that "no one need doubt whether I can charm the ladies!"[26] He inveigles Thisbe by humorously inventorying her physical features which he occasionally likens to those of Dutch women. Gramsbergen's insincere Pyramus is somewhat reminiscent of the lute-playing suitor attempting to charm his impassive lady in Sorgh's painting. Perhaps the little depiction of Pyramus and Thisbe above this pair was included for comic effect to underscore satirically the melodramatic efforts of the dandified musician.[27] Women who are skeptical of those who importune them abound in seventeenth-century Dutch poetry and song.[28]

The general trajectory of Sorgh's art (with some exceptions, naturally) from early, thinly painted, monochromatic representations of peasants to works more refined in subject and style in his later career is one followed by other Rotterdam painters.

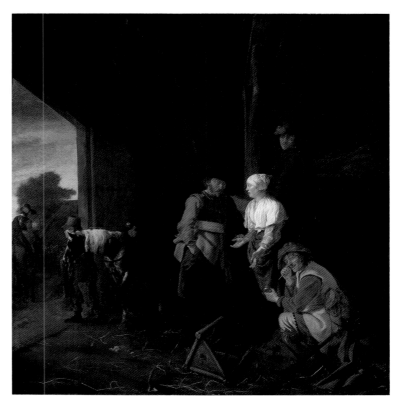

178 Ludolf de Jongh, *Paying the Hostess*, c. 1650–55 (oil on panel, 66 × 63 cm). Private collection.

Ludolf de Jongh

In many respects, Ludolf de Jongh's (1616–1679) stylistic and thematic development runs parallel to that of Sorgh.[29] De Jongh was born in a village outside of Rotterdam, the son of Leendert Leendersz. de Jongh, a tanner and cobbler (and eventual innkeeper), and Annetge Leuvens. His father's occupation was seemingly modest but this did not prevent him from bequeathing the artist and his five siblings a considerable estate. According to Houbraken, the primary source of biographical information about de Jongh, the family moved to Rotterdam and the young man was sent to study with a succession of masters in several cities, including the Rotterdam peasant painter mentioned above, Saftleven, followed by Anthonie Palamedesz. (1601–1673) in Delft, and lastly, the second generation Utrecht Caravaggist Jan van Bijlert (c. 1597/8–1671). With his studies concluded around 1635–6, de Jongh embarked upon a seven-year sojourn in France, probably residing in Paris. He resettled in Rotterdam in 1643 and quickly established himself as one of the leading painters in the city. His inherited wealth freed him to some extent from the constraints of the art market, to wit, from having to specialize in a particular type (or types) of painting to ensure a steady income. Therefore, his œuvre is tremendously varied and includes several novel approaches to portraiture, and

unusual landscape and genre painting subjects as well. However, during the last two decades of his life, de Jongh's output diminished as he became saddled with the responsibilities of several public offices to which he had been appointed.

De Jongh's earliest genre paintings, dating from the 1640s, often feature peasants or soldiers in darkened, monochromatic interiors with lively color accents in a manner reminiscent of the work of both Saftleven and especially Palamedesz.[30] By the early 1650s, in what would become his most productive decade as an artist, de Jongh began to modify his style, no doubt in response to dramatic changes already affecting Dutch genre painting during this critical period. Compared with his earlier pictures, de Jongh's *Paying the Hostess* of around 1650–55 (fig. 178), for example, contains a reduced number of figures who occupy a proportionally larger amount of space.[31] Furthermore, de Jongh has employed somewhat lighter tonalities here, a tendency that became even more pronounced as the decade progressed. And while the stable interior recalls the settings of de Jongh's initial paintings – and for that matter, paintings by Sorgh and Saftleven – spatial recession is articulated in a much more logical though exaggerated way.

Paying the Hostess is actually signed, falsely, "Pr. d. Hooch." This is not the only instance in which a work by de Jongh was once ascribed to the much more prolific Pieter de Hooch; surely the

older artist's modest, disparate output accounts for this phenomenon, despite his obvious talent.[32] The confusion with de Hooch in this particular panel is understandable given the perspectival arrangement. Although de Hooch eventually proved much more talented at rendering perspective, de Jongh's influence upon the young painter, who also hailed from Rotterdam, was profound – the older master conceivably served as de Hooch's teacher.[33] The motif of the soldier digging in his pockets to pay the stable's owner was adopted by de Hooch for a painting signed and dated 1658 (London, Marquis of Bute Collection).[34] The interplay of these figures is more spirited in de Jongh's painting. The duplicitous nature of their interaction – hardly surprising in a picture related to traditional guardroom imagery – is underscored by the smirking soldier on the ground below them. His right index finger is positioned just below his eye, a gesture that warned seventeenth-century audiences to be alert for possible danger. In this context, the danger must involve deceit, namely, that someone is being duped, either the gesturer's comrade-in-arms, or, more likely, the hostess.[35]

Much like Sorgh, de Jongh largely eliminated soldier and peasant subjects from his late production – being independently wealthy he was theoretically less attentive to market forces. Still, de Jongh could not have completely ignored changing tastes in prosperous Rotterdam, the Province of Holland's second leading port. And like Sorgh, de Jongh's personal circumstances probably played a role in his choice of subject matter.

With delightful hyperbole, Houbraken reports that upon his return from France de Jongh had so completely forgotten his mother tongue that his parents had to enlist an interpreter to communicate with him![36] Exaggerations aside, de Jongh's fluency in French could have only ingratiated him with Rotterdam society since French was the international language of seventeenth-century elites. His ability to secure a loan in 1652 from Rotterdam's *burgemeester* (mayor) for payment on a house also demonstrates his close connections with the city's regents. And that house, which cost the then huge sum of 5600 guilders, stood in one of Rotterdam's premier neighborhoods. That very same year, after a search for "an able and qualified person who commands respect," de Jongh was appointed to the salaried rank of major in the town's newly expanded civic guard – membership of which presupposed a certain degree of social and financial status. Thereafter contemporary documents refer to him as "major" as opposed to "painter."[37] Later in life, in 1665, de Jongh left Rotterdam after assuming the post of sheriff (another appointment reserved at that time for persons of rank) in the nearby village of Hillegersberg. These official positions combined with several business ventures impinged upon de Jongh's artistic career and his output decreased accordingly. Nevertheless, during these years de Jongh executed some of his most original and urbane paintings.

Luxury and sophistication abound, for instance, in the *Woman Receiving a Letter* which de Jongh painted around 1663–5 (fig. 179).[38] A liveried messenger has entered the *voorhuis* or vestibule of an elegant home and is received by the mistress. This fairly large vestibule is paved with marble tile and adorned with elaborate, architectural ornamentation. Gilt-leather wall-panels are situated behind the seamstress to the left. The crowning embellishment of this vestibule however is the large painting representing Ovid's story of Diana and Actaeon, complete with a gold, auricular carved frame, a type that had become extremely fashionable by the 1660s.[39]

De Jongh's signature was discovered on the painting of Diana and Actaeon only in 1938; hitherto, the *Woman Receiving a Letter* was attributed to Pieter de Hooch, thus constituting yet another example of the confusion once surrounding the work of these two native Rotterdamers. It will be recalled that by 1663–5 de Hooch had already been residing in Amsterdam for several years. Still, the younger master occasionally turned to de Jongh's work for inspiration even if their artistic relationship had grown more reciprocal over time.[40] De Hooch primarily responded to de Jongh's *mises-en-scène* for the latter's garrish, saturated light effects and moderately awkward perspective are alien to his work. Yet de Jongh surpassed the younger painter in his spirited narrative in which the messenger's large hound and the lady's dainty spaniel cleverly echo the interactions of the principal protagonists.

The witty correlations between the canvas's motifs extend to the painting of Diana and Actaeon on the wall behind.[41] In his *Metamorphoses*, an ancient Roman text that was enormously trendy among the highborn in early modern Europe, Ovid relates that the hunter Actaeon espied the chaste goddess Diana and her maidens bathing.[42] In retribution for his voyeurism Diana changed the hunter into a stag and his dogs immediately devoured him. De Jongh's fictitious painting is based upon an engraving by Antonio Tempesta (1555–1630) who illustrated the *Metamorphoses* in 1606.[43] However, de Jongh has purposefully reduced the number of figures depicted in the engraving so that they correspond exactly to those inhabiting the vestibule. Thus, the three women in the history painting match the three in the interior, as does the courier with Actaeon and even the hound and spaniel with the pack of dogs – now reduced to two – who attack him.

The significance of these parallels is not clear and perchance deliberately so. Undoubtedly the artist intended his audience to appreciate the witty analogies between the male intruder in the history painting and the "intruding" messenger in the *voorhuis*. Moreover, one may posit a connection between the mistress and the chaste Diana. The former has received a letter – almost certainly a love letter – from a courier, the representative of the missive's author, the true Actaeon. Seventeenth-century commentaries on the tale of Diana and Actaeon usually interpret it in admonitory terms, as an illustration of the dangers of lust. Perhaps within the stylish, amorous context of de Jongh's canvas, the history painting in the gilt frame alludes to the unseen con-

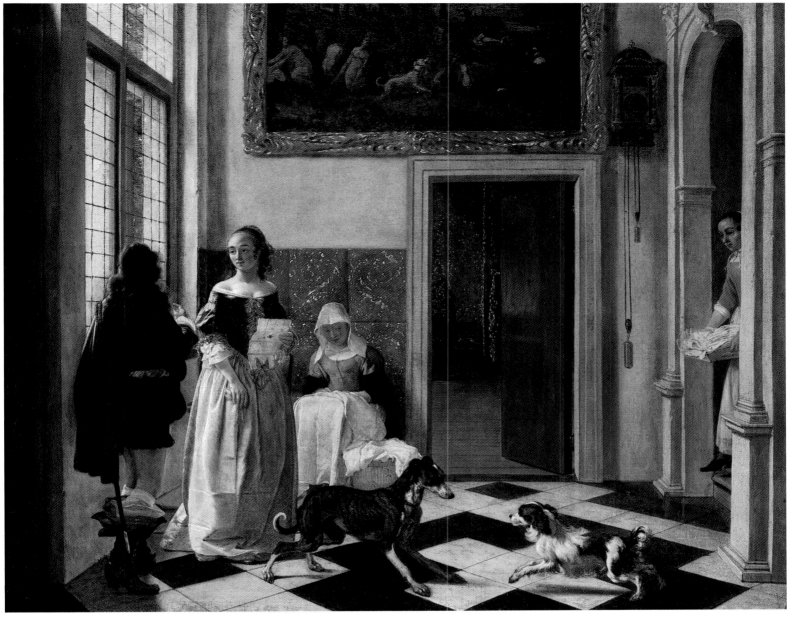

179 Ludolf de Jongh, *Woman Receiving a Letter, c.* 1663–5 (oil on canvas, 59.6 × 72.3 cm). Ascott, The Anthony de Rothschild Collection (The National Trust).

tents of the letter that imperils its reader, or so the contemporary viewer may have imagined.

The chic, luxurious air of the *Woman Receiving a Letter* is intensified in de Jongh's last paintings, which are characterized by unprecedented levels of rarefaction. Between the late 1660s and 1676 the master painted a highly original series of canvases depicting the leisure activities of the beau monde at their country estates. One of the last known pictures in this series, *A Formal Garden* (fig. 180), dated about 1675, depicts a number of society women enjoying the sweet scent of flowers in the presence of a gentleman within the pleasurable confines of a huge

garden.[44] The overall, bright palette and attenuated forms of these females betoken de Jongh's ultimate style and are characteristic of late seventeenth-century Dutch genre painting in general. The figures' modish clothing confirms their august status as does the very garden itself. Extensive axes demarcate the parameters of this garden, one adorned with statuary, vases, an orange tree, and embroidered parterres in the French manner. The very edge of the rear façade of what must be an imposing country house appears at the far right.

During the decades following the Treaty of Münster (1648), many persons (who were already affluent) accumulated spectac-

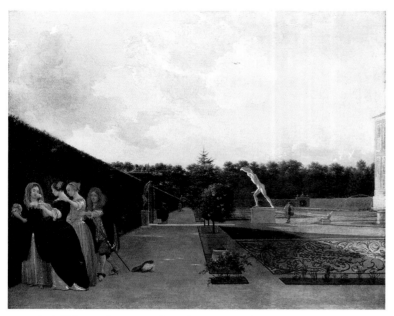

180 Ludolf de Jongh, *A Formal Garden*, c. 1675 (oil on canvas, 60.3 × 74.9 cm). Windsor, The Royal Collection.

181 Modern photograph of Hofwyck.

ular fortunes that they conscientiously utilized to adopt certain aspects of the lifestyles earlier associated almost exclusively with the country's small noble class, a phenomenon termed aristocratization. The purchase (or construction) of rural houses or estates (and the aristocratic titles that sometimes accompanied the latter) was a priority for those seeking to augment their position in the hierarchical society of the Dutch Republic.[45] The possession of a home in the country with gardens therefore imputed additional status to the owner.

Idyllic country life had captured the European imagination since antiquity as the writings of such promient Roman authors as Virgil, Pliny the Younger, and Horace demonstrate.[46] Their eloquent advocacy of the merits and advantages of bucolic existence were echoed in texts by Renaissance authors and in the lifestyles of Italian and French aristocrats. Within the heavily urbanized Dutch Republic, rural living became all the rage, accelerating in the latter seventeenth century under the impetus of aristocratization and such books as Jan van der Groen's *Den nederlandtsen hovenier* (The Dutch Gardener), first published in Amsterdam in 1669.[47] This treatise, reprinted nine times between 1669 and 1721, served as a vade mecum for all matters horticultural but it also includes an ode and introduction to country life, extolling it as an enchanting and salubrious alternative to the fetid city.

Van der Groen's thinking was informed by the ancient authorities and especially by the so-called *hofdichters* (country-house poets) from whom he liberally quotes. Often commissioned, their enormously popular poems (known as *hofdichten* or country-house poems) celebrate the country life and were penned by some of the most prominent literary figures of the day, including Constantijn Huygens (1596–1687) and Jacob Cats (1577–1660) who composed verses honoring their own estates.[48] And in classic, early modern fashion their panegyrics entwine the bucolic with theology and culture. For the stimulation of the intellect through contemplation of art and literature inevitably enhances the elite experience of rural life. As Erik de Jong states in his excellent study of Dutch gardens and landscape architecture, "Country life stands for a double ideal of nature and culture, and this idea is essential for the appearance, content, and experience of nature in the Dutch garden."[49]

De Jongh's painting must be understood in relation to the passion for gardens in this period in general as well as the phenomenon of aristocratization in particular.[50] And in the manner customary to all genre painters he embellishes actualitities, confecting pictorial conventions, direct observation, and artistic license.[51] Frits Scholten has pointed out the relationship of de Jongh's depictions of country life to earlier seventeenth-century representations of love gardens.[52] However, in comparison with these pictorial antecedents (for example, fig. 44), de Jongh presents gardens and residences that are emphatically native as opposed to principally fantastic. Yet the structure and grounds depicted in *A Formal Garden* are surely exaggerated in grandeur. The scale of the mansion in this picture, so far as can be determined from what little of it is shown, is more akin to courtly dwellings of this period built for the Prince of Orange and other notable aristocrats.[53] The typical rural home of a Dutch patrician or regent, however beautiful, was much more modest in scale, as a modern photograph of Hofwyck attests (fig. 181).

This country residence just outside The Hague was owned by Huygens, the wealthy dilettante and cultured secretary to the Prince of Orange.[54] De Jongh thus idealizes country living, providing vicarious participation for his elite audiences regardless of whether they actually owned rural estates. In fact, one of his paintings of this theme appears in the death inventory (1686) of Gerard van Dalfssen, a jurist formerly residing in The Hague who did not own a country house.[55]

In sum, de Jongh emerges as an innovative and influential artist whose contributions to seventeenth-century Dutch genre painting have been obscured by his small output and its unfortunate confusion with the work of other masters, especially Pieter de Hooch.

Jacob Ochtervelt

Jacob Ochtervelt (1634–1682) was born in Rotterdam during the winter of 1634.[56] Our knowledge about his early circumstances is sketchy. His father worked as a bridgeman in the city and his two brothers eventually became sailors. Both of these professions paid rather poorly during the seventeenth century. Ochtervelt's slow social and financial rise began with his artistic training. According to Houbraken, he entered the studio of the Haarlem landscapist Nicolaes Berchem (1620–1683) together with his fellow Rotterdammer, de Hooch; if this information is accurate, Ochtervelt's study years must have occurred sometime between 1646, the date of Berchem's return from Italy, and 1655, the year in which the young painter married in Rotterdam.[57]

Ochtervelt's first genre paintings were executed in the middle of the 1650s (for example, fig. 182).[58] The sculpturesque figures in unusual costumes that populate these raucous works with nondescript settings are reminiscent of the art of the Utrecht Caravaggisti along with those by the so-called Italianate painters, Dutch artists (among them Berchem) who depicted Italian motifs and settings. The frequently rowdy character of these initial forays into genre painting – his early work also included some landscapes with prominent figures – continued in paintings made during the early 1660s, the period in which the artist began to produce representative Dutch interiors.

At this time Ochtervelt fell under the spell of the art of Frans van Mieris (1635–1681), his near-exact contemporary from Leiden who forged an enormously successful career as a painter of erotic subject matter. In particular, van Mieris's *Oyster Meal* (fig. 183) of 1661, known in numerous contemporary copies, influenced several paintings by Ochtervelt of the same subject.[59] For instance, an oyster meal dating to about 1663–5 (fig. 184) adopts the principal components of van Mieris's painting: a philanderer importuning a provocatively dressed female to partake of the succulent oysters that he tenders on a silver platter.[60]

The respective works display stylistic affinities as well in their glowing palette and meticulous execution. Yet Ochtervelt's use of light is much more sophisticated. In contrast to van Mieris's fairly even illumination, Ochtervelt employs chiaroscuro as a compositional and narrative aid: the light strikes the brilliant satin and velvet of the woman's attire while her admirer is largely submerged in shadow, as are the van Mieris-like accouterments in the surrounding room – note the bedsheets hanging suggestively from the balcony above the figures recalling those found in the Leiden painter's *Inn Scene* (see fig. 110).[61] Ochtervelt also imparts a striking angularity to his figures, which in this picture is most obvious in the suitor's hunched pose and in the positioning of the woman's left arm. The use of oblique postures and gestures became a hallmark of Ochtervelt's style, one which imparts a distinct theatrical flair to his work. Judging from his leering gaze, van Mieris's oyster-bearing lecher seems more debauched than his counterpart in Ochtervelt's painting. Yet the unseemly appearance of the females in both works of art provides clues to their true identities and the general import of the subject.

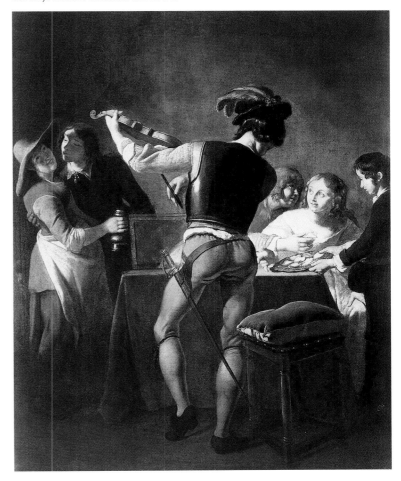

182 Jacob Ochtervelt, *Merry Company with Violinist*, c. 1655 (oil on canvas, 115 × 112 cm). Present location unknown.

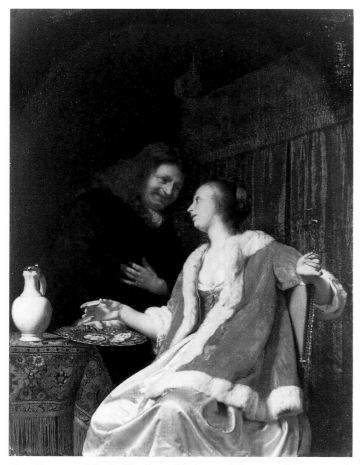

183 Frans van Mieris, *The Oyster Meal*, 1661 (oil on panel, 27 × 21 cm). The Hague, Mauritshuis.

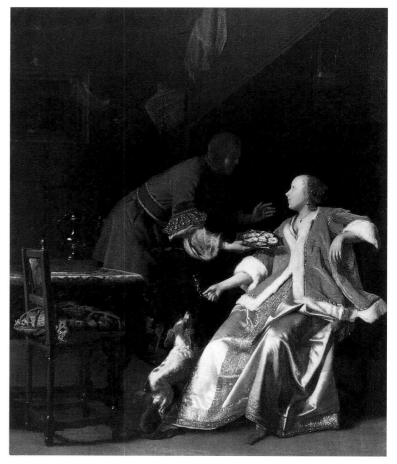

184 Jacob Ochtervelt, *The Oyster Meal*, c. 1663–5 (oil on canvas, 54 × 44.5 cm). Private collection.

Any seventeenth-century viewer would have easily recognized what readily escapes viewers today: the oysters are laden with carnal overtones.[62] According to the ancient mythographers, Aphrodite (known to the Romans as Venus), was conceived in an oyster shell which subsequently transported her to the island of Cyprus.[63] To ancient and early modern minds, Aphrodite symbolized love, sex, and fertility; such concepts were also linked, by association, to oysters. In the Dutch Republic, emblemata, domestic treatises, medical texts, erotic poetry and songs contain seemingly countless references to the aphrodisiacal power of oysters.[64] Cats, for example, writing in *Houwelyck* (Marriage; 1625), condemns the use of concoctions meant to stimulate the libido, ones composed of castor oil, nettle seeds, artichokes, and oyster juice. And the eminent Dordrecht physician, Johan van Beverwijck (1594–1647), with his customary clinical detachment, observes that oysters "whet the appetite, and the desire to eat and have intercourse, both of which appeal greatly to lusty and delicate people."[65] In his *Oyster Meal*, Ochtervelt underscores the sexual potency of the briny delicacy proffered by the suitor by brilliantly illuminating his hand and the platter, thus disconnecting them from his otherwise

obscured form. In turn, they visually overlap the similarly illumined body of the female who, in this context, is likely a prostitute.

Roughly contemporaneous with *The Oyster Meal* are a series of pictures by Ochtervelt whose subject matter is wholesome. Like his Rotterdam colleagues Sorgh and de Jongh, Ochtervelt gradually increased his production of less offensive themes, electing to portray the elegant, leisurely existence of the upper classes. These thematic alterations were undoubtedly the result of market demands and perhaps, to a much lesser extent, the artist's own changing fiscal circumstances. Ochtervelt was never as successful financially as Sorgh and de Jongh, whose earnings were generously supplemented by income from other sources. Nevertheless, archival evidence reveals that he and his wife led a comfortable existence.[66]

Among his most impressive representations of elite life are Ochtervelt's renditions of entrance halls. These imaginative paintings feature members of high society who meet socially inferior vendors and musicians at the door of their dignified urban dwellings, the threshold separating the private space of the *voorhuis* (vestibule or entrance hall) from the public one of the

185 Jacob Ochtervelt, *Street Musicians at the Door*, 1665 (oil on panel, 68.6 × 55.9 cm). St. Louis, City Art Museum of St. Louis, Gift of Mrs. Eugene A. Perry.

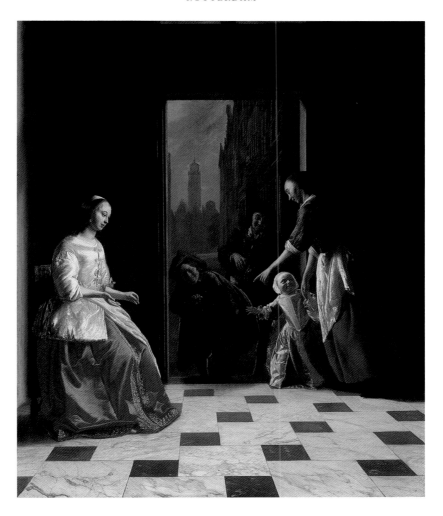

outside world. Pictorial precedents can be found for Ochtervelt's vendors in the work of Sorgh (see fig. 175) but the latter's representations of peddlers hawking foodstuffs are usually situated in the kitchen.[67] Much closer chronologically and thematically to Ochtervelt's renditions are those by the Leiden artist Quirijn van Brekelenkam, whose tradespeople have actually entered the *voorhuis* in order to serve their affluent customers.[68]

The *Street Musicians at the Door* of 1665 (fig. 185), one of nine surviving versions of this theme, is especially beautiful.[69] Within the elegant confines of a *voorhuis* paved with marble, a mistress, her servant, and young daughter delight to the music made by the violinist and hurdy-gurdy player poised at the door. On one level, the artist emphasizes the social differences between the two respective groups by their physical position within the canvas and by their clothing, contrasting the bright, satin garments of the mother and daughter with the drab attire of the street musicians. But on another level, this quixotic scene accentuates concord, for the happy, deferential performers and their well-to-do audience signal placid acceptance of social hierarchies. This endorsement of the social order is purely fictional however, since

the painting was certainly intended for a wealthy client. It thus adopts an elite perspective axiomatically; as Mariët Westermann has insightfully observed, the encounter is rendered from deep within the *voorhuis* so the picture adopts the psychological position (and societal views) of those who could afford the artist's exquisite paintings.[70]

It is instructive to compare Ochtervelt's ragtag musicians with their hurdy-gurdy and flute-playing counterparts in Adriaen van de Venne's *Fray en Leelijck* (see fig. 85) painted some thirty years earlier. Both images were intended for elite audiences and both fashion base persons in conformity with prevailing elite tastes. Wealthy, discriminating collectors of van de Venne's day preferred depictions of itinerant musicians as repulsive figures bent on deceiving people for personal gain. But as the decades progressed, this imagery underwent substantial changes under the influence of burgeoning wealth and evolving notions of civility. Thus by the 1660s roving hurdy-gurdy players and violinists in art, much like peasants, soldiers, and prostitutes, had been sanitized and transformed into innocuous, humane types to accommodate the decorous penchants of prospective buyers.[71]

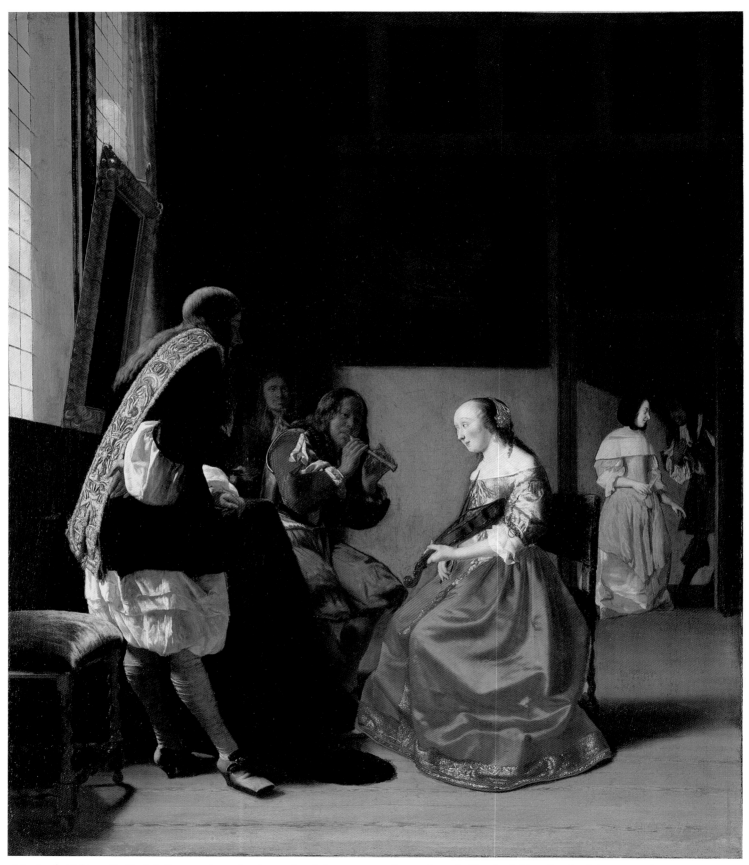

186 Jacob Ochtervelt, *Musical Company in an Interior*, c. 1670 (oil on canvas, 58.5 × 48.9 cm). Cleveland, The Cleveland Museum of Art.

187 Detail of fig. 186.

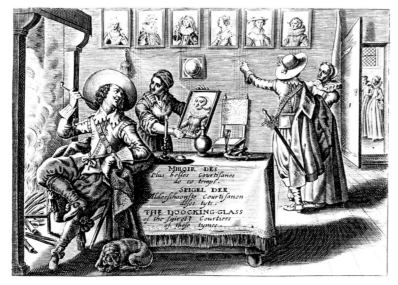

188 Frontispiece from Crispijn de Passe the Younger, *Miroir des plus belles courtisans de ce temps*, ?Amsterdam, 1631. The Hague, Koninklijke Bibliotheek.

Musical Company in an Interior of around 1670 (fig. 186) betrays the influences of these latter artists, particularly ter Borch, in the costumes of the foreground protagonists as well as their postures, notwithstanding Ochtervelt's propensity to render figures obliquely.[72] Moreover, these elongated figures, another indicant of Ochtervelt's late style, are placed within an evenly lit room (hence lacking the complex chiaroscuro of his earlier works) whose spatial disposition is reminiscent of de Hooch's interiors.

At first glance, the *Musical Company in an Interior* appears to be an elegant gathering of well-heeled youths. A young woman plays a violin accompanied by a male on the recorder. Another man, sporting an elaborately embroidered sash, stands to the woman's left while a servant (identifiable as such because of his plainer outfit) proffers wine to the group. At the entrance to the room, another woman and man converse. The picture exudes an aura of calm and finesse. Nevertheless, the series of female portraits on the wall behind the figures discloses the true nature of its subject (fig. 187). There is strong evidence that actual brothels displayed portraits like these to assist clients in selecting their partners.[73] The unusual grouping of portraits in Ochtervelt's painting actually echoes those found in contemporary book illustrations of bordellos (fig. 188).

Once the significance of the background portraits has been ascertained other motifs in Ochtervelt's painting corroborate its subject. The recorder and violin were base instruments often associated with dance halls, brothels, and other dubious establishments.[74] The sash worn by the elegant gentleman in the left foreground has a loop at the end which confirms that it is meant to hold a sword and, in fact, the hilt of the sword overhangs the table to his left. These motifs indicate that the gentleman is a soldier; his presence here is highly appropriate as it conforms to time-honored pictorial traditions of portraying soldiers as habitués of brothels.

Ochtervelt's sublimation of the more distasteful aspects of prostitution imagery in this canvas is standard for artists of his generation who increasingly devoted themselves to representing genteel themes. The transformation of his work toward refined ends therefore parallels the artistic development of his Rotterdam colleagues Sorgh and de Jongh, and is microcosmic of the evolution of Dutch seventeenth-century genre painting in general.

During the latter stages of Ochtervelt's career, his art grew progressively refined. (And the degree of refinement further intensified in paintings made after his relocation to Amsterdam in 1674.) The resultant material splendor of his shimmering surfaces frequently outdoes the later works of Sorgh and de Jongh, which exhibit similar effects, for Ochtervelt had more thoroughly absorbed the style of van Mieris (and other Leiden *fijnschilders*) and that of ter Borch. His astonishingly well-preserved

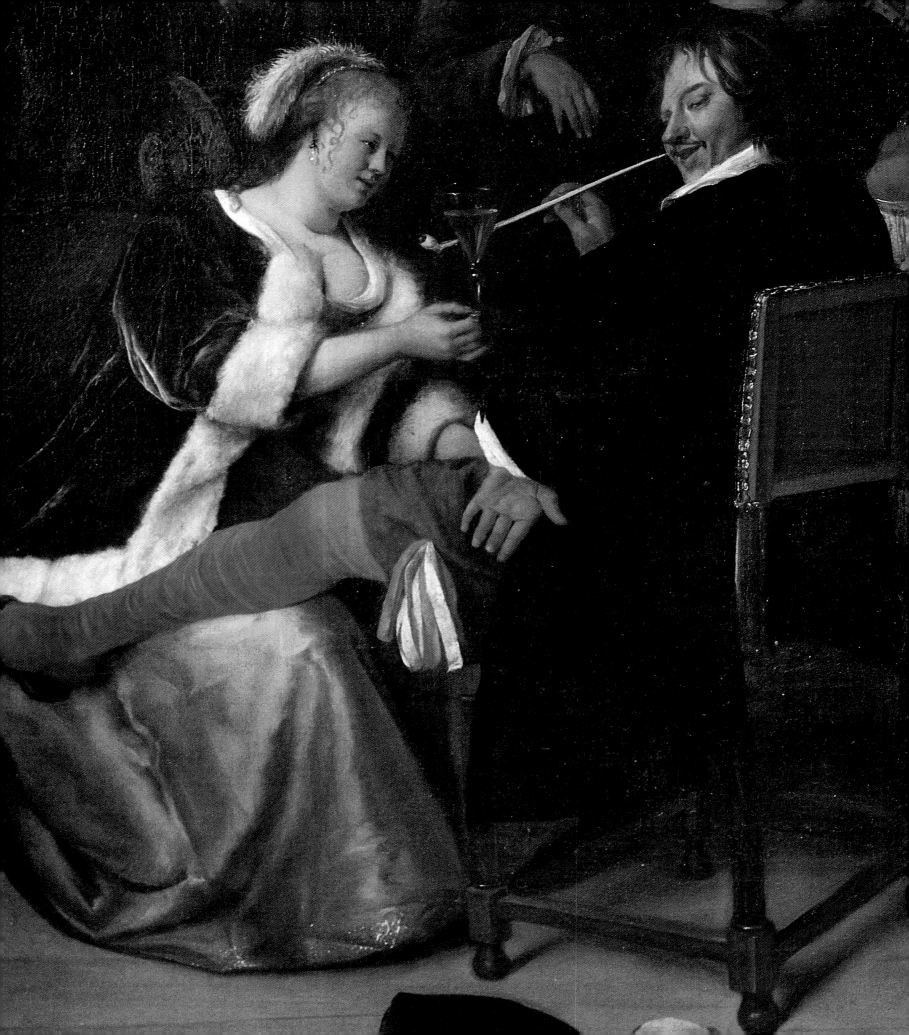

CHAPTER FOURTEEN

JAN STEEN

In many respects the art and life of Jan Havicksz. Steen (1626–1679) confute some of the basic premises of this book.[1] Steen's incessant peregrinations, for example, distinguish him from any number of artists who can be closely identified with their specific cities of residence. He dwelled alternatively in his native town of Leiden, The Hague, Delft, Leiden again, the village of Warmond (north of Leiden), and Haarlem before resettling permanently in Leiden during the last decade of his life. Steen's multiple addresses are matched by the diversity of styles in which he painted, unlike many other masters who tended to perfect a particular manner and then practice it with only minor variation for the duration of their careers. Furthermore, the humorous, sometimes scatological aspects of Steen's sundry art subvert significant numbers of contemporary genre paintings with refined and wholesome subject matter created in this era of flourishing civility.

Steen was born into a Catholic family with a long, upper middle-class ancestry in Leiden.[2] His father, Havick Steen (1602–1670), initially worked as a grain merchant but eventually inherited a share of a brewery called the Red Halberd which his own father (the artist's grandfather) had owned jointly with other family members until his death in 1625; by 1639 Havick Steen had become the sole proprietor of this brewery. As a youngster Jan Steen possibly learned the brewing trade but evidently his parents had a more estimable career for him in mind. In November 1646, he was enrolled in the University of Leiden (an act that presupposed his prior matriculation in Latin School which was open only to boys of affluent families, many of whom intended to pursue further education at a university).[3]

Steen's tenure at the university was brief: within eighteen months, specifically on 18 March 1648, he enrolled in Leiden's newly established Guild of St. Luke as a master painter. The question of Steen's teacher(s) – for his admission to the guild required previous training – remains something of a mystery. The artist's first biographer, Arnold Houbraken (1660–1719), claimed for Steen the tutelage of the prominent landscapist Jan van Goyen (1596–1656) who lived in The Hague.[4] In 1729, a second biographer, Campo Weyerman (1677–1747), added that before entering van Goyen's studio Steen had studied in Utrecht with Nicolaes Knüpfer (1603–1655) and subsequently in Haarlem with Adriaen van Ostade.[5]

Steen married van Goyen's daughter, Margriet van Goyen (after 1622–1669) in 1649. If the young artist was indeed a member of the landscapist's atelier at this time it must have been in the capacity of an assistant as opposed to a mere pupil because he had been certified a master painter in Leiden in 1648 and continued to pay guild dues in that city so that he could sell paintings there. Weyerman's assertion of earlier training in the studios of Knüpfer and van Ostade is therefore probably correct and presumably took place in the years before Steen's enrollment at the University of Leiden.[6] However, the artist's first pictures relate more closely to those by van Ostade and especially works by his younger brother, Isack van Ostade (1621–1649).

The village setting and bright foliage of Steen's *Village Festival with the Ship of Saint Rijn Uijt* (fig. 189) of about 1653, for example, recall a number of pictures by Isack van Ostade (fig. 190).[7] But unlike van Ostade's placid denizens of the countryside Steen's are mostly rowdy and recall peasant imagery of the earlier seventeenth century. The festive figures to the left, particularly the frenetic and ungainly peasants dancing, are reminiscent of those found in pictures by Vinckboons (see fig. 51). The definitive source for both Vinckboons's and Steen's depictions of peasants was of course the work of the renowned Flemish artist Pieter Bruegel the Elder. That Vinckboons would be responsive to a fellow Fleming's work at that comparatively early stage in the development of Dutch genre painting is entirely understandable. By comparison, Steen's interest in Bruegel and sixteenth-century Netherlandish art in general, which persisted throughout his career, was atypical for he labored in an era in which genre painters were generally producing stylistically and thematically innovative art for a progressively sophisticated clientele.[8]

Steen's most conspicuous pictorial archaism in the *Village Festival* is the curious vessel at the far right.[9] This little boat's passengers belong to a higher social class than its crew or the carousing peasants on the shore. Social differences aside, the figures in the vessel are thoroughly Bruegelian in their fundamentally disconnected manner of portrayal, each engaged in disparate activities – fishing, music-making, vomiting, reading – which impart an allegorical dimension to them. The flag on the boat, displaying the city colors of Leiden, elucidates this strange scenario: it includes an ace of spades, a yellow stocking, and a jug, together literally illustrating the popular Dutch proverb, "Kaart, kous en kan maken menig arm man" (Card [gambling], stocking [women] and jug [drinking] make many a man poor).

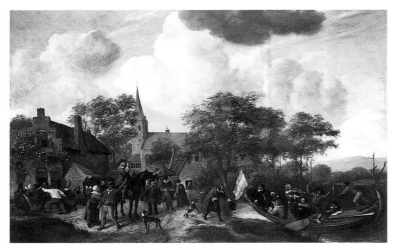

189 Jan Steen, *Village Festival with the Ship of Saint Rijn Uijt*, c. 1653 (oil on panel, 42.5 × 66.5 cm). Private collection.

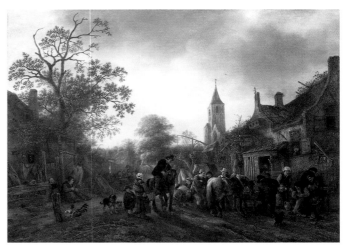

190 Isack van Ostade, *The Halt at the Inn*, 1645 (oil on canvas, 50.9 × 66 cm). Washington D.C., National Gallery of Art, Widener Collection.

The inscription flanking these elements of dissipation, *Rijn Uijt* ("cleaned out" or "broke"), amplifies their meaning. This small vessel of debased persons evokes much older Netherlandish representations of the "ship of fools" (fig. 191), popularly known as the *blauwe schuit* (blue ship), which was surely Steen's intention.[10] Like the boat in the *Village Festival* the *blauwe schuit* transports passengers who embody folly, humankind's most egregious foible.

Possibly induced to quit The Hague because of van Goyen's mounting financial difficulties Steen moved to Delft in 1654. In July of that year he leased a brewery there called the "Snake" with the financial backing of his father. But the hapless combination of the lingering recession caused by the first Anglo-Dutch war, the general decline of the brewing industry in Delft, and the catastrophic explosion of one of the arsenals in that city in 1654 ultimately doomed the father and son's business venture. By July 1657 Steen was calling himself a "former brewer."[11] During his years in Delft he naturally remained active as a painter, executing, among other works, several stunning portraits and genre scenes of peasant life.[12]

By the spring of 1658, if not earlier, Steen had returned to his native Leiden. However, his stay there was quite brief because the record of his dues payment to the guild that year already notes his departure from the city. Shortly thereafter he rented a still extant house in the village of Warmond, just north of Leiden, where he would remain until the summer of 1660. Through the course of his three-decade career Steen was extremely prolific and roughly 350 works (of varied quality) survive. Forty or so bear dates and at least five of these were painted in Warmond. As Lyckle de Vries has astutely observed, the high percentage of dated works from the master's brief Warmond period indicates that Steen attached great importance to his development during these years.[13]

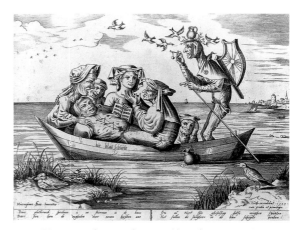

191 Pieter van der Heyden, *Die blau schuyte*, 1559 (engraving). Rotterdam, Museum Boijmans Van Beuningen.

The Warmond-period pictures also evidence a brief stylistic shift on the painter's part, most likely undertaken owing to the impetus of the Leiden *fijnschilders*, especially van Mieris. Datable to this phase of Steen's career is his *Doctor's Visit* (fig. 192), possibly the first of his numerous representations of this theme painted during the 1660s.[14] This panel owes much to van Mieris's rendition of a physician dated 1657 (fig. 193), known in two versions.[15] Here (and in other, contemporary pictures) Steen mimics the meticulous surface effects of van Mieris's work without employing the latter's complicated, multilayered technique. Steen's interior, particularly the staircase leading to a back room, also approximates that by his Leiden colleague despite its greater expansiveness.[16] And lastly, the master's comic point of departure was to some extent inspired by van Mieris's, as both artists portray the doctor as a charlatan dressed in outlandish garments that display closer affinities to the attire of stock figures in theater than to current fashions.[17]

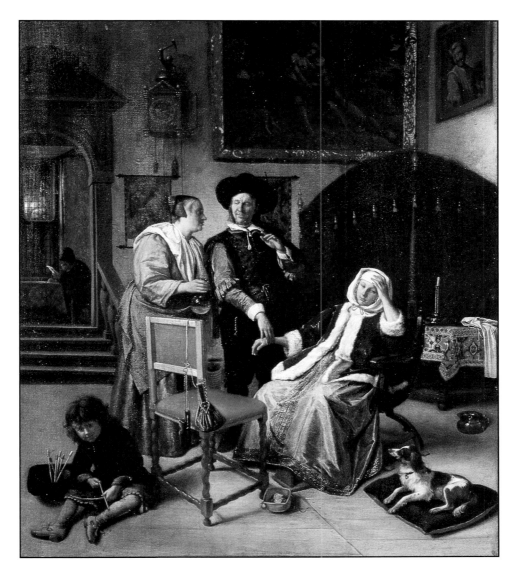

192 (*above*) Jan Steen, *The Doctor's Visit*,
c. 1661–2 (oil on panel, 47.5 × 41 cm). London,
The Board of Trustees of the Victoria & Albert
Museum, exhibited at Apsley House, Wellington
Museum.

193 (*left*) Frans van Mieris, *The Doctor's Visit*,
1657 (oil on copper, 33 × 27 cm). Vienna,
Kunsthistorisches Museum.

Steen represents the doctor checking the pulse of a teary, enfeebled young woman who strikes the classic pose of a melancholic. This suffering female's purse and keys, symbolic of her authority in the home, hang idly over the chair before her. The physician glances knowingly at the maid standing anxiously beside him, clutching a flask containing her mistress's urine. In contrast to Samuel van Hoogstraten's *Doctor's Visit* (fig. 132) in which the practitioner solemnly examines his patient's urine in an attempt to make a diagnosis, Steen infuses his panel with comedy, as he inevitably does in nearly all of his work.

A series of strategically placed motifs in and around the central group of figures cleverly and humorously comment upon the woman's condition – *furor uterinis* or hysteria – and its cure.[18] A brazier with a ribbon suspended from it lies adjacent to one of the chair legs. According to contemporary medical experts, the principal symptom of her condition, the roaming uterus – an organ thought to be independent with distinct preferences in taste and smell – could be induced to return to its proper anatomical position by the fetid odors of smoldering ribbons.[19] Directly opposite the brazier is a young lad seated on the floor who smirks and gazes at the viewer while placing a blunt arrow on his toy bow: he clearly plays the role of a domesticated Cupid.[20] The dog lying faithfully next to its mistress, with a heart pendant dangling from its collar, signals similar associations. Love, or more candidly expressed, coitus, is definitely what this young woman needs to restore her physical and mental equilibrium.[21] The source of the woman's difficulties is actually seated in the back room: an old man, he is clearly incapable of impregnating his wife. The *topos* of the impotent, elderly lover was popular in seventeenth-century Dutch culture.[22]

The large picture on the background wall of Ovid's tragic couple, Venus and Adonis embracing, comments upon the suffering female's unfulfilled urges. Adonis went hunting despite his lover's impassioned objections, a decision that cost him his life and left Venus alone with only memories of her lover.[23] The smaller picture is a replica of Frans Hals's *Peeckelhaering* (Pickle-Herring; see fig. 12).[24] This popular theatrical buffoon was known for his prodigious consumption of drink, induced by his similarly immense appetite for salty herring.[25] He is foolishness incarnate and his presence in *The Doctor's Visit* likely alludes to the pompous doctor.

Yet Steen's picture is much more than a simple conglomeration of static motifs. His greatest gift as an artist was his unrivalled ability to weave such motifs into the greater context of a superlative comical narrative. Here the story is told through the figural gestures and facial expressions rendered with consummate skill. The haughty physician makes his diagnosis by assessing his patient's pulse and urine, diagnostic tools that had grown controversial among medical experts of Steen's day.[26] In effect, his persona, with his questionable procedures and clothing, pokes fun at doctors still practicing what was considered in some circles antiquated medicine. As Mariët Westermann has amply demonstrated doctors were the focus of innumerable farces, jokes, and comic tales (the latter two gathered in jestbooks, a highly popular literary genre of the day).[27] Frequently, the punchlines and plots centered around unknowing physicians confounded by their female patients' illnesses, as this joke from a jestbook published in 1665 makes clear:

It happened recently in Zwolle that a certain young daughter, from sorrow over a lover she could not get, became sick, and laid down in bed, so that a doctor was brought along, to see what might ail her. Coming to her he grabbed her hand to learn what hurt her. The manservant, knowing her illness, said: "My lord, you have touched in the wrong place, because you have felt her arm which is not where she suffers, and you have left her abdomen, where she aches, unconsoled." "Oh!" said she, "my sweet Klaes, that's just what I thought: I would rather entrust my healing to you than to this doctor."[28]

Following traditional comic theory, satirical art and literature entertain their audiences by employing subject matter drawn mostly from life presented in a purportedly direct, unvarnished manner.[29] In this sense then the connections between comic themes in contemporary literature and theater and Steen's art are obvious.[30] However, in response to widespread changes in taste after 1650, comic themes also shifted from their traditional focus upon the peasantry and related low-life types toward persons and situations drawn from higher social milieu. Despite these thematic alterations comedy in the Dutch Republic remained richly nuanced and ambiguous (as it is in most epochs), which cautions one against pursuing an overly monolithic reading of Steen's pictures.[31] Steen and his literary counterparts adopted analogous themes and strategies to heighten their audiences' awareness of the droll component of the scenarios depicted, among the latter, the use of specific gestures or expressions or even distinctive protagonists (such as the little Cupid in *The Doctor's Visit*) who cue or inform the viewer/reader of the true nature of the goings-on.

In the summer of 1660, Steen and his growing family moved to Haarlem where he joined the local guild the following year. Steen would remain in Haarlem until 1670 in what became the most productive and outstanding decade of his career. Works of these years are characterized by increasingly large formats and looser brushwork. Stimulation for these stylistic changes possibly came from the Flemish painter Jacob Jordaens (1593–1678), who spent part of 1661 in Amsterdam executing commissions for the new Town Hall, and from Haarlem painting of the earlier seventeenth century – during Steen's residency there the city was no longer a major center for genre painting.[32]

The Dissolute Household (fig. 194), dated about 1661–4, ranks among the most important pictures painted by the artist during his initial Haarlem period. Indeed, the attention to detail and to

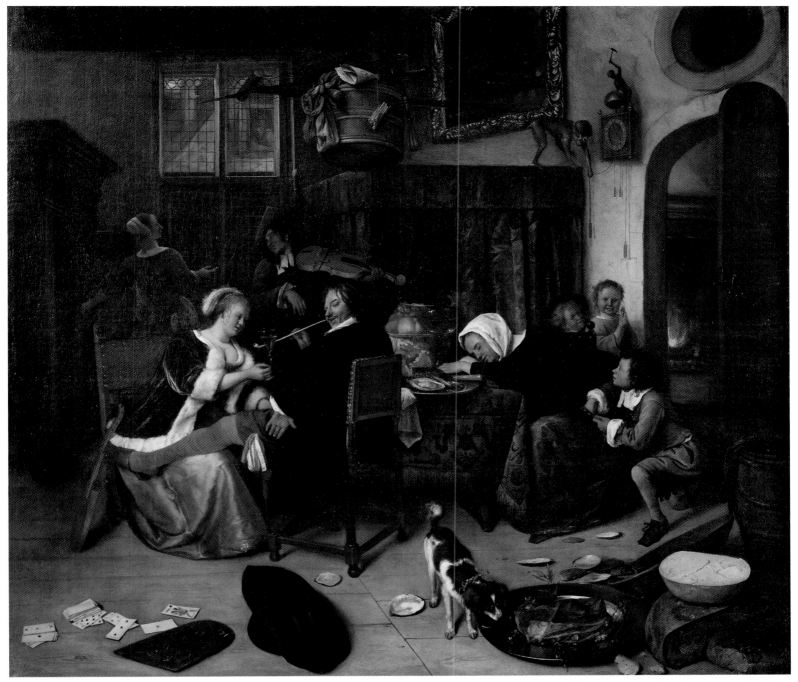

194 Jan Steen, *The Dissolute Household*, c. 1661–4 (oil on canvas, 80.5 × 89 cm). London, The Board of Trustees of the Victoria & Albert Museum, exhibited at Apsley House, Wellington Museum.

narrative in this superb canvas suggests that Steen had a specific patron in mind when he painted it.[33] This quintessential Steen painting portrays a scene of utter chaos and parental abandon: the *materfamilias* slumbers in an alcoholic stupor (note the large wineglass on the table beside her) while her pipe-smoking husband cavorts with a busty strumpet (identified as such by the

feather in her hair) – his leg is slung over her lap, a pose replete with sexual connotations for seventeenth-century viewers.[34] The neglectful couple's offspring run riot in the cluttered and disorderly interior; one of them actually picks his mother's pocket. The maid in the background, entertaining a violinist, has stolen a necklace and otherwise neglected her responsibilities: an unat-

195 Crispijn van de Passe the Elder after Marten de Vos, *Discordia* (engraving). Amsterdam, Rijksprentenkabinet.

196 Frontispiece from *Den nieuwen clucht-vertelder*, Amsterdam, 1665. London, The British Library.

tended roast in the room seen through the doorway at the right has fallen into the fire. The folly of these figures' actions is underscored by an ape – a creature that epitomized foolishness in the European mind – who has stopped the clock, a literal depiction of the idea that senseless people always forget time.[35]

Littering the foreground floor in ostensible disarray are a host of things; ostensible because the artist has paradoxically arranged them strategically to convey the impression that he captured a moment in time thereby enhancing the overall veracity of the scene. Moreover, the strategic placement of motifs comments upon the uproarious and wanton happenings unfolding in the room: there are oyster shells – oysters were considered aphrodisiacs at this time; playing cards, including the ace of hearts; a dog licking a discarded serving platter holding a large slab of meat from which sprouts a myrtle sprig, a plant identified with Venus; and a slate, used in taverns to tally a customer's drinks, inscribed, "*Bedurfve huyshouw*" or "Dissolute Household," hence the title of this canvas.[36] The figures positioned directly above these motifs echo their painstaking placement for Steen has carefully bisected the composition along the line of the father's chair back. This clarifies the meanings of the neglectful parents: the frolicsome husband embodies lust and his somnolent spouse, sloth, two sins thought to be intimately linked.[37]

The basket suspended from the ceiling is filled with items associated with impoverishment and punishment including a sword, an empty purse, a birch rod (for disciplining youngsters), a crutch, and a clapper, a contraption carried by people with contagious diseases to warn others of their proximity. The presentation here of reckless behavior and its consequences, compressed into a single image, is strongly reminiscent of the pictorial strategies of sixteenth-century artists. So too is the painting's very subject which can be linked to German and Netherlandish prints of disorderly households accenting apathetic parents who neglect their duties and children (fig. 195).[38] *The Dissolute Household* constitutes yet another example of Steen's interest in rather antiquated pictorial imagery.

Once again the comic force of the picture is conveyed by more than the simple aggregate of its component parts, for Steen has cleverly used his own physiognomic features for the face of the profligate smoker. This is just one of a sizeable number of pictures in which a Steen-like figure appears, often engaged in questionable activities. H. Perry Chapman has rightly argued that Steen inserted himself into his paintings to heighten their verisimilitude and plausibility.[39] His presence imparts a distinctive comic cast to them and is intended to intensify the viewer's response as well as remind him or her of the "staged" nature of what they see. Steen functions in his paintings in a manner akin to fools in sixteenth-century art and even to actors on stage who address the audience and enlighten them concerning the significance of specific persons or events.[40] This of course is no accident as Steen's pictures were strongly tied to early modern

conceptions of both comedy and the theater which in turn displayed marked parallels with art theory.[41]

The question of the extent to which contemporary viewers recognized Steen (and, sometimes, members of his family) in his pictures is one that is quite difficult to answer.[42] Undoubtedly, some discerning collectors who were acquainted with the artist himself delighted in this engaging and challenging pictorial device.[43] Other cognoscenti, who were unfamiliar with the painter, may have ascertained the frequent inclusion of a signature figure in Steen's pictures even if they were unable to identify him. As such, this frequently snickering character conceivably brought to mind the laughing narrators who grace the frontispieces of contemporary jestbooks (fig. 196), texts which exhibit fascinating parallels with Steen's pictures.[44] Steen must have realized the commercial possibilities of including his visage in his pictures. But this potential marketing aspect of his art should not be overstated because many viewers were probably completely unaware of it. Additionally, there are other facets of the master's work that would have enhanced its marketability more so, for instance, his calculated use of archaistic motifs and themes, a practice that distinguishes him from a host of contemporary genre painters.

Houbraken certainly recognized Steen's countenance in his paintings. His account of Steen's life is analogous to his biography of Adriaen Brouwer (see Chapter 2) which is no mere coincidence given the jocular, ribald qualities of both artists' works.[45] In the biographer's hands, Steen, like Brouwer, emerges as a boozing jokester and prankster who impregnated his master's daughter – Houbraken relates that "he treated [her] so farcically that she began to swell by the day." Thereafter, the painter's father "put him in a brewery in Delft," a venture inherently doomed by his jolly wife's uninterest in bookkeeping – Houbraken adds that she did not take care of the household either – and Steen's habit of "buying wine with his money instead of malt." A subsequent enterprise as a tavern proprietor likewise floundered for Steen "was his own best customer." Houbraken adds that Steen suffered continual financial problems induced primarily by his habit of drinking and gambling away the money earned from selling his paintings. This biography influenced Weyerman's which was embellished with even more spicy tales. As a result, the myth of the bohemian Steen was born, one which was tremendously appealing to later generations of art lovers.

Justifiably circumspect scholars of the 1960s and 1970s dismissed Houbraken's anecdotes as notorious fabrications or as products of his own classicistic biases.[46] However, it is now known that the author's primary motivation was to craft tales that elucidated the supposed congruities between Steen's life and art.[47] Houbraken's approach accords fully with contemporary practice predicated on the notion that biography has to be shaped – sometimes in contradiction to hard evidence – in order to evoke the identity of the person in question, and this is done, according to traditions dating back to antiquity, by fashioning lively stories. Houbraken portrays Steen as a perpetual souse who is financially insecure yet irrepressibly cheerful. His humorous disposition and related, intemperate proclivities are fully embodied in his art. As the author himself so aptly phrased it, "his [Steen's] paintings are like his way of life and his way of life is like his paintings."[48]

Houbraken's spirited description of Steen's life and career is ingeniously enlivened with crude colloquialisms otherwise absent in his biographies of painters whose pictures conformed more closely to the classical precepts current at the time he was writing. Houbraken greatly admired Steen's work but in his view only ill-bred painters could conceive of the coarse subjects and motifs that the painter routinely created – accordingly, the author's biography needed to read in a similarly coarse and comic manner.[49] In some respects, Houbraken's biography reveals a debt to comic literature and thus resembles jestbooks (such as the one quoted from above) in its succession of witty yarns communicated by a whimsical narrator.[50] This is not to imply that Houbraken's and Weyerman's biographies are completely fantastic. Both accounts contain much truth – Steen did operate a brewery and a tavern, for example – for the two writers received some first-hand information from Steen's friend and fellow artist Carel de Moor.[51] Nevertheless, their biographies are quite fanciful and obscure certain facts that perhaps more accurately reflect Steen's character and reputation in his own day. Apparently, he was a diligent painter: how else can one account for his sizeable œuvre? And many of his pictures reveal his knowledge of literature, both ancient and modern, reflective no doubt of his comparatively high level of education. Moreover, he held several official posts during the 1670s in Leiden's Guild of St. Luke, and even his own family undoubtedly considered him reliable and trustworthy as his appointment in 1669 as guardian over his father's under-age heirs attests.[52]

As stated above, Steen's years in Haarlem were the most productive and important of his career. His most successful works during this period self-consciously and playfully subvert the wholesome imagery that had become so fashionable during the economically heady decades following the Treaty of Münster. For instance, paintings of children at school, a theme popularized by Gerrit Dou (see fig. 107), resounded with references to learning, vigilance, and studiousness. But in Steen's hand serious instructors and conscientious pupils are replaced by aged dimwits in outlandish attire who are either completely oblivious to their charges' mischief or aggressively mete out discipline with their omnipresent wooden spoons (fig. 197).[53]

Even the ritual of the lying-in visit, associated with childbirth, was not spared Steen's parodying brush. He completely supplants Gabriel Metsu's dignified representation of this theme (see fig. 170), for instance, with a hilarious and witty scene of a flustered

197 Jan Steen, *The Schoolmaster*, *c*. 1663–5 (oil on canvas, 109 × 81 cm). Dublin, The National Gallery of Ireland.

elderly father who is mocked by a throng of clamorous women as he receives his newborn twins (fig. 198).[54] Comprehending his bafflement and consequently the "punchline" of this painting hinges upon a knowledge of the bizarre procreative beliefs of early modern Europeans: owing to the supposedly primary role of ejaculate in conception twins were considered proof of exceptional male potency.[55] Steen's old man must be impotent – since common wisdom held that the aged were infertile – and therefore completely incapable of having sired one infant, let alone two! A younger, virile man must have fathered them as the old fool, much to his consternation, has suddenly realized.[56]

Related to Steen's pictures of childbirth celebrations and dissolute households are his five renditions of the popular proverb (still recited today in the Netherlands), "As the old sang, so pipe the young."[57] The version reproduced here (fig. 199), in the Rijksmuseum in Amsterdam, is signed and dated 1668, like the canvas just discussed (see fig. 198). The concentration of paint-

ings dated 1667 and 1668 in Steen's œuvre betokens another brief, seminal period in the master's development (the first one having occurred during his stay in Warmond).[58] Indeed, these two pictures recall others made during the 1660s in their rendition of space – Steen's use of perspective was largely intuitive in this regard – and their compositional complexity in which a dense cluster of figures are relationally clarified through the painter's superb orchestration of vivid glances and gestures. Pictures by such artists as Metsu and Pieter de Hooch, who were residing in nearby Amsterdam during this decade, probably provided a general stimulus for Steen's intricate interiors.[59]

These ambitious canvases also exhibit softer light effects than Steen had hitherto employed along with subdued colors applied with dazzling brushwork. He had always been a fairly rapid worker (frequently applying pigment wet-on-wet) and over the course of his career perfected an efficient application technique which is much in evidence here.[60] Using the tip of the brush,

198 (*above*) Jan Steen, *Twin Birth Celebration*, 1668 (oil on canvas, 69.2 × 78.8 cm). Hamburg, Kunsthalle.

199 (*left*) Jan Steen, *As the Old Sang, So Pipe the Young*, 1668 (oil on canvas, 110.5 × 141 cm). Amsterdam, Rijksmuseum.

Steen applied his paint to a particular form on the canvas and then spread it thinly from that point outward, modeling that form in the process. As a result, his surfaces combine thicker and thinner passages of paint within minute areas, thereby imparting scintillating variegation to them and superb replication of diverse textures and stuffs.

These various pictorial devices are utilized to great effect in *As the Old Sang*. This canvas, in essence a boisterous inversion of contemporary paintings of domestic virtue (see fig. 113), depicts a joyous, dysfunctional, multi-generational family who literally act out the proverb (which appears on a piece of paper tacked to the fireplace behind them). The proverb refers to children's propensity to imitate the behavior of their parents. Seventeenth-century pedagogical experts (usually moralists and clergymen) of all religious persuasions considered youngsters highly impressionable, capable of permanently retaining whatever they were first taught, be it good or evil.[61] Hence, they all earnestly advocated training as a means to mold good behavior regardless of whether they deemed children innately sinful or innocent.[62] The theory of education's efficacy over natural instinct to foster proper behavior in children was perhaps expressed most compendiously by the English Puritan divines John Dod and Robert Cleaver: "For we are changed and become good, not by birth, but by education."[63] Consequently appeals were made to parents to fashion their families into *kleyne kercken* (little churches), oriented to ethical values based on scripture, characterized by service to its individual members and God, and most importantly, dedicated to raising pious offspring.[64]

Against these moralists' sobering observations about child-rearing, at least one of whom invoked the proverb "As the old sang" didactically, Steen adopts an approach to this pedagogical subject which is as blithe as it is amusing.[65] The adults in this picture are either inebriated (the toasting grandfather), foolish (the singing grandmother and the bagpipe player), or gluttonous (the corpulent mother with the equally stout toddler beside her), and are entirely negligent toward their progeny. As if to underscore the grown-ups' folly, Steen himself stands behind them blowing hard on his bagpipes, an instrument allied with unbridled oafs.[66] As this figure pipes on his instrument a boy plays his flute on the opposite side of the table. This child in his duet with the adult literally enacts the proverb as do his siblings, gleefully engaged in disreputable activities in imitation of their elders. The little boy in the foreground, for example, greedily sucks on the spout of the tankard held by his sister. This tankard, used to serve wine and similarly strong drink, was known as a "*pijpkan*" in Dutch. Its presence thus provides another clever pun on the proverb as do the pipes (pipe is "*pijp*" in Dutch) held by the two sneering children by the fireplace and the adolescent lustily smoking in the window at the left.

Steen's depictions of *As the Old Sang* are indebted to precedents by the Flemish painter Jordaens who was working in Amsterdam in 1661. The older master first depicted the proverb in 1638 in a painting that was subsequently engraved (fig. 200).[67] Like Jordaens, Steen locates the visual enactment of the proverb in a domestic setting in a canvas of comparatively large dimensions involving multigenerational participants. However, Jordaens's versions of the theme feature cramped, if not claustrophobic, spaces calculated for maximum moralizing impact. And the frequent presence of jesters and owls (time-honored symbols of wisdom but also, paradoxically, of moral blindness and folly), as well as gleaming stone placards inscribed with the proverb, enhances that effect. By comparison, Steen's depictions appear less artificial looking and much more humorously handled.

This raises the question of how contemporary viewers perceived Steen's paintings in general. Older scholarly arguments promulgating a strict didactic reading of these images seem inconsistent with their funny tone and *joie de vivre*. Instead, satirical art and literature, following traditional comic theory, entertained their audiences by drawing subject matter principally from life, presenting it truthfully in a purportedly straightforward manner. Moreover, jocular texts and paintings conform to the age-old notion that truth is revealed through laughter. But as the prefaces to many texts attest, laughable characters paradoxically promote virtue through the exhibition of inane, contemptible behaviors that no principled, respectable person would be caught imitating.[68] Truth in this context therefore refers to human folly. The owners of Steen's paintings, whose social backgrounds ranged from middle class to elite, implicitly understood this.[69] Yet it strains credibility to maintain that they looked at pictures such as *As the Old Sang* to warn themselves about the dangers

200 Schelte à Bolswert after Jacob Jordaens, *As the Old Sang, So Pipe the Young* (engraving). Amsterdam, Rijksprentenkabinet.

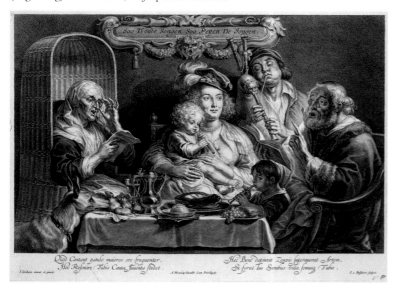

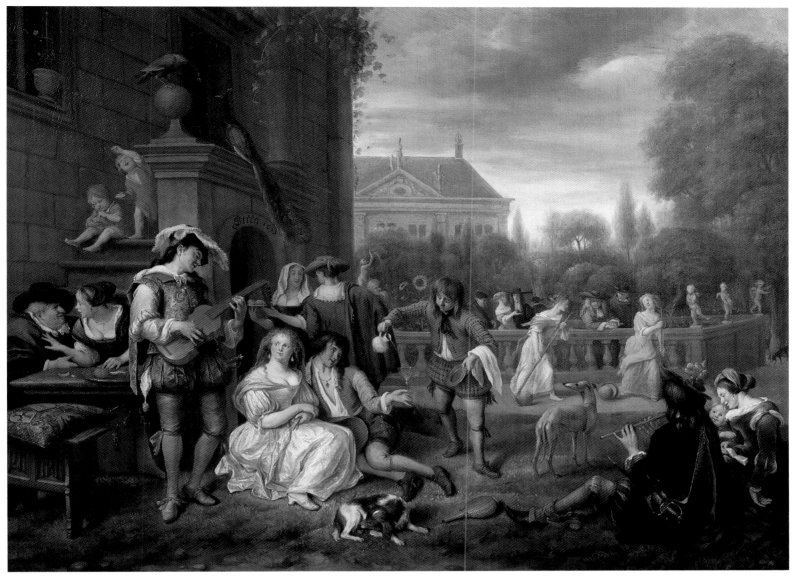

201 Jan Steen, *Garden Party*, 1677 (oil on canvas, 67 × 88 cm). Private collection, England.

of becoming poor parental role models through excessive revellry. Rather, Steen's art must have served to affirm a viewer's presumed social status and respectability with amusing and even uproarious scenarios involving caricatured figures whose pathologies were too easily assailable to entice him or her seriously.[70] Furthermore, the atavistic flavor of the painter's work, often entailing bawdy motifs, probably appealed to a certain nostalgia among high-born viewers for an earlier era in which civilizing codes were less evolved.[71]

With the death of Steen's wife in 1669, followed by that of his father in 1670, the painter returned for good to his native Leiden. He registered anew with the Guild of St. Luke there and with his six children moved into his deceased father's house.

What few documents survive from this final decade of Steen's life suggest his emotional recovery from these tragic events: between 1670 and 1674 he held several important posts in the guild and remarried in 1673. However, times were difficult in the wake of the catastrophic French invasion which engulfed the Netherlands in 1672. As a result many artists, who were the purveyors of suddenly superfluous luxury goods, became impoverished. In an effort to supplement his shrinking income Steen opened a tavern in his home in late 1672.[72] Through it all, he continued to work, and in fact painted more history paintings than he had in preceding years. His genre paintings of this period, despite their uneven quality, exhibit loose and dashing brushwork and lively narratives.

Steen's *Garden Party* of 1677 (fig. 201) demonstrates that even at this late stage of his career he was still capable of attracting important patronage: the coat-of-arms of the Paedts, one of Leiden's powerful regent families, is embroidered on the pillow lying on the bench in the left foreground.[73] One of five garden parties painted during the final phase of Steen's career, this picture, with its splendid portrayal of the alfresco leisure activities of the affluent, evokes precedents by Gerbrandt van den Eeckhout (see fig. 162), Jacob van Loo, and especially the works of an older generation of painters, most notably those by David Vinckboons (see fig. 44). Yet Steen's bright, high-key palette, for example, often described as proto-rococo, fully accords with late seventeenth-century tastes. And his patent infusion of wit and humor into this conventional theme further distinguishes this painting from its antecedents.

A ballustrade in the middleground sequesters the revellers: those in front of it, dressed in archaic, quasi-theatrical attire, generally indulge dubious behaviors while being observed by a background group adorned in current fashion. The eminent historian of Dutch art Abraham Bredius, writing in 1927, first hypothesized that the *Garden Party* was commissioned to celebrate an impending marriage in the Paedts family.[74] More recently, Westermann has amplified his hypothesis, observing that the combination of festivity and light-hearted presentation of foolish conduct here recalls the types of entertainment routinely performed at weddings in the Dutch Republic.[75] The painting consequently appealed to its urbane owner on several levels.

Steen's art therefore confutes some of the basic premises of this book; his frequently uncouth work was different from that of many of his colleagues who were producing pictures with intrinsically wholesome subject matter. Nevertheless, Steen's paintings had great appeal for a wide range of collectors and connoisseurs who clearly enjoyed his entertaining and at times risqué examinations of human foibles. The fact that his pictures rose in value (often dramatically) in the decades following his death is perhaps the ultimate paradox since notions of civility and propriety achieved unprecedented levels of intensity and refinement at that very same time. Had he lived to see it, Steen probably would have relished the potential hypocrisy in all of this.[76]

CHAPTER FIFTEEN

THE DUTCH REPUBLIC, 1672–1702

Historians of the Dutch Republic commonly refer to the year 1672 as the *rampjaar*, or the year of disaster.[1] Faced with the ominous threat of armed aggression against the Netherlands the States General appointed William III (1650–1702) captain and admiral general of the nation's military forces in February 1672. That May he confronted a powerful coalition which had declared war on the Netherlands, consisting of France, England, the Prince-Bishopric of Münster, and the Electorate of Cologne. Spearheading this coalition was the French king, Louis XIV (ruled 1643–1715), whose huge army invaded the country from the east as a large French and English armada simultaneously attacked from the west.

The numerically and qualitatively inferior Dutch forces were no match for those of Louis XIV and his allies; within three short weeks the Provinces of Gelderland, Overijssel, and Utrecht had been overrun with the city of Utrecht capitulating on 23 June. The Dutch troops withdrew to the so-called "water line," a final line of defense along the Province of Holland's borders created by flooding the surrounding countryside to impede and ultimately halt the French juggernaut. Meanwhile, the naval threat in the North Sea abated with a Dutch victory over the allied fleet off the English coast in early June under the bold leadership of the legendary admiral Michiel de Ruyter (1607–1676).

The catastrophic events of May and June 1672 had a devastating effect on the economy and Dutch society.[2] The stock market in Amsterdam plummeted and there was a massive run on the banks; maritime trade abruptly came to a standstill as ships were kept in port to prevent their seizure by privateers; and the art market collapsed ruining artists and art dealers alike – this is only logical since art generally becomes a dispensable luxury item in times of grave emergency. The financial difficulties in which many artists and art dealers suddenly found themselves were typified by the situation of Vermeer, as poignantly reported by his widow, Catharina Bolnes. In July 1677, about eighteen months after the painter's death, she was still saddled with onerous debts. In an effort to secure financial clemency from the Delft authorities Bolnes testified that "during the long and ruinous war with France [her late husband] not only had been unable to sell any of his art but also, to his great detriment, was left sitting with the paintings of other masters that he was dealing in."[3]

Thousands of refugees from the east who were fleeing the invading forces choked the roads and waterways while in many urban centers in the western regions of the United Provinces, thus far spared the direct horrors of war, rioting erupted. With the backing of local militia companies, enraged mobs in such cities as Amsterdam, Rotterdam, and Dordrecht openly challenged the regents whom they accused of negligence and treason, as many of the latter initially advocated negotiating with France in order to save the nation. In a rare display of true democracy in the Dutch Republic these very same crowds vociferously demanded the revocation of the Perpetual Edict (see Chapter 6) and the consequent elevation of William III, the Prince of Orange, to the Stadholderate.

Having no other options, and with growing fear for their own personal safety, the regents acquiesced: in July the States of Holland and Zeeland voted to abolish the Perpetual Edict and appoint William III the Stadholder. This act must be construed in relation to broader political and religious struggles within the Dutch Republic. In effect, the regents' submission to popular will ended their twenty-two-year domination of national and local politics and thus signaled the triumph of the Orangist party. Emboldened by their successes Orangists of all social stripes called for the purging of town councils to replace theologically liberal States Party advocates with more conservative Calvinists who espoused like-minded politics. In late August a frenzied mob in The Hague brutally murdered and dismembered Johan de Witt (along with his brother, Cornelis), the Pensionary and States Party advocate who had capably led the Dutch Republic during the Stadholderless period. Massive demonstrations ensued in several cities which led to the purging of many town councils and ultimately to the consolidation of the Prince of Orange's authority. With much of the country occupied by the aggressors, outspoken opposition to the Stadholder was understandably minimal.

Initially, the news from the eastern front remained dismal. By the middle of the summer the French had captured Nijmegen and their German allies had subdued substantial portions of the Province of Groningen. And in these and other occupied regions widespread pillaging inflicted great losses upon the population and worsened an already decimated economy. Fortunately, these territorial gains constituted the height of the enemy's war effort. For miraculously, the water line, the last line of defense established at the Province of Holland's borders held and during 1673 de Ruyter scored a series of brilliant naval victories against the French and English. England's naval setbacks, combined with

Dutch privateering, made an already economically draining war for the British even more unpopular; their king, Charles II, consequently signed a treaty with the Netherlands in February 1674 thereby depriving Louis XIV of his principal ally. Charles's withdrawal from the conflict was followed soon after by that of the Prince-Bishop of Münster.

In the meantime the Dutch had forged their own alliances with their erstwhile enemy Spain, the Elector of Brandenburg, and Leopold I, the Holy Roman Emporer (ruled 1658–1705). Their combined might compelled Louis XIV to divert troops to the south and paved the way for a number of offensives that eventually forced the French army to evacuate its positions along the water line. By June 1674, roughly two years after the commencement of hostilities, France's possession of Dutch territory had been reduced to two cities along the border with the Spanish Netherlands.

Having rescued his nation from disaster with his statesmanship and successes in the field, William III enjoyed unprecedented power and prestige at this time. Yet paradoxically, renewed security in the United Provinces, which William III had fought so strenuously to attain, created a fairly stable environment in which disgruntled regents reasserted their opposition to his policies. The inherent tensions between States Party supporters and Orangists were only exacerbated by William III's appointment of many of his unscrupulous cronies to the purged town councils. Furthermore, the Stadholder continued to prosecute the war despite massive debt, heavy taxation, and a sputtering economy, which did little to endear him to the regents and many segments of the population at large. As Jonathan Israel has observed in his excellent survey of Dutch history during the early modern period, William III's foreign policy was fundamentally at odds with that of the States Party regents. His geo-political preoccupations with his nemesis, Louis XIV, engendered a wider view of the Dutch Republic's essential interests than the regents' narrower perspective of safeguarding the country's commercial vitality.[4]

Gradually, resistance to the Prince of Orange's policies crystallized, led by the ever-recalcitrant city of Amsterdam. As the war wound down, Louis XIV cleverly sought to exploit these inherent domestic tensions by attempting to persuade the States Party faction to sign a separate peace treaty with France. Amsterdam's regents coaxed their colleagues in many of Holland's other towns to follow suit, thus exacerbating the animosity between them and William III. However, this endeavor came to nothing as the French king recanted several of his promised concessions. Eventually, a formal peace treaty was signed with France and all of its allies in Nijmegen in August 1678; it included a provision to reduce tariffs imposed years earlier by Louis XIV against Dutch goods which helped to revive the economy (albeit temporarily) during the next decade.

Ever wary of French intentions William III tried to mollify his opponents because he would need their support for what he foresaw as the unavoidable resumption of hostilities with Louis XIV. The Stadholder therefore permitted the restoration of those regents who years earlier had been purged from various town councils. William III's forebodings vis-à-vis French territorial ambitions proved well-founded as Louis XIV massed troops on the borders of the Spanish Netherlands, Alsace, and Lorraine in 1683 in order to seize disputed districts there. The anxious Spaniards requested Dutch assistance in accordance with the stipulations of a pact signed between the two nations in 1673. Unfortunately, inherent factional bickering in the Dutch Republic led to only a partial fulfillment of the Spanish request; after some delay, and over the objections of many towns led by Amsterdam, Delft, and Leiden, troops were sent south but kept strictly in reserve. This crisis was settled in France's favor in August 1684, a setback that induced William III to redouble his efforts to accommodate his political adversaries. He embarked upon a strategy of forging consenses among rival factions and advocating toleration as part of a general attempt to refrain from further alienating power blocks resistant to his aims. Henceforth, the Prince of Orange enjoyed better relationships with his opponents whose sympathies had also shifted after 1685 in response to the migration of thousands of Huguenot (French Protestant) refugees to the Dutch Republic after Louis XIV revoked the Edict of Nantes which had hitherto granted them religious freedom.

The temporary recovery of many sectors of the Netherlands's economy during the 1680s adversely affected economic conditions in France, one of its main commercial rivals. In 1687 Louis XIV dangerously raised the stakes in this economic confrontation by introducing harsh tariffs on many Dutch products. When the Nethelanders threatened retaliation he seized 100 Dutch vessels at three French ports. William III realized that this escalating commercial conflict would inevitably beget a military one. In order to prevent an alliance between France and England – likely for the Catholic James II (ruled 1685–1688) of England, facing intense domestic opposition, had grown increasingly dependent upon French support – William III, with the backing of the regents, embarked upon an extremely risky invasion of the British Isles. His intention was to dethrone James II and in his place appoint himself and his wife, Mary (James II's daughter whom he had married in 1677), joint sovereigns of England; the English armed forces could then be enlisted in the coalition opposing France.[5] Fortunately, the Stadholder's invasion, which took place in November 1688, was a brilliant success: William III and Mary II were crowned joint sovereigns in February 1689 (the entire event became known as the Glorious Revolution).[6]

Whatever anxieties the regents harbored about William III's potential ambitions to expand his power at their expense could not be addressed at the moment because the Dutch Republic became embroiled in a second war with France. The Nine Years War (1688–1697) was a long and arduous struggle that ended in a military stalemate. But this conflict sparked by commercial

rivalry ushered in a long period of economic contraction and decline that persisted into the early nineteenth century. Dutch trade in the Mediterranean and West Africa were particularly hard hit as was domestic textile production. Yet despite the grave mercantile conditions William III's political position within the Netherlands remained unchallenged thanks in part to the omnipresent threat to vital Dutch interests in the ambitious person of Louis XIV. William III died childless in England in March 1702. The regents ignored his request that a relative be appointed Stadholder of Holland and promptly discontinued the political functions of the office. The vicissitudes of Dutch politics, namely the seemingly endless power struggle between Orangists and members of the States Party, once again found the latter ascendant: the nation thus entered a second Stadholderless period which lasted until 1747.

★ ★ ★

The cataclysmic events of the spring of 1672 so ravaged the Dutch economy that it would never entirely recoup its former prominence. Later generations, confronted with the Netherlands' profoundly diminished political and economic influence, believed that the tragic events of the 1670s as well as a reprobate populace precipitated the country's downfall.[7] For example, eminent men of letters, writing in the eighteenth century, were unable to comprehend fully the weighty economic and political factors underlying the Dutch Republic's decline. Hence they blamed it principally upon a crisis in spirit among the people (particularly the elites) who, attracted to French culture, had supposedly retreated from the lofty moral principles of the Golden Age.

These very same authors also called attention to the decline of contemporary art.[8] The reasons thought to underlie art's demise were almost identical to those that had supposedly affected culture at large: moral laxity and the pervasive, pernicious French influence. The impoverished state of art was exacerbated by greedy merchants who ignored contemporary pictures in favor of potentially lucrative trading in ones from the earlier seventeenth century. Although the commercial pursuit of earlier Dutch art was decried, that art was nonetheless championed for its naturalism; unlike the tainted work of the late seventeenth century, "authentic" Dutch painting, it was argued, possessed truth and candor as its painters pursued nothing more than the imitation of the very deeds of the creator. This reasoning, infused with nationalism, led to the widespread view that Dutch art should be identified primarily with landscape, still life, and genre painting, though in this context, the last was identified solely with wholesome imagery.

It was only in the nineteenth century that Dutch writers finally began to evaluate the seventeenth with greater historical discernment. For them, the illustrious Golden Age belonged to a distant past that could never be restored. Nevertheless, they clung to their conviction of a past and present organically interwoven, constructed upon a simple, unmediated link between contemporary conditions and earlier developments. In this fervently nationalistic era, historians explored the past as a means by which to advance their nation's sense of identity. The zeal for the old Republic's alleged moral and cultural superiority continued unabated in this respect since the immutable Dutch character had supposedly been established during the glorious seventeenth century. Historians thus fashioned a utopian vision of the Golden Age that owed less to historical realities than to blind efforts to establish and document the erstwhile greatness of the nation in the hope of providing continuity with, inspiration for, and, ultimately, justification of the present. For these writers it was Dutch painting of the true Golden Age and not that of the late seventeenth century that provided unmediated access to the wholesome values and indeed the very spirit of their illustrious ancestors. In fact, much of the terminology they invoked to describe genuine Dutch art is identical to that used to describe the national character: sober, simple, honest, and Calvinistic.

Scholars of our own era have rightly dismissed earlier accounts of a moral and cultural crisis that purportedly gripped the Republic and sent it hurtling into headlong descent.[9] However, a few art historians continue to consider Dutch painting of the late seventeenth century utterly stagnant.[10] An essential question to ask in this regard is how contemporaries, that is, connoisseurs of the late seventeenth and early eighteenth centuries perceived the art of their own day. Did they too hold this view? Samuel van Hoogstraten, for example, in his *Inleyding tot de hooge schoole der schilderkonst* (Introduction to the Lofty School of Painting; published in 1678, the year in which the Peace of Nijmegen was concluded), opined quite the opposite. He believed "that painting in our country as in a new Greece, is at the peak of its floresence."[11] De Lairesse, artist and author of *The Art of Painting*, actually believed that Dutch painting had degenerated much earlier in the seventeenth century on account of such uncouth artists as Brouwer and Pieter van Laer (1599–?1642). De Lairesse credited the art of his own day – he was active as a painter until 1690 – with effectively reversing the decline.[12]

Houbraken primarily thought of the Golden Age of Dutch art as a pre-1675 phenomenon, but he did wax rhapsodic in his biographies about several painters whose careers extended well into the eighteenth century, especially Adriaen van der Werff whom he considered the greatest living Dutch artist.[13] Moreover, Houbraken bemoaned the loss in this period of the once-heralded specialization of Dutch painters along with plummeting prosperity among them, problems thought to be key contributing factors to the general malaise. He also blamed chang-

ing paradigms of interior design for the current situation, to wit, the growing preference for large-scale, painted wall hangings that rendered easel painting obsolete in terms of home decor.[14] Campo Weyerman, whose biographies followed in the wake of Houbraken's, identified the Peace of Rijswijk of 1697 as a watershed: Dutch painting rapidly waned thereafter.[15] And Johan van Gool (?1690–1763), writing in 1750, was equally specific about the onset of a decline: for him, 1710 was the critical year and it was the popularity of wall hangings and especially the corrupting influence of art dealers who encouraged the collection of old masters that accounted for the inauspicious turn of events.[16]

This brief survey suggests that many contemporaries still regarded the last quarter of the seventeenth century as a vital period for painting. But the research of economic historians indicates that the conditions under which art was produced and sold had changed significantly by this time. The art market was actually beginning to encounter difficulties in the decade preceding the French invasion. There had already been a downturn in the number of new master painters entering the profession in the 1660s, and, as Jan de Vries has documented, over the course of the next twenty years the number of new artists shrank to a level approximately a quarter of that of the middle of the century.[17] The reasons for this rather rapid drop undoubtedly reside in the fact that paintings are durable goods and can thus very easily saturate a prospective market causing conspicuous oversupply. Through the course of the seventeenth century up until the period under consideration here the market continually expanded. By the 1670s and 1680s there was a glut of older pictures which, coupled with the severe economic downturn, generated a noticeable drop in demand, factors that must have made a potential art career extremely unappealing to many young men.[18] Therefore, one can justifiably speak of a quantifiable decline in art during this period as well as a decline in traditional specialization in particular genres.

The market was hardest hit in the arena of cheaper, mass-produced art which is no surprise given the devastating economic consequences of the disastrous 1670s upon lower and middle-class wage-earners.[19] Conversely, those citizens of pronounced wealth and social status were less directly affected by the downturn. Indeed the disparities between the income of the rich and the poor continued to increase during the late seventeenth century just as it had done in earlier decades.[20] Therefore the affluent could continue to purchase new paintings only now from a much reduced pool of artists. Consequently, as, among others, Houbraken and van Gool observed, artists became increasingly dependent upon individual patrons for their livelihood as the more open, speculative market shrank.[21] The work of these painters was of typically uncompromisingly high quality and cost and so several masters, despite laboring in a tight market, accrued tremendous wealth and social status, often in the service of patrons outside the Netherlands.

As the purchase and display of works by the leading genre painters increasingly became the prerogative of elites in the second half of the century, so genre paintings were targeted at the very same audiences even more strongly because the dynamics of that market had been altered somewhat by broader economic circumstances. Yet if one adheres to what to my mind is the misleading yet lingering notion that genre paintings were intended primarily for the middle class then the dynamics of the late seventeenth-century art market would seem to break more decisively with art markets earlier in that century.[22] To the contrary, there were actually some continuities between the markets of say, 1650 and 1690 – recall that several artists were already working for specific patrons (and not on speculation) at the earlier date, among them, Dou, van Mieris, and Vermeer.

It would be erroneous to conclude that Dutch seventeenth-century genre painting developed rectilinearly in the direction of an ever more faithful representation of the surrounding world (as discussed in Chapter 8). Within this faulty developmental paradigm, pictures produced late in the century evidence a lack of initiative at best and are degenerately classicizing at worst. However, the evolution of genre painting is more accurately viewed as shifting incessantly from certain prevailing stylistic and thematic conventions to others. For example, exceptions aside, paintings of the 1650s and 1660s generally exhibited striking mimetic effects and wholesome subject matter. Thus, those made during the late seventeenth century, with their bright, polished look and amalgam of classicizing elements reflect changing conventions as opposed to a loss of artistic vigor and ambition.

As has been demonstrated repeatedly, conventions were altered in response to a variety of stimuli not the least of which were changing tastes and expectations among audiences. Therefore, late seventeenth-century Dutch genre painting owes as much to contemporary taste as it does to the previously discussed economic factors even if this has not been sufficiently explored. Contemporary taste can be ascertained by examining cultural forces that shaped elite life in the Dutch Republic during the waning decades of the century.

★ ★ ★

The brief historical survey above has described how the Netherlands was locked in a seemingly endless confrontation with France on a variety of economic and political fronts. Commercial competition between the two nations led to war on two separate occasions and the intervening times of peace were filled with tension. Yet remarkably (and paradoxically), the hatred inspired by the despotic Louis XIV did not preclude a rampant

Francophilia among the upper strata of Dutch society.[23] Already present early in the seventeenth century, Francophila accelerated during its second half under the dual impetuses of aristocratization and civility.

For many affluent Dutch citizens the accumulation of spectacular fortunes during the economically heady years following the Treaty of Münster translated into the wholesale adaptation of certain aspects of the lifestyles earlier associated almost exclusively with the country's small aristocratic class. This phenomenon of aristocratization enabled elites to detach themselves further within the hierarchical society of the Dutch Republic from those groups below them.[24] Concepts of civility, to wit, the adherence to evolving codes of manners, dress, and bodily carriage, were thus pivotal to aristocratization.

During the final years of the century notions of civility continued to intensify. For a fertile source of inspiration in their quest to demarcate themselves further from their social subordinates elites naturally turned to France, the country whose culture was considered the most "civilized" in Europe at that time. Hence the Dutch elites used the French language for social discourse and were captivated by other aspects of French life, including fashion, music, literature, and art.[25] Civility was endemic to the French, and was developed to an extremely refined state in the concept of *honnêteté*.[26] The *honnête homme* was obliged to exercise obedience and docility in deference to prescribed behavioral codes and was to avoid all excess. He was to please through gallantry and politeness; attempts to impress others by calling attention to himself would have been anathema. Numerous treatises on civility, initially directed toward the French elite, were extremely popular (both in translation and in the vernacular) in the Dutch Republic during the late seventeenth century.[27] These texts celebrated the *honnête homme* and *honnête femme* who in their general comportment and lifestyle expressed the values so highly esteemed in Louis XIV's France: the regulation of the passions, reasonableness, decorum, discreet communication through wordless expressions and subtle gestures, polish, and gallantry.[28]

The enthusiastic reception of French cultural ideals in the Netherlands during Louis XIV's reign served to influence many aspects of contemporary Dutch culture. For example, Dutch theater underwent a profound transformation as a result of its exposure to French models. This book has demonstrated how stage productions metamorphosed from the frequently ribald farces of the early seventeenth century (see Chapter 4) to ones reinvigorated with wholesome plots often centering on marriage and related domestic issues (see Chapter 6). Notions of civility had undoubtedly inspired these changes and during the late seventeenth century, as such notions intensified, the theater underwent analogous modifications.[29]

During the first war with France, the theater, like other forms of entertainment, fell on hard times; the municipal authorities in

Amsterdam, for instance, closed the famous playhouse there for five years (1672–7) partly in response to the political situation. (Naturally, this delighted Calvinist preachers who considered the theater frivolous and offensive.) Once it reopened, its productions were characterized by propriety and seemly use of language. For example, performances of the legendary works of Gerbrand Adriaensz. Bredero (see Chapter 2) expurgated his patently risqué dialogues for the sake of decency.[30] These changes were initiated through the auspices of the learned society Nil Volentibus Arduum (Nothing is Difficult for the Willing) which had been founded in the autumn of 1669 and subsequently gained influence upon the playhouse's overseers.[31] This society was dedicated to civilizing Dutch stage productions by cleansing them of perceived transgressions of propriety. Inspired by French classical theater (and in turn, that of antiquity), specifically the plays and theoretical writings of the renowned French playwright Pierre Corneille (1606–1684), Nil Volentibus Arduum advocated decorous entertainments based upon fixed precepts for the express purpose of edifying the audience.

The artist and theorist de Lairesse was intimately involved in the society's activities and actually designed stage sets for the Amsterdam playhouse.[32] De Lairesse had emigrated to the Dutch Republic from the Spanish Netherlands and eventually settled in Amsterdam around 1665. Nil Volentibus Arduum idolized Corneille, as did de Lairesse, but the latter's true contemporary hero was Nicolaes Poussin (1594–1665), the celebrated French painter of the classicist style. De Lairesse, highly acclaimed in his own day, is commonly regarded as the "Dutch Poussin." He played a leading role in fostering the classicizing style that typifies much late seventeenth- and early eighteenth-century Dutch painting.[33] (Ironically, later generations of intellectuals censured his "foreign-looking" work for having triggered the decline of the Golden Age of Dutch art.) Having tragically gone blind in 1690 de Lairesse spent his last years lecturing on art and dictating his influential treatise, *The Art of Painting*.[34]

The precepts outlined in *The Art of Painting* share much with Dutch books of the same bent and especially with several important French treatises.[35] De Lairesse's enthusiasm for antiquity pervades his complex yet eloquent volume. He considered the art of the ancients a source of incomparable beauty, one worthy of imitation because it evinced moral perfection. He entreated painters to cast their subjects in an antique form in which physical beauty and moral perfection would be fused thereby elevating their art to a higher level of reality. Much like the devotees of Nil Volentibus Arduum ascribed edifying purposes to theater so too did de Lairesse to painting. Likewise, the creation of the latter was to be governed by a rational system of classical rules and be decorous in appearance.

One section of the treatise is entitled "Of Use and Abuse in Painting," an unmistakable allusion to an important theoretical treatise on the theater, *Gebruik én misbruik des tooneels* (Use and

Abuse of the Stage), written by de Lairesse's friend the lawyer Andries Pels (1631–1681) who was one of the founders of Nil Volentibus Arduum.[36] In this section, de Lairesse states that "The *Use* [in painting] lies in handling noble and edifying subjects . . . so as at once to delight and instruct," while "the *Abuse* appears in treating obscene and viscious subjects; which disquiet the mind and put modesty to blush."[37] This use and abuse in painting are addressed throughout the treatise. In one memorable passage, the author decries the decoration of fine apartments with:

> pictures of beggars, obscenities, a Geneva-stall, tobacco-smoakers, fidlers, nasty children easing nature, and other things more filthy. Who can entertain his friend or a person of repute in an apartment lying thus in litter, or where a child is bawling, or wiped clean? . . . [Such pictures] are therefore too low and unbecoming subjects for ornament, especially for people of fashion, whose conceptions ought to surpass the vulgar.[38]

This itemization of objectionable subjects reads of course like a description of those dear to early seventeenth-century painters and audiences – one needs only to recall de Lairesse's firm belief in Dutch painting's earlier, lamentable state of decline. His sentiments on inappropriate subject matter echo those of other bona fide classicists including Jan de Bisschop (1628–1671), a lawyer and amateur draftsman and printmaker. De Bisschop's most important contribution to the classicizing movement in the Dutch Republic were two illustrated volumes which could be used as model books by artists: the *Signorum veterum icones* (Depictions of Old Sculptures; 1668–9) with 100 engravings of classical sculptures and the *Paradigmata graphices variorum artificum* (Examples of Engraving by Various Artists; 1671) with engravings after drawings by famous Italian Renaissance masters and their early baroque disciples.[39] The Latin preface to the latter tome is dedicated to the Amsterdam regent and art collector Jan Six (1618–1700). Here de Bisschop castigates traditional Dutch art in language reminiscent of de Lairesse: "Paintings hardly dis-

played anything but the dregs of humanity, beggars, crippled and dirty; disgusting brothels; and junketings so foul that one would not even be allowed to express them in words without first making a statement of one's honor."[40]

It is fascinating that both de Lairesse and de Bisschop linked art and social status by disassociating vulgar pictures from the civilized taste of the high-born.[41] Conversely, their unabashed enthusiasm for the lofty content and excellence of antique art was confidently associated with elite values. In his study of *The Art of Painting* Arno Dolders insightfully observed that de Lairesse was likely projecting seventeenth-century moral ideals upon antiquity.[42] De Lairesse and de Bisschop were writing from the perspective of the upper class to which they belonged; thus for both there was naturally little difference between the moral supremacy they projected upon the ancients and the high standards of behavior promulgated in contemporary elite circles. De Lairesse's and de Bisschop's theoretical assertions likely struck a responsive chord with many contemporary cognoscenti. Therefore, heightened civility expressed through taste within certain, elevated social circles must have exercised at least some influence upon the limited range of themes depicted by genre painters as well as the declining number of specialties in late seventeenth-century Dutch art in general.

But there is much more to de Lairesse's assessment of Dutch genre painting than a mere rebuff of distasteful art. His censure of offensive art serves as a foil to a substantive discussion of how painters can enoble genre painting.[43] De Lairesse's detailed instructions are fascinating because they reflect his knowledge of contemporary genre pictures – at least until the onset of his blindness in 1690. Therefore in many instances his prescriptions simply codify the practices of genre artists during the century's final decades and the early eighteenth century. De Lairesse's observations and more importantly the genre paintings themselves collectively shed much light on traditional scholarly theories concerning the so-called decline of Dutch painting during the late seventeenth century.

CHAPTER SIXTEEN

LEIDEN

Circumstances in Leiden during the Stadholdership of William III epitomize the formidable political and economic problems confronting the Netherlands' major cities during those years.[1] Leiden had traditionally been a pro-Orangist town even during the Stadholderless period. However, the political upheavals and controversies of the 1670s and 1680s thrust Leiden into bitter factional strife from which it emerged more closely aligned politically with such solid States Party cities as Amsterdam. Owing to its increasing economic problems Leiden's regents frequently found themselves at odds with William III over his ongoing struggle with Louis XIV and its ramifications for commerce.

The cornerstone of Leiden's wealth and prestige was its renowned textile industry which had flourished throughout much of the seventeenth century. Yet by the 1670s this industry entered into a prolonged period of contraction precipitated principally by increased commercial competition with England and especially with France. Rivalries with France emerged in two arenas: the manufacture of textiles and the international trade in raw materials and the finished products themselves. With respect to the former, factories for the production of fine cloth had been established in the Languedoc region of France during the 1660s with the assistance of Dutch workers who had been recruited by the French economic minister Jean-Baptiste Colbert (1619–1683). Within twenty-five years the textiles produced there rivalled those made in Leiden (and other Dutch centers). For the Dutch, this competition was exacerbated by the French dominance of trade in the Mediterranean and the Levant – French naval supremacy in these vital regions was achieved during the Nine Years War (1688–97; see Chapter 15). Thus, raw materials became difficult to import and established markets for Dutch cloth collapsed.

These events helped send the economy of Leiden into a long tailspin from which it never fully recovered. As a result, Leiden's population eventually began to decline; by the late eighteenth century it stood at roughly 31,000 denizens, less than half the number recorded in 1667.[2] Remarkably, despite the general economic downturn, wealth inquality, that is, the financial disparities between the "haves" and the "have-nots," continued to increase during the late seventeenth century in Leiden just as it did in many other Dutch towns.[3] Elites were therefore not as deeply affected as middle- and lower-class laborers by the wors-

ening situation, which is only logical given the latter's former role as the mainstay of the city's textile industry.

Regardless of the trying times wealthy persons were still financially capable of purchasing art.[4] As was discussed in Chapter 8, Leiden had developed into an illustrious center for Dutch genre painting under the auspices of the *fijnschilders* (fine painters) Dou and especially van Mieris. Dou and van Mieris worked more frequently for patrons who lived in other cities (and countries) but their paintings were still collected locally to some extent. Moreover, through their studios passed members of the younger generation who would paint for connoisseurs both at home and abroad.[5] Thus, systems of patronage, so vital to late seventeenth-century Dutch painters, were well-ensconced in Leiden. Yet patrons were now serviced by fewer artists as the economic downturn dissuaded many aspirants from entering the profession.[6]

Frans van Mieris the Elder and Willem van Mieris

During the last decade of van Mieris's life, his style shifted in the direction of heightened refinement and even a certain virtuosic flamboyance. To modern tastes, the visual effects of these pictures can seem excessive and for that reason, they have sometimes been described as "mannered."[7] The artist's *Musical Company of Gentlemen and Ladies*, signed and dated 1681, typifies his late approach to genre painting (fig. 202).[8] A group of elegant figures are depicted in a stately interior with classicizing architectural embellishments. Four of the six concentrate on music-making while a suavely dressed female, seen from behind, stands to the side holding a cittern festooned with bright blue ribbons. Images of young people engaged in music-making were conventional (see figs. 44 and 177), but earlier renditions rarely match the general atmosphere of luxury and gentility of this scene.

Otto Naumann has observed that van Mieris typically neglected the understructure of his figures during his late period owing to his pursuit of dazzling effects involving the play of hard light across various textures and surfaces. Indeed, the myriad reflections reverberating off the satin skirts of the two women in the foreground effectively disembody their forms. Equally characteristic for the master is the attenuated quality of the protagonists' anatomies – to the point of distortion – and their

202 Frans van Mieris, *Musical Company of Gentlemen and Ladies*, 1681 (oil on panel, 46.3 × 38.5 cm). Private collection.

droopy physiognomic features. The general stylistic qualities of *A Musical Company of Gentlemen and Ladies* can be seen in the work of many other genre painters of this period which collectively testify yet again to shifting pictorial conventions as the century progressed. But although the quality of van Mieris's work does fluctuate somewhat during his last years it would be erroneous to consider this symptomatic of a decline in Dutch art.[9] Certainly van Mieris's patrons did not think so: for example, a painting of a related subject, dated 1675, was purchased by Cosimo III de' Medici (1642–1723), the Grand Duke of Tuscany, for the then lavish sum of 2500 guilders.[10] Moreover, as discussed in Chapter 15, art theorists and biographers of the late seventeenth and early eighteenth centuries tended to hold contemporary painting in high esteem.

Gerard de Lairesse, for example, was enthusiastic about the art of his own day and credited it with reversing a decline manifested earlier in the century in the work of painters who in his view created vulgar, physically defective imagery. In fact, van Mieris is championed in de Lairesse's *The Art of Painting* as a painter par excellence of the "modern manner": "Francis Mieris has not only curiously followed his master Gerrard Dou, in the elegant modern manner, but is, in some things, his superior . . ."[11] De Lairesse was certainly not the first commentator to invoke the term "modern" when discussing seventeenth-century Dutch painting: its analogous use by Karel van Mander to connote the contemporaneousness of paintings by David Vinckboons and its appearance in Haarlem inventories of the 1630s listing pictures by Dirck Hals has already been discussed. Connoisseurs were also familiar with this descriptor; Pieter Teding van Berkhout (1643–1713), mentioned earlier in relation to Vermeer (see Chapter 11), likewise invoked it to describe a collection in Rotterdam that he saw in 1677.[12]

However, de Lairesse utilizes the term in the context of a far-reaching discussion "Of Things Antique and Modern" which

comprises Book III of his *Art of Painting*.[13] According to the author, the superior antique is limitless in the notable events it can potentially represent, from historical episodes of antiquity to those of the present day. The modern, by contrast, is identifiable exclusively with genre painting for it "is limited within certain narrow bounds . . . for it may or can represent no more than what is present, and that too in a manner which is always changing."[14] Despite its limitations de Lairesse offers pragmatic instruction (involving hypothetical works of art) concerning how the modern mode, to wit, genre painting, can be ennobled so that it can simulate the antique mode.

Genre painting should not wallow in crudities as it did in the hands of earlier generations of artists; rather it should ascend de Lairesse's representational hierarchy to the "citizen or city-like style" and, ultimately, to the "courtly style" which is said to better nature itself.[15] This is accomplished by following the rules of the antique, namely, by infusing a painting with classicizing features so as to approximate the antique without actually being so – de Lairesse repeatedly inveighs against the mixture of genuinely antique and modern elements in an artwork.[16] So, among other things, paintings must contain beautiful figures whose physical attributes improve upon nature. Equally commendable is the graceful comportment of these figures as well as their dress, "if it does not quite chime in" with current fashions.[17] In this sense, modern genre paintings, enhanced with beautiful and virtuous features, will be aggrandized and therefore more closely resemble history painting, the purest thematic and stylistic expression of the antique mode.[18]

As noted in the last chapter, many of de Lairesse's pronouncements simply codify practices established by genre painters in the years immediately preceding his blindness (1690), which explains, for example, his esteem for the art of van Mieris. In this respect, many of van Mieris's late pictures conform to de Lairesse's precepts. The elongated figures in *A Musical Company of Gentlemen and Ladies*, for instance, exude an air of elegance and gracefulness and, in fact, are reminiscent of the standing females *à l'antique* in de Lairesse's illustration of proper and improper carriage and manners (see fig. 120).[19] The posture of these ladies is appropriate, in de Lairesse's own words, for "people of condition." In the painting, the woman to the right holding the cittern is particularly impressive; her broad back with muscular shoulder blades recalls ancient statuary.[20] Furthermore, the figures' clothing, especially that of the females, does "not quite chime in" with current fashions. And lastly, the architectural ornamentation with its classical proportions and aesthetic, contributes to the panel's urbane, distinguished aura.[21]

A Musical Company of Gentlemen and Ladies was painted in 1681, the year of the artist's death. By then his talented son Willem van Mieris (1662–1747), who had trained with his father, had probably assumed a leading role in the studio (even though he did not enter the Leiden painter's guild until 1683).[22] According-

ing to Campo Weyerman (1677–1747), an early eighteenth-century biographer of both masters, Willem (whom he called "a meritorious artist") had actually painted the infant Christ in his father's late *Holy Family*.[23] Willem van Mieris was the prolific practitioner of many genres but the majority of his oeuvre consists of fairly conventional genre paintings that demonstrate strong links to the work of his father, Dou, and other *fijnschilders* of the previous generation.

Like his father Willem van Mieris enjoyed the patronage of many prominent collectors in the Netherlands and abroad. His principal maecenas however, Pieter de la Court van der Voort (1664–1739), resided in Leiden.[24] De la Court van der Voort was an immensely wealthy textile manufacturer who amassed a stupendous art collection which he carefully inventoried in 1731.[25] Much is consequently known about the collection and the type of work that van Mieris executed on his patron's behalf. De la Court van der Voort purchased fifteen original paintings by the artist at prices ranging from a respectable 60 to a costly 1600 guilders (with an average price of about 150 guilders) and also engaged him in making copies after works by Frans van Mieris – including six genre paintings – and other artists who had died before this wealthy connoisseur began assembling his collection. Curiously, Willem van Mieris was also hired to overpaint several of his patron's works (including two by his short-lived brother, Jan van Mieris [1660–1690]) and add staffage to still others.[26]

Many of Willem van Mieris's genre paintings exhibit a fascinating amalgam of influences, reflecting his obviously detailed knowledge of his father's art, the *fijnschilder* tradition in general, and the newer classicizing orientation of so many artists of his day. *The Escaped Bird* of 1687 (fig. 203), for example, can be linked to Frans van Mieris's representation of the same subject, completed in 1676 (fig. 204), during Willem's tenure in his father's studio.[27] The younger painter has represented a female figure in an Italianate setting, posed before a large classical column. Her right arm rests on a wicker birdcage as she watches her feathered pet fly off in the upper right of the panel. The subject not only derives from Frans van Mieris, so too does the precise execution – note the extraordinarily meticulous wicker – which in Willem's hands is much more delicate than the comparatively hard surface qualities of the older master's panel. Willem's painting does not exude so much a proto-rococo aesthetic (as has been argued[28]) as a classicizing one. Consider the setting, the figure's idealized smooth features and especially her knotted hair and fanciful, bright, satin outfit which can only be described as mock antique.[29] *The Escaped Bird*, much like Frans van Mieris's earlier depiction, completely conforms to de Lairesse's aforementioned precepts for ennobling genre painting by imparting to it a classical veneer.

The painting's subject may seem arcane to modern viewers who are at a loss to grasp its meaning. Willem van Mieris's audiences by contrast easily recognized its import: a bird escaping its

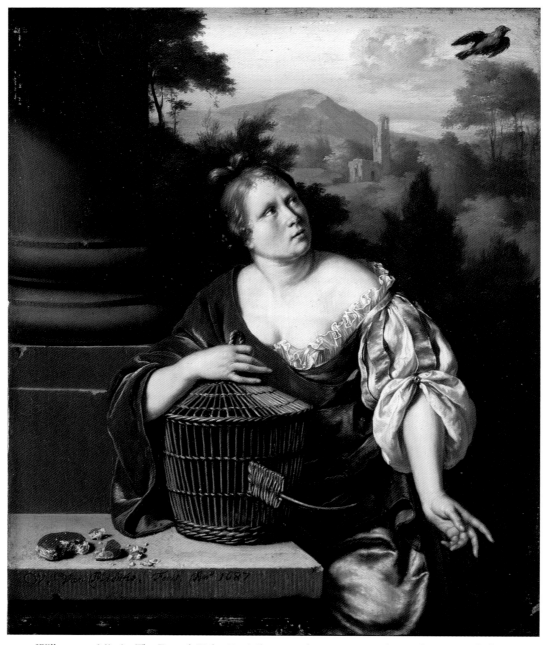

203 Willem van Mieris, *The Escaped Bird*, 1687 (oil on panel, 20.5 × 16.9 cm). Hamburg, Kunsthalle.

cage was a metaphor for lost virginity. A similar scene appears in the *pictura* to an emblem by Jacob Cats (fig. 205), cryptically inscribed "Reperire, perire est" (To discover is to be undone).[30] The explanatory verses elucidate this inscription and the image:

> Where that her mayden-head did lye, faire Joane did
> aske her nourse . . .
> I pray you take this box quoth shee, this keepes your
> mayden-head.
> (Within that box there was a byrde) the nourse scarse
> looked astray,

> But sone the box had opened, and the byrde was
> flowne away.
> Of what light-stuffe are mayden-heads then? quoth
> Joane . . .
> Which if you seeke, they flie away, and lost, when as
> th'are founde.[31]

In the decades between the initial publication of Cat's emblem and van Mieris's image the fleeing bird metaphor was adopted by other Dutch authors and, for that reason, knowledge of the emblem was likely not necessary for contemporary viewers to

understand the paintings.[32] Yet it is fascinating that with one exception, the theme was principally portrayed by late seventeenth-century Dutch painters.[33] This is not, however, the only instance of explicitly moralizing art produced by Dutch artists during this period.[34] In fact, this trend militates against the view endorsed by some scholars that Dutch genre painting evolved from being a fundamentally moralistic art to one primarily aesthetic.[35] The growing interest among van Mieris and his colleagues in uplifting art should be probably construed in light of the increasing civility of contemporary society, in accordance with the ideals of Nil Volentibus Arduum and de Lairesse's notions of exemplary art creating "an ardour for virtue."[36]

During the early eighteenth century Willem van Mieris began to depict genre imagery that was less demonstrably antique and thus more closely connected to the work of his father's teacher, Dou. These pictures, including many niche scenes, are the ones upon which Willem van Mieris's reputation primarily rests today.[37] This is only logical since these paintings are the ones most reminscent of traditional Dutch art or, more accurately, longstanding constructs of what constitutes traditional Dutch art. Prototypical is *A Mother Feeding Her Child* of 1707 (fig. 206), which relates thematically and stylistically to Dou's famed images of domestic virtue (see fig. 106). But characteristically, van Mieris employs a cooler palette, more even light effects, and a profusion of detail that surpasses even Dou's art in its intensity. And his porcelain-like figures are idealized, their physical imperfections eliminated much like any tangible signs of detritus in the quaint setting. (In this sense van Mieris's hygienic glossing of lower-class life for upper-class consumption recalls paintings by Cornelis Bega). Johan van Gool was especially enthusiastic about this painting in his biography and praised van Mieris's rendition of the wicker basket (hanging overhead) which he deemed powerfully painted and unsurpassed in the rendition of detail.[38]

The distinctly antique air of *The Escaped Bird* versus – to invoke de Lairesse's use of the term – the modern *Mother Feeding Her Child* was probably intended to appeal to the diverse tastes of contemporary collectors who perhaps preferred one type over another. For example, the only surviving genre painting from de la Court van der Voort's collection of works by the artist, a fish-seller of 1717 (Antwerp, Koninklijk Museum voor Schone Kunsten), was executed in a purely modern mode and, judging at least from descriptions of them, so were the other two genre subjects owned by him.[39]

In contrast, *The Lute Player* of 1711 is a genre work by Willem van Mieris executed in an antique-looking manner (fig. 208). Unlike *The Escaped Bird*, *The Lute Player*, which was probably commissioned by one of the artist's German princely patrons, constitutes a classicistic reworking of highly conventional imagery within the genre painting repertoire (see fig. 177).[40] A Dou and Frans van Mieris-like curtain is pulled back to reveal a social gathering in which a splendidly attired female tunes her

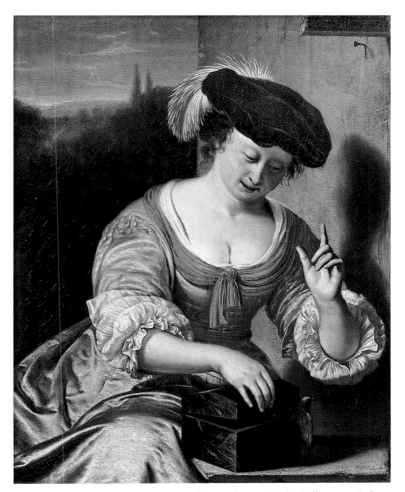

204 Frans van Mieris, *A Woman with a Bird in a Small Coffer*, 1676 (oil on panel, 16.5 × 13.5 cm). Amsterdam, Rijksmuseum.

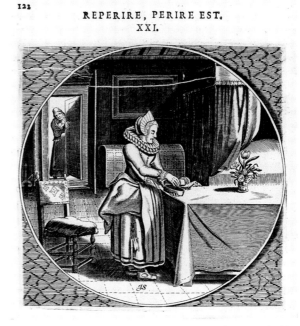

205 Illustration from Jacob Cats, *Proteus ofte minne-beelden verandert in sinnebeelden*. Rotterdam, 1627. Amsterdam, Universiteits-Bibliotheek Amsterdam.

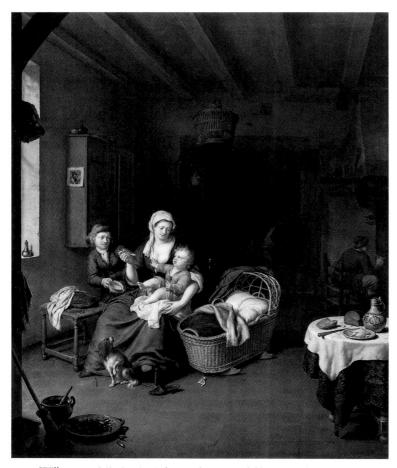

206 Willem van Mieris, *A Mother Feeding Her Child*, 1707 (oil on panel, 56.9 × 48.4 cm). Chicago, The Art Institute of Chicago, Gift of Edson Keith, 1890.42.

207 Gerard de Lairesse, *Five Female Heads* (etching). Amsterdam, Rijksprentenkabinett.

lute as a young suitor – perhaps the owner of the violin on the table – offers her a glass of wine.[41] The presence of a plate of oysters on the floor, classical statuary representing Venus and Hercules, and a distant relief of a nude man embracing a woman (from an as yet unidentified mythological source) suggests that the scene is one of attempted seduction. However, sexuality is entirely sublimated here as it often is in civilized post-1650 art (see fig. 186).

What is most extraordinary about *The Lute Player* is its preponderantly antique tenor. The statuary, possibly modeled on examples drawn from Jan de Bisschop's tomes illustrating the great works of antiquity and the Italian Renaissance (see Chapter 15), and the niches in which they are situated, imbue the room with an atmosphere of monumental sophistication.[42] And the figures themselves, especially the pivotal female musician with her porcelain flesh and gently rouged cheeks, seem like statues come to life. This woman's facial features recall the late work of Frans van Mieris (see fig. 202) but her profile, with her aqualine nose, echoes those of innumerable ladies by de Lairesse (fig. 207)

and, by extension, the classical models (mostly French) that inspired him.

Her costume is coloristically splendid: she wears a mustard-yellow velvet dress with blue trim (and deep décolleté) and a striking, peach-colored satin skirt. This attire too is meant to evoke the world of antiquity. In a section on portraiture in *The Art of Painting* de Lairesse advises his readers to mix fashion "with what is painter-like; as the great Lely [Peter Lely, 1618–80] did, and which is called the painter-like or antique manner, but by the ignorant commonality, the Roman manner . . . On mentioning the Roman manner, I find that it signifies a loose airy undress, somewhat favouring of the mode, but in no wise agreeing with ancient Roman habit."[43] De Lairesse thus advocated psuedo-antique attire to create timeless images of sitters and handily circumvent the problem of portraying the vexing vagaries of current fashion. Furthermore, by invoking the famous English portraitist Lely, he once again codified what had become an established practice, in this case among portrait painters. Only the source for such dress in portraiture was not Lely but his illus-

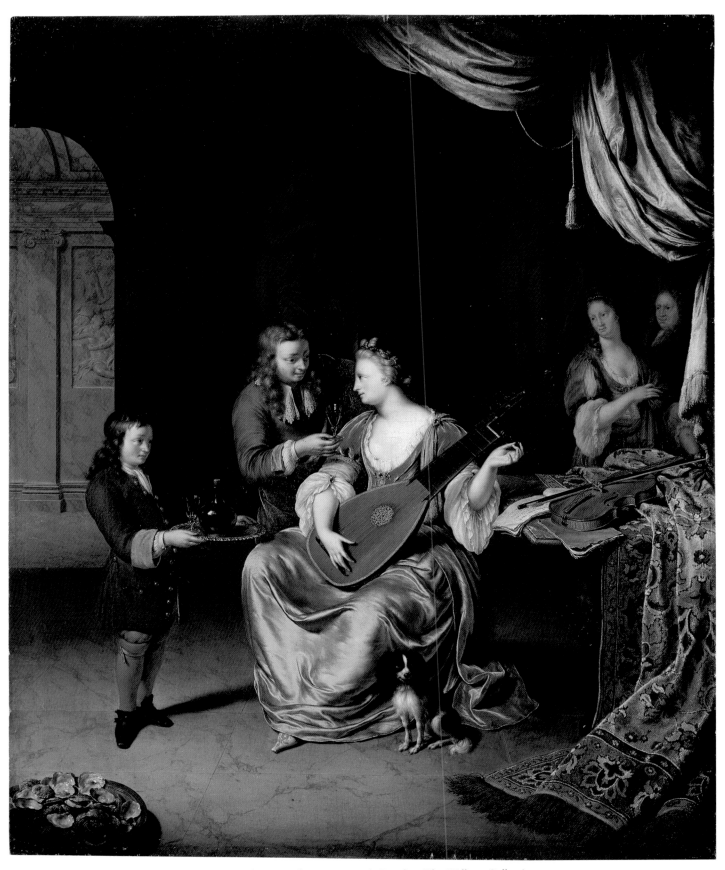

208 Willem van Mieris, *The Lute Player*, 1711 (oil on panel, 50 × 40.5 cm). London, The Wallace Collection.

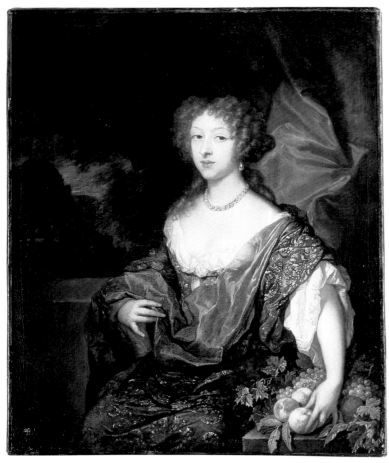

209 Caspar Netscher, *Portrait of a Woman*, 1679 (oil on canvas, 49 × 39 cm). Private collection.

study drawing with Dou and thereafter, in early 1672, to the atelier of the Amsterdam portraitist Abraham van den Tempel (*c.* 1622/3–1672).[47] After van den Tempel's death, the fledgling artist returned to Leiden to study with Frans van Mieris and then, finally, traveled to Dordrecht for further instruction with Godfried Schalcken. In 1683, de Moor joined the Guild of St. Luke in Leiden and, like Willem van Mieris, eventually held a number of important administrative posts within it. From the outset, de Moor executed genre paintings, and history paintings, but over time portraiture, for which he was in tremendous demand, dominated his output. He became an internationally acclaimed portraitist: the Grand Duke of Tuscany commissioned a self-portrait from him in 1702, and in 1714 he was knighted by the Holy Roman Emperor Charles VI (ruled 1711–40) for his services in this capacity.[48]

Given his training and place of residence it is hardly surprising that de Moor's genre pictures partake of Leiden traditions, though not exclusively those of the *fijnschilders*. His *Prayer Before a Meal* of about 1695 (fig. 210), for example, owes much to depictions of this popular theme by Jan Steen who upon his return to Leiden in 1670 befriended the young artist.[49] In particular, there are striking parallels between de Moor's canvas and one by Steen of around 1667–71 presently in the John G. Johnson Collection of the Philadelphia Museum of Art (fig. 211).[50] Both represent a lower-class family humbly engaged in prayer before their meager meal – the pose of de Moor's fervent boy behind the table is nearly the mirror image of the one in Steen's painting. But whereas Steen's gaunt figures (who are comparatively loosely painted) convincingly suggest the burdens of the downtrodden, de Moor's representation provides a hygienic, paradoxically polished view of poor people. His family is robust and idealized much like the one in Willem van Mieris's *Mother Feeding Her Child* (see fig. 206). Evidently, figures with classicizing features were in great demand in late seventeenth-century art as patrons desired artworks that were civilized and refined in virtually every respect, regardless of the social status of the persons portrayed.[51]

De Moor's *Angler* of about 1700 (fig. 212) is virtually unique among his limited number of genre works and, indeed, among seventeenth-century Dutch genre paintings in general.[52] In a bucolic setting, a barefoot youth reclining beside a pond or canal gazes at his fishing line whilst observed by a milkmaid – identifiable as such by her attire – and her pipe-smoking companion who lean upon a rough-hewn rail. De Moor's relatively precise application of paint (no doubt inspired by Leiden's *fijnschilders*) enhances the physical refinement of the protagonists who, much like those by van Mieris, exhibit porcelain-like skin and, in the case of the fisherboy, an aqualine nose. This urchin's tattered garments and rustic hat seem incongruous with his smooth, pure form (much like the family in *Prayer Before a Meal*) almost as if he were an actor donning a costume for a stage production set in the country.

trious predecessor Anthony Van Dyck (1599–1641).[44] Van Dyck's fantastic costume attributes became popular in the Netherlands only during the 1670s and were modulated through French influences.[45] As a result, women sport mock antique costumes in late seventeenth- and early eighteenth-century Dutch portraits (fig. 209) that are reminiscent of the attire of van Mieris's lute player.

Willem van Mieris's tremendously successful career continued unabated into the 1720s. By that decade, however, a certain decline in the technical quality of his work can be detected and this was hastened by his failing eyesight during the 1730s.

Carel de Moor and Matthijs Naiveu

Carel de Moor (1656–1738) is hardly a household name today, even in his native country, yet during his lifetime he was considered one of the greatest Dutch painters.[46] Born in Leiden to an art dealer (according to Arnold Houbraken who presumably received this information at first hand), de Moor was sent to

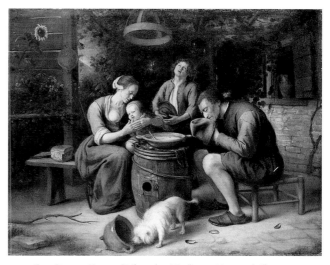

210 Carel de Moor, *Prayer Before a Meal, c.* 1695 (oil on canvas, 61 × 64.5 cm). Dunkirk, Musée de Dunkerque.

211 Jan Steen, *Prayer Before the Meal, c.* 1667–71 (oil on canvas, 62.9 × 78.1 cm). Philadelphia, Philadelphia Museum of Art, John G. Johnson Collection.

212 Carel de Moor, *Angler, c.* 1700 (oil on canvas, 62 × 75 cm). Amsterdam, Rijksmuseum.

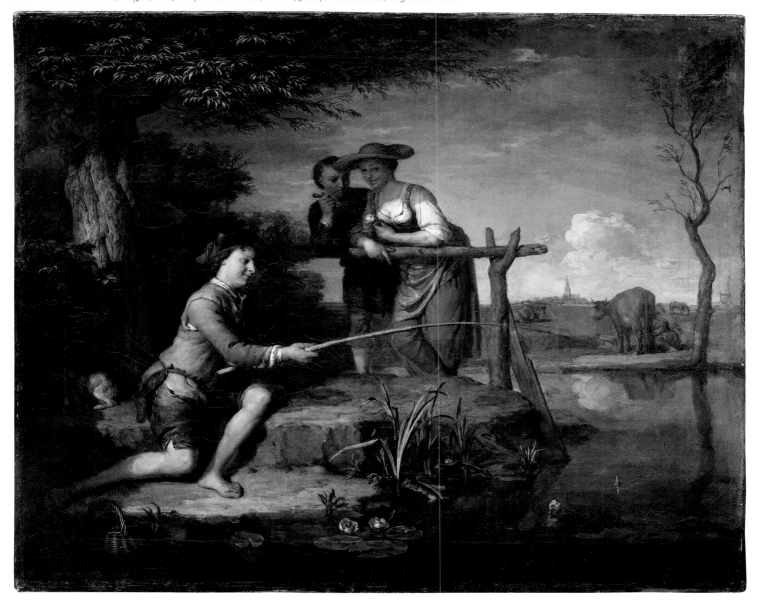

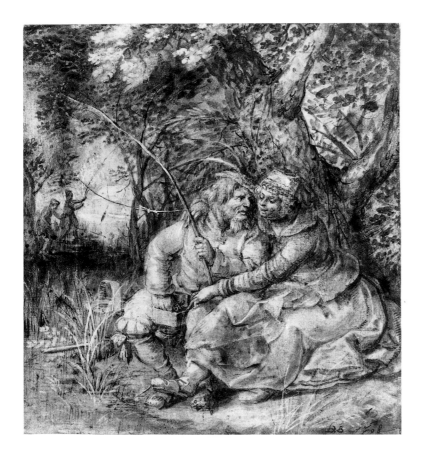

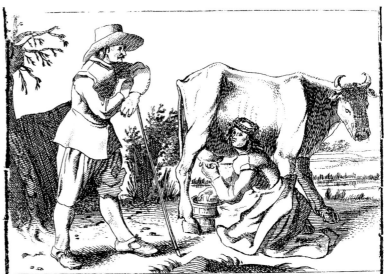

214 (*above*) Illustration from *Incogniti Scriptoris Nova poemata*, n.p., 1624. The Hague, Koninklijke Biobliotheek.

215 (*facing page*) Matthijs Naiveu, *The Newborn Baby*, 1675 (oil on canvas, 64.1 × 80 cm). New York, The Metropolitan Museum of Art, Purchase, 1871 (71.160).

213 (*left*) David Vinckboons, *Elderly Fisherman with a Girl*, 1608 (drawing, 25.3 × 22.3 cm). Paris, Collection of Frits Lugt, Institut Néerlandais.

The tranquility of the scene and the beauty of the figures belie the erotic content of *The Angler* which would have been readily apparent to de Moor's audience.[53] In Dutch literature, fishing (much like birding, discussed in Chapter 12) conveyed a variety of conflicting sexual associations ranging from impotence to coitus. In the visual arts, the pastime (which is mostly depicted in book illustrations) likewise connotes carnality. Such is the case with a drawing by Vinckboons dated 1608 (fig. 213), in which an elderly yokel and his much younger companion both reach for worms conspicuously located in a box between his legs; clearly their interests extend well beyond angling. In light of the significance of the boy's activity in *The Angler*, the milkmaid's presence can hardly be coincidental: in the popular imagination milkmaids, much like maidservants, were sterotypically coquettish and libidinous.[54] They are often featured in contemporary scatological jokes, for instance, whose punchlines hinge upon milk as a euphemism for semen.[55] Moreover, in a riddle book dated 1624, composed by Leiden University students, the milkmaid's actions, as seen in an engraving (fig. 214), are anything but innocent. The accompanying poem, like the others in this seemingly innocuous little tome, employs a titillating set of double-entendres:

> Joyfully she seizes on a muscle-like object,
> And strokes it up and down until,

> With a squeeze she makes the sweetest sap flow,
> Which she puts in the opening between her legs.[56]

The tranquil, stylish air of de Moor's picture with its elegantly composed figures, certainly seems incongruous with the strong erotic connotations of the motifs contained within it. Yet this is consistent with the appearance of so many genre paintings from the latter seventeenth and early eighteenth centuries that sublimate sexuality in the interests of taste informed by civilized values.[57] Clearly, de Moor possessed great skills as a genre painter but he unfortunately abandoned this type of art in favor of portraiture which accounts for his once lofty reputation.

Matthijs Naiveu (1647–1726) was another pupil of Dou's who after completing a two-year apprenticeship in that master's studio (1667–9) went on to enjoy an enormously successful career.[58] However, Naiveu's reputation has likewise suffered over the centuries to the point that knowledge of his work is generally limited to specialists today. Predominantly a genre painter, Naiveu enrolled in the Guild of St. Luke in Leiden in 1671 and eventually served in it as a headman. In the summer or fall of 1678 the artist moved to Amsterdam, undoubtedly because of the potential commercial opportunities there. In 1696, he was appointed to a bureaucratic post as hop inspector for the city but this position did not hamper his artistic career. To the contrary, Naiveu remained highly productive until the early 1720s.

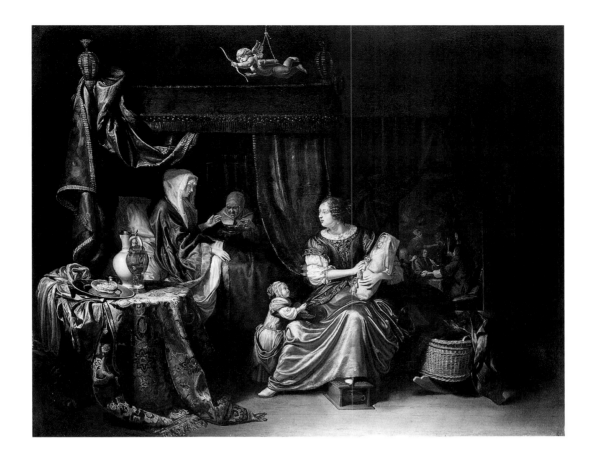

Naiveu executed his first genre paintings in the late 1660s; these works betray his familiarity with Dou's thematic prototypes, among them, depictions of domesticity.[59] During the 1670s he expanded his repertoire to include subjects not specifically associated with Dou, for example, the *Newborn Baby* (fig. 215). This painting, dated 1675 – the year of the artist's own marriage and of the birth of his first child – represents the ritual of the lying-in visit in which female callers would celebrate a new arrival.[60] The principal precedent for this canvas is Gabriel Metsu's noteworthy rendition of 1661, probably commissioned by the wealthy Amsterdam regent Jacob Jansz. Hinloopen (see fig. 170).[61]

In Naiveu's canvas the convalescent mother (wearing a beautiful lavender-colored robe appropriate for the celebratory occasion) is fed broth by a dutiful servant (or midwife) as she converses with a fashionably dressed friend who holds the tightly swaddled infant. In a distant room, the *paterfamilias* celebrates with his comrades before a large painting of a stormy seascape similar to the one seen in Metsu's painting whose presence implies the newborn's tribulations during its journey through life.[62] Naiveu's painting is filled with a plethora of meticulously rendered objects reflective of *fijnschilder* traditions.[63] These articles refer to the customs associated with the lying-in visit. The covered glass goblet on the table, for instance, contains *kandeel*, a celebratory drink traditionally served on such occasions. On the plate beside it is a small, hollowed-out loaf of festive bread

filled with sugared caraway seeds or sugar-coated cinammon sticks. The plaster statue of the flying Cupid above the bed probably alludes to the newborn as well. In sum, Naiveu portrays the happy event with dignity and propriety.

In the following decades Naiveu continued to work in the *fijnschilder* style but with less polished and refined effects.[64] Furthermore, his palette grew brighter and he frequently introduced into his work a profusion of decorative details. His highly conventional *Children Blowing Bubbles* of about 1700 (fig. 216) is indebted to earlier representations by Naiveu's famous predecessors in Leiden, most notably Frans van Mieris (see fig. 101) for the subject and Dou (see fig. 102) for the niche setting, curtain, and plaster relief below. But the bright palette (most evident in the children's costumes) and especially the profusion of ornamentation, including plaster Cupids, fanciful scrolls, and vegetative forms anticipate in some respects the gradual emergence of the rococo style in the Netherlands during the eighteenth century.[65]

As discussed in Chapter 7, the motif of bubble-blowing in Dutch art traditionally symbolizes the ephemerality of human existence (see fig. 100). Such notions are certainly present in Naiveu's canvas but they are compounded by the presence of the plaster Cupids on plinths to either side of the niche. A bird rests on the finger of one Cupid while the other holds a bridle. In early modern Europe, these motifs were well-known pedagogical metaphors.[66] Only a tame bird will alight on someone's

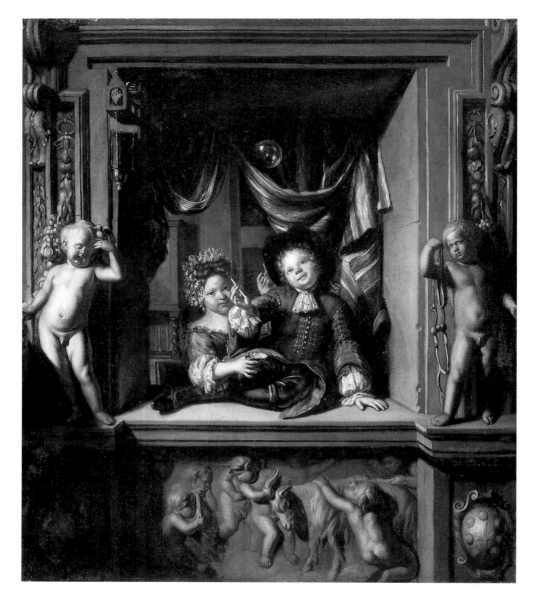

216 Matthijs Naiveu,
Children Blowing Bubbles,
c. 1700 (oil on canvas,
49.6 × 41.5 cm). Boston,
Museum of Fine Arts,
Gift by Subscription;
89.506.

fingers; just as this creature's instincts can be modified through training, so too can a child's. In the same vein, a horse must be spurred and bridled so that it will obey its master just as disciplining children is fundamental to their rearing. In this context, the goat being subdued in the frieze below perhaps provides similar commentary. The general import of the picture probably emphasizes proper instruction in view of life's brevity. Naiveu's painting thus constitutes another example of the growing interest in didactic art during the late seventeenth century.

In essence, genre painting in Leiden during the Stadholder-ship of William III retained much of its earlier vitality even if it was practiced by fewer artists. Such talented painters as Willem van Mieris and de Moor cleverly fused the influence of their *fijnschilder* predecessors with classicizing tendencies currently in vogue. The resultant work should not be considered symptomatic of a decline but rather of a new set of conventions introduced into genre painting at that moment in time, impelled by sweeping socio-cultural and economic change.

DELFT

The disastrous events of the 1670s intensified Delft's economic and artistic decline and hastened the city's alliance with the States Party in disputing William III's policies toward the French because of their potentially damaging impact upon commerce.[1] Delft's traditional brewing and textile industries, having succumbed to heated competition from neighboring towns (most notably, Rotterdam and Leiden), were long on the wane – though the former had finally stabilized on a greatly diminished scale.[2] Faience manufacture (particularly the renowned imitations of oriental porcelain), which was in its most dynamic phase of production during the 1660s, did provide a providential boon to the economy that partly offset the dire consequences of the reeling brewing and textile industries, but by 1678 the number of potteries in Delft was already starting to drop and during the eighteenth century increasing competition from France and Germany sent this vital enterprise into headlong descent as well.[3]

The profound economic contraction of the city (and surrounding countryside – which exacerbated the situation in the city) naturally affected Delft's population. From its peak of roughly 25,000 inhabitants in 1665 – a truly modest number compared with other cities in the Province of Holland such as Amsterdam and Rotterdam – Delft's population shrank some forty percent during the next seventy years: only 15,000 persons resided there in 1733.[4] Microcosmic of this general decline was the situation vis-à-vis the arts in Delft. During the 1650s a number of talented painters had already departed for opportunities elsewhere. This exodus only accelerated during the following decade; indeed, by the *rampjaar*, 1672, the ranks of artists were vastly depleted. Among the genre painters only Johannes Vermeer and Cornelis de Man remained.[5] Yet genre painting survived in Delft bolstered not only by the arrival of Johannes Verkolje in 1673 but also, more importantly, by the city's proximity to the nation's capital, The Hague. Curiously, in the decades following the Treaty of Münster, portraiture in Delft, which comprised such an important part of its artistic output before 1650, was largely ceded to specialists from The Hague; conversely, Delft's genre painters made substantial inroads in The Hague whose potential market was much more lucrative than that of their native town.[6]

★ ★ ★

Johannes Vermeer

By the late 1660s Johannes Vermeer had entered the final phase of his relatively brief career (see Chapter 11). In the intervening years he had become a well-respected member of Delft's artistic community and in this capacity enjoyed the esteem and patronage of elite collectors in that city and beyond, even if his laborious technique limited his production. Initially, his success continued but the war with France (and perhaps the death of his maecenas Pieter Claesz. van Ruijven in 1674) irreparably damaged his livelihood.

A Lady Writing a Letter with Her Maid of about 1670–71 (fig. 217) is widely acclaimed as one of the finest pictures of the artist's late period.[7] This canvas, which represents a fashionable lady composing a letter while her maid gazes serenely out the window to her right, bears all the hallmarks of Vermeer's ultimate stylistic development. The crystalline, refined features of the figures, the linear precision with which they are composed, and the general abstraction of forms toward geometric ends, all perceptible to a lesser degree in Vermeer's earlier work, are fully consummated here. The maid's garments, for example, are so sharply defined in terms of light and shadow that they actually resemble the fluting on classical columns. The extraordinary crispness of her clothing is echoed by her mistress's white sleeves and collar. Even the carpet on the table upon which the mistress writes shares these abstract features; unlike the tactility of the carpet in the *Young Woman with a Water Pitcher* (see fig. 156), painted some six years earlier, it hangs in a most artificial, box-like manner.

In effect, these stylistic devices impart an aura of dignified grandeur to the painting which melds seamlessly with its subject, letter writing, a cultured leisure activity of the upper classes in an era in which sizeable portions of the populace were illiterate. The theme of letter writing and reading in Dutch genre painting revolves around love and courtship (see Chapters 2 and 7) largely, though not exclusively, from a female perspective. Vermeer's letter writer is completely absorbed in her task. She is undoubtedly responding to the crumpled letter on the floor in front of the table, a motif made all the more visually arresting by the bright red wax seal beside it – together they introduce an intrusive element to an otherwise pristine interior.[8] The maid's presence in this context is not coincidental since in popular literature and theater (and in genre painting) servants

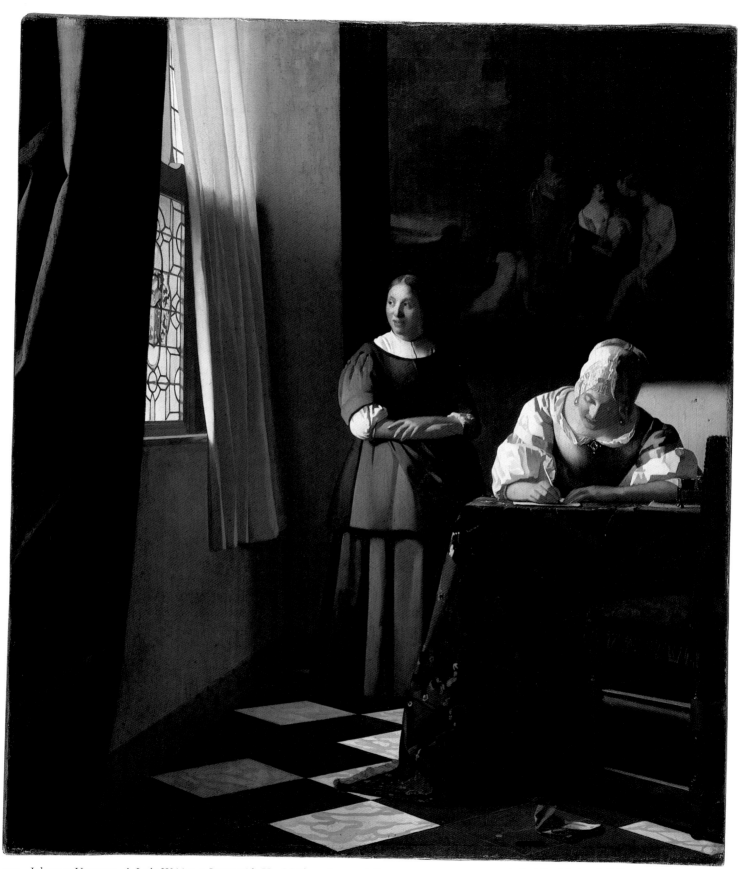

217 Johannes Vermeer, *A Lady Writing a Letter with Her Maid, c.* 1670–71 (oil on canvas, 72.2 × 59.7 cm). Dublin, National Gallery of Ireland.

function as vital confidants in their mistresses' and masters' amorous pursuits. In fact, many of the practical guides to courtship advised lovers to use servants as go-betweens in their relationships, especially for the purpose of delivering letters.[9]

Yet characteristically for Vermeer, the deeper implications of the proceedings in this chamber are elusive despite the presence of an additional, tantalizing clue: the large painting on the back wall representing the Old Testament story of the infant Moses's rescue from the bulrushes by Pharoah's daughter and her hand-maidens.[10] Note how the letter-writer and her servant are enframed by this picture and, more specifically, how the form of the mistress echoes its central grouping. Moreover, the interstice between the lady and her maid is replicated by the three, central figures in the background picture and the additional one standing aside. Lisa Vergara's intriguing suggestion that the visual linking of Pharoah's daughter and the lady invites the viewer to ascribe the former's noble attributes to the latter may well be correct.[11] And on a more fundamental level Vermeer may have intended to draw some parallel between the divine protection of Moses and that of the absent lover to whom the woman writes.[12] In the end it is difficult, if not impossible, to determine more precisely the significance of this canvas for contemporaries.

Scholars have sometimes invoked the term classicistic to describe the style of this painting and other late works by Vermeer because of their decorous restraint and elegance. However, the term is perhaps misleading in this context if one applies it in the sense that Vermeer's contemporaries understood it and as de Lairesse codified it in his *Art of Painting*.[13] In de Lairesse's taxonomy Vermeer is a modern painter, a practitioner of the elegant modern mode who unfortunately does not tran-scend its limitations by ennobling his pictures with antique-like details.[14] Or phrased differently, from an art-historical perspec-tive, Vermeer's pictures adhere to conventions established by the slightly older generation of Dou and ter Borch as opposed to the truly classicizing conventions presently being developed by such "vanguard" artists as Willem van Mieris and Eglon van der Neer. The relative conservatism of Vermeer's work, even at a time when pictorial conventions were shifting, is reflective of his patrons' taste as well as of Delft art within the broader context of late seventeenth-century Dutch genre painting. Nevertheless, the master's pictures are unrivaled in their refinement and capacity to evoke mood through the most economizing means – he therefore brings the modern mode (in its completely non-classicizing manifestation) to its zenith.

The refinement and abstraction evidenced in *A Lady Writing a Letter with Her Maid* are especially intense in Vermeer's single-figure pictures from this period, among them, *The Lace-Maker* of about 1671–2 (fig. 218).[15] This small canvas represents a young lady in a bright yellow bodice making lace, intensely immersed in her task. The painter once again utilizes crisp light effects to define the woman's form. Her nose, for example, is cleanly

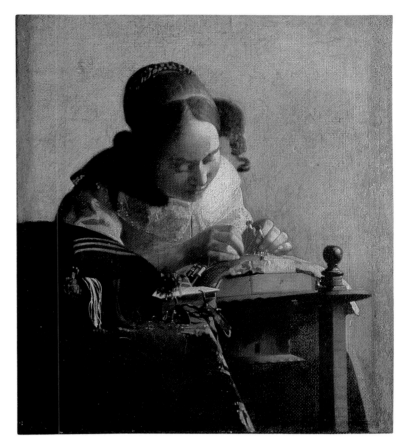

218 Johannes Vermeer, *The Lace-Maker*, c. 1671–2 (oil on canvas, 23.9 × 20.5 cm). Paris, Musée du Louvre.

and symmetrically bisected by shadow and sunlight as are the proximal and middle phalanges of the fingers on her right hand. The lace-maker's body and elaborate coiffure are consequently simplified and display a strongly geometricized quality. But most remarkable in terms of abstraction is the lace protruding from the lace-making cushion in the left foreground. It has the appearance and consistency of melted wax; the optically pecu-liar qualities of this motif along with the seemingly collapsed depth of field of the painting once again raise the question of the artist's possible use of a camera obscura. However, by this point in his career Vermeer had become an expert at replicating the enchanting ocular effects produced by the apparatus without having to have direct recourse to it.

The spellbinding visual effects of *The Lace-Maker* (and other paintings of the master's late period) were created by relatively economical means. As Arthur K. Wheelock, Jr has noted, Vermeer simplified his technique in his last paintings by, *inter alia*, using opaque paints more extensively than glazes and by abbreviating various textures and stuffs, especially drapery.[16] Yet Vermeer's economy of means was matched by his typical economy of message: *The Lace-Maker* lacks the constellation of motifs found

in other paintings of this theme (see fig. 95) which amplify its associations of domestic virtue.[17]

Vermeer's repeatedly superb delineation of quintessentially radiant feminine beauty, the depiction of which contemporary art theorists exalted as one of painting's highest goals, was noted in Chapter 11.[18] Vermeer was certainly not the only artist to "specialize" in portrayals of beautiful women; the same can be said of Dou, ter Borch, and many other contemporary masters. Collectively, their work catered to elite predilections in a culture captivated by female pulchritude as countless works of contemporary Dutch amatory literature (particularly those infused with Petrarchan sentiments) attest. Van Ruijven, Vermeer's important patron who at one time owned some twenty paintings by the artist, including *The Lace-Maker*, probably found this aspect of the artist's work immensely appealing and trendy.[19]

The degree to which difficult personal circumstances induced by war and economic contraction prompted Vermeer's less elaborate, late technique and the subsequent characteristics of his paintings in this final phase of his activity cannot be determined. Nevertheless, marked changes in his art did occur at a time when Vermeer was suffering increasing financial hardship, exacerbated by the responsibilities of having to provide for a large family – at his death in 1675 he left a widow and eleven children, ten of whom were minors. But contemporary taste, in the form of the art market, surely continued to play a role in the genesis of these paintings (just as it did in virtually all Dutch art),[20] and acknowledging this helps in placing them more squarely within the artistic and cultural framework of the Dutch Republic during the waning decades of the seventeenth century.

The economic turmoil induced by "the long and ruinous war with France," as his wife Catharina Bolnes put it, evidently affected the production and sale of art everywhere, but Vermeer's problems were worsened by his laborious approach to his craft and, related to this, his relatively low rate of production and somewhat restricted clientele. These latter factors, which go far in explaining the high prices that the artist commanded for his pictures, were in the end detrimental not only to his career but, if his widow is to be believed, to his health as well.

Cornelis de Man and Johannes Verkolje

Cornelis de Man (1621–1706) continued the legacy of Vermeer and Pieter de Hooch in Delft.[21] The circumstances of de Man's youth and artistic training are not known. After enrolling in the Guild of St. Luke in late 1642, he embarked upon an approximately ten-year journey through France and Italy. The age at which he began his travels (twenty-one) and the countries he visited (France and Italy) indicate that his parents were probably affluent. During this period young men from well-to-do families were customarily sent on the *Groote*

tour (Great Tour) to supplement their education.[22] Upon his return to Delft around 1652, he rapidly established himself as a prominent artist and citizen who through his long and productive career repeatedly served his profession as one of the headmen of the Guild of St. Luke, eventually working with Vermeer in that capacity.[23] He was also appointed to the administrative board of the Delft's Chamber of Charity in 1680 – a position traditionally reserved for members of the elite. De Man initially painted portraits and peasant imagery, but the departure of several prominent masters from the city, including de Hooch, probably motivated his interest in depicting new subject matter including striking church interiors and elegant genre paintings of upper-class life.

De Man's *Geographers at Work* of around 1670 (fig. 219) is representative of the types of genre pictures to which he principally devoted his later career.[24] The canvas shows three men in a richly furbished, wainscoted interior – de Man frequently depicted males, which is fascinating because the artist himself was a life-long bachelor. Moreover, given his personal wealth, he probably inhabited prosperous quarters analogous to those seen in his work. The two standing gentlemen wear silk kimonos. These luxurious articles of clothing were used as house robes and were all the rage among elites in the Dutch Republic during the late seventeenth and eighteenth centuries. The shoguns of Japan presented Dutch merchants of the East India Company with thirty kimonos at the signing of the annual trade treaty in Edo. Recognizing the enormous potential profits from the sale of these garments, the East India Company eventually commissioned oriental tailors to manufacture them. In the Netherlands and other European countries they rapidly acquired value among gentlemen as status symbols.[25]

The architectonic quality of *Geographers at Work* recalls any number of Delft genre paintings. The picture's perspective is relatively simple and almost "funnel-like." The mirror, hung at an angle behind the gentlemen recalls Vermeer's paintings as does the motif of the man touching the globe, seen, for instance, in one of the famous master's two paintings of single males (fig. 220).[26] In fact, the connection with Vermeer's two representations of scientists probably inspired the title of de Man's canvas by which it has been known since the middle of the nineteenth century.[27] But the absence of scientific instruments in this painting casts doubt on the customary identification of its subject matter. Recently, Kees Zandvliet has convincingly proposed that de Man actually portrayed two merchants and a sailor discussing a potential sea route to Asia.[28] The sailor, seated and clothed in seaman's garb, points to a map of Greenland and the polar regions, specifically to a route used in a famous expedition in 1596–7 to discover a passage to Asia, and in response one of the merchants points to China on the large globe on the table. In sum, the painting highlights de Man's skills as a figure painter and his interest in narrative.

219 Cornelis de Man, *Geographers at Work*, c. 1670 (oil on canvas, 81 × 68 cm). Hamburg, Kunsthalle.

220 Johannes Vermeer, *The Astronomer*, 1668 (oil on canvas, 51.5 × 45.5 cm). Paris, Musée du Louvre.

One of de Man's best-known and most beautiful genre paintings is his *Man Weighing Gold* (fig. 221), likewise executed around 1670.[29] In a comfortable interior, a gentleman weighs gold at a table watched by a seated woman, perhaps his wife. The artist cleverly suggests the chill of early morning by the thick garments worn by the pair, the woman's pose (which possibly has added significance), the crumpled bedding beside the box bed, and the presence of a young servant placing peat in the hearth to ignite a fire. The perspective system in this picture is much more sophisticated than that of the *Geographers at Work* and corroborates de Man's contemporary renown for this aspect of his art. For example, in a list of "present day painters" and their subjects, compiled by the Amsterdam surgeon Jan Sysmus between the years 1669 and 1678, de Man is commended for his use of perspective.[30] This is hardly surprising for as was noted in Chapter 11, intricate perspective was probably recognized as a salient feature of Delft art.[31]

Perspective in *A Man Weighing Gold* is constructed upon an oblique, dual-point system. This complex system was common in paintings of church interiors, particularly in Delft, and de Man was undoubtedly familiar with it from his own, earlier renditions of such spaces.[32] Furthermore, it was adopted by some genre

painters including Jan Steen, who resided in Delft during the mid-1650s. The conspicuous floor tiles and beamed ceiling intensify the illusionistic effects of the perspective as does the richly carved wainscoting and mantelpiece. The canvas highlights the master's formidable mimetic skills in delineating the cracks and imperfections in plaster (above the mantelpiece), in introducing a delicate play of light and shadow across fabric and wood, and in convincingly depicting crevices in the massive wooden beam above the box bed.

Figures weighing coins were a time-honored theme in Dutch and Flemish painting and can be dated to the fifteenth century.[33] Older persons are usually shown engaging in this activity because the theme was most frequently associated with avarice and greed. Dotage and impending death were thought to cause the aged to cling desperately and foolishly to money and other worldly goods.[34] Thus, seventeenth-century artists created conventional images in which an elderly person is surrounded by coins, jewels, money bags, precious vessels, and so forth, supplemented occasionally by ancillary figures.[35]

By contrast, de Man's gold-weigher is youthful. Yet similar ideas were probably present here, communicated with a level of subtlety for which de Man is not normally known. Walter

221 Cornelis de Man, *Man Weighing Gold*, *c.* 1670 (oil on canvas, 81.6 × 67.6 cm). Private collection.

Liedtke astutely questioned how contemporaries would have perceived the man's action of tending to his hoard of coins – a money bag lies in the trunk in the lower right corner – even before the morning fire has been kindled. Also, in early modern European cultures, the complacent woman's pose, with her arms folded, was often identified with idleness.[36] Liedtke further recognizes a sense of irony in the furnishings, namely, the portrait of Prince Maurits (see Chapter 1) and the tiny roundels representing Christ and the Virgin Mary on the mantelpiece. These pictures represent personages, both divine and mortal, whose lives embodied self-sacrifice unlike the smug couple intent on assessing their material wealth.[37]

If *A Man Weighing Gold* does in fact expose the vices of avarice and sloth it does so subtly, in a manner that requires close scrutiny of its beautifully rendered details. The canvas would thus constitute yet another example of moralizing art which seems to have enjoyed a certain vogue during the late seventeenth century. The growing interest among painters and patrons in edifying art should probably be construed in light of the increasing civility of contemporary society.[38] Questions of meaning aside, de Man's interiors portray a halcyon world of comfort and privilege. Even allowing for the invariable artistic liberties taken with elements of authentic decor, it can be said that the style of these chambers and their embellishments are decidedly traditional, if not old-fashioned, in an era in which changing interior design paradigms rendered much extant decoration obsolete.[39] Therefore, de Man, like Vermeer, produced art that by contemporary standards was relatively conservative.

The final master to be discussed in this chapter is Johannes Verkolje (1650–1693), who given the general decline of art in Delft, is said to be "responsible for a sort of Indian summer in Delft painting."[40] Verkolje, the son of a locksmith, was born in Amsterdam in 1650. According to his biographer Arnold Houbraken, Verkolje was something of a prodigy whose artistic

222 Johannes Verkolje, *The Messenger*, 1674 (oil on canvas, 59 × 53.5 cm). The Hague, Mauritshuis.

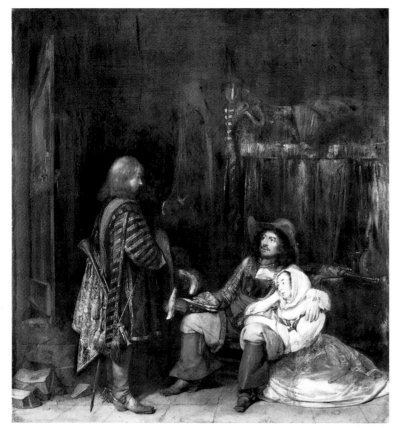

223 Gerard ter Borch, *Unwelcome News*, 1653 (oil on canvas, 67.7 × 59.5 cm). The Hague, Mauritshuis.

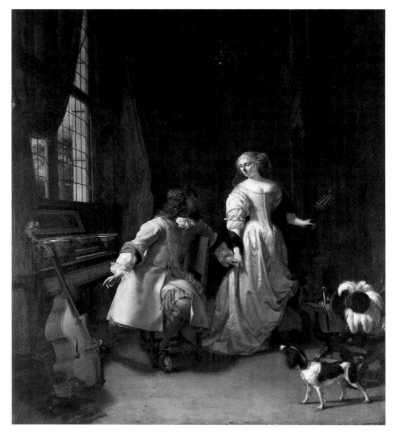

224 Johannes Verkolje, *Elegant Couple in an Interior*, ?1674 (oil on canvas, 96.5 × 57.1 cm). Private collection.

talents inadvertently surfaced after a childhood accident: he was struck in the heel or ankle by a dart and the wound became seriously infected leaving him bedridden. His parents purportedly provided catchpenny prints for his amusement and he soon began to copy them.[41] Eventually Verkolje entered the studio of Jan Andriesz. Lievens (1644–1680) with whom he studied for six months. In 1672, Verkolje moved to Delft and shortly thereafter married a local resident, Judith Voorheul. In June 1673 he enrolled in the Guild of St. Luke and repeatedly served as one of the headmen of that organization. Primarily a specialist in portraiture and genre painting, Verkolje's two-decade career was immensely successful. Houbraken relates that his portraits commanded high prices and that he was famous at his death in 1693.[42]

Vermeer has been called the last of several Delft painters to depict a patrician ideal but it was actually Verkolje, who survived him by some eighteen years and who also practiced portraiture wherein this ideal was most effectively realized for patrons.[43] Pictures such as *The Messenger* of 1674 (fig. 222) are saturated with elite values.[44] An officer and lady play tric-trac in a stately room whose ornamentation is much more *en vogue* than that seen in de Man's interiors. The lady, seated on an ornately carved stool, is dressed in a striking satin dress of a type routinely found in

paintings by ter Borch (see Chapter 7), with whose work Verkolje was doubtlessly familiar. In fact, in its subject and presentation, *The Messenger* strongly recalls ter Borch's *Unwelcome News* (fig. 223), painted twenty-one years earlier.[45] The table, bedecked with an expensive carpet, holds the game board as well as wine and fruit, the latter lying on an expensive silver serving tray. The iridescent splendor of all of these objects and the very space itself are enhanced by Verkolje's detailed paint application and bright palette. (Prior to his move to Delft Verkolje customarily employed darker tonalities and more ponderous atmospheric effects.[46])

A messenger delivers a note to the officer; judging from the latter's facial expression, he knows that the news cannot be good. The large painting on the back wall, partially covered by a majestic scarlet curtain, amplifies the significance of the scenario unfolding in the foreground. This picture represents the *Death of Adonis* from Ovid's ever-popular *Metamorphoses*.[47] According to Ovid, Venus was in love with the young, avid sportsman Adonis and warned him about going on the hunt. Adonis ignored her advice and was then mortally wounded by a wild boar sent by Venus's estranged and jealous lover, Mars. Venus subsequently discovered Adonis's body – as depicted in the picture on the back

wall – and mourned over it. The implications of this story for the officer seem clear: the message undoubtedly summons him to return to his troops and hence to war where he might be killed (like Adonis), leaving an anguishing belle (like Venus).[48] The cruel fortunes to which the couple have been subjected are cleverly underscored by their interrupted tric-trac game – note that the lady is just about to throw the dice. Known in the seventeenth-century as *verkeerspel* (literally, "game of change"), tric-trac symbolized for contemporaries the vagaries of fate.[49] In light of ter Borch's *Unwelcome News* and others of this theme, it must have appealed greatly to contemporary beholders by encouraging exciting speculation on the fortunes of the persons depicted.

The trappings of polite society, very much in evidence in *The Messenger*, are also prominently displayed in *Elegant Couple in an Interior*, probably dated 1674 (fig. 224).[50] In a sumptuous chamber, an exquisitely dressed young man beckons his lute-holding, modish sweetheart to join him in a duet – he will play the viola da gamba propped up against a virginal. The richly evocative exchange of glances here is one often found in paintings by ter Borch (see fig. 89). Verkolje's refined technique, especially his exquisite renderings of fabrics, is likewise reminiscent of ter Borch's (as well as that of the Leiden *fijnschilders*; see

Chapter 8). In essence, the picture elegantly upgrades conventional imagery of music and courtship (see figs. 44 and 89) by presenting it in an atmosphere of rarefied splendor and politesse.

Scholars have frequently asserted that late seventeenth-century Dutch genre painters were simply content to proffer highly stylized and refined versions of the themes popularized by their illustrious predecessors. This is to some extent true for Delft painting during this period for, as has been repeatedly demonstrated, genre painters in this city characteristically produced conservative work in response to the tastes of local collectors (and those in The Hague who preferred such pictures). However, this assertion, with its implication of a lack of initiative on the part of Dutch artists, is ultimately reductive. The conservatism of late seventeeth-century genre painting in Delft is not matched, for example, by contemporary art in Leiden: even a casual comparison of Verkolje's *Elegant Couple in an Interior* with Willem van Mieris's *Lute Player* (see fig. 208) demonstrates this. The latter picture, infused with motifs *à l'antique*, displays the new stylistic conventions as opposed to those adhered to by Delft painters (and some of their colleagues in other towns).[51] Furthermore, in the hands of the masters discussed in the final chapter of this book, these new conventions grew quite sophisticated, taking genre painting to its very stylistic and thematic limits in the process.

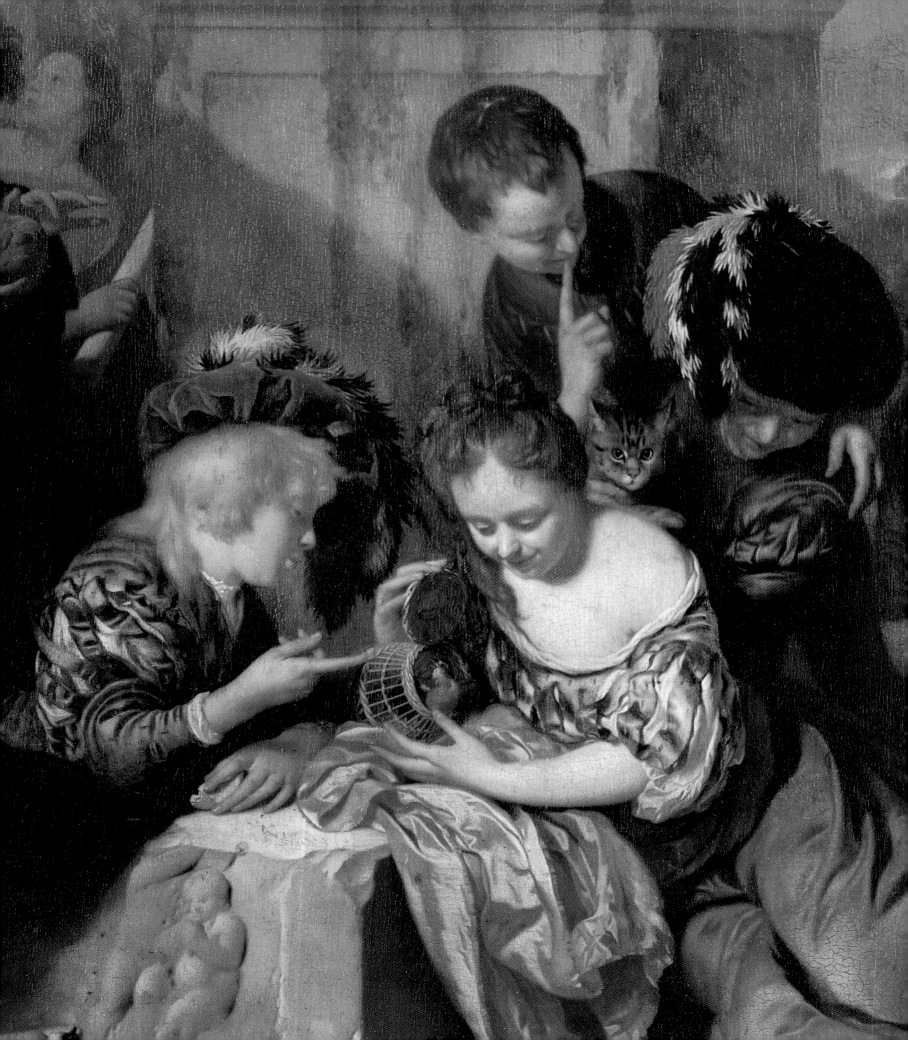

CHAPTER EIGHTEEN

GODFRIED SCHALCKEN, EGLON VAN DER NEER, AND ADRIAEN VAN DER WERFF

The final artists to be discussed in this book, Godfried Schalcken, Eglon van der Neer, and Adriaen van der Werff, are grouped together because all three enjoyed international reputations during their lifetimes. All three traveled abroad and van der Neer and van der Werff held prestigious appointments as painters to several European courts. Moreover, all three practiced similar styles which together with their incessant traveling served to lessen traditional stylistic disparities between genre pictures produced in different cities. In their talented hands genre painting achieved its developmental apogee, at least according to Gerard de Lairesse's prescriptions of what comprises fashionable and proper genre art. In some respects, then, they can be considered, along with Willem van Mieris, Carel de Moor, and Matthijs Naiveu, the endmost masters of the Golden Age of Dutch genre painting.[1]

Godfried Schalcken

Schalcken (1643–1706) was born in a village outside of Breda (a city near the border with the Spanish Netherlands).[2] In 1654, his family moved to his mother's native town, Dordrecht, where Schalcken's father, a clergyman, accepted an appointment as the headmaster of the local Latin School. In 1656 Schalcken entered the studio of Samuel van Hoogstraten, where he remained for six years. He completed his artistic training in Leiden in the atelier of Dou before returning to Dordrecht. It is not known precisely when the young artist returned there, but the earliest documentary evidence, a reference to his role as color-bearer for the local militia company, is dated 1675.[3]

During his career Schalcken made genre paintings, history paintings, an occasional still life, and portraits but it was the last that truly established his reputation among contemporaries. The departure of Nicolaes Maes for Amsterdam in 1673 paved the way for Schalcken to assume the position of Dordrecht's most prominent portrait painter. And by the 1680s the artist had become internationally famous on the basis of his portraiture as well as his astonishing rendering of candlelight in nocturnal images of all genres. At that time his paintings were being sold in Paris by the art dealer Johan van der Brugge. In 1691, while continuing to dwell in Dordrecht, Schalcken enrolled in the painter's association, the *Confrerie* in The Hague (see Chapter 5), undoubtedly to expand his portraiture practice by literally purchasing the right to paint in that wealthy and urbane city.

The following year Schalcken moved his family to England where they resided until 1697. Houbraken, the artist's principal biographer, reports that the English, already enamored with his style, attracted Schalcken to their country where his earnings were considerable.[4] The master must have been drawn to England at this time by potential commercial prospects for the Dutch Stadholder, William III, fortuitously sat on the English throne. Schalcken returned to the Netherlands in 1698 and settled in The Hague. He also began to execute commissions for Johan Wilhelm von der Pfalz, the Elector Palatine (1658–1716), and possibly visited his court in Düsseldorf in 1701.[5] Schalcken died in The Hague in 1706, an esteemed and immensely wealthy artist.

Schalcken's earliest works do not recall the art of van Hoogstraten despite his extended stay in the older artist's studio. By comparison, Dou's influence upon the young *fijnschilder* was formidable, no more so than during the initial phase of his career. Schalcken's *Sausage Maker* of around 1665–70 (fig. 225), for example, is indebted to Dou's depictions of enticing young women (often kitchenmaids) in niches preparing food (see fig. 103).[6] As was noted in Chapter 8, paintings of this sort present maids stereotypically as lazy and lustful figures in accordance with well-entrenched, contemporary biases.[7] Schalcken's picture partakes of this tradition with the notable difference that it is much more explicitly libidinous than Dou's representations. The unequivocally phallic connotations of the sausage here are enhanced by the provocative manner in which the winsome young woman holds it.[8]

The unabashed eroticism of Schalcken's *Sausage Maker* is matched by that of other works by the artist and by some of his colleagues.[9] Yet in this period of flourishing civility one would expect that such a subject would have been eschewed in elite social circles. De Lairesse and Jan de Bisschop had linked art and social status by disassociating vulgar imagery from the refined tastes of the highborn. The popularity of lewd subjects by Schalcken and other painters is therefore as perplexing as the analogous popularity of Dutch pornographic literature at this

225 Godfried Schalcken, *The Sausage Maker, c.* 1665–70 (oil on canvas, 31 × 24 cm). Present location unknown.

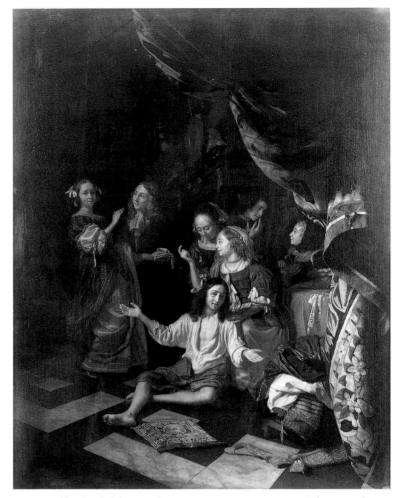

226 Godfried Schalcken, *Lady Come a' Courting, c.* 1670–75 (oil on panel, 63.5 × 49.5 cm). London, The Royal Collection.

time.[10] The only satisfactory explanation for this curious phenomenon (besides hypocrisy, an inherent human foible throughout history[11]) involves issues of privacy. Pornographic books, typically published in duodecimo, were easier to conceal than paintings and consequently were considered more "private."[12] Paintings on the other hand, owing to their size, were more difficult to hide.[13] So it is probably no coincidence that many late seventeenth-century, erotic genre paintings were executed on a relatively small scale.[14] Hence, *The Sausage Maker*, measuring roughly a mere twelve by nine inches, was probably meant to be enjoyed, both for its humor and potential titillation, in private.

Over time Schalcken began to distance himself more fully from the influence of his erstwhile teacher, Dou. By the 1670s his thematic repertoire had expanded significantly beyond that of his famous master's. One of the most fascinating and beautiful examples of his new subject matter is *Lady Come a' Courting* (fig. 226), painted around 1670–75.[15] Schalcken's canvas was

mentioned by this title in an archival document dated 1676 and also by Houbraken, who recognized the artist's physiognomic features in those of the semi-clad youth seated on a cushion on the floor (though this figure is certainly not a self-portrait of the artist).[16] Houbraken also commented that Schalcken was said to have worked for a month on the splendid curtain hanging in the right foreground. The rather meticulous description of textures in this picture certainly evokes the paintings of Dou. However, its surface is much livelier than those found in Dou's later work – which became increasingly hard and dry – even if individual brushstrokes are scarcely evidenced in comparison with those of Dou's paintings. Furthermore, Schalcken's palette is brighter in keeping with changing tastes during this period.

The title, *Lady Come a' Courting*, refers to a popular game in which maidens gradually disrobe a young man.[17] Although little is known about this game today, its illustration here has led some specialists to postulate the painting's connection to older pictorial themes depicting the war between the sexes, specifically, the

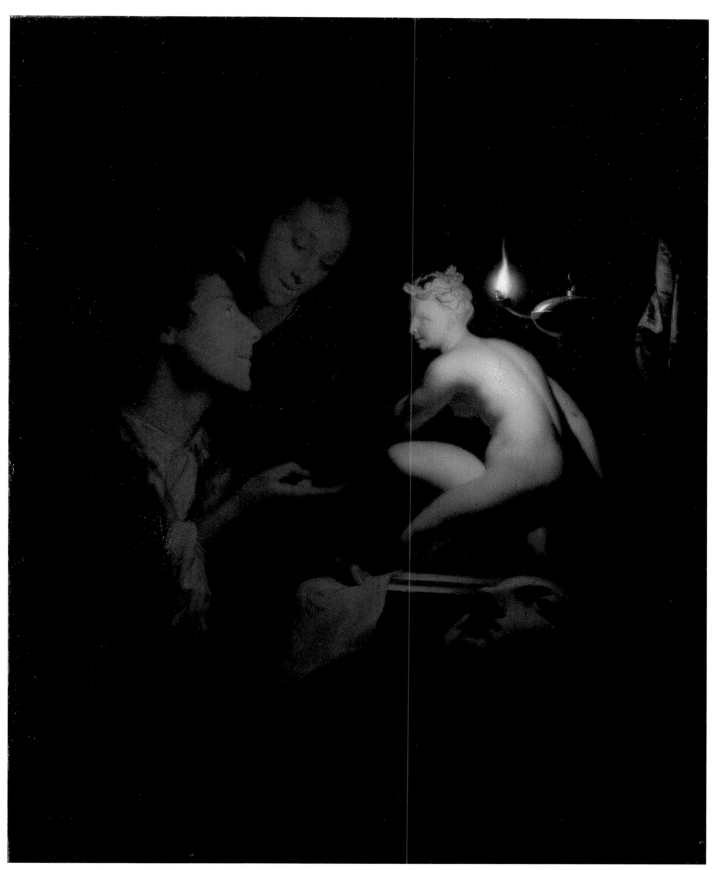

227 Godfried Schalcken, *Artist and Model Looking at an Ancient Statue by Lamplight*, c. 1675–80 (oil on canvas, 44 × 35 cm). Private collection.

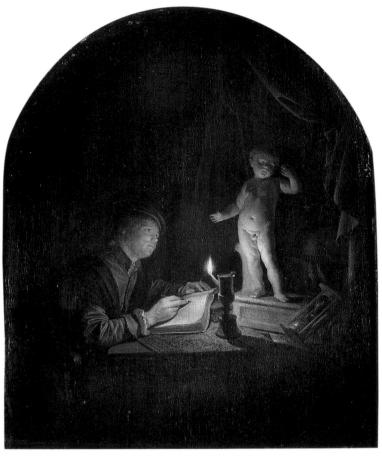

228 Gerrit Dou, *An Artist Drawing by Candlelight* (oil on panel, 29 × 23.5 cm). Brussels, Musées Royaux des Beaux-Arts, M.I. 86.

229 Illustration from Jan de Bisschop, *Signorum veterum icones*. N.p., 1668–9. Private collection.

so-called "battle for the trousers."[18] This theme, in which men are relieved of their breeches (usually) by peasant women, symbolizes innate female aggression.[19] Likewise, Calvinist emblems have been invoked in an effort to interpret Schalcken's painting in moralizing terms, admonishing the viewer about the dangers of cunning women.[20] Such interpretations are inconsistent, however, with its light-hearted, merrymaking tone. Rather, as Peter Hecht has astutely observed, the very popularity of this game motivated both Schalcken's canvas and censorious Calvinist writings independently of one another, and presumably with different intentions.[21]

As mentioned above, Schalcken was acclaimed during his lifetime (and by later generations) for his candlelight depictions.[22] His interest in such portrayals unquestionably stemmed from his experiences in Dou's atelier: Dou frequently depicted nocturnal scenes during the early 1660s (see fig. 107), precisely the same time that Schalcken was under his tutelage. Schalcken eventually surpassed his master in the rendition of artificial illumination both in the complexity of effects and in the much wider range of subjects (and genres) to which he applied it. Schalcken's representations of this sort left an indelible impression upon their audiences. The English engraver and antiquary George Vertue (1684–1756), for instance, admired them greatly. Writing in the early eighteenth century, he states that Schalcken's "rendering [of] a single effect of light was all his excellence . . . He placed the object and a candle in a dark room and looking through a small hole, painted by day-light what he saw in the dark chamber."[23] Vertue was a mere boy during Schalcken's tenure in England. Although his anecdotal account of the artist's working method can hardly be accurate it does pay testimony to the esteem in which his art was held in England even after his death.

A strikingly beautiful example of Schalcken's nocturnal imagery is his *Artist and Model Looking at an Ancient Statue by Lamplight* painted around 1675–80 (fig. 227).[24] Here an artist and his model – sometimes identified, mistakingly in my view, as a self-portrait of Schalcken and his wife, Françoise van Diemen (1661–after 1706) – inspect a Hellenistic statuette of a crouching Aphrodite (known to the Romans as Venus) by the light of an oil lamp.[25] The subject relates to Dou's paintings of men working by candlelight, including at least one of an artist sketching a Cupid (fig. 228), but Schalcken's canvas reveals a more sophisticated and vivid articulation of reflections.[26] Furthermore, he seemed to have understood precisely how candlelight diminishes the coloristic intensities of surrounding objects. In essence, the picture (and numerous others like it) provided a pretext for Schalcken to demonstrate his virtuosic mimetic skills, cleverly implied in this instance through the rendition of an artist.

The *Artist and Model* also demonstrates the painter's ability to produce works that conform closely to de Lairesse's precepts for ennobling genre painting by imparting to it a classical veneer (see Chapter 16).[27] Note the woman's dress *à l'antique* and, obviously,

230 Godfried Schalcken, *Gentleman Offering a Lady a Ring in a Candlelit Bedroom, c.* 1698 (oil on panel, 37.2 × 29.2 cm). Private Collection, North America.

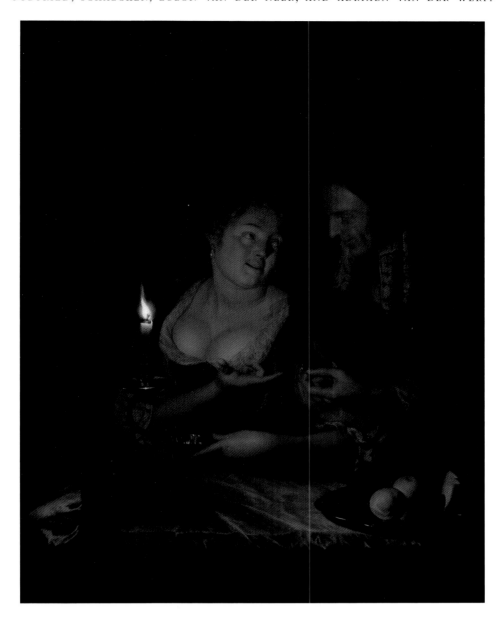

230 Godfried Schalcken, *Gentleman Offering a Lady a Ring in a Candlelit Bedroom, c.* 1698 (oil on panel, 37.2 × 29.2 cm). Private Collection, North America.

the classical statue itself whose pose likely derives from an illustration (fig. 229) from de Bisschop's *Signorum veterum icones* (Depictions of Old Sculptures; 1668–9).[28] De Bisschop's volume, one of two that served as model books for painters, was seminal for the classicizing movement in the Dutch Republic (see Chapter 15). The squatting Aphrodite's presence here functions as the source of the painter's inspiration as does his model.[29] His gesture of pointing to the statue (with a sketch of it in hand), while simultaneously gazing at the young lady clarifies this. Both embody, in flesh and in stone respectively, quintessentially beautiful women. Seventeenth-century Dutch art theorists exalted the depiction of archetypal female pulchritude as one of painting's highest goals.[30] Collectively, the representation of comely women in genre paintings catered to elite predilections in a culture captivated by beauty

as countless works of contemporary amatory literature (particularly those infused with Petrarchan sentiments) attest.

During Schalcken's late career, portrait commissions and history paintings occupied much of his time. He did, however, occasionally produce genre paintings such as his *Gentleman Offering a Lady a Ring in a Candlelit Bedroom* (fig. 230).[31] The predominantly coppery hue, cast by the candle, and the very amplitude of figures who now proportionally occupy a larger percentage of the panel, indicate that it was painted in the 1690s, perhaps shortly after Schalcken's return from England. The innocuous title of this work belies its subject: the bosomy woman who is the focus of her eager admirer's attention is probably a prostitute. Consequently, the man's gift is intended to purchase her temporary affections. As Eric Jan Sluijter has repeatedly

demonstrated, Dutch artists routinely depicted beguiling temptresses who seductively embody the enticing artistic techniques that engendered them.[32] And surely the sophisticated, luminous effects that alluringly enhance the woman's ample cleavage intensify the viewer's enchantment with her.

Nighttime scenes in older Netherlandish art were often equated in a moralistic sense with voluptuousness and profligacy.[33] The malevolently coiled snake forming the base of the candlestick in Schalcken's panel suggests that it too evoked similar associations. This motif (and possibly the fruit on the table) alludes to Eve, the Old Testament temptress whose deceitful actions doomed the human race. The compelling combination of admonition and eroticism here offers pleasures as well as dangers through the simple act of beholding the panel, which undeniably contributed to its appeal.[34] The *Gentleman Offering a Lady a Ring* thus constitutes yet another example of the remarkable, albeit limited interest in moralizing imagery in late seventeenth-century Dutch genre painting.

Schalcken's death in 1706 effectively signaled the end of the contributions made to Dutch genre painting by the three internationally renowned artists under discussion in this chapter. Although Schalcken was survived by Van der Werff, the latter had ceased painting genre subjects long before 1706.

Eglon van der Neer

Eglon van der Neer (1634–1703), a contemporary of Schlacken's, achieved a comparable level of renown.[35] Born in Amsterdam, he was trained initially by his father, the landscapist Aert van der Neer (*c.* 1603/4–1677) and furthered his studies under the tutelage of Jacob van Loo. According to Houbraken, van der Neer went to France around 1654 where he entered the service of Friedrich van Dohna (1621–1688), the Dutch governor of the principality of Orange (owned by the House of Orange; see Chapter 1). By early 1659 the young artist had returned to his native country, marrying immediately thereafter the daughter of a wealthy Rotterdam functionary in the judicial court. The couple settled in Rotterdam only around 1664 after the first of their sixteen children was born. Despite living primarily in Rotterdam, van der Neer spent considerable time in Amsterdam and also in The Hague where he joined the *Confrerie* in 1670. His wife died in 1677 and two years after this tragedy he moved to Brussels in the Spanish Netherlands where he would reside until 1689.[36] He remarried in Brussels and, if Houbraken is correct, had an additional nine children.

By the 1680s van der Neer's reputation must have grown considerably for in the summer of 1687 he was appointed court painter to Charles II of Spain (ruled 1665–1700). He does not seem to have ever traveled to Spain and in fact, during the next decade, had to importune the Spanish court repeatedly to pay

for a portrait sent there. In 1690 van der Neer, once again a widower, was appointed court painter to Johan Wilhelm von der Pfalz, the aforementioned Elector Palatine. The artist probably remained in the Spanish Netherlands, however, only taking up residence in Düsseldorf around 1695.[37] Van der Neer married for a third time (in 1697) while at court, remaining there until his death in 1703. He executed many fascinating genre paintings but over the course of his career, with his deepening contacts with two major European courts, portraits, history paintings (the two genres generally preferred at court), and especially landscapes began to dominate his output.

Van der Neer's first pictures date to the 1660s, the decade in which Dou, Frans van Mieris, Gerard ter Borch, and Gabriel Metsu were at the height of their careers, working in a flourishing market awash with disposable income. Van der Neer's paintings from this early period, among them his *Lady Drawing* of about 1665 (fig. 232), clearly resembles these masters' works.[38] Its subject can be linked to a work by Metsu (fig. 231) while the lady's shimmering satin attire and the overall, serene ambience of the panel strongly recall paintings by ter Borch.[39] The connections between the work of van der Neer and ter Borch were readily apparent to contemporaries. In a biography of van der Werff, a former pupil of van der Neer's, it is stated that his

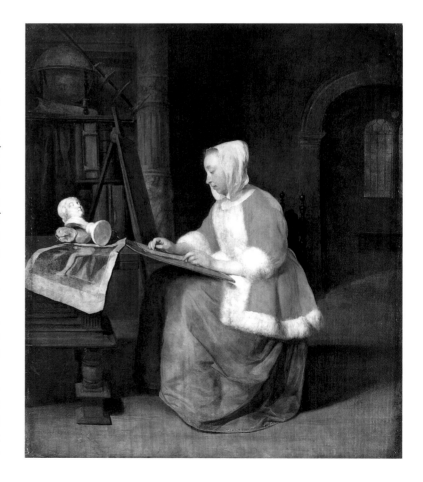

232 (*right*) Eglon van der Neer, *a Lady Drawing*, *c.* 1665 (oil on panel, 30.3 × 25.6 cm). London, The Wallace Collection.

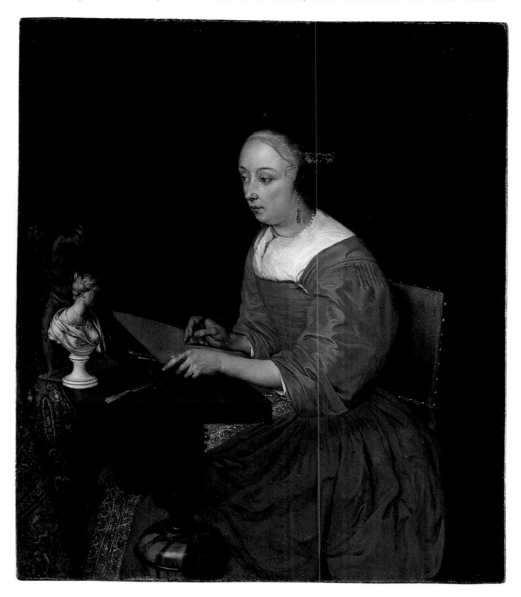

231 (*facing page*) Gabriel Metsu, *Young Lady Drawing*, *c.* 1655–60 (oil on panel, 33.7 × 28.7 cm). London, The National Gallery.

teacher worked in the modern manner (like ter Borch) "in order to flaunt satin dresses and other articles of clothing . . ."[40] Indeed, the rendering of the satin in the *Lady Drawing* is extraordinary but its precision is less reminiscent of ter Borch's art than that of the *fijnschilders* Dou and van Mieris (see fig. 112). Yet van der Neer's starkly lit surfaces exhibit a certain hardness and coolness, an exactitude that distances them peculiarly from the more delicate, lifelike qualities of his colleagues' paintings.

The *Lady Drawing* is probably not meant to represent a professional woman artist at work but rather a female member of the upper classes practicing drawing. Daughters of elite families were sometimes taught the rudiments of art (which could encompass drawing, painting, or even calligraphy), along with music and poetry as part of a broader pedagogical and social strategy to inculcate tangible signs of polite accomplishment and

gentility in order to enhance their standing in society, particularly among respectable suitors.[41] And, on another, related level, van der Neer's picture, like Schalcken's *Artist and Model* (see fig. 227) and seemingly countless other paintings from this period of increasing civility, celebrates female beauty, embodied by both the lady drawing and the tiny bust on the table before her.

As van der Neer matured as a painter he began to distinguish himself more fully from his sources of inspiration both in style and in subject matter. Magnificently shimmering satin reappears in his *Interior with a Woman Washing Her Hands* of 1675 (fig. 233), for example, but stylistically speaking, van der Neer has infused this panel with a rarefied level of elegance and refinement seldom witnessed in Dutch genre painting.[42] The image is, in de Lairesse's terms, executed in an elegant modern mode but "improved" with classicizing features, *inter alia*, the richly orna-

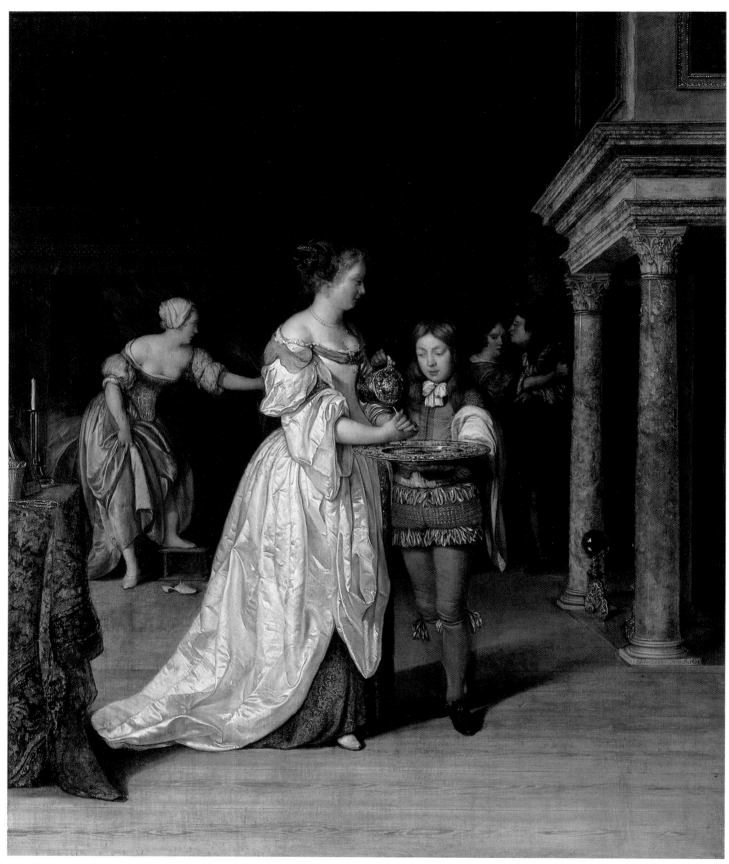

233 Eglon van der Neer, *Interior with a Woman Washing Her Hands*, 1675 (oil on panel, 49 × 39.5 cm). The Hague, Mauritshuis.

mented mantelpiece with Corinthian columns. De Lairesse also stresses the portrayal of sundry emotional states – he mentions "efficacious passions" – in genre painting, thereby aggrandizing it so that it more closely resembles history painting, the purest thematic and stylistic expression of the superior antique mode.[43] Van der Neer renders a tempestuous exchange between background figures in an emotionally charged manner as a maid forcefully prevents a young man from approaching her unkempt mistress.[44]

This background, stage-like scene amplifies the action of the sartorially splendid lady in the foreground, who washes her hands with the assistance of a boy dressed in a French page's outfit, holding a sumptuous silver basin and ewer. Washing had been ritualistically associated with cleansing and purification in a spiritual sense since biblical times.[45] In late medieval and early modern art and literature the motif of the basin and ewer was identified with the very same concept. Accordingly, the lady washing her hands in the foreground is literally and figuratively separated from the quarreling group in the background. And that group, judging from the mistresses' state of dishevelment, can only be involved in disreputable activities. In sum, van der Neer's *Interior with a Woman Washing Her Hands* depicts a highly unusual subject, but its edifying content is one encountered with some frequency in late seventeenth-century Dutch genre painting.[46] What is truly remarkable about these works is their explicit and inescapable didacticism, particularly in contrast to many of those conceived earlier in the century whose prescriptive values are more elusive owing to the multiple interpretive possibilities that they proffer. The growing interest among van der Neer and his colleagues in singularly uplifting art should probably be construed in light of the heightened civility of contemporary society.

Genre paintings by van der Neer that date from the late 1670s and 1680s confirm his attention to a more progressive genre style, one thoroughly imbued with an antique air as practiced concurrently by, among others, Willem van Mieris. *Playing Children* of 1679 (fig. 234) constitutes an outstanding example of a painting participating in conventions under development at the time.[47] The ingrained view of van der Neer as an artist who produced vacuous variations on the pictures of ter Borch *et al.*, overlooks his more innovative works such as this one.[48] In July 1682 this panel, having been brought to the Spanish Netherlands by the artist when he relocated there three years earlier, was added to the inventory of paintings owned by the Antwerp aesthete and dealer Diego Duarte (before 1616–1691).[49] Duarte paid for it with 300 guilders cash and two unidentified paintings whose collective value was estimated between 100 and 150 guilders. Worth roughly 400 to 450 guilders, *Playing Children* thus ranked among the most expensive works by Netherlandish artists in Duarte's inventory.[50] The cost of this picture alone, which indicates its status as a luxury item, should disabuse any lingering

234 Eglon van der Neer, *Playing Children*, 1679 (oil on panel 34 × 26.6 cm). Schwerin, Staatliches Museum.

notion that van der Neer and his colleagues were working for middle-class audiences.

This work exhibits the same hard and crisp surface effects as van der Neer's earlier pictures but here they are implemented in a classical setting, replete with majestic architectural ruins, statues, and figures clothed in pseudo-antique garb. Van der Neer has created a veritable ancient town in a hilly, Arcadian setting that unfolds behind the two boys playing with a cat and dog in the foreground.[51] Several contemporary texts equate the mischievous behavior of children or, conversely, their docility, with that of domestic pets.[52] However, the significance of the foreground scene in the painting is unclear beyond its general reference to the life stage of childhood.[53]

Van der Neer's paintings resound with his technical wizardry which is best seen in his extraordinary rendering of fabrics. His skills made him one of the most celebrated late seventeenth-century Dutch genre painters even if he has been largely forgotten today.

Adriaen van der Werff

Much is known about the life and career of Adriaen van der Werff (1659–1722) whom Houbraken christened as the brightest star in the Netherlands' artistic firmament.[54] Houbraken's lengthy biography is quite useful but our principal source of information was also Houbraken's: the biography of van der Werff as recorded around 1719–20 by his son-in-law Adriaen Brouwer (d. 1750).[55] Van der Werff was born in Kralingen, near Rotterdam, the son of a miller. His creative talents began to surface at age nine and consequently, around 1668–9, his reluctant parents, who initially opposed an artistic career for their son, arranged for him to study with a minor Rotterdam painter, Cornelis Picolet (1626–1679).[56]

By 1670 his first period of instruction had ended. After a brief hiatus, van der Werff entered the Rotterdam studio of van der Neer around 1671, where he would spend four formative years.[57] There, the fledgling artist was tutored in the *fijnschilder* traditions

235 Adriaen van der Werff, *Musical Pair, c.* 1679–80 (oil on canvas, 48 × 35.5 cm). Private collection.

to which his teacher adhered. Van der Werff quickly excelled in this style; according to his biography, a copy he made as a thirteen-year-old of a painting by Frans van Mieris completely fooled connoisseurs in Leiden, the home of that renowned painter.[58] In fact, van der Werff became so skilled that van der Neer entrusted him to complete the draperies in his own paintings. The pupil van der Werff therefore gradually assumed the role of adept assistant, as the contract that his father renewed with van der Neer confirms.[59] In her monograph on van der Werff, Barbara Gaehtgens insightfully observes that van der Neer, whose own career evidences many parallels with that of his adroit student, must have served as his mentor in the broadest sense of that term.[60] Presumably, the older master's tremendous success and reputation left a lasting impression upon his ward.

At the tender age of seventeen van der Werff commenced his own career, working initially as a portraitist and genre painter.[61] His very first, independent genre paintings, completed during 1676–8, approximate those of his master in subject, in figural types, and especially in the hard, slick manner in which they were executed.[62] However, van der Werff was too talented an artist to continue working in his master's style indefinitely. Already by the end of the 1670s, his style had shifted appreciably. The pose of the lute-playing female in the *Musical Pair*, painted around 1679–80 (fig. 235), may relate to several prototypes by van der Neer but its paint application, while still exacting and thus *fijnschilder*-like, shows more variation.[63] Thus, the sparkling facture of this picture is soft, as opposed to van der Neer's typically crisp surfaces, and the light effects are much warmer.

Van der Werff also imparts an air of elegance and refinement to the *Musical Pair* which surpasses even that of his teacher's work. The suave figures are literally enveloped in swathes of flowing drapery; their fanciful costumes, especially that of the lute player, conform to de Lairesse's precepts concerning the use of "loose and airy undress" to simulate antique garb without actually being so.[64] The presence of a niche with statues in the background also alludes to the world of antiquity. In essence, van der Werff has infused the *Musical Pair* with a classicizing ambience in the manner subsequently codified by de Lairesse in *The Art of Painting.*[65]

The *Musical Pair* communicates gentility and distinction in other, more subtle ways. Consider, in this context, the poses of the figures. In relatively relaxed modern society, posture rarely functions as a delineator of social status. By contrast, early modern societies featured rigorously demarcated social hierarchies and within them such phenomena as dress, demeanor, and posture spoke volumes about one's station in life. The graceful bearing of van der Werff's musicians, particularly that of the woman, bring to mind the standing females in de Lairesse's illustration of proper and improper carriage and manners (see fig.

120).[66] The posture of these ladies is appropriate, in the author's own words, for "people of condition." And de Lairesse's words imply what the perceptive research of Herman Roodenburg has confirmed: the remarkable congruity between the renowned classicist's terminology and that used by the writers of treatises of civility (see Chapter 15) to prescribe decorous behavior for their ever-responsive readers.[67] Evidently for de Lairesse, certain facets of what contributed to a proper painting corresponded rather closely with the elevated standards of deportment promulgated within contemporary elite circles, standards that he personally witnessed.[68]

The links between de Lairesse, late seventeenth-century Dutch genre painting, and treatises of civility probably ran even deeper, though their possible connections have not been sufficiently explored.[69] For instance, the often stilted, restrained narratives of multi-figure genre paintings from this period have been noted and construed in largely negative terms. Yet it is entirely feasible that the lack of animation among the figures reflects contemporary behavioral ideals expressed by Antoine de Courtin and other "experts" on civilizing conduct. In their writings, one repeatedly encounters injunctions against effusive actions, against excessive "motions or contortions of the body."[70] To the contrary, the reader is encouraged to comport himself or herself "modestly and gravely, without any such noise or obstreperousness."[71]

In addition to the figural poses, the general brightness of van der Werff's palette, one characteristic of late seventeenth-century Dutch art in general, likely connoted notions of fashionable gentility. Painterly styles, exemplified in de Lairesse's opinion by the art of Rubens and especially by that of Rembrandt, were by his own day deemed uncivilized owing to their overly sensuous colors, blurred contours, and heavy shading, all of which demonstrated innate and personal talent at the expense of the infallible rules of art.[72] Conversely, as a closer reading of de Lairesse's treatise confirms, a brighter, polished style that conforms to theoretical precepts, as practiced by Willem van Mieris, van der Neer, van der Werff, and de Lairesse himself, was judged more agreeable, refined, and civil.[73]

The *Musical Pair* was clearly intended for an elite buyer. Although this buyer has not been identified much is known about the circles of van der Werff's patronage thanks to his biography. All of the artist's genre paintings were executed during the 1670s and 1680s. Unfortunately van der Werff's biographer does not discuss this early period of his career in great detail, but does tell us that Adriaen Paets (1657–1712), a wealthy official in the Dutch Admiralty (and future director of the Rotterdam chamber of the Dutch East India Company), paid 350 guilders for a "little piece with children."[74] Paets was an important local collector who assisted the artist in cultivating contacts among other connoisseurs. Late seventeenth-century Rotterdam had weathered successive political and economic crises more successfully than had many of its sister cities with the result that it was home to

a group of wealthy and distinguished cognoscenti who had amassed some of the most important collections of classical art (both ancient and modern) in the Netherlands.[75] The presence in Rotterdam of these men, who would play a profound role in van der Werff's career, possibly explains why the master never moved away from the city for opportunities elsewhere despite his eventual, international reputation.

Besides, van der Werff had no need to relocate since he easily marketed his pictures in other Dutch towns and in foreign countries. For example, *Playing Children Before a Statue of Hercules* of 1687, was commissioned from the artist by an affluent Amsterdam merchant, Philip Steen (fig. 236).[76] It was van der Werff's final genre painting and his most ambitious one as well.[77] He has depicted two groups of children surrounded by ancient statuary and reliefs: those in the foreground play with their pets to the neglect of their artistic training while their companions in the middleground diligently attend to their studies. The contrast between virtue and vice here is cleverly underscored through a series of motifs, ranging from the disparities in dress between the luxuriously attired group in the foreground and the more simply clad children behind them, to the statue of Hercules pummelling a personification of Envy. The panel, like a host of other late seventeenth-century genre paintings, has an unequivocally didactic meaning, in this instance revolving around the pursuit of virtue over vice in general as well as the application of this ethical desideratum for artistic training in particular.

Van der Werff's image is thoroughly imbued with an antique spirit. Although the children's costumes are clearly differentiated by their lavishness or lack thereof, both types are probably meant to evoke ancient garb.[78] The artist has also included a variety of busts, statuary, fragments of friezes, and so forth to impart authenticity to the setting. However, as Barbara Gaehtgens has demonstrated, the figures of Hercules and Envy are culled from illustrations from two model books (including one by de Bisschop) and even a near-contemporary ensemble by the Flemish sculptor Artus Quellinus (1609–1668) in the Amsterdam Town Hall.[79] The purely fantastic sculpture in this panel also demonstrates the painter's virtuosity; it allowed him to illustrate abstract concepts without sacrificing the visual coherency of the representation as a genre painting.[80] Yet with bold wit van der Werff also challenges the very art of sculpture by painting bright red blood spilling down from the monochrome statue of Hercules trouncing Envy. This intriguing detail can only refer to *paragone*, the lively, early modern European theoretical debate concerning which of the two arts, painting or sculpture, was superior – van der Werff and his fellow artists obviously heralded painting as the superior art.[81] (Van der Werff's illustrious forebearer, Dou, and many of artists generally associated with his *fijnschilder* circle, including Schalcken, likewise depicted motifs that playfully allude to painting's superiority to sculpture.[82]) In this pictorial context, the blood pouring down the statue, virtuosically and

236 Adriaen van der Werff, *Playing Children Before a Statue of Hercules*, 1687 (oil on panel, 46.8 × 35 cm). Munich, Alte Pinakothek.

cleverly (despite its potential gruesomeness) trumps van der Werff's sculpted sources of inspiration by vividly representing something that sculptors are entirely unable to depict with equal veracity.

Van der Werff's *Playing Children Before a Statue of Hercules*, with its decidedly antique mien, is strongly reminiscent of his teacher van der Neer's *Playing Children* (see fig. 234) painted eight years previously. But the student betters his master here in a picture that far exceeds its precedent in complexity of subject and in execution. Once again, the viewer encounters the soft, gleaming effects of van der Werff's surfaces, distanced as they are from the crisp, cool qualities of van der Neer's art. The spatial transitions in the younger artist's work are also more convincing; space gradually unfolds below a painted arch that cleverly alludes to the *fijnschilder* tradition (see fig. 102).[83] Gaehtgens has rightly placed van der Werff's achievement here within the broader context of seventeenth-century theories of *aemulatio* or emulation whereby young artists were encouraged to extract the most appealing details from works by their illustrious forebears in order to create art that ultimately surpasses all prototypes.[84]

However fundamental were concepts of emulation for late seventeenth-century Dutch genre painting they do not alone account for its stylistic and thematic characteristics. For more was at work here in this era of economic retrenchment than a simple desire on the part of artists to outdo their immediate predecessors as if they lacked the initiative or incentive to attempt anything else. In effect, under the influence of changing cultural and market conditions, van Mieris, de Moor, van der Neer, and van der Werff introduced a series of new pictorial conventions, rooted in classical art and later codified by de Lairesse. In fact, *Playing Children Before a Statue of Hercules* may conceivably be considered the culmination *avant la lettre* of de Lairesse's dictates concerning the aggrandizement of genre painting to make it closely resemble history painting, the purest thematic and stylistic expression of his revered antique mode.[85]

If anything, the panel was a milestone in van der Werff's career, or as the master's son-in-law biographer put it, "the foundation of his good fortune."[86] In 1696, Johan Wilhelm von der Pfalz, the Elector Palatine, purportedly traveling incognito in Amsterdam, purchased the *Playing Children Before a Statue of Hercules* from its owner, Steen, and subsequently employed the artist in what became a nineteen-year appointment as his nonresident court painter with an enormous salary (initially, 4000 guilders per annum).[87] Moreover, in the year in which the picture was completed, 1687, van der Werff married the wealthy Margaretha Rees (1669–1731), whose guardian, the prominent collector Nicolaes Flinck (1646–1723), became an invaluable mentor in enlightening him about the purported superiority of classical art.[88] These serendipitous events converted van der Werff into a classicizing history painter par excellence who, in the process, abandoned genre painting altogether.

What is remarkable about the three artists discussed in detail in this chapter, is the levels of patronage that they all enjoyed. The collection of genre paintings had increasingly become the prerogative of the elite over the course of the seventeenth century, and at its end this process reached its culmination owing to changes in the art market forced by war and economic contraction. Yet despite the overall downturn in the production of genre paintings, their collective level of quality remained high. Perhaps with some justification, then, several art theorists and biographers of this era discerned a genuine decline in Dutch art only in the eighteenth century proper.

CONCLUSION

This book has surveyed the thematic and stylistic development of genre painting from its incipient stages during the first decades of the seventeenth century; through its technical zenith, achieved by about 1660; and finally, to its continued vitality through the 1680s, 1690s, and the early eighteenth century. I wish to conclude simply by restating several of the book's most salient observations.

Foremost among them is the distinct conventionality of seventeenth-century Dutch genre painting. This term referred not only to the repetition of specific styles and motifs but also to the restricted number of themes that artists depicted, ones that were continually repeated, often over several generations. It would be erroneous to conclude that Dutch seventeenth-century genre painting developed rectilinearly in the direction of ever more faithful representations of the surrounding world. To the contrary, it is much more accurate to view genre painting's development through the course of the century as incessantly shifting from one predominant set of stylistic and thematic conventions to another. Viewed diachronically, there was a progressive development of new themes and styles in genre painting in the seventeenth century as well as an alteration or revitalization, and at times, even decline of older ones. This was the result of artists' response to personal aesthetic interests, to pictorial traditions, and especially to the demands of the art market.

The art market, that somewhat nebulous term used to describe those persons or groups who purchased works of art in the Dutch Republic, was critical in this regard. The market actually functioned as a dynamic system of supply and demand for pictures and was affected equally by artists and consumers. In this sense, the creation of highly conventional genre painting was affected by its prospective purchasers: since painters worked for the market, namely, for specific patrons or for an unknown audience on speculation, they were compelled to produce pictures that catered to the tastes and expectations of that audience. Demand therefore influenced the content of works, inducing some genre painters to specialize in particular subjects known to sell well or, conversely, to jettison those that sold poorly. Some of the best masters also experimented with entirely new subjects, thus shifting thematic conventions in the process. Demand also influenced style as artists periodically modified conventions by introducing stylistic innovations to make their works more attractive or even to lower overall production costs.

Integral to taste, and hence to demand and the art market, during this period were evolving notions of civility. Already in evidence in the sixteenth century, civility as a binding behavioral, ethical, and cultural force among elites developed appreciably during the second half of the seventeenth century, exerting a tremendous impact upon Dutch society. In the Netherlands, like all hierarchically structured societies of early modern Europe, elites utilized concepts of civility to designate in a broad or narrow sense the special qualities of their own conduct and to emphasize the refinement of that conduct, to wit, their "standards," in contradistinction to those of purportedly simpler, socially inferior people. Elite members of society flaunted their supposed supremacy via ever-increasing self-control over, among other things, many aspects of public life including general comportment and table manners. They also ideologically consolidated their class status by exhibiting cultural superiority in their taste in literature, theater, and in art.

Evolving notions of civility and concurrent prosperity affected the upper classes' discrimination in matters artistic. In turn artists responded to changing tastes by making stylistic adjustments to their work and by introducing new themes into the repertoire of genre painting while altering existing ones to render them palatable to a more cultured clientele. By the middle of the century this clientele, composed mainly of elite members of society, had assumed a commanding role in the acquisition of genre paintings by the foremost artists and in the development of significant art collections. As a result, middle-class participation in the market for the finest genre paintings, which was never really substantial to begin with, decreased significantly as the century progressed. Yet the modern, ambiguous notion that Dutch genre painting was targeted primarily at "the middle class" remains firmly entrenched. The domination of the art market by elites intensified later in the century because the dynamics of that market had been altered dramatically by broader economic circumstances. The concomitant intensification of civilizing values in Dutch society near the century's end also explains the appearance at this time (albeit on a limited scale) of genre paintings with explicitly moralizing content. What is truly remarkable about these late seventeenth-century pictures is their inescapable didacticism compared with many of those conceived earlier in the century whose prescriptive values are more elusive owing to the multiple interpretive possibilities that they proffered.

Representations of peasants provide an illuminating example of the effect of civilizing notions on art. Throughout much of the first half of the seventeenth century, condescending images of animalistic, unruly peasants, destined for less sophisticated and refined audiences (see figs. 26 and 42), affirmed social stratification while providing an endless source of entertainment. Thereafter, under burgeoning influences of civility (and such related concepts as privacy and domesticity), more tempered renditions of peasants appeared (see figs. 121 and 128). These later images reflected as well as shaped more refined sensibilities on the part of certain members of the elite, who now considered earlier paintings coarse and brutish and consequently desired more agreeable renditions of boors. Lastly, in the extreme stages of this civilizing process, namely, during the late seventeenth century, these very same patrons abhorred and rejected depictions of peasants altogether.

The metaphenomenon informing the vicissitudes of the art market and the cultural and financial forces that shaped it was, of course, the relative vitality of the Dutch economy as a whole. There exist striking parallels between economic developments and artistic ones that can hardly be a coincidence. Improvement during the 1590s in the nation's military fortunes vis-à-vis its revolt against its Spanish overlords served to stabilize the United Provinces and created the conditions under which the economy could flourish. The economic surge of the late sixteenth and early seventeenth centuries was sustained by the vast influx of immigrants from the Southern Netherlands (and other regions of Europe) beginning already in the late 1570s. The successive waves of immigration also brought many artists to the Netherlands. The auspicious combination then of rising numbers of accomplished painters and a flourishing economy – indeed the two were interdependent – decisively affected Dutch painting and the art market for years to come. The fertile economic and cultural atmosphere of the Netherlands during the first two decades of the seventeenth century provided ideal conditions for artists to introduce into genre painting numerous thematic and stylistic innovations that served to increase their output and indeed the very marketability of their works. In fact, the demand for pictures of varying quality and cost became so great that one can rightly speak of the Dutch Republic as Europe's first mass market for such luxury consumer goods.

Thereafter, the ratification of the Treaty of Münster (1648) that ended the protracted war with Spain, proved one of the most economically auspicious events of the Golden Age. Its salutary impact was felt on all aspects of Dutch life for literally decades to come. Historians have identified the period 1648–72 as one in which the Dutch economy peaked. The flourishing economic conditions increased the purchasing power of many Netherlanders. Nevertheless, regents, patricians, and upper-class merchants, that is, the elite of the day, experienced the greatest financial gains, widening the disparity between their income and that of persons of lower social status.

Wealth animated the art market in the Dutch Republic on a scale hitherto unseen during this generally prosperous era. It is therefore no accident that the aforementioned period in which Dutch genre painting achieved its technical zenith, 1660, was the same one in which the national economy was at its peak. (It was also the period in which civility had crystallized among elites.) The influence of wealth accounts for another truly remarkable phenomenon at this time. In this heavily urbanized nation which witnessed keen commercial competition between cities, many artists literally abandoned those towns in economic decline for the brighter prospects of those that were booming. As a result, cities such as Utrecht and Haarlem, which were so critical to the formative years of Dutch genre painting, henceforth played a negligible role in its ongoing development. Conversely, towns enjoying great economic vitality, Leiden and Amsterdam among them, developed into flourishing centers for the production of genre painting.

The hitherto healthy economy was devastated by the French invasion of 1672. Consequently, the art market collapsed ruining artists and art dealers alike. This is only logical since art usually becomes a dispensable luxury item in times of grave emergency. But the art market was already beginning to encounter difficulties in the decade preceding the French invasion. There was a downturn in the number of new master painters entering the profession in the 1660s, a decline that would accelerate during the next twenty years. The reasons for this rather rapid drop undoubtedly reside in the fact that paintings are durable goods and can thus very easily saturate a prospective market, causing conspicuous oversupply. The market for paintings had continually expanded through much of the seventeenth century, but by the 1670s and 1680s there was a glut of older pictures which, coupled with the severe economic downturn engendered by the ruinous war with France, probably dissuaded many young men from becoming artists.

The market for cheaper, mass-produced pictures was most dramatically altered by the events of 1672 because the already limited incomes of persons of lower- and middle-class status, the principal purchasers of such art, were largely decimated. Affluent citizens, however, were far less affected by the dismal economic situation so were not at all deterred from buying new art, although their choice of artists was now sharply reduced. Genre paintings were being produced in small numbers during this period, but this scarcely influenced their level of quality or their high cost. In fact, several masters accrued great wealth and reputation, often while working for patrons living in foreign countries. In light of the persistent vitality of genre painting, albeit on a diminished scale, it is hardly surprising that a number of art theorists and biographers considered its decline purely an eighteenth-century phenomenon.

NOTES

INTRODUCTION

1 Two important, earlier studies of seventeenth-century Dutch genre painting approximate the present book in terms of scope: Philadelphia 1984 and Brown 1984. Their relative strengths and weaknesses are discussed in an insightful review by Smith 1987b.

2 See Washington D.C. 1995–6; Hartford 1998–9; and Washington D.C. 2000.

3 Certainly, genre paintings were produced in other European countries during the seventeenth century but not on the prodigious scale that one finds in the Netherlands.

4 For the conventionality of Dutch art, see Goedde 1986; *idem* 1989, pp. 16, 20, 163–4, and *passim*; Sluijter 1990b, pp. 21–2 and *passim*; Franits 1993a, pp. 13–14, 57–8, 167–8, and *passim*; Goedde 1997; and Sluijter 2000b, pp. 267–8, and *passim*.

5 My use of the expression, "transfigure the commonplace" is taken from Honig 2001, p. 294 and *passim*.

6 Eric Jan Sluijter has studied these qualities of seventeenth-century Dutch paintings exhaustively; see, for example, Sluijter 2000a.

7 Van Hoogstraten 1678, pp. 75–87. For this fascinating treatise, see Brusati 1995, pp. 218–56 and *passim*; and Czech 2002. For her enlightening comments on this particular passage in the treatise, see Westermann 2000b, p. 50.

8 For the history of the term "genre painting," see Stechow and Comer 1975–6. See also Blankert 1987, an interesting attempt to define genre painting as a type of art depicting anonymous figures. See also Salomon 1998b, pp. 19–20; and Gaehtgens 2002, a useful anthology of writings on genre painting, dating from antiquity to the early twentieth century.

9 De Pauw-de Veen 1969, pp. 167–79, provides a summary of terminology used in the seventeenth century to describe genre paintings.

10 Blankert 1995–6, pp. 32–3, discusses Sysmus's use of these succinct, descriptive terms and their implications for our understanding of genre paintings.

11 See further Chapter 2. In the early eighteenth century, Gerard de Lairesse expounded upon this term and compared it with "the antique," a superior mode in his view; see Chapter 16.

12 See, for example, the embellished account of a British traveler to the Netherlands in 1640 quoted by Slive 1995, p. 5. See also Montias 1982, pp. 269–70; and Bok 2001a, p. 206.

13 Among others, John Michael Montias has analyzed the prices of pictures and other aspects of the seventeenth-century Dutch art market, a subject of increasing investigation during the last two decades; see, for example, his classic study, Montias 1982. See also Goosens 2001, pp. 288–94; and Biesboer 2001, pp. 37–9, both of whom discuss the cost of genre paintings produced by artists in Haarlem.

14 Preparation for an artistic career in the Dutch Republic presupposed a certain level of affluence because of the cost of training; see Bok 1994, pp. 43–4.

15 These status-laden titles are discussed by Haks 1996, pp. 98 and 101.

16 See, for example, Bok 1994, pp. 90–130; Montias 1994; de Marchi and van Miegroet 1998; Falkenburg *et al.* 1999; Franits 2001; and Goosens 2001, pp. 229–75 and *passim*.

17 See further the discussion in Chapter 3.

18 Angel [1642] 1996, pp. 243–4. Hahn 1996, pp. 44–74, contains numerous other quotations of similar import from contemporary, Dutch art-theoretical literature.

19 De Marchi and van Miegroet 1998.

20 *Ibid.*, pp. 223–5.

21 *Ibid.*, pp. 225 and 235–6.

22 This desideratum on Picart's part must be linked to contemporary notions of civility and their impact on taste and art; see Chapters 6 and 15 below.

23 De Marchi and van Miegroet 1998, p. 225.

24 *Ibid.*, p. 223.

25 The social stratification of Dutch society is discussed in Chapter 1. As shall be demonstrated, middle-class participation in the market for the finest genre paintings, which was never really substantial to begin with, decreased significantly as the century progressed. Yet the modern, ambiguous notion that Dutch genre painting was targeted primarily at "the middle class" remains firmly entrenched. For contemporary art collectors, see, for example, Fock 1986–92; Bok 1994, pp. 53–96; Goosens 2001, pp. 362–70; Biesboer 2001; and Sluijter 2001–2. Other scholarly studies of collectors and patrons will be cited in ensuing chapters.

26 North 1997, pp. 82–105, provides a useful overview of the art market in the seventeenth century.

27 See Montias 1988, pp. 244–56. See also Goosens 2001, pp. 252–75. For the relative values of copies compared with original works of art at this time, see de Marchi and van Miegroet 1996.

28 For lotteries, auctions, and so on in relation to the art market, see de Marchi 1995; Boers 1999; Montias 1999; Goosens 2001, pp. 238–52; and Montias 2002.

29 This was the conclusion reached by de Marchi and van Miegroet 1994, p. 453.

30 Loughman and Montias 2000. See also Fock 1986–92, pp. 23–7; *idem* 2001; Goosens 2001, pp. 358–62; and Sluijter 2001–2.

31 See Loughman and Montias 2000, p. 124.

32 For the following discussion, see Renger 1997; and de Jongh 1999, pp. 212–19.

33 A noteworthy selection of de Jongh's writings have recently been published as a book in English; see de Jongh 2000a, *idem* 2000c–f.

34 For the following section of this Introduction, which discusses and critiques iconological readings of Dutch seventeenth-century paintings, see Franits 1994, pp. 129–34 and *passim*. See also de Jongh 1999. In his recently translated collected essays, de Jongh 2000c, p. 19, acknowledges Panofsky's influence upon his interpretive method but rightly calls attention to several major conceptual differences between them.

35 Panofsky 1962, pp. 3–17. See also Holly 1984, pp. 158–93.

36 Panofsky 1953, pp. 140–44. Panofsky argues that disguised symbolism was first developed in trecento Italy and then perfected in the Low Countries where it quickly became an intrinsic feature of Netherlandish art.

37 Panofsky 1934, p. 127.

38 For the links between de Jongh's and Panofsky's method, see Falkenburg 1993, pp. 161–2.

39 See de Jongh 1967, pp. 21–2; and especially *idem* 1997.

40 Cats 1627, no. 38 and fol. C3. The English translation quoted here appears in the back of this edition of the book, along with other translations of most of the amatory versions of the emblems. For Cats's book, see the monumental study by H. Luijten 1996.

41 For example, by Alpers 1983, pp. 229–34. See also Bedaux 1990, 74–6.

42 In Franits 1994, pp. 136, 139 and *passim*, I refer to this as an image's "visual specificity," fixed

by the artist but mediated through the experiences and background of individual viewers.

43 See Holly 1984, pp. 158–93; and for further literature on this topic, critiquing both de Jongh and Panofsky, see Franits 1994, p. 145 n. 12.

44 This point has been made by, among others, Sutton 1984, p. xxi; and Bedaux 1990, pp. 12–16. For his defense of the concept of concealed symbols, see de Jongh 2000c, pp. 15–18.

45 Among many others, Sluijter 1990b, pp. 6–7; *idem* 1997, p. 87; and *idem* 1998a, p. 234, has frequently called attention to this problem. See also Vanbergen 1986, pp. 104–9 and 111–12; and Willems 1993, pp. 130–35 and *passim*. De Jongh 1990, p. 37, himself notes that a number of scholars are preoccupied with the issue of form and content and their mutual relationship. See also *idem* 1998, pp. 167–9, and *idem* 2000c, pp. 13–14.

46 Sluijter 1997, p. 220 n. 84; and *idem* 2000b, p. 288 and *passim*, calls attention to the curious distinction that some scholars make between "meaning" and "meaninglessness" when interpreting art.

47 Alpers 1983. Scholarly reviews of this book varied markedly; among the last, and most illuminating, was Honig 1990.

48 Barthes used the term "reality effect" to describe the formative strategies of French realist authors; see Barthes 1982.

49 Sluijter 1997. See also *idem* 1990b, pp. 22–6.

50 For an insightful explanation of why discussions of meaning and content are generally lacking in theoretical writings, see de Jongh 1998, p. 170; and *idem* 2000c, pp. 18–19.

51 Sluijter 1997, *passim*. Ample documentation for this – at least for the Leiden *fijnschilders* – is provided by *idem* 1988c, pp. 15–23. See also *idem* 2000a.

52 Amsterdam 1989–90.

53 For example, Bruyn 1991; Falkenburg 1991, pp. 129–34; de Jongh 1992, pp. 279–80; *idem* 1999, pp. 222–3; Sluijter 1999a, pp. 265–6; and *idem* 2000b. See also Hecht 1997.

54 See, for example, Sluijter 2000a; *idem* 2000b; and *idem* 2000c.

55 See, for example, Bedaux 1990; Franits 1994; *idem* 1996; Salomon 1996; Mandel 1996; Kettering 1997; Roodenburg 1997a; Honig 1997; Sluijter 1997; Westermann 1997a; *idem* 1997b; Sluijter 1998a; Salomon 1998a; *idem* 1998b; Vergara 1998; Westermann 1999a; Sluijter 2000b; Chapman 2000; Kettering 2000; Franits 2001; Hochstrasser 2001; Chapman 2001; Hollander 2001; and *idem* 2002. See also Westermann 2002a, an assessment of the current state of scholarship in the field of seventeenth-century Dutch art.

56 As Sluijter 1998a, pp. 239–41 and *passim*; and Westermann 2002a, pp. 353, 356–7, and

passim, point out, more recent analyses of Dutch genre painting, inspired by post-modern methodologies, have not been well-received in the Netherlands itself. Likewise, they seem to have been to be poorly received in Canada, judging at least from the frequently caustic remarks of Horn 2000, vol. 1, pp. 570–697.

57 L. de Vries 1998b, pp. 218–19, argues for a survey of the development of different genres of seventeenth-century Dutch art according to "chains of emulation," namely, how artists emulated the work of successful precursors in their respective fields. For the concept of emulation, see further Chapters 8 and 18.

58 For this fascinating problem, see Brown 1981, pp. 57–61; Montias 1982, pp. 179–82; de Vries 1985; Chong 1994, p. 9; L. de Vries 1998b, pp. 220–21; Liedtke 2000, pp. 11–38 and *passim*; *idem* 2001b, pp. 15–18; and *idem* 2001e, pp. 53–4.

59 For descriptions of commutes between Delft and The Hague during this period, including those by Beck, see Liedtke 2001b, pp. 3, 6–8. For Beck's diary, see Beck [1624] 1993. For the horse-drawn barge service, which was extensive in the Dutch Republic, see de Vries 1981.

60 See, for example, Montias 1982, pp. 74–111, on guild regulations in Delft.

61 Liedtke 1984; *idem* 1988; *idem* 2000, pp. 143–69; *idem* 2001e, pp. 88–9. Liedtke's provocative thesis will be referred to in various chapters of this book.

62 For town descriptions as a literary genre, see Haitsma Muller 2000. See also *idem* 1993; van Nierop 1993; and Verbaan 2001.

63 See further Chapters 8 and 11.

64 This is true of virtually all Dutch cities with the exception of wealthy, cosmopolitan Amsterdam (see Chapter 12); see Montias 1988, p. 253. On the basis of his detailed examination of painting collections in Haarlem between 1572 and 1745, Biesboer 2001, pp. 28–9, notes that these collections were limited in their scope as collectors preferred pictures by local artists. However, in inventories compiled after the middle of the century one begins to find more works by painters from outside of Haarlem.

65 Loughman and Montias 2000, p. 102.

66 See, for example, the analogous situation in The Hague as described by Vermeeren 1998–9.

CHAPTER ONE

1 For the following discussion concerning the Dutch revolt against the Spanish, see the important study by Parker 1977. See also Israel 1995, pp. 129–275.

2 At this juncture some of the general features of Dutch society, politics, religion, and

economy will be explored. Dutch culture, discussed briefly here, is addressed more substantively throughout the book.

3 Aerts 2001 examines the origins of this traditional view in nineteenth-century conceptions of the Golden Age.

4 See Prak 2001 as well as Dorren 1998 and Frijhoff and Spies 1999, pp. 182–4.

5 See Meijer Drees 2001. See also Dorren 1998.

6 As shall be discussed in Part II of the book, the concept of civility greatly influence genre painting, in terms of the changing tastes of its patrons as the century progressed.

7 All of the following studies examine social stratification in the Netherlands on the basis of contemporary sources, though not all propose specific strata: see Roorda 1961, pp. 39–58; Groenhuis 1977, pp. 44–76, especially pp. 62–6 (the findings of Roorda and Groenhuis are deftly summarized by North 1997, pp. 47–9); van der Ree-Scholtens *et al.* 1995, pp. 183–7; Streng 1997, pp. 19–33; de Vries and van der Woude 1997, pp. 561–9; Frijhoff and Spies 1999, pp. 188–90, who observe that there was less rumination over social strata earlier in century, much more so after 1650, which is perhaps a reflection of the general Dutch consciousness of having established an independent nation; and Meijer Drees 2001, pp. 67–9, who points out that contemporary authors clearly speak of social hierarchies in the Dutch Republic but remain conspicuously silent as to where their parameters lay.

8 See the study by Soltow and van Zanden 1998, which persuasively argues that prolonged economic prosperity in the Dutch Republic gradually led to the increasing concentration of wealth into the hands of a smaller segment of the population. Thus there was a marked inequality of wealth and income in the country which deepened as it became progressively more prosperous.

9 Holland is often mistakingly identified by foreigners as the name of the country when, in fact, it is simply its principal province.

10 Frijhoff 1997–8, p. 13, provides a useful description of the Stadholder's position and responsibilities within the Dutch Republic.

11 For a helpful survey of the history of this family in their capacity as Stadholders, see Rowen 1988.

12 Scholarship on the status and role of the Reformed Church within seventeenth-century Dutch society is voluminous; for purposes of expediency, I will simply refer the reader to the masterful survey of Dutch history in the early modern period by Israel 1995, pp. 221–2, 226–8, 361–72, 391–4, 422–4, 434–6, 598–603, and 609.

13 For tolerance vis-à-vis religious pluralism in the Dutch Republic, see the excellent col-

lection of essays edited by Hsia and van Nierop 2002.

14 For the following discussion, see Israel 1995, pp. 421–505. See also Utrecht 1994.

15 For Maurits, see Amsterdam 2000.

16 During the so-called Stadholderless period, however, the Pensionary, Johan de Witt, would rise to substantial power; see Chapter 6.

17 For the following discussion, see Israel 1995, pp. 506–46. See also Groenveld 1997–8.

18 For the economic miracle of the 1590s, see Israel 1989, pp. 38–79; and *idem* 1995, pp. 307–27.

19 The Dutch economy would remain somewhat sluggish until the ratification of the Treaty of Münster in 1648, at which time it would begin to flourish once again; see Chapter 6.

20 See the now-classic study by Briels 1978. See also the important study by Gelderblom 2000, which convincingly modifies many traditional views concerning the immigration of entrepreneurs from the Southern Netherlands. Large numbers of immigrants also came from the regions ringing the North Sea, including Germany and Scandinavia; many of them were eventually employed in maritime enterprises in the port cities of the Dutch Republic.

21 Briels 1997, p. 28, who points out that some of these painters were actually "rough painters" who specialized in decorative painting or even house painting. Nevertheless, at least ninety of them were artists in the traditional sense of the term.

22 See the graph reproduced in J. de Vries 1991, p. 273.

23 Bok 1994, p. 209, astutely called attention to this phenomenon.

24 This phenomenon is examined in more detail in Chapters 2 and 3.

CHAPTER TWO

1 For the following discussion of Haarlem's history, see Temminck 1983; Haarlem 1990, pp. 37–71; Wijsenbeek-Olthuis and Noordegraaf 1993, pp. 39–42; van der Ree-Scholtens *et al.* 1995, pp. 141–263; Israel 1995, *passim*; de Vries and de Woude 1997, pp. 275–6, 290–91, and *passim*; Dorren 2001, pp. 19–38 and *passim*; Biesboer 2001, pp. 1–43; and Stapel 2002.

2 Curiously, as Stapel 2002 demonstrates, Haarlem's city council preferred to extol the town's beer-brewing industry as its principal font of prosperity because affluent brewers dominated that council. It was only in the 1640s that the linen industry was finally recognized as the main source of Haarlem's prosperity; by this decade the former refugees

who controlled this industry had been fully integrated into civic life.

3 See also the population statistics for Haarlem during the early modern era in Lourens and Lucassen 1997, pp. 61–2, which differ slightly from those presented here.

4 See Goosens 2001, pp. 43–51, who provides statistics for the relative proportions of immigrant and native artists working in Haarlem.

5 This academy is discussed by McGee 1991, pp. 75–95; and van Thiel 1999, pp. 59–62, 71, and *passim*. See also Miedema 1987, pp. 13–17.

6 As Boers 1999, p. 197, notes, the number of painters working there increased from ten to eighty between 1605 and 1634. According to the same scholar, publishing under the name Goosens 2001, p. 31, the number increased from roughly thirteen artists active in 1605 to around eighty-three by 1635.

7 Horse-drawn barges constituted a highly developed commuting system within the Dutch Republic; see de Vries 1981. And the "Amsterdam–Haarlem line" was among the most popular. According to Temminck 1983, p. 18, "In 1661, a peak year, 164,281 paying passengers arrived in Haarlem from Amsterdam in this manner."

8 For Goltzius's activities in this regard, see Filedt Kok 1991–2.

9 For van de Velde, see the monograph by Keyes 1984.

10 Haarlem's most renowned painter, Frans Hals (himself a Flemish immigrant), possibly played a part in the development of this theme as well; see further the discussion below.

11 For the following discussion of terms, see Nevitt 2003, pp. 24–5.

12 For this term, see de Pauw-de Veen 1969, pp. 175–8.

13 The iconographic origins of this theme are explored in Chapter 3.

14 Keyes 1984, pp. 80–81, links van de Velde's painting to this print. Amsterdam 1997a, p. 185, translates the print's inscription as follows: "Let us pass the time, dear friends. Without fear of the slanderers Who sound an infamous discourse Wounding the honour of courtesans."

15 Sluijter 1997, p. 86.

16 *Olipodrigo of nieuwe kermis-kost* 1654–5, pt. 2, p. 121. Van Mander [1603–4] 1994–9, vol. 1, pp. 377–8, recounts a related story of a peasant attempting to explain a painting of Danae by Cornelis Ketel (1548–1616) to the artist's wife; he confuses its subject with that of the Annunciation to the Virgin Mary. Van de Venne 1635, pp. 231–41, contains a lengthy passage in which peasants visiting the annual *kermis* in The Hague (see Chapter 5) make utterly ignorant comments about paintings for sale. For van de Venne's passage, see Vaeck 1994a, vol. 3, pp. 716–20. For immigration in

the early seventeenth century and its ramifications for Dutch art and culture, see Chapter 1 as well as the discussion below.

17 See also the following studies of seventeenth-century Dutch art which directly address issues of reception and audience response: Kemp 1986; Becker 1992; *idem* 1993; Hahn 1996; Kleinmann 1996, pp. 234–9 and *passim*; and Kettering 1997. See also Franits 1994, pp. 137–40.

18 Van Mander's comments, recorded in 1592, are cited in Amsterdam 1976, pp. 274–5.

19 See Temminck 1984, p. 17.

20 For songbooks, see further Chapter 3.

21 For Hals, see the monumental study by Slive 1970–74. See also London 1990 and Grimm 1990.

22 See Slive 1970–74, vol. 1, pp. 9–12.

23 For this painting, see Slive 1970–74, vol. 1, p. 72, and vol. 3, cat. no. 20, who points out that *Jonker Ramp and His Sweetheart* is the romantic title given to it in the late eighteenth century when it was thought that the male protagonist actually portrayed a member of one of Haarlem's militia companies.

24 Among Hals's earliest genre paintings is his famed *Shrovetide Revellers* of about 1615 (New York, The Metropolitan Museum of Art); see Slive 1970–74, vol. 3, cat. no. 5. Earlier still, though uncertain in its attribution, is a *Garden Party* (see fig. 17); to be discussed later in this chapter.

25 See Slive 1970–74, vol. 3, cat. no. 20, citing earlier studies as well as a representation of this subject by Hals mentioned in a document dated 1646.

26 Slive 1970–74, vol. 1, pp. 73–4, citing Hooft 1630, the published version of a play first performed on the Amsterdam stage during that very same year. Bergström 1966, pp. 162–4, first introduced specialists to this ostensibly moralizing farce in the context of his discussion of Rembrandt's historiated *Self-Portrait with Saskia* as a depiction of the Prodigal Son with a prostitute (Dresden, Gemäldegalerie).

27 Chapman 1990, p. 118.

28 See further the discussion in Chapter 4.

29 For Hals's painting and the engraving after it, see London 1990, cat. no. 31. See also Slive 1970–74, vol. 1, pp. 80 and 94–7; vol. 3, cat. no. 64. In the late seventeenth century Hals's painting was in the collection of Hendrick Bugge van Ring (d. 1669), a wealthy Leiden connoisseur. For Bugge van Ring's impressive art collection, see Westermann 1997b, pp. 64–5; Kloek 1998, p. 35; and Sluijter 2001–2, pp. 116–26. For the character of *Peeckelhaering* in contemporary art and culture, see Gudlaugsson 1975, pp. 57–9; and Weber 1987, pp. 133–6.

30 For the associations of teeth in seventeenth-century Dutch painting, see further the discussion below.

31 *Nugae Venales sive Thesaurus ridendi & Jocandi* 1648. Cited by Slive in London 1990, p. 216. Hals's painting likewise appears on the back wall of Jan Steen's uproarious *Baptismal Party* (Berlin, Gemäldegalerie); see Slive 1970–74, vol. 1, p. 96, fig. 93.

32 For the *Boy Playing a Violin* see Slive 1970–74, vol. 3, cat. no. 53; and London 1990, cat. no. 26. Grimm 1990, p. 291, unconvincingly attributes this picture to the "Circle of Frans Hals," without explanation. For Hals's depictions of music-making children in general, see Stukenbrock 1993, pp. 138–53.

33 The boy gazes upward to the left; as will be seen in the discussion of Judith Leyster's *Young Flute Player* (see fig. 40) below, the upward glance is often associated with inspiration and is thus highly appropriate for the depiction of performers.

34 Hals's technique, called the rough manner in contemporary parlance (see note 120 below), gradually fell out of favor as the seventeenth century progressed. However, Hals's reputation was resuscitated during the nineteenth century; his technique in particular aroused great interest among connoisseurs and artists, especially the Impressionist painters; see Jowell 1990.

35 Stukenbrock 1993, pp. 40–55, discusses depictions of children by Hals's students and followers.

36 For the painting of the singing girl (in a private collection), see Slive 1970–74, vol. 3, cat. no. 54; and London 1990, cat. no. 25. Grimm 1990, p. 291, attributes this painting as well (erroneously in my opinion) to the circle of Frans Hals.

37 Slive, writing in London 1990, p. 202, notes that these two pictures may be identifiable with two of the three little pictures by Hals described in a 1661 inventory as representing the Five Senses. Slive also points out that the lozenge format of the panels possibly indicates their use as inserts into a cabinet or musical instrument, "a use not incompatible with the suggestion that they may have belonged to a Five Senses series." See also Slive 1970–74, vol. 1, pp. 79–80.

38 See Noordenfalk 1985. The standard study of the Five Senses in Northern European art remains Li 1955.

39 See Veldman 1991–2.

40 Haverkamp-Begemann 1959 is the standard study on Buytewech. See also Kunstreich 1959; and Paris 1975.

41 Orlers 1641, p. 375, who mentions that Jan Lievens (1607–1674) copied etchings by "Geestighe Willem."

42 For this painting, see Haverkamp-Begemann 1959, cat. no. II; Kunstreich 1959, pp. 70–71; and Philadelphia 1984, cat. no. 25.

43 See Slive 1970–74, vol. 1, pp. 31–3 and vol 3., cat. no. L-1; and Sutton 1984, p. xxix. Grimm

1990, pp. 87 and 101, attributes this painting to Buytewech, incorrectly in my opinion.

44 The facade of this church was depicted several times by the architectural painter Pieter Saenredam (1597–1665); see Utrecht 2000–01, cat. nos. 4–7. Whether the building that appears in Buytewech's painting is based upon one depicted in an earlier print by Goltzius, as Groot 2002, pp. 38–9, maintains, is debatable.

45 For example, Haverkamp-Begemann 1959, pp. 27, 33, and *passim*.

46 The classic study of apes in art is Janson 1952.

47 For this painting, see Haverkamp-Begemann 1959, cat. no. V; Kunstreich 1959, p. 69 and *passim*; and Rotterdam 1998, no. 9.

48 Haverkamp-Begemann 1959, cat. nos. 28 and 29.

49 For the motif of smoking in Dutch genre painting, see the discussion below.

50 Haverkamp-Begemann 1959, pp. 24–9, first suggested parallels between Buytewech's pictures and Bredero's plays, several of which the artist possibly illustrated. Bredero's *Spaanschen Brabander* is available in English translation; see Bredero [1617] 1982. See also the insightful analysis of this play by van Stipriaan 1997a, with references to earlier scholarly studies of it. See also *idem* 1996b, pp. 171–4 and *passim*.

51 See van Stipriaan 1997b, especially pp. 107–9.

52 These tensions and related issues are discussed by Briels 1985a. See also Roodenburg 1991a, pp. 25–9 and 33.

53 Bredero [1617] 1982, p. 47. However, Bredero also satirizes the foibles of native Dutchmen, in effect playing off the clichés of the haughtiness and pretentiousness of immigrants against the dullness and incivility of native Netherlanders. As van Stipriaan 1996a; *idem* 1996b, pp. 171–3 and *passim*; and *idem* 1997a, repeatedly and convincingly argues, Bredero's farce is best understood as ironic and ambiguous in intent, constructed as it is around the deceitfulness of the characters. The purported simplicity of the Dutch (with both positive and negative connotations), as a fundamental aspect of the formation of their national identity during the early modern period, is explored by Briels 1985a; van Stipriaan 1996a; and Meijer Drees 1997, pp. 57–72 and *passim*. See also Wesseling 2001, pp. 114–20.

54 Cited by Roodenburg 1991a, pp. 26 and 34–5. See also *idem* 1991b, pp. 156–7; Groeneweg 1995, p. 217; and Briels 1995a, pp. 28 and 29.

55 For critiques of fashion during this period see the delightful article by Luijten 1996.

56 Teelinck 1624, pp. 193–4. Cited by Nevitt 2003, p. 122, from where my translation is taken.

57 Visscher [1614] 1949, p. 154. This text was first cited in connection with Buytewech by

Haverkamp-Begemann 1959, pp. 32–4. My translation is taken from Nevitt 2003, p. 116. See also *idem* 2001, p. 95. For Visscher's emblems in relation to Dutch notions of national identity, see Meijer Drees 1997, pp. 60–67 and *passim*.

58 Chapman 2000, pp. 58–60; and Nevitt 2003, pp. 111–22 and 128–40.

59 For the map in this picture – which reappears in two other paintings by the artist – and its significance, interpreted along similar lines as here, see Hedinger 1986, pp. 24–33.

60 A modern monograph on Dirck Hals is still lacking. For a short but useful essay on his life and work, along with a summary bibliography, see Groot 2000.

61 See Rotterdam 1998, p. 34.

62 For this picture, see Amsterdam 1976, cat. no. 26.

63 Hals also made drawings of each of the individual senses which were engraved by Cornelis Kittensteyn; the figures in the resultant engravings are clearly related to those in the painting, for example, the man with the spyglass; reproduced in Amsterdam 1976, p. 123, fig. 26a. See also Groot n. d., pp. 13–14.

64 Li 1955, pp. 84–9.

65 For this problem, see the insightful observations of Bruyn 1993–4.

66 Biesboer 1993, p. 75 and *idem* 2001, pp. 22 and 73 no. 9. Hals's pictures were not overly expensive; the same can be said of the work of several other genre painters during this period, among them, Jan Miense Molenaer (see below). As shall be discussed in Chapters 7 and 8, as the century progressed, genre paintings by the most important artists rose tremendously in cost and thus became the exclusive collecting prerogative of elite collectors.

67 Van Mander [1603–4] 1994–9, vol. 1, pp. 457; on p. 394 van Mander also uses the term to describe a work by Goltzius. See also the examples quoted by de Pauw-de Veen 1969, pp. 171, 173, 174, and 179. See also Nevitt 2003, pp. 29–30. In the early eighteenth century, Gerard de Lairesse expounded upon this term in comparison with "the antique," a superior mode in his view; see Chapter 16.

68 For this painting, see Amsterdam 1976, cat. no. 25; Mainz 1997, pp. 204–6; and Beaujean 2001, pp. 72–3. Equally innovative are Dirck Hals's depictions of mothers and children, works which rank among the earliest examples of the theme in Dutch genre painting of domestic virtue; see Worcester 1993, cat. no. 27. For this theme, see further Chapters 8 and 11.

69 Liedtke 1984, pp. 322–3; *idem* 1988, p. 100. The fact that van Delen was inspired by Flemish engravings after designs by Hans Vredeman de Vries (1527–1606) and his son, Paul Vredeman de Vries (1567–after 1630),

70 Liedtke 1988, p. 100.

71 The valuable Frankfurt 1993 provides a comprehensive look at the depiction of reading and writing in Dutch art of every conceivable type, including history painting.

72 See Amsterdam 1976, cat. nos. 2 and 71; Naumann 1981, vol. 1, pp. 111–17; de Jongh 1997, pp. 50–51.

73 De Jongh 1997, pp. 50–51, cites this tome, observing that over thirty pages of this volume are gathered in a section entitled, "Various Love Letters for All Kinds of Quandaries and Situations." A sample of one of these love letters is quoted in Chapter 7.

74 Goedde 1989, p. 148, observed that the ships in this little picture were sailing close-hauled into a fresh breeze. De Jongh 1967, p. 52, who was the first to decipher Hals's painting, thought that the little picture represented a storm. According to Goedde 1989, p. 148, "The reference to the seas of love seems plausible, but a precise reading of mood through the seascape seems untenable."

75 Krul 1634, pp. 2–3. De Jongh 1967, pp. 50–55, was the first scholar to cite Krul's verses in connection with Dutch genre paintings, including Hals's *Woman Tearing a Letter*. My English translation is taken from Blankert 1978, p. 54.

76 This explains Brouwer's frequent inclusion in surveys and exhibition catalogues pertaining to both Dutch and Flemish art. For Brouwer's life and artistic career, see Knuttel 1962; New York 1982; and Munich 1986.

77 De Bie 1661, pp. 91–4; von Sandrart 1675–80, vol. 1, p. 305; Bullart 1682, vol. 2, pp. 487–9; and Houbraken 1753, vol. 1, pp. 318–33.

78 For Bruegel's reception in the seventeenth century see Reznicek 1979; Muylle 1984; and Gatenbröcker 2002, pp. 13–17. For Vinckboons's interest in Bruegelian imagery, see Silver 2001, pp. 75–80. For Bruegel and Brouwer specifically, see Renger 1987.

79 For this painting, see Rotterdam 1990, cat. no. 1.

80 Houbraken 1753, vol. 1, p. 318, who also states that Brouwer was born in Haarlem. See also Knuttel 1962, p. 12.

81 For questions of costume in Brouwer's paintings and related bibliography, see Munich 1986, p. 30.

82 Renger 1987, p. 269 and figs. 7 and 8. A similar pose is found in Molenaer's *The King Drinks*, see fig. 36.

83 Even if other artists imaged Brouwer as a gentleman-painter (see fig. 27), he did self-consciously fashion himself as a rogue on at least one occasion by portraying himself and two of his colleagues as smokers in a lowly tavern (New York, The Metropolitan Museum of Art); see further Chapman 1996, p. 19, and the scholarly literature she cites on p. 23 n. 60. The earliest reference to this painting, however, is not found in any of the biographies under discussion here but in Weyerman 1729–69, vol. 2, p. 69.

84 De Bie 1661, pp. 91–4.

85 *Ibid.*, p. 93. My translation is taken partly from Boston 1993–4, p. 416 n. 6 (the original Flemish is incorrectly transcribed there).

86 De Bie's construct of Brouwer's character is neatly summarized by Raupp 1987, p. 229.

87 Houbraken 1753, vol. 1, pp. 318–33. Houbraken's biography of Brouwer was strongly influenced by earlier accounts of the artist's life, most notably that by de Bie 1661, pp. 91–4. See Horn 2000, vol. 1, pp. 82–3, 109–10, 217–20, 227–9, and 318–19, who provides an English translation of a substantial part of Houbraken's biography.

88 Klinge 1982, p. 9.

89 See Munich 1986, pp. 9–11.

90 See *ibid.*, p. 9.

91 See Knuttel 1962, p. 14; and Munich 1986, p. 10.

92 One of the most renowned Dutch genre painters of the seventeenth century, Johannes Vermeer, used the same title; see Haks 1996, pp. 98 and 101 and Chapter 11.

93 For the interest among wealthy collectors in paintings of peasants, see Montias 1990b, pp. 363–4.

94 Chapman 1993 and *idem* 1996, pp. 12–14. For Houbraken's treatise, see also the articles by Cornelis 1995 and Hecht 1996, which rightly modify the conventional view that the author was a dogmatic classicist. See as well the recent, monumental study by Horn 2000, marred somewhat by his cantankerous criticism (see vol. 1, pp. 570–697) of much of the present scholarship on Dutch art in general and on Houbraken in particular, including various aspects of the studies cited here.

95 Chapman 1993. See also Westermann 1997b, pp. 18–26 and 92–9. See further Chapter 14. See also the critique of Chapman's study by Horn 2000, vol. 1, pp. 655–60 and *passim*.

96 See Munich 1986, pp. 12–13. Naturally, Houbraken's tales concerning Steen are more incisive than those told about Brouwer because the former artist represented himself so frequently in his genre pictures; see further the discussion in Chapter 14. Brouwer did, however, depict himself as a rogue in at least one of his pictures; see note 83 above.

97 For Houbraken's linking of an artist's personality and lifestyle with his work, see Horn 2000, vol. 1, pp. 184–92.

98 For this celebrated series, see Raupp 1984, pp. 45–163; Spicer 1994; and Luijten 1999–2000.

99 See note 83 above for a brief discussion of Brouwer's painting of himself and two of his colleagues smoking in a tavern.

100 See Ellenius 1960, p. 151; Alpers 1975–6, p. 119 n. 15; Amsterdam 1976, p. 256; Muylle 1986; and Vandenbroeck 1987.

101 Wind 1985–6 and Raupp 1987. For the depiction of Diogenes in Netherlandish art and literature, see Schmitt 1993.

102 Von Sandrart 1675–80, vol. 1, p. 305. The English translation here is taken from Boston 1993–4, p. 416 n. 7.

103 De Bie 1661, p. 91. The English translation is taken from Amsterdam 1997a, p. 313.

104 I say supposedly because, as shall be discussed in Chapter 3, there are upper-class biases at work here in these constructions. Essentially, they present a more faithful version of upper-class perceptions of lower-class lifestyles than of the latter's actual lifestyles. For the concept of the comic in art and literature of this period, see Alpers 1975–6; Amsterdam 1976, pp. 26–7 and *passim*; Miedema 1981; Raupp 1983, a masterful article that presents a complex but perhaps too rigorously structured argument; and especially Westermann 1997a; *idem* 1997b, pp. 89–253 and *passim*; and *idem* 2002b. For general studies of humor in this period, see the relevant essays in Bremmer and Roodenburg 1997; Verberckmoes 1999; and Dekker 2001.

105 Bredero [1622] 1971, p. 8, "Wat my belangt, ick heb anders geen boek geleerd als het boek des gebruiks; zo ik dan door onwetenheid der uytlandser spraken, wetenschappen, en konsten hebbe gedoold, verschoont mij ongeleerde lekebroeder, en geeft den Duitse wat toe, want ick heb als een schilder, de schilder-achtige spreuke gevolgd, die daer zeit: Het zijn de beste schilders die 't leven naast komen . . . Ik hebbe zo veel als ik vermocht de boerterijen met de zoetste boere-woorden uitgedrukt." For this passage, see further Alpers 1975–6, pp. 117–18, who points out (n. 7), that Bredero worked with the Flemish artist François Badens, and that there are records of now-lost paintings by him; Franits 1993a, p. 12; Westermann 1997b, p. 100; and Jansen 2001, pp. 231–2 and *passim*. For the influence of contemporary painting upon the literary style of writers in the Dutch Republic, see Porteman 1979; *idem* 1983; and *idem* 1984.

106 In an important study, van Stipriaan 1996b argues that moralization is at best a secondary feature in farces. Rather, farces offered contemporary elite audiences entertainment in the form of complex plots revolving around themes of deceit, ambiguity, fiction, and illusion. The pleasures of unraveling a farce's witty language, subtle deceptions, and manipulations sharpened the audience members' capacity for discernment.

107 See Sluijter 1997 and de Jongh 2000c, pp. 14–15, who points out that some pictures contain "psuedo-morals," namely, moralizing features that were not to be taken seriously.

108 In Brouwer's *Tavern Interior* just discussed, a peasant smokes a pipe amidst his guzzling companions. For *Peasants at Moerdyck*, see New York 1982, cat. no. 3; and Philadelphia 1984, cat. no. 21. The imaginative title of this painting is taken from an eighteenth-century French engraving, which, incidentally, shows the picture extended on both sides along with other compositional changes; these later additions have subsequently been removed. This print is reproduced and discussed by Scholz 1985, no. 170.

109 For the following discussion, see Amsterdam 1976, cat. no. 7; Munich 1986, pp. 35–8; Broos 1987, cat. no. 14; Amsterdam 1997a, cat. nos. 64 and 76; Luijten 1996, vol. 2, pp. 301–11; Gaskell 1997; and Augustin 1998. For a general history of tobacco use in the Netherlands, see Brongers 1964.

110 A painting by Brouwer is listed as representing a "*toback drincker*" (tobacco drinker) in the 1669 death inventory of Magdelena van Loo, the wife of Titus van Rijn, the son of Rembrandt van Rijn; see Broos 1987, p. 86. Like Rubens, Rembrandt was an avid collector of Brouwer's paintings.

111 In contemporary Dutch painting (including works by Codde), figures of a higher social status sometimes smoke as well. However, these depictions rarely, if ever, show "inebriated" smokers of the type encountered in representations of peasants. For some examples, see Augustin 1998, figs. 13–15.

112 Gaskell 1997, pp. 73–7. For other forms of negative self-definition, see especially Vandenbroeck 1984, pp. 118–19; Antwerp 1987, pp. 141–8.

113 Along related lines, Konrad Renger, writing in Munich 1986, p. 43, interprets upper-class responses to Brouwer's art within the framework of Stoic philosophy, which was popular among elites of this era. The excessive passions of the peasants depicted by Brouwer were diametrically opposed to the concept of self-control which was pivotal to Stoic philosophy.

114 For a photograph of a rare, surviving tobacco pouch from this period, see Amsterdam 1997a, cat. no. 76, fig. 2. The author of this catalogue entry, Eddy de Jongh, discusses several prints in which tobacco smoking, that is, the blowing of smoke which rapidly dissipates, evokes notions of transience.

115 See Renger, writing in Munich 1986, p. 41.

116 Bosch's painting of this subject is located in Madrid, Museo del Prado. See Fresia 1991, pp. 184–6.

117 See Raupp 1987, p. 242. For an interesting article that discusses the depiction of pain in these images of peasants, though principally from the perspective of medical history, see Pelling 1996.

118 For the following discussion, see van Andel 1981; Fresia 1991, pp. 172–261; Leiden 1993–4; and Frijhoff 1996.

119 Franciscus de le Boe Sylvius (d. 1672), a prominent professor of medicine and collector in Leiden, owned one of Brouwer's depictions of a quack doctor which was displayed in the front hall of his house. Surely the artist's humorous intentions in this picture were recognized and enjoyed by this well-respected physician; see Sluijter 2001–2, pp. 107, 228 n. 30. See also the poem about a Brouwer painting of a quack written by the painter Willem Schellinks in 1656, translated and discussed by Westermann 1997b, pp. 96–7. See also Amsterdam 1997, cat. no. 60.

120 For Rubens, see Belkin 1998; for Van Dyck, Brown 1983. For the stylistic options of the so-called rough manner, as opposed to the so-called neat or smooth manner, see Emmens 1997, pp. 15–16; Alpers 1988, pp. 16–20; and van de Wetering 1992, pp. 13–22. For some critics and connoisseurs, Van Dyck's pictures were associated with the rough style while for others (among them Houbraken), the artist's pictures were equated with a style that was neat. What this really demonstrates is the mutability of these terms in the hands of critics of different periods, critics whose assessments and opinions of art cannot be separated from the taste of contemporary elite groups; see further Franits 1995, pp. 410–11 n. 10.

121 My use of the term "graceful air" is adopted from the excellent article by Muller 1990–91. Although Muller's article is largely devoted to history painting, his finds seem equally applicable – if not more so – to portraiture.

122 Similar intentions are evidenced in the grisailles executed by Adriaen van de Venne; see further Chapter 5. Westermann 1999b masterfully examines van de Venne's grisailles from an ironic perspective and links them to works by Brouwer in the process (pp. 243–4). For the fusion of sophisticated painting styles with base imagery, see also Falkenburg 1991, pp. 136–7.

123 See further Chapters 9, 15, and 18.

124 Most of the scholarship on van Ostade has focused on his drawings and etchings; see, for example, Schnackenburg 1981; Athens, Ga 1994. There is no modern monographic study of his paintings.

125 Houbraken 1753, vol. 1, p. 347.

126 Renger, writing in Munich 1986, p. 65, believes that such interiors owe much to contemporary genre painting in Rotterdam, as practiced by, among others, Cornelis Saftleven (1607–1681). Renger pp. 45–6, claims the same for some of Brouwer's interiors. It is indeed difficult to determine the pictorial source for these spaces; they do owe something to sixteenth-century art (though most sixteenth-century images of peasants depict them outdoors). Moreover, the representation of interior space in these Haarlem paintings is similar to that depicted somewhat earlier in paintings by Rotterdam artists.

127 For van Ostade's artistic relationship with Rembrandt, which perhaps has been overstated somewhat, see Gerson 1969, pp. 140–41; Schnackenburg 1970, p. 158; and Stone-Ferrier 1994, pp. 24–8.

128 Follinus 1613. On fols. 34v–37v Follinus discusses the nose and its various shapes. Sullivan 1994, pp. 77–90, contains an extensive discussion of physiognomic treatises in relation to Bruegel's depictions of peasants.

129 See, for example, *Neusboekje* 1718, fol. C2v. For nose books in general, see Schuur 1978–9. As Schuur points out, nose books were often appended to almanacs which were produced in prodigious numbers during the early modern period; for these latter texts, which remain understudied in relation to contemporary genre painting, see Delft 1997–8; and the exhaustive study by Salman 1999.

130 For Molenaer, see Weller 1992; and Raleigh 2002.

131 Surviving guild records for the first three decades of the seventeenth century are fragmentary; see Miedema 1980, vol. 2, pp. 419, 420, and 1036. For the guild's reorganization, see Taverne 1972–3 and Goosens 2001, pp. 74–7 and *passim*.

132 For this painting, see Weller 1992, pp. 233–4; and Worcester 1993, cat. no. 30.

133 For Hals's depictions of children, see Slive 1970–74, vol. 1, pp. 80–81, 88–91, and *passim*; Koslow 1975; Philadelphia 1984, cat. no. 47; London, 1990, cat. nos. 15, 16, 25–9, and 34–6; Stukenbrock 1993; and Worcester 1993, cat. nos. 19–21.

134 Weller 1992, pp. 68–73 and *passim*; *idem* 2002, pp. 16–17; and Biesboer 1993, pp. 82–3, discuss the many connections between the art of Molenaer and Dirck Hals. Biesboer speculates (p. 83) that both Molenaer and Leyster may have been Dirck Hals's pupils.

135 See Durantini 1983. Roberts 1998 and Dekker 2000 provide historical perspectives on childhood. See also Schama 1987, pp. 481–561.

136 Children were also the subjects of genre paintings by the Utrecht Caravaggisti; see Chapter 4.

137 See Dekker 2000, pp. 3–11.

138 See, for example, Dirck Hals's painting of children playing cards: Worcester 1993, cat. no. 26.

139 See Durantini 1983, pp. 185–91; Amsterdam 1997a, pp. 92–3; and Dekker 2000, pp. 73–80.

140 See Durantini 1983, pp. 267–78; Worcester 1993, cat. nos. 3, 13, and 30; and Amsterdam 1997a, cat. no. 35. See also the inscription on the print after a lost Frans Hals painting of children playing with a cat (fig. 39).

141 Miedema 1981, pp. 204–8, and Salomon 1998a, p. 319, discuss the pictorial origins in

sixteenth-century Italian art of this motif. The equation of exposed teeth with uncouth persons explains their display in Codde's *Guardroom* discussed in Chapter 3 (fig. 56). For excessive laughter as an indicator of ill-breeding, see Miedema 1977, p. 211; *idem* 1981, pp. 204–8; and Verberckmoes 1999, p. 76. See also Haarlem 1986b, pp. 15 and 18; Westermann 1997b, pp. 89–92 and *passim*; and Verberckmoes 1999, pp. 38–82.

142 For the comic component of Molenaer's work, see the important essay by Westermann 2002b.

143 For this painting, see Raupp 1984, pp. 282–3; Weller 1992, pp. 25–6 and 89–92; Hannover 1999, pp. 10–12; Weller 2002, pp. 9–10; and Westermann 2002b, p. 54.

144 Weller 1992, pp. 25–6. However, Westermann 2002b, pp. 55–6, points out the frequently "tableau-like" qualities of Molenaer's interiors (especially early in his career), which can be related to contemporary theatrical productions.

145 The artist in Molenaer's picture has occasionally been identified as a self-portrait, to my mind implausibly. For artists' self-portraits during this period, see the monumental study by Raupp 1984. Genre paintings of artists in their studios were more frequently painted during the second half of the seventeenth century, no doubt a reflection of the growing social status of those in the profession; for an example, see fig. 102.

146 See also Pot's *Artist in a Studio* (The Hague, Bredius Museum). In recent years, several scholars have attributed Pot's panel to Molenaer; see Raleigh 2002, cat. no. 10. For Codde's depictions of artists and connoisseurs in art studios see, for example, Amsterdam 1976, cat. no. 12; and Hannover 1999, p. 31, fig. 13.

147 *A Painter in His Studio* is in fragile condition; unfortunately, this prevents us from determining whether the picture-within-the-picture contains a large canvas (which would augment the overall wit of Molenaer's painting immeasurably). The artist in the picture-within-the-picture stands before a flat white surface whose appearance differs from that of the surrounding "walls": is this a large canvas?

148 Martin 1905, pp. 13 and 17.

149 For an interesting essay on Molenaer's studio practices, including his use of props and models, see von Bogendorf Rupprath 2002.

150 Weller 1992, p. 92. For Raupp's analysis, see Raupp 1984, pp. 282–3. Molenaer's unusual picture likely exerted an impact on contemporary Flemish art, most notably upon Joos van Craesbeeck (*c.* 1605–1654/62). See, for example, van Craesbeeck's *Artist's Studio*, reproduced in Munich 1986, p. 105, fig. 58.

151 See Weller 1992, pp. 11–55, who examines the paradox of Molenaer's mounting legal problems during the year 1636 and his remarkable productivity at that time. Despite his early financial difficulties, Molenaer eventually became one of the wealthiest citizens of Haarlem; see Goosens 2001, pp. 204–5, 224, 226, 227, and 228.

152 Weller 1992, p. 136, errs in assuming that "Amsterdam did not possess as well an established tradition of low genre as did Haarlem."

153 See Weller 1992, p. 153; and Broersen 1993, p. 23, both citing earlier sources. See also Goosens 2001, pp. 288–9 and 160–61, where it is noted that until 1670, Molenaer's name appears more often than that of any other artist in inventories of the possessions of deceased owners of his paintings compiled in the cities of Haarlem, Amsterdam, and Leiden. Westermann 2002b, pp. 48–9, discusses some of the titles given to Molenaer's paintings in these inventories (which she culled from the Getty Provenance Index) for the insight they provide into the contemporary appreciation of the painter's skill in rendering comic imagery.

154 The paintings by Molenaer listed in de Renialme's inventory were valued between 6 and 60 guilders. (See further Broersen 1993, pp. 23 and 24; and Goosens 2001, pp. 288–90.) Even allowing for the propensity among notaries to undervalue works of art in inventories – they often considered them "second-hand goods" – these sums were not exceptionally steep. Nevertheless, to place this in perspective, it would have taken the average skilled worker in Amsterdam in 1640 two full months to pay for a Molenaer picture worth 60 guilders; see Chapter 1 for an outline of the social strata within Dutch society and their estimated annual earnings. Moreover, in a few instances, Molenaer's paintings did sell for fairly hefty sums. For example, the well-to-do patron of his *Peasants Carousing* of 1662 (Boston, Museum of Fine Arts) paid 380 guilders for that canvas; see Raleigh 2002, cat. no. 36. For de Renialme and other dealers in the Dutch Republic, see Montias 1988. Molenaer himself dealt in paintings by other artists which was a common practice at the time (see Wijsenbeek-Olthuis and Noordegraaf 1993, p. 50; and Broersen 1993, p. 24). Since the surviving documents pertaining to Molenaer contain no further references to art dealers such as de Renialme one must conclude that the former had attained sufficient notoriety in his profession to sell his own work and occasionally that of other masters; see Broersen 1993, p. 29, and especially, Goosens 2001, pp. 261–5.

155 See Biesboer 2001, p. 37, for a table of genre artists and the prices of their pictures as culled from contemporary inventories. See also note 154 above.

156 For this picture, see Baumstark 1980, no. 80; New York 1985a, cat. no. 169; Basel 1987, cat. no. 58; Weller 1992, p. 144; and Raleigh 2002, cat. no. 19, where it is dated *c.* 1634–5. For the probable pendant to this painting, the *Battle Between Carnival and Lent* (Indianapolis, Indianapolis Museum of Art), see *ibid.*, cat. no. 18.

157 For this document, see Hofrichter 1989, p. 19; and Weller 1992, p. 165, both citing an earlier source.

158 For representations of Twelfth Night in Dutch art, see van Wagenberg-ter Hoeven 1993–4; and *idem* 1997. Molenaer's depictions of this theme in turn inspired Jan Steen (see Chapter 14); see Westermann 1997b, pp. 146–7. The two artists certainly knew one another as they collaborated in 1658 on a sale of paintings in the village of Heemstede, where Molenaer had purchased a house ten years earlier; see Westermann 1997b, p. 56, citing an earlier source.

159 For Teniers's depictions of *The King Drinks*, see van Wagenberg-ter Hoeven 1993–4, pp. 78–80; and *idem* 1997, pp. 123–5. See also Raleigh 2002, p. 121.

160 This quotation comes from a pamphlet written by Caspar Coolhaes in 1607; it is cited by van Wagenberg-ter Hoeven 1993–4, p. 94.

161 See some of the contemporary prints illustrating this procession, reproduced in *ibid.*, figs. 1–3.

162 *Ibid.*, fig. 10, reproduces one of these king's letters.

163 Most scholars writing on the theme of *The King Drinks* confuse the methods by which the king was chosen by conflating those of the bean-cake with the paper-strip lottery. Van Wagenberg-ter Hoeven 1997, pp. 30–31, contains a detailed discussion of the various rituals through which a king was chosen to preside over the festivities.

164 For a picture of a rare surviving crown, see Royalton Kisch 1984, fig. 15.

165 For a late-medieval image of gluttony, in which a man guzzles from a jug, see Raleigh 2002, p. 123, fig. 2.

166 This old woman is often misidentified as "the queen"; see the clarifying discussion in van Wagenberg-ter Hoeven 1997, p. 103.

167 *Ibid.* For the concept of inversion (called the *omgekeerde wereld* in Dutch) as a leitmotif in festive celebrations, see s'Hertogenbosch 1992.

168 See van Wagenberg-ter Hoeven 1997, p. 62, who states that William III, Prince of Orange and future king of England (see Chapter 15), did in fact participate in Twelfth Night celebrations organized by his grandmother in The Hague in 1662. With remarkable prescience he was chosen king for the evening.

169 Inscriptions on prints and even on some paintings depicting the theme of the king drinks (particularly those by Jordaens) and related Twelfth Night festivities run the

gamut from benign to admonitory, thus demonstrating the complexity of their reception among contemporary viewers; see the many examples illustrated in *ibid.*

170 For Leyster, see Hofrichter 1989; and Worcester 1993, a catalogue whose authors reduce the number of pictures attributed by Hofrichter to Leyster to less than half. For the tantalizing question of the working relationship between Molenaer and Leyster, see Biesboer 1993, pp. 82–4; and Weller 2002, pp. 16–17.

171 For example, see Hofrichter 1989, p. 14; Broersen 1993, pp. 19–20; and Levy-van Halm 1993, pp. 69–70.

172 For female artists in the Dutch Republic in general, see Kloek, Sengers, and Tobé 1998 and Honig 1999–2000. See also Kloek 1993.

173 See Hofrichter 1989, p. 82 doc. no. 18.

174 *Ibid.*, p. 82 doc. no. 13.

175 For this painting, see Hofrichter 1989, cat. no. 13; and Worcester 1993, cat. no. 3.

176 In the Dutch edition of his book describing Haarlem, Schrevelius 1648, pp. 384–5, briefly discusses Leyster, whom he calls "de rechte Leyster in de konst" ("the true leading star in art"), thus cleverly punning upon her name. For this passage, see Hofrichter 1989, p. 30; and Broersen 1993, p. 23.

177 For the lost painting by Hals, see Slive 1970–74, vol. 3, cat. no. L3–3. The thesis of Hofrichter 1989, cat. no. 13, that the engraver of the print mistakingly attributed the original painting to Frans Hals is surely incorrect. See Worcester 1993, cat. no. 3.

178 The brushwork in Molenaer's *Children Playing with a Cat* (fig. 34; which may have also stimulated Leyster's interest in the subject) is even further removed from that which is seen in paintings by Hals; see the discussion above.

179 According to the guild's draft charter of 1631, applicants to the guild had to have studied previously with a master for at least three years, followed by another year working as an assistant with a master, or working independently. Perhaps Leyster fell under this last category, working independently, when she produced her Hals-like pictures. See further Biesboer 1993, p. 78; and Levy-van Halm 1993, p. 69. For the guild's draft charter, see Miedema 1980, vol. 1, pp. 91–135; and Goosens 2001, pp. 74–7 and *passim*. Goosens 2001, pp. 69–108, contains an extensive discussion of workshop practices and artistic training in early seventeenth-century Haarlem. See also Biesboer 2001, pp. 17–19.

180 Hofrichter 1989, cat. no. 38, dates the painting to about 1635 (though it may date to as early as 1630). See also Worcester 1993, cat. 11. Biesboer 1993, p. 78, regards the painting as falling more under the influence of Hals. Leyster's parents moved to a village near

Utrecht after declaring bankruptcy in 1625 (see Broersen 1993, pp. 17–19). There is no evidence, however, that Leyster accompanied them and subsequently became familiar there with the work of the Utrecht Caravaggisti. As Biesboer 1993, p. 77, points out, the stylistic innovations of these painters had already been adopted in Haarlem in the early 1620s. Moreover, Leyster possibly saw paintings by Utrecht masters in Haarlem collections; see further van Eck 1993–4, p. 108, and the discussion below. However, pictures by the Utrecht Caravaggisti in Haarlem collections are presently found only in inventories that postdate Leyster's death; see Biesboer 2001, pp. 200 no. 158, 220 no. 57, and 240 no. 8.

181 Hofrichter 1989, cat. no. 38, notes that the large inventory of the possessions of Molenear (and presumably at least some of those of Leyster) composed upon his death in 1668, includes a violin and two transverse flutes; see item nos. 178 and 194 in the inventory, conveniently reproduced in Hofrichter 1989, pp. 87–103, Appendix.

182 This aspect of Leyster's painting is discussed extensively in Worcester 1993, cat. no. 11.

183 For the following discussion, see Worcester 1993, p. 128; and Sonnema 1990, pp. 41–8, who believes that the boy's expression in Leyster's painting is devoid of harmonic significance. For the upward glance as a stock expression in Western European art, see Dresden 1998–9.

184 For an example, see Worcester 1993, cat. no. 17. See also note 180 above.

185 See Hofrichter 1989, cat. no. 16; and Worcester 1993, cat. no. 8.

186 Hofrichter 1982.

187 Franits 1987, pp. 64–6. Worcester 1993, cat. no. 8, provides an overview of the often conflicting interpretations of *The Proposition* and illustrates much supporting material.

188 See Broersen 1993, pp. 21–30. See also the relevant documents, transcribed in Hofrichter 1989, pp. 83–4.

189 The essay by Kloek 1993, examines Leyster's roles in this regard in comparison to those of other women in the Dutch Republic.

CHAPTER THREE

1 For the following discussion of Amsterdam, see Regin 1976; Kistemaker and van Gelder 1983; Israel 1989, *passim; idem* 1995, *passim;* and de Vries and van der Woude 1997, *passim*.

2 Kistemaker and van Gelder 1983, p. 90, point out that the stock exchange was not "as now, a place for trading share certificates, but one for dealing in goods (literally 'stocks')." For an overview of Amsterdam's economic development during this period, see Lesger 2001. For Amsterdam's extensive involvement in

world trade, see the literature cited in note 1 above as well as Israel 1989, *passim*.

3 See Briels 1985b, pp. 117–18. See also Lesger 2001, pp. 72–3 and 75–6.

4 For Amsterdam's population figures, see Nusteling 1997 and Lourens and Lucassen 1997, pp. 55–7.

5 See Knotter 1987; Dudok van Heel 1997; Ottenheym 1997; and Hart 2001, pp. 132–4 and 144–6.

6 For Vinckboons, see the studies by Goossens 1977; and Lammertse 1989.

7 For Bruegel's reception in the seventeenth century see Reznicek 1979; Muylle 1984; and Gatenbröcker 2002, pp. 13–17. For Vinckboons's interest in Bruegelian imagery, see Silver 2001, pp. 75–80.

8 As one would expect, the scholarly literature on peasants in the art of Bruegel – and for that matter peasants in sixteenth-century art in general – is voluminous. Therefore, I cite only a few of the more recent studies: Raupp 1986; Antwerp 1987, pp. 63–116; Moxey 1990, pp. 35–66; Sullivan 1994; and Kavaler 1999.

9 Helpful for the following discussion are: Alpers 1975–6; Philadelphia 1984, cat. no. 122; Antwerp 1987, pp. 86–101 and *passim;* and Amsterdam 1997a, cat. no. 15.

10 Van Mander 1603–4, fol. 299ᵛ. This passage is quoted in translation in Amsterdam 1997a, p. 106, in connection with an engraving of a *kermis* after a drawing by Vinckboons.

11 Popular amusements of this sort are discussed in the old but still valuable book by ter Gouw 1871. For popular celebrations with Catholic roots, see s'Hertogenbosch 1992.

12 For example, Stridbeck 1956, pp. 214–30; and Philadelphia 1984, cat. no. 122. Moxey 1989, provides a comprehensive review of the often conflicting interpretations of Bruegel's images of peasants. Alpers 1972–3 and *idem* 1975–6 are two ground-breaking articles that provided an alternative to traditional, moralizing interpretations of representations of peasants. Alpers stressed the ethnographic and comical aspects of peasant images of the sixteenth and early seventeenth centuries. At the time, her interpretations struck some scholars – particularly Dutch ones – as extreme; see Miedema 1977, a study that Alpers herself rebutted in detail: Alpers 1978–9. Vandenbroeck 1984, p. 79, assesses Alpers's and Miedema's respective positions, concluding that both erroneously placed the "value-free" and moral interpretations in opposition to one another. See as well the insightful comments of Muylle 1984; and van Vaeck 1994a, vol. 3, pp. 659–63.

13 This is the illuminating conclusion made by Vandenbroeck 1984, pp. 118–19. See also Antwerp 1987, pp. 141–8. Streng 1997, pp. 19–33, surveys the hierarchical divisions within the Dutch Republic; see also Chapter 1.

One of Vinckboons's paintings of a *kermis* was owned by Anthonetta van Haarlem, a wealthy woman from a Dordrecht regent family who was the widow of a Catholic merchant; see Loughman 1992–3, p. 55.

14 For this painting, see Philadelphia 1984, cat. no. 121; Vienna 1992, no. 122; and Franits 1993a, pp. 38–41. Goodman 1992, provides an excellent overview of the theme in seventeenth-century Dutch and Flemish art, while focusing upon Rubens's renowned representation of it in Madrid, Museo del Prado. See as well Pittsburgh 1986; and Vetter 2002.

15 See the discussion in Chapter 2 concerning Esaias van de Velde's representations of garden parties.

16 In clear contrast to the painting under discussion here an engraving after a drawing by Vinckboons depicts a garden party with the Prodigal Son being thrown out of a brothel in the background; illustrated in Amsterdam 1976, p. 273, fig. 72a; and Braunschweig 2002, cat. no. 28.

17 For songbooks, see Keersmaekers 1981; *idem* 1985, pp. 9–11 and 119; Grootes 1987, pp. 73–5; Spies 1987, pp. 90–96; and Grijp 1994, pp. 69–70. See also Snoep 1968–9, pp. 78–81; and Nevitt 2003, pp. 14–16, 50–57, and *passim*. The anthology by Veldhorst 1999, provides a charming selection of seventeenth-century Dutch songs transcribed for modern performance.

18 See the discussion about emblems in the Introduction above.

19 See Hooft [1611] 1983, pp. 20–22 and 46–7; Keersmaekers 1985, pp. 56, 78, 119, and *passim*; and Grootes 1987, p. 84.

20 See Hooft [1611] 1983, pp. 25–9 and 66.

21 See Snoep 1968–9, p. 78, fig. 2.

22 Lammertse 1989, pp. 26–32 discusses Vinckboons's intimate contacts among literati in early seventeenth-century Amsterdam.

23 Vinckboons's illustration also appears on the title page of *Den nieuwen lust-hof* 1602. See Keersmaekers 1985, p. 115; and Nevitt 2003, pp. 47–9. Garden parties were also painted on virginals during this period; see the early seventeenth-century Dutch virginal illustrated and discussed in Braunschweig 2002, cat. no. 32.

24 Goodman 1982, pp. 247–59, took a significant step in recognizing that such images – her study focuses on Rubens's *Garden of Love* (Madrid, Museo del Prado) – were "viewed as secular, light-hearted works, not as abstruse allegories" (p. 255). Hellerstadt wisely argues in Pittsburgh 1986, p. 47, that the interpretation of such scenes should rest upon the degree to which the festivities represented are excessive.

25 However not every picture of this theme could have been interpreted in this manner;

others have a pronounced didactic content – see the discussion of Esaias van de Velde's depictions of garden parties in Chapter 2. Clearly, the pictorial context assists us in defining their interpretive parameters.

26 For Codde and Duyster, see Playter 1972.

27 See *ibid.*, Appendix VI.

28 See *ibid.*, Appendix IV.

29 See also Philadelphia 1984, cat. no. 28.

30 Contemporary perspectives on dancing are analyzed in detail by Naerebout 1989; *idem* 1990; and Kolfin 1999.

31 Voetius 1644, pp. 94 and 59. Cited by Kolfin 1999, p. 153.

32 Quintijn 1629, pp. 116–17. Cited and discussed by Kolfin 1999, pp. 150–60. For Quintijn's book, see *idem* 2001. For this particular illustration, see further Kolfin 2001, p. 175. The illustrations for the book were designed by Adriaen van de Venne; for this artist, see Chapter 5.

33 See Schama 1980, pp. 12–13; Mandel 1996; and Franits 1997a, pp. 115–16.

34 Fig. 50 originally appeared in Crispijn van de Passe the Elder's print series, *Hortus Voluptatum* (The Garden of Delights) of 1599. In this context, it is reproduced and discussed by Veldman 2001, pp. 23, 116 n. 38, 143, and fig. 23, who translates the Latin inscription as follows: "You charm the heart, you transport the senses, and when you flow/ Into the ear, the legs lift merrily from the floor to your sound./ Who can deny, unless he be made of stone (although Orpheus/ Made even rocks dance), that your power, Music, is divine." Veldman 2001, p. 23, also notes that the illustration is taken from a detail of a large print by Nicolaes de Bruyn after a design by Vinckboons.

35 See Roodenburg 1997a; Kolfin 1999, pp. 165–7; Roodenburg 2000, pp. 64–74; and Jung 2001, pp. 321–36.

36 Huygens 1987, pp. 23–4; cited by Roodenburg 1997a, pp. 178–9.

37 These two prints are discussed by Antwerp 1987, p. 100; Amsterdam 1997a, p. 117 (the source for the English translation of the Latin inscription quoted here); Roodenburg 1997a, p. 183; Kolfin 1999, p. 165; and Roodenburg 2000, pp. 71–3. See also the engraving from de Lairesse 1778, which illustrates the postures of the highborn versus those of the peasantry (fig. 120 and Chapter 8).

38 For this picture, see Amsterdam 1976, cat. no. 21.

39 See *ibid.*; Sonnema 1990, pp. 28–126; Kyrova 1994, pp. 39–41; The Hague 1994, *passim*; and Amsterdam 1997a, cat. no. 12.

40 See de Pauw-de Veen 1969, pp. 170–71. General surveys of *kortegaarde* imagery can be found in Naarden 1996; Kersten 1998; and Kunzle 2002, pp. 357–92. See also Salomon 1998b, pp. 33–7.

41 There are also a number of late sixteenth- and early seventeenth-century paintings and prints of soldiers committing violence against peasants (including several by Vinckboons). These works are discussed by Fishman 1982. See also Kunzle 2002, pp. 257–356.

42 As shall be discussed in Chapters 7 and 12, the final cessation of hostilities in 1648 accounts to some extent for the waning interest in the types of representations of soldiers that were popular during the 1620s and 1630s.

43 See Kersten 1998, p. 214 n. 16.

44 Angel [1642] 1996, p. 248.

45 See van Deursen 1991, pp. 26–31; and Kettering 2000, p. 109–10.

46 Angel [1642] 1996, p. 244.

47 For example, Adriaen van de Venne's account of the annual militia-company procession in The Hague during the May *kermis*: van de Venne 1635, pp. 124–6. This poem is discussed at length by van Vaeck 1994a, vol. 3, pp. 761–9. See also Kettering 2000, p. 110; Kettering 2000, p. 117 n. 27, also quotes several other contemporary texts that treat soldiers condescendingly. For van de Venne's activities as an artist, see Chapter 5.

48 For this painting, see New Brunswick 1983, cat. no. 8; Göttingen 1987, cat. no. 19; and Delft 1998, cat. no. 123.

49 Van Deursen 1991, p. 28.

50 See further the discussion about laughter and teeth in Chapter 2.

51 Montias 1990c.

52 Goosens 2001, pp. 316–21, in her exhaustive study of the Haarlem art market, has recently pointed out that the prices recorded in inventories for pictures by practitioners of the tonal style were only slightly lower than those by painters laboring in the older, more highly finished styles. Goosens consequently concludes that artists produced works in the quickly executed tonal style in order to increase their earnings and thus their income. Her findings are enlightening but, as Bok 1998, p. 104, observes, appraisals in probate inventories and auctions are of only limited value for deducing the original prices of paintings because notaries and auctioneers tend to underestimate their worth.

53 Israel 1997.

54 Sluijter 1999b. Sluijter's study is principally concerned with landscape paintings.

55 *Ibid.*, p. 131. See also Goedde 1997, pp. 142–3.

56 For example, when Adriaen van Ostade adopted Adriaen Brouwer's tonal approach (see Chapter 2) he was following an emulative paradigm initiated by Dutch artists in response to Flemish painting some twenty years previously.

57 For the theme of hostage- and booty-taking, which was also depicted by Codde, see Chapter 4.

CHAPTER FOUR

1 For the following introductory remarks see Vijlbrief 1950; Faber 1986; Bok 1994, pp. 131–63 and *passim*; Kaplan 1995; *idem* 1997; de Vries 1997; and de Bruin *et al.* 2000, pp. 191–313.

2 Meierink and Bakker 1997 discuss patronage during this period within the Province and city of Utrecht.

3 See Kaplan 1995, pp. 277–8; Israel 1995, pp. 377–82; and Kaplan 1997, pp. 69–70.

4 See the population statistics for Utrecht between 1400 and 1795, given by Lourens and Lucassen 1997, pp. 87–8.

5 De Vries 1997, p. 50.

6 See Bok 1994, pp. 165–8. Overviews of painting in Utrecht during this period can be found in: Huys Janssen 1990; Utrecht 1986; and San Francisco 1997.

7 For Wtewael, see Lowenthal 1986; for Moreelse, see de Jonge 1938; and for Bloemaert, see Roethlisberger 1993.

8 Bok 1997, pp. 93.

9 The term critical mass was coined by Montias 1982, p. 181.

10 See Bok 1994, pp. 167–8, and *idem* 1997, pp. 91–3.

11 Passe 1643. For this book and the drawing academy, see de Klerk 1989; Bok 1994, pp. 78–89; and *idem* 1997, pp. 93–4.

12 Bok 1994, p. 191, provides statistics concerning the number of Utrecht artists who visited Italy between 1561 and 1650. Orr 1997 examines the impact of their experiences in Italy.

13 See London 2001. For Caravaggio, see the classic study by Friedländer 1974, along with the recent survey by Puglisi 1998.

14 For van Baburen, see Slatkes 1969; Utrecht 1986–7, pp. 173–93; and Slatkes 2000a.

15 Slatkes 1965, pp. 25–7. See further Judson and Ekkart 1999, pp. 4–5, for the interest in Caravaggio in the Netherlands in the very early seventeenth century. Friedländer 1974, pp. 259–60, provides a transcription and translation of van Mander 1603–4, fol. 191–191ᵛ, who remarks that, "There is also a certain Michael Angelo of Caravaggio who is doing remarkable things in Rome." For Caravaggism in the Netherlands, see von Schneider 1933; Utrecht 1986–7; Klessman 1988; San Francisco 1997; and Raleigh 1998.

16 Slatkes 1969, p. 7. For Manfredi, see Cremona 1987. Von Sandrart 1675–80, vol. 1, p. 301, in his biography of the Flemish Caravaggist Gerard Seghers (1591–1651), terms several features of Manfredi's influential style, the "Manfredi manier" (Manfredi method). See further Cuzin 1980; and Cremona 1987, *passim*.

17 For this picture, see Slatkes 1969, pp. 76–8, cat. no. A12; Philadelphia 1984, cat. no. 1; and The Hague 1990–91, cat. no. 5. For the theme of mercenary love in earlier Northern European art, see the classic study by Renger 1970.

18 Sutton and Stebbins 1986, p. 46, argue that the elderly woman in *The Procuress* is a gypsy fortune-teller, as opposed to a procuress. If their hypothesis is correct, the picture would then combine prostitution with fortune-telling. The old woman's very plain costume conforms more with what gypsies, rather than procuresses, wear in contemporary art – the theme of gypsy fortune-telling was also popularized by Caravaggio and his followers. However, her gesture is a traditional one of dispute, codified in the well-known contemporary manual of hand gestures and rhetoric by Bulwer [1644] 1974, pp. 177 and 193, fig. Q. Besides, gypsies are invariably shown reading the palms of clients; if this woman were a gypsy it would appear as if she were predicting her own future which can hardly be the case.

19 For sixteenth-century representations of the parable, see Renger 1970. For other pictorial precedents, see Judson 1959, pp. 75–7.

20 Blankert 1986–7, p. 33, astutely likens the stylized effects of clothing in van Baburen's pictures to crinkled aluminum foil.

21 For example, Philadelphia 1984, cat. nos. 1 and 49; and Utrecht 1986–7, cat. no. 63.

22 See, for example, a painting of a brothel by the Utrecht Caravaggist, Jan van Bijlert (*c.* 1597/8–1651), formerly with Sotheby's in London (auctioned, 9 April 1986, lot 99), where the Prodigal Son is depicted in the background fleeing from broom-wielding prostitutes (identifiable with Huys Janssen 1998, cat. no. 22). Van Bijlert's inclusion of the Prodigal Son in this painting is unusual and is far outweighed by secular scenes of brothels lacking any references whatsoever to this infamous character from the Bible.

23 See especially the monumental study by van de Pol 1996 (upon which the following discussion is based) concerning prostitution in Amsterdam during the seventeenth and eighteenth centuries. For the history of prostitution in Utrecht, see van der Wurf-Bodt 1988.

24 Van de Pol 1996, pp. 307–17. Van de Pol (pp. 312–13) points out that the typical cost of a prostitute's clothing, as recorded in notarial documents, indicates that they wore cheap imitations of garments favored by elite women. However, these clothes were comparatively expensive for the strumpets who donned them.

25 For changes in the organization of brothels through the seventeenth and eighteenth centuries, see van de Pol 1985.

26 For the prevalent contemporary view of innately aggressive female sexuality, see, among others, van de Pol 1988a, p. 139; *idem* 1988b, pp. 170–72; and Dixon 1995, pp. 159–67 and *passim*.

27 For farces whose plots involve devious prostitutes, see, for example, van Santen 1617; Bredero 1617; and Hooft 1634. For stories of deceitful, conniving prostitutes in jest books, see, for example, *Cluchtboeck* 1637, pp. 135–8; *De geest van Jan Tamboer* 1659, pp. 144–45; and *Haerlemsche eerlycke uren* 1663, pt. 2, pp. 20–21. For jest books, see Schmidt 1986; Verberckmoes 1999, pp. 139–53; and Dekker 2001, pp. 25–40 and *passim*. See also Westermann 1997b, *passim*, who is the first historian of Dutch art to investigate exhaustively this rich body of source material.

28 For the following discussion, see van Stipriaan 1996b, pp. 1–105 and *passim*.

29 Sluijter 2000b, p. 294, observes that, "One could even say that the image of such a lovely woman also literally seduces the interested buyer because he must disburse a substantial sum to own such a beauty." Although Sluijter is discussing a painting by Gerrit Dou of a woman playing a clavichord (his fig. 239), his observations seem equally valid for van Baburen's picture. See also Honig 1998a, pp. 57–8. For an alternative viewpoint, which makes an intriguing though not entirely convincing attempt to place the display of coinage in images of prostitution within a broader economic context of monetary exchange as a regulator of desire, see Adams 1999.

30 For this picture, see Slatkes 1969, cat. no. A20; and Mainz 1997, pp. 30–32. Van de Pol 1990, p. 124, observes that the withered flesh of the procuress in brothel scenes contrasts with that of the nubile young prostitutes, thereby subtly underscoring the transitory beauty of the latter.

31 There is much evidence of a penchant among elites for comic ribaldry in art and especially in literature; see for example, Blok 1976, p. 7; van Stipriaan 1996b, pp. 29–30 and 163–5; Kleinmann 1996, pp. 240–42; Roodenburg 1997b, pp. 119–121; Verberckmoes 1999, pp. 59–82; de Jongh 2000a, pp. 46–58; and Dekker 2001, pp. 8–9, 15, and *passim*. See also the discussion of Barlaeus's Latin poem discussed later in this chapter.

32 For example, Eykbergh 1659, p. 268, fulminates against the types of scandalous art that he claims is commonly found in gentlemen's houses in some of the Netherlands' most splendid cities: "One finds there naked statues of men and women: one finds there whorish paintings: one sees such postures there that tender souls are astonished." (Daer vintmen naeckte beelden van Mans ende van Vrouwen: daer vindtmen hoerachtighe schilderijen: daer siet men soodanighe posturen/ voor de welcken de teeren zielen verbaest staen . . .) It was de Jongh 2000a

(originally writing in 1968–9), pp. 53–6, who first called attention to the observations of ministers and moralists concerning the dangers of erotic art works for viewers. De Jongh's observations were amplified by Eric Jan Sluijter in a number of studies, including Sluijter 1986, pp. 269–81; *idem* 1993, pp. 37–8; and *idem* 2000c, pp. 118–23. It should be pointed out that in all of these studies the author's primary focus was history paintings. However, Sluijter has applied these insights to genre paintings depicting women: see, for example, *idem* 1988a, pp. 156–9; and *idem* 1997, p. 219 n. 74.

33 For this painting, see Slatkes 1969, pp. 72–6, cat. no. A23. See also Slatkes 1995.

34 Slatkes 1995, p. 9.

35 Slatkes 1969, pp. 73–5; and *idem* 1995, p. 10. The print includes the inscription "Babeuren pinxit," or, "Baburen painted." Slatkes believes that the engraving most likely constitutes a variation on the painting under consideration here rather than a copy of a now-lost painting.

36 See further Amsterdam 1976, cat. no. 22; Worcester 1993, cat. no. 9; and Amsterdam 1997a, cat. no. 39.

37 Friedländer 1974, p. 84, first raised the question of the influence of picaresque novels on the subject matter of Caravaggist painting. I also benefited from a paper on the subject given by Ethan Matt Kavaler at the Institute of Fine Arts in a colloquium on Dutch painting held during the fall 1981 semester. See further Franits 1997a, p. 118; Porzio 1998; and Langdon 2001.

38 This novel was first published in Spain in 1554 – its author is unknown; see Rico 1984, pp. 1–29. For the picaresque novel in the Netherlands, see van Gorp 1978, pp. 57–61, 175–7, and *passim*; and Leemans 2002, pp. 53–68 and *passim*.

39 See for example, Aleman 1622, pp. 157–8.

40 Langdon 2001, p. 46, used the term "international craze" as she explored the relationship between picaresque novels and the art of Caravaggio and his circle.

41 Actual illustrations by Dutch artists of specific passages from picaresque novels are rare; see Leonaert Bramer's drawings of episodes from the popular novel *Lazarillo de Tormes* in Delft 1994, cat. nos. 6–11. Curiously, the Dutch translation of the picaresque novel by Quevedo 1642 is dedicated to the Friesian painter Wybrand de Geest (1592–c. 1662).

42 For ter Brugghen, see Nicolson 1958; Dayton 1965; Slatkes 1986–7; Utrecht 1986–7, pp. 65–170; and Slatkes 2000b.

43 Bok 1997, p. 379, posits that the artist might be identifiable with a certain Hendrick ter Bruggen, who in the spring of 1607 was named as a cadet in the army of Count Ernst

Casimir of Nassau-Dietz. If this person is indeed the painter then he could not have traveled to Italy until 1607 at the earliest.

44 For these paintings, see Nicolson 1958, cat. nos. A14 and A15; Utrecht 1986–7, cat. nos. 10 and 11; Moiso-Diekamp 1987, pp. 167–8, 487, cat. no. A3; and San Francisco 1997, cat. no. 41.

45 See Slatkes 1969, cat. no. A9 (who recognizes the participation of a second, inferior hand in this painting otherwise by van Baburen), and San Francisco 1997, cat. no. 37.

46 Slatkes 1996, pp. 199–200, addresses some of the scholarly objections to this hypothesis.

47 See Kettering 1983, pp. 37–41. Bok 1988, published an archival document dated 1623 concerning the disputed sale in Utrecht of an Italian picture of a flute player, attributed alternatively to the Italian Renaissance masters Correggio (?1489–1534) and Giorgione (c. 1477/78–1510). This document proves the presence of at least one Italian painting of a flute player in Utrecht during this period. Slatkes, writing in San Francisco 1997, p. 257, rightly points out that the figures' costumes in ter Brugghen's pendants are completely atypical for genre painting; although "we tend to refer to such paintings as 'genre,' it is unlikely that the patrons who commissioned and purchased such works would have thought of them as 'scenes of everyday life'."

48 As shall be discussed, Vermeer was well aware of the art of the Utrecht Carvaggisti: van Baburen's *Procuress*, owned by Vermeer's mother-in-law, appears in the background of two of his paintings (see fig. 157).

49 For pendants in seventeenth-century Dutch art in general, see Moiso-Diekamp 1987.

50 The following discussion is based on Slatkes's entries in Utrecht 1986–7, cat. nos. 10 and 11; and San Francisco 1997, cat. no. 42.

51 For this painting, see Utrecht 1986–7, cat. no. 14 (which includes a photograph of an x-ray revealing the alterations); Boston 1992, cat. no. 16; Franits 1993–4, pp. 81–2; and Raleigh 1998, cat. no. 11. As Sutton, writing in Boston 1992, p. 130, states, the man's masked disguise is familiar from contemporary images of *commedia dell'arte*. He adds that figures donning such masks sometimes mingle with figures in contemporary attire in genre paintings – see, for example, Philadelphia 1984, cat. no. 28.

52 Teeth and their associations are discussed in Chapter 2.

53 Van Beverwijck 1652, pp. 141–2, for example, admonishes old men to refrain from sexual activity because at their age it will hasten death by accelerating the process by which the body cools and drys out. See also de Jongh 1981–2, pp. 153–5. Franits 1993–4, surveys the often conflicting views of the elderly

and their ramifications for seventeenth-century Dutch and German art.

54 Stewart 1977, surveys the theme of unequal lovers in Northern European art of the fifteenth and sixteenth centuries. See also de Wildt 1995. For seventeenth-century depictions, which become far less frequent as the century progressed, see Braunschweig 1978, cat. no. 22; Amsterdam 1997a, cat. no. 9; and Westermann 1997b, pp. 218–25.

55 See the reproductions in Stewart 1977. See also Amsterdam 1997a, cat. no. 9. Authors of the era, when describing unequal couples, often call attention to the wrinkled, leathery skin of an old suitor; see, for example, *Den bloem-hof van de Nederlantsche ieucht* 1610, p. 77; and Bredero [1622] 1971, p. 44. Spies 1994, surveys the the theme of unequal love in literature from the sixteenth to the eighteenth centuries.

56 Stewart 1977, pp. 60–61, discusses the motif of glasses as a metaphor of moral deception.

57 For this painting, see Nicolson 1958, pp. 85–6, cat. no. A53; Müller-Hofstede 1988, pp. 19–21; The Hague 1990–91, cat. no. 15; Müller-Hofstede 1993, p. 45; and Raleigh 1998, cat. no. 12.

58 The standard study of the history of old age is Minois 1989. See also van Kooij 1987.

59 See for example, de Brune 1636, p. 253: "What is oldness? Nothing than coldness./ Oldness itself is nothing other/than sickness, and weakness with grief." (Wat is de oudheyd? Niet dan verkoutheid./ De oudheyd zelfs is anders niet,/ Als ziect', en kranckheyd met verdriet.) See also van Kooij, p. 456. Croon 1665, p. 369, calls old age one of the "three profferings of death" (dry boden des doodts). Cats 1632, Appendix after pt. 3, pp. 12–13, published a series of proverbs about old age, under the title: *Ouderdom, sieckte, doot* (Old Age, Sickness, Death). Laurentius 1599, pp. 176–7, contains a detailed yet poetic description of the physical problems experienced by the elderly. (Laurentius, the French physician to King Henri IV, ranks among the most respected medical authorities in Europe in the early seventeenth century.) Franits 1993a, pp. 161–94, contains a more detailed discussion of virtuous old age in seventeenth-century Dutch art and literature.

60 Cats 1665, p. 63, "Voorwaer den ouden dagen, die leyt ons tot de reden,/ Of sendt haer boden uyt door ons geheele leden;/ Sy klopt ons aen den arm, of borst, of swacken voet,/ En leert ons dat men haest van hier verhuysen moet." This passage is found in Cats's *Ouderdom* (Old Age), a book written when the author himself was well into his seventies. Like so many of his contemporaries, Cats relies upon literary *topoi* to describe old age and the conduct most befitting it. However, given the author's own

elderly state, it is difficult to dismiss the possibility that the book reflects personal experience. In it, Cats repeatedly states that people over sixty years old are elderly. Ripa 1644, p. 395, places old age between fifty and sixty years. On the question of what constituted old age, chronologically speaking, during the early modern period, see further Gilbert 1967; and de Jongh 1981–2, p. 154 n. 31.

61 Van de Venne 1623, p. 107. (For van de Venne, see further Chapter 5.) This literary *topos* is found in numerous works of the period; see, for example, de Brune 1636, p. 251. The *topos* of the elderly already having a foot in the grave is illustrated in the *pictura* of an emblem by Rollenhagen 1611–13, vol. 1, no. 75.

62 The observations of these authors may strike the modern reader as oxymoronic. Typical is the following passage from de Brune 1636, p. 72: "Through old age all things perish: But avarice and wisdom stand. There it all diminishes, ages and stiffens, avarice and wisdom remain" ("Door oudheyd alle dingh vergaet: Maer ghierigheyd en wijsheit staet. Daer't al verkleent, verout, verstijft, De ghierigheyd en wijsheyd blijft").

63 See Cats 1625, pt. 6, *voor-reden*, fol. 4 ★ iiijᵛ, and pt. 6, p. 24; Pers 1648, pp. 164–6; Brooks 1667, pp. 52 and 49–70.

64 For example, Messiae 1607, p. 165; and Pers 1648, p. 165.

65 Nicolson 1958, p. 86, identifies the old man's attire.

66 Van Veen 1607, pp. 40–41. Müller-Hofstede 1988, pp. 19–21; *idem* 1993, p. 45, cites this emblem in connection with the painting. Slatkes 2001, pp. 309–10, construes the *Old Man Writing by Candlelight* in more negative terms.

67 Van Leyden's painting is reproduced in Raleigh 1998, p. 103, fig. 2.

68 For the enduring impact of Netherlandish pictorial traditions for the work of the Utrecht Caravaggisti, see Kloek 1988.

69 For van Honthorst, see Judson 1959; Braun 1966; Utrecht 1986–7, pp. 276–302; Judson and Ekkart 1999; Papi 1999; and Slatkes 2000c.

70 Von Sandrart 1675–80, vol. 1, pp. 291 and 303.

71 No paintings by van Honthorst survive from the period of 1620–21 but he was undoubtedly active at that time. For *The Dentist*, see Judson 1959, pp. 77–9, cat. no. 191; Braun 1966, pp. 84–6, 161–3, and cat. no. 34; and Judson and Ekkart 1999, cat. no. 275.

72 This passage from an unpublished manuscript by Mancini is quoted by Judson 1959, pp. 40–41; and Judson and Ekkart 1999, p. 12.

73 It is not known whether *The Dentist* was commissioned directly by the Duke of Buckingham; nevertheless, the picture's presence in the Duke's collection must have attracted the attention of many English con-

noisseurs, thereby contributing to the decision to invite van Honthorst to the English court in 1628; see further Judson and Ekkart 1999, p. 212 n. 5.

74 See Braunschweig 1978, cat. no. 21; and Amsterdam 1997a, cat. no. 43. For two surveys of this theme in Netherlandish art (which can be traced to the late fifteenth century), written from the perspective of the history of dentistry, see Wasserfuhr 1977 and de Maar 1993.

75 New York 1985b, cat. no. 98, depicts a painting of a tooth-puller attributed to Caravaggio; this attribution has not been accepted by all Caravaggio scholars however.

76 Anthony Van Dyck, for example, received such a chain from his patron, Charles I of England. The artist wears it in one of his self-portraits (Cheshire, The Duke of Westminster). For artists' gold chains, see Becker 2002.

77 For the capacity of seventeenth-century Dutch paintings to deceive the viewer, see Sluijter 1988c, pp. 19–23 and *passim*; Brusati 1995, pp. 158–9, 162–8, and *passim*; Westermann 1997b, pp. 234–6 and 240–42; and Sluijter 2000a, pp. 258–61 and *passim*. Cropper 1991, pp. 197–9; and Langdon 2001, p. 51, address the concept of deception in pictures by Caravaggio and his Italian followers.

78 For this canvas, see Judson 1959, cat. no. 120; Braun 1966, cat. no. 65; Judson and Ekkart 1999, cat. no. 284; and Dekiert 1999. Young men interacting with prostitutes can be seen in paintings by ter Brugghen (Paris, Musée du Louvre and Ponce, Museo de Arte de Ponce); see Nicolson 1958, figs. 67 and 93.

79 However, as Müller-Hofstede 1988, pp. 28–9, points out, the use of silhouettes in painting was already codified in Netherlandish art theory.

80 The motif of the *kannekijker* enjoyed a long tradition within Netherlandish art; see, for example, some of the sixteenth-century images reproduced in Renger 1970, figs. 32, 76, 77, and 83.

81 Barlaeus 1628, vol. 2, p. 182. See Dekiert 1999, pp. 149–51. Dekiert's discovery of the poem in Barlaeus's published work is important because the section of van Honthorst's painting that contains the poem is in extremely poor condition. Therefore, not all of the verses have made sense to earlier scholars who attempted to transcribe them: see Judson 1959, pp. 206–7; and Braun 1966, pp. 205–6.

82 Barlaeus 1628, vol. 2, p. 182, "Epigramma in picturam Honthorstij pictoris Ultrajectini, qua vitam lascivientis inter scorta studiosi exhibebat: Ite procul siccae, nimis anxia pondera, chartae,/ Nec tenerum vexet pagina docta caput./ Thais amor meus est, studium

risusque, iocique/ Et Bromio petulans mixta puella Deo./ Victa gemit Pallas, dum me lasciva parentem/ Patricio tandem nomine virgo beat./ Sic malesana meos Circe transformat honores,/ Et studio-sus sum, qui studiosus eram." Donald Mills and Jeffrey Carnes, my colleagues at Syracuse University who specialize in classical Latin, kindly provided the translation.

83 For Thais, see Kroll and Mittelhaus 1934, cols. 1184–5.

84 Homer, *Odyssey*, bk. 10, vv. 233–43.

85 See Sluijter 1988a, pp. 157–8; *idem* 1997, pp. 85–6; and *idem* 2000b, p. 294. See also Westermann 1997b, 234–6 and 250–51 n. 121.

86 For essays addressing the significance, *in bono* and *in malo* of ponderous chiaroscuro in the work of the Caravaggisti (with many references to earlier studies), see Müller-Hofstede 1988; and Slatkes 2001. See also Rzepínska 1986, an erudite study that attempts to place the popularity of chiaroscuro in early seventeenth-century art within its broader historical and cultural context. Related as well is Seidel 1996, a study of the motif of the candle in art and its significance. Munich 1998–9 offers an exhaustive examination of night scenes throughout the history of Western art.

87 Dekiert 1999, argues that the painting is predominantly didactic on the basis of its reputed connections to contemporary prints of ill-advised, disrespectful youth. Moreover, Diekert associates van Honthorst's painting with "Cornelius literature." This term refers to a series of plays as well as small, illustrated books that discuss the antics of Cornelius, a stock figure who embodies the life of the dissolute, pseudo-student. Among Cornelius's many mishaps is his fathering of a bastard child. These plays, some of which were written by pastors, appear to have had a strong didactic component, but the same is not always true for the small, illustrated books with similar titles, intended for the university student market. Peter Rollos was an especially popular author of such books; for example, Rollos 1619. See also fig. 79. In my opinion, van Honthorst's painting can also be linked to the *topos* of the rowdy, lascivious student who appears in seventeenth-century Dutch literature; see, for example, *De Leydsche straat-schender of de roekeloose student* 1756. Judson and Ekkart 1999, p. 221, conclude, to my mind erroneously, that the painting represents a "complicated allegory illustrating the victory of love over scholarship combined with the idea of *vanitas*."

88 See Antwerp 1987, pp. 141–8.

89 For this picture, see Judson 1959, cat. no. 168; Braun 1966, cat. no. 49; Philadelphia 1984, cat. no. 48; Utrecht 1986–7, cat. no. 64; and Judson and Ekkart 1999, cat. no. 241.

90 For these precedents, see Utrecht 1986–7, p. 291, fig. 129; and Judson and Ekkart 1999, fig. 73.

91 As several scholars have noted, another painting by the artist, a *Singing Elder with a Flute* (Schwerin, Staatliches Museum), of the same year and approximate size as the *Merry Violinist*, may have belonged to this hypothetical series. For that painting, see Judson and Ekkart 1999, cat no. 244.

92 For example, the frontispiece to Ubeda 1605, depicts the novel's principal protagonists surrounded by the essential accouterments of those who lead the life of rogues; among the musical instruments illustrated there are a tambourine, drums, flutes, and a violin. This frontispiece is illustrated by Langdon 2001, p. 46, fig. 11.

93 See Judson and Ekkart 1999, cat. no. 253.

94 See Amsterdam 1976, pp. 60–61; Becker 1984, p. 23; de Jongh 1997, pp. 49–50; and *idem* 2000b, p. 16;

95 Salomon 1998b.

96 For this picture, see *ibid.*, p. 55, checklist no. 75; and Kunzle 2002, color plates 12–16 (with commentary), p. 370.

97 In fact, Duck's *Gallant Company* (Nîmes, Musées d'Art et d'Histoire) includes a copy of Codde's *Dancing Lesson* (fig. 47) on the background wall. For the *Gallant Company*, see Amsterdam 1976, cat. no. 18; and Salomon 1998b, pp. 111–12, checklist no. 59, fig. 101.

98 Salomon 1998b, p. 36.

99 The hopelessly convoluted plots of contemporary theatrical productions sometimes include hostage scenes, though these principally involve family members in conflict whereas paintings presumably depict soldiers and hostages who bear no relation to one another. Nevertheless, the tragic, emotional tenor of the former sometimes equals that of the latter; see for example, vanden Bergh 1621 and Coleveldt 1634. For actual abductions, most often occuring among the nobility where aristocrats would sometimes kidnap in the name of love and/or financial gain, see van Nierop 1993b, pp. 85–92.

100 For this painting, see Minneapolis 1985, cat. no. 9; Vienna 1992, cat. no. 41; and Salomon 1998b, pp. 84–7, checklist no. 18A.

101 Duyster, for example, who, as has been noted, influenced Duck, painted a sleeping soldier; see Paris 1991, cat. no. 15. For the motif of sleep in Duck's work and in Dutch art in general, see Salomon 1984; and *idem* 1998b, *passim*.

102 For this gesture, see Morris *et al.* 1979, pp. 147–60; Amsterdam 1997a, cat. no. 77; and de Jongh 2001.

103 For this etching, see Amsterdam 1997a, cat. no. 77.

104 Amsterdam 1997a, p. 363, fig. 1, depicts both gestures in a drawing by Albrecht Dürer

(1471–1528). See also de Jongh 2001, pp. 23 and 28.

105 See Salomon 1998b, pp. 28, 91, and *passim*, who argues that Duck's paintings were intended for members of the middle class.

CHAPTER FIVE

1 See the quotations in Neuman 1998–9, pp. 13 and 17. For overviews of The Hague in the seventeenth century, see Keblusek 1997, pp. 18–23 and 45–55; Frijhoff 1997–8; and Neuman 1998–9. See also Frijhoff 1997–8, pp. 11–12.

2 A recent, fascinating book by Knevel 2001, explores the world of bureaucrats in The Hague during the seventeenth century.

3 Lourens and Lucassen 1997, p. 109, record slightly lower statistics for The Hague's population at this time.

4 See the statistics published by Kubesek 1997, pp. 46–7.

5 Montias 1990, p. 61. For painting in The Hague during the seventeenth century, see Gaehtgens 1995–6 and Buijsen 1998–9.

6 Frederick v of the Palatinate and his Queen fled to the Netherlands after Protestant defeats in Bohemia at the opening of the Thirty Years War; see Chapter 1. For the Bohemian court in The Hague, see Keblusek 1997–8a. For the art market and patronage in The Hague, see The Hague 1997–8b and Vermeeren 1998–9.

7 As for Dutch art, Frederik Hendrik and Amalia van Solms were fond of paintings from Haarlem and especially Utrecht; see van der Ploeg and Vermeeren 1997–8b, pp. 55–6; and The Hague 1997–8b. Buijsen 1998–9, p. 32, table 3, demonstrates that a majority of painters in The Hague practiced portraiture.

8 Buijsen 1998–9, pp. 46–7, reproduces a late seventeenth-century map of The Hague which indicates the locations of the homes of many of the city's most prominent artists.

9 For the *Confrerie*, see Rehorst 1995–6; and Buijsen 1998–9, pp. 41–3. The latter states that only after 1719 did the *Confrerie* become known as the *Confrerie Pictura*; p. 40 n. 26.

10 According to Keyes 1984, p. 35, "The artist as a pace setter became the artist as a taste maker. He was progressively more influenced by current taste in The Hague . . ."

11 The Hague 1998–9, p. 86, notes that van Bassen was probably the grandson of the clerk of the Court of Holland in The Hague. Furthermore, Leidtke 1991, p. 37, citing a communication from Bernhard Vermet, states that van Bassen stemmed from a family of the lesser nobility in eastern Holland. This supposition is further amplified in New York 2001b, p. 222. See also Vermet 2000, p. 13.

12 See Keyes 1984, p. 86. Van Bassen and van de

Velde jointly executed at least one painting of a garden party, a theme, as already noted, that was already part of the latter's repertoire. For this picture (Vienna, Kunsthistorisches Museum), signed by van de Velde and dated 1624, see Keyes 1984, cat. no. 65, color plate XVII.

13 For this painting, see Keyes 1984, cat. no. XXVI, who dates it to the early or mid-1620s. See also New York 2001, cat. no. 7, where Axel Rüger proposes the date of around 1618–20 on the basis of the figures' costumes (p. 226).

14 See Keyes 1984, pp. 86–7 (quoting archival discoveries made by Abraham Bredius in the early twentieth century). See also Montias 1982, pp. 198–9. The very same document includes the following item: "A Banquet in which Esaias van de Velde painted the figures, 150 guilders." This laconic description could refer to one of van de Velde's garden parties but more likely refers to another joint collaboration with an unidentified painter.

15 The classic study of apes in art is Janson 1952. However a fettered ape is one that is restrained so one can also argue that the motif represents profligate desires under control. Keyes 1984, p. 90, links the poses of the dandy and women in the foreground of the painting to an engraving (after a drawing by Karel van Mander) of a young reveller and prostitutes (see Keyes 1984, fig. 50), with a moralizing inscription.

16 See Liedtke 1991, p. 33.

17 Axel Rüger writing in New York 2001, p. 226.

18 For Hans Vredeman de Vries, see Lemgo 2002.

19 For the convincing theory of a regional style in South Holland and Zeeland, see Liedtke 1984; *idem* 1988; *idem* 2000, pp. 145–8 and 151–68; *idem* 2001, pp. 135–8. *Idem* 2001, points out that regional styles appear less pronounced after 1650. Middelburg, where Adriaen van de Venne resided before his relocation to The Hague in 1625, was a major center for Dutch painting (particularly still-life painting) during the early seventeenth century; see Amsterdam 1984.

20 See Chapter 11.

21 De Bie 1661, p. 234. See also Royalton-Kisch 1988, pp. 37–8; Bol 1989, pp. 13–15; and Royalton-Kisch 2000, pp. 360–61.

22 Cats 1625. The illustration reproduced here is found in pt 4, fol.. 95r. Van de Venne cleverly included one of his own paintings as a picture adorning the wall of a well-appointed interior depicted in Cats 1625, pt. 5, p. 25. This picture-within-the-picture depicts the Prince of Orange and his retinue on horseback and corresponds closely to the artist's painting in Darmstadt, Hessisches Landesmuseum (Bol 1989, p. 68, fig. 58). Bol 1989,

pp. 112–41, contains a lengthy discussion of van de Venne's activities as a book illustrator. See also Royalton-Kisch 1988, pp. 51–3. Van de Venne also provided the drawings for the illustrations in Quintijn 1629: see Kolfin 2001; and fig. 49 in this book.

23 See Liedtke 1984, pp. 330–33.

24 For photographs of paintings from van de Venne's Middelburg period, see Bol 1989, pp. 11–76. During this period, the artist executed at least one painting of a garden party; see Briels 1997, p. 88, fig. 11.

25 For example, Amsterdam 2000, cat. no. 246. See also Amsterdam 2000, cat. 137, for a portrait that van de Venne painted of Maurits in about 1618, in other words, when the artist still was residing in Middelburg.

26 See, for example, Bol 1989, p. 70, fig. 60.

27 For this picture, see New York 1988, cat. no. 51; Boston 1992, cat. no. 151; Westermann 1999a, pp. 46–7; and *idem* 1999b, pp. 238 and 248–9. (Westermann's excellent article forms the basis for the discussion here.) Van de Venne's earliest work in grisaille dates to 1621; however, this technique did not dominate his output until after his move to The Hague in 1625.

28 Technically speaking, *Fray en Leelijck* is a brunaille as opposed to a grisaille which in its most strict definition refers to monochrome painting executed in shades of gray. As Krieger 1996, p. 672, observes, "The term grisaille, as commonly used today, itself only inadequately describes the various modes it subsumes. Their only common feature is the more or less exclusive use of non-coloured pigments, while they diverge technically and aesthetically to an often astonishing extent."

29 See Houston 1974; and Krieger 1996.

30 Westermann 1999c, p. 238. On a more practical level, grisailles were occasionally used as *modelli* for engravings or polychrome paintings.

31 Houston 1974 contains numerous examples of both types.

32 See Westermann 1999c, p. 238, who points out that van de Venne articulated strands of hair by scratching through the upper paint layers of the picture with a semi-sharp instrument, just as Rembrandt had done in his early self-portraits.

33 See The Hague 1994, cat. no. 43, a representation of a poor, beggar couple by van de Venne with the inscription *Armoe soekt list* (Poverty Leads to Cunning). This picture is polychrome but is clearly related to the artist's grisailles (see Plokker 1984, no. 19). Van de Venne occasionally produced polychrome versions of grisaille subjects to expand the overall market for such imagery (to be discussed later in this chapter). The old man playing the hurdy-gurdy in *Armoe soekt list* is strongly reminiscent of the flute player in *Fray en Leelijck*.

34 Plokker 1984, p. 15. Plokker's hypothesis concerning the homonym *grauw* was criticized by van Thiel 1986, p. 67, whose critique was in turn effectively rebutted by Westermann 1999c, p. 254 n. 13.

35 Westermann 1999c, pp. 248–9. See also Miedema 1984, pp. 5, 11–12, 15–16, and *passim*. Bol 1989, pp. 83–4, provides numerous other examples of homonyms in van de Venne's grisailles. See also Plokker 1984. Van Vaeck 1988, pp. 103–7, discusses seventeenth-century definitions of homonymy including van de Venne's own understanding of the term.

36 For seventeenth-century attitudes toward poverty and beggary, see Amsterdam 1965–6; Braunschweig 1978, pp. 133–4; Reinold 1981, pp. 13–47; Muller 1985, pp. 72–5 and *passim*; Tóth-Ubbens 1987; van Wijngarden 2000; and van der Vlis 2001.

37 For the fusion of sophisticated painting styles with base imagery, see also Falkenburg 1991, pp. 136–7. From her preliminary survey of owners of van de Venne grisailles, Westermann 1999c, p. 251, observes that they were "recorded in a wide range of inventories and sales, in most major cities of Holland, including Amsterdam, The Hague, Haarlem, Leyden, and Dordrecht." Van de Venne simultaneously made grisailles with more traditional, elevated subject matter, for example, his portraits of the exiled King of Bohemia, Frederick v of the Palatinate and his wife, Elizabeth; see Bol 1989, p. 71, fig. 62. De Bie 1661, p. 231, mentions still other pictures of this sort painted for the Prince of Orange and the King of Denmark; see further Westermann 1999c, p. 244.

38 See Westermann 1999a, pp. 46–7; *idem* 1999b, pp. 245–9. See, however, the recent article by Vaeck 2001, which challenges this hypothesis. Vaeck believes that these images should more suitably be associated with the ancient tradition of rhyparography, namely, the depiction of base and trivial subjects in painting.

39 See further Westermann 1999c, p. 251. See also note 37 above.

40 See note 33 above.

41 Plokker 1984, pp. 15–16.

42 See Bol 1989, pp. 94 and 99, fig. 83, who records the date 16[5]2; and Plokker 1984, no. 22, who records the date as 1650. *Ibid.*, also enumerates some lengthier versions of this proverb, which appears in a "truncated form" on the panel.

43 For the phenomenon of the tonal or monochromatic style, see the discussion in Chapter 3.

44 For the theme of the *kermis* in Dutch art, see Chapter 3.

45 See the discussion in Chapter 3.

46 Van de Venne 1635. See Royalton-Kisch 1988, pp. 54–7; van Vaeck 1994a; *idem* 1994b; and

Westermann 1999c, pp. 233–4, 237–8, and *passim*. Van Vaeck 1994a, vol. 3, pp. 826–60, explores van de Venne's reputation as an author and his influence among contemporaries.

47 For an illustration of this quack at work, see van de Venne 1635, p. 99. See also Fresia 1991, pp. 212–16; and van Vaeck 1994a, vol. 3, pp. 754–6. Van de Venne identifies him as a "*vrije meester*," literally, "free master"; as noted in Chapter 2, *vrije meesters* were largely self-taught and often specialized in a single procedure or care for a particular type of illness or injury. The illustration in van de Venne 1635 recalls the artist's depiction of a quack dentist (Sibiu, Muzeul Brukenthal), reproduced in Bol 1989, p. 95, fig. 84. For quacks in contemporary comedy, who, incidentally, often have German accents, see Dekker 2001, pp. 125–7.

48 Van de Venne 1635, p. 151. (The translation is taken from The Hague 1994, p. 306.) This passage belongs to a section of van de Venne's book that itemizes forty-two different types of fiendish beggars; see Westermann 1999c, p. 255 n. 19.

49 For these glosses, see van Vaeck 1994, vol. 3, pp. 804–25; *idem* 1994b, pp. 22–3; and Westermann 1999c, p. 234.

50 See the classic study by Hagstrum 1958; Lee 1967; and more recently Gent 1981; and Weber 1991.

51 In other instances, however, the didactic aspects of the grisailles remain in the forefront; see, for example, van de Venne's comical representation of a horse defecating coins as people of all social stripes greedily gather them (Budapest, Szépmüvészeti Múzeum), inscribed, *Alle menschen behaegen* (It Pleases Everyone). For this picture, see Utrecht 1987, cat. no. 41. Curiously, van de Venne's most explicitly moralizing grisailles frequently include figures who belong to the upper classes.

52 Although van de Venne's grisailles were initially targeted at elite buyers (and then, as has been discussed, were marketed to a broader audience), his *Tafereel van de belacchende werelt* was intended for a wider readership; see van Vaeck 1994a, vol. 3, pp. 629–31, 863.

53 I deliberately say "a high point" as opposed to "the high point" because of the presence of Jan Steen in The Hague during the early 1650s (see Chapter 14) as well the talented portraitist and genre painter Caspar Netscher who moved to The Hague in 1662 (see Chapter 7). Samuel van Hoogstraten also executed a few genre paintings there in the early 1670s (see Chapter 10).

54 Liedtke 2001, pp. 51–3.

CHAPTER SIX

1 For the following overview, see Israel 1989, pp. 197–291; *idem* 1995, pp. 610–19; de Vries and van der Woude 1997, pp. 409–503 and 672–5; and Troost 2001, pp. 13–79.

2 For Johan de Witt, see the monumental study by Rowen 1978.

3 De Vries and van der Woude 1997, pp. 673–5, place the onset of the decline of the Dutch economy in the early 1660s; see further Chapter 15.

4 The city of Delft emerged as an important art center not really because of its own economy, which had stagnated somewhat by the middle of the century, but because of its proximity to The Hague. As noted in Chapter 5, Delft artists eventually captured a large share of the market for genre pictures in The Hague. See also Chapter 11. Israel 1997, p. 476 n. 99, attributes the rise of schools of painting in Holland's port cities (among them, The Hague, Rotterdam, and Dordrecht) to the general expansion of the economy. Since this expansion largely bypassed inland areas of the Dutch Republic cities such as Utrecht experienced a decline as art centers; see further, *idem* 1995, pp. 612–18. For Utrecht's demise, see Bok 1994, pp. 176–7 and *passim*.

5 Among the classic studies of aristocratization are: Roorda 1964; and *idem* 1978, pp. 38–9 and *passim*. However, recent research has modified certain aspects of Roorda's hypothesis; see Spierenburg 1981, pp. 19–31. See also Streng 1997, pp. 30–33; and Kooijmans 1987, pp. 100–01, who argues convincingly that it was not the goal of every patrician to become a member of the aristocracy, nor was it even expedient. See also de Jong 1987; Noordam 1994; and Palmen 1998, pp. 218–20. At the same time, members of the nobility continued to maintain their privileged position within the Republic. As van Nierop 1993b, p. 217 and *passim*, has shown, the nobility may have shared political power with the urban patriciate but they "carefully guarded their exclusivity by defending their privileges, by emphasizing their social distance from other groups, and most of all by endogamy." See also Wijsenbeek-Olthuis 1996b.

6 Spierenburg 1981, pp. 19–31. Burke 1994, pp. 131–2, adopts an interesting quantitative approach to the problem of aristocratization. In Burke's view a true measurement of having achieved aristocratic status is whether or not a person maintained an occupation and whether he owned a country house. On the basis of statistics presented on p. 132, Burke argues that the shift toward aristocratic lifestyles was a gradual one, as opposed to a sudden one, and that it became predominant only around 1700. Yet Burke's statistics appear to contradict him: during the years 1650–72, the number of elite citizens without occupations doubled while the number who owned country houses increased fourfold. In my opinion, this statistical evidence suggests a less protracted process of aristocratization, one that predominated earlier than Burke allows. Paradoxically, this evidence is more consistent with Spierenburg's argument than with Burke's. For the phenomenon of country-house construction in relation to aristocratization, see Schmidt 1977–8, esp. pp. 441–6. See further Chapter 13.

7 Elias 1978; and *idem* 1982. Elias's seminal studies first appeared in German in 1939.

8 For the linking of these aspects of public life with civility, see Spierenburg 1981, pp. 5–13; Elias 1978; Muchembled 1990, pp. 165–233; Roodenburg 1991a, pp. 23–5 and 29–35; *idem* 1997a; and *idem* 2000.

9 For a study of elite entertainment in the early modern period, including art, literature, and the theater, see de Jongste *et al.* 1999. In recent years, the links between civility and Dutch art have been increasingly investigated: see, for example, Smith 1987a, p. 423; *idem* 1988, p. 52; L. de Vries 1991, pp. 229–30; Franits 1996; Salomon 1996, pp. 55–6; Westermann 1997, p. 100 and *passim*; Salomon 1998a; *idem* 1998b, p. 125; Kettering 2000, pp. 114–15; de Jongh 2000a, pp. 46–58; Becker 2001; and Franits 2001. See also Roodenburg 1991a, pp. 23–5 and 29–35; *idem* 1997a; and *idem* 2000.

10 Roodenburg 1991b, pp. 154–7, observes that most of the publications in translation of foreign civility manuals appeared in the Dutch Republic after 1650. This is probably no mere coincidence given the intensification of concepts of civility there after the middle of the century. Such manuals are discussed in more detail in Chapters 15 and 18. Interest in "civility offensives" among the regents, via their proclamation of placards intended to control public behavior and hence promote a "modern lifestyle" among the populace reflecting their own values, likewise peaked around the middle of the century, at least in the city of Utrecht; see Bogaers 1985. See also Dorren 2001, pp. 91–2.

11 See, for example Prynne 1639, pp. 37, 49, 50, and 73; and Voetius 1772, pp. 23, 26, and 28, who remarks that plays are so unchaste that they differ little from whorehouses and are perhaps worse since they show sordid things in public. The Calvinist reaction to seventeenth-century Dutch theater has been well-studied; see for example, Groenendijk 1986; *idem* 1989; Pels [1681] 1978, pp. 11–16; and van Stipriaan 1996b, pp. 174–6.

12 Leuker 1992, pp. 108–310. See also van Stipriaan 1994.

13 For example, Wijsenbeek-Olthuis and Noordegraaf 1993, pp. 51–2; Israel 1997, p. 468; and Goosens 2001, pp. 366–70.

14 In the Introduction, it was noted that the evidence strongly suggests the coexistence of two disparate markets (with some overlap naturally) servicing clientele of differing financial means by providing pictures of diverse quality and cost through a variety of venues.

15 Goosens 2001, p. 370. See further the discussion that follows in the chapters comprising this part of the book.

CHAPTER SEVEN

1 For ter Borch, see Gudlaugsson 1959–60; The Hague 1974; and Kettering 1988.

2 For the artistic and cultural scene in seventeenth-century Zwolle, see Zwolle 1997. See also Streng 1997.

3 For ter Borch's childhood, see Gudlaugsson 1959–60, vol. 1, pp. 10–20; and Kettering 1988, vol. 1, pp. xxix–xxxi. Kettering 1998, vol. 1, p. 92, cat. nos. GJr 1–GJr 18, reproduces some extraordinary drawings that the artist made as a child. These drawings form part of the studio estate of the ter Borch family, now preserved at the Rijksprentenkabinett in Amsterdam. For one of Gerard ter Borch the Elder's rare paintings, see Zwolle 1997, cat. no. 1.

4 Gudlaugsson 1959–60, vol. 2, pp. 15–16, transcribes a letter, dated 3 July 1635, written to ter Borch while he was in London by his father. Ter Borch's painting of the oath ratifying the Treaty of Münster is now in the National Gallery in London; see The Hague 1998.

5 See Montias 1989, pp. 101–3 and 308 doc. no. 251.

6 Ter Borch was only one of a number of artists who influenced the course of genre painting at this time. To their ranks can also be added Gerrit Dou (see Chapter 8), Jacob van Loo (see Chapter 12) and Gerbrand van den Eeckhout (see Chapter 12).

7 Mirrors and their meanings are discussed in greater detail in Chapter 8. For a rare and truly exquisite toilette set made in the same decade as ter Borch's painting, see Newark 2001–2, cat. no. 113.

8 For Duyster's influence upon ter Borch, seen in the rendition of fabrics as well as the generally reticent air of their pictures, see Gudlaugsson 1959–60, vol. 1, p. 42 and *passim*; and Playter 1972, pp. 133–4. See also note 41 below.

9 For the following remarks, see Kettering 1999, pp. 46–50.

10 The English term alderman best describes ter Borch's position as a representative of his ward on Zwolle's *Gezworen gemeente*.

11 For ter Borch's patrons in various cities within the Province of Holland, see Gudlaugsson

1959–60, vol. 2, cat. nos. 99, 114, 121, 122, 141, and C65. See also Kettering 1997, p. 106, and p. 115 where she states that ter Borch's works "would have been owned and viewed by middle class persons." However, the scant information we have about the prices of his works – found in death inventories where notaries routinely underestimated their worth – indicates that owners of his pictures were frequently upper middle class at the very least (see, for example, the prices listed in note 12 below). Gudlaugsson 1959–60, vol. 2, pp. 251–75, contains a section documenting lost portraits and genre paintings by ter Borch and the values assigned to them by notaries.

12 Gudlaugsson 1959–60, vol. 2, p. 25, where a painting of soldiers is valued at 60 guilders and one representing a shepherdess is valued at 120 guilders.

13 See *ibid.*, vol. 1, p. 120, and vol. 2, cat. no. 146a.

14 For this painting, see *ibid.*, vol. 1, pp. 116–19 and vol. 2, cat. no. 139; Smith 1987a, pp. 422–3; Kettering 1997, pp. 98, 113–14; and Washington D.C. 1995, pp. 26–30.

15 Groeneweg 1997–8a, p. 211, observes that, "In paintings of Dutch interiors which offer a glimpse of life in well-to-do circles, such as those by Vermeer, Metsu and ter Borch, the different rules of etiquette governing the wearing of black for men and women are often expressed in their clothes. The gentlemen are dressed in black silk, even at home, but the ladies are *chez elles* in their colorful silk *déshabillés*, embellished with gold and silver lace." She adds that "After 1660 black began to lose some of its value as formal wear for gentlemen of rank." See also *idem* 1995.

16 Sutton 1984, p. xlv, and Arthur K. Wheelock, Jr., writing in Washington D.C. 1995, p. 27, claim that the two principal figures in ter Borch's painting are making obscene gestures. However, as Kettering 1997, pp. 226–7 n. 66, observes, this hypothesis is inconsistent with the tone of the painting. Moreover, gestures were rigidly codified in early modern Europe; if the woman is indeed making an obscene gesture she does so incorrectly. The position of her hands superficially resembles the fig gesture (discussed in Chapter 4) but this is always made with one hand, not two (see fig. 81). The male's gesture – if it is even supposed to represent a specific gesture – was most frequently (though not exclusively) construed as one of approbation; see Morris *et al.* 1979, pp. 99–118.

17 Kettering 1997.

18 Forster 1969 remains the principal study of Petrarchism in European literature. For its influence in Dutch literature, see Ypes 1934. See also Roose 1971, pp. 18–23.

19 For example, van Veen 1608, p. 185; Hooft [1611] 1983, nos. 3, 15, 21, and 24; and Heinsius 1616, nos. 32 and 39.

20 See Kettering 1988, vol. 2.

21 The following observations are drawn from Kettering 1997, pp. 102, 103, 110, and *passim*.

22 See further Franits 1993a, pp. 31–4; and Apeldoorn 1989.

23 Gudlaugsson 1959–60, vol. 1, pp. 116–17 attempts to link the picture to a contemporary emblem warning of the dangers of false hopes in courtship (followed by Washington D.C. 1995, p. 27). The resultant insertion of a moralizing tenor into the picture is inconsistent with its tone despite the superficial resemblance between its *pictura* and the painting. It thus epitomizes the problems of invoking emblems as sources to interpret paintings (see further the Introduction).

24 As shall be discussed in Chapter 11, Vermeer's paintings are equally ambiguous.

25 Kettering 1997, p. 113.

26 By comparison, the cost of genre paintings by leading artists during the earlier seventeenth century varied sufficiently to make some of them affordable for members of the middle class (see Chapters 3 and 5). However, as the decades progressed, middle-class collectors were increasingly unable to purchase similar types of pictures, a fact not always recognized by historians of Dutch art. To the contrary, a surprising number of scholars continue to argue that Dutch genre paintings were primarily marketed to middle-class audiences.

27 For this painting, see Gudlaugsson 1959–60, vol. 1, pp. 114–17; vol. 2, cat. no. 143; The Hague 1974, cat. no. 41; Philadelphia 1984, cat. no. 10; Philadelphia 1990, cat. no. 10; Frankfurt 1993, cat. no. 11; and Kettering 2000, pp. 110–15. Sutton n.d., pp. 9–10, convincingly argues that ter Borch's *Woman Sealing a Letter* (private collection; Gudlauggson 1959–60, vol. 2, cat. no. 144) is the pendant to his *Officer Writing a Letter, with a Trumpeter*. Earlier scholars had erroneously recorded this picture's dimensions and consequently did not link it to its pendant.

28 For the following observations, see Kettering 2000, pp. 110 and 113.

29 For ter Borch's early drawings of soldiers, see, for example, Kettering 1988, vol. 1, cat. nos. GJr1 and GJr2. For his early paintings of soldiers, see Gudlaugsson 1959–60, vol. 1, figs. 6, 11, 12, 21, and 25.

30 For these motifs, see Kettering 2000, pp. 113 and 114. In the seventeenth-century, love was also thought to reside in the liver in addition to the heart; see Veenstra 1968, pp. 107–8.

31 The following remarks are drawn from Kettering 2000, pp. 110–15, and the fascinating discussion of trumpeters by Kunzle 2002, pp. 608–12, drawn from among other sources, the letters of Constantijn Huygens, who in his capacity as secretary to the Prince of Orange, Frederik Hendrik (see Chapter 1), accompanied him on military campaigns.

32 See Kunzle 2002, p. 611. Kunzle points out that trumpeters enjoyed diplomatic immunity and were therefore usually unarmed – yet ter Borch's trumpeter carries a sword.

33 Gudlaugsson 1959–60, vol. 2, cat. no. 144, identifies our painting as the possible picture by ter Borch listed in Oortmans-de La Court's death inventory as a "Een trompetter en krijgsoverste."

34 Puget de la Serre 1658, p. 70 no. 142. A Dutch edition of this French work was first published in 1651. Puget de la Serre's popular tome provides evidence of the surging interest among the Dutch after the middle of the century in all things French, particularly objects and phenomena associated with gentility and civility; see further Chapter 15.

35 Kettering 2000, p. 114. See also Kunzle 2002, pp. 30 and 598–600, who perhaps ties post-1648 images of soldiers too closely to the diminished circumstances of the army in this era in which the regents dominated national politics (see Chapter 6). Equally problematic is his thesis (p. 620) that ter Borch's renditions of "domesticated soldiers" were conditioned by his own political views, a "personal defensive and neutralizing reaction" to disorder caused by soldiers whose *esprit de corps* had been greatly lessened by the political situation. Helgerson 2000, pp. 79–119 (based on an earlier article), offers a similarly fascinating yet not entirely convincing political reading of paintings of soldiers by ter Borch and his colleagues.

36 For this picture, see Gudlaugsson 1959–60, vol. 1, p. 124; vol. 2, cat. no. 164; Philadelphia 1984, cat. no. 12; and Kettering 1997, pp. 98 and 111.

37 See de Winkel 2001, pp. 60–61. The fact that ter Borch's modish female holds a handkerchief contradicts de Winkel's statement that by the middle of the century, younger women no longer carried what had become an outdated fashion accessory (p. 60). Although ter Borch's picture does not transcribe contemporary life directly many of the garments and furnishings that he portrays do approximate current fashions.

38 Of interest in this context of evolving civility and personal accessories is an anonymous portrait (in my opinion wrongly attributed to Cornelis de Man; for this artist, see Chapter 17) of a family at the dinner table. The oldest son is depicted dabbing his mouth with a large napkin as a sign of his good breeding. For this portrait, see Newark 2001–2, cat. no. 82.

39 For example, Houbraken 1753, vol. 3, p. 39. Similarly, Houbraken, vol. 3, p. 174, observes that Eglon van der Neer (see Chapter 18) painted merry companies dressed in the modern manner of ter Borch. Likewise, in the biography of Adriaen van der Werff (see

Chapter 18), recorded by his son-in-law, it is said that this artist painted satin dresses and other garments in the "modern manner" of ter Borch. For this passage, see Gaehtgens, 1987a, p. 433.

40 See van de Wetering 1993, pp. 30–35.

41 During his stay in London in 1635 ter Borch received a mannequin from his father; see the letter transcribed in Gudlaugsson 1959–60, vol. 2, pp. 15–16. The mannequin may have been used as an aid in painting clothing. In this context, it is also tempting to speculate that ter Borch had seen paintings by Orazio Gentileschi (1563–1639) during his stay in London. Gentileschi, who resided in London between 1626 and 1639, was one of Charles I's court painters. The Italian master was renowned for his extraordinary rendition of fabrics, including satin.

42 Kettering 1997, p. 103. See also van der Wetering 1993, p. 35.

43 Peter C. Sutton writing in Philadelphia 1984, p. 150, itemizes some of the motifs that appear continuously in ter Borch's paintings.

44 Fock 1998; and idem 2001–2. See also Wijsenbeek-Olthuis 1996a. The furnishings depicted in Dutch genre paintings are discussed in more detail in Chapter 11.

45 Fock 1998, pp. 223–5; and idem 2001–2, p. 96, points out that in those rare cases when chandeliers appear in domestic inventories, they are itemized as "church chandliers."

46 See Kettering 1997, pp. 102–3.

47 For this painting, see Gudlaugsson 1959–60, vol. 1, pp. 133–4; vol. 2, cat. no. 189; Amsterdam 1976, cat. no. 1; and Philadelphia 1984, cat. no. 15.

48 See Amsterdam 1976, cat. no. 1, with several contemporary literary references to this metaphor. There is also an ornate, silver platter on the table whose contents are difficult to determine. According to Schama 1987, p. 433, it contains oysters, but it may only hold fruit; there is a prominent peach, sliced in half, lying upon it.

49 Kunzle 2002, p. 613, makes the cogent observation that the bottom-most button of the four on the soldier's breeches, in other words, the one nearest his crotch, is conspicuously undone. Kunzle also sees a "blunt sexual threat" in the placement of his huge, square military boot-toe adjacent to the delicate, shoe-point of the young lady.

50 Alpers 1997, p. 64, paraphrases a story from a fictitious "guide" to Amsterdam's whorehouses, 't Amsterdam Hoerdom 1681, pp. 31–2, in which a male visitor to a brothel is confused by an elegantly dressed woman wearing a wedding ring. When he asks his guide, the devil, why a man would take his wife to just such a place, the devil responds that this is not his wife but a whore. See also the clothing worn by prostitutes in van de Passe 1631.

51 See van de Pol 1996, p. 307–17.

52 Kettering 1997, p. 114.

53 Brazen display of the female anatomy in genre paintings from the later seventeenth century is most often seen in pictures by less talented masters who usually worked for relatively unsophisticated clientele; consider, for example, the art of the now obscure painter Johannes Tilius (d. after 1694); see The Hague 1998–9, p. 352.

54 Burke 1978a, pp. 3–6 and 20; idem 1978b, pp. 23–9 and 270–81; Bogaers 1985, pp. 120–21 and passim; Muchembled 1990, pp. 111–21 and passim; Frijhoff 1992a, pp. 25–31 and passim; Burke 1994, pp. xix–xx; and Leemans 2002, pp. 168–9. See also Frijhoff 1984.

55 The possession of taste, like other aspects of civility, provided a means by which elites – or those who aspired to be part of the elite – could distance themselves from the masses. In this sense, the adoption by artists of specific painting styles can sometimes be said to convey values centering around good taste, intelligence, sophistication, and superiority. Naturally, the masses were identified with popular taste which was considered debased because it was unlearned and sense-oriented; see Moriarty 1988, pp. 96–7 and 190–91. (To my knowledge, no comparable, comprehensive study exists of taste in the Netherlands during this period, but see the comments of Jansen 2001, pp. 335–42.) See further Chapter 12.

56 For following discussion, see Wieseman 2002, pp. 23–35.

57 Ibid., p. 26.

58 Ibid., p. 53.

59 See ibid., pp. 53–7, who notes the strong thematic connection between these pictures and those by ter Borch.

60 For this painting, see London 1992b, pp. 245–7; Franits 1993a, pp. 1, 76–80, from which the following analysis is drawn; and Wieseman 2002, p. 57, cat. no. 16.

61 This very same symbol of clasped hands appears on pairs of embroidered bridal gloves that have actually survived to this day; see du Mortier 1984.

62 For the motif of clasped hands, see Haarlem 1986b, p. 54, cat no. 28, and passim.

63 See Wieseman 2002, p. 57. For Vermeer, see Chapter 11.

64 See Franits 1993a, pp. 97–100.

65 See for example, Amsterdam 1976, cat. nos. 64 and 68; and de Jongh 2000a, pp. 33–4.

66 Plutarch 1575. A reprint of Plutarch's book is appended to van Marcon-velle 1647, pp. 200–45. Curiously, the 1575 reprint contains only forty-three laws while van Marcon-velle lists forty-nine.

67 Plutarch 1575, no. 25; and van Marcon-velle 1647, pp. 224–5 no. 31.

68 For example, Houwaert 1622–3, vol. 2, p. 651; and Hazart 1678, p. 259.

69 For example, Eddy de Jongh, writing in Haarlem 1986b, pp. 44–5, also cites Plutarch's book as an important source for interpreting portraits of families playing instruments as metaphors of concord; see Plutarch 1575, no. 8. Unworn shoes as domestic metaphors also appear in sixteenth- and seventeenth-century emblem books, for example, and Corrozet 1543, fol. N viii. b; and Coornhert 1610, no. 23.

70 See Amsterdam 1976, cat. no. 51; and Cheney 1987.

71 Van de Venne 1623, p. 97, "Vorsse-mossels, zijn gheleken/ Met de seegbaer vrouwen-lien,/ Die beset, en eerbaer spreken,/ En na 't huys staegh ommesien/ Wijven moeten al sté-vast/ Dregen, mossel-huysigh-last." Cats 1625, pt. 4, fol. 91ᵛ, employs similar imagery in advising wives about proper conduct while their husbands travel: "leeft om desen tijt gelijck een mossel doet" (live at this time like a mussel does). See also the broadsheet after van de Venne of a mussel-man which includes these verses; illustrated and discussed in Amsterdam 1997a, cat. no. 47.

72 For this picture, see Naumann 1981, vol. 1, pp. 112–13; and Wieseman 2002, p. 60, cat. no. 45.

73 As suggested by Naumann 1981, vol. 1, p. 113. The scholarship on melancholia and art is voluminous; see, for example, Klibansky, Panofsky, and Saxl 1964.

74 See Bedaux 1975; Petterson 1987; Dixon 1995; and Petterson 2000.

75 Ferrand [1623] 1990, pp. 238 and 243. See also van Beverwijck 1656, pp. 33–45; and Petterson 2000, pp. 293–314.

76 These popular notions were heavily influenced by Petrachan sentiments, something which Ferrand 1623, p. 243, belittles.

77 Wieseman 2002, p. 67.

78 For this painting, which is falsely signed and dated 1670, see Southampton 1978, cat. no. 18; London 1991, vol. 1, pp. 283–4; and Wieseman 2002, cat. no. 94.

79 This tazza is now in the Rijksmuseum in Amsterdam.

80 De Jongh 1967, pp. 81–5. For other images of bubble-blowers and their vanitas associations, see Amsterdam 1976, cat. no. 4; and Amsterdam 1997a, cat. no. 61.

81 Angel [1642] 1996, p. 25, for example, addresses painting's capacity to transcend nature's limitations. See Sluijter 2000a, pp. 220–22, which profoundly influenced my interpretation of Netscher's painting, as did idem 1998b, pp. 179 and 188; Brusati 1990–91, pp. 174–5; and idem 1997, pp. 150 and 157.

82 For van Mieris's painting of 1663, which was frequently copied, see Naumann 1981, vol. 2, cat. no. 58.

83 For *kunstkammers* as well as the general interest in the exotic and unusual in the Dutch Republic, see Amsterdam 1992; Bergvelt and Kistemaker 1992; and Amsterdam 1999–2000b.

84 In this context it is fascinating that the boy holds a beret, a common attribute of painters; for this attribute, see Chapman 1990, pp. 49–50. The boy in van Mieris's painting (fig. 101) cited here in connection with Netscher's panel also wears a beret. Naumann 1981, vol. 2, p. 76, is surely correct in stating that this motif may hold the key to a different interpretation of van Mieris's picture – as opposed to traditional ones explaining it purely in *vanitas* terms. Curiously, upon first impression, the beret in Netscher's painting resembles an artist's palette which may not be mere visual coincidence.

CHAPTER EIGHT

1 For the following overview, see Leiden 1976–7, pp. 7–14; Israel 1989, pp. 34–5, 116–17, 192–6, 260–64, and 308; *idem* 1995, pp. 864–5 and *passim*; de Vries and van der Woude 1997, pp. 283–7; and Korevaar 2001–2. The relationship of Leiden's textile industry to its art is thoroughly explored by Stone-Ferrier 1985.

2 *Laken* manufacture was not restricted solely to Leiden but the city remained its principal producer.

3 For the following population figures, see Lourens and Lucassen 1997, pp. 113–14.

4 For the Council of Forty and elite society in Leiden, see Noordam 1994. Noordam (pp. 101 and 105) concludes that aristocratization (see Chapter 6) did not take firm root in Leiden because its patricians and regents manifested only sporadic interest in such aristocratic trappings as country houses, coaches, and so forth. On the other hand, some Catholic elites in Leiden, who were excluded from holding political office, did purchase country houses, among them, the wealthy collector Hendrick Bugge van Ring (see note 119 below); see Sluijter 2001–2, p. 116.

5 Much has been written about the University of Leiden; see, for example, Lunsingh Scheurleer and Meyjes 1975; and Amsterdam 1975.

6 For the rise of the art market in Leiden at this time after two decades of contraction, see Romein 2001.

7 See Montias 1990a, p. 62.

8 See Leiden 1976–7, p. 10; Sluijter 1988c, pp. 29–33. See also Romein 2001, pp. 82–4 and *passim*, who attributes great importance to the role of the guild in the recovery of the art market in Leiden.

9 For Dou, see Martin 1902; Sumowski 1983–94, vol. 1, pp. 498–607; Baer 1990;

Washington D.C. 2000; Baer 2000; and Sluijter 2000a.

10 Many of Dou's early genre paintings represent aged people; see, for example, Washington D.C. 2000, cat. nos. 2 and 4. The theme of the elderly in Dutch genre painting was discussed in Chapter 4 and will be examined in more detail in Chapter 10.

11 During the 1630s Rembrandt made several drawings of sitters in niches; see, for example, Benesch 1973, vol. 2, p. 102, cat. no. 433. Prototypes for Dou's niche-format paintings can also be found in the art of the Utrecht Caravaggisti. Van Honthorst's *Merry Violinist* (fig. 77), for example, displays many similarities with Dou's picture. Fifteenth-century portraits by Netherlandish artists rank among the more distant pictorial ancestors of the niche format; see Hans Memling's *Portrait of a Young Man* (New York, The Metropolitan Museum of Art). Kleinmann 1996, provides a comprehensive look at Dou's niche paintings. See also Honig 1998a, pp. 48–9; and Sluijter 2000a, pp. 231–3.

12 For this painting, see Leiden 1988, cat. no. 10; Amsterdam 1983, cat. no. 17; Amsterdam 1989–90, cat. no. 6; Baer 1990, cat. no. 63; Washington D.C. 2000, cat. no. 20; Hollander 2002, pp. 48–102; and Hecht 2002, pp. 186–97.

13 For the beret as an attribute of artists, see Chapman 1990, pp. 49–50.

14 See Sluijter 1988c, p. 36. Hecht 2002, p. 194, raises the intriguing possibility that Duquesnoy's brother, Jérôme (1602–1654), who returned to his native Brussels after François's death in 1643 with the latter's possessions, may have sold some of the famed artist's sculptures and plaster casts in Leiden and in other places.

15 See Raupp 1978, who generally adopts a traditional, moralizing view of this theme, including a version of the painting under discussion here (pp. 109–11). Houbraken 1753, vol. 3, pp. 110–11, vividly describes the late seventeenth-century painter Gerard de Lairesse's habit of playing the violin to inspire his art work. This passage is cited by Guido Jansen, writing in Amsterdam 1983, p. 124. For de Lairesse, see further in this chapter and Chapters 15 and 16.

16 The working artist's smoking companion may refer to the intellectual contemplation of the art of painting as it does in other paintings where a smoking artist is the main subject; see Leiden 1988, p. 100; and Sluijter 1990a, pp. 295 and 298. Raupp 1984, pp. 239–40, by contrast, construes the motif in admonitory terms. A positive interpretation of smoking would have been less likely when it was depicted decades earlier. As noted in Chapter 2, increasing social acceptance of tobacco legitimized depictions

of respectable smokers as opposed to the peasants and similar base persons shown smoking in early seventeenth-century Dutch paintings.

17 The interaction of color harmonies in paintings are fundamental to what seventeenth-century Dutch art theorists called "*houding*," a somewhat nebulous term skillfully elucidated in the important article by Taylor 1992.

18 See Leiden 1988, p. 101; Weber 1993; and Kyrova 1994, pp. 54 and 57–8.

19 Paradoxically, the illusion in this picture is actually incorrect; see Hollander 2002, p. 67, who observes that, "By displaying all edges of the stone frame simultaneously, he [Dou] reveals more of it than would be visible in reality."

20 Hecht 2002, p. 191.

21 See Leiden 1988, pp. 101, 103.

22 See Hecht 2002, pp. 191–5. See also *idem* 1984 and Munich 2002.

23 See further the observations of Hecht 2002, p. 191, in this regard. Hecht concludes his interesting article with some helpful ruminations concerning how to approach Dou's art with its dual concerns for dazzling (and playful) mimesis and conventional narratives (p. 201).

24 For this painting, see Sumowski 1983–94, vol. 1, p. 532, cat. no. 279; Amsterdam 1989–90, cat. no. 4; Baer 1990, cat. no. 59; and Sluijter 2000b, pp. 271–5.

25 See the discussions and literature cited by Schama 1987, pp. 455–60; Carlson 1994, pp. 90–91; Hollander 1994, pp. 146 and 154 n. 34; Sluijter 2000b, pp. 274 and 340 n. 24; and Sarnowiec 2001. Dekker 1999, pp. 99 and 102, observes that in elite circles, maids were "sometimes regarded as little better than prostitutes."

26 *Zeven duivelen, regerende en vervoerende de hedendaagsche dienst-maagden* 1682. For this text, see Sarnowiec 2001, who clarifies long-standing confusion about its contents as opposed to those of a book published in the same year by Simon de Vries (de V[ries] 1682) with an identical title that has only minor variations in spelling. As Sarnowiec 2001, points out, the principal difference between these volumes is one of tone: the anonymous work is raucous while de Vries's text is moralistic.

27 Our suspicions as to the credibility of this book (and of de V[ries] 1682) are further aroused by a work that appeared several years later, countering their arguments: *De seven engelen der dienst-maagden, zijnde een rare en behnopte wederlegginge tegen een nu-onlangs uitgegeven boekje genaamd 7. duivelen der dienst-maagden* 1697.

28 *Zeven duivelen* 1682, pp. 116 and 130. The corresponding chapter in de V[ries] 1682, runs from pp. 162–236. For these chapters, see

29 See the illustration in Sluijter 2001b, p. 275, fig. 210, from one of Jacob Cats's emblem books of the late 1620s which shows a maid similarly exposed.

Sarnowiec 2001, pp. 206−7 and 213−14 respectively.

30 *Ibid.*, pp. 273−4, discusses Dou's sources of inspiration.

31 See Kavaler 1986−7; Kleinmann 1996, pp. 229−32 and *passim*; de Jongh 2000a, pp. 22−46; and Sluijter 2000b, pp. 275−81.

32 Sluijter 2000b, pp. 274−5.

33 The social realities to which I refer are discussed in more detail in Chapter 11. Sarnowiec 2001, pp. 200−02, notes that *Zeven duivelen* 1682 and de V[ries] 1682, were both written partly in response to an ordinance concerning servant behavior published in Amsterdam in 1682.

34 See Baer 1990, pp. 83−4 and *passim*; *idem* 2000, p. 40; and Hollander 2002, p. 54.

35 Angel [1642] 1996. For this treatise, see Miedema 1989. For Angel's treatise and Dou's paintings, see the important study by Sluijter 2000a, upon which the following observations are based.

36 Angel [1642] 1996, p. 248. See also Sluijter 2000a, p. 246.

37 Orlers 1641, p. 378.

38 See Wood 1995.

39 The full text of this advertisement, translated into English, can be read in Martin 1902, pp. 66−9.

40 See further Sluijter 1988c, pp. 15−17. Whether the characteristics of Leiden's genre paintings are attributable to the inhabitants' "urban subconsciousness," namely, the collective experiences of those living within the city, as de Bièvre 1995, provocatively argues, cannot be proven.

41 During the seventeenth-century the term *fijnschilder* was actually used to distinguish true artists from house painters and related, lowly professions; see de Pauw-de Veen 1969, pp. 16−36; Naumann 1981, vol. 1, pp. 12−13; Amsterdam 1989−90, p. 14 n. 4; and Wieseman 2002, p. 59. Wheelock 2000 surveys Dou's reputation in subsequent centuries. See also Kleinmann 1996, pp. 14−22.

42 Angel [1642] 1996, p. 238. For Spiering's patronage, see Baer 1990, pp. 88−91. Another important collector of Dou's paintings was the prominent University of Leiden professor of medicine, Franciscus de le Boe Sylvius, who owned eleven of them; see Sluijter 2001−2, pp. 105−16.

43 Martin 1902, pp. 66−9. See also Baer 1990, p. 104; and Sluijter 2000b, p. 37, who observes that commercial interests probably underlay this exhibition. Thus, a variety of subjects may have been placed on display for financial reasons.

44 The preciousness of Dou's pictures, as reflected in their immense cost, probably explains the frequent use of cases − some with covers painted by the artist himself − to protect them; see further Baer 2000, p. 49 n. 111; Sluijter 2001−2, p. 229 nn. 35 and 36; and Wadum 2002, pp. 71−2. For the economic aspects of the art of Dou and his fellow *fijnschilders* see John Michael Montias 1987a, p. 462; and *idem* 1994, p. 65. See also Sluijter 1988c, pp. 24−8.

45 In connection with van Mieris, who was equally well paid (see below), Naumann 1981, vol. 1, p. 24 n. 20, itemizes housing costs in Delft and Leiden during this period.

46 For Dou's patronage, see Gaskell 1982; and Baer 1990, pp. 87−108.

47 Goosens 2001, pp. 369−70. For an overview of collecting among Leiden elites, see Fock 1986−92, p. 7.

48 See Baer 2000, pp. 44−5 n. 41. Hecht writing in Amsterdam 1989−90, downplays the importance of subject matter for Dou and the other *fijnschilders* on the grounds that the primary goal of their art was the virtuosic simulation of reality; see the critique by Sluijter 2000b. See also Hecht 2002.

49 Queen Christina of Sweden did return ten of Dou's paintings sent to her by the Swedish minister to the Netherlands and patron of the artist, Pieter Spiering. However, these pictures were most likely returned because the Queen preferred Italian art; see Martin 1902, pp. 44−7.

50 Baer 2000, p. 41.

51 The depiction of virtuous elderly women was one of Dou's early specialties; this imagery arose initially in the circle of Rembrandt and his studio but was popularized by his erstwhile student. See Franits 1993a, pp. 169−72, 182−3, and *passim*; and Baer 2000, p. 38. See also Chapter 10.

52 For example, Protestant Reformers and humanists of the early sixteenth century wrote important tracts and books about domestic life, advocating specific roles and responsibilities for individual family members, particularly women. For the writings of Luther, Erasmus, and others on this topic, see Ozment 1983, pp. 50−72 and 132−54. There were also several works concerning marriage and the family published before the Reformation, for example, von Eyb 1472.

53 For domestic conduct books, see Hull 1982, pp. 31−70; and Groenendijk 1984. Pivotal to this literary tradition was Cats 1625, arguably the most popular domestic treatise of the seventeenth century. For this important text, see ten Berge 1979, pp. 77−95.

54 For this painting, see Sumowski 1983−94, vol. 1, p. 533, cat. no. 284; Broos 1987, cat. no. 20; Franits 1993a, pp. 16 and 84; Amsterdam 1989−90, cat. no. 7; and Washington D.C. 2000, cat. no. 21. Scattered precedents for Dou's domestic themes can be found in the work of Judith Leyster and Dirck Hals (see Worcester 1993, cat. no. 27) and Gerard ter Borch; the latter executed several paintings of this theme in the early 1650s (see Gudlaugsson 1959−60, vol. 1, figs. 95, 96, and 98). There is also a fascinating series of five engravings of women performing domestic tasks by the female artist Geertruid Roghman; see Peacock 1993−4.

55 For the original occasion for which this picture was commissioned, see Broos 1987, p. 117. Boersma 2000, pp. 57−8 and 61, examines the numerous alterations that Dou made to the painting over a long period of time.

56 For the Dutch gift, see Broos 1987, pp. 111−12 (citing earlier literature). See also Baer 1990, pp. 93−7.

57 Evelyn 1959, p. 413.

58 Boersma 2000, p. 59. Von Sandrart 1675−80, vol. 1, p. 321, contains a wonderful account of Dou's fastidious working methods. See also Baer 2000, pp. 39−40; Schölzel 2001, pp. 20−22; and Wadum 2002.

59 Franits 1993a, pp. 83−4. See also the discussion in Chapter 7.

60 *Ibid.*, p. 84.

61 The term "reality effect" was coined by the French literary scholar Roland Barthes to describe the formative strategies of French realist authors; see Barthes 1982.

62 On the basis of his study of inventories in seventeenth-century Leiden, Sluijter 2001−2, pp. 115 and 119, concludes that tonal paintings were no longer in vogue by the 1660s.

63 Brusati 1997, p. 157, discusses a parallel phenomenon in contemporary still-life painting. Indeed, the conventions dominating genre painting during the 1650s and 1660s can be seen in all types of Dutch art just as earlier conventions were evidenced in Dutch art in general.

64 Unfortunately, the ravages of time have caused Dou's painting to darken somewhat, a fate common to many seventeenth-century paintings; see the scholarly literature on this problem surveyed by Hollander 2002, p. 211 n. 22.

65 Much of the following discussion is drawn from Franits 2001a. Chapman 2001−2, pp. 133 and 143, argues that paintings of domestic life helped to shape the urban elite's sense of communal consciousness as political and economic circumstances forced them to reconsider their relation to the community and state. And central to their formation of a new collective identity was the family, increasingly envisioned as the building block of society. While such reflections on the part of the urban elite were likely, Chapman's thesis overlooks the fact that the concept of the family as a microcosm of the state, having originated in the political thought of anti-

quity, was universally acknowledged in early modern Europe. In other words, there is nothing that is uniquely or even intrinsically Dutch about this concept – in fact, its most eloquent exponent, Jean Bodin (1530–1596), was French. It is perhaps significant that notions of family and state are not featured in the most comprehensive study to date of Dutch identity formation around 1650: Meijer Drees 1997. Furthermore, Chapman's thesis does not adequately explain why domestic imagery became popular only after 1650 while the Dutch effectively achieved nationhood in 1609. Presumably, the construction of a new collective identity was already well under way at this earlier date.

66 De Lairesse 1778, p. 101, "Francis Mieris has not only curiously followed his master Gerrad Dou, in the elegant modern manner. . . ." See Sluijter 1988c, pp. 23–4. Despite this statement, de Lairesse (along with other art theorists) was not entirely enamored with *fijnschilder* painting; see L. de Vries 1998a, pp. 127–8. De Lairesse's treatise was first published in 1707 in Dutch with the title, *Groot schilderboek*. (In English, this actually translates to the "Great Book on Painting" but for unknown reasons eighteenth-century British editions of the work translate the title as *The Art of Painting*.) De Lairesse's protracted discussion of the "modern manner" (in relation to the superior "antique manner") is examined in more detail in Chapter 16.

67 De Lairesse 1778, p. 98. De Lairesse's notion of the "modern manner" will be discussed in more detail in Chapter 16. See also the discussion in the Introduction concerning an order for pictures submitted in March 1663 by the Antwerp-born but Parisian-based art dealer Jean-Michel Picart to his Antwerp supplier, Matthijs Musson. Picart specified that he did not want any subjects that were potentially offensive through their vulgarity or crudity. That Picart would want non-offensive, namely, civilized subject matter in the pictures he was ordering should come as no surprise since his clients were French; France was the country whose culture was considered the most "civilized" in Europe at that time (see further Chapter 15).

68 For example, de Lairesse 1778, p. 22. See further Chapter 15.

69 De Lairesse considered the art of the ancients a source of incomparable beauty, one worthy of imitation because he believed it evinced moral perfection. His repeated pronouncements on the lofty content and excellence of antique art prompted Dolders 1985, pp. 217–18, to remark that the artist was likely projecting seventeenth-century moral ideals upon it.

70 See Baer 2000, p. 45 n. 43. Dou also depicted tantalizing, young maids in niches, pictures

that influenced a younger generation of *fijnschilders*, especially Godfried Schalcken (see Chapter 18). For these images, see the discussion of fig. 103 above, and Kleinmann 1996, *passim*; and Sluijter 2000b, pp. 271–81.

71 Houbraken 1753, vol. 2, pp. 5–6, ". . . zyn penceel tot het verbeelden van waardiger en prysselyker voorwerpen . . ." See Amsterdam 1989–90, pp. 56 and 58; and Horn 2000, vol. 1, p. 457.

72 Van Hoogstraten 1678, p. 268, writing three years after Dou's death, extolled his use of artificial illumination: "Should anyone desire to have the light flame of a candle or lamp shine in his painting he should certainly satisfy that desire, taking good note of the difference between the light and that which is illuminated, just as Gerard Dou and his followers did so admirably." This translation is taken from Filedt Kok *et al.* 2001, p. 184. See also the candlelight paintings of Dou's pupil, Godfried Schalcken, discussed in Chapter 18.

73 For this painting, see Sumowski 1983–94, vol. 1, p. 534, cat. no. 289; Amsterdam 1989–90, cat. no. 9; Baer 1990, cat. no. 110; and Washington D.C. 2000, cat. no. 28.

74 Peter C. Sutton, writing in Philadelphia 1984, pp. 318–19, provides an excellent summary of actual educational practices in the Dutch Republic. See also van Doorninck and Kuijpers 1993.

75 For the following quotations from contemporary texts and for the pedagogical notions underlying the *Night School*, see Emmens 1997, p. 19.

76 Rodenburgh 1619, p. 374 no. 67. In the *Night School* Dou has also included an unlit lantern; perhaps he intended some sort of pedagogical contrast between it and the illuminated lantern and candles.

77 Dafforne 1627, fols. 5–6.

78 For the motif of the curtain in Dou's art, see Gaskell 1982, pp. 19–20; Sluijter 1988c, pp. 21–3; Leiden 1988, cat. no. 9; Amsterdam 1989–90, cat. no. 5; Washington D.C. 2000, cat. no. 16.; Sluijter 2000a, pp. 19–20; and Hollander 2002, pp. 69–76.

79 Pliny the Elder, *Natural history*, bk. 35, chap. 36.

80 Traudenius 1662, p. 17. Sluijter 2000a, p. 209, cites Traudenius's poem and translates it as follows: "If Zeuxis saw this banquet, he would be deceived again:/ Here lies no paint, but life and spirit on the panel./ Dou does not paint, oh no, he performs magic with the brush." Dou's outstanding pupil, van Mieris who is discussed later in this chapter, was also praised in connection with Zeuxis and Parrhasius. Westermann 1999a, pp. 36–7, interprets Dou's *Maid with a Basket of Fruit* (Waddesdon Manor, National Trust; her fig. 1) as a demonstration of his mimetic skills coupled with clever references to Pliny the

Elder's story: "But to the most conscientious connoisseurs the picture must have resembled a sly play of the artist on the tradition of illusionist painting and on the viewers themselves. The elaborate bird house on the right, empty for the moment, would have alerted many a contemporary that this girl is displaying her grapes for the same reason Zeuxis painted his: to lure birds. In Dou's case, the marveling viewer is the bird, held captive by Dou as securely as Zeuxis was by his rival. Close scrutiny of the bird contraption reveals the master of this game, for its glass water bowl reflects the artist and his easel in exquisite minature."

81 See Brusati 1995, pp. 9–15 and *passim*; and *idem* 1999, pp. 62–5.

82 Van Mander [1603–4] 1994–9, vol. 1, p. 322. This passage is cited by Brusati 1995, p. 11; and *idem* 1999, p. 62. For Vredeman de Vries, see Lemgo 2002.

83 Von Sandrart 1675–80, vol. 1, p. 310. This passage is cited by Brusati 1999, p. 63.

84 Brusati 1999, pp. 63–4. *Idem* 1995, p. 156 and *passim*, repeatedly demonstrates how fundamental this is to van Hoogstraten's notion of art and self. See Czech 2002, pp. 44–5, 230–47, and *passim*.

85 Brusati 1999, p. 63, "What is striking in all these stories is their emphasis on the aesthetic value accorded to illusionist artifice both by merchants and by sovereigns, by those within court circles and those who competed for honor in the commercial sphere."

86 For this portrait, see Baer 1990, cat. no. 88; The Hague 1990–91, cat. no. 18; and Washington D.C. 2000, cat. no. 27. See also Gaskell 1982, p. 21; Sluijter 1988c, pp. 24–8.

87 For Dutch artists' self-portraits, see the classic study by Raupp 1984.

88 According to Houbraken 1753, vol. 3, p. 2. For van Mieris, see Naumann 1981. For Dou's pupils and followers, see Robinson 1974, pp. 89–100; Leiden 1988; and Amsterdam 1989–90.

89 See Naumann 1981, vol. 1, pp. 38–40.

90 For this painting, see Slatkes 1981, p. 143; Naumann 1981, vol. 1, pp. 55–6 and 104; vol. 2, cat. no. 23; Amsterdam 1989–90, cat. no. 13; and Broos 1987, cat. no. 42.

91 The same can be said of the work of Godfried Schalcken (see Chapter 18).

92 With his *Old Lover* (Florence, Uffizi), van Mieris also represented the even older theme of unequal love where an enervated elderly man or woman seeks the affections of a much younger member of the opposite sex (compare fig. 68).

93 See de Jongh 1972, a classic study of emulation in seventeenth-century Dutch art. See also Raupp 1984, pp. 168–81; Gaehtgens 1987b, pp. 99 and 104–5. Kemmer 1998, p. 97, notes that biographers such as von Sandrart

and Houbraken were fully cognizant of the emulative qualities of van Mieris's art vis-à-vis that of Dou's.

94 See Naumann 1981, vol. 1, p. 132. See also Houbraken 1753, vol. 3, p. 5.

95 Archduke Leopold Wilhelm had served as Viceroy of the Spanish Netherlands from 1647 to 1656. Residing in Brussels, he assembled a massive art collection consisting primarily of Italian and Flemish paintings. The pictures that he purchased from van Mieris (see below) were ordered directly from Vienna; see Naumann 1981, p. 24 n. 21.

96 Von Sandrart 1675–80, vol. 1, p. 321, recorded the price for the painting as 2000 guilders which was amended to 1000 guilders by Houbraken 1753, vol. 3, p. 3. See further, Naumann 1981, vol. 2, p. 34.

97 For this painting, see Amsterdam 1976, cat. no. 42; Naumann 1981, vol. 2, cat. no. 31; and Hecht 1997, p. 93. Dou painted several shops; see, for example, Washington D.C. 2000, cat. no. 35.

98 Amsterdam 1976, p. 173, convincingly suggests that the artist depicted an ornate interior to give his Austrian patron an impression of Dutch opulence and, with the depiction of a large number of fabric bolts, of Leiden's acclaimed status as a textile-producing town. The banner in the right foreground of the painting includes the city of Leiden's coat-of-arms and the partial inscription [Lu]gdunum [Batavorum], the ancient Roman name of the city. For the implausible chandelier in the painting, see Fock 2001a, p. 138. For a rare depiction of a realistic-looking, seventeenth-century Dutch shop, namely one lacking the typical fabrications of contemporary genre painting, see de Kommen 2001, p. 31, fig. 30.

99 The banner and its germane inscription are analyzed in Amsterdam 1976, p. 173. My thanks to Jeffrey Carnes, my colleague in classical languages at Syracuse University, for his assistance in translating the inscription.

100 For the representation of the elderly in Dutch art, see Chapters 4 and 10.

101 Hecht 1997, p. 221 n. 8. The admonitory interpretation of the little painting in Amsterdam 1976, p. 173, seems incompatible with the frolicsome tone of the *Cloth Shop*. See also Beaujean 2001, pp. 191–2.

102 Von Sandrart 1675–80, vol. 1, p. 321, who must have seen the *Cloth Shop* years before he wrote his very brief biography of the artist, described the silk, wool, and ribbons as being powerfully and naturally rendered.

103 For this painting, see Naumann 1981, vol. 1, pp. 78 and 82; vol. 2, cat. no. 76; and Philadelphia 1984, cat. no. 76.

104 Van Mieris's teacher Dou also executed an intriguing painting of a woman gazing into a mirror: *Lady at her Toilet* (Rotterdam, Museum Boijmans van Beuningen); see

Leiden 1988, cat. no. 16; Rotterdam 1998, cat. no. 20; and Washington D.C. 2000, cat. no. 32.

105 The motif of the discarded shoe has been discussed already in connection with Caspar Netscher's *Lace-Maker* (fig. 95) where it functions as a reference to domestic virtue. In contrast, van Mieris's painting presents shoes in an entirely different visual context, and consequently, they must have evoked different associations for contemporaries. In fact, in contemporary Dutch art and literature shoes were well-known erotic metaphors; see de Jongh 2000a, pp. 33–4.

106 The following discussion of the mirror and female beauty is drawn from Sluijter 1988b and *idem* 2000c, pp. 112–31.

107 See Sluijter 2000c, pp. 144–59.

108 *De Zeeusche nachtegael* 1623, pt. 1, pp. 59–60, "Begeerich is de oog, verlangend' is de mens;/ 'tVerlangen is in my te meer om dese reden,/ Om dat ick sie een beelt dat lijf en heeft noch reden,/ Beweging noch gevoel, en evenwel een schijn . . . De oog is noyt vervult, 'tgewens is noyt versaet./ Soo lang men met de cunst en min-sucht omme-gaet." This passage is cited and translated by Sluijter 1998c, pp. 274 and 277. For van de Venne's own work as a genre painter, see Chapter 5.

109 De Monconys 1665–66, vol. 2, p. 157.

110 Van Leeuwen 1672, pp. 191–2. Houbraken 1753, vol. 3, pp. 161–2, insightfully remarks that he has "seen artworks by him [van Slingelandt] that excelled above those of his master [Dou], but the rub is that by this practice the same are somewhat stiffer." This passage is quoted and translated by Horn 2000, vol. 1, p. 554. For the "stiffness" of van Slingelandt's style, see further the discussion below.

111 For this painting, see White 1982, cat. no. 184; and Franits 1993a, pp. 116–17.

112 For van Slingelandt's painting, see Amsterdam 1989–90, cat. no. 47; Franits, 1993a, pp. 55–6; and Leiden 2001, pp. 114–15. Van Mieris's painting is discussed by Naumann 1981, vol. 1, pp. 60–61, 63, 68, 110, and 128 and in vol. 2, cat. no. 35; Philadelphia 1984, cat. no. 75; Leiden 1988, cat. no. 23; and Franits 1993, p. 55.

113 For recorders, flutes, and their phallic symbolism, see *De nieuwe hofsche rommelzoo* 1655, pp. 120–24; The Hague 1994, pp. 182–4 and *passim*; and de Jongh 1997, pp. 46–7.

114 Annegret Laabs, writing in Leiden 2001, p. 114, argues that the lady is fending off the suitor and thus displaying her virtue. Moreover, the dog is said to illustrate fidelity "in the face of this sexual harassment." Laabs's moralizing interpretation disregards the generally playful air of the picture.

115 Blasius 1663, p. 245, "Gelukkig Hondje, uw voorspoedig Lot benijd is:/ Gelukkig Hondje

die de schoot/ Van Celestyn so vaak genoot/ En wierd van haar gestreelt, so sacht, dat het my spijt is."

116 For van Brekelenkam, see Lasius 1992.

117 The significance of these depictions of virtuous elderly persons is discussed in Chapters 4 and 10.

118 See Sluijter 1988c, p. 41.

119 One exception was the wealthy collector Hendrick Bugge van Ring (d. 1669): an inventory of his enormous collection compiled in 1667 lists eighteen paintings by van Brekelenkam as well as a collaborative still life by van Mieris and the scarcely known Adriaen van der Spelt (Chicago, The Art Institute of Chicago; illustrated by Sluijter 1988c, p. 27, fig. 11). As Sluijter (p. 41) points out, van Ring and van Brekelenkam were both Catholics and they probably knew each other because of their shared faith. Van Ring also owned several paintings by the artist with decidedly Catholic subject matter. Further information about van Ring and other Leiden collectors during this period can be found in Fock 1986–92 and Sluijter 2001–2.

120 For this theme in van Brekelenkam's art, see Lasius 1989; and *idem* 1992, pp. 55–6.

121 See, for example, van Slingelandt's *Tailor's Workshop* (Jerusalem, Israel Museum; reproduced in Lasius 1992, fig. 19). Van Brekelenkam's paintings of shoemakers were also influential. Shoemakers can be found in the work of other Dutch painters but it was van Brekelenkam who almost single-handedly popularized their representation; see *idem* 1989 and *idem* 1992, pp. 54–5.

122 See Leiden 1988, p. 89.

123 The motif appears in other Dutch genre paintings of this period, most notably in Vermeer's *Girl with the Wine Glass* (fig. 154). Salomon 1998a, pp. 320–22, discusses the significance of elegantly holding a wineglass in relation to contemporary notions of civility. My own interpretation of the motif in van Brekelenkam's painting is indebted to hers.

124 De Lairesse 1778, pp. 29–30.

125 This lies at the heart of the process of aristocratization discussed in Chapter 6. De Vries 1993, p. 106, points out this phenomenon with respect to consumer acquisitions, a rubric under which the purchase of art would fall. Fock 1998, p. 240 n. 158, quotes a fascinating archival document of 1645 in which the Amsterdam merchant Nicolaes Spiljeurs rented an expensive Turkish carpet for several weeks so that it could be included in a portrait of himself that was currently being painted. Although Fock does not say so, surely Spiljeurs wanted to include the carpet in his portrait for the associations of status that it evoked. De Vries 1974, p. 235, states that the rural population of the seven-

teenth century was particularly receptive to urban cultural values.

126 See Elias 1982, pp. 300–19; and Salomon 1998b, p. 125.

CHAPTER NINE

1 For the following discussion, see Haarlem 1990, pp. 50–51; Wijsenbeek-Olthuis and Noordegraaf 1993, p. 51; Diederiks and Spierenburg 1995, pp. 163, 169, 172–4, 176–7, and 187; Dorren 2001, pp. 34–6 and 209–11; and Biesboer 2001, pp. 1–43.

2 Dorren 2001, pp. 34–5. Dorren's statistics, based on archival research, are convincing though at odds with those given by Israel 1995, pp. 328 table 12 and 621 table 30, who observes an increase in population until 1688 followed by a gradual decline. See also Lourens and Lucassen 1997, pp. 61–2.

3 See Temminck 1983, p. 19, who states that those French refugees who did actually relocate in Haarlem helped establish the silk industry there. See also Groenveld *et al.* 1995, p. 143.

4 See Dorren 2001, pp. 35–6.

5 Diederiks and Spierenburg 1995, p. 187.

6 For the decline of the art market in Haarlem, see Biesboer 2001, pp. 41–3.

7 For this painting, see London 1999, p. 26. The following discussion is based on Franits 1996.

8 For this painting, see Broos 1987, cat. 43.

9 For example, Miedema 1977, p. 219; Schnackenburg 1981, vol. 1, pp. 28–33 and 58; *idem* 1984; and Munich 1986, p. 66.

10 As Schnackenburg, 1981, vol. 1, p. 31, observes, by 1647 van Ostade had developed his definitive style, one which would only be subject to very minor changes during his long career.

11 Von Bode 1956, pp. 170–71.

12 Schnackenburg 1981, vol. 1, p. 58, makes precisely this criticism of von Bode's view. Nevertheless, there is substantial evidence that from the late sixteenth century onward peasants became increasingly prosperous with the entire process leveling off in about 1670; see de Vries 1974, pp. 214–35 and 242. Moreover, some peasants were eventually able, particularly after the middle of the century, to purchase art. However, as *idem* 1975, p. 222, points out, notary valuations of peasant inventories indicate that these pictures were not oils but for the most part decorative boards and hangings. See also *idem* 1981, pp. 219–20. For these extremely modest "collections," and for the comparatively high prices of paintings of peasant subjects owned by affluent collectors, see Montias 1990b, pp. 361–4.

13 Miedema 1977, p. 219.

14 For example, Reznicek 1979, pp. 160–61; Schnackenburg 1981, vol. 1, pp. 58–9; *idem* 1984, pp. 35–41.

15 For the literary *topos* of the happy, productive peasant, see Meertens and de Groot 1942. For sixteenth-century images of the same, see Reznicek 1979, fig. 5; Schnackenburg 1981, vol. 1, p. 25; and Sullivan 1994, pp. 15–18 and 33–4.

16 Schnackenburg 1984, pp. 35 and 37, discusses this print; see also Athens, Ga 1994, cat. no. 120.

17 For this print, see Athens, Ga 1994, cat. nos. 86 and 87. However, not all of van Ostade's etchings of peasant life are placid; see, for example, Athens, Ga 1994, cat. nos. 45 and 114.

18 For actual peasant dwellings in the seventeenth century, see Voskuil 1979.

19 Yet, at the same time, depictions of unruly peasants continued to retain much of their earlier vitality even if they were somewhat tempered, particularly in the work of such artists as Cornelis Bega (discussed later in this chapter), Abraham Diepraam (?1622–?1670), Cornelis Dusart (1660–1704), and Richard Brakenburg (1650–1702).

20 For the interest among wealthy collectors in paintings of peasants, see Montias 1990b, pp. 363–4.

21 De Vries 1977, pp. 83–8; and L. de Vries 1991, pp. 217, 220, and 229–31.

22 De Vries 1977, p. 84. *Idem* 1991, p. 220, cannot completely explain the reasons for this growing aestheticization in Dutch art; he consequently raises but quickly dismisses the possibility that the so-called civilizing process may have played a role in these changes.

23 See the Introduction for a critique of the use of emblems to interpret paintings.

24 See further the criticisms in de Jongh 1980, p. 184; Smith 1987a, p. 423 n. 67; Franits 1996, p. 21 n. 19; and Salomon 1998b, p. 22. The propensity to separate form from content is symptomatic of the iconological roots of de Vries's thinking; see further the Introduction. Curiously, moralization in genre painting would become quite pronounced during the last decades of the seventeenth century; see Part III of this book.

25 For Bega, see Scott 1984.

26 Houbraken 1753, vol. 1, p. 349.

27 The principal genealogical study of Bega's family is Begheyn 1979.

28 The companions originally intended to travel to Italy but military conflicts in Northern Italy prevented them from doing so. Extensive excerpts and illustrations from van der Vinne's journal from the trip have been published; see van der Vinne [1652–5] 1979. See also Scott 1984, pp. 8–13 and 31–7, who argues that several drawings in that journal should be reattributed to Bega.

29 For Bega's early career, see Scott 1984, pp. 31–59.

30 A brothel scene by Bega (Bourdeaux, Musée des Beaux-Arts) actually includes a couple copulating, a motif rarely encountered in seventeenth-century Dutch art; see Scott 1984, cat. no. 101; and Bourdeaux 1990, cat. no. 1.

31 For this painting, see Scott 1984, cat. no. 67; and Capetown 1997, cat. no. 4.

32 Scott 1984, p. 72.

33 For de Grebber, see Rotterdam 1999–2000, pp. 116–43. For Teniers, see New York 1982, pp. 56–142; and Antwerp 1991.

34 Tobacco and smoking in Dutch genre painting are discussed in Chapter 2.

35 Muchembled 1990, pp. 34 and 35, who observes that popular wisdom held that God had created man and animal as well as a "type" that lay in-between, namely, the peasant who was to inhabit the country.

36 See Scott 1984, cat. nos. 144, 146, 146a, and 147.

37 For this painting, see *ibid.*, pp. 104–7 and 196–8; and Philadelphia 1984, cat. no. 3.

38 For a brief, useful discussion of the status of alchemy in seventeenth-century Europe (upon which the following remarks are based), see Dixon and ten-Doesschate Chu 1989. For alchemy in the Dutch Republic, see Jorink 1999, pp. 35–6; and Scholz 1999. See also Snelders 1972, who examines a late seventeenth-century Dutch play about a repentant alchemist.

39 For the drawing and engraving, see New York 2001a, cat. nos. 60 and 61. Both Peter C. Sutton, writing in Philadelphia 1984, p. 134; and Scott 1984, pp. 106 and 197, cite the print after Bruegel in connection with Bega's painting.

40 See Snelders 1972. Alchemists were also the subject of many contemporary jokes; see, for example, *Den vaeck-verdryver van de swaermoedighe gheesten* 1620, pp. 125 no. 3 and 144 no. 91.

41 Van Ostade's *Alchemist* (London, The National Gallery) of 1661, contains the inscription "oleum et operaram perdis" (you lose your time and effort), an obvious comment upon the alchemist's fruitless exertions. For this painting, see Southampton 1978, cat. no. 13; and Brown and Maclaren 1991, pp. 298–99. Scott 1984, pp. 106–7, discusses the close connections between Bega's representations of alchemists and those of his Haarlem colleague Thomas Wijck (?1616–1677).

42 As identified by Scott 1984, p. 198.

43 In both this picture and another version on canvas (Philadelphia, Chemical Heritage Foundation), the alchemist is about to place one of several red, nugget-like objects on his scales. Peter C. Sutton, writing in Philadelphia 1984, p. 133, suggests that this substance could be one of a number of different minerals favored by alchemists. Recently, Principe and de Witt 2002, pp. 24–5, have proposed that these red lumps may well represent the

philosopher's stone, the ultimate goal of alchemy (see above). Their admittedly tentative conclusion that the painting might laud the self-sufficiency of the alchemist because he has discovered the means to support himself is inconsistent with the tone set by its hopelessly messy interior and the long-standing pictorial conventions of mockery to which it adheres.

44 For the *Duet*, see Scott 1984, pp. 99–100, cat. no. 132; and Philadelphia 1984, cat. no. 4.

45 Scott 1984, p. 210.

46 The instrument played by the man is either a vioin or a viola da braccio. Violins are smaller than viole da braccio. Unfortunately it is impossible to identify the instrument more precisely in this painting because part of it is hidden behind the woman's back. For this information I wish to thank my colleague Amanda Winkler of Syracuse University, who specializes in Northern European music of the seventeenth century.

47 Scott 1984, *passim*, discusses Bega's extensive drapery studies and his repeated use of specific models. Several of these drawings can be seen in Washington D.C. 1982, pp. 105–7.

48 See Scott 1984, p. 87 and *passim*.

49 See, for example, The Hague 1994, cat. no. 4. The ostensibly antique features of Bega's picture anticipate developments in late seventeenth-century genre painting; see Chapter 16.

50 Scott 1984, p. 215.

51 See the 1668 death inventory of Molenaer's possessions, transcribed in English in Hofrichter 1989, p. 99; and Raleigh 2002, pp. 181–7. However, as several scholars have observed, the presence of such a large number of paintings in this inventory suggests that Molenaer may have worked as an art dealer. Sluijter 2001–2, p. 123, notes that a painting by Bega was owned by Hendrick Bugge van Ring, a wealthy Leiden Catholic who amassed a huge collection. Many of Bega's paintings, along with pictures by other prominent Haarlem masters, are also found in the inventory of the possessions of the artist's sister Aeltie Pieters Begga, compiled in August 1684 after her death; see Biesboer 2001, pp. 270–74. She had undoubtedly inherited them from her brother; see Begheyn 1979, pp. 275–6; and Biesboer 2001, p. 270. Pictures by Bega in seventeenth-century inventories are estimated between 18 and 80 guilders. But as Bok 1998, p. 104, points out, appraisals in probate inventories and auctions are of only limited value for understanding the original prices of paintings because notaries and auctioneers treated them as second-hand goods and thus tended to underestimate their true worth.

52 The picture is listed in the inventory of the paintings in van Uylenburgh's possession compiled on 16 October 1675 on the occasion of his bankruptcy; this inventory is reproduced by Dudok van Heel 1982, pp. 84–6. For van Uylenburgh and other prominent art dealers in the Netherlands, see Montias 1988.

53 The same holds true for the grisailles of Adriaen van de Venne; see Chapter 5. For the fusion of sophisticated painting styles with base imagery, see also Falkenburg 1991, pp. 136–7.

CHAPTER TEN

1 For the following discussion, see Loughman 1992–3, pp. 34–44; and especially, Frijhoff *et al.* 1998.

2 See Lourens and Lucassen 1997, p. 104.

3 Loughman 1992–3, p. 36; Israel 1995, p. 328; and Nusteling 1998, pp. 75–9. See also Lourens and Lucassen 1997, pp. 56–7 and 116–17.

4 For this synod, see Israel 1995, pp. 460–65.

5 For the following remarks, see Elliott 1990 and van Lieburg 1998.

6 Despite this simple characterization of the situation in Dordrecht it is important to recall that political and theological strife in the Dutch Republic involved factions as members of every social stratum potentially held conflicting views; see further Chapter 1 above. Schotel 1998, pp. 19–23, captures some of the complexity of such disputes in Dordrecht at the middle of the century.

7 See the statistics published by Loughman 1992–3, pp. 45 and 52 table 5.

8 *Ibid.*, p. 46 table 2.

9 *Ibid.*

10 For van Hoogstraten, see Sumowski 1983–94, vol. 2, pp. 1286–1386; Dordrecht 1992–3, pp. 188–209 and *passim*; Roscam Abbing 1993; Brusati 1995; and *idem* 2000.

11 Van Hoogstraten 1678, p. 257; and Houbraken 1753, vol. 2, p. 155. See also Brusati 1995, pp. 19–24.

12 For this treatise, see Brusati 1995, pp. 218–56 and *passim*; and Czech 2002.

13 A particularly valuable study of van Hoogstraten's social and literary connections is Thissen 1994. See also Brusati 1995, pp. 46–51 and *passim*.

14 Houbraken 1753, vol. 2, pp. 157–8, 160. For the medallion, see Roscam Abbing 1993, pp. 42–3 doc. no. 29, fig. 11. For an example of its use in one of van Hoogstraten's paintings, see Brusati 1995, plate XIII. For gold chains, given as gifts to artists during this period, see Becker 2002.

15 Brusati 1995, p. 51.

16 Roscam Abbing 1993, pp. 59–60 doc. no. 71.

17 See note 28 below.

18 For this picture, see Paris 1970–71, cat. no. 117; Franits 1983–5, pp. 28–9; Sumowski 1983–94, vol. 2, p. 1304, cat. no. 894; and Brusati 1995, pp. 83–6, 204, 310–11 n. 45, and 364 n. 88.

19 The original painting by ter Borch exists in two versions; see Gudlaugsson 1959–60, cat. no. 110. The attribution of this pastiche to his pupil Caspar Netscher (see Chapter 7) by Gudlaugsson, cat. no. 110N, has been convincingly refuted by Wieseman 2002, cat. no. 1.

20 See the recent, exhaustive study by Hollander 2002, pp. 7–47 and *passim*. In van Hoogstraten's own theory book, he uses the closely related term "*deurzicht*" (van Hoogstraten 1678, p. 190). *The Slippers* also anticipates several wonderful, large paintings with similar qualities that van Hoogstraten executed during his five-year sojourn in England, commencing in 1662; see Brusati 1995, pp. 91–109.

21 Kettering 1997, pp. 109 and 111.

22 For the possible meanings of these motifs, see Franits 1983–5, p. 29. Brusati 1995, p. 204, inexplicably identifies the ter Borch pastiche as a "love-letter painting."

23 Brusati 1995, p. 108. Brusati also notes (on p. 204) the optical inconsistencies of this unfortunately poorly preserved painting. She speculates that it may have been seen originally through some sort of viewing device. Brusati further suggests that it was possibly one of the "perspectives in rooms" described by Houbraken 1753, vol. 2, p. 158, as having been seen through "a hole made in the wall." For the conservation and attribution problems of *The Slippers*, see Paris 1970–71, pp. 110–11.

24 For example, Johannes Vermeer's *Love Letter* (Amsterdam, Rijksmuseum) employs a similar spatial construction; see Franits 2001, plate 29.

25 For *Two Women by a Cradle*, see Sumowski 1983–94, vol. 2, p. 1294, cat. no. 836; Springfield 1993, pp. 50–53; Brusati 1995, pp. 121–22 and p. 358 checklist no. 64; Newark 2001–2, cat. no. 47. For the *Doctor's Visit*, see Bedaux 1975, pp. 24–7; Amsterdam 1976, cat. no. 30; Sumowski 1983–94, vol. 2, p. 1294, cat. no. 838; Brusati 1995, pp. 124–26 and 357–8 checklist no. 62; Dixon 1995, pp. 67–72 and 173–4; and Petterson 2000, pp. 127–8, 129 n. 336.

26 Paintings by Pieter de Hooch (see Chapter 11) are most frequently cited in connection with van Hoogstraten's late depictions of mothers and infants; see for example, Springfield 1993, p. 50; and Brusati 1995, pp. 120–21. Van Hoogstraten's Dordrecht colleague Nicolaes Maes executed a number of paintings of women with infants in cradles; see fig. 133 below.

27 See Roscam Abbing 1993, pp. 96–7 doc. no. 44.

28 See Brusati 1995, pp. 113–15, figs. 73–80. Roscam Abbing 1993, pp. 70–71 doc. no. 94, states that the artist executed these portraits in The Hague between October and December 1671. Based on the wording of another document, dated 6 November 1673, Roscam Abbing 1993, pp. 71–2 doc. no. 99 speculates that van Hoogstraten only decided to return to Dordrecht permanently in 1673.

29 At least one of Van Hoogstraten's representations of a mother with an infant was in fact owned by a member of The Hague's elite; see Roscam Abbing 1993, pp. 93–4 doc. no. 32, for the listing from the estate inventory (compiled in 1687) of Gerard van Dalffsen, solicitor for the Court of Holland. For the prices of van Hoogstraten's paintings, see Loughman 1992–3, p. 50 table 3B and *passim*; Thissen 1994, pp. 95–6; and Brusati 1995, pp. 126–7, who states that, "Assessments of the value of his pictures in estate inventories and auctions suggest that Van Hoogstraten's work fetched moderate sums during the seventeenth century."

30 For pendants in seventeenth-century Dutch art in general, see Moiso-Diekamp 1987.

31 For example, Bedaux 1975, p. 24; Amsterdam 1976, p. 135; Springfield 1993, pp. 50–52; Brusati 1995, p. 124.

32 For the following discussion see Petterson 1987; Dixon 1995, especially pp. 69–72 and 173–4; and Petterson 2000.

33 Amsterdam 1976, p. 135, cites van Hoogstraten 1678, p. 119, who mentions the gesture of the fingers enfolded in one another as a reference to pregnancy. Therefore it is argued that the woman in the *Doctor's Visit* is pregnant. However, a closer reading of this passage confirms that van Hoogstraten was discussing a woman who was extremely pregnant ("die op 't uyterste zwanger is") and one, moreover, who is identified with envious witchcraft, a meaning hardly applicable to the painting. The gesture is more commonly expressive of mental anguish; see, for example, Bulwer [1644] 1974, pp. 39–40 and 115, fig. K.

34 For example, Aristotle, whose theories remained authoritative during the seventeenth century, considered felines the most promiscuous of all animals; see Amsterdam 1976, pp. 146 and 285–7; and Dixon 1995, pp. 70–71. De Jongh 2000a, p. 43.

35 See Amsterdam 1976, pp. 285–7.

36 The following remarks are taken from Amsterdam 1976, pp. 136–7 (see also the related literature cited there). Van Hoogstraten probably saw Raphael's fresco during his trip to Italy in 1652. He also knew it from reproductive engravings; see the one reproduced in Amsterdam 1976, p. 136, fig. 30b.

37 Dixon 1995, pp. 173–4. Amsterdam 1976, pp. 136–7, considers the inclusion of the detail of the *School of Athens* a moral counterweight to other motifs in the picture. Brusati's complicated interpretation (Brusati 1995, p. 126) of this detail is predicated upon the assumption that contemporaries recognized Raphael's fresco for what it truly was: a representation of philosophers and other accomplished men from antiquity.

38 Brusati 1995, p. 124. For the customs and decor associated with birth and lying-in rituals (in which the infant would be presented to female friends), see Lunsingh-Scheurleer 1971–2. See also Chapter 16.

39 For Maes, see Sumowski 1983–94, vol. 3, pp. 1951–2174; Dordrecht 1992–3, pp. 25–8, 226–51, and *passim*; Robinson 1996; and Kremper 2000.

40 In his biography of Maes, Houbraken 1753, vol. 2, p. 273, calls the painter's first teacher a "common master," in other words, one of no great repute.

41 See Kremper 2000, pp. 70–72. For Cuyp, see Dordrecht 1992–3, pp. 144–55; and *idem* 2002.

42 For this painting, see Sumowski 1983–94, vol. 3, p. 2013, cat. no. 1333; Worms 1992, cat. no. 34; Robinson 1996, pp. 162–3, checklist no. A32, who argues that its setting is based on that of a now-lost picture by Jan Victors (1619/20–c. 1676); and Kremper 2000, pp. 53 and 279, cat. no. A3. The influence of Rembrandt's history paintings upon Maes's earliest genre paintings has often been noted.

43 It is worth noting that virtuous women are often compared to bright light (including sunlight) in contemporary literature; see for example, v[an der] D[oes] 1622, fol. C2; Cats 1625, pt. 4, fol. 30ʳ; Hofferus 1635, pp. 86–7; Sprankhuisen 1658, pt. 1, p. 150; and Schaep 1671, pp. 241–2.

44 For this picture, see Sumowski 1983–94, vol. 3, p. 2022, cat. no. 1367; Franits 1993a, pp. 175–7; Robinson 1996, pp. 167 and 247, checklist no. A26; and Kremper 2000, pp. 61 and 355, cat. no. D6.

45 Kremper 2000, p. 53, points out that Maes made innovative use of the lighting techniques found in Rembrandt's portraits for his genre pictures.

46 The motif of the devious cat pulling on the tablecloth is difficult to interpret. Is transience, a notion so clearly expressed by other motifs in the painting, implied by the fact that the animal will cause all of the food and dishes to fall off the table? Perhaps the cat's long association with evil is meant to contrast the woman's piety in order to illustrate the pervasive power of sin. For this creature's association with evil, see Durantini 1983, p. 275 and the literature cited in note 34 above.

47 For the following remarks, see Franits 1993a, pp. 161–89; and *idem* 1993–4, pp. 78–81. See also Chapter 4.

48 The thick, fur-lined clothing invariably worn by elderly persons in Dutch genre paintings nearly always refers to transience regardless of whether they are imaged in positive or negative contexts, a point that seems to have been misunderstood by Arthur K. Wheelock, Jr., writing in Washington D.C. 1995, p. 163 n. 8.

49 See Kremper 2000, figs. 21, 25–30, and 48–50.

50 For this painting, see Amsterdam 1976, cat. no. 33; Southampton 1978, cat. no. 23; Slatkes 1981, p. 120; Sumowski 1983–1994, vol. 3, p. 2017, cat. no. 1352; Salomon 1984, pp. 191–7; Robinson 1987, p. 291 and *passim*; Franits 1993a, p. 108; Robinson 1996, pp. 167, 205–6, and 245 checklist no. A18, and *passim*; and Kremper 2000, pp. 53 and 281, cat. no. A9.

51 Salomon 1987, pp. 332–3, discusses several pictorial precedents for Maes's thieving feline in late medieval and sixteenth-century art.

52 See Amsterdam 1976, p. 145; Southampton 1978, p. 33; Slatkes 1981, p. 120; Salomon 1984, p. 191; and Robinson 1987, p. 291.

53 Salomon 1984, pp. 192 and 195, who argues that the painting actually depicts two servants (as opposed to a housewife and servant), cites a number of interesting late fifteenth- and sixteenth-century precedents for its subject matter and composition.

54 Even images of slothful peasants by the highly inventive Adriaen Brouwer (see Chapter 2) cannot match Maes's in complexity; see Munich 1986, color plate 3.

55 Robinson 1987, p. 291, who cites Bulwer [1644] 1974, p. 177 canon VIII and p. 193 fig. H.

56 See Kremper 2000, pp. 124–5 n. 54, who also calls attention to a drawing of *Abraham and the Three Angels* by Maes, possibly datable to 1653, which already demonstrates his knowledge of perspective. Most scholars believe that van Hoogstraten influenced Maes and that the former was back in Dordrecht as early as 1654. Yet Roscam Abbing 1993, p. 48 doc. no. 39, has published a document that places van Hoogstraten in Regensburg, Germany, as late as December 1655. Therefore, he could not have returned to Dordrecht until the winter of 1656 at the earliest. And during most of his prior years in Dordrecht, that is, about 1648–51, Maes was living in Amsterdam.

57 For Koedijck, see Wheelock 1973, pp. 269–70; Robinson 1974, pp. 92 and 98–9 nn. 8 and 9; Sutton 1980, p. 20; *idem* 1984; Philadelphia 1984, cat. no. 59; Liedtke 1988, pp. 97 and 101; *idem* 2000, *passim*; and Hollander 2002, pp. 112–15.

58 See Liedtke 1984; *idem* 1988; *idem* 2000, pp. 145–48 and 151–68; and *idem* 2001, pp. 135–8. *Idem* 2001, points out that regional styles appear less pronounced after 1650.

59 See Hollander 2002, pp. 18–35, who discusses the use of space in art as a rhetorical device.

60 De Brune 1660, vol. 2, p. 386 no. 620, "Een keucken-meyt moet d'eene ooghe, naer de panne, en d'ander naer de katte hebben." This passage is quoted with reference to Maes's painting in Amsterdam 1976, p. 146. De Brune's observation that maids must be vigilant when working in the kitchen is reminiscent of the censure in domestic treatises of indolent servants who allow food to be stolen by cats and dogs, for example, Gouge 1622, p. 624. (Gouge was an English Puritan divine whose writings were well known in the Netherlands.)

61 See the discussions and literature cited by Schama 1987, pp. 455–60; Carlson 1994, pp. 90–91; Hollander 1994, pp. 146 and 154 n. 34; and Sluijter 2000b, pp. 274 and 340 n. 24.

62 *Zeven duivelen, regerende en vervoerende de hederdaagsche dienst-maagden* 1682. See also Chapter 8 note 26 in this volume.

63 See Chapter 8 note 28 in this volume.

64 The social realities to which I refer are discussed in Chapter 11. Sarnowiec 2001, pp. 200–02, notes that *Zeven duivelen* 1682 and de V[ries] 1682, were both written partly in response to an ordinance concerning servant behavior published in Amsterdam in 1682.

65 For this painting, see Amsterdam 1976, cat. no. 34; Slatkes 1981, p. 122; Sumowski 1983–94, vol. 3, p. 2023, cat. no. 1370; Philadelphia 1984, cat. no. 67; Robinson 1987, pp. 299–308; Dordrecht 1992–93, cat. no. 62; Hollander 1994; Robinson 1996, pp. 170–71, 203–5, 209–21, and 244, checklist A15; Honig 1997, pp. 196–7; Kremper 2000, p. 286, cat. no. A24; Osaka 2000, cat. no. 22; Newark 2001–2, cat. no. 46; and Hollander 2002, pp. 103–48.

66 In the positioning of these figures, Smith 1990, pp. 80–81, argues for a basic dichotomy between high and low in the social and moral senses of those terms.

67 In the version under consideration here, the gesture simultaneously serves to point out the bust of Juno above the woman (see below).

68 See Langedijk 1964, pp. 3–4, fig. 2.

69 Robinson 1996, p. 218.

70 See Bulwer [1644] 1974, pp. 128–9 and 143, fig. H. Amsterdam 1976, p. 149; Robinson 1987, p. 302; Hollander 1994, p. 140. Also relevant, though less directly so, are sixteenth-century prints where a fool, unseen by the perpetrators, gestures toward the viewer to underscore the profligacy of the scene in question (for an example, see Robinson 1987, p. 303, fig. 18). In these instances however, the gesture is closer to that by the housewife in the *Idle Servant* than that made by her counterpart in the *Eavesdropper*. Most scholars note the gesture's use in contemporary theater.

71 See de Jongh 2000e, especially p. 76. See also Hedinger 1986, a study devoted to the depiction of maps in Dutch genre painting.

72 See the texts cited in Amsterdam 1976, pp. 146 and 149. Whether this metaphor is applicable to the thieving cat in Maes's *Idle Servant*, as the authors maintain, is debatable.

73 Juno's presence here is no accident since seventeenth-century political and religious thought held that the household was a microcosm of the state; see, for example, Wittewrongel 1661, vol. 1, pp. 1–5; and Oomius 1661, pp. 266–7. See also Schochet 1975.

74 Honig 1997, p. 197, suggests that Juno may actually be asleep.

75 For example, Amsterdam 1976, p. 149; Hollander 1994, p. 140; Robinson 1987, p. 302; Dordrecht 1992–3, p. 241; and Hollander 1994, p. 140.

76 The following comments owe much to the discussions by Hollander 1994, pp. 142–6; and *idem* 2002, pp. 103–48. Liedtke 2000, p. 162, suggests that Maes's rendition of space here was inspired by contemporary treatises of perspective (his fig. 216).

77 For the spatial layout of Dutch houses at this time, see Loughman and Montias 2000, pp. 22–30.

78 However, country homes were generally not adorned as lavishly as the interior in Maes's painting; see Fock 2001–2, p. 226 n. 11. See also Chapter 13.

79 Hollander 1994, p. 149; *idem* 2002, p. 128. Hollander 2002, p. 140 notes that in genre painting vistas into other rooms became a popular way of organizing domestic interiors and the female personnel within them.

80 Hollander 1994, p. 149.

81 For the following observations see Dordrecht 1992–3, p. 241. For the *voorhuis*, which evolved from a front room (often spanning the width of of the structure) to a vestibule or entrance hall over the course of the seventeenth century, see Loughman and Montias 2000, pp. 23, 27–8, and *passim*.

82 For this picture, see Robinson 1987, pp. 297–9; London 1992a, cat. no. 37; Robinson 1996, pp. 210–11; Krempel 2000, p. 280, cat. no. A5; and Hollander 2002, p. 134.

CHAPTER ELEVEN

1 For the following discussion, see Delft 1981; Delft 1982–3; Israel 1989, *passim*; *idem* 1995, *passim*; Plomp 1996, pp. 15–19; Abels 1996; van der Wiel 1996; van der Wulp 1996; de Vries and van der Woude 1997, pp. 65, 305–9, 320, and 520; and Bok 2001a.

2 See Israel 1989, p. 267 table 6.19. See also Montias 1982, pp. 293–317.

3 For Delft's population statistics during the seventeenth century, see Lourens and Lucassen 1997, pp. 102–3.

4 For example, by Peter C. Sutton, writing in Hartford 1998–9, p. 20.

5 Even after the French invasion of 1672, which led to the resurgence of the Orangist party, Delft's regents resisted the Stadholder's efforts to dominate local politics; see Chapter 15.

6 For these two masters who both died in Amsterdam, see Plomp 1996, pp. 26–8; Liedtke 2000, p. 143; *idem* 2001e, pp. 72–6; New York 2001, pp. 318–21 and 349–51.

7 For the economic aspects of art in Delft, see the monumental study by Montias 1982. See also van der Veen 1996; and Bok 2001a, pp. 205–10.

8 For example, de Hooch registered with the *Confrerie*, the painters' professional organization, in The Hague in 1660. For the presence of paintings by Delft artists in The Hague, see further Buijsen 1998–9, p. 38; Vermeeren 1998–9, pp. 54 and 57. See also Liedtke 2001e, pp. 51–2; and *idem* 2001d, p. 132.

9 For Fabritius, see Brown 1981; Sumowski 1983–94, vol. 2, pp. 979–97; Liedtke 2000, pp. 32–79; Liedtke 2001c, pp. 115–20; and New York 2001, pp. 247–63.

10 Van Hoogstraten 1678, p. 11. Brown 1981, pp. 160–61, provides full transcriptions and English translations of various passages about Fabritius in van Hoogstraten's text.

11 Brown 1981, p. 41.

12 Van Bleyswijck 1667, p. 852, describes the explosion and Fabritius's last hours. Brown 1981, pp. 159–60, provides a transcription and English translation of the text.

13 For this picture, see Brown 1981, pp. 48–9, cat. no. 8; Sumowski 1983–94, p. 986, cat. no. 607; Liedtke 2000, pp. 35–7; New York 2001, cat. no. 20; and Kunzle 2002, p. 603.

14 Walter Liedtke kindly provided this information. See also Liedtke 2000, p. 266 n. 113; and the various hypotheses concerning the soldier's actions summarized in New York 2001, p. 257.

15 Liedtke 2000, pp. 35 and 266 n. 113.

16 *Ibid.*, p. 37, mentions the existence in seventeenth-century Amsterdam of a St. Anthony's gate; Fabritius probably knew it from his time there in Rembrandt's studio. Moreover, *ibid.*, pp. 35 and 37, construes St. Anthony as a possible reference to diligence and willpower as he overcame various temptations.

17 See the literature cited in New York 2001, p. 258 n. 6.

18 For militia companies in Delft and in the Dutch Republic at large, see Singeling 1981; Haarlem 1988; and especially Knevel 1994. See also fig. 9.

19 Liedtke 2000, p. 35, raises the intruiging possibility that the scene occurs in early morning

20 See de Jongh 1981–2, pp. 118–23.

21 Rüger, writing in New York 2001, p. 258. For other types of painting in Delft, see New York 2001, *passim*. Brown 1981, pp. 57–61, was the first scholar to address the propensity to overestimate Fabritius's contributions to Delft painting.

22 For de Hooch, see Sutton 1980; Kersten 1996, pp. 131–70; Hartford 1998–9; Liedtke 2000, pp. 143–85; *idem* 2001d, pp. 132–45; and New York 2001, pp. 266–91.

23 Houbraken 1753, vol. 2, pp. 34–5. This would have occured sometime between Berchem's return from Italy in 1646 and 1652 when de Hooch was recorded as residing in Delft; see Sutton 1980, p. 9. That there is no trace of Berchem's style in de Hooch's work should not be considered unusual. The Rotterdam painter Ludolf de Jongh (1616–1679) may have also served as de Hooch's teacher, a hypothesis that seems more credible; see further the discussion in Chapter 13.

24 The document in question is summarized in Sutton 1980, p. 145 no. 15. The following discussion is articulated more fully in Franits 1989. See also the objections of Sutton, writing in Hartford 1998–9, pp. 85–6 n. 141; and Liedtke 2000, p. 279 n. 31, whose reference to de Jongh 1980, p. 182, fails to clarify matters as the term "*dienaar*" (servant) in the seventeenth century did not refer exclusively to indentured persons.

25 For this painting, see Sutton 1980, pp. 13–14, cat. no. 12; Dublin 1986, pp. 67–8; Kersten 1996, pp. 134–5; and Hartford 1998–9, cat. no. 5 (where it is said to be the possible pendant of cat. no. 6).

26 For de Hooch and de Jongh, see Fleischer 1978; Sutton 1980, pp. 12–13 and *passim*; Fleischer 1989, pp. 71–7 and *passim*; and Liedtke 2000, pp. 160–62.

27 For this painting, see Sutton 1980, p. 78, cat. no. 17; Kersten 1996, p. 138; and Hartford 1998–9, cat. no. 7.

28 For brooms, see Franits 1993a, pp. 77 and 97–100, based in part on an earlier lecture by Eddy de Jongh, which was later published as de Jongh 2000d. See also by Schama 1987, pp. 375–97 and *passim*, whose anthropologically based interpretations of brooms emphasize cleanliness and the affirmation of such values as vigilance and patriotism.

29 Oomius 1661, pp. 211–13.

30 For civility and hygiene, see Goudsblom 1977–8; and Vigarello 1988.

31 See Sennett 1977, pp. 16–19 and 89–106; Lukacs 1970, pp. 622–5; Chartier 1989; Castan 1989; Goodman 1992; Schuurman and Spierenburg 1996a; and Segalen 1996. For public versus private in seventeenth-century Dutch literature, see Smits-Veldt 2000. For the art-historical perspective on privacy, see Smith 1988, p. 52; *idem* 1992; Hollander 1994, *passim*; Franits 1996, p. 13; Salomon 2000, especially pp. 144–5; Franits 2001a, pp. 297–9; Hollander 2001, *passim*; and *idem* 2002, *passim*.

32 For example, Loughman and Montias 2000, pp. 22–30; Hollander 2001, pp. 274–5; and Westermann 2001–2, pp. 24–31. See also Ottenheym 1997, pp. 41–6.

33 See Hollander 2001; and *idem* 2002, pp. 161–76.

34 Hollander 2001 and *idem* 2002, pp. 179 and 199, takes a slightly different view, arguing that the omnipresence of the outside world in de Hooch's work, suggested by windows and courtyards, for example, literally illustrates the instability of concepts of public and private at this time. For other, important studies that examine the gendering of space, see Honig 1997 and Salomon 2000, pp. 149–53.

35 Sutton, writing in Hartford 1998–9, p. 120. For this picture, see also Sutton 1980, pp. 21, 23, 30, and 83–4, cat. no. 32; Philadelphia 1984, cat. no. 54; The Hague 1990–91, cat. no. 34; and Newark 2001, cat. no. 48.

36 The erotic interpretation of this motif by Durantini 1983, p. 27, is inconsistent with the wholesome tone of this painting.

37 See Cats 1625, pt. 5, p. 56; and Erasmus 1664, pp. 276–96. Mothers who allowed their offspring to be nourished with animal milk were vigorously condemned. Amazingly, medical experts believed that these children would develop the behavioral traits of the animals from whom they had received milk; see, for example, van Beverwijck 1656, p. 167, who relates that a child fed by a canine routinely woke up at night and barked with other dogs! Franits 1993a, pp. 114–19, contains a lengthy discussion of breastfeeding in Dutch art.

38 For example, Slatkes 1981, pp. 120 and 124; and Kersten 1996, p. 139.

39 For example, Blankert 1978, p. 30.

40 Liedtke 1984; *idem* 1988; *idem* 2000, pp. 145–8 and 151–68; and *idem* 2001d, pp. 135–8. *Idem* 2001c, pp. 99–100, points out that regional styles appear less pronounced after the middle of the century.

41 See the studies by Liedtke cited in the previous note.

42 For example, the setting of *A Woman Nursing* strongly resembles that of de Hooch's *A Woman Peeling Apples* (London, The Wallace Collection); see London 1992b, pp. 167–9.

43 See Hollander 2001, pp. 274–5; and *idem* 2002, pp. 150–51.

44 For this picture, see Sutton 1980, pp. 24, 26, 55, 84, and 85, cat. no. 34; Slatkes 1981, p. 124; Franits 1989, pp. 563–5; London 1991, vol. 1, pp. 197–8; Hartford 1999, cat. no. 18; Liedtke 2000, pp. 181–4; New York 2001, cat. no. 30;

45 Liedtke, writing in New York 2001, p. 282.

46 A pinhole is visible in a *Courtyard of a House in Delft* in the shadow of the door beside the woman in the vestibule; see Hartford 1998–9, p. 124. For de Hooch's perspective and working methods, see further Hartford 1998–9, pp. 40–42 and *passim* and fig. 36.

47 Sutton, writing in Hartford 1998–9, p. 30.

48 See Liedtke 2001a, pp. 28, 569 n. 16, who notes the erroneous assumption among specialists that this tablet was imbedded in the archway of the original cloister. See also *idem*, writing in New York 2001, p. 282.

49 For example, Sutton 1980, p. 84; Slatkes 1981, p. 124; and London 1991, p. 200.

50 Slatkes 1981, p. 124. See also Franits 1989, p. 565.

51 For the following observations, see Haks 1982, pp. 89–90, 167–74, and *passim*; van de Pol 1982; *idem* 1983; Jongejan 1984; Carlson 1994; Dekker 1994; *idem* 2002; and Schama 1987, pp. 405–6, 455, 456 and 459–60, who remarks that the occasional presence of servants in family portraits provides evidence that they were sometimes well integrated into the family circle.

52 Jongejan 1984, p. 216. See also Haks 1982, pp. 168–70 and the discussion by Sarnowiec 2001, pp. 200–02, of an ordinance published in Amsterdam in 1682 and its ramifications for two contemporary texts that associated housemaids with the seven deadly sins (see Chapters 8 and 10). See also the ordinances published in Purmerend in 1696, reprinted in Fritschy 1980, vol. 2, pp. 75–80. Roodenburg 1990, p. 260, cites several cases that came before the Amsterdam consistories – assemblies of deacons and elders who administered discipline for the Reformed Church – of pregnant maids who had allegedly tempted the men of the house to have sex with them. Roodenburg 1990, pp. 281 and 289, also cites cases of adultery committed by men and their housemaids. The diary of Constantijn Huygens, Jr. (1628–1697) records several instances of housemaids preyed upon by their employers; see Dekker 2002, pp. 84–5.

53 The main reason for the artist's partial fall into obscurity was the rather limited size of his œuvre. Before the invention of photography, the ability to recognize works by a particular artist often hinged upon the quantity originally produced. Large numbers of paintings guaranteed familiarity since these would appear with frequency in private collections and at auctions. Thus such Dutch masters as Berchem and Philips Wouwermans (1619–1668) enjoyed great prestige among eighteenth- and early nineteenth-century connoisseurs while the names of Vermeer and others with comparatively small outputs were sometimes forgotten. Yet Vermeer's name

never sank entirely into oblivion: see the recent essays by Broos 1995–6, pp. 55–61; *idem* 1998; Jowell 1998; and Hertel 2001, pp. 142–9 and *passim*.

54 As one would suspect, the literature on Vermeer is voluminous. Recommended among the many studies are: Blankert 1978; Wheelock 1981; Slatkes 1981; Blankert, Montias, and Aillaud 1988; Montias 1989; Arasse 1994; Wheelock 1995; Washington D.C. 1995–6; Gaskell and Jonker 1998; Liedtke 2000, pp. 187–263; *idem* 2001d, pp. 145–69; New York 2001, pp. 359–406; Franits 2001b; and *idem* 2001c. Somewhat older though still quite useful is Gowing 1970.

55 For Vermeer as the subject of novels, poems, and an opera, see Hertel 2001, pp. 156–60; and Wheelock and Glass 2001.

56 See Montias 1989, pp. 76–8; and *idem* 1991, p. 46. Vermeer's father was also related by marriage to Egbert van der Poel (1621–1664), a Delft native and prolific painter of peasant interiors and conflagration scenes who resided in the city until 1654; see Montias 1991, pp. 44–5.

57 Montias 1982, p. 88; and van der Veen 1996, p. 126. For Vermeer's activities as an art dealer, about which little is known, see Montias 1989, pp. 185 and 219.

58 Van Bleyswijck 1667, p. 854. It was Blankert 1978, pp. 147–8, who discovered that surviving copies of van Bleyswijck's book contained two different versions of the last stanza of Bon's poem.

59 The Delft painter Leonard Bramer (1596–1674) is another possible candidate for Vermeer's teacher. There is strong evidence that he was a friend of the artist's family. A document dated 5 April 1653 reveals Bramer's presence during an attempt to persuade the latter's future mother-in-law to sign the act of consent for the registration of the marriage banns between Vermeer and her daughter; see Montias 1989, pp. 99 and 308 doc. no. 249. For Bramer's work, see Delft 1994.

60 Montias 1989, pp. 105–7 and 110. Vermeer was required to pay an entrance fee of 6 guilders when he was admitted into the Guild of St. Luke in 1653. Usually, new admittees into the guild whose fathers had been members – as was the case with Vermeer – were required to pay 3 guilders provided that they had trained for two years with a master of the guild. According to van der Veen 1996, p. 126, the only plausible explanation for the higher admission fee is that Vermeer's training had occurred outside of Delft.

61 Montias 1989, pp. 106–7, 110, 123–4 and 296 doc. no. 188. See also *idem* 1991, p. 43.

62 For the importance of history painting in seventeenth-century Dutch art, see Blankert 1980.

63 Some specialists consider Vermeer's earlier *Procuress*, signed and dated 1656 (Dresden,

Gemälde Galerie Alte Meister), a history painting while others recognize it as a genre painting; see New York 2001, cat. no. 66. For *An Officer and Laughing Girl*, see Blankert 1978, pp. 32–5 and 156, cat. no. 5 and *passim*; Wheelock 1981, pp. 82 and 84; Slatkes 1981, pp. 27–8; Blankert, Montias, and Aillaud 1988, p. 40 and 173, cat. no. 5, and *passim*; Wheelock 1995, pp. 55–61; Liedtke 2000, pp. 209–10; *idem* 2001d, pp. 155–6 and *passim*; Franits 2001b, pp. 14 and 16.

64 See Montias 1989, pp. 101–3 and 308 doc. no. 251. Ter Borch also visited The Hague (situated close to Delft) executing a portrait commission there in 1649; see Chapter 7.

65 See Wheelock 1995, p. 65.

66 Liedtke 2000, p. 210, believes that widely accepted hypotheses of Vermeer's use of the camera obscura – to whatever degree – are overstated in relation to *An Officer and Laughing Girl* and other paintings by the artist.

67 Steadman 2001. For Hockney's hypotheses and symposium, see the *New York Times*, 29 November 2001, pp. E1 and E4; and 4 December 2001, pp. E1 and E3. Hockney has also recently published a book concerning the purported use of optical devices by Western European masters over the centuries.

68 For Vermeer and the camera obscura, see Seymour 1964; Schwarz 1966; Fink 1971; Wheelock 1977a, pp. 283–301; Wheelock 1977b, pp. 285–95; Delsaute 1998; and Steadman 2001. The following discussion is to a large extent based on the work of these scholars.

69 See, for example, Constantijn Huygens's enthusiastic comments about the image projected by the camera obscura, as discussed by Wheelock 1977a, p. 93. Huygens (1596–1687) was a noted author, outstanding connoisseur of art, and secretary to the Prince of Orange, Frederik Hendrik (see Chapter 1).

70 See Liedtke 2000, pp. 39–79; and *idem* 2001c.

71 Westermann 2002a, p. 358.

72 This was noted by Wheelock 1981, p. 88; and numerous, similiar examples in Vermeer's art could be cited. For *The Milkmaid*, see, most recently, New York 2001b, cat. no. 68.

73 Delsaute 1998, p. 120. See also the critique of Delsaute's hypothesis and those of other scholars who downplay Vermeer's use of the camera obscura, in Steadman 2001, pp. 135–55.

74 See further Liedtke 2000, pp. 207, 209, 210–11, and *passim*; and *idem* 2001d, pp. 155–6, who almost completely dismisses Vermeer's potential interest in the device.

75 According to Groeneweg 1997–8, pp. 206 and 228 n. 48, pearls were an important status symbol in Vermeer's day. For *The Girl with the Wine Glass*, see Braunschweig 1978, cat. no. 39; Blankert 1978, pp. 40–41 and 159, cat. no. 11, and *passim*; Wheelock 1981, p. 92;

Slatkes 1981, p. 49; Blankert, Montias, and Aillaud, pp. 108–9 and 178–9, cat. no. 11, and *passim*; Washington D.C. 1995–6, cat. no. 6; Salomon 1998a, pp. 319–22; Liedtke 2000, pp. 215–17; *idem* 2001b, pp. 158 and 160; and Franits 2001b, pp. 21 and 22. For the *Young Woman with the Water Pitcher*, see Blankert 1978, p. 41, cat. no. 12; Wheelock 1981, pp. 114 and 116; Slatkes 1981, p. 50; Blankert, Montias, and Aillaud, p. 109, cat. no. 12; Wheelock 1995, pp. 105–11; Washington D.C. 1995–6, cat. no. 11; Liedtke 2000, pp. 226–8; *idem* 2001d, p. 161 and *passim*; and New York 2001b, cat. no. 71. For women in Vermeer's art in general, see Vergara 2001.

76 The preceding observations were taken from Wheelock 1981, p. 116; and *idem* 1995, pp. 108–11. See also Washington D.C. 1995–6, p. 148; and Wheelock 2001. Wheelock's studies of Vermeer's technique rank among the most perceptive and sensitive to date. See as well the recent studies by Gifford 1998; Costaras 1998; and Wadum 1998.

77 In particular, *The Girl with the Wine Glass* (fig. 154) has often been associated with van Mieris's work; see Slatkes 1981, p. 49; Blankert 1978, p. 41; Wheelock 1981, p. 92; Blankert 1995–6, p. 37; and Washington D.C. 1995–6, cat. no. 6. For van Mieris, see Naumann 1981.

78 In some of Vermeer's paintings motifs that would have clarified their meanings were painted out, thereby contributing to their ambiguity and overall appeal; see, for example, New York 2001, cat. no. 67.

79 Salomon 1998a, p. 319, examines the pictorial origins in sixteenth-century Italian art of this motif. See also the discussion in Chapter 2.

80 See *ibid.*, pp. 319–20.

81 De Lairesse 1778, pp. 29–30. Salomon 1998a, pp. 319–20, links this text to Vermeer's painting. For de Lairesse's illustration and its sociocultural implications, see further Chapter 8.

82 Has the man dozing in the background succumbed to narcosis as intimated by the wine jug and wrapping paper for tobacco that lie on the table upon which his elbow rests? Contrary to Wheelock's assertion (Washington D.C. 1995–6, p. 116) the bowl of a tobacco pipe does not seem to be included among the items on the table. Wheelock 1981, p. 92; and Nevitt 2001, p. 90, following Bedaux 1975, p. 35, have also argued that the man's pose with his head resting on his hand signifies his melancholic state but he is actually asleep.

83 Most scholars, rightly to my mind, see a contrast between the actions of the men in Vermeer's painting and the staid portrait of the male wearing out-of-date fashions upon the wall behind them. Beaujean 2001, p. 155, points out some convincing parallels between this portrait and Frans Hals's *Portrait of Jacob*

Pietersz. Olycan (The Hague, Mauritshuis), his fig. 93. Nevertheless, his idea that the clothing worn by the figure in the portrait is meant to contrast the frivolous attire of the dandies below him is grounded in the mistaken assumption that black garments evoke notions of sobriety. As Groeneweg 1995 has demonstrated, such garments were associated with luxury and sophistication.

84 The coat-of-arms was first identified as a personification of temperance by Rüdiger Klessman, writing in Braunschweig 1978, pp. 166–7. For an alternative to Klessman's widely accepted hypothesis, see Weber 1998, p. 303. As the result of research first published in 1942, it is known that the coat-of-arms in Vermeer's painting (and seen as well in his *Glass of Wine*, Berlin, Gemäldegalerie) was that of Jannetge Jacobsdr. Vogel, who died in 1624. She was the first wife of Vermeer's neighbor, Moses J. Nederveen.

85 De Winkel 1998, p. 329, has identified the type of garments worn by the woman in this picture.

86 See Snoep-Reitsma 1973 and Amsterdam 1976, p. 195.

87 For the linking of luminosity and virtuous womanhood, see Franits 1993a, pp. 31 and 206 n. 48; and Vergara 2001, pp. 65–6.

88 Chapman 2001, pp. 239 and 255.

89 See Sluijter 1998c, pp. 271–7. See also Goodman 2001, *passim*.

90 This discovery was made by Jan van der Waals and published in *idem* 1992, pp. 181–2. For Vermeer's title, see Haks 1996, pp. 98 and 101. According to Liedtke 2001d, pp. 149–50, a "certain gentility is suggested by the [items in] inventory made shortly after Vermeer's death." See also Haks 1996, pp. 103–4; and Montias 1998, pp. 100–01. However, there is some evidence that during the second half of the seventeenth century citizens of less substantial means gained membership into militia companies. For militia companies in general, see Singeling 1981; Haarlem 1988; and especially Knevel 1994.

91 See Leidtke 2001b, p. 17; and *idem* 2001d, pp. 157, 160, and 164.

92 De Monconys 1665–6, vol. 2, pp. 136 and 147–9. The owner's quotation of such an exorbitant price may possibly be construed as a feeble attempt to impress a well-to-do foreigner. See further Montias 1989, pp. 180–81. For Vermeer's painting procedures and the materials he utilized, see Gifford 1998; Costaras 1998; and Groen *et al.* 1998.

93 The following paragraphs are based on Montias's important archival findings concerning van Ruijven and his wife; see Montias 1987b, pp. 68–71; *idem* 1989, pp. 246–51; and *idem* 1998, pp. 93–9.

94 For the following discussion, see Montias 1987, pp. 71–3; and *idem* 1989, pp. 251–7. Initially, and for reasons that are not clear, Magdelena van Ruijven's estate was divided between Dissius and his father Abraham. Among Abraham's share were fourteen paintings, including six by Vermeer. His son Jacob inherited these along with the rest of his father's estate when Abraham died in 1694; see Montias 1989, pp. 254–5.

95 For a complete transcription and translation of the list of paintings auctioned, see Montias 1989, pp. 363–4 doc. no. 439.

96 It was Wijsenbeek-Olthuis 1987, p. 269, who first noted the presence of a now-lost mythological painting by Vermeer among the van Berckel family possessions. For van Assendelft's patronage, see Broos 1995–6, p. 48; see also Wijsenbeek-Olthuis 1987, pp. 266 and 392 n. 16.

97 See Montias 1989, pp. 182–3 and 318–19 doc. no. 298.

98 See Blankert, Montias, and Aillaud 1988, pp. 156 and 205. See further Blankert 1995–6, pp. 32–3 and 43 n. 8.

99 Montias 1991a, pp. 48–51. See also *idem* 1998, pp. 99–100; and Broos 1995–6, pp. 49–50.

100 Wadum 1995–6, pp. 71–2, rightly interprets this statement as a reference to Vermeer's carefully constructed interior scenes such as *The Love Letter* (Amsterdam, Rijksmuseum); see Washington D.C. 1995–6, cat. no. 18, where it is stated that van Berckhout may have had this painting in mind. For Vermeer's use of perspective, see Wadum 1995; and *idem* 1995–6.

101 Van Bleyswijck 1667, pp. 852–3.

102 Liedtke 2001b, p. 15 and *passim*, identifies these general stylistic characteristics of Delft painting.

103 See Liedtke 2000, pp. 11–38 and *passim*; *idem* 2001b, pp. 15–18; and *idem* 2001e, pp. 53–4, who provides a comprehensive look at the problem of a Delft School, concluding with a "qualified yes" that there was one. See also the earlier comments of Brown 1981, pp. 57–61; Montias 1982, pp. 179–82; and de Vries 1985. Regardless of whether one subscribes to the theory of a Delft School, de Bièvre's hypothesis (de Bièvre 1995), that the stylistic features of Vermeer's work reflect a sense of urban subconsciousness grounded in the collective experience of life in Delft, is too speculative.

104 For *The Concert*, see Blankert 1978, pp. 45 and 162–3, cat. no. 17; Wheelock 1981, pp. 120 and 122; Slatkes 1981, p. 66; Blankert, Montias, and Aillaud, pp. 120 and 183–4, cat. no. 17; Wheelock 1995, pp. 113–19; Liedtke 2000, pp. 246–7.

105 Tragically, the painting was stolen in 1990 and has not yet been recovered. My comments here are based on the perceptive observations of Wheelock 1981, pp. 120 and 122; and *idem* 1995, pp. 113–19.

106 Goodman 2001, pp. 85–8. Goodman discusses several earlier studies of the painting's iconography.

107 See the preceding note. See also Beaujean 2001, pp. 147–78, for a detailed analysis of Vermeer's use of pictures within his paintings. Beaujean discusses *The Concert* on pp. 174–5. The woman raises her hand as they sing, a gesture that appears in other representations of music-makers. This gesture is commonly assumed to signify temperance (see for example Moreno 1982, pp. 56–7). Goodman 2001, p. 86, argues that according to the musical practices of the time, no one would be required to set the pace of an informal performance. Therefore it is much more likely that gestures underscore the expressive effects or content of the song. Nevertheless, in October 1989, at the Historians of Netherlandish Art conference in Cleveland, Kenneth Be gave a paper on Pieter de Hooch's *Portrait of a Family Making Music* (Cleveland, Cleveland Museum of Art), where the very same gesture appears. In explaining this gesture, Be cited several contemporary music treatises which stress the importance of keeping the beat with one's hand.

108 Weber 1998. This essay is a shorter, English version of *idem* 1994.

109 This can be seen by comparing, among others, *The Glass of Wine* (Berlin, Gemäldegalerie; Franits 2001c, plate 9) and *The Girl with the Wine Glass* (fig. 154) or the *Girl Reading a Letter at an Open Window* (Dresden, Gemäldegalerie Alte Meister; Franits 2001c, plate 7) and *An Officer and Laughing Girl* (fig. 151).

110 See especially Swillens 1950, pp. 69–77 and 113–21; and Steadman 2001, pp. 73–100. See also Montias 1989, pp. 194–5. In Liedtke 2001f (a review of Steadman 2001), p. 643, Liedtke points out the utter implausibility of Vermeer's interiors, a fact that escaped Steadman despite his insistence that Vermeer continually manipulated a camera obscura in the same actual setting to produce his pictures.

111 See Swillens 1950, pp. 77–90; Welu 1975; and Montias 1989, pp. 194–5.

112 For this inventory, see Montias 1989, pp. 220–22 and 339–44 doc. no. 364; and Haks 1996, pp. 97–8.

113 See Montias 1989, pp. 159, 171 and 317 doc. no. 291.

CHAPTER TWELVE

1 For the following discussion of Amsterdam, see Regin 1976; Kistemaker and van Gelder 1983; Israel 1989, *passim*; Burke 1994; Israel 1995, *passim*; and de Vries and van der Woude 1997, *passim*.

2 For Amsterdam's population over the centuries, see Nusteling 1997. See also Lourens and Lucassen 1997, pp. 55–7.

3 See Edwards 1999.

4 Israel 1999.

5 See van der Wee 1996 and Diederiks 1996. See also O'Brien 2001a, pp. 18–19 and 25.

6 See Hart 2001, p. 133 and table 6.1.

7 See Dudok van Heel 1997; Ottenheym 1997; and Hart 2001, pp. 132–4 and 144–6.

8 An idea of the type of furnishings and decorative accouterments preferred by elites at this time can be gleaned from Newark 2001–2.

9 J. de Vries 1999. De Vries, p. 81, also discusses the fascinating study by Schama 1987 which imaginatively addressed the tensions between luxury consumption and morality in the Dutch Republic.

10 A certain Jacob van Loo had signed a contract in Amsterdam dated 1635 to deliver ten paintings to an art dealer in exchange for two tulips and 180 guilders; it is uncertain whether this refers to the artist under consideration here, who can only be definitively placed in Amsterdam in 1642. Rotterdam 1999–2000, pp. 164 and 166, provides the most useful biography on the artist. A monograph on van Loo is, unfortunately, still lacking. See also Klingsöhr-Leroy 1996.

11 For this painting, see Franits 1993a, pp. 47–51; and Slatkes 1981, p. 132, who suggests that it represents an elegant updating of the earlier, more bawdy portrayals of brothels because of the presence of the canopied bed in the room, the large glass on the table, and the shell – an attribute of Venus – in the pediment above the door. This interpretation is somewhat problematic and inconsistent with the general tone of the picture. Moreover, the presence of a canopied bed does not necessarily mean that a room in a brothel or even a bedroom is being represented. During much of the seventeenth century, beds could be found in any number of rooms, including the kitchen. While the shell is unquestionably an attribute of Venus, it is not necessarily a symbol of sexual impropriety. After all, Venus herself sometimes appears on the title pages of songbooks devoid of prurient content. See, for example, the title page to *Nieuwen ieucht spiegel c.* 1620. Therefore contemporaries did not always construe the presence of Venus or her attributes among courting young people negatively.

12 Petrarchism in seventeenth-century Dutch culture is discussed in Chapter 7.

13 Krul 1644, pt. 1, p. 316. The inscription on fig. 159 (which cleverly rhymes in Dutch) can be loosely translated as "Sweethearts who love, have taken leave of their senses." Van Loo's painting may well convey the same idea through the motif of the young lady who has put her sewing aside.

14 Visscher 1614, p. 178, ". . . die dan by henlieden de tweede plaetse van gheacht te wesen wil bejaghen, die moet hem stellen om haer te dienen met een soete boertighe, ver-maeckelijcke praet, mydende alle dorperheyd en vilonie, sonder haer kaeckelen ende snappen te berispen, nimmermeer haer puys pronckende kleederen te bejocken; maer al prysen wat zy doen en voortstellen, dan sal hy in haer gheselschap voor een volmaect Courtisaen ghepresen worden."

15 See further the discussion concerning emblems and interpretation in the Introduction.

16 Van Loo had a reputation for depicting nudes, especially female nudes; see Rotterdam 1999–2000, cat. no. 26.

17 For van den Eeckhout, see Sumowski 1983–94, vol. 2, pp. 719–909; and Broos 2000.

18 See *De nieuwe hofsche rommelzoo* 1655, a miscellany of poems and songs by prominent Amsterdammers including van den Eeckhout (p. 28).

19 For this painting, see Sumowski 1983–94, vol. 2, p. 747, cat. no. 501; Philadelphia 1984, cat. no. 43; Pittsburgh 1986, cat. no. 27; and Franits 1993a, pp. 41–4.

20 Peter C. Sutton, writing in Philadelphia 1984, p. 201, observes that contemporary Flemish painters such as the influential Gonzales Coques (1614/18–1684) depicted families on terraces and beneath stone porticoes. Van Loo also represented merry companies on terraces; see, for example, Philadelphia 1984, cat. no. 64.

21 See Forster 1969, *passim*; Goodman 1982, pp. 256–8; and *idem* 2001, pp. 80–83.

22 According to Kettering 1988, vol. 2, pp. 426, 435, 449, and *passim*, Gesina ter Borch used the motif of the fan several times in her poetry album to suggest the cold-heartedness of the lady who spurns her suitor's affection. For the symbolism of the fan in Dutch art, see further Smith 1982, pp. 81–9 and *passim*.

23 For this picture, which can also be dated to the early 1650s, see Sumowski 1983–94, vol. 2, p. 747, cat. no. 507; and Franits 1993a, p. 44.

24 This woman's hand gesture recalls that of the singer in Vermeer's *Concert* (fig. 157); see the discussion in Chapter 11.

25 In other visual contexts the gesture of the head resting on the hand signifies sloth (see fig. 137). There is an enormous amount of scholarly literature on melancholia and art; see, for example, Klibansky, Panofsky, and Saxl 1964; and Bedaux 1975, pp. 27–9 and *passim*. See also Kettering 1988, vol. 2, pp. 499 and 587, for two illustrations of melancholic lovers from Gesina ter Borch's poetry album. Veldhorst 1999, pp. 53–4, transcribes a popular, seventeenth-century Dutch love song, entitled, "Powerful Medicine for Those Tormented with Melancholy . . ."

26 See, for example, Bedaux 1975, p. 39, fig. 24.

27 See, for example, Hooft [1611] 1983, emblem no. ix. See also fol. 75 of Gesina ter Borch's poetry album; illustrated and discussed in Kettering 1988, vol. 2, pp. 457–8 and 565.

28 The theme was also painted by Pieter de Hooch (see Chapter 11) and Ludolf de Jongh (see Chapter 13).

29 See also Helgerson 2000, pp. 79–119 (based on an earlier article), who maintains that the frequent presence of soldiers in domestic settings in genre paintings of the 1650s and 1660s reflects Dutch anxieties concerning the political implications of a powerful military. The author's thesis, however provocative, overlooks the pictorial conventions from which this imagery evolved (and deviated), a recurrent problem in the publications of non-specialists writing on seventeenth-century Dutch art. See also Kunzle 2002, pp. 30 and 598–600, who perhaps ties post-1648 images of soldiers too closely to the diminished circumstances of the army in this era in which the regents dominated national politics (see Chapter 6).

30 For Metsu, see Gudlaugsson 1968; and Robinson 1974.

31 See the discussion of Metsu's early period by Robinson 1974, pp. 15–23. Jan Steen (see Chapter 14), who lived in Leiden for several years during the 1650s, had been a pupil of Knüpfer's and could have introduced Metsu to his work and possibly the artist himself; see Robinson 1974, pp. 18–19. Gudlaugsson 1968, p. 16, sees a direct relationship between Metsu and Knüpfer, without Steen's intermediacy.

32 Metsu's chronology is difficult to establish because he rarely dated his pictures: of the roughly 150 that survive, only nineteen have dates. Moreover he often varied the style in which they were painted. For *The Hunter's Gift* see Robinson 1974, pp. 26, 56, and *passim*; Slatkes 1981, p. 145; Philadelphia 1984, cat. no. 71; Franits 1993b, pp. 303–7; and de Jongh 2000a, pp. 33–5.

33 De Jongh 2000a, p. 33.

34 *Ibid.*, p. 22, from whence this English translation is taken.

35 The erotic meaning of the bird in this painting is enhanced by the fact that it is a partridge, a species traditionally considered libidinous; see *ibid.*, p. 28.

36 For example, Wheelock 1976, p. 458; Slatkes 1981, p. 145; Naumann 1981, vol. 1, pp. 110–11; and Philadelphia 1984, p. 250. See also Smith 1987a, p. 415.

37 See further Chapter 7. Sewing and footwear were also well-known erotic metaphors; see for example, Amsterdam 1976, cat. nos. 64 and 68; and de Jongh 2000a, pp. 33–4. However, the pictorial contexts in which these motifs occur are often more raucous and lascivious and feature females of dubious morals.

38 Houwaert 1622–3, bk. 2, p. 107.

39 Wheelock 1976, p. 458. The art market in Amsterdam was much more open than that of other cities; a comparatively high percentage of the pictures sold and collected there were by artists from other towns. For overviews of the art market in Amsterdam and collecting activities there, see Montias 1991b; *idem* 1999; Bok 2001b; and Montias 2002.

40 See Robinson 1974, pp. 28–9. However, as Gudlaugsson 1968, p. 31, pointed out, this is all a matter of degree; Metsu's technique is still broader in comparison with van Mieris's. Nevertheless, Metsu is still occasionally (and erroneously) called a *fijnschilder*, for example, by Horn 2000, vol. 1, pp. 419 and 586.

41 See Robinson 1974, pp. 28–9. See also New York 1984, cat. no. 32.

42 This likely explains the presence of men offering hunting trophies to their wives in contemporary Dutch portraiture; see, for example, *A Family Group* by Bartholomeus van der Helst (London, The Wallace Collection) in London 1992b, pp. 142–4.

43 In light of the book's oblong format, it is probably a songbook. Many seventeenth-century Dutch songbooks, especially those primarily composed of sacred music, had edifying contents. One of the most popular songbooks of this type was Camphuysen 1644. An enormous number of secular songbooks were also published during this period, often containing amorous songs. Since these also professed to have edifying intentions, it is impossible to state unequivocally that the songbook in Metsu's painting is a religious one.

44 See de Jongh 1967, pp. 28–31; and Haarlem 1986b, cat. no. 20. A grapevine also appears in Psalm 128, a favorite psalm among seventeenth-century authors and theologians because it employs metaphorical imagery to describe domestic life as well as female fertility; see de Jongh 1974, pp. 179 and 189–90; Franits 1986, pp. 40–42; and *idem* 1993a, pp. 82 and 142–3.

45 Cats 1632, pt. 1, p. 69. See also van der Minnen 1684, pp. 76–7.

46 For this painting, see Robinson 1974, pp. 53–4; Wheelock 1976, p. 458; Sutton 1997, pp. 28–9; Amsterdam 1997b, cat. no. 20; Osaka 2000, cat. no. 26; and Newark 2001–2, cat. no. 57. Walter Liedtke kindly provided the manuscript for his entry on the picture which will appear in his forthcoming catalogue of the Dutch paintings at The Metropolitan Museum of Art.

47 For the customs and decor associated with birth and lying-in rituals, see Lunsingh-Scheurleer 1971–2. See also Chapter 16.

48 Wheelock 1976, p. 458, wonders whether Metsu influenced de Hooch because the latter's work only moved in the direction of the former's elegance after he moved to Amsterdam.

49 See van Gent 1997, pp. 127–9 and fig. 2, who published an archival document connecting the family in a Metsu portrait (Berlin, Gemäldegalerie) to Hinloopen. Van Gent also provides biographical details about Hinloopen life. He was probably involved with his family's business in the linen industry. In true oligarchic fashion Hinloopen married the daughter of one of Amsterdam's burgomasters in 1657 and was himself elected to the position of alderman in the town council in 1661, the year that Metsu's picture was completed. Less credible, however, is van Gent's admittedly tentative suggestion that the Berlin portrait and the genre painting under consideration here were pendants (p. 131).

50 Vos 1726, vol. 1, p. 388. Vos's poem was first cited in connection with Metsu's painting by Schneede 1968, p. 55 n. 35. See also Weber 1991, pp. 173–4. Houbraken 1753, vol. 3, p. 41, was also tremendously impressed by the *Visit to the Nursery*.

51 See Loughman and Montias 2000, pp. 27–8; and Westermann 2001–2, pp. 29–30.

52 Goedde 1989, p. 156.

53 In addition, the intentional use of a governmental building as the setting for a domestic scene may possibly allude to the concept of the family as a microcosm of the state, an essential component of European political theory during the seventeenth century; see Franits 1993a, pp. 112 and 227 n. 11. See also Chapman 2001–2, pp. 133 and 143, whose understanding of this concept is to my mind problematic (see Chapter 8, note 65).

54 For this painting, see Broos 1987, cat. no. 41; and Amsterdam 1997b, cat. no. 21.

55 Goedde 1989, p. 156, interprets the stormy seascape as an admonition not to stray from the harmony that the music-makers have achieved.

56 However, it is difficult to determine whether several of de Hooch's paintings of around 1660–61 were executed in Delft or Amsterdam; see Sutton 1980, p. 30; and Hartford 1998–9, pp. 47–8. The very last phase of de Hooch's career in Amsterdam, that is, the late 1670s and early 1680s, was marked by paintings of increasingly inferior quality. The reasons for the conspicuous decline in the quality of his work are not entirely clear but aside from the general problems confronting the art market at that time (see Chapter 15) it is worth noting that de Hooch died in the Amsterdam insane asylum in 1684; see Sutton 1980, p. 40.

57 But de Hooch's pictures were much more modest in price than those by Dou and other Leiden artists. Sutton 1980, p. 54, briefly examines the prices of de Hooch's paintings, beginning with those that appear in Justus de la Grange's inventory of 1655 (see Chapter 11). In this inventory eleven pictures by the artist were valued between 6 and 20 guilders. The fact that a painting by Gerrit Dou was likewise valued at 6 guilders in this inventory should raise our suspicions about the accuracy of the notary's judgments. For the limited use of probate inventories and auctions for assessing the value of art, see Bok 1998, p. 104. See also Montias 1990a, pp. 68–9; and Loughman 1992–3, p. 51. Sutton 1980, p. 54, states that the value of de Hooch's paintings began to rise significantly only after the artist's death in 1684.

58 For this picture, see Sutton 1980, cat. no. 52; Slatkes 1981, p. 126; Franits 1993a, pp. 104–7; and *idem* 2001a, p. 307.

59 As Sutton 1980, pp. 30–31; and *idem*, writing in Hartford 1998–9, p. 52, observes, the finer execution of de Hooch's pictures at this time suggests his knowledge of the work of the *fijnschilders*. However, like Dou, not all of de Hooch's subject matter painted in this finer style was intrinsically wholesome.

60 For the same point in connection with Dutch still-life painting, see Hochstrasser 2001, p. 224 and *passim*.

61 Fock 1998 and *idem* 2001–2. See also Wijsenbeek-Olthuis 1996a.

62 In artisan houses, the *voorhuis* retained its older function as an actual room (often spanning the entire width of the structure) most often used as a workspace; see Loughman and Montias 2000, pp. 23 and 27–8.

63 Fock 1998, pp. 219 and 225; and *idem* 2001–2, pp. 91 and 96. For the following discussion, see Franits 2001a.

64 In de Hooch's particular case his intricate perspectival systems can likewise be construed on one level as self-conscious pictorial strategies on the artist's part to augment the marketability of his paintings.

65 Bok 1994, p. 204, points out that wealthy buyers not only purchased pictures for decorative or investment reasons but also for the reasons of status. Hochstrasser 2001, p. 205, quotes a well-known passage from the diaries of the seventeenth-century English connoisseur John Evelyn in which he terms Dutch paintings commodities. Wijsenbeek-Olthuis 1992, p. 95, observes that household goods had two sorts of functions, namely, their use and status. By the latter, she meant how these objects reveal the owner's rank and social connections to the outside world. Thus, considerations of status play an important role in the decoration and use of rooms. Wijsenbeek-Olthuis's view of the status

associations of household goods is largely applicable to paintings.

66 However, not all of de Hooch's pictures depict wholesome subjects. But as is typical of artists of his generation, de Hooch's paintings of disreputable imagery are rendered in a fairly innocuous manner. Sutton, writing in Hartford 1998–9, p. 15, concludes that de Hooch's clientele was largely composed of middle and upper middle-class patrons. Nevertheless, de Hooch's paintings still bespeak the same wholesome, civilized values as expensive pictures destined for a more elite clientele because elite ideals generally have a "trickle down effect": persons of lower social status often (though not always) aspire to lifestyles and values associated with their superiors (see also Chapter 8). This lies at the heart of the process of aristocratization, discussed in Chapter 6. De Vries 1993, p. 106, points out this phenomenon with respect to consumer acquisitions, a rubric under which the purchase of art would fall. Moreover, *idem* 1974, p. 235, states that the rural population of the seventeenth century was particularly receptive to urban cultural values. Fock 1998, p. 240 n. 158, quotes a fascinating archival document of 1645 in which an Amsterdam merchant rented an expensive Turkish carpet to include in a portrait of himself that he had commissioned. This merchant surely wanted the carpet present in his portrait for its associations of status.

67 Bourdieu 1984.

68 See note 66 above.

69 In recent years, Bourdieu's work has been increasingly cited by scholars of the early modern Netherlands: for example, Wijsenbeek-Olthuis 1992, p. 80; *idem* 1994, p. 44; and Burke 1994, pp. xxi–xxii.

70 Not only the acts of purchasing and displaying paintings imputed status to the owner but as Honig 1998b, pp. 170–212, has demonstrated, the very knowledge of different artistic styles, articulated in the language of the skilled connoisseur, connoted social rank and distinction as well.

71 The possession of taste, like other aspects of civility, provided a means by which the elites – or those who aspired to be part of the elite – could distance themselves from the masses. In this sense, the adoption by artists of specific painting styles can sometimes be said to convey values centering around good taste, intelligence, sophistication, and superiority. Naturally, the masses were identified with popular taste which was considered debased because it was unlearned and sense-oriented; see Moriarity 1988. To my knowledge, no comparable, comprehensive study exists of taste in the Netherlands during this period.

72 Chartier 1988, p. 39. See also Frijhoff 1992a, pp. 25–31.

CHAPTER THIRTEEN

1 For Rotterdam's history, see Hazewinkel 1974–5, vols. 2–4; Roelofsz. 1994–5; Israel 1989, pp. 61–2, 289–90, and *passim*; *idem* 1995, pp. 311–12, 394–5, 654–5, and *passim*; and de Vries and van der Woude 1997, pp. 268, 320, 405, 520, and *passim*.

2 See Lourens and Lucassen 1997, pp. 116–17.

3 See Roelofsz. 1994–5, p. 22.

4 See *ibid* and Delahay and Schadee 1994–5.

5 For this group (which included painters from Dordrecht and Middelburg), see the early study by Heppner 1946, and more recently, Schneeman 1982, pp. 64–79; and James 1994–5. I have omitted Cornelis Saftleven's brother, Herman Saftleven (1609–1685) from this discussion because he had settled permanently in Utrecht around 1632.

6 For Sorgh, see Schneeman 1982.

7 Houbraken 1753, vol. 2, p. 90, basing himself on information gathered from the artist's nephew.

8 At this time, the artist changed his signature from "Sorch" to "Sorgh," which facilitates the dating of his early work. For the *Barn Interior with Amorous Couple*, see Schneeman 1982, p. 66, cat. no. 7; Rotterdam 1994–5, cat. no. 51; and Rotterdam 1998, cat. no. 53.

9 By 1636 Sorgh had taken on a pupil which confirms his status as a master painter by that date; see Schneeman 1982, pp. 26–7.

10 See the literature cited in note 5 above.

11 See Schneeman 1982, pp. 3–4, 55–6, and 64–70, for a discussion of the scholarly literature on this important topic. See also James 1994–5.

12 For this picture, see Schneeman 1982, pp. 95–6 and 116, cat. no. 36; and Braunschweig 1988–9, cat. no. 35, who proposes a completely implausible erotic interpretation of its subject.

13 Sorgh's kitchen interiors from this period likewise became more monumental and light-suffused. For the *Fish Market* and its pendant, the *Vegetable Market*, see Schneeman 1982, pp. 135–6, cat. nos. 47 and 48; *idem* 1988, pp. 170–71; and Kassel 1996, vol. 1, p. 285.

14 The literature on this subject is voluminous and is surveyed in the recent, thought-provoking study by Honig 1998b. For the following comments, see also Schneeman 1982, pp. 130–47; *idem* 1988; Stone-Ferrier 1989; and Honig 2001.

15 For cityscape painting, see Toronto 1977.

16 For example, Spaan 1738, pp. 399–400 and *passim*. See also Schneeman 1988, pp. 170–71; and Honig 2001, pp. 301–2.

17 Today Nijenrode Castle is a famed institute for the study of the Dutch language.

18 See Kassel 1996, vol. 1, p. 285. For the Baron van Wyttenhorst's collection, see Friedländer 1905 (who mistakingly attributed the inventory to the Baron's son, Herman); de Jonge 1932; and Meierink and Bakker 1997, pp. 75–7. As Schneeman 1988, p. 171, states, the painter Jan Baptist Weenix (1621–1660/61) occasionally acted as the Baron's agent. Nevertheless, I fail to see the connection that Schneeman makes between Weenix's work and that of his fellow Italianate painters – Dutch artists who incorporated Italian motifs and settings into their pictures – and Sorgh's market scenes. See also *idem* 1982, pp. 135–9.

19 See Schneeman 1982, pp. 283–4 doc. no. 16A.

20 See Sutton 1984, p. li. However, the subject matter of Sorgh's later paintings is already anticipated by several executed during the 1640s (for example, fig. 175); see Schneeman 1982, pp. 99 and 100.

21 For this painting, see Amsterdam 1976, cat. no. 60; Schneeman 1982, pp. 125–30, cat. no. 66; Rotterdam 1994–5, cat. no. 53; and de Jongh 2000b, pp. 144–5. The interpretation of Sorgh's painting offered here owes much to H. Rodney Nevitt. At this point in his career Sorgh also continued to paint portraits and occasionally seascapes as he had done previously.

22 For music and love, see The Hague 1994, *passim*, with references to the earlier, voluminous literature.

23 Ovid, *Metamorphoses*, bk. 4, vv. 55–166. According to Beaujean 2001, p. 141, Sorgh's picture of Ovid's story is based upon an engraving by Antonio Tempesta who illustrated the *Metamorphoses* in 1606 (see further below).

24 Shakespeare's comic reworking of the sad story of Pyramus and Thisbe appears in his *A Midsummer Night's Dream*. For a comprehensive survey of the tale of Pyramus and Thisbe in art, literature, and music, see Schmitt-von Mühlenfels 1972. For parodical treatments of Pyramus and Thisbe, including Shakespeare's, see Schmitt-von Mühlenfels 1972, pp. 125–51.

25 Gramsbergen 1650. For Gramsbergen's farce in relation to Shakespeare's version of the tale, see Schmitt-von Mühlenfels 1972, p. 146.

26 Gramsbergen 1650, fol. B3ᵛ.

27 Amsterdam 1976, cat. no. 60; and de Jongh 2000b, pp. 144–5, argue that the picture of Pyramus and Thisbe imparts weighty, moralizing notions to the panel, an interpretation that seems inconsistent with its tone.

28 For example, *Den nieuwen lust-hof* 1602, pp. 28–30.

29 For de Jongh, see Fleischer 1989; Fleischer and Reiss 1993; Scholten 1993–4; and Kersten 1996, pp. 162–8.

30 Scholten 1992, p. 51, argues that de Jongh's early pictures of merry companies date to about 1635.

31 For this picture, whose format has been altered by the addition of an approximately fifteen-centimeter strip to the top of the panel, see Fleischer 1989, pp. 69–70; and Fleischer and Reiss 1993, p. 668.

32 Many of the false de Hooch signatures on de Jongh's paintings probably date from the nineteenth century, the period in which de Hooch's work was at the peak of its popularity.

33 See Fleischer 1978, p. 65; and Scholten 1992, p. 52. See also Sutton 1980, pp. 12–13 and *passim*.

34 Photos of these two respective works appear side by side in Fleischer 1989, figs. 80 and 81.

35 For a comprehensive analysis of this gesture (known as the "eyelid pull") in Western European culture, see Morris *et al.* 1979, pp. 69–78. According to Fleischer 1989, p. 69, the gesture indicates that something happening or being said should not be taken at face value, in other words that someone is being misled. Previously, Sutton 1982–3, p. 34, in explaining its presence in Jan Steen's *Tavern Scene with Pregnant Hostess* (his plate 8), had argued that the gesture made an ironical comment on the scene.

36 Houbraken 1753, vol. 2, pp. 33–4.

37 See Fleischer 1989, p. 17, citing earlier archival documents.

38 For this picture, see Kuretsky 1979, pp. 34–5; Scholten 1985; Fleischer 1989, pp. 73–5; Scholten 1994–5, p. 147; Kersten 1996, p. 168; and Newark 2001–2, cat. no. 8. As Scholten 1994–5, p. 149, points out, the luxurious air of this picture is anticipated by de Jongh's landscapes with hunters to the 1650s (for example, his fig. 3). Conversely, during this period de Jongh occasionally reverted to the style of his older, monochromatic interiors; see *ibid.*, p. 147, fig. 8.

39 See van Thiel and de Bruyn Kops 1995, pp. 212–15.

40 See Kersten 1996, p. 169, figs. 164–6, who illustrates several paintings by de Hooch that were possibly inspired by the *Woman Receiving a Letter*.

41 For the following paragraphs, see Kuretsky 1979, pp. 34–5; Scholten 1985, pp. 27–30; Hollander 2002, pp. 184–5; and Weber 1998, p. 302, who discusses the background picture in connection with his hypothesis concerning the relation of paintings-within-paintings to contemporary rhetoric (see further Chapter 11).

42 Ovid, *Metamorphoses*, bk. 3, vv. 136–250.

43 See Beaujean 2001, p. 141.

44 For this painting, which was also once attributed to de Hooch, see Fleischer 1989, p. 77.

45 Such was the case with Johannes Vermeer's great patron, Pieter Claesz. van Ruijven, who, as was noted in Chapter 11, paid a truly astronomical sum (16,000 guilders) for a noble title and domain in 1669. For the phenomenon of country-house construction in relation to aristocratization, see Schmidt 1977–8, especially pp. 441–6.

46 See van Veen 1985, pp. 127–51 and *passim*; W. de Vries 1998, *passim*; and de Jong 2000, pp. 7–9.

47 Van der Groen 1669. For this text, see de Jong 2000, pp. 3–7, 17, and *passim*. See also Schama 1987, pp. 290–93; and W. de Vries 1998, pp. 19–27.

48 For *hofdichten*, see Schmidt 1978–9; van Veen 1985; and, more recently, W. de Vries 1998. For a photo of Huygens's estate, see fig. 181 below. See also note 54 below.

49 De Jong 2000, p. 7. However, not all country-house poets would have subscribed to this point of view. Peter Vlaming, for example, writing in 1710, desires no pictures or tapestries on the walls of his estate because they pale in comparison with nature's beautiful panorama; see W. de Vries 1998, p. 260.

50 See Scholten 1994–5, pp. 150–51. Wieseman 2002, pp. 94–110, discusses the influence of aristocratization upon contemporary portraiture, as evidenced in the work of Caspar Netscher (see Chapter 7).

51 For a survey of the representation of gardens in Dutch art of all genres, see Wages 1996.

52 Scholten 1994–5, p. 151, who also points out the connections with illustrations in such books as van der Groen 1669.

53 See Scholten 1994–5, p. 151, fig. 12, for another depiction of an elegant garden that includes over half of the rear façade of a grand mansion, and p. 150, where Scholten claims that the façade of the mansion in that painting resembles the rear façade of the Huis ten Bosch, the country estate of the Princes of Orange, lying in the vicinity of The Hague. For the Huis ten Bosch and other courtly estates and gardens in the Dutch Republic, see the recent study by Sellers 2001.

54 For *Hofwyck* and Huygens's lengthy poem dedicated to it, see van Strien and van der Leer 2002. For the phenomenon of country-house construction in the Dutch Republic, see Schmidt 1977–8.

55 See Scholten 1994–5, p. 150, citing an earlier archival study. Entirely fictional country estates sometimes appear in seventeenth-century Dutch portraiture where they are meant to enhance the status of the sitters; see, for example, Haarlem 1986b, p. 223 and cat. no. 49, a portrait of the Rotterdam merchant Eeuwout Eeuwoutsz. Prins and his family by an anonymous artist (perhaps Jacob van der Merck [1610–1664]). The family is posed proudly before a beautiful castle and grounds that they did not own.

56 For Ochtervelt, see Kuretsky 1979.

57 See Houbraken 1753, vol. 2, pp. 34–5, who only mentions Ochtervelt in passing. Fleischer 1978, p. 65, proposes that both de Hooch and Ochtervelt studied with de Jongh. In view of the early work of both artists this seems more probable for the former than the latter; see Scholten 1992, p. 52.

58 See Kuretsky 1979, pp. 10–15.

59 For van Mieris's picture (and its copies), see Naumann 1981, vol. 2, cat. no. 36. Note that the female holds her wineglass in a very elegant manner associated with highborn persons (see Chapter 8 and figs. 119 and 120). As Westermann 1996, p. 60, observes, misapplied social codes, that is, portraying vile people with sophisticated conduct, was a principle of comic representation followed by many Dutch painters. Fig. 182, an early picture by Ochtervelt, shows a platter of oysters being placed on a table between the revellers. Such platters are frequently seen in earlier seventeenth-century Dutch paintings of merry companies; see Cheney 1987, pp. 141–2, who notes a hiatus in the portrayal of oysters in merry company scenes between roughly 1635 and 1640 and their reemergence around 1660 in works such as those under consideration here.

60 For Ochtervelt's picture, see Kuretsky 1979, pp. 17 and 62–3, cat. no. 23.

61 So too does the crucifix suspended from the woman's neck, a motif that Kuretsky 1979, p. 30 n. 17, interprets (incorrectly in my view) "as a moralizing counterpart to the life of the senses or as a reminder of spiritual virtue." The crucifix simply identifies its wearer as a Catholic just as it does in van Mieris's painting.

62 For the following discussion, see Amsterdam 1976, cat. no. 51; and Cheney 1987.

63 For a comprehensive study of the representation of Aphrodite/Venus in Western European art, see Antwerp 2001.

64 See the literature cited in Amsterdam 1976, cat. no. 51; and Cheney 1987. Oysters were also slang for female genitalia; see Amsterdam 1976, p. 204. In his diary, Constantijn Huygens, Jr. (1628–1697) records the attempt of a Dutch nobleman to use oysters to seduce a young lady; see Dekker 1999, p. 99.

65 Cats 1625, pt. 5, p. 27; and Beverwijck 1656, p. 126. Both texts are cited and translated by de Jongh 1997, p. 42. See also the joke about the aphrodisiac "Spanish fly" (as it is still known today) in *De geest van Jan Tamboer* 1659, p. 127.

66 See Kuretsky 1979, p. 5.

67 See Schneeman 1982, p. 116, who argues that Sorgh influenced Ochtervelt's imagery of this type.

68 See Kuretsky 1979, p. 36, fig. 126. Mariët Westermann, writing in Newark 2001–2,

p. 157, mentions the possible influence of de Jongh's *Woman Receiving a Letter* (fig. 179), which also takes place in the *voorhuis*. Moreover, Peter C. Sutton, writing in Philadelphia 1984, p. 279, observes that figures standing in backlit doorways can be found in the work of de Hooch.

69 For this picture, see Kuretsky 1979, pp. 35 and 63, cat. no. 24; Burke 1980, p. 16; Philadelphia 1984, cat. no. 87; Westermann 2001–2, p. 74; and Newark 2001–2, cat. no. 7.

70 Westermann 2001–2, p. 74. See also the equally insightful comments of Schama 1987, pp. 570–72. The Getty Provenance Index lists appraised values of between 40 and 150 guilders for several paintings by Ochtervelt that appear in late seventeenth-century death inventories. See Bok 1998, p. 104, for the limited use of probate inventories and auctions in determining the value of art.

71 As Schama 1987, p. 572, phrases it, these socially marginal figures are represented as "insiders' outsiders." See the diachronic survey of depictions of hurdy-gurdy players in Dutch art in Reinold 1981, pp. 94–128.

72 For this picture, which was unknown to Kuretsky 1979, see Franits 2001a, p. 301.

73 Roos 1684, p. 164 no. 13, remarks that the practice of hanging portraits of prostitutes in brothels was quite common and known to all.

74 See The Hague 1994, cat. nos. 14, 24, and 39; and Amsterdam 1997a, cat. no. 38, where the licentious associations of these instruments are discussed.

CHAPTER FOURTEEN

1 The literature on Steen is voluminous; among the noteworthy studies in recent decades are: de Vries 1977; Braun 1980; Westermann 1997b; Washington D.C. 1996; and Kloek 1998.

2 The most recent bibliographic study of Steen was published by Bok 1996, from whose findings my comments are drawn.

3 *Ibid.*, p. 35 n. 47, points out that Steen's parents may have wanted him to become a physician like his uncle, Jacobus, who enrolled in the medical faculty at the university on the same day.

4 Houbraken 1753, vol. 3, p. 13.

5 Weyerman 1729–69, vol. 2, p. 348. For Weyerman's book, see Broos 1990.

6 It has sometimes been suggested that Steen studied with these masters between 1646 and 1648 (for example, Kloek 1998, p. 15). Yet scholars who propose these dates admit that this would have been a relatively short training period and, moreover, that Steen would have been rather old to begin his tutelage.

7 For this painting, see Braun 1980, cat. nos. 77 and A-323; and Washington D.C. 1996, cat.

no. 4. Westermann 1997b, pp. 69–70, identifies one of its early owners. For Steen's works in general during this period, see de Vries 1977, pp. 29–37.

8 Jan Miense Molenaer (see Chapter 2) provided an important precedent for Steen in this regard as he himself repeatedly utilized Bruegelian imagery in his pictures; see, for example, Raleigh 2002, cat. nos. 18 and 25. See also Westermann 2002b, pp. 52 and 60 n. 38. For Steen's archaistic interests in sixteenth-century art, see de Groot 1952, pp. 56–68 and 74–97; Washiington D.C. 1996, cat. nos. 2, 3, and *passim*; Westermann 1997b, pp. 194–200 and *passim*; and *idem* 1999b. De Vries 1977, pp. 88–9, envisions Steen's archaisms and general approach to genre painting as a "rearguard action" on the artist's part against prevailing trends. For de Vries these trends asserted the primacy of the aesthetic, formal aspects of genre paintings at the expense of their meanings, a phenomenon for which the author coined the term "*iconographische slijtage*" (iconographic erosion); see my critique of this theory in Chapter 9.

9 The following interpretation is based on that by Arthur K. Wheelock, Jr., writing in Washington D.C. 1996, pp. 109 and 111.

10 De Groot 1952, p. 84, points out that St. Reyn-Uijt was the mock patron saint of drinkers. For the ship of fools in late medieval culture, see the masterful study by Pleij 1983, pp. 108–25 and *passim*.

11 Bok 1996, p. 30.

12 At this time Steen painted one of his most famous portraits, the so-called *Burgher of Delft and His Daughter* of 1655; see Washington D.C. 1996, cat. no. 7. For an example of one of his peasant pictures from this period, see Sutton 1982–3, pp. 15–16. See also de Vries 1977, pp. 38–45.

13 De Vries 1977, pp. 46–7; and *idem* 1996, pp. 71–2.

14 I follow Brown 1997, p. 83, who believes that *The Doctor's Visit* was painted somewhat earlier than the customary date ascribed to it, around 1661–2. For this picture, see de Vries 1977, pp. 56–7 and 99; Braun 1980, cat. no. 186; London 1982, cat. no. 162; Dixon 1995, p. 166; Washington D.C. 1996, cat. no. 16; Westermann 1997b, pp. 103–5; and Petterson 2000, *passim*. For Steen's other versions of this theme, see de Vries 1977, pp. 98–100; Dixon 1995, *passim*; and Petterson 2000, pp. 70–94. De Vries 1996, p. 70, observes that Steen often addressed a particular theme repeatedly during a relatively brief period in his career. De Vries, pp. 72–3, also discusses van Mieris's influence upon Steen.

15 See Naumann 1981, vol. 2, cat. nos. I 20 (Vienna, Kunsthistorisches Museum) and II 20 (Glasgow, Art Gallery and Museum Kelvingrove). As Naumann, notes, the

Glasgow version was possibly owned by Petronella Oortmans-de la Court (1624–1707), the widow of a wealthy Amsterdam brewer who had a significant art collection. Likewise, Steen's *Drawing Lesson* (Los Angeles, J. Paul Getty Museum) was possibly in Oortmans-de la Court's possession, along with two additional pictures by the artist; see Westermann 1997b, pp. 65–6.

16 De Vries 1996, p. 72, considers the view to the back room in Steen's painting a quotation from the work of such Delft and Dordrecht painters as Pieter de Hooch and Nicolaes Maes (see Chapters 10 and 11, respectively).

17 For the costumes of Steen's figures and their connections with the theater, see the classic study by Gudlaugsson 1975. C. M. Kauffmann, writing in London 1982, opines that "the wide hat and slashed sleeves were part of the rather conservative professional dress of the 17th century."

18 See Petterson 1987; Dixon 1995, especially pp. 69–72 and 173–4; and Petterson 2000. See further Chapter 10 for a detailed discussion of *furor uterinis*.

19 See Dixon 1995, pp. 143–7.

20 De Vries 1977, p. 57, believes that the blunt arrows allude to the impossibility of a cure for the woman's ailment. According to Braun 1980, cat. no. 186, "Cupid's" blunt arrows refer to the impotency of the old man in the background. Wheelock, writing in Washington D.C. 1996, p. 153 n. 6, proposes that the arrows are meant to be lit like flares; therefore Cupid is waiting to "light a fire" with the right lover. See also Petterson 2000, p. 439.

21 Sometimes Steen is much more transparent. In another painting of this theme (Rotterdam, Museum Boijmans Van Beuningen), a young lad (also acting as Cupid?) brandishes an instrument used in the seventeenth century to give enemas. Westermann 1997a, p. 143, discusses clystering in contemporary slang as a metaphor for intercourse. In effect the darling little Cupid suggests that coitus will cure the patient. See also Dixon 1993.

22 Wheelock, writing in Washington D.C. 1996, p. 153 n. 6, argues that the elderly man is probably the young lady's father, as does Westermann 1997b, p. 105. However, if the young woman were indeed the daughter of the man in the background she would not have the customary attributes of the housewife beside her, namely, the purse and keys. For sexually enervated old men, see the discussion of Hendrick ter Brugghen's *Unequal Couple* (fig. 68) in Chapter 4. See also the discussion of fig. 198 later in this chapter.

23 Ovid, *Metamorphoses*, bk. 10, vv. 529–59. According to Weber 1994, p. 301, Steen's painting-within-the-painting derives from

an engraving by Maarten van Heemskerck (1498–1574).

24 At the time, Hals's painting was in the collection of Hendrick Bugge van Ring (d. 1669), a wealthy Leiden connoisseur. Bugge van Ring also owned six of Steen's paintings as well as eighteen by Quirijn van Brekelenkam (see Chapter 8); all three men were Catholics which possibly explains Bugge van Ring's interest in their work. See Westermann 1997b, pp. 64–5; Kloek 1998, p. 35; and Sluijter 2001–2, pp. 116–26.

25 For the character of *Peeckelhaering* in contemporary art and culture, see Gudlaugsson 1975, pp. 57–9; and Weber 1987, pp. 133–6.

26 See the literature cited by Bedaux 1975, pp. 22 and 24. Dixon 1995, pp. 75–9, takes issue with such findings; see also Dixon pp. 186–9. The fact that a stupid, quackish doctor is a target of ridicule here may have made such paintings appealing to bona fide physicians. The eminent University of Leiden professor and physician, Franciscus de le Boe Sylvius (1614–1672), who also had an outstanding art collection, owned a quack doctor by Adriaen Brouwer (see Chapter 2); see Sluijter 2001–2, p. 107.

27 Westermann 1997a, pp. 142–7; and *idem* 1997b, pp. 100–05 and *passim*. For jestbooks, which were extremely popular collections of short, comic anecdotes, see Verberckmoes 1999, pp. 26–31, 139–51, and *passim*; and Dekker 2001, pp. 25–40 and *passim*. For a discussion of doctors in contemporary farces, see Petterson 2000, pp. 390–403.

28 *Den nieuwen clucht-verteller.* 1665, p. 187. The joke published here is quoted and translated by Westermann 1997a, p. 143; and Westermann 1997b, p. 102.

29 I say purportedly because, as already noted, upper-class biases are sometimes at work in these constructions, particularly when lower-class types are the subject of comedy. Essentially, the presentation of base persons more faithfully reflects upper-class perceptions of lower-class lifestyles than the latter's actual lifestyles themselves. For the concept of the comic in art and literature of this period, see Alpers 1975–6; Amsterdam 1976, pp. 26–7 and *passim*; Miedema 1981; Raupp 1983, which presents an exhaustive but perhaps too rigorously structured argument; and especially Westermann 1997a; *idem* 1997b, pp. 89–253 and *passim*; and *idem* 2002b. For general studies of humor during this period, see the relevant essays in Bremmer and Roodenburg 1997; Verberckmoes 1999; and Dekker 2001.

30 These connections have been throughly explored by Westermann 1996; *idem* 1997a; and *idem* 1997b, upon which the following discussion is based.

31 Westermann 1996, p. 53, discusses the potential open-endedness of *The Doctor's Visit*. See

also *idem* 1997a, pp. 142–7; and *idem* 1997b, pp. 101–5.

32 Jordaens had previously worked on a commission for the Prince of Orange in The Hague during 1649–50. However, Steen's Haarlem-period pictures were most strongly influenced by him so if the two artists met, it would have been during Jordaens's stay in Amsterdam; see also Sutton 1982–3, p. 35. For this Flemish painter's many travels and contacts in the Netherlands, see Antwerp 1993, vol. 1, pp. 14–18. Steen undoubtedly met Jan Miense Molenaer (see Chapter 2) during these years (and earlier, Molenaer's wife Judith Leyster, who died in 1660; see Chapter 2) given their similar artistic interests. Their names appear on a document dated 13 August 1658 concerning the sale of paintings; see Bok 1996, pp. 30–31. Raleigh 2002, *passim*, repeatedly stresses the importance of Molenaer's imagery for Steen. See also Westermann 2002b, pp. 52 and 60 n. 38. For Steen's Haarlem period in general, see de Vries 1977, pp. 51–66.

33 Westermann 1997b, p. 63. For this painting, see also de Vries 1977, pp. 65 and 133 n. 126; Schama 1979, pp. 103–7; Braun 1980, cat. no. 197; London 1982, cat. no. 164; and Philadelphia 1984, cat. no. 109 (where, following de Vries 1977, the picture is dated to about 1668).

34 For the "slung-leg motif" see the literature cited by Westermann 1997a, p. 169 n. 12. Note as well that the prostitute holds her wineglass in a very elegant manner associated with suave persons (see Chapter 8 and figs. 119 and 120). As Westermann 1996, p. 60, observes, misapplied social codes, that is, portraying base people with sophisticated conduct, was a principle of comic representation followed by many Dutch painters. Some of the studies cited in the previous note call attention to the bright stocking on the Steen-character's slung leg, claiming that it alludes in seventeenth-century Dutch to slang for the vagina and promiscuous women. However, the stocking is worn by a man, not a woman.

35 See Schama 1979, pp. 105 and 107, from whose penetrating analysis of the picture the following observations are taken.

36 For purposeful disarray in Steen's work and its relation to contemporary comic literature and the theater, see Westermann 1997a, p. 163; and *idem* 1997b, p. 118.

37 See Salomon 1987, p. 334. The woman's pose relates to earlier illustrations of sloth (fig. 138) and to Nicolaes Maes's *Idle Servant* (fig. 137; see Chapter 10). Sloth and lust are two of the so-called seven deadly sins.

38 See Salomon 1987, pp. 317–19, fig. 3; Chapman 1995, pp. 382–4; and Westermann 1997b, pp. 226–7.

39 See Chapman 1990–91; *idem* 1995; and *idem* 1996. More difficult to verify, however, is Chapman's insistence that members of Steen's family played similar roles in his work despite their generic resemblance to one another; see also Broos 1987, p. 355.

40 For an example of fools in a sixteenth-century print where they serve to condition our responses, see Chapman 1996, p. 47, fig. 9.

41 See Chapman 1990–91, pp. 185 and 190; *idem* 1993, pp. 137–9; and *idem* 1995, p. 375. See also de Jongh 1996, p. 42; Westermann 1996, pp. 54–5 and *passim*; *idem* 1997b, pp. 258 and *passim*; and Horn 2000, vol. 1, pp. 138–40. Steen's most conspicuously theatrical work is *The World as a Stage* (The Hague, Mauritshuis); see Amsterdam 1976, cat. no. 62; and Westermann 1997b, pp. 232–3.

42 See the literature cited in note 39 above. See also the comments of de Jongh 1996, p. 43; Brown 1997, p. 84; Kloek 1998, pp. 11, 24–9, and *passim*; and Horn vol. 1, pp. 655–8.

43 Perhaps this was the case for the Leiden collector Hendrick Bugge van Ring; see note 24 above.

44 For this point, see Westermann 1997a, p. 157; and *idem* 1997b, p. 114.

45 Houbraken 1753, vol. 3, pp. 12–26. Houbraken's life of Steen is conveniently published in English (from a translation by Michael Hoyle) in Washington D.C. 1996, pp. 93–7 (whence my quotations are taken). However, see Horn 2000, vol. 1, pp. 131–2, for some of the problems with Hoyle's translation.

46 For Houbraken's treatise, see the articles by Cornelis 1995 and Hecht 1996, which rightly modify the conventional view that the author was a dogmatic classicist. See as well the recent, monumental study by Horn 2000, marred somewhat by his cantankerous opposition to much of the present scholarship involving Houbraken (vol. 1, pp. 570–697), including various aspects of the studies cited here.

47 Thanks primarily to the research of Chapman 1993. See also *idem* 1996, pp. 12–14; Westermann 1997b, pp. 18–26 and 92–9. See also the critique of Chapman's study by Horn 2000, vol. 1, pp. 655–60 and *passim*.

48 Houbraken 1753, vol. 3, p. 13. My quotation and subsequent ones (see below) are taken from Washington D.C. 1996, p. 93.

49 For Houbraken's linking of artists' personalities and lifestyles with their work, see Horn 2000, vol. 1, pp. 184–92.

50 See Westermann 1996, p. 54; *idem* 1997a, p. 138; and *idem* 1997b, p. 24.

51 Weyerman 1729–69, vol. 2, p. 364; and Houbraken 1753, vol. 3, p. 25. Bok 1996, p. 33, believes that Houbraken and Weyerman are more trustworthy than is generally

assumed because both based their biographies on oral sources, the most important of which was de Moor. See also de Vries 1977, p. 8; and Horn 2000, vol. 1, pp. 118–20.

52 Bok 1996, p. 32. See also Westermann 1997b, pp. 59–60.

53 For fig. 197, see Philadelphia 1984, cat. no. 107; and Dublin 1986, pp. 145–8. For other depictions of schoolrooms by Steen, see Washington D.C. 1996, cat. nos. 35 and 41.

54 For this painting, see Durantini 1983, pp. 304–6; Hamburg 2001, pp. 267–8; and Westermann 1997b, pp. 172–3. Westermann 1997b, pp. 116–18 and especially pp. 166–74, contains an excellent discussion of the ritual of the lying-in visit and its subversion in comic painting and literature.

55 For early modern European beliefs (with an emphasis on the Netherlands) concerning sex and reproduction, see the fascinating studies by Roodenburg 1985; and idem 1989.

56 Westermann 1997b, p. 183 n. 104, points out that the father's gesture of scratching his head always signaled bafflement or embarrassment in seventeenth-century texts. In this case, embarrassment is undoubtedly what the man is experiencing at having incomprehensibly produced twins. Alternatively, Magnus [1669] 1992, p. 99, argues that multiple births can be caused by "excessive motion on the part of the woman during coitus," the implication being that lusty women are more inclined to have twins.

57 For studies of Steen's depictions of this theme, see de Vries 1977, pp. 57–8 and passim; Sutton 1982–3, pp. 35–6; Broos 1987, cat. no. 59; Németh 1990; Washington D.C. 1996, cat. no. 23; and Westermann 1997b, pp. 159–66 and passim. See also Amsterdam 1997, cat. no. 50.

58 De Vries 1996, p. 78.

59 See de Vries 2000, pp. 338–9.

60 See Butler 1982–3, p. 45 and passim; and Bijl 1996, p. 88 and passim.

61 Protestants in particular wrote exhaustively on this topic; for example, Dod and Cleaver 1612, fols. G2ᵛ, K4ᵛ, Q3–Q3ᵛ, R3, and passim; De Swaef [1621] 1740, pp. 77–91; and Gouge 1622, pp. 543ff. See also Groenendijk 1984, pp. 150–52; Roberts 1998, pp. 166–8; and Dekker 2000, pp. 9–10.

62 In some circles, especially those of the Puritans and Pietists, it was believed that Adam's original sin had imputed to all of his descendents inherently corrupt natures which could be subdued only through discipline and intense indoctrination in religion and ethics commencing at the earliest possible age. Thus, the parental commission to rear children properly had eternal consequences. See de Swaef [1621] 1740, pp. 77–156; Gouge 1622, pp. 536–47; Wittewrongel 1661, vol. 1, pp. 182–98, and vol. 2, pp. 741–59; and

Wallenkamp 1661, pp. 93–138. See also Groenendijk 1984, pp. 146–56; Roberts 1998, pp. 166–8; and Dekker 2000, pp. 9–10. Not all seventeenth-century theorists believed that children had inherently corrupt natures; see the discussion of these conflicting views as they potentially relate to Steen's pictures in Németh 1990, pp. 272–3; Chapman, writing in Washington D.C. 1996, p. 174; and Westermann 1997b, p. 164.

63 Dod and Cleaver 1612, fol. S3ᵛ. See also Taffin 1640, fol. 207ᵛ.

64 See Taffin 1640, fol. 215ᵛ; Oomius 1661, Preface and pp. 4 and 5; Wittewrongel 1661, vol. 1, p. 2; and Teellinck 1627, p. 192.

65 The Spanish Netherlands' most popular moralist, the Catholic Adriaen Poirters invokes the proverb in Poirters [1646] 1935, p. 73. This passage is cited by Németh 1990, pp. 272–3, as well as other relevant literature. Westermann 1997b, p. 166, proposes the intriguing hypothesis that with negative examples in representations of As the Old Sang, Steen "may be thumbing his nose at excessive Reformatory zeal, that his works could have appeared to participate in the derision of the Reformation . . ."

66 As discussed in Chapter 2 (and elsewhere), musical instruments in early modern Europe carried class and gender connotations. For bagpipes, see The Hague 1994, pp. 202–5, 246.

67 For this engraving see Amsterdam 1997, cat. no. 50. For Jordaens's depictions in relation to those by Steen, see Németh 1990; and Westermann 1997b, pp. 161–2.

68 See de Jongh 1996, pp. 43–4 and 46; Westermann 1996, p. 60; and Westermann 1997b, pp. 122–5. See also Schama 1979, p. 107.

69 For the owners of Steen's paintings, see Westermann 1997b, pp. 60–73.

70 An exception may have been representations of seductive women. The capacity of depictions of female nudity in seventeenth-century Dutch art to arouse desire in viewers has been examined by Sluijter 1988a, pp. 157–8; idem 1997, 85–6; and idem 2000b, p. 294. As Sluijter has repeatedly demonstrated, Dutch artists routinely depicted beguiling temptresses who embody the seductive painting techniques that engendered them. See also Westermann 1997b, 234–6 and 250–51 n. 121.

71 See Westermann 1997a, p. 164; and idem 1997b, pp. 122–5.

72 See Bok 1996, p. 32, who also notes that the artist stopped making mortgage payments on his deceased father's house from the moment he took possession of it. This occured before the French invasion, however, and indicates that the artist was already experiencing financial difficulties during his first months back in his native town.

73 For this painting, see Braun 1980, cat. no. 373; Washington D.C. 1996, cat. no. 49; and Westermann 1997b, pp. 62–3, 203, and 204–5. For the Paedts family, see Noordam 1994, passim. See also Sluijter 1988c, p. 39.

74 Bredius [1927], p. 54.

75 Westermann 1997b, pp. 204–5. See also Chapman, writing in Washington D.C. 1996, p. 259 n. 12.

76 For the prices of Steen's pictures, see Westermann 1997b, pp. 71–2.

CHAPTER FIFTEEN

1 For the following discussion, see Roorda 1978; Israel 1989, pp. 292–358; idem 1995, pp. 796–862; Sman 1996; de Vries and van der Woude 1997, pp. 409–503 and 674–81; Munt 1997; Dreiskämper 1998; and Troost 2001.

2 De Vries and van der Woude 1997, pp. 674–81, argue that the onset of the decline of the Dutch economy began in the early 1660s.

3 This translation is taken from Montias 1989, p. 212. Bolnes's testimony was probably exaggerated slightly in order to elicit sympathy. Sman 1996, p. 136, quotes the journal of Vermeer's contemporary L. van der Saan, who stated that, "Before the war, when trade and business was flourishing, people in Holland who did not know very well what to do with their money, and how they could best invest it to their enjoyment, would pay something between 500 and 600 and up to 1,000 guilders for a painting . . . But from the year 1672 until 1694, so long as the grievous wars continued many no longer desired to buy paintings . . . Then many scarcely earned in one year what in former times they had recklessly spent in one hour."

4 Israel 1995, pp. 819, 825, and 854.

5 As noted in Chapter 6, William III was the nephew of the English king, Charles II; his mother, Mary, was that British monarch's sister.

6 The social, cultural, and political ramifications of the Glorious Revolution in America, England, and The Netherlands are addressed in Washington D.C. 1989.

7 For the following remarks, see Koolhaas-Grosfeld 1982; Carasso 1984; Blaas 1985; Koolhaas-Grosfeld 1986; Schutte 1988; de Jongh 1990–91; Grijzenhout 1992; L. de Vries 1999; Van Sas 1999; and Aerts 2001.

8 For their understanding of Dutch literature of the Golden Age, see the important study by Wiskerke 1995.

9 For example, Sutton 1980, pp. 35–6; Naumann 1981, vol. 1, pp. 80–82; and Wieseman 2002, pp. 45–8 and passim.

10 For example, Haak 1984, pp. 499–503, whose views are endorsed by Horn 2000, vol. 1,

pp. 98–9. Surprisingly, de Vries 1989 (who has done much to further the study of late seventeenth-century Dutch art), p. 271, states that, "If anything can be said about late-17th-century Dutch art in general, it should be formulated in a negative way."

11 Van Hoogstraten 1678, p. 300. This passage is cited by L. de Vries 1999, p. 34. For van Hoogstraten's own genre paintings, see Chapter 10.

12 See de Vries 1990, p. 87; and L. de Vries 1999, pp. 34–5.

13 See Horn 2000, vol. 1, pp. 93–103. See also Grijzenhout 1992, p. 327; and Cornelis 1998, pp. 151–2.

14 For the evolution of interior design between 1650 and 1750, see Fock 2001a; and Pijzel-Dommisse 2001.

15 Weyerman 1729–69, vol. 4, p. 395. See Broos 1990, p. 163.

16 Van Gool 1750–51, vol. 1, pp. 69, 126, and 357–62; and vol. 2, pp. 105–16 and *passim*. See de Vries 1990, pp. 87–101.

17 For example, J. de Vries 1991, pp. 264, 267–68, 270, and 273 and table 2. Unfortunately de Vries does not provide decade-by-decade statistics – it would be interesting to know whether this drop in artists accelerated only during the 1670s, that is, during years of the first war with France; see Munt 1997, p. 30. See also Montias 1987a, pp. 462–4; *idem* 1991b, p. 343; Bok 1994, p. 120–30 and *passim*; and *idem* 2001b, pp. 204–9.

18 The view of Horn 2000, vol. 1, pp. 102–3, that there is no necessary connection between the changing state of the economy and the evolution of the arts is naive. (Evidently, if Houbraken does not link art and the economy in his writings then for Horn there can be absolutely no link between them despite the abundant findings of modern economic historians to the contrary.) Equally problematic is Horn's erroneous sketch of the contraction of the Dutch economy which is said to begin as early as 1650 (see Horn 2000, vol. 1, p. 102).

19 See the literature cited in note 17 above.

20 See Soltow and van Zanden 1998, pp. 40–41.

21 See L. de Vries 1999, p. 36.

22 See for example, Montias 1987a, p. 463; and de Vries 1989, p. 269.

23 Naturally, the vogue for all things French aroused the ire of patriotic preachers and moralists during the first war with France; see Munt 1997, pp. 15–19. And this was not the first time that Francophilia was mocked; see Visscher [1614] 1949, p. 194; and Bredero [1617] 1982.

24 See further the discussion in Chapter 6.

25 The influence of French art on Dutch art is largely, though not exclusively, confined to portraiture and history painting; see Brenninkmeyer-De Rooij 1986; Franits 1995;

and Wieseman 2002, pp. 49–50 (who believes that this influence was restricted to history painting only). The scholarly literature on the impact of French culture in the Netherlands is extensive: see, for example, Dijkshoorn 1925; Spierenburg 1981, pp. 19, 22, 28, and 31; Frank-van Westrienen 1983, pp. 203–42; and Frijhoff 1989, who insightfully points out (p. 598) that anti-French attitudes of the late seventeenth and eighteenth centuries (generated by among other factors, the *rampjaar*) have been inadvertently adopted by some modern historians who construe "*verfransing*" (Frenchification) as a lack of faith in Dutch culture. See also Burke 1993, an important study that explores the use and adaptation of language (including French) among specific social circles in early modern Europe as part of ongoing strategies to distinguish themselves from other groups.

26 For *honnêteté*, see Stanton 1980; Morarity 1988, pp. 46–52, 83–105, and *passim*; and Weyl 1989. See also Goodman 1992, pp. 33–7; and Brusati 1995, pp. 53–5, who discusses the Dutch translation by Samuel van Hoogstraten (see Chapter 10) of one of the most popular treatises on *honnêteté*, Faret 1657. The initial treatises on *honnêteté* that appeared in the early seventeenth century owed much to Baldassare Castiglione's acclaimed *Book of the Courtier* (1528), which appeared in several Dutch editions during the 1660s. However, as the century progressed the concept evolved to the point where it eventually diverged from and subsequently superseded its celebrated Italian model. Castiglione's notion of civility emphasized the gentleman's exemption from rules of behavior since he theoretically possessed the facility to transcend them, whereas the French notion stressed conformity through strict observation of these very same rules; see Stanton, pp. 19–22; and Weyl 1989, pp. 2–3 and 16–20.

27 For example, Faret 1657; [de Courtin] 1672, whose title in translation explicitly states that "mannerliness is customary among gallant French folk" – undoubtedly this title contributed to this highly popular book's appeal despite the fact that it first appeared in Dutch during the *rampjaar*! See Roodenburg 1991b, pp. 154–7, who observes that most of the publications in translation of foreign civility manuals in the Dutch Republic appeared after 1650. This is probably no accident given the intensification of concepts of civility there after the middle of the century; see Chapter 6. Unfortunately for elites these popular manuals facilitated the adoption of French etiquette among their social inferiors, thus providing yet another example of the "trickle-down effect" discussed in Chapter 8. In a similar vein, Zijlmans 1999, pp. 127–44, discusses French societies established by

wealthy female Huguenot refugees in late seventeenth-century Rotterdam. As Zijlmans points out, the refined manners and social codes of these women served to distance them from their social inferiors, yet this did not prevent middle-class women from imitating their lifestyles and conversation.

28 For the comparative terminology of European civility manuals of the early modern period, see den Boer 2001. For the terms employed specifically by Dutch authors to connote civility, ones laden with social and ethical dimensions, see Grootes 2001.

29 See van Stipriaan 1994, pp. 390–91, 398, and *passim*. See also the recent historiographic survey of late seventeenth-century Dutch theater, Duits 2002.

30 See the example provided by de Jongh 2000a, p. 48. See also Jansen 2001, pp. 274–5 and *passim*. Such decorous modifications can likewise be seen in various literary genres; see Salman 1999, p. 197; Frijhoff and Spies 1999, p. 576; and Dekker 2001, pp. 30–31.

31 For this learned society, see Dongelmans 1982; Harmsen 1989; and Gelderblom 1999–2000.

32 These stage sets are discussed in detail by L. de Vries 1998a, pp. 134–65.

33 For de Lairesse's artistic career, see Roy 1992; and L. de Vries 1998a.

34 De Lairesse 1778.

35 For recent studies of de Lairesse's treatise, see Roy 1992, pp. 88–104; Dolders 1995; Kemmer 1998; L. de Vries 1998a, pp. 71–132; and *idem* 2002.

36 See Pels [1681] 1978. See also L. de Vries 1998a, pp. 93–5.

37 De Lairesse 1778, p. 62.

38 *Ibid.*, p. 98. As shall be discussed in Chapter 18, certain styles of painting were likewise considered unseemly. Notwithstanding these theoretical perspectives, Godfried Schalcken enjoyed a considerable reputation as a painter of scatological genre scenes; see further Chapter 18.

39 See the facsimile edition of these two books with commentary, by van Gelder and Joost [1668–9, 1671] 1985.

40 Van Gelder and Jost [1668–9, 1671] 1985, vol. 1, p. 228, de Bisschop's dedication in Latin to Jan Six (translated by David Freedberg). This dedication differs slightly from the Dutch one, which appeared in the same book. For these passages, see Gaehtgens 2002, pp. 149–57. For Six, see van Gelder and Jost [1668–9, 1671] 1985, vol. 1, pp. 18–19.

41 As several scholars have noted, de Lairesse and de Bisschop framed their discussions in terms of evolving notions of what constituted the *schilderachtige* (picturesque) in art. Earlier in the seventeenth century, the picturesque in art was associated with humble and even base subject matter; by the latter part of the

century, it referred to more estimable imagery, rendered in a bright, clear manner; see Emmens 1979, pp. 152–68; and Bakker 1995. See also the broader studies in van Eck *et al.* 1994.

42 Dolders 1985, pp. 217–18. See also Roodenburg 1993, p. 160.

43 See Kemmer 1998.

CHAPTER SIXTEEN

1 For the following discussion, see Prak 1985, pp. 58–63 and *passim*; Israel 1990, p. 310–12, 317–18, and *passim*; *idem* 1995, *passim*; and de Vries and van der Woude 1997, pp. 285–90.

2 See Lourens and Lucassen 1997, p. 114, who also record a peak population of 70,000 in 1732, which suggests that the decline was most dramatic in the middle of the eighteenth century.

3 See Soltow and van Zanden 1998, pp. 38–40.

4 These very same persons were also enthralled by French culture in all of its manifestations; see Noordam 1994, pp. 98–100; and Chapter 15.

5 For local and foreign collectors of pictures by Leiden's most prominent artists into the early eighteenth century, see Sluijter 1988c, pp. 36–46; and *idem* 2001–2.

6 Naumann 1981, vol. 1, p. 81, discusses declining enrollment in the city's Guild of St. Luke during this period. Nevertheless, the establishment of a drawing academy in Leiden in 1694 provides evidence of the continued vitality of art there. Willem van Mieris and Carel de Moor (artists who are discussed later in this chapter) served with one other colleague as its first directors; see Sluijter 1988c, p. 33.

7 See Naumann 1981, vol. 1, p. 79. Van Mieris's *Young Woman Standing Before a Mirror* (fig. 112) discussed in Chapter 8, dates to about 1670 and so technically belongs to the artist's late period (for which see Naumann 1981, vol. 1, pp. 78–86). However, that picture bears closer stylistic affinities with those executed during the 1660s than those under consideration here.

8 For this painting, see Naumann 1981, vol. 1, p. 84, and vol. 2, cat. no. 103; and The Hague 1994, cat. no. 26.

9 Various inconsistencies can be seen in *A Musical Company of Gentlemen and Ladies*, for example, the awkward position of the male to the far right and the unevenly painted tablecloth; see The Hague 1994, pp. 234–5, where it is proposed that the artist's son Willem van Mieris (see below) finished the painting. See also Naumann 1981, vol. 1, pp. 78–9.

10 See Naumann 1981, vol. 1, p. 29, and vol. 2, cat. no. 102.

11 De Lairesse 1778, p. 101. For recent studies of this treatise, first published in 1707 in Dutch, see Roy 1992, pp. 88–104; Dolders 1995; Kemmer 1998; L. de Vries 1998a, pp. 71–132; and *idem* 2002.

12 See Delahay and Schadee 1994–5, p. 35. See also examples of the use of the term quoted by de Pauw-de Veen 1969, pp. 171, 173, 174, and 179.

13 De Lairesse 1778, pp. 96–109. For the following remarks, see the important study by Kemmer 1998, which attempts to clarify many of the more confusing aspects of de Lairesse's argument. See also Vergara 1998, pp. 246–7.

14 De Lairesse 1778, p. 99.

15 *Ibid.*, p. 105. The courtly style is the most thoroughly classicizing of all the potential modes of genre painting.

16 See *ibid.*, pp. 96–100 and *passim*.

17 *Ibid.*, p. 108.

18 *Ibid.*

19 See de Lairesse 1778, pp. 31–3. See also Kemmer 1998, pp. 98–9, who links van Mieris's *Concert* (Florence, Galleria degli Uffizi; his fig. 8) to this very same illustration. *The Concert* was the painting mentioned above for which the Grand Duke of Tuscany paid 2500 guilders.

20 This figure's pose, back, and broad shoulders loosely recall those of an ancient statue of Venus, published in Perrier [*c.* 1730], plate 84.

21 See Kemmer 1998, pp. 111–12.

22 For Willem van Mieris, for whom no modern monograph exists, see Fock 1983; Leiden 1988, pp. 152–69; Amsterdam 1989–90, pp. 103–28; Sluijter 1996a; and Leiden 2001, pp. 86–110 (all with references to further literature).

23 Weyerman 1729–69, vol. 2, pp. 345–6. For this picture, see Naumann 1981, vol. 1, p. 85, and vol. 2, cat. no. 121, who observes that it is largely the work of Willem van Mieris.

24 After his marriage to a wealthy Leiden woman in 1686, de la Court van der Voort moved to that town from Amsterdam. For this collector, whose older cousin, Petronella Oortmans-de la Court has been mentioned several times in this book, see Fock 1983 and Sluijter 1988c, pp. 35–6 and 42–5.

25 De la Court van der Voort also owned Dou's *Night School* (fig. 107) discussed in Chapter 8. Arnold Houbraken dedicated the second volume of his artists' biographies to de la Court van der Voort; see Horn 2000, vol. 1, p. 507, and vol. 2, illus. 113.

26 See Fock 1983, pp. 263–5. For Jan van Mieris, see Leiden 1988, pp. 149–51.

27 For Willem van Mieris's painting, see Hamburg 2001, pp. 184–5; for his father's version, see Naumann 1981, vol. 1, p. 82 (discussed there in relation to Willem's picture), and vol. 2, cat. no. 108.

28 Naumann 1981, vol. 1, p. 82.

29 The figure's unusual, knotted hair is similar to that of a female statue in Jan de Bisschop, *Signorum veterum icones* (1668–9; see Chapter 15); see van Gelder and Jost [1668–9, 1671] 1985, vol. 2, plate 76. Moreover, the position of the woman's head in the panel recalls that of a statue from the same text; see van Gelder and Jost [1668–9, 1671] 1985, vol. 2, plate 51.

30 Cats 1627, pp. 124–7 no. 21. For this emblem, see H. Luijten 1996, vol. 2, pp. 393–406. De Jongh 1967, pp. 40–42; Amsterdam 1976, p. 226; and de Jongh 2000a, pp. 43–6, all cite this emblem in connection with paintings depicting escaped birds.

31 Cats 1627, fol. B2ᵛ. The English translation quoted here appears in the back of this edition of the book along with translations of most of the amatory versions of the other emblems. For Cats's book, see the monumental study by H. Luijten 1996.

32 See H. Luijten 1996, vol. 2, p. 398.

33 The one exception is a picture by Pieter van Noort (*c.* 1600–1672), a now obscure Leiden painter who settled in the provincial town of Zwolle by the early 1650s; see Zwolle 1997, cat. no. 37; and de Jongh 2000a, pp. 44, 46.

34 See further below and Chapters 17 and 18.

35 See L. de Vries's theory of iconographic erosion examined in Chapter 9.

36 De Lairesse 1778, p. 279. Although the author is discussing portraiture in this context, his statement certainly applies to genre painting as well; see also pp. 96–117.

37 For van Mieris's niche pictures, see for example, Leiden 1988, cat. no. 40; and Amsterdam 1989–90, cat. no. 23.

38 Van Gool 1750, vol. 1, p. 193. Van Gool's description in this passage strongly suggests that he was looking at this particular painting though this cannot be conclusively determined; see Peter Hecht writing in Amsterdam 1989–90, p. 120 n. 2.

39 For the painting in Antwerp, see Fock 1983, p. 263 and fig. 1. For descriptions of other genre paintings in the collection, see Hofstede de Groot 1907–28, vol. 10, p. 156 ?no. 201; p. 183 no. 295.

40 For this painting, see London 1992b, pp. 214–15, where it is noted that it was probably commissioned by Lothar Franz, Baron Schönborn (1655–1729).

41 At first glance the woman's instrument appears to be a theorbo. However, in theorbos the peg-box is aligned with the neck (see fig. 74) whereas here it is bent back sharply, indicating that it is indeed a lute.

42 For the statue of Venus, see van Gelder and Jost [1668–9, 1671] 1985, vol. 2, *Icones*, plate 47; for Hercules, *idem* vol. 2, *Paradigmata*, plate 37 (specifically, the figure in the upper right).

43 De Lairesse 1778, pp. 264, 265.

44 Eventually de Lairesse gives proper credit to Van Dyck; *ibid.*, p. 272. For antique dress in

portraiture (as opposed to actual fashions) during this period, see Groeneweg 1985; *idem* 1997; and Gordenker 2001, pp. 22–4 and *passim*.

45 See Gordenker 2001, pp. 74–5. For another point of view, see Wieseman 2002, pp. 49–50.

46 For de Moor, for whom there is no modern monograph, see Leiden 1988, pp. 182–6; and Ekkart 1996.

47 Houbraken 1753, vol. 3, pp. 343–4.

48 See also *ibid.*, vol. 3, pp. 345–8, for several poems extolling de Moor's portraits of foreign dignitaries.

49 For de Moor's picture, see Lille 1972, cat. no. 41. Both Weyerman 1729–69, vol. 2, p. 364, and Houbraken 1753, vol. 3, p. 25, relied on de Moor for information about Steen's life and career.

50 For Steen's representation of grace, see Sutton 1982–3, pp. 29–31; Franits 1986, pp. 47–9; and *idem* 1993a, pp. 152–4.

51 Pictures such as the one under consideration here provided important precedents for the idealized genre paintings of such eighteenth-century painters as Jean-Baptiste Greuze (1725–1805); see Kemmer 1998, pp. 113–15.

52 For this painting, see Amsterdam 1976, cat. no. 46. De Moor's last teacher, Schalcken, also painted a young boy fishing (*c.* 1670–75; Berlin, Gemäldegalerie); see Beherman 1988, cat. no. 157.

53 For the following remarks, see Amsterdam 1976, cat. no. 46; and de Jongh 2000a, pp. 30–32.

54 See Amsterdam 1997a, cat. no. 52. Milkmaids were rarely depicted in seventeenth-century Dutch genre painting; for another representation, by Nicolaes Maes (see Chapter 10), in which the milkmaid is being fondled, see Krempel 2000, cat. no. D33.

55 For example, *Olipodrigo of nieuwe kermis-kost* 1654–55, pt. 1, p. 74.

56 *Incogniti Scriptoris Nova poemata* [1624] 1972, p. 96. My translation of the poem is taken from Amsterdam 1997a, p. 261, where other literary references, including one from the 1760s, are cited. Occasionally, the illustrations of *Incogniti Scriptoris Nova poemata* [1624] 1972 have been linked directly to Dutch genre paintings in an effort to argue for sexual content regardless of the visual context and tone of the image in question; for this problem, see further Franits 1993b, pp. 302–3.

57 Not all pictures from this period sublimate sexuality entirely; see, for instance, the paintings of Godfried Schalcken (discussed in Chapter 18).

58 Previously Naiveu had studied with Abraham Toorenvliet (*c.* 1620–1692), a minor Leiden artist. For Naiveu, for whom no modern monograph exists, see Leiden 1988, pp. 186–96 and *passim*; and Sluijter 1996b.

59 For example, his *Interior with a Young Woman Spinning*, illustrated and discussed by Franits 1993a, pp. 30–32, fig. 20.

60 Walter Liedtke kindly provided the manuscript for his entry on the picture which will appear in his forthcoming catalogue of the Dutch paintings at The Metropolitan Museum of Art. Naiveu also returned to the theme later in his career; see Leiden 1988, cat. no. 58.

61 See also Jan Steen's farcical treatment of the theme, fig. 198.

62 Goedde 1989, p. 156.

63 For the following, see Liedtke's forthcoming catalogue entry. For the customs and decor associated with birth and lying-in rituals, see Lunsingh-Scheurleer 1971–2.

64 As Sluijter 1988c, p. 42, notes, the prices for Naiveu's paintings during his lifetime – at least at auction – were not exceptionally high, ranging from 25 to 50 guilders per lot.

65 Naiveu's influence on the eighteenth-century painter, Cornelis Troost (1696–1750) has often been noted.

66 For animals as pedagogical metaphors in seventeenth-century Dutch art, see Bedaux 1990, pp. 109–69; and Franits 1990.

CHAPTER SEVENTEEN

1 See Wijsenbeek-Olthuis 1982–3; Israel 1989, p. 388 and *passim*; *idem* 1995, pp. 1006–9 and *passim*; de Vries and van der Woude 1997, pp. 308–9 and 520–21.

2 Wijsenbeek-Olthuis 1982–3, p. 59, observes that after a tremendous downturn, there were fifteen breweries in 1674, a number that remained stable until 1730. Moreover, beer production during this late period (1674–1730) peaked in 1685.

3 See Israel 1989, p. 267 table 6.19.

4 See Wijsenbeek-Olthuis 1982–3, pp. 57–8; and Lourens and Lucassen 1997, p. 103.

5 See Montias 1982, pp. 338–49 tables A.2 and A.3, listing the painters inscribed in the Delft Guild of St. Luke from 1613 to 1679 and their specialties. The number of new enrollees began to decrease during the 1660s.

6 At least one painting by Vermeer was owned by a resident of The Hague: a "face by Vermeer" was listed in the death inventory (composed in August 1664) of Johannes Larson, an English sculptor who lived in that city where he worked for both the Dutch and English courts; see Montias 1989, pp. 182–3 and 318–19 doc. no. 298. Additionally, in 1674, Vermeer's maecenas, Pieter Claesz. van Ruijven was recorded as living in The Hague; see Montias 1989, p. 251. Pieter de Hooch (see Chapters 11 and 12) registered in 1660 with the painters' professional association in The Hague, the *Confrerie* (see Chapter 5). For the presence of paintings by

Delft artists in The Hague, see further Buijsen 1998–9, p. 38; and Vermeeren 1998–9, pp. 54 and 57. See also Liedtke 2001e, pp. 51–2; and *idem* 2001d, p. 132.

7 For this painting, see Blankert 1978, pp. 25 and 56 and cat. no. 27; Wheelock 1981, p. 146; Slatkes 1981, p. 101; Blankert, Montias, and Aillaud 1988, cat. no. 27; Wheelock 1995, pp. 157–62; Washington D.C. 1995–6, cat. no. 19; Vergara 1998; Liedtke 2000, pp. 254–6; *idem* 2001d, p. 168 and *passim*; and Franits 2001b, p. 25.

8 According to Nevitt 2001, p. 105, discarded letters cast to the floor are a recurring motif in contemporary romances; see the example that he quotes.

9 See, for example, van Heemskerck 1622, fol. 15ᵛ. A servant performs precisely this role in Vermeer's *Love Letter*; for this painting, see Washington D.C. 1995–6, cat. no. 18.

10 This picture-within-the-picture is reminiscent of history paintings by Peter Lely (1618–1680), a Dutch expatriot who worked in England; for these works, see Foucart 1989. This picture also appears, in a much smaller format, in Vermeer's *Astronomer* (see fig. 220). The works of art that Vermeer reproduces in his paintings are often based upon actual prototypes either owned by family members (see fig. 59) or in his stock as an art dealer.

11 See Vergara 1998, pp. 238–40. Vergara, p. 238, also calls attention to a previously unknown French poem dedicated to the story of Moses's discovery which was reprinted in Dutch seven times between 1654 and 1700.

12 Wheelock 1981, p. 146; and *idem* 1995, p. 162.

13 De Lairesse 1778, pp. 96–109.

14 The thesis of Vergara 1998, that Vermeer combined the antique and modern modes in his painting, actually violates de Lairesse's precepts. De Lairesse 1778, pp. 96–100, repeatedly warns artists against doing so; see Chapter 16 above. See also Liedtke 2000, p. 254; and *idem* 2001d, p. 168 and also pp. 164–66, who discusses the inherent problems of the so-called classicism of Vermeer's work.

15 For *The Lace-Maker*, see Blankert 1978, p. 56, cat. no. 26; Wheelock 1981, p. 144; Slatkes 1981, p. 94; Blankert, Montias, and Aillaud 1988, cat. no. 26; Washington D.C. 1995–6, cat. no. 17; Liedtke 2000, pp. 256–7; and *idem* 2001d, p. 164.

16 Wheelock 1995, p. 159 and *passim*.

17 See Franits 1993a, pp. 22–9, 35–6, 136–8, and *passim*.

18 See Sluijter 1998c, pp. 271–7. See also Goodman 2001, *passim*.

19 See Liedtke 2001b, p. 17; and *idem* 2001d, p. 160. For contemporary Dutch literature celebrating female beauty, see Vergara 1998, pp. 242–3; and especially, Nevitt 2001; and Goodman 2001.

20 See Liedtke 2000, pp. 252 and 253–4; and *idem* 2001d, pp. 164 and 168.

21 For de Man, for whom no modern monograph exists, see Brière-Misme 1935, as well as the literature cited here in subsequent endnotes.

22 See Frank-van Westrienen 1983.

23 See Montias 1989, p. 317 doc. no. 291.

24 For this picture, see Brière-Misme 1935, pp. 110–12; Kersten 1996, pp. 194–5; and Hamburg 2001, pp. 162–3. The chronology of de Man's work is difficult to establish because only one of his pictures is dated; see further Brière-Misme 1935.

25 The popularity of kimonos among elites explains their presence in contemporary portraiture; see the examples illustrated in London 1990, cat. no. 74. For kimonos in general, with respect to their enthusiastic reception in the Dutch Republic, see Breukink-Peeze 1989.

26 A similar mirror is seen in Vermeer's *Music Lesson*; for this painting, see Washington D.C. 1995–6, cat. no. 8.

27 See Hamburg 2001, p. 163.

28 Zandvliet 1998, pp. 250, 252.

29 For this painting, see Brière-Misme 1935, pp. 104–5; Philadelphia 1984, cat. no. 69; Kersten 1996, pp. 192–4; Osaka 2000, cat. no. 29; and New York 2001b, cat. no. 42.

30 Cited by Brière-Misme 1935, p. 9, whose own source was a series of articles by Abraham Bredius published in the journal *Oud Holland* during the 1890s.

31 Walter Liedtke, writing in New York 2001b, p. 310, points out that the same compliment may also have been paid to other artists (ones not active in Delft) including Jacob Ochtervelt (see Chapter 13) and Gabriel Metsu (see Chapter 12).

32 For de Man's depictions of church interiors, see Liedtke 2000, pp. 136–8.

33 For example, in paintings by Petrus Christus (New York, The Metropolitan Museum of Art, The Robert Lehman Collection) and Hieronymous Bosch (Washington D.C., National Gallery of Art).

34 See, for example, the remarks of Cats 1625, pt. 6, pp. 30–32; de Brune 1636, p. 72; and Pers 1648, p. 166. See also Amsterdam 1976, pp. 139–41; and Franits 1993–4, pp. 82–3.

35 See, for example, Braunschweig 1993–4, cat. no. 59.

36 This important observation was made by Liedtke, writing in New York 2001b, p. 310.

37 *Ibid*. For other interpretations of the painting, see Philadelphia 1984, pp. 246–7; and Osaka 2000, pp. 165–6.

38 Increasing civility may also explain Ogier 1682, a seemingly anachronistic moralizing text (given its comparatively late publication date) examining the seven deadly sins.

39 For the evolution of interior design between 1650 and 1750, see Pijzel-Dommisse 2001;

and Fock 2001a, especially p. 148, where de Man's painting is discussed.

40 Kersten 1996, p. 213.

41 Houbraken 1753, vol. 3, pp. 282–3. See Horn 2000, vol. 1, pp. 363–4.

42 Houbraken 1753, vol. 3, pp. 284 and 285.

43 Liedtke 2001d, p. 168–9. For examples of Verkolje's portraiture, see New York 2001b, cat. nos. 61 and 62.

44 For *The Messenger*, regarded by many art historians as Verkolje's masterpiece, see Amsterdam 1976, cat. no. 70; Broos 1987, cat. no. 64; and New York 2001b, cat. no. 63.

45 See Broos 1987, pp. 379–80.

46 See Peter C. Sutton, writing in Philadelphia 1984, p. 335.

47 Ovid, *Metamorphoses*, bk. 10, vv. 519–59 and 710–39.

48 This interpretation of the painting is based on that by Liedtke, writing in New York 2001b, p. 358, who also sees a possible allusion in it to war with the French. See also p. 358 n. 8, where Liedtke convincingly challenges traditional scholarly references to Karel van Mander's gloss of this story from Ovid's *Metamorphoses* as an explanation for the picture on the back wall.

49 In addition to the literature cited in note 44 above, see also Amsterdam 1976, pp. 110–11; and Amsterdam 1997, pp. 205–6.

50 For this painting, see Philadelphia 1984, cat. no. 115; Franits 1993a, p. 54; and Kersten 1996, p. 214. Scholars have read the date upon it as either 1671 or 1674 but the former year seems unlikely as the artist was only eighteen at that time. Moreover, stylistically the picture belongs to Verkolje's Delft period. The picture on the back wall in the painting undoubtedly represents a mythological subject but it has not yet been identified.

51 As noted in Chapter 16, Willem van Mieris practiced both modes simultaneously.

CHAPTER EIGHTEEN

1 As noted in Chapter 15, contemporary art theorists and biographers expressed different views concerning the date at which Dutch art supposedly fell into decline.

2 For Schalcken, see Beherman 1988; Amsterdam 1989–90, pp. 181–216; Dordrecht 1992–3, pp. 263–73; and Jansen 2000.

3 John Loughman, writing in Dordrecht 1992–3, p. 263 n. 1, observes that this document has been mistakingly dated 1665.

4 See Houbraken 1753, vol. 3, p. 176.

5 See Beherman 1988, p. 21. As shall be discussed, Johan Wilhelm von der Pfalz was a great admirer of Dutch painting; both Eglon van der Neer and Adriaen van der Werff became his court painters. For his art collec-

tion and patronage, see Gaehtgens 1987a, pp. 59–66.

6 For *The Sausage Maker*, see Beherman 1988, cat. no. 144; and Sluijter 2000b, p. 275.

7 See the discussions and literature cited by Schama 1987, pp. 455–60; Carlson 1994, pp. 90–91; Hollander 1994, pp. 146 and 154 n.34; Sluijter 2000b, pp. 274 and 340 n. 24; and Sarnowiec 2001. Dekker 1999, pp. 99 and 102, states that in elite circles maids were "sometimes regarded as little better than prostitutes."

8 The woman's attire seems too elegant for her to be a maid. She does, however, appear to be wearing an apron. Unfortunately, Schalcken's painting has not been examined by specialists in decades; it was last seen on the art market in France in 1957.

9 See, for example, Sluijter 2000b, figs. 217 and 218.

10 Mijnhardt 1993, p. 296, considers the flourishing of pornographic literature in the Dutch Republic during the late seventeenth century a reflection of liberal Dutch sexual morals at that time. Leemans 2002, pp. 145–74, by contrast, presents a more nuanced view, one that takes into account the heightened civility of that period. She regards the rise of pornographic literature between 1670 and 1700 as a deliberate reaction to those authorities who attempted to restrict its publication and circulation. For sexual practices and interests among Dutch elites during this period, see Dekker 1999.

11 As Leemans 2002, pp. 127–30, demonstrates, many pornographic novels of the period deliberately expose the hypocrisy of their characters, in effect, encouraging readers to dismantle their own hypocritical façades in the process.

12 In his diary, Constantijn Huygens, Jr. (1628–1697) writes about a pornographic book shown to him by a friend who claimed to have found it in the bushes while hunting near William III's castle at Dieren; see Kamphuis 1984–5, p. 11; and Dekker 1999, p. 104. See also de Jongh 2000a, p. 46 and 57; and Leemans 2002, p. 164, who observes that it is highly improbable that someone would have left such an expensive book – expensive because pornographic books were usually finely illustrated – in the bushes. Rather, the friend's excuse seems a transparent one for having had such a book in his possession.

13 This can be deduced from van Lieburg 1989, p. 44, who quotes a fascinating document dated 22 December 1662 in which a consistorial visit to the home of a member of one of Utrecht's Dutch Reformed congregations uncovered his possession of "oneerbaere schilderijen" (dishonorable paintings).

14 Roodenburg 2000, pp. 77–81, illustrates and discusses two portraits of differing sizes of

Willem van Heijthuysen by Frans Hals. The life-size portrait (Munich, Bayerische Staatsgemäldesammlungen) depicts van Heijthuysen in a formal pose while the far smaller one (Brussels, Musées Royaux des Beaux-Arts) shows him in a relaxed pose. An inventory of the sitter's possessions made after his death in 1650 reveals that his life-size portrait hung on the ground floor in a room used to receive visitors. But his small portrait in a relaxed pose hung in a secluded room upstairs in the house, a room that, Roodenburg surmises, was more private. Thus smaller paintings could much more easily be concealed from inquisitive viewers.

15 For this picture, see Amsterdam 1976, cat. no. 57; White 1982, cat. no. 180; Philadelphia 1984, cat. no. 99; Beherman 1988, cat. no. 164; and Amsterdam 1989–90, cat. no. 37.

16 Houbraken 1753, vol. 3, p. 176. For the archival document, see Bredius 1915, pp. 116–17, which, most interestingly, lumps Dou, van Mieris, and Schalcken together in a case of alleged slander; see also the commentary by Peter Hecht, writing in Amsterdam 1989–90, p. 182.

17 Houbraken 1753, vol. 3, p. 176, remarks that Dordrecht's young people were accustomed to playing this game at gatherings.

18 For example, Otto Nauman, writing in Philadephia 1984, p. 301.

19 For this theme, see Amsterdam 1997a, cat. no. 23, and the scholarly literature cited there.

20 See Amsterdam 1976, pp. 95 and 223; and Philadelphia 1984, p. 301.

21 Hecht, writing in Amsterdam 1989–90, p. 185. See also Amsterdam 1989–90 p. 185 n. 8.

22 See, for example, the enthusiastic comments of Houbraken 1753, vol. 3, pp. 176–7, concerning Schalcken's candlelit pictures. See also Hecht 1980, pp. 29–31.

23 Walpole 1782, vol. 3, pp. 243 and 244. Vertue's observations were recorded in a lengthy manuscript called the "Note-books," which after his death in 1752 were purchased at auction by the famous antiquary Horace Walpole (1717–1797). Walpole reworked them in the book quoted here, which first appeared in 1762–71.

24 For this painting, see Beherman 1988, cat. no. 54; Dordrecht 1992–3, cat. no. 72; and Munich 2002, cat. no. 121.

25 Behermann 1988, p. 151, argues that the painting is actually a self-portrait of the artist and his wife. However, Schalcken frequently used himself and members of his family as models in his paintings (see fig. 226), a practice common among seventeenth-century Dutch painters; see, for example, fig. 88, in which Gerard ter Borch depicted his half-sister Gesina as a beautiful maiden at her toilet.

26 Schalcken's painting is linked to fig. 228 by Marjorie E. Wieseman, writing in Dordrecht

1992–3, p. 267. Wieseman, p. 267 n. 5, notes that compositionally Schalcken's painting is more closely related to a picture by Dou of a couple reading by candlelight (London, Collection of Her Majesty the Queen; see White 1982, cat. no. 47).

27 For another example, see Schalcken's portrayal of a young woman blowing on a brazier of coals (Beherman 1988, cat. no. 196).

28 Van Gelder and Jost [1668–9, 1671] 1985, vol. 2, plate 77. This illustration is cited by Wieseman, writing in Dordrecht 1992–3, p. 267, who claims that the statuette in Schalcken's painting is in mirror image to it.

29 Beherman 1988, p. 151, notes a resemblance between the face of Aphrodite and that of the model, said to be, erroneously in my view, a portrait of the artist's wife.

30 See Sluijter 1998c, pp. 271–7. See also Goodman 2001, passim. Wieseman, writing in Dordrecht 1992–3, p. 267, intriguingly proposes that Schalcken intended the female to function as the artist's muse.

31 For this panel, see Beherman 1988, cat. no. 247 (who only knew it from an eighteenth-century engraving); and London 1999, pp. 22–4.

32 See Sluijter 1988a, pp. 157–8; idem 1997, pp. 85–6; and idem 2000b, p. 294. See also Westermann 1997b, pp. 234–6 and 250–51 n. 121.

33 See Müller Hofstede 1988, pp. 21–3 and passim; and Slatkes 2001, p. 309. Munich 1998–9, offers an exhaustive examination of night scenes throughout the history of Western art. See also Seidel 1996, a study of the motif of the candle in art and its significance.

34 See the literature cited in note 32 above.

35 For van der Neer, see Gaehtgens 1987a, pp. 42–5; Amsterdam 1989–90, pp. 129–54; Wieseman 2000; and, especially, the recent study by Schavemaker n. d.

36 Schavemaker n. d., pp. 11–12, believes that van der Neer moved to Brussels around 1682.

37 See ibid., p. 15.

38 For this painting, see London 1992b, pp. 236–8; and Schavemaker n. d., cat. no. 35. This is one of several pictures by the artist of attractive females seated at a table, engaged in a variety of activities. For other paintings of this sort, see Amsterdam 1989–90, cat. no. 25.

39 For Metsu and van der Neer, including the two pictures illustrated here, see Robinson 1974, pp. 66–7. For a possible copy by van der Neer after a ter Borch painting (New York, The Metropolitan Museum of Art), see New York 1985, p. 272; Amsterdam 1989–90, p. 130, fig. 25c; and Schavemaker n. d., cat. no. 31. See also Schavemaker n. d., pp. 21 and 23–4.

40 See Gaehtgens 1987a, p. 433 (fol. 2), ". . . om satijne rokjes en andere kleetjes te vertoonen . . ." See also Houbraken 1753, vol. 3, p. 174,

and, for his comments, Horn 2000, vol. 1, p. 108. One needs only to recall that the complexities of rendering satin draped over the human form made it incumbent upon painters to utilize actual samples to ensure its proper replication (see Chapter 7). Thus the reproduction of satin in a genre painting was a labor-intensive endeavor; in this respect satin dresses in genre paintings betokened value in a figurative sense as well as a commercial sense for the prospective buyer. The purchaser was consequently guaranteed an authentic work of art of uncompromisingly high quality and value whose genesis was contigent upon the use of a costly textile. See Kettering 1997, p. 103. See also van der Wetering 1993, p. 35.

41 See Walsh 1996, pp. 56–9, who notes (p. 59) that the handful of paintings of women in studios were all executed within a thirty-year period. For women artists and amateurs, see Honig 1999–2000.

42 For this painting, see Amsterdam 1976, cat. no. 48; and Schavemaker n. d., p. 28, cat. no. 45. In a painting dated about 1655, ter Borch had depicted a maid with a basin and ewer assisting her mistress who washes her hands (Dresden, Gemäldegalerie).

43 De Lairesse 1778, pp. 106–7 and passim. See Kemmer 1998, pp. 102–4.

44 Wheelock, writing in Washington D.C. 1995, p. 166, links van der Neer's background scene to Metsu's Intruder of about 1660 (Washington D.C., National Gallery of Art).

45 For the following comments, see Snoep-Reistma 1973, pp. 286–8; and Amsterdam 1976, p. 195.

46 Other paintings by van der Neer, which include a ewer and basin – a favorite motif of the artist – are more ambiguous, for example his Elegant Conversation (Private Collection); for this canvas, see Philadelphia 1984, cat. no. 82; and Newark 2001–2, cat. no. 84.

47 For this painting, see Amsterdam 1989–90, cat. no. 26; and Schavemaker n. d., pp. 28 and 29 and cat. no. 54. Houbraken 1753, vol. 3, p. 174, states that van der Neer, "painted companies dressed in the Modern manner dressed like Terburg, sometimes also something else, seeing he was inclined to variation." Perhaps the "something else," to which Houbraken refers, was a painting such as Playing Children. See Horn 2000, vol. 1, p. 108, from where my translation of Houbraken is taken.

48 The origins of this bias may lie in the statements from van der Werff's biography concerning his experiences in van der Neer's studio, in which his master purportedly "followed nature" regardless of whether it was beautiful or ugly, the implication being that he did not apply the rules of classical art to

improve his subject matter. See Gaehtgens 1987a, pp. 45 and 433 (fol. 2). Schavemaker n. d., p. 29, inexplicably states that the *Playing Children* cannot be called classicistic and, in fact, still recalls genre paintings made in the modern mode.

49 See Peter Hecht, writing in Amsterdam 1989–90, pp. 134 and 136, and the literature cited there relating to Duarte's collection. Hecht, p. 136 n. 2, states that an inscription in the artist's own hand on the back of the panel indicates that it was painted in Rotterdam. Duarte also owned a genre painting by Johannes Vermeer (see Chapter 11); see Montias 1989, p. 358 doc. no. 415; and Liedtke 2001b, pp. 8–9.

50 That the *Playing Children* probably formed part of Duarte's stock – as opposed to his actual collection – can be inferred from its absence in the inventory of his possessions made at the time of his death in 1691.

51 Similar settings can be found in the work of Michael Sweerts (1618–1664) and, as Schavemaker n. d., p. 28, notes, Jan Baptist Weenix (1621–?1660/61).

52 See Durantini 1983, pp. 267–78; Worcester 1993, cat. nos. 3, 13, and 30; and Amsterdam 1997a, cat. no. 35. For domesticated animals as references to docility in Dutch art, see Bedaux 1990, pp. 109–69; and Franits 1990.

53 The toddler immediately behind the boys holds a windmill, a time-honored attribute of childhood; see the comments of Gaehtgens 1987b, p. 105, who considers the picture richly symbolic. See also Hecht's critique, in Amsterdam 1989–90, p. 136 n. 2.

54 Houbraken 1753, vol. 3, pp. 387–8. For van der Werff, see Rotterdam 1973; Gaehtgens 1987a; *idem* 1987b; Amsterdam 1989–90, pp. 247–79; Thiels 1994–5; and Rotterdam 1994–5, pp. 245–64.

55 See Gaehtgens 1987a, pp. 16–17 and 433–9, who dates this manuscript, with editorial corrections in van der Werff's own hand, to about 1719–20. Horn 2000, vol. 2, p. 747 n. 104, noting Houbraken's death in 1719, concludes that a date of 1720 for this manuscript would imply that his widow added the material to the third volume of his treatise (published posthumously).

56 Snoep 1973, p. 7, states that the story of van der Werff's parents' resistance to his career choice smacks of well-established legends about talented artists. See the objections of Horn 2000, vol. 1, pp. 157 and 158. See also *idem*, vol. 1, pp. 348–9. For Picolet, see Gaehtgens 1987a, p. 42; and Rotterdam 1994–5, p. 293, cat. no. 33.

57 The dates 1675–9, proposed by Peter C. Sutton writing in Philadelphia 1984, p. 357, for van der Werff's apprenticeship with van der Neer, are surely incorrect. In 1679, van der Werff was twenty years old; yet as his

biography states, he became an independent master at age seventeen (see Gaehtgens 1987a, p. 434 [fol. 3]; see also Houbraken 1753, vol. 3, p. 392).

58 See Gaehtgens 1987a, p. 433 (fol. 2). See also Houbraken 1753, vol. 3, pp. 389–90.

59 See Gaehtgens 1987a, p. 433 (fol. 3). See also Houbraken 1753, vol. 3, p. 391.

60 Gaehtgens 1987a, p. 43.

61 Judging from the wording in the artist's biography (see Gaehtgens 1987a, p. 434 [fol. 4]), van der Werff was probably painting mostly portraits. His total output as a genre painter is actually quite small; only eighteen genre paintings are recorded by Gaehtgens 1987a.

62 For example, the *Boy with a Mousetrap* of 1676; for this painting, see Philadelphia 1984, cat. no. 125; Gaehtgens 1987a, cat. no. 1; and Rotterdam 1994–5, cat. no. 70.

63 For this painting, see Gaehtgens 1987a, p. 87 and cat. no. 9 (to which she assigns a slightly earlier date than the one proposed here); and Rotterdam 1994–5, cat. no. 71. Past interpretations of its subject have failed to take into account the fact that one of the strings on the woman's lute has snapped; this explains her companion's grin as well as the barking dog beside his own instrument.

64 De Lairesse 1778, pp. 264 and 265. The man's long jacket may be a silk kimono, an article of Japanese clothing that was all the rage among elite men in the Dutch Republic; see Chapter 17.

65 De Lairesse 1778, pp. 96–109. This treatise was first published in 1707 in Dutch.

66 See *ibid.*, pp. 31–3. See also Kemmer 1998, pp. 98–9, who links van Mieris's *Concert* (his fig. 8) to this very same illustration. *The Concert* was the painting mentioned above for which the Grand Duke of Tuscany paid 2500 guilders.

67 Roodenburg 1993, p. 160. For the comparative terminology of European civility manuals of the early modern period, see den Boer 2001. For the terms employed specifically by Dutch authors to connote civility, ones laden with social and ethical dimensions, see Grootes 2001.

68 For example, de Lairesse 1778, pp. 31–2, "I missed no opportunity of making observations, and noting them in my pocket-book . . . Nay, when I saw a handsome gentlewoman walking in the street, I made it my business to enquire into the reason of her grace, and in what it consisted . . . by such researches, as these, we come to knowledge of what is handsome and ugly, as well by the one sort of people as the other . . . Let me then persuade the artist to this method . . ." See also Roodenburg 1993, p. 160.

69 See the valuable comments concerning the fusion of art and life in Dutch painting at this time by Smith 1987a, p. 423.

70 [De Courtin] 1671, p. 56.

71 *Ibid.*, p. 28.

72 See de Lairesse 1778, pp. 22–3. See further Franits 1995; and *idem* 1996, pp. 15–18. For the infallible rules of art, see Chapter 15.

73 De Lairesse 1778, pp. 22–3.

74 Gaehtgens 1987a, p. 434 (fol. 4). Gaehtgens 1987a, cat. no. 17, identifies a panel representing children looking at ancient sculptures as the probable picture owned by Paets. For a portrait of Paets by Pieter van der Werff (Adriaen's brother and assistant), see Thiels 1994–5, p. 153 and fig. 1.

75 For these collections, see Gaehtgens 1987a, pp. 48–52; Jansen 1993, pp. 15–21; and Delahay and Schadee 1994–5. For Rotterdam's flourishing cultural life (particularly after 1670), see Zijlmans 1999, with many references to Adriaen Paets.

76 As is stated in van der Werff's biography; see Gaehtgens 1987a, p. 434 (fol. 4). For this painting, see Amsterdam 1976, cat. no. 74; Gaehtgens 1987a, pp. 96–100 and *passim* and cat. no. 18; *idem* 1987b, pp. 104–6; and Amsterdam 1989–90, p. 136.

77 For the complex symolism of this picture, from whence this brief summary is taken, see Knuttel 1966; Becker 1976 (who amplifies Knuttel's findings); and Amsterdam 1976, cat. no. 74 (which summarizes the results of these earlier studies).

78 Past studies of the picture (see note 77 above), only regard the attire of the children in the middleground as antique. As Gordenker 2000, p. 22, states, the use of the term antique to describe clothing had a much wider range of applications in the seventeenth century than it does for scholars today. Moreover, the outfit worn by the girl in the foreground of the painting recalls that seen in contemporary portraits of sitters dressed *à l'antique* (see fig. 209).

79 See Gaehtgens 1976, p. 48; and *idem* 1987a, p. 220. For the Amsterdam Town Hall, see Chapter 12.

80 See Kemmer 1998, p. 107.

81 See Hecht 1984; *idem* 2002; and Munich 2002.

82 See fig. 102. For other examples of this playful trumping of sculpture by *fijnschilders*, see Hecht 2002, figs. 13, 16, and 17.

83 See Gaehtgens 1987a, p. 98

84 Gaehtgens 1987b, pp. 99, 104–5; and *idem* 1987a, pp. 98–9. See also Amsterdam 1989–90, p. 136 n. 2. Van der Neer himself emulated the pictorial precedents for his work as did Schalcken. For emulation, see the classic study by de Jongh 1972; and Raupp 1984, pp. 168–81.

85 De Lairesse 1778, p. 108. Several scholars have noted an actual "blurring" of the various genres of Dutch art at this time; for example, history painting adopts some of the charac-

teristics of genre painting and vice versa; see Kuretsky 1980–81, pp. 254–5; Sluijter 1986, pp. 119–20; and Smith 1987a, p. 423. In many respects, this blurring was anticipated by the art of Jan Steen (see Chapter 14); see de Vries 1983; and Westermann 1997b, pp. 254–75, 288–92, and *passim*.

86 Gaehtgens 1987a, p. 434 (fol. 4).

87 For van der Werff's activities as a court painter to Johan Wilhelm von de Pfalz, see Gaehtgens 1987a, pp. 66–74.

88 Flinck was the son of the erstwhile Rembrandt assistant, Govaert Flinck (1615–1660).

BIBLIOGRAPHY

PRIMARY SOURCES

Aleman, Mateo. *The Rogue: Or the Life of Guzman de Alfarache*. London, 1622.

Amsterdamsch Hoerdom, 't. Amsterdam, [1681].

Angel, Philips. *Praise of Painting* [1642]. Translated by Michael Hoyle, Introduction and Commentary by Hessel Miedema. *Simiolus* 24 (1996): 227–58.

Barlaeus, Caspar. *Poemata*. 2 vols. Leiden, 1628.

Beck, David. *Spiegel van mijn leven; een Haags dagboek uit 1624*. Introduced and annotated by Sv. E. Veldhuijzen. Hilversum, 1993.

Bergh, A. vanden. *Ieronimo*. Utrecht, 1621.

Beverwijck, Johan van. "Schat der gesontheydt." In *Alle de wercken, zo in de medicyne als chirurgie van de heer Joan van Beverwyck*. Amsterdam, 1656.

Bie, Cornelis de. *Het gulden cabinet vande edele vry schilder-const*. Antwerp, 1661.

Blasius, Joannes. *Fidamants kusjes*. Amsterdam, 1663.

Bleyswijck, Dirck van. *Beschryvinge der Stadt Delft*. Delft, 1667.

Bloem-hof van de Nederlantsche ieucht, Den. Amsterdam, 1610.

Bredero, Gerbrand Adriaensz. *The Spanish Brabanter. A Seventeenth-Century Dutch Social Satire in Five Acts* [1617]. Introduced and translated by H. David Brumble III. Binghamton, 1982.

——. *Moortje*. Amsterdam, 1617.

——. *Boertigh, amoreus, en aendachtigh groot liedboeck* [1622]. Edited by A. A. van Rijnbach. Rotterdam, 1971.

Brune, Johan de. *Nieuwe wyn in oude le'er-zacken*. Middelburg, 1636.

——. *Bankket-werk van goede gedagten*. 2nd edn. 2 vols. Middelburg, 1660.

Bullaert, Isaac. *Académie des sciences et des art, contenant les vies, & les eloges historiques des hommes illustres*. 2 vols. Amsterdam, 1682.

Bulwer, John. *Chirologia: Or the Natural Language of the Hand* [1644]. Introduced and edited by James W. Cleary. Carbondale/Edwardsville, 1974.

Camphuysen, Dirck Rafaelsz. *Stichtelycke rymen*. 5th edn. Rotterdam, 1644.

Cats, Jacob. *Houwelyck. Dat is de gansche gelegentheyt des echten staets*. 6 pts. Middelburg, 1625.

——. *Proteus ofte minne-beelden verandert in sinnebeelden*. Rotterdam, 1627.

——. *Spiegel vanden ouden ende nieuwen tijdt*. 3 pts. The Hague, 1632.

——. *Ouderdom, buyten-leven, en hof-gedachten, op Sorgh-Vliet*. in: *Alle de wercken*. 3rd edn. pt. 8. Amsterdam, 1665.

Cluchtboeck. Amsterdam, 1637.

Coleveldt, J. J. *Hartoginne van Savoyen*. Amsterdam, 1634.

Coornhert, D. V. *Recht ghebruyck ende misbruyck ende misbruyck van tydlicke have*. 2nd edn. Amsterdam, 1610.

Corrozet, Gilles. *Hecatongraphie*. Paris, 1543.

[Courtin, A. de]. *The Rules of Civility*. London, 1671.

——. *Nieuwe verhandeling van de welgemanierdheidt, welke in Vrankryk onder fraeye lieden gebruikelyk*. Amsterdam, 1672.

Croon, P. *Almanach voor heden en morgen . . . voor een nieuw-iaer*. Antwerp, 1665.

Dafforne, Richard. *Grammatica ofte leez-leerlings steunsel*. Amsterdam, 1627.

Dod, John, and Robert Cleaver. *A Godly Forme of Houshold Government*. 5th edn. London, 1612.

D[oes], I[ohan] v[an der]. *Den lof der vrouwen*. Gorinchem, 1622.

Erasmus. *Colloquia familiaria. Dat is: gemeensame tsamenspreeckingen*. Utrecht 1664.

Evelyn, John. *The Diary of John Evelyn*. Edited by E. S. de Beer. London, 1959.

Eyb, A. von. *Ehebüchlein*. Nuremberg, 1472.

Eykbergh, Petrus. *De Basuyn van Sodoma ende Gomorra*. Amsterdam, 1659.

Faret, Nicolas. *Den eerlyken jongeling, of de edele konst van zich by groote en kleyne de doen eeren en beminnen* [1630]. Translated by Samuel van Hoogstraten. Dordrecht, 1657.

Follinus, Hermannus. *Physiognomia, ofte menschenkenner*. Haarlem, 1613.

Geest van Jan Tamboer, De. Amsterdam, 1659.

Gelder, Jan G. van, and Ingrid Jost, *Jan de Bisschop and His Icones & Paradigmata* [1668–9, 1671]. *Classical Antiquities and Italian Drawings for Artistic Instruction in Seventeenth Century Holland*. 2 vols. Edited by Keith Andrews. Doornspijk, 1985.

Gool, Johan van. *Den nieuwe schouburg der Nederlantsche kunstschilders en schilderessen*. 2 vols. The Hague, 1750–51.

Gouge, William. *Of Domesticall Duties*. London, 1622.

Gramsbergen, M[atthijs]. *Kluchtige tragoedie: of den Hartoog van Pierlepon*. Amsterdam, 1650.

Groen, Jan van der. *Den nederlandtsen hovenier*. Amsterdam, 1669.

Haerlemsche eerlycke uren. 2 pts. Haarlem, 1663.

Hazart, Cornelis. *Het gheluckich ende deughdelyck houwelyck*. Antwerp, 1678.

Heemskerck, Johan van. *Pub. Ovidii Nasonis minne-kunst, gepast op d'Amsterdamsche vryagien*. Amsterdam, 1622.

Heinsius, Daniel. *Neder-duytsche poemata*. Amsterdam, 1616.

Hofferus, Adrianus. *Neder-duytsche poemata*. Amsterdam, 1635.

Hooft, Peter Cornelisz. *Emblemata amatoria* [1611]. Introduction by K. Porteman. Leiden, 1983.

Hooft, W. D. *Heden-daeghsche verlooren soon*. Amsterdam, 1630.

——. *Clughtigh-spel, Andrea de Piere, peerde-kooper*. 2nd edn. Amsterdam, 1634.

Hoogstraten, Samuel van. *Inleyding tot de hooge schoole der schilderkunst*. Rotterdam, 1678.

Houbraken, Arnold. *De groote schouburgh der Nederlandtsche konstschilders en schilderessen* [1718–21]. 2nd edn. 3 vols. The Hague, 1753.

Houwaert, Johan Baptist. *Pegasides pleyn. Ofte den lust-hof der maechden*. 5th edn. 16 bks. Rotterdam, 1622–3.

Huygens, Constantijn. *Mijn jeugd*. Translated and annotated by C. L. Heesakkers. Amsterdam, 1987.

Incogniti Scriptoris Nova poemata [1624]. 3rd edn. Introduction by Jochen Becker. Soest, 1972.

Krul, Jan Harmensz. *Minne-beelden: toe-ghepast, de lievende ionckheyt*. Amsterdam, 1634.

——. *Pampiere wereld*. 4 pts. Amsterdam, 1644.

Lairesse, Gerard de. *The Art of Painting* [1707]. 2nd English edn., translated by John Frederick Fritsch. London, 1778.

Laurentius, Andreas. *A Discourse of the Preservation of the Sight: of Melancholike Diseases; of Rheumes, and of Old Age*. Translated by R. Surphlet. London, 1599.

Leeuwen, Simon van. *Korte besgryving van . . . Leyden*. Leiden, 1672.

Leydsche straat-schender of de roekeloose student, De [1683]. 5th edn. Amsterdam, 1756.

Magnus, Albertus. *Women's Secrets* [1669]. Translation and Commentary by Helen Rodnite Lemay. Albany, 1992.

Mander, Karel van. *Het schilder-boeck*. Haarlem, 1603–4.

——. *The Lives of the Illustrious Netherlandish and German Painters* [1603–4]. 6 vols. Translated by Derry Cook-Radmore *et al.*, introduced and edited by Hessel Miedema. Doornspijk, 1994–9.

Marcon-velle, Jan van. *Van het geluck en ongeluck des houwelicks . . . hier achter is noch byghevoeght, 49. gheboden of wetten des houwelicks door Plutarchus*. Wormer-Veer, 1647.

Messiae, Petrus. *De verscheyden lessen*. Leiden, 1607.

Minnen, Joncker Livinus vander [pseud.]. *Den eerelycken pluck-voghel*. 4th edn. Brussels, 1684.

Monconys, Balthasar de. *Journal des voyages de monsieur de Monconys*. 2 vols. Lyon, 1665–6.

Neusboekje, in: *Nieuw Worckumer Almanach*. Leeuwarden, 1718.

Nieuwen clucht-vertelder, Den. Amsterdam, 1665.

Nieuwe hofsche rommelzoo, De. N. p., 1655.

Nieuwen ieucht spiegel. N. p., n. d. [*c.* 1620].

Nieuwen lust-hof, Den. Amsterdam, 1602.

Nieuwen verbeterden lust-hof, Den. Amsterdam, 1607.

Nugae Venales sive Thesaurus ridendi & Jocandi. N. p., 1648.

Ogier, Willem. *De seven hooft-sonden*. Amsterdam, 1682.

Olipodrigo of nieuwe kermis-kost. 2 pts. Amsterdam, 1654–5.

Oomius, Simon. *Ecclesiola, dat is kleyne kercke*. Amsterdam, 1661.

Orlers, Jan. *Beschrijvinge der stadt Leyden*. 2nd edn. Leiden, 1641.

Passe the Elder, Crispijn van de. *Le miroir des plus belles courtisannes de ce temps*. N. p., 1631.

Passe the Younger, Crispijn van de. *Van 't licht der teken en schilderkunst*. Amsterdam, 1643.

Pels, A. *Gebruik, én misbruik des tooneels* [1681]. Introduction and Commentary by Maria A. Schenkeveld-van der Dussen. Culemborg, 1978.

Perrier, François. *Eigentlyke afbeeldinge van hondert der aldervermaerdste statuen, of antique-beelden, staande binnen Romen* [1638]. N. p., N. d. [*c.* 1730].

Pers, D. P. *Gezangh der zeeden*. Amsterdam, 1648.

Plutarch. *Den spieghel des houwelicks*. N. p., 1575.

Poirters, Adriaen. *Het masker vande wereld afgetrocken* [1646]. Oisterwijk, 1935.

Puget de la Serre, Jean. *The Secretary in Fashion: Or, An Elegant and Compendious Way of Writing All Manner of Letters*. 2nd edn. Translated by J. M. London, 1658.

Prynne, William. *Histrio-mastix ofte schouw-spels treurspel*. Translated by I. H. Leiden, 1639.

Quevedo, Francisco de. *Seven wonderlycke ghesichten, in welcke alle de ghebreken deser eeuwe*. Leeuwarden, 1642.

Quintijn, Gillis. *Hollandsche-Liis met de Brabandsche-Bely*. The Hague, 1629.

Ripa, Cesare. *Iconologia, of uytbeeldingen des verstands*. Translated by D. P. Pers. Amsterdam, 1644.

Rodenburgh, Theodore. *Eglentiers poetens borstweringh*. Amsterdam, 1619.

Rollenhagen, Gabriel. *Nucleus emblematum Selectissimorum*. 2 vols. Arnhem and Utrecht, 1611–13.

Rollos, Peter. *Philotheca Corneliana*. Frankfurt, 1619.

Roos, Axilium. *Den Amsteldamsen Diogenes, of philosophische bloemhof*. Utrecht, 1684.

Sandrart, Joachim von. *Teutsche Academie der edlen Bau-, Bild- und Malerei-Künste*. 3 vols. Nuremberg, 1675–80.

Santen, G. C. van. *Lichte wigger*. Leiden, 1617.

Schaep, Jan Claesz. *Bloem-tuyntje*. 2nd edn. Amsterdam, 1671.

Schrevelius, Theodorus. *Harlemias*. Haarlem, 1648.

Seven engelen der dienst-maagden, zijnde een rare en beknopte wederlegginge tegen een nu-onlangs uitgegeven boekje genaamd 7. duivelen der dienst-maagden, De. Leiden, 1697.

Spaan, Gerard van. *Beschryvinge der stad Rotterdam* [1698]. 3rd edn. Rotterdam, 1738.

Sprankhuisen, Dionysius. *Lof en plicht des houwelyx*. In *Opuscula practica ofte alle de stichtelijke werken*. pt. 1., pp. 135–52. Amsterdam, 1658.

Swaef, Joannes de. *De geestelycke queeckerye van de jonge planten des Heeren* [1621]. Middelburg, 1740.

Taffin, Jean. *De boetveerdicheyt des levens*. 12th edn. Amsterdam, 1640.

Teellinck, Willem. *Den spieghel der zedicheyt*. Amsterdam, 1626.

Teellinck, Willem. *Noodwendigh vertoogh, aengaende den tegenwoordigen bedroefden staet van Gods volck*. Middelburg, 1627.

Traudenius, Dirck. "Rymbundel." In *Tyd-zifter, dat is kort bericht of onderwijs van de onderscheidinge en afbeeldinge de tydts, gevolgd door rymbundel*. Amsterdam, 1662.

Ubeda, Francisco Lopez de. *La picara Justina*. N.p., 1605.

Vaeck-verdryver van de swaermoedighe gheesten, Den. Amsterdam, 1620.

Veen, Otto van. *Quinti Horatii Flacci emblemata*. Antwerp, 1607.

——. *Amorum emblemata*. Antwerp, 1608.

Venne, Adriaen van de. *Tafereel van sinne-mal*. Middelburg, 1623.

——. *Tafereel van de belacchende werelt*. The Hague, 1635.

Vinne, Adriaen Laurensz. van der. *Dagelijckse aentekeninge van Vincent Laurensz. van der Vinne; reisjournaal van een Haarlems schilder 1652–1655*. Introduction and Commentary by Bert Sliggers, Jr. Haarlem, 1979.

Visscher, Roemer. *Sinnepoppen* [1614]. Edited by L. Brummel. The Hague, 1949.

Voetius, G. *Een kort tractaetjen van de danssen*. Utrecht, 1644.

——. *Twist-reden tegen de schouw spelen* [1650]. 2nd edn. Amsterdam, 1772.

Vos, Jan. *Alle de gedichten* [1662]. 2nd edn. 2 vols. Amsterdam, 1726.

V[ries], S[imon] de. *Seven duyvelen, regeerende en vervoerende de hedendaeghsche dienst-maegden*. Amsterdam, 1682.

Wallenkamp, Bernhardum. *Inleydinghe in Zionsschole*. Utrecht, 1661.

Walpole, Horace. *Anecdotes of Painting in England*. 5 vols. 2nd edn. London, 1782.

Weyerman, Jacob Campo. *De levens-beschryvingen der Nederlandsche konst-schilders en konst-schilderessen*. 4 vols. The Hague/Dordrecht, 1729–69.

Wittewrongel, Petrus. *Oeconomia Christiana ofte Christelicke huys-houdinghe*. 3rd edn. 2 vols. Amsterdam, 1661.

Zeeusche nachtegael, De. 3 pts. Middelburg, 1623.

Zeven duivelen, regerende en vervoerende de hedendaagsche dienst-maagden. Amsterdam, 1682.

SECONDARY SOURCES

Aalbers, J., and M. Prak, eds. *De bloem der natie; adel en patriciaat in de Noordelijke Nederlanden*. Meppel and Amsterdam 1987.

Abels, Paul. "Church and Religion in the Age of Vermeer." In Haks and van der Sman 1996, pp. 68–77.

Adams, Ann. "Money and the Regulation of Desire. The Prostitute and the Marketplace in Seventeenth-Century Holland." In Fumerton and Hunt 1999, pp. 229–53.

Aerts, Remieg. "De burgerlijkheid van de Gouden Eeuw." In Hendrix and Drees 2001, pp. 5–22.

Aerts, Remieg, and Henk te Velde, eds. *De stijl van de burger; over Nederlandse burgerlijke cultuur vanaf de middeleeuwen*. Kampen, 1998.

Alpers, Svetlana. "Bruegel's Festive Peasants." *Simiolus* 6 (1972–3): 163–76.

——. "Realism as a Comic Mode: Low-Life Painting Seen Through Bredero's Eyes." *Simiolus* 8 (1975–6): 115–44.

——. "Taking Pictures Seriously: A Reply to Hessel Miedema." *Simiolus* 10 (1978–9): 46–50.

——. *The Art of Describing: Dutch Art in the Seventeenth Century*. Chicago and London, 1983.

—— (1997). "Picturing Dutch Culture." In Franits 1997b, pp. 57–67.

Andel, M. A. van. *Chirurgijns, vrije meesters, beunhazen en kwakzalvers; de chirurgijnsgilden en de praktijk der heelkunde (1400–1800)*. The Hague, 1981.

Arasse, Daniel. *Vermeer: Faith in Painting*. Princeton, 1994.

Augustin, Roland. *Der Geschmack des Neuen: Das Motiv des Tabakrauchens und seine Modernität in der niederländischen Kunst*. Frankfurt am Main and New York, 1998.

Baer, Ronni. "The Paintings of Gerrit Dou (1613–1675)." Ph.D. dissertation, New York University, 1990.

——. "The Life and Art of Gerrit Dou." In Washington D.C., 2000, pp. 26–52.

Bakker, Boudewijn. "*Schilderachtig*: Discussions of a Seventeenth-Century Term and Concept." *Simiolus* 23 (1995): 147–62.

Barnes, Susan J., and Arthur K. Wheelock, Jr., eds. *Van Dyck 350*. Washington D.C., 1994

Barthes, Roland. "The Reality Effect." In *French Literary Theory Today. A Reader*, edited by T. Todorov, translated by R. Carter, pp. 11–17. Cambridge and New York, 1982.

Baumstark, R. *Masterpieces from the Collection of the Princes of Liechtenstein*. New York, 1980.

Beaujean, Dieter. *Bilder in Bildern: Studien zur niederländischen Malerei des 17. Jahrhunderts*. Weimar, 2001.

Becker, Jochen. "'Diese emblematische Stück stellet die Erziehung der Jugend vor.' Zu Adriaen van der Werff, München, Alte Pinakothek, Inv. Nr. 250." *Oud Holland* 90 (1976): 77–107.

——. "'De duystere sin van de geschilderde figueren': zum Doppelsinn in Rätsel, Emblem und Genrestück." In Vekeman and Müller-Hofstede 1984, pp. 17–29.

——. "Der Blick auf den Betrachter: Mehrdeutigkeit als Gestaltungsprinzip niederländischer Kunst des 17. Jahrhunderts." In *Acts of the 27th International Congress of the History of Art (1989)*, section 7, pp. 77–92. Strasbourg, 1992.

——. "Beholding the Beholder: The Reception of 'Dutch' Painting." *Argumentation* 7 (1993): 67–87.

——. "'Il faut cultiver notre jardin.' Beelden van beschaving." In de Boer 2001, pp. 149–93.

——. "Aan een gouden keten: eerbewijzen voor kunstenaars." *De Zeventiende Eeuw* 18 (2002): 51–64.

Bedaux, Jan Baptist. "Minnekoorts-, zwangerschaps- en doodsverschijnselen op zeventiende-eeuwse schilderijen." *Antiek* 10 (1975): 17–42.

——. *The Reality of Symbols; Studies in the Iconology of Netherlandish Art 1400–1800*. The Hague and Maarssen, 1990.

Begheyn, P. J. "Biografische gegevens betreffende de Haarlemse schilder Cornelis Bega (c. 1632–1664) en zijn verwanten." *Oud Holland* 93 (1979): 270–78.

Beherman, Thierry. *Godfried Schalcken*. Paris, 1988.

Belkin, Kristin Lohse. *Rubens*. London, 1998.

Benesch, Otto. *The Drawings of Rembrandt*. 2nd edn. 6 vols. London, 1973.

Berg, W. van den, and J. Stouten, eds. *Het woord aan de lezer; zeven literatuurhistorische verkenningen*. Groningen, 1987.

Berge, Domien ten. *De hooggeleerde en zoetvloeiende dichter Jacob Cats*. The Hague, 1979.

Bergström, Ingvar. "Rembrandt's Double-Portrait of Himself and Saskia at the Dresden Gallery: A Tradition Transformed." *Nederlands Kunsthistorisch Jaarboek* 17 (1966): 143–69.

Bergvelt, Ellinoor, and Renée Kistemaker, eds. *De wereld binnen handbereik; Nederlandse kunst- en rariteitenverzamelingen, 1585–1735*. Amsterdam, 1992.

Bevers, Ton. *Artists-Dealers-Consumers: On the Social World of Art*. Hilversum, 1994.

Biesboer, Peter. "Judith Leyster: Painter of 'Modern Figures.'" In Worcester 1993, pp. 75–92.

——. *Netherlandish Inventories 1: Collections of Paintings in Haarlem 1572–1745*. Edited by Carol Togneri. Los Angeles, 2001.

Bièvre, Elisabeth de. "The Urban Subconscious: The Art of Delft and Leiden." *Art History* 18 (1995): 222–52.

Bijl, Martin. "The Artist's Working Method." In Washington D.C., 1996, pp. 83–91.

Blaas, P. B. M. "De Gouden Eeuw: overleefd en herleefd. Kanttekeningen bij het beeldvormingsproces in de 19de eeuw." *De Negentiende Eeuw* 9 (1985): 109–30.

Blade, Timothy Trent. "The Paintings of Dirck van Delen." Ph.D. dissertation, University of Minnesota, 1976.

Blankert, Albert. *Vermeer of Delft*. New York, 1978.

——. "General Introduction." In Washington D.C. 1980, pp. 15–33.

——. "Caravaggio en Noord-Nederland." In Utrecht 1986–7, pp. 17–41.

——. "What is a Dutch Seventeenth Century Genre Painting? A Definition and Its Limitations." In *Holländische Genremalerei im 17. Jahrhundert; Symposium Berlin 1984 (Jahrbuch Preussischer Kulturbesitz, Sonderband 4)*, edited by Henning Bock and Thomas W. Gaehtgens, pp. 9–32. Berlin, 1987.

——. "Vermeer's Modern Themes and Their Tradition." In Washington D.C., 1995–6, pp. 31–45.

Blankert, Albert, John Michael Montias, and Gilles Aillaud. *Vermeer*. New York, 1988.

Blok, F. F. *Caspar Barlaeus; From the Correspondence of a Melancholic*. Assen and Amsterdam, 1976.

Bock, Henning, and Thomas W. Gaehtgens, eds. *Holländische Genremalerei im 17. Jahrhundert; Symposium Berlin 1984 (Jahrbuch Preussischer Kulturbesitz, Sonderband 4)*. Berlin, 1987b.

Bode, Wilhelm von. *Die Meister der holländischen und flämischen Malerschulen*. 8th ed. Leipzig, 1956.

Boekhorst, Peter te *et al.*, eds. *Cultuur en maatschappij in Nederland 1500–1850; een historisch-antropologisch perspectief*. Heerlen 1992.

Boer, Pim den. "Vergelijkende begripsgeschiedenis." In *Beschaving; een geschiedenis van de begrippen hoofsheid, heusheid, beschaving en cultuur*, edited by Pim den Boer, pp. 15–78. Amsterdam, 2001.

Boers, M. E. W. "Een nieuwe markt voor kunst: de expansie van de Haarlemse schilderijenmarkt in de eerste helft van de zeventiende eeuw." In *Kunst voor de markt 1500–1700 (Nederlands Kunsthistorisch Jaarboek 50)*, edited by Reindert Falkenburg *et al.*, pp. 195–219. Zwolle, 1999.

Boersma, Annetje. "Dou's Painting Technique." In Washington D.C. 2000, pp. 54–63.

Bogaers, Llewellyn. "Een kwestie van macht? De relatie tussen de wetgeving op het openbaar gedrag en de ontwikkeling van de Utrechtse stadssamenleving in de zestiende en zeventiende eeuw." In *Beschikken en beschaven; katholieke en protestante beschavingsoffensieven in de zestiende en zeventiende eeuw (Volkskundig Bulletin 11)*, edited by J. J. Voskuil *et al.*, pp. 102–26. Amsterdam, 1985.

Bogendorf Rupprath, Cynthia von. "Molenaer in His Studio: Props, Models, and Motifs." In Raleigh 2002, pp. 27–41.

Bok, Marten Jan. "On the Origins of the Flute Player in Utrecht Caravaggesque Painting." In Klessman 1988, pp. 135–41.

——. "Vraag en aanbod op de Nederlandse kunstmarkt, 1580–1700." Proefschrift, Universiteit van Utrecht, 1994.

——. "The Artist's Life." In Washington D.C. 1996, pp. 25–37.

——. "Biographies." In San Francisco 1997, pp. 370–93.

——. "Pricing the Unpriced: How Dutch Seventeenth-Century Painters Determined the Selling Price of Their Work." In *Art Markets in Europe, 1400–1800*, edited by Michael North and David Ormrod, pp. 103–11. Aldershot, 1998.

——. "Society, Culture, and Collecting in Seventeenth-Century Delft." In New York 2001a, pp. 196–210.

—— (2001b). "The Rise of Amsterdam as a Cultural Centre: The Market for Paintings, 1580–1680." In O'Brien 2001, pp. 196–209.

Bol, Laurens J. *Adriaen Pietersz. van de Venne, Painter and Draughtsman*. Doornspijk, 1989.

Bostoen, Karel *et al.*, eds. *"Tweelinge eener draagt": woord en beeld in de Nederlanden (1500–1750) (De Zeventiende Eeuw 17 no. 3)*. Hilversum, 2001.

Bourdieu, Pierre. *Distinction: A Social Critique of the Judgement of Taste*. Translated by Richard Nice. Cambridge, Mass., 1984

Braun, H. "Gerrit und Willem van Honthorst." Ph.D. dissertation, Georg-August-Universität, Göttingen, 1966.

Braun, Karel. *Alle tot nu toe bekende schilderijen van Jan Steen (Meesters der schilderkunst)*. Rotterdam, 1980.

Brederoo, N. et al., eds. *Oog in oog met de spiegel*. Amsterdam, 1988b.

Bredius, A. "Onbekende schilders, o.a. Casparus Smits, zich ook genoemd hebbende Theodorus Hartkamp." *Oud Holland* 33 (1915): 112–20.

———. *Jan Steen*. Amsterdam, n. d. [1927].

Bremmer, Jan, ed. *From Sappho to De Sade; Moments in the History of Sexuality*. London and New York, 1989.

Bremmer, Jan and Herman Roodenburg, eds. *A Cultural History of Humour*. Oxford, 1997.

Brenninkmeyer-De Rooij, Beatrijs. "Correspondances et interactions entre peintres français et hollandais au XVIIᵉ siècle." In Paris 1986, pp. 47–76.

Breukink-Peeze, Margaretha. "Japanese Robes: A Craze." In *Imitation and Inspiration: Japanese Influence on Dutch Art*, edited by Stefan van Raay, pp. 53–60. Amsterdam, 1989.

Brewer, John and Roy Porter, eds. *Consumption and the World of Goods*. London and New York, 1993.

Briels, Jan. *De Zuidnederlandse immigratie 1572–1630*. Haarlem, 1978.

———. "Brabantse blaaskaak en Hollandse botmuil; cultuurontwikkelingen in Holland in het begin van de Gouden Eeuw." *De Zeventiende Eeuw* 1 (1985a): 12–36.

———. *Zuidnederlanders in de Republiek 1572–1630: een demografische en cultuurhistorische studie*. Sint-Niklaas, 1985b.

———. *Vlaamse schilders en de dageraad van Hollands Gouden Eeuw 1595–1630*. Antwerp, 1997.

Brière-Misme, Clotilde. "Un émule de Vermeer et de Pieter de Hooch: Cornelis de Man." *Oud Holland* 52 (1935): 1–26 and 97–120.

Broekhuijsen, Marijke, and Myrle Tjoeng, eds. *Wat heet oud; gedachten over het ouder worden*. Baarn, 1994.

Broersen, Ellen. " 'Judita Leystar': A Painter of 'Good, Keen Sense'." In Worcester 1993, pp. 15–38.

Bromley, J. S., and E. H. Kossmann, eds. *Britain and The Netherlands*. Groningen, 1964.

Brongers, Georg A. *Nicotiana Tabacum. The History of Tobacco and Tobacco Smoking in the Netherlands*. Amsterdam, 1964.

Broos, Ben. *Meesterwerken in het Mauritshuis*. The Hague, 1987.

———. "Un celebre Peijntre nommé Verme[e]r." In Washington D.C. 1995–6, pp. 47–65.

———. "Vermeer: Malice and Misconception." In Gaskell and Jonker 1998, pp. 19–33.

———. "Eeckhout, Gerbrand van den." In Turner 2000, pp. 100–05.

Broos, Ton J. *Tussen zwart en ultramarijn; de levens van schilders beschreven door Jacob Campo Weyerman (1677–1747)*. Amsterdam and Atlanta, 1990.

Brown, Christopher. *Carel Fabritius*. Ithaca, 1981.

———. *Van Dyck*. Ithaca, 1983.

———. *Images of a Golden Past; Dutch Genre Painting of the 17th Century*. New York, 1984.

———. "Review of Exhib. cat. Washington D.C., *Jan Steen: Painter and Storyteller*." *Simiolus* 25 (1997): 81–4.

Bruin, R. E. de, et al., eds. *"Een paradijs vol weelde"; geschiedenis van de stad Utrecht*. Utrecht, 2000.

Brusati, Celeste. "Stilled Lives: Self-Portraiture and Self-Reflection in Seventeenth-Century Netherlandish Still-Life Painting." *Simiolus* 20 (1990–91): 168–82.

———. *Artifice and Illusion: The Art and Writing of Samuel van Hoogstraten*. Chicago and London, 1995.

——— (1997). "Natural Artifice and Material Values in Dutch Still Life." In Franits 1997b, pp. 144–57.

———. "Honorable Deceptions and Dubious Distinctions: Self-Imagery in Trompe-l'Oeil." In Copenhagen 1999, pp. 49–73.

———. "Hoogstraten, Samuel van." In Turner 2000, pp. 169–75.

Bruyn, Josua. "Review of Peter Hecht, *De Hollandse fijnschilders*." *Oud Holland* 105 (1991): 64–9.

———. "A Turning-Point in the History of Dutch Art." In Amsterdam 1993–4, pp. 112–21.

Buijsen, Edwin. "Tussen 'konsthemel' en aarde; panorama van de schilderkunst in Den Haag tussen 1600 en 1700." In The Hague, 1998–9, pp. 27–49.

Burke, James D. "Dutch Paintings." *Bulletin, St. Louis Art Museum* 15 no. 4 (Winter 1980): 5–24.

Burke, Peter. *Dutch Popular Culture in the Seventeenth Century: A Reconnaissance*. Rotterdam, 1978a.

———. *Popular Culture in Early Modern Europe*. New York, 1978b.

———. *The Art of Conversation*. Ithaca and London, 1993.

———. *Venice & Amsterdam: A Study of Seventeenth-Century Elites*. 2nd edn. Cambridge, 1994.

Butler, Marigene H. "Appendix: An Investigation of the Technique and Materials Used by Jan Steen." *Philadelphia Museum of Art Bulletin* 78 (1982–3): 44–61.

Carasso, Dedalo. "De schilderkunst en de natie; beschouwingen over de beeldvorming ten aanzien van de zeventiende-eeuwse Noord-Nederlandse schilderkunst." *Theoretische Geschiedenis* 11 (1984): 381–407.

Carlson, Marybeth. "A Trojan Horse of Worldliness? Maidservants in the Burgher Household in Rotterdam at the End of the Seventeenth Century." In Kloek et al. 1994, pp. 87–96.

Castan, Nicole. "The Public and the Private." In Chartier 1989, pp. 403–45.

Cavalli-Björkman, Görel, ed. *Rembrandt and His Pupils: Papers Given at a Symposium in Nationalmuseum Stockholm, 2–3 October 1992*. Stockholm, 1993.

Chapman, H. Perry. *Rembrandt's Self-Portraits; A Study in Seventeenth-Century Identity*. Princeton, 1990.

———. "Jan Steen's Household Revisited." *Simiolus* 20 (1990–91): 183–96.

———. "Persona and Myth in Houbraken's Life of Jan Steen." *Art Bulletin* 75 (1993): 135–50.

———. "Jan Steen as Family Man. Self-Portrayal as an Experiental Mode of Painting." In Falkenburg et al. 1995, pp. 368–93.

———. "Jan Steen, Player in His Own Paintings." In Washington D.C. 1996, pp. 11–23.

———. "Propagandist Prints, Reaffirming Paintings: Art and Community during the Twelve Years Truce." In Wheelock and Seeff 2000, pp. 43–63.

———. "Women in Vermeer's Home: Mimesis and Ideation." In Westermann et al. 2001, pp. 237–71.

———. "Home and the Display of Privacy." In Newark 2001–2, pp. 129–52.

Chartier, Roger. *Cultural History; Between Practices and Representations*. Translated by Lydia G. Cochrane. Ithaca, 1988.

———. "Introduction." In *Passions of the Renaissance (A History of Private Life, vol. 3)*, edited by Roger Chartier, translated by Anton Goldhammer, pp. 163–4. Cambridge, Mass., and London, 1989.

Cheney, Liana de Girolami. "The Oyster in Dutch Genre Paintings: Moral or Erotic Symbolism." *Artibus et Historiae* 15 (1987): 135–58.

Chong, Alan. "Arent de Gelder and the Art Scene in Dordrecht." In Moltke 1994, pp. 9–18.

Cornelis, Bart. "A Reassessment of Arnold Houbraken's *Groote schouburgh*." *Simiolus* 23 (1995): 163–80.

———. "Arnold Houbraken's *Groote schouburgh* and the Canon of Seventeenth-Century Painting." *Simiolus* 26 (1998): 144–61.

Costaras, Nicola. "A Study of the Materials and Techniques of Johannes Vermeer." In Gaskell and Jonker 1998, pp. 145–67.

Cropper, Elizabeth. "The Petrifying Art: Marino's Poetry and Caravaggio." *Metropolitan Museum Journal* 26 (1991): 193–226.

Cuzin, Jean-Pierre. "Manfredi's *Fortune Teller* and Some Problems of 'Manfrediana Methodus.'" *Bulletin of the Detroit Institute of Arts* 58 (1980): 15–25.

Czech, Hans-Jörg. *Im Geleit der Musen; Studien zu Samuel van Hoogstratens Malereitraktat Inleyding tot de hooge schoole der schilderkonst: anders de zichtbaere werelt (Rotterdam 1678)*. New York, Munich, and Berlin, 2002.

Dekker, Rudolf. "Maid Servants in the Dutch Republic: Sources and Comparative Perspectives." In Kloek *et al.* 1994, pp. 97–101.

——. "Sexuality, Elites, and Court Life in the Late Seventeenth Century: The Diaries of Constantijn Huygens, Jr." *Eighteenth Century Life* 23 (1999): 94–109.

——. *Childhood, Memory and Autobiography in Holland from the Golden Age to Romanticism.* New York, 2000.

——. *Humour in Dutch Culture of the Golden Age.* New York, 2001.

——. "Upstairs and Downstairs: meiden en knechts in het dagboek van Constantijn Huygens Jr." *Mededelingen van de Stichting Jacob Campo Weyerman* 25 (2002): 78–88.

Delahay, Sasja, and Nora Schadee. "Verzamelaars en handelaars in Rotterdam." In Rotterdam, 1994–5, pp. 31–41.

Delsaute, Jean-Luc. "The Camera Obscura and Painting in the Sixteenth and Seventeenth Centuries." In Gaskell and Jonker 1998, pp. 111–23.

Deursen, A. Th. van. *Plain Lives in a Golden Age: Popular Culture, Religion and Society in Seventeenth-Century Holland.* Translated by Maarten Ultee. Cambridge, 1991.

Diederiks, Herman. "Amsterdam and Its Role in the Distribution of Culture in the Early Modern Period." In *Cities and the Transmission of Cultural Values in the Late Middle Ages and Early Modern Period (Records of the 17th International Colloquium Spa, 16–19.V.1994)*, pp. 73–83. Brussels, 1996.

Diederiks, H. A., and P. C. Spierenburg, "Economische en sociale ontwikkelingen." In Ree-Scholtens 1995, pp. 169–97.

Diekiert, Marcus. "'Sic Malesana Meos Circe Transformat Honores'. Der Student als Exempel des 'unberaten Jugend' in einem Nachtstück des Gerard van Honthorst." *Münchner Jahrbuch des Bildenden Kunst* 50 (1999): 147–70.

Dijkshoorn, J. A. *L'influence francaise dans les moeurs et les salons des Provinces-Unies.* Paris, 1925.

Dixon, Laurinda S. "Some Penetrating Insights: The Imagery of Enemas in Art." *Art Journal* 52 (1993): 28–35.

——. *Perilous Chastity: Women and Illness in Pre-Enlightenment Art and Medicine.* Ithaca, 1995.

Dixon, Laurinda S. and Petra ten-Doesschate Chu. "An Iconographical Riddle: Gerbrandt van den Eeckhout's *Royal Repast* in the Liechtenstein Princely Collections." *Art Bulletin* 71 (1989): 610–27.

Dolders, Arno. "Some Remarks on Lairesse's *Groot schilderboek.*" *Simiolus* 15 (1985): 197–220.

Dongelmans, Bernardus P. M. *Nil Volentibus Arduum, documenten en bronnen.* Utrecht, 1982.

Doorninck, Marieke van, and Erika Kuijpers. *De geschoolde stad; onderwijs in Amsterdam in de Gouden Eeuw.* Amsterdma, 1993.

Dorren, Gabrielle. "De eerzamen: zeventiende-eeuws burgerschap in Haarlem." In Aerts and te Velde 1998, pp. 60–79.

——. *Eenheid en verscheidenheid: de burgers van Haarlem in de Gouden Eeuw.* Amsterdam, 2001.

Dreiskämper, Petra. *"Redeloos, radeloos, reddeloos"; de geschiedenis van het rampjaar 1672.* Hilversum, 1998.

Dresen-Coenders, Lène. "'Wegh-wyser ten houwelick.'" In Apeldoorn, 1989, pp. 20–52.

Dudok van Heel, Bas. "Regent Families and Urban Development in Amsterdam." In van Kessel and Schulte 1997, pp. 124–45.

Duits, Henk. "1670–1700: een verwaarloosd tijdvak uit de zeventiende-eeuwse toneelgeschiedenis." *Spiegel der Letteren* 44 (2002): 22–31.

Durantini, Mary Frances. *The Child in Seventeenth-Century Dutch Painting.* Ann Arbor, 1983.

Eck, Caroline *et al.*, eds. *Het schilderachtige: studies over het schilderachtige in de Nederlandse kunsttheorie en architectuur 1650–1900.* Amsterdam, 1994.

Eck, Xander van. "Review of James Welu (ed.), *Judith Leyster: A Dutch Master and Her World.*" *Simiolus* 22 (1993–4): 105–09.

Edwards, Elizabeth. "Roles, Status and Power; Amsterdam Regents in the Later Part of the Seventeenth Century." *Dutch Crossing* 23 (1999): 218–37.

Egmond, Florike *et al.*, eds. *Kometen, monsters en muilezels; het veranderde natuurbeeld en de natuurwetenschap in de zeventiende eeuw.* Haarlem, 1999.

Ekkart, Rudolf. "Moor, Karel de." In Turner 1996, vol. 22, p. 50.

Elias, Norbert. *The History of Manners.* Translated by Edmund Jephcott. New York, 1978.

——. *Power & Civility.* Translated by Edmund Jephcott. New York, 1982.

Elliott, John Paul. "Protestantization in the Northern Netherlands, A Case Study: The Classis of Dordrecht, 1572–1640." Ph.D. dissertation, Columbia University, 1990.

Emmens, Jan. *Rembrandt en de regels van de kunst* [1968]. Amsterdam, 1979.

—— (1997). "A Seventeenth-Century Theory of Art: Nature and Practice (1969)." In Franits 1997b, pp. 15–20.

Enenkel, Karl *et al.*, eds. *Modelling the Individual: Biography and Portrait in the Renaissance.* Amsterdam, 1998.

Faber, Dirk E. A. "De toestand in de Republiek." In Utrecht, 1986–7, pp. 13–16.

Falkenburg, Reindert. "Recente visies op de zeventiende-eeuwse Nederlandse genre-schilderkunst." *Theoretische Geschiedenis* 18 (1991): 119–40.

——. "Iconologie en historische antropologie: een toenadering." In Halbertsma and Zijlmans 1993, pp. 139–74.

Falkenburg, Reindert *et al.*, eds. *Beeld en zelfbeeld in de Nederlandse kunst, 1550–1750 (Nederlands Kunsthistorisch Jaarboek 46).* Zwolle, 1995.

Falkenburg, Reindert, *et al.*, eds. *Kunst voor de markt 1500–1700 (Nederlands Kunsthistorisch Jaarboek 50).* Zwolle, 1999.

Filedt Kok, Jan Piet. "Hendrick Goltzius – Engraver, Designer and Publisher, 1582–1600." In *Goltzius-Studies: Hendrick Goltzius (1558–1617) (Nederlands Kunsthistorisch Jaarboek 42–3)*, edited by Reindert Falkenburg *et al.*, pp. 159–218. Zwolle, 1991–2.

Filedt Kok, Jan Piet *et al. Netherlandish Art in the Rijksmuseum 1600–1700.* Amsterdam and Zwolle, 2001.

Fink, Daniel A. "Vermeer's Use of the Camera Obscura – A Comparative Study." *Art Bulletin* 53 (1971): 493–505.

Fishman, Jane Susannah. *"Boerenverdriet": Violence Between Peasants and Soldiers in Early Modern Netherlands Art.* Ann Arbor, 1982.

Fleischer, Roland E. "Ludolf de Jongh and the Early Work of Pieter de Hooch." *Oud Holland* 92 (1978): 49–67.

——. *Ludolf de Jongh (1616–1679): Painter of Rotterdam.* Doornspijk, 1989.

Fleischer, Roland E., and Susan Scott Munshower, eds. *The Age of Rembrandt; Studies in Seventeenth-Century Dutch Painting.* State College, Penn., 1988.

Fleischer, Roland E., and Stephen Reiss. "Attributions to Ludolf de Jongh: Some Old, Some New." *Burlington Magazine* 135 (1993): 668–77.

Fock, C. Willemijn. "Willem van Mieris en zijn mecenas Pieter de la Court van der Voort." *Leids Kunsthistorisch Jaarboek* 2 (1983): 261–82.

——. "Kunstbezit in Leiden in de 17de eeuw," In *Het Rapenburg; Geschiedenis van een Leidse gracht*, 6 vols., edited by Th. H. Lunsingh Scheurleer *et al.*, vol. 5a, pp. 3–36. Leiden, 1986–92.

——. "Werkelijkheid of schijn. Het beeld van het Hollandse interieur in de zeventiende-eeuwse genreschilderkunst." *Oud Holland* 112 (1998): 187–246.

——(2001a). "1650–1700." In Fock 2001b, pp. 81–179.

——. "Semblance or Reality? The Domestic Interior in Seventeenth-Century Dutch Genre Painting." In Newark 2001–2, pp. 83–101.

Fock, C. Willemijn, ed. *Het Nederlandse interieur in beeld 1600–1900.* Zwolle, 2001b.

Forster, Leonard. *The Icy Fire: Five Studies in European Petrarchism*, Cambridge, 1969.

Foucart, Jacques. "Peter Lely: Dutch History Painter." *Mercury* 8 (1989): 17–26.

Franits, Wayne. "The Relationship Between Emblems and Dutch Paintings of the Seventeenth century." *Marsyas* 22 (1983–5): 24–32.

——. "The Family at Grace: A Theme in Dutch Art of the Seventeenth Century." *Simiolus* 16 (1986): 36–49.

——. "'The Vertues Which Ought to be in a Compleate Woman': Domesticity in Seventeenth-Century Dutch Art." Ph.D. dissertation, Institute of Fine Arts, New York University, 1987.

——. "The Depiction of Servants in Some Paintings by Pieter de Hooch." *Zeitschrift für Kunstgeschichte* 52 (1989): 559–66.

—— (1990). "'Betemt de jeughd, Soo doet sy deughd': A Pedagogical Metaphor in Seventeenth-Century Dutch Art." In Sluijter 1990, pp. 217–26.

——. *Paragons of Virtue: Women and Domesticity in Seventeenth-Century Dutch Art.* Cambridge and New York, 1993a.

——. "Wily Women? On Sexual Imagery in Dutch Art of the Seventeenth Century." In *From Revolt to Riches; Culture and History of the Low Countries 1500–1700*, edited by Theo Hermans and Reinier Salverda, pp. 300–19. London, 1993b.

——. "Zwischen Frömmigkeit und Geiz: Das Alter in Genredarstellungen." In Braunschweig, 1993–4, pp. 78–86.

——. "Between Positivism and Nihilism: Some Thoughts on the Interpretation of Seventeenth-Century Dutch Paintings." *Theoretische Geschiedenis* 21 (1994): 129–52.

——. "'Young Women Preferred White to Brown': Some Remarks on Nicolaes Maes and the Cultural Context of Late Seventeenth-Century Dutch Portraiture." In Falkenburg *et al.* 1995, pp. 394–415.

——. "Domesticity, Privacy, Civility, and the Transformation of Adriaen van Ostade's Art." In *Images of Women in Seventeenth-Century Dutch Art: Domesticity and the Representation of the Peasant*, edited by Patricia Phagan, pp. 3–25. Athens, Ga., 1996.

—— (1997a). "Emerging From the Shadows: Genre Painting by the Utrecht Caravaggisti and Its Contemporary Reception." In San Francisco, 1997, pp. 114–20.

——, ed. *Looking at Seventeenth-Century Dutch Art: Realism Reconsidered.* Cambridge and New York, 1997b.

——(2001a). "'For People of Fashion'. Domestic Imagery and the Art Market in the Dutch Republic." In Westermann *et al.* 2001, pp. 295–316.

—— (2001b). "Johannes Vermeer: An Overview of His Life and Stylistic Development." In Franits 2001c, pp. 8–26.

——, ed. *The Cambridge Companion to Vermeer.* Cambridge and New York, 2001c.

Frank-van Westrienen, Anna. *De groote tour; tekening van de educatiereis der Nederlanders in de zeventiende eeuw.* Amsterdam, 1983.

Freedberg, David, and Jan de Vries, eds. *Art in History, History in Art: Studies in Seventeenth-Century Dutch Culture.* Santa Monica, 1991.

Fresia, Carol Jean. "Quacksalvers and Barber-Surgeons: Images of Medical Practitioners in 17th-Century Dutch Genre Painting." Ph.D. dissertation, Yale University, 1991.

Friedländer, Max J. "Das Inventar der Sammlung Wyttenhorst." *Oud Holland* 23 (1905): 63–8.

Friedländer, Walter. *Caravaggio Studies* [1955]. 1st paperback edn. Princeton, 1974.

Frijhoff, Willem. *Cultuur, mentaliteit: illusies van elites?* Nijmegen, 1984.

——. "Verfransing? Franse taal en nederlandse cultuur tot in de revolutietijd." *Bijdragen en mededelingen betreffende de geschiedenis der Nederlanden* 104 (1989): 592–609.

——(1992a). "Inleiding: historische antropologie." In Frijhoff 1992b, pp. 11–38.

——. "Medical Education and Early Dutch Practitioners: Towards a Critical Approach." In Marland and Pelling 1996, pp. 205–20.

—— (1997–8). "The Princely Court in The Hague: A National and European Perspective." In The Hague, 1997–8a, pp. 10–17.

Frijhoff, Willem *et al.*, eds. *Cultuur en maatschapij in Nederland 1500–1850; een historisch-antropologisch perspectief.* Heerlen, 1992b.

Frijhoff, Willem, *et al.*, eds. *Geschiedenis van Dordrecht van 1572 tot 1813.* Hilversum, 1998.

Frijhoff, Willem, and Marijke Spies. *1650: Bevochten eendracht.* The Hague, 1999.

Fritschy, Wantje, ed. *Fragmenten vrouwengeschiedenis.* 2 vols. The Hague, 1980.

Fumerton, Patricia, and Simon Hunt, eds. *Renaissance Culture and the Everyday.* Philadelphia, 1999.

Gaehtgens, Barbara. "*Paradigmata Graphices*: Adriaen van der Werff and the Pattern Books of François Perrier and Jan de Bisschop." In *Tribute to Wolfgang Stechow (Print Review 5)*, edited by Walter L. Strauss, pp. 44–57. New York, 1976.

——. *Adriaen van der Werff 1659–1722.* Munich, 1987a.

——(1987b). "Imitare und Aemulare im Werk Adriaen van der Werffs." In Bock and Gaehtgens 1987, pp. 91–116.

——. "Hofkunst-Staatskunnst-Bürgerkunst. Bemerkungen zur Kunst des 17. Jahrhunderts in Den Haag." In Berlin 1995–6, pp. 10–23.

——, ed. *Genremalerei.* Berlin, 2002.

Gaskell, Ivan. "Gerrit Dou, His Patrons and the Art of Painting." *Oxford Art Journal* 5 (1982): 15–23.

—— (1997). "Tobacco, Social Deviance, and Dutch Art in the Seventeenth Century (1984)." In Franits 1997b, pp. 68–77.

Gaskell, Ivan, and Michiel Jonker, eds. *Vermeer Studies.* Washington D.C., 1998.

Gatenbröcker, Silke. "Dorfkirmes und Bauernhochzeit – Anmerkungen zu den Ursprüngen der Genredarstellung." In Braunschweig 2002, pp. 8–19.

Gelderblom, Arie Jan. "A Rejuvenating Corset: Literary Classicism in the Dutch Republic." In Rotterdam 1999–2000, pp. 54–61.

Gelderblom, Oscar. *Zuid-Nederlandse kooplieden en de opkomst van de Amsterdamse stapelmarkt (1578–1630).* Hilversum, 2000.

Gent, Judith van. "Portretten van Jan Jacobsz. Hinloopen en zijn familie door Gabriel Metsu en Bartholomeus van der Helst." *Oud Holland* 112 (1997): 127–38.

Gent, Lucy. *Pictures and Poetry 1560–1620: Relations Between Literature and the Visual Arts in the English Renaissance.* Leamington Spa, 1981.

Gerson, H. "Rembrandt en de schilderkunst in Haarlem." In *Miscellanea I. Q. van Regteren Altena*, edited by H. Miedema, R. W. Scheller, and P. J. J. van Thiel, pp. 138–42. Amsterdam, 1969.

Gifford, E. Melanie. "Painting Light: Recent Observations on Vermeer's Technique." In Gaskell and Jonker 1998, pp. 185–99.

Gilbert, Creighton. "When Did a Man in the Renaissance Grow Old?" *Studies in the Renaissance* 14 (1967): 7–32.

Goedde, Lawrence O. "Convention, Realism, and the Interpretation of Dutch and Flemish Tempest Painting." *Simiolus* 16 (1986): 139–49.

——. *Tempest and Shipwreck in Dutch and Flemish Art: Convention, Rhetoric, and Interpretation.* University Park, 1989.

—— (1997). "Naturalism as Convention: Subject, Style, and Artistic Self-Consciousness in Dutch Landscape." In Franits 1997b, pp. 129–43.

Goodman, Dena. "Public Sphere and Private Life: Toward a Synthesis of Current Historiographical Approaches to the Old Regime." *History and Theory* 31 (1992): 1–20.

Goodman, Elise. "Rubens' *Conversatie á la Mode*: Garden of Leisure, Fashion and Gallantry." *Art Bulletin* 64 (1982): 247–59.

——. *Rubens: The Garden of Love as Conversatie à la mode.* Amsterdam and Philadelphia, 1992.

——. "The Landscape on the Wall in Vermeer" [1989]. In Franits 2001, pp. 73–88.

Goosens, Korneel. *David Vinckboons* [1954]. Doornspijk, 1977.

Goosens, Marion Elisabeth Wilhelmina. "Schilders en de markt: Haarlem 1605–1635." Proefschrift, Rijksuniversiteit te Leiden, 2001.

Gordenker, Emilie E. S. *Van Dyck and the Representation of Dress in Seventeenth-Century Portraiture*. Turnhout, 2001.

Gorp, H. van. *Inleiding tot de picareske verhaalkunst*. Groningen, 1978.

Goudsblom, Johan. "Civilisatie, besmettingsangst en hygiëne; beschouwingen over een aspect van het Europese civilisatieproces." *Amsterdams Sociologisch Tijdschrift* 4 (1977–8): 271–300.

Gouw, J. ter. *De volksvermaken*. Haarlem, 1871.

Gowing, Lawrence. *Vermeer*. 2nd edn. New York, 1970.

Grijp, Louis Peter. "Dutch Music of the Golden Age." In The Hague 1994, pp. 63–79.

Grijzenhout, Frans. "A Myth of Decline." In Jacob and Mijnhardt 1992, pp. 324–37.

Grijzenhout, Frans, and Henk van Veen, eds. *The Golden Age of Dutch Painting in Historical Perspective*. Cambridge and New York, 1999.

Grimm, Klaus. *Frans Hals: The Complete Work*. Translated by Jürgen Riehle. New York, 1990.

Groen, Karin M. *et al*. (1998). "Scientific Examination of Vermeer's *Girl with a Pearl Earring*." In Gaskell and Jonker 1998, pp. 169–83.

Groenendijk, L. F. *De nadere reformatie van het gezin; de visie van Petrus Wittewrongel op de Christelijke huishouding*. Dordrecht, 1984.

——. "De Nadere Reformatie en 'de scholen der ydelheyt' (I)." *Documentatieblad Nadere Reformatie* 10 (1986): 77–93.

——. "De Nadere Reformatie en het toneel." *De Zeventiende Eeuw* 5 (1989): 141–53.

Groeneweg, Irene. "Kanttekeningen bij een 18de-eeuws Nederlands vrouwenportret in 'antique kleeding.'" *Leids Kunsthistorisch Jaarboek* 4 (1985): 415–36.

——. "Regenten in het zwart: vroom en deftig?" In Falkenburg *et al*. 1995, pp. 199–251.

——. "Portretkostuums; kanttekeningen bij een 18de-eeuws Nederlands vrouwenportret in 'antique kleeding.'" *Kostuum* (1997): 5–23.

—— (1997–8). "Court and City: Dress in the Age of Frederik Hendrik and Amalia." In The Hague 1997–8a, pp. 201–18.

Groenhuis, G. *De predikanten. De sociale positie van de gereformeerde predikanten in de Republiek der Verenigde Nederlanden voor 1700*. Groningen, 1977.

Groenveld, Simon. "Fredrick Henry and His Entourage: A Brief Political Biography." In The Hague 1997–8, pp. 18–33.

Groenveld, S. *et al*. (1995). "Geografische, institutionele en politieke ontwikklingen." In Ree-Scholtens *et al*. 1995, pp. 141–68.

Groot, Agnes. "Drank en minne: een vroeg 17de eeuws gezelschap van Dirk Hals." *Kunstlicht* 15 (n. d.): 10–16.

——. "Dirck Hals." In Turner 2000, pp. 143–4.

——. "Goltzius' prent Luna en vrolijke gezelschappen; een beeldcitaat van Goltzius in vrolijke gezelschappen van Willem Buytewech en Dirck Hals." *Kunstlicht* 23 (2002): 33–9.

Groot, C. W. de. *Jan Steen: beeld en woord*. Utrecht and Nijmegen, 1952.

Grootes, E. K. "Het jeugdige publiek van de 'nieuwe liedboeken' in het eerste kwart van de zeventiende eeuw." In *Het woord aan de lezer; zeven literatuurhistorische verkenningen*, edited by W. van den Berg and J. Stouten, pp. 72–88. Groningen 1987.

——. "Heusheid en beleefheid in de zeventiende eeuw." In den Boer 2001, pp. 131–45.

Gudlaugsson, S. J. *Gerard ter Borch*. 2 vols. The Hague 1959–60.

——. "Kanttekeningen bij de ontwikkeling van Metsu." *Oud Holland* 83 (1968): 13–43.

——. *The Comedians in the Work of Jan Steen and His Contemporaries* [1945]. Translated by James Brockway. Soest, 1975.

Haak, Bob. *The Golden Age: Dutch Painters of the Seventeenth Century*. Translated and edited by Elizabeth Willems-Treeman. New York, 1984.

Hagstrum, Jean H. *The Sister Arts: The Tradition of Literary Pictorialism and English Poetry from Dryden to Gray*. Chicago, 1958.

Hahn, Andreas. *". . . dat zy de aanschouwers schynen te willen aanspreken": Untersuchungen zur Rolle des Betrachters in der niederländischen Malerei des 17. Jahrhunderts*. Munich, 1996.

Haitsma Muller, Eco. "De eerste Hollandse stadsbeschrijvingen uit de zeventiende eeuw." *De Zeventiende Eeuw* 9 (1993): 97–116.

——. "Descriptions of Towns in the Seventeenth-Century Province of Holland." In Wheelock and Seeff 2000, pp. 24–32.

Haks, Donald. *Huwelijk en gezin in Holland in de 17de en 18de eeuw*. Assen, 1982.

——. "The Household of Johannes Vermeer." In Haks and van der Sman 1996, pp. 92–105.

Haks, Donald, and Marie Christine van der Sman, eds. *Dutch Society in the Age of Vermeer*. Zwolle, 1996.

Halbertsma, Marlite, and Kitty Zijlmans, eds. *Gezichtspunten: een inleiding in de methoden van de kunstgeschiedenis*. Nijmegen, 1993.

Harmsen, Antonius J. E. "Onderwys in de tooneel-poëzy; de opvattingen over toneel van het kunstgenootschap *Nil Volentibus Arduum*." Proefschrift, Universiteit van Amsterdam, 1989.

Hart, Marjolein 't (2001). "The Glorious City: Monumentalism and Public Space in Seventeenth-Century Amsterdam." In O'Brien 2001b, pp. 128–50.

Haverkamp-Begemann, Egbert. *Willem Buytewech*. Amsterdam, 1959.

Hazewinkel, H. C. *Geschiedenis van Rotterdam* [1940–42]. 4 vols. Zaltbommel, 1974–5.

Hecht, Peter. "Candlelight and Dirty Fingers, or Royal Virtue in Disguise: Some Thoughts on Weyerman and Godfried Schalcken." *Simiolus* 11 (1980): 23–38.

——. "The *Paragone* Debate: Ten Illustrations and a Comment." *Simiolus* 14 (1984): 125–36.

——. "Browsing in Houbraken: Developing a Fancy for an Underestimated Author." *Simiolus* 24 (1996): 259–74.

—— (1997). "Dutch Seventeenth-Century Genre Painting: A Reassessment of Some Current Hypotheses (1992)." In Franits 1997b, pp. 88–97.

——. "Art Beats Nature, and Painting Does It Best of All: The *Paragone* Competition in Duquesnoy, Dou and Schalcken." *Simiolus* 29 (2002): 184–201.

Hedinger, Bärbel. *Karten in Bildern; zur Ikonographie der Wandkarte in holländischen Interieurgemälden des 17. Jahrhunderts*. Hildesheim and New York, 1986.

Hekma, Gert, and Herman Roodenburg, eds. *Soete minne en helsche boosheit: Seksuele voorstellingen in Nederland 1300–1850*. Nijmegen, 1988.

Helgerson, Richard. *Adulterous Alliances: Home, State, and History in Early Modern European Drama and Painting*. Chicago and London, 2000.

Hendrix, Harald, and Marijke Meijer Drees, eds. *Beschaafde burgers: burgerlijkheid in de vroegmoderne tijd*. Amsterdam, 2001.

Heppner, A. "Rotterdam as the Center of a 'Dutch Teniers Group.'" *Art in America* 34 (1946): 14–30.

Hertel, Christiane (2001). "Seven Vermeers: Collection, Reception, Response." In Franits 2001c, pp. 140–60.

Hochstrasser, Julie Berger. "Imag(in)ing Prosperity: Painting and Material Culture in the 17th-century Dutch Household." In Westermann *et al*. 2001, pp. 195–235.

Hofrichter, Frima Fox. "Judith Leyster's *Proposition*: Between Virtue and Vice." In *Feminism and Art History*, edited by Mary D. Garrard and Norma Broude, pp. 172–81. New York, 1982.

——. *Judith Leyster: A Woman Painter in Holland's Golden Age*. Doornspijk 1989.

Hofstede de Groot, Cornelis. *Beschreibendes und kritisches Verzeichnis der Werke der hervorragendsten holländischen Maler des XVII. Jahrhunderts*. 10 vols. Esslingen, 1907–28.

Hollander, Martha. "The Divided Household of Nicolaes Maes." *Word and Image* 10 (1994): 138–55.

——. "Public and Private Life in the Art of Pieter de Hooch." In Westermann *et al*. 2001, pp. 273–93.

——. *An Entrance for the Eyes: Space and Meaning in Seventeenth-Century Dutch Art*. Berkeley, 2002.

Honig, Elizabeth Alice. "An Enterprise of Describing. Svetlana Alpers' Art Historical

Strategies." *Theoretische Geschiedenis* 17 (1990): 33–9.

—— (1997). "The Space of Gender in Seventeenth-Century Dutch Painting." In Franits 1997b, pp. 186–201.

——. "Counting Out Their Money: Money and Representation in the Early Modern Netherlands." *Leidschrift* 13 no. 2 (1998a): 31–65.

——. *Painting and the Market in Early Modern Antwerp*. New Haven and London, 1998b.

——. "'Artistieke' vrouwen in de Noordelijke Nederlanden in de vroegmoderne tijd." In Antwerp 1999–2000, pp. 43–57.

——. "Desire and Domestic Economy." *Art Bulletin* 83 (2001): 294–315.

Holly, Michael Ann. *Panofsky and the Foundations of Art History*. Ithaca, 1984.

Horn, Hendrik J. *The Golden Age Revisited: Arnold Houbraken's Great Theatre of Netherlandish Painters and Paintresses*. 2 vols. Doornspijk, 2000.

Hsia, R. Po-Chia, and H. F. K. van Nierop, eds. *Calvinism and Religious Toleration in the Dutch Golden Age*. Cambridge and New York 2002.

Hull, Suzanne W. *Chaste, Silent & Obedient: English Books for Women 1475–1640*. San Marino, 1982.

Huys Janssen, Paul. *Schilders in Utrecht, 1600–1700*. Utrecht, 1990.

——. *Jan van Bijlert 1597/98–1671; Catalogue Raisonné*. Amsterdam and Philadelphia, 1998.

Israel, Jonathan. *Dutch Primacy in World Trade 1585–1740*. Oxford, 1989.

——. *The Dutch Republic: Its Rise, Greatness, and Fall, 1477–1806*. Oxford, 1995.

——. "Adjusting to Hard Times: Dutch Art During Its Period of Crisis and Restructuring (*c.* 1621–*c.* 1645)." *Art History* 20 (1997): 449–76.

——. "De economische ontwikkeling van Amsterdam in de tijd van Rembrandt." *Jaarboek Amstelodamum* 91 (1999): 62–77.

Jacob, Margaret C., and Wijnand W. Mijnhardt , eds. *The Dutch Republic in the Eighteenth Century: Decline, Enlightenment, and Revolution*. Ithaca and London, 1992.

James, Roel. "Van 'boerenhuysen' en 'stilstaende dingen.'" In Rotterdam, 1994–5, pp. 135–41.

Jansen, Guido. "French Painting in Dutch Collections." In Rotterdam 1993, pp. 11–32.

——. "Schalcken, Godfried." In Turner 2000, pp. 328–9.

Jansen, Jeroen. *Decorum; observaties over de literaire gepastheid in de renaissancistische poëtica*. Hilversum, 2001.

Janson, H. W. *Ape and Ape Lore in the Middle Ages and the Renaissance*. London, 1952.

Jong, Erik de. *Nature and Art: Dutch Garden and Landscape Architecture, 1650–1740*. Translated by Ann Langenakens. Philadelphia, 2000.

Jong, Joop de. *Een deftig bestaan. Het dagelijks leven van regenten in de 17de en 18de eeuw*. Utrecht and Antwerp 1987.

Jonge, C. H. de. "Utrechtse schilders der XVIIde eeuw in de verzameling van Willem Vincent, Baron van Wyttenhorst." *Oudheidkundig Jaarboek* 1 (1932): 120–34.

——. *Paulus Moreelse: portret- en genreschilder te Utrecht (1571–1638)*. Assen, 1938.

Jongejan, Marlies. "Dienstboden in de Zeeuwse steden 1650–1800." *Spiegel Historiael* 19 (1984): 214–21.

Jongh, Eddy de. *Zinne- en minnebeelden in de schilderkunst van de zeventiende eeuw*. N. p. [Amsterdam], 1967.

——. "The Spur of Wit: Rembrandt's Response to an Italian Challenge." *Delta* 12 (1972): 49–67.

——. "Grape Symbolism in Painting of the 16th and 17th Centuries." *Simiolus* 7 (1974): 166–91.

——. "Review of Peter C. Sutton, *Pieter de Hooch*." *Simiolus* 11 (1980): 181–5.

——. "Bol Vincit Amorem." *Simiolus* 12 (1981–2): 147–61.

——. "Enige aspecten van de ikonologie, gisteren en vandaag." In *Aspecten van viftig jaar kunsthistorisch onderzoek 1938–1988*, pp. 31–48. Brussels, 1990.

——. "Real Art and Not-So-Real Dutch Art. Some Nationalistic Views of Seventeenth-Century Netherlandish Painting." *Simiolus* 20 (1990–91): 197–206.

——. "De dissonante veelstemmigheid sinds Haaks *Hollandse schilders in de Gouden Eeuw*." *Theoretische Geschiedenis* 19 (1992): 275–91.

——. "Jan Steen, So Near and Yet So Far." In Washington D.C. 1996, pp. 39–51.

—— (1997). "Realism and Seeming Realism in Seventeenth-Century Dutch Painting," [1971] In Franits 1997b, pp. 21–56.

——. "Painted Words in Dutch Art of the Seventeenth Century." In *History of Concepts: Comparative Perspectives*, edited by Karin Tilmans *et al.*, pp. 167–89. Amsterdam, 1998.

——. "The Iconological Approach to Seventeenth-Century Dutch Painting." In Grijzenhout and van Veen 1999, pp. 200–23.

——(2000a). "A Bird's-Eye of Erotica. *Double Entendre* in a Series of Seventeenth-Century Genre Scenes" [1968–9]. In de Jongh 2000f, pp. 21–58.

——. "De heidense poëet gekerstend en gemoraliseerd." In *Dankzij de tiende muze; 33 opstellen uit Kunstschrift*, pp. 139–46. Leiden, 2000b.

——(2000c). "Opinions and Objections." In de Jongh 2000f, pp. 9–19.

——(2000d). "The Broom as Signifier: An Iconological Hunch." In de Jongh 2000f, pp. 193–214.

——(2000e). "The Changing Face of Lady World" [1973]. In de Jongh 2000f, pp. 59–82.

——. *Questions of Meaning: Theme and Motif in Dutch Seventeenth-Century Painting*, edited and translated by Michael Hoyle. Leiden, 2000f.

——. "'Hangt dan der mannen eer nu aan der vrouwen aars?'" *Kunstschrift* 45 no. 4 (2001): 20–29.

Jongste, Jan de *et al.*, eds. *Vermaak van de elite in de vroegmoderne tijd*. Hilversum, 1999.

Jorink, Eric. *Wetenschap en wereldbeeld in de Gouden Eeuw*. Hilversum, 1999.

Jowell, Frances S. "The Rediscovery of Hals." In London, 1990, pp. 61–86.

——. "Vermeer and Thoré-Bürger: Recoveries of Reputation." In Gaskell and Jonker 1998, pp. 35–57.

Judson, J. Richard. *Gerrit van Honthorst: A Discussion of His Position in Dutch Art*. The Hague, 1959.

Judson, J. Richard, and Rudolf E. O. Ekkart. *Gerrit van Honthorst 1592–1656*. Doornspijk, 1999.

Jung, Vera. *Körperlust und Disziplin: Studien zur Fest- und Tanzkultur im 16. und 17. Jahrhundert*. Cologne and Vienna, 2001.

Kamphuis, G. "Lezers van libertijnse literatuur in de zeventiende eeuw." *De Boekenwereld* 1 (1984–5): 11–14.

Kaplan, Benjamin. *Calvinists and Libertines: Confession and Community in Utrecht, 1578–1620*. Oxford, 1995.

——. "Confessionalism and Its Limits: Religion in Utrecht, 1600–1650." In San Francisco 1997, pp. 60–71.

Kavaler, Ethan Matt. "Erotische elementen in de markttaferelen van Beuckelaer, Aertsen en hun tidgenoten." In Ghent 1986–7, pp. 18–26.

——. *Pieter Bruegel: Parables of Order and Enterprise*. Cambridge and New York, 1999.

Keblusek, Marika. *Boeken in de hofstad: Haagse boekcultuur in de Gouden Eeuw*. Hilversum, 1997.

—— (1997–8). "The Bohemian Court at The Hague." In The Hague 1997–8a, pp. 47–57.

Keersmaekers, A. A. "Drie Amsterdamse liedboeken 1602–1615. Doorbraak van de renaissance." *Nieuwe Taalgids* 74 (1981): 121–33.

——. *Wandelend in den nieuwen lust-hof: studie over een Amsterdams liedboek 1602-(1604)-1607-(1610)*. Nijmegen, 1985.

Kemmer, Claus. "In Search of Classical Form: Gerard de Lairesse's *Groot schilderboek* and Seventeenth-Century Dutch Genre Painting." *Simiolus* 26 (1998): 87–115.

Kemp, Wolfgang. "Kunstwerk und Betrachter: Der rezeptionsästhetische Ansatz." In *Kunstgeschichte: Eine Einführung*, edited by Hans Belting *et al.*, pp. 203–21. Berlin, 1986.

Kersten, Michiel C. C. "Pieter de Hooch and Delft Genre Painting 1650–1675." In Delft 1996, pp. 129–210.

——. "Interieurstukken met soldaten tussen circa 1625 en 1660." In Delft 1998, pp. 183–217.

Kessel, Peter van, and Elisja Schulte, eds. *Rome ★ Amsterdam: Two Growing Cities in Seventeenth-Century Europe.* Amsterdam, 1997.

Kettering, Alison McNeil. *The Dutch Arcadia: Pastoral Art and its Audience during the Golden Age.* Montclair, 1983.

——. *Drawings from the Ter Borch Studio Estate.* 2 vols. The Hague, 1988.

——. "Ter Borch's Ladies in Satin," [1993]. In Franits 1997b, pp. 98–115.

——. "Gerard ter Borch's Portraits for the Deventer Elite." *Simiolus* 27 (1999): 46–69.

——. "Gerard ter Borch's Military Men: Masculinity Transformed." In Wheelock and Seeff 2000, pp. 100–19.

Keyes, George S. *Esaias van den Velde 1587–1630.* Doornspijk, 1984.

Kistemaker, Renee, and Roelof van Gelder. *Amsterdam: The Golden Age 1275–1975.* Translated by Paul Foulkes. New York 1983.

Kleinmann, Ute. *Rahmen und Gerahmtes. Das Spiel mit Darstellung und Bedeutung. Eine Untersuchung des illusionistischen Rahmenmotivs im Oeuvre Gerrit Dous.* Frankfurt am Main, 1996.

Klerk, E. A. de. "'Academy-Beelden' and 'Teeken-Schoolen' in Dutch Seventeenth-Century Treatises on Art." In *Academies of Art Between Renaissance and Romanticism (Leids Kunsthistorisch Jaarboek 5–6),* edited by A. W. A. Boschloo *et al.,* pp. 283–7. The Hague, 1989.

Klessman, Rüdiger, ed. *Hendrick ter Brugghen und die Nachfolger Caravaggios in Holland.* Braunschweig, 1988.

Klibansky, Raymond, Erwin Panofsky, and Fritz Saxl. *Saturn and Melancholy; Studies in the History of Natural Philosophy, Religion, and Art.* New York, 1964.

Klinge, Margret. "Introduction." In New York 1982, pp. 9–26.

Klingsöhr-Leroy, Cathrin. "Loo, Jacob van." In Turner 1996, vol. 19, pp. 644–5.

Kloek, Els. "The Case of Judith Leyster: Exception or Paradigm?" In Worcester, 1993, pp. 55–68.

Kloek, Els, Catherine Peters Sengers, and Esther Tobé, eds. *Vrouwen en kunst in de Republiek: een overzicht.* Hilversum, 1998.

Kloek, Els *et al.,* eds. *Women of the Golden Age: An International Debate on Women in Seventeenth-Century Holland, England and Italy.* Hilversum, 1994.

Kloek, Wouter (1988). "The Caravaggisti and the Netherlandish Tradition." In Klessman 1988, pp. 51–7.

Kloek, Wouter Th. *Een huishouden van Jan Steen.* Hilversum, 1998.

Knevel, Paul. *Burgers in het geweer: de schutterijen in Holland, 1550–1700.* Hilversum, 1994.

——. *Het Haagse bureau: zeventiende-eeuwse ambtenaren tussen staatsbelang en eigenbelang.* Amsterdam, 2001.

Knotter, A. "Bouwgolven in Amsterdam in de 17de eeuw." In *Wonen in het verleden 17e–20e eeuw,* edited by P. M. M. Klep *et al.,* pp. 25–37. Amsterdam, 1987.

Knüttel, Brigitte. "Spielende Kinder bei einer Herkulesgruppe. Zu einer Tugend-Allegorie von Adriaen van der Werff." *Oud Holland* 81 (1966): 245–58.

Knuttel, Gerard. *Adriaen Brouwer: The Master and His Work.* Translated by J. G. Talma-Schilthuis and Robert Wheaton. The Hague, 1962.

Kolfin, Elmer. "'Betaamt het de Christen de dans te aanschouwen?' Dansende elite op Noordnederlandse schilderijen en prenten (circa 1640–1645)." In Jongste *et al.* 1999, pp. 153–73.

——. "'Drincken ende klincken kunje sien ter naste plaet'; de boekillustraties van Adriaen van de Venne in Quintijns *De Hollandsche-Liis met de Brabandsche-Bely*" [1629]. In Bostoen 2001, pp. 169–98.

Kommen, Arjan de (2001). "The World of the 17th-Century Artist." In Filedt Kok *et al.* 2001, pp. 21–40.

Kooij, Cora van. *Van de oude mensen vroeger en nu: over de geschiedenis van de ouderdom en de zorg voor oude mensen.* Deventer, 1987.

Kooijmans, L. "Patriciaat en aristocratisering in Holland tijdens de zeventiende en achttiende eeuw." In Aalbers and Prak 1987, pp. 93–103.

Koolhaas-Grosfeld, E. "Nationale versus goede smaak; bevordering van nationale kunst in de Nederland: 1780–1840." *Tijdschrift voor Geschiedenis* 95 (1982): 605–36.

——(1986a). "Op zoek naar de Gouden Eeuw: de herontdekking van de 17de eeuwse Hollandse schilderkunst." In Haarlem 1986, pp. 28–49.

Korevaar, Gerbrand. "Leiden in Rembrandt's Time." In Kassel 2001–2, pp. 12–21.

Koslow, Susan. "Frans Hals *Fisherboys*: Exemplars of Idleness." *Art Bulletin* 57 (1995): 418–32.

Kremper, León. *Studien zu den datierten Gemälden des Nicolaes Maes (1634–1693).* Petersberg, 2000.

Krieger, Michaela. "Grisaille." In Turner 1996, vol. 13, pp. 672–7.

Kroll, Wilhelm, and Karl Mittelhaus, eds. *Paulys Realencyclopädie der classischen Altertumswissenschaft.* 2nd series. Stuttgart, 1934.

Kunstreich, Jan S. *Der "geistreiche Willem"; Studien zu Willem Buytewech (1591–1624).* Kiel, 1959.

Kunzle, David. *From Criminal to Courtier: The Soldier in Netherlandish Art 1550–1672.* Leiden and Boston, 2002.

Kuretsky, Susan Donahue. *The Paintings of Jacob Ochtervelt (1634–1682).* Montclair, 1979.

——. "Independents and Eccentrics." In Washington D.C., 1980, pp. 253–7.

Kyrova, Magda. "Music in Seventeenth-Century Dutch Painting," In The Hague, 1994, pp. 31–62.

Lammertse, Friso. "David Vinckboons (1576–1632), schilder en tekenaar in Amsterdam." In Amsterdam 1989, pp. 13–43.

Langdon, Helen. "Cardsharps, Gypsies and Street Vendors." In London 2001, pp. 42–65.

Langedijk, Karla. "Silentium." *Nederlands Kunsthistorisch Jaarboek* 15 (1964): 3–18.

Lasius, Angelika. "Die Schuhmacher- und Schneiderdarstellungen des niederländischen Malers Quiringh Gerritsz. van Brekelenkam." *Wallraf-Richartz-Jahrbuch* 50 (1989): pp. 141–61.

——. *Quiringh van Brekelenkam.* Doornspijk, 1992.

Lee, Rensselaer W. *Ut Pictura Poesis: The Humanistic Theory of Painting.* New York, 1967.

Leemans, Inger. *Het woord is aan de onderkant; radicale ideeën in Nederlandse pornografische romans 1670–1700.* N. p. [Nijmegen], 2002.

Lesger, Clé. "Clusters of Achievement: The Economy of Amsterdam in Its Golden Age." In O'Brien 2001, pp. 63–80.

Leuker, Maria-Theresia. *"De last van 't huys, de wil des mans . . . ," Frauenbilder und Ehekonzepte im niederländischen Lustspiel des 17. Jahrhunderts.* Münster, 1992.

Levy-Van Halm, Koos. "Judith Leyster: The Making of a Master." In Worcester, 1993, pp. 69–74.

Li, Chu-tsing. "The Five Senses in Art: An Analysis of Its Development in Northern Europe." Ph.D. dissertation, State University of Iowa, 1955.

Lieburg, Fred A. van. *De Nadere Reformatie in Utrecht ten tijde van Voetius; sporen in de gereformeerde kerkeraadsacta.* Rotterdam, 1989.

——. "Geloven op vele manieren." In Frijhoff *et al.* 1998, pp. 271–304.

Liedtke, Walter. "Toward a History of Dutch Genre Painting." In *De arte et libris; Festschrift Erasmus,* edited by A. Horodisch, pp. 317–36. Amsterdam, 1984.

——. "Toward a History of Dutch Genre Painting II: The South Holland Tradition." In Fleischer and Munshower 1988, pp. 95–131.

——. "The Court Style: Architectural Painting in The Hague and London." In *Perspectives; Saenredam and the Architectural Painters of the 17th Century,* pp. 31–42. Exh. cat., Rotterdam, Museum Boymans-van Beuningen, 1991.

——. *A View of Delft: Vermeer and His Contemporaries.* Zwolle, 2000.

—— (2001a). "Delft and the Arts Before 1600." In New York 2001b, pp. 20–41.

—— (2001b). "Delft and the Delft School: An Introduction." In New York 2001b, pp. 2–19.

—— (2001c). "Delft Painting 'In Perspective': Carel Fabritius, Leonaert Bramer, and the

Architectural and Townscape Painters From About 1650 Onward." In New York 2001b, pp. 98–129.

—— (2001d). "Genre Painting in Delft after 1650: De Hooch and Vermeer." In New York 2001b, pp. 130–69.

—— (2001e). "Painting in Delft from about 1600 to 1650." In New York 2001b, pp. 42–97.

—— (2001f). "Review of Philip Steadman, *Vermeer's Camera.*" *Burlington Magazine* 143 (2001f), pp. 642–3.

Loughman, John. "Een stad en haar kunstconsumptie: openbare en privé-verzamelingen in Dordrecht, 1620–1719." In Dordrecht 1992–3, pp. 34–64.

Loughman, John, and John Michael Montias. *Public and Private Spaces; Works of Art in Seventeenth-Century Dutch Houses.* Zwolle, 2000.

Lourens, Piet, and Jan Lucassen. *Inwoneraantallen van Nederlandse steden, ca. 1300–1800.* Amsterdam, 1997.

Lowenthal, Anne Walter. *Joachim Wtewael and Dutch Mannerism.* Doornspijk, 1986.

Luijten, Ger. "Frills and Furbelows: Satires on Fashion and Pride Around 1600." *Simiolus* 24 (1996): 140–60.

——. "The *Iconography*: Van Dyck's Portraits in Print." In Amsterdam 1999–2000a, pp. 73–91.

Luijten, Hans. *Jacob Cats; Sinne- en minnebeelden.* 3 vols. The Hague, 1996.

Lukacs, John. "The Bourgeois Interior." *American Scholar* 39 (1970): 616–30.

Lunsingh Scheurleer, Theodoor H. "Enkele oude Nederlandse kraamgebruiken." *Antiek* 6 (1971–2): 297–332.

Lunsingh Scheurleer, Theodoor H., and G. H. M. Posthumus Meyjes, eds. *Leiden University in the Seventeenth-Century: An Exchange of Learning.* Leiden, 1975.

Maar, F. E. R. de. *Vijf eeuwen tandheelkunde in de Nederlandse en Vlaamse kunst.* Nieuwegein, 1993.

Mandel, Oscar. *The Cheerfulness of Dutch Art: A Rescue Operation.* Doornspijk, 1996.

Marchi, Neil de. "The Role of Dutch Auctions and Lotteries in Shaping Art Market(s) of 17th Century Holland." *Journal of Economic Behavior and Organization* 28 (1995): 203–21.

Marchi, Neil de, and Hans J. van Miegroet. "Art, Value, and Market Practices in the Netherlands in the Seventeenth Century." *Art Bulletin* 76 (1994): 451–64.

——. "Pricing Invention: 'Originals,' 'Copies,' and Their Relative Value in Seventeenth Century Netherlandish Art Markets." In *Economics of the Arts – Selected Essays*, edited by V. A. Ginsburgh and P.-M. Menger, pp. 27–70. Amsterdam, 1996.

——. "Novelty and Fashion Circuits in the Mid-Seventeenth-Century Antwerp–Paris Art

Trade." *Journal of Medieval and Early Modern Studies* 28 (1998): 201–46.

Marland, Hilary, and Margaret Pelling, eds. *The Task of Healing; Medicine, Religion and Gender in England and the Netherlands, 1450–1800.* Rotterdam, 1996.

Martin, Willem. *Gerard Dou.* Translated by Clara Bell. London, 1902.

Martin, Willem. "The Life of the Dutch Artist in the Seventeenth Century." *Burlington Magazine* 7 (May 1905): 125–8; 7 (September 1905): 416–27; 7 (October 1905): 13–24.

McGee, Julie L. *Cornelis Corneliszoon van Haarlem (1562–1638); Patrons, Friends and Dutch Humanists.* Nieuwkoop, 1991.

Meertens P. J., and Jan H. de Groot. *De lof van den boer; de boer in de Noord- en Zuidnederlandsche letterkunde van de middeleeuwen tot heden.* Amsterdam, 1942.

Meierink, Ben Olde, and Angelique Bakker. "The Utrecht Elite as Patrons and Collectors." In San Francisco 1997, pp. 72–85.

Meijer Drees, Marijke. *Andere landen, andere mensen; de beeldvorming van Holland versus Spanje en Engeland omstreeks 1650.* The Hague, 1997.

——. "Zeventiende-eeuwse literatuur in de Republiek: burgerlijk?" In Hendrix and Drees 2001, pp. 63–80.

Miedema, Hessel. "Realism and Comic Mode: The Peasant." *Simiolus* 9 (1977): 205–19.

——. *De archief-bescheiden van het St. Lukasgilde te Haarlem: 1497–1798.* 2 vols. Alphen aan den Rijn, 1980.

——. "Feestende boeren – lachende dorpers." *Bulletin van het Rijksmuseum* 29 (1981): 191–213.

——. *Fraey en aerdigh, schoon en moy in Karel van Manders Schilder-boeck.* Amsterdam, 1984.

——. "Kunstschilders, gilde en academie; over het probleem van de emancipatie van de kunstschilders in de Noordelijke Nederlanden van de 16de en 17de eeuw." *Oud Holland* 101 (1987): 1–34.

——. "Philips Angels *Lof der schilderkunst.*" *Oud Holland* 103 (1989): 181–222.

Mijnhardt, Wijnand W. "Politics and Pornography in the Seventeenth- and Eighteenth-Century Dutch Republic." In *The Invention of Pornography; Obscenity and the Origins of Modernity, 1500–1800*, edited by Lynn Hunt, pp. 283–300. New York, 1993.

Minois, Georges. *History of Old Age: From Antiquity to the Renaissance.* Translated by S. H. Tenison. Chicago and London, 1989.

Moiso-Diekamp, Cornelia. *Das Pendant in der holländischen Malerei des 17. Jahrhunderts.* Frankfurt am Main, 1987.

Moltke, J. W. von. *Arent de Gelder; Dordrecht 1645–1727.* Doornspijk, 1994.

Montias, John Michael. *Artists and Artisans in Delft: A Socio-Economic Study of the Seventeenth Century.* Princeton, 1982.

——. "Cost and Value in Seventeenth-Century Dutch Art," *Art History* 10 (1987a): 455–66.

——. "Vermeer's Clients and Patrons." *Art Bulletin* 69 (1987b): 68–76.

——. "Art Dealers in the Seventeenth-Century Netherlands." *Simiolus* 18 (1988): 244–56.

——. *Vermeer and His Milieu: A Web of Social History.* Princeton, 1989.

——. "Estimates of the Number of Dutch Master-Painters, Their Earnings and Their Output in 1650." *Leidschrift* 6 no. 3 (1990a): 59–74.

——. "Socio-Economic Aspects of Netherlandish Art from the Fifteenth to the Seventeenth Century: A Survey." *Art Bulletin* 72 (1990b): 358–73.

——. "The Influence of Economic Factors on Style." *De Zeventiende Eeuw* 6 (1990c): 49–57.

——. "A Postscript on Vermeer and His Milieu." *Mercury* 12 (1991a): 42–52.

——(1991b). "Works of Art in Seventeenth-Century Amsterdam: An Analysis of Subjects and Attributions." In Freedberg and de Vries 1991, pp. 331–72.

—— (1994). "The Sovereign Consumer: The Adaptation of Works of Art to Demand in The Netherlands in the Early Modern Period." In Bevers 1994, pp. 57–76.

—— (1998). "Recent Archival Research on Vermeer." In Gaskell and Jonker 1998, pp. 93–109.

—— (1999). "Auction Sales of Works of Art in Amsterdam (1597–1638)." In Falkenburg *et al.* 1999, pp. 145–93.

——. *Art at Auction in 17th Century Amsterdam.* Amsterdam, 2002.

Moreno, Ignacio L. "Vermeer's *The Concert*: A Study in Harmony and Contrasts." *Rutgers Art Review* 3 (1982): 51–7.

Moriarty, Michael. *Taste and Ideology in Seventeenth-Century France.* Cambridge and New York, 1988.

Morris, Desmond *et al. Gestures: Their Origins and Distributions.* London, 1979.

Mortier, Bianca M. "De handschoen in de huwelijkssymboliek van de zeventiende eeuw." *Bulletin van het Rijksmuseum* 32 (1984): 189–201.

Moxey, Keith. "Pieter Bruegel and Popular Culture." In Tokyo 1989, pp. 42–52.

——. *Peasants, Warriors, and Wives: Popular Imagery in the Reformation.* Chicago and London, 1990.

Muchembled, Robert. *De uitvinding van de moderne mens: collectief gedrag, zeden, gewoonten en gevoelswereld van de middeleeuwen tot de Franse revolutie.* Translated by Rosalie Siblesz and Tess Visser. Amsterdam, 1990.

Muller, Jeffrey M. "The Quality of Grace in the Art of Anthony Van Dyck." In Washington D.C. 1990–91, pp. 27–36.

Muller, Sheila D. *Charity in the Dutch Republic: Pictures of Rich and Poor for Charitable Institutions*. Ann Arbor, 1985.

Müller Hofstede, Justus (1988). "Artificial Light in Honthorst and ter Brugghen: Form and Iconography." In Klessman 1988, pp. 13–43.

——. "Vita Mortalium Vigilia: Die Nachtwache der Eremiten und Gelehrten." In Frankfurt, 1993, pp. 34–46.

Munt, Annette. "The Impact of the *Rampjaar* on Dutch Golden Age Culture." *Dutch Crossing* 21 (1997): 3–51.

Muylle, J. " 'Pier den Drol – Karel van Mander en Pieter Bruegel. Bijdrage tot de literaire receptie van Pieter Bruegels werk ca. 1600." In Vekeman and Müller-Hofstede 1984, pp. 137–44.

——. "*Genus gryllorum. Gryllorum pictores*. Legitimatie, evaluatie en interpretatie van genreiconografie en van de biografieën van genreschilders in de Nederlandse kunstliteratuur (ca. 1550–ca. 1750)." Ph.D. dissertation, Catholic University of Louvain, 1986.

Naerebout, Frederick Gerald. "Another Battle Fought and Lost: Seventeenth Century Dutch Predikanten and the Dance." *Working Papers in Dance Studies* 2 (1989): 20–44.

——. " 'Snoode exercitien'; het zeventiende-eeuwse Nederlandse protestisme en de dans." *Volkskundig Bulletin* 16 (1990): 125–55.

Németh, István. "Het spreekwoord 'Zo d'ouden zongen, zo pijpen de jongen' in schilderijen van Jacob Jordaens en Jan Steen: motieven en associaties." *Jaarboek van het Koninklijk Museum voor Schone Kunsten Antwerpen* (1990): 271–86.

Neuman, Els. " 'Aller steden pronkjuweel': Den Haag in de 17de eeuw." In The Hague 1998–9, pp. 13–24.

Nevitt, H. Rodney (2001). "Vermeer on the Question of Love." In Franits 2001c, pp. 89–110.

——. *Art and the Culture of Love in Seventeenth-Century Holland*. Cambridge and New York, 2003.

Nicolson, Benedict. *Hendrick Terbrugghen*. The Hague, 1958.

Nierop, H. F. K. van. "How to Honour One's City: Samuel Ampzing's Vision of the History of Haarlem." *Theoretische Geschiedenis* 20 (1993a): 268–82.

——. *The Nobility of Holland: From Knights to Regents, 1500–1650* [1984]. Translated by Maarten Ultee. Cambridge and New York, 1993b.

Noordam, Dirk Jaap. *Geringde buffels en heren van stand: het patriciaat van Leiden, 1574–1700*. Hilversum, 1994.

Nordenfalk, Carl. "The Five Senses in Flemish Art before 1600." In *Netherlandish Mannerism. Papers Given at a Symposium in Nationalmuseum Stockholm, September 21–22, 1984*, edited by Görel Cavalli-Björkman, pp. 135–54.

North, Michael. *Art and Commerce in the Dutch Golden Age*. Translated by Catherine Hill. New Haven and London, 1997.

Nusteling, Hubert. "The Population of Amsterdam and the Golden Age." In van Kessel and Schulte 1997, pp. 71–84.

—— (1998). "De bevolking: van raadsels naar oplossingen." In Frijhoff *et al.* 1998, pp. 72–108.

O'Brien, Patrick (2001a). "Reflections and Mediations on Antwerp, Amsterdam and London in Their Golden Ages." In O'Brien 2001b, pp. 3–35.

O'Brien, Patrick *et al.*, eds. *Urban Achievement in Early Modern Europe; Golden Ages in Antwerp, Amsterdam and London*. Cambridge and New York, 2001b.

Orr, Lynn Federle. "Reverberations: The Impact of the Italian Sojourn on Utrecht Artists." In San Francisco 1997, pp. 100–13.

Ottenheym, Koen. "The Amsterdam Ring of Canals: City Planning and Architecture." In van Kessel and Schulte 1997, pp. 33–49.

Ozment, Steven. *When Fathers Ruled: Family Life in Reformation Europe*. Cambridge, Mass., and London, 1983.

Palmen, Eric (1988). "De politieke elite." In Frijhoff *et al.* 1998, pp. 211–20.

Panofsky, Erwin. "Van Eyck's 'Arnolfini' Portrait." *Burlington Magazine* 64 (1934): 117–27.

——. *Early Netherlandish Painting: Its Origin and Character*. 2 vols. Cambridge, Mass., 1953.

——. *Studies in Iconology. Humanistic Themes in the Art of the Renaissance*. 2nd edn. New York, 1962.

Papi, Gianni. *Gherardo delle notti: Gerrit Honthorst in Italia*. Soncino, 1999.

Parker, Geoffrey. *The Dutch Revolt*. Ithaca, 1977.

Parker William N., and Eric L. Jones, eds. *European Peasants and Their Markets*. Princeton, 1975.

Pauw-de Veen, Lydia de. *De begrippen "schilder", "schilderij", en "schilderen" in de zeventiende eeuw*. Brussels, 1969.

Pauwels, Yves *et al.*, eds. *Théorie des arts et création artistique dans l'Europe du Nord du XVIᵉ au début du XVIIIᵉ siècle*. Lille, 2002.

Peacock, Martha Moffitt. "Geertruydt Roghman and the Female Perspective in 17th-Century Dutch Genre Imagery." *Woman's Art Journal* 14 (1993–4): 3–10.

Peeters, Harry *et al.*, ed. *Vijf eeuwen gezinsleven. Liefde, huwelijk en opvoeding in Nederland*. Nijmegen, 1988.

Pelling, Margaret. "The Body's Extremities: Feet, Gender and the Iconography of Healing in Seventeenth-Century Sources." In Marland and Pelling 1996, pp. 221–51.

Petterson, Einar. "*Amans Amanti Medicus*: Die Ikonologie des Motivs *Die ärztliche Besuch*." In Bock and Gaehtgens 1987, pp. 193–224.

——. *Amans Amanti Medicus; Das Genremotiv "Der ärtzliche Besuch" in seinem kulturhistorischen Kontext*. Berlin, 2000.

Phagan, Patricia, ed. *Images of Women in Seventeenth-Century Dutch Art; Domesticity and the Representation of the Peasant*. Athens, Ga., 1996.

Pijzel-Dommisse, Jet (2001). "1700–1750." In Fock 2001b, pp. 181–259.

Playter, Caroline Bigler. "Willem Duyster and Pieter Codde: The 'Duystere Werelt' of Dutch Genre Painting, c. 1625–1635." Ph.D. dissertation, Harvard University, 1972.

Pleij, Herman. *Het gilde van de Blauwe Schuit; literatuur, volksfeest en burgermoraal in de late middeleeuwen*. 2nd edn. Amsterdam, 1983.

Ploeg, Peter van der, and Carola Vermeeren (1997–8). " 'From the 'Sea Princes' Monies': The Stadholder's Art Collection." In The Hague 1997–8b, pp. 34–60.

Plokker, A. *Adriaen Pietersz. van de Venne (1589–1662): de grisailles met spreukbanden*. Louvain and Amersfoort, 1984.

Plomp, Michiel. "Painting in the City of Delft 1600–1650." In Delft 1996, pp. 13–40.

Pol, Lotte C. van de. "Vrouwencriminaliteit in de Gouden Eeuw." *Ons Amsterdam* 34 (1982): 266–8.

——. *Vrouwencriminaliteit en prostitutie in de tweede helft der 17e eeuw in Amsterdam*. The Hague, 1983.

——. "Van speelhuis naar bordeel? Veranderingen in de organisatie van de prostitutie in Amsterdam in de tweede helft van de 18e eeuw." *Documentatieblad Werkgroep Achttiende Eeuw* 17 (1985): 157–72.

——(1988a). "Beeld en werkelijkheid van de prostitutie in de zeventiende eeuw." In Hekma and Roodenburg 1988, pp. 109–44.

——(1988b). "Seksualiteit tussen middeleeuwen en moderne tijd." In Peeters 1988, pp. 163–93.

——. "Het Amsterdams hoerdom. Prostitutie in de zeventiende en achtiende eeuw." Ph.D. dissertation, Erasmus Universiteit, Rotterdam, 1996.

Porteman, K. "Vondel en de schilderkunst." *Vlaanderen* 172 (1979): 299–305.

——. "Iets over het literaire realisme in de zeventiende eeuw." *Neerlandica Wratislaviensia* 1 (1983): 99–114.

——. "Geschreven met de linkerhand? Letteren tegenover schilderkunst in de Gouden Eeuw." In Spies 1984, pp. 93–113.

Porzio, Francesco. "Aspetti e problemi della scene di genere in Italia." In Brescia 1998, pp. 17–41.

Prak, M. *Gezeten burgers; de elite in een Hollandse stad, Leiden 1700–1800.* The Hague, 1985.

——. "Het oude recht der burgeren: de betekenis van burgerschap in het Amsterdam van de zestiende en zeventiende eeuw." In Hendrix and Drees 2001, pp. 23–42.

Principe, Lawrence M., and Lloyd de Witt. *Transmutations: Alchemy in Art. Selected Works from the Eddleman and Fisher Collections at the Chemical Heritage Foundation.* Philadelphia, 2002.

Puglisi, Catherine R. *Caravaggio.* London, 1998.

Raupp, Hans-Joachim. "Musik im Atelier; Darstellungen musizierender Künstler in der niederländischen Malerei des 17. Jahrhunderts." *Oud Holland* 92 (1978): 106–29.

——. "Ansätze zu einer Theorie der Genremalerei in den Niederlanden im 17. Jahrhundert." *Zeitschrift für Kunstgeschichte* 46 (1983): 401–18.

——. *Untersuchungen zu Künstlerbildnis und Künstlerdarstellung in den Niederlanden im 17. Jahrhundert.* Hildesheim and New York, 1984.

——. *Bauernsatiren. Entstehung und Entwicklung des bäuerlichen Genres in der deutschen und niederländischen Kunst ca. 1470–1570.* Niederzier, 1986.

——. "Adriaen Brouwer als Satiriker." In Bock and Gaehtgens 1987, pp. 225–51.

Ree-Scholtens, G. F. van der *et al.*, eds. *Deugd boven geweld; een geschiedenis van Haarlem, 1245–1995.* Hilversum, 1995.

Regin, Deric. *Traders, Artists, Burghers: A Cultural History of Amsterdam in the 17th Century.* Assen, 1976.

Rehorst, Chris. "Confrerie Pictura und Haagsche Teekenacademie. Zur Geschichte der Akademie in Den Haag." In Berlin 1995–6, pp. 24–7.

Reinink, Wessel, and Jeroen Stumpel, eds. *Memory & Oblivion; Proceedings of the XXIXth International Congress of the History of Art Held in Amsterdam, 1–7 September 1996.* Dordrecht, 1999.

Reinold, Lucinda Kate. "The Representation of the Beggar as Rogue in Dutch Seventeenth-Century Art." Ph.D. dissertation, University of California, Berkeley, 1981.

Renger, Konrad. *Lockere Gesellschaft. Zur Ikonographie des Verloren Sohnes und von Wirtshausszenen in der niederländischen Malerei.* Berlin, 1970.

——. "Adriaen Brouwer. Seine Auseinandersetzung mit der Tradition des 16. Jahrhunderts." In Bock and Gaehtgens 1987, pp. 253–82.

—— (1997). "On the History of Research Concerning the Interpretation of Dutch Painting." In Franits 1997b, pp. 9–14.

Reznicek, E. K. J. "Bruegels Bedeutung für das 17. Jahrhundert." In Simson and Winner 1979, pp. 159–64.

Rico, Francisco. *The Spanish Picaresque Novel and the Point of View.* Translated by C. Davis. Cambridge, 1984.

Roberts, Benjamin. *Through the Keyhole: Dutch Child-Rearing Practices in the 17th and 18th Century: Three Urban Elite Families.* Hilversum, 1998.

Robinson, Franklin. W. *Gabriel Metsu (1629–1667): A Study of His Place in Dutch Genre Painting of the Golden Age.* New York, 1974.

Robinson, William W. "The *Eavesdroppers* and Related Paintings by Nicolaes Maes." In Bock and Gaehtgens 1987, pp. 283–313.

——. "The Early Works of Nicolaes Maes, 1653–1661." Ph.D. dissertation, Harvard University, 1996.

Roelofsz, Annelien. "Schilders in zeventiende-eeuws Rotterdam." In Rotterdam 1994–5, pp. 15–30.

Roethlisberger, Marcel. *Abraham Bloemaert and His Sons: Paintings and Prints.* 2 vols. Doornspijk, 1993.

Romein, Ed. "Knollen en citroenen op de Leidse kunstmarkt: over de rol van kwaliteit in de opkomst van de Leidse fijnschilderstijl." *De Zeventiende Eeuw* 17 (2001): 75–94.

Roodenburg, Herman. "The Autobiography of Isabella de Moerloose: Sex, Childrearing and Popular Belief in Seventeenth Century Holland." *Journal of Social History* 18 (1985): 517–40.

——. "*Venus Minsieke Gasthuis*: Sexual Beliefs in Eighteenth-Century Holland." In Bremmer 1989, pp. 84–107.

——. "Onder censuur; de kerkelijke tucht in de gereformeerde gemeente van Amsterdam, 1578–1700." Proefschrift, Vrije Universiteit te Amsterdam, 1990.

——. "Over korsetten, lichaamshouding en gebaren. Een cultuurhistorische verkenning van de 'nieuwe fatsoenen' tussen ruwweg 1580 en 1630." *Textielhistorische Bijdragen* 31 (1991a): 20–39.

——. "The 'Hand of Friendship': Shaking Hands and Other Gestures in the Dutch Republic." In *A Cultural History of Gestures from Antiquity till the Present Day*, edited by Jan Bremmer and Herman Roodenburg, pp. 152–89. Cambridge, 1991b.

——. "Over scheefhalzen en zwellende heupen: enige argumenten voor een historische antropologie van de zeventiende-eeuwse schilderkunst." *De Zeventiende Eeuw* 9 (1993): 152–68.

—— (1997a). "How to Sit, Stand, and Walk: Toward a Historical Anthropology of Dutch Paintings and Prints." In Franits 1997b, pp. 175–85.

—— (1997b). "To Converse Agreeably: Civility and the Telling of Jokes in Seventeenth-

Century Holland," In Bremmer and Roodenburg 1997, pp. 112–33.

——. "On 'Swelling' the Hips and Crossing the Legs: Distinguishing Public and Private in Paintings and Prints from the Dutch Golden Age." In Wheelock and Seeff 2000, pp. 64–84.

Roorda, D. J. "The Ruling Classes in Holland in the Seventeenth Century." In Bromley and Kossman 1964, pp. 109–32.

——. *Partie en factie: de oproeren van 1672 in de steden van Holland en Zeeland* [1961]. Revised edn. Groningen, 1978.

Roose, Lode. '*En is 't de liefde niet,' Het Nederlandse sonnet in de zestiende en zeventiende eeuw.* Leiden, 1971.

Roscam Abbing, Michiel. *De schilder & schrijver Samuel van Hoogstraten 1627–1678: eigentijdse bronnen & oeuvre van gesigneerde schilderijen.* Leiden, 1993.

Rowen, Herbert H. *John de Witt, Grand Pensionary of Holland, 1625–1672.* Princeton, 1978.

——. *The Princes of Orange: The Stadholders in the Dutch Republic.* Cambridge and New York, 1988.

Roy, Alain. *Gérard de Lairesse (1640–1711).* Paris, 1992.

Royalton Kisch, Martin. "The King's Crown: A Popular Print for Epiphany." *Print Quarterly* 1 (1984): 43–6 and 51.

——. *Adriaen van de Venne's Album in the Department of Prints and Drawings in the British Museum.* London, 1988.

——. "Venne, Adriaen (Pietersz.) van de." In Turner 2000, pp. 360–63.

Rzepínska, Maria. "Tenebrism in Baroque Painting and Its Ideological Background." *Artibus et Historiae* 13 (1986): 91–112.

Salman, Jeroen. *Populair drukwerk in de Gouden Eeuw: de almanak als lectuur en handelswaar.* Zutphen, 1999.

Salomon, Nanette. "Dreamers, Idlers and Other Dozers: Aspects of Sleep in Dutch Art." Ph.D. dissertation, Institute of Fine Arts, New York University, 1984.

——. "Jan Steen's Formulation of the Dissolute Household, Sources and Meanings." In Bock and Gaehtgens 1987, pp. 315–43.

——. "Domesticating the Peasant Father: The Confluent Ideologies of Gender, Class, and Age in the Prints of Adriaen van Ostade." In Phagan 1996, pp. 41–69.

—— (1998a). "From Sexuality to Civility: Vermeer's Women." In Gaskell and Jonker 1998, pp. 309–25.

——. *Jacob Duck and the Gentrification of Dutch Genre Painting.* Doornspijk, 1998b.

——. "Early Netherlandish *bordeeltjes* and the Construction of Social 'Realities.'" In Wheelock and Seeff 2000, pp. 141–63.

Sarnowiec, Malgorzata. "De zeven zonden van het dienstmeisje: een moralistische en liberti-

jnse verse beschreven en verbeeld." In Bostoen 2001, pp. 199–224.

Sas, N. C. F. van. "Dutch Nationality in the Shadow of the Golden Age: National Culture and the Nation's Past, 1780–1914." In Grijzenhout and van Veen 1999, pp. 49–68.

Schama, Simon. "The Unruly Realm: Appetite and Restraint in Seventeenth Century Holland." *Daedalus* 108 (Summer 1979): 103–23.

——. "Wives and Wantons: Versions of Womanhood in 17th-Century Dutch Art." *Oxford Art Journal* 3 (1980): 5–13.

——. *The Embarrassment of Riches: An Interpretation of Dutch Culture in the Golden Age.* New York, 1987.

Schavemaker, Eddy. "Eglon Hendrik van der Neer." Doctoraal scriptie, Universiteit van Utrecht, N. d.

Schmidt, Kees. "Hollands buitenleven in de zeventiende eeuw. I. De opkomst van de buitenplaatsen." *Amsterdams Sociologisch Tijdschrift* 4 (1977–8): 434–49.

——. "Hollands buitenleven in de zeventiende eeuw. II. De wassende stroom hofdichten." *Amsterdams Sociologisch Tijdschrift* 5 (1978–9): 91–109.

Schmidt, P. P. *Zeventiende-eeuwse kluchtboeken uit de Nederlanden.* Utrecht, 1986.

Schmitt, Stefan. *Diogenes. Studien zu seiner Ikonographie in der niederländischen Emblematik und Malerei des 16. und 17. Jahrhunderts.* Hildesheim and New York, 1993.

Schmitt-von Mühlenfels, Franz. *Pyramus und Thisbe. Rezeptionstypen eines Ovidischen Stoffes in Literatur, Kunst und Musik.* Heidelberg, 1972.

Schnackenburg, Bernhard. "Die Anfänge des Bauernninterieurs bei Adriaen van Ostade." *Oud Holland* 85 (1970): pp. 158–69.

——. *Adriaen van Ostade; Isack van Ostade; Zeichnungen und Aquarelle.* 2 vols. Hamburg, 1981.

——. "Das Bild des bäuerlichen Lebens bei Adriaen van Ostade." In Vekeman and Müller-Hofstede 1984, pp. 30–42.

Schneede, Uwe. "Gabriel Metsu und der holländische Realismus." *Oud Holland* 83 (1968): 44–61.

Schneeman, Liane T. "Hendrick Martensz. Sorgh: A Painter of Rotterdam." Ph.D. dissertation, Pennslyvania State University, 1982.

——. "Hendrik Martensz. Sorgh as Painter of Market Scenes." In Fleischer and Munshower 1988, pp. 169–87.

Schneider, Arthur von. *Caravaggio und die Niederländer.* Marburg, 1933.

Schochet, Gordon J. *Patriarchalism in Political Thought.* New York 1975.

Schölzel, Christoph. "The Technique of the Leiden *Fijnschilders.*" In Leiden 2001, pp. 16–24.

Scholten, Frits. "'. . . dat menighen onbedachten Actaeon van zijn eyghen lusten wort ghevangen . . .'." *Akt* 26 (1985): 26–32.

——. "Review of Roland E. Fleischer, *Ludolf de Jongh.*" *Oud Holland* 106 (1992): 49–54.

——. "Ludolf de Jongh en de aristocratisering van het genre." In Rotterdam 1994–5, pp. 143–52.

Scholz, Bernhard F. "De rol van 'ervaring' in het werk van de zeventiende-eeuwse bergmeester en alchemist Goossen van Vreeswijck (1626–c. 1689). In Egmond 1999, pp. 72–87.

Scholz, Horst. *"Brouwer Invenit." Druckgraphische Reproduktionen des 17.–19. Jahrhunderts nach Gemälden und Zeichnungen Adriaen Brouwers.* Marburg, 1985.

Schotel, Peter. "Strijd om de macht." In Frijhoff 1998, pp. 15–37.

Schutte, G. J. *Het calvinistisch Nederland.* Utrecht, 1988.

Schuur, A. J. "'Wat moet ik voor mijn neus betalen?' Over twee achttiende-eeuwse 'neusboekjes'." *Spektator* 8 (1978–9): 104–18.

Schuurman, Anton, and Pieter Spierenburg (1996a). "Introduction: Between Public and Private." In Schuurman and Spierenburg 1996b, pp. 7–11.

Schuurman, Anton, and Pieter Spierenburg, eds. *Private Domain, Public Inquiry; Families and Life-Styles in The Netherlands and Europe, 1550 to the Present.* Hilversum, 1996.

Schuurman, Anton J., and Lorena S. Walsh, eds. *Material Culture: Consumption, Life-Style, Standard of Living, 1500–1900 (Proceedings Eleventh International Economic Congress).* Milan, 1994.

Schwartz, Heinrich. "Vermeer and the Camera Obscura." *Pantheon* 24 (1966): 170–80.

Scott, Mary Ann. "Cornelis Bega (1631/32–1664) as Painter and Draughtsman." Ph.D. dissertation, University of Maryland, 1984.

Segalen, Martine. "The House Between Private and Public; A Socio-Historic Overview." In Schuurman and Spierenburg 1996b, pp. 240–53.

Seidel, Katrin. *Die Kerze: Motivgeschichte und Ikonologie.* Hildesheim and New York, 1996.

Sellers, Vanessa Bezemer. *Courtly Gardens in Holland 1600–1650: The House of Orange and the Hortus Batavus.* Woodbridge and Amsterdam, 2001.

Sennett, Richard. *The Fall of Public Man.* New York, 1977.

Seymour, Charles. "Dark Chamber and Light-Filled Room: Vermeer and the Camera Obscura." *Art Bulletin* 46 (1964): 323–31.

Silver, Larry. "The Importance of Being Bruegel: The Posthumous Survival of the Art of Pieter Bruegel the Elder." In New York 2001a, pp. 67–84.

Simson, Otto von, and Matthias Winner, eds. *Pieter Bruegel und seine Welt.* Berlin, 1979.

Singeling, B. P. Th. "De Delftse schutterij." In Delft 1981, pp. 140–45.

Slatkes, Leonard J. *Dirck van Baburen (ca. 1595–1624): A Dutch Painter in Utrecht and Rome.* 2nd edn. Utrecht, 1969.

——. *Vermeer and His Contemporaries.* New York, 1981.

——. "Het werk van Hendrick ter Brugghen." In Utrecht 1986–7, pp. 43–51.

——. "Hendrick ter Brugghen's *Gamblers.*" *The Minneapolis Institute of Arts, Bulletin* 67 (1995): 6–11.

——. "Bringing Ter Brugghen and Baburen Up-To-Date." *Bulletin du Musée National de Varsovie* 37 (1996): 199–219.

——(2000a). "Baburen, Dirck (Jaspersz.) van." In Turner 2000, pp. 7–8.

——(2000b). "Brugghen [Terbrugghen], Hendrick (Jansz.) ter." In Turner 2000, pp. 61–7.

——(2000c). "Honthorst, Gerrit [Gérard] (Hermansz.) van [Gherardo delle Notti; Gherardo Fiammingo]." In Turner 2000, pp. 158–65.

——. "'An Ineffable Light and Splendour': Nocturnes, Night Scenes and Artificial Illumination." In London 2001, pp. 306–37.

Slive, Seymour. *Frans Hals.* 3 vols. London and New York, 1970–74.

——. *Dutch Painting 1600–1800.* New Haven and London, 1995.

Sluijter, Eric Jan. "De 'heydensche fabulen' in de Noordnederlandse schilderkunst circa 1590–1670," Proefschrift, Rijksuniversiteit te Leiden, 1986.

——. "'Een stuck waerin een juffr. voor de spiegel van Gerrit Douw,'" *Antiek* 23 (1988a): 150–61.

——(1988b). "'Een volmaekte schildery is als een spiegel van de natuer': spiegel en spiegelbeeld in de Nederlandse schilderkunst van de zeventiende eeuw." In Brederoo 1988, pp. 146–63.

——. "Schilders van 'cleyne, subtile ende curieuse dingen'; Leidse 'fijnschilders' in contemporaine bronnen." In Leiden 1998c, pp. 14–77.

——(1990a). "Een zelfportret en 'de schilder in zijn atelier': het aanzien van Jan van Mieris." In Sluijter *et al.* 1990b, pp. 287–307.

——. "Hoe realistisch is de Noordnederlandse schilderkunst van de zeventiende eeuw? De problemen van een vraagstelling." *Leidschrift* 6 no. 3 (1990b): 5–39.

——. "Rembrandt's Early Paintings of the Female Nude: *Andromeda* and *Susanna.*" In Cavalli-Björkman 1993, pp. 31–54.

——. "Mieris, Willem van." In Turner 1996, vol. 21, pp. 488–9.

——. "Naiveu, Matthijs." In Turner 1996, vol. 22, p. 442.

——. "Didactic and Disguised Meanings? Several Seventeenth-Century Texts on Painting and

the Iconological Approach to Dutch Paintings of This Period" [1988]. In Franits 1997b, pp. 78–87.

——. "Overvloed en onbehagen: interdisciplinariteit en het onderzoek naar zeventiende-eeuwse Nederlandse beeldende kunst." *De Zeventiende Eeuw* 14 (1998a): 231–45.

——(1998b). "The Painter's Pride: The Art of Transience in Self-Portraits from Isaac van Swananburgh to David Bailly." In Enenkel 1998, pp. 173–96.

—— (1998c). "Vermeer, Fame and Female Beauty: The *Art of Painting.*" In Gaskell and Jonker 1998, pp. 265–83.

——(1999a). "New Approaches in Art History and the Changing Image of Seventeenth-Century Dutch Art Between 1960 and 1990." In Grijzenhout and van Veen 1999, pp. 247–76.

—— (1999b). "Over Brabantse vodden, economische concurrentie, artistieke wedijver en de groei van de markt voor schilderijen in de eerste decennia van de zeventiende eeuw." In Falkenburg *et al.* 1999, pp. 113–43.

——(2000a). "In Praise of the Art of Painting: On Paintings by Gerrit Dou and a Treatise by Philips Angel of 1642" [1993]. In Sluijter 2000d, pp. 198–263.

——(2000b). "On *Fijnschilders* and Meaning," [1991]. In Sluijter 2000d, pp. 264–95.

——(2000c). "Venus, Visus and Pictura," [1993]. In Sluijter 2000d, pp. 86–159.

——. *Seductress of Sight: Studies in Dutch Art of the Golden Age*, translated by Katy Kist and Jennifer Kilian. Zwolle, 2000d.

——. "'All Striving to Adorn Their Houses with Costly Peeces': Two Case Studies of Paintings in Wealthy Interiors." In Newark 2001–2, pp. 103–27.

Sluijter, Eric Jan *et al.*, eds. *Nederlandse portretten; bijdragen over de portretkunst in de Nederlanden uit de zestiende, zeventiende en achttiende eeuw* (*Leids Kunsthistorisch Jaarboek* 8). The Hague, 1990b.

Sman, Marie Christine van der. "The Year of Disaster: 1672." In Haks and van der Sman 1996, pp. 136–40.

Smits-Veldt, Mieke B. "Images of Private Life in Some Early-Seventeenth-Century Dutch Ego-Documents." In Wheelock and Seeff 2000, pp. 164–77.

Smith, David R. *Masks of Wedlock: Seventeenth-Century Dutch Marriage Portraiture*. Ann Arbor, 1982.

——. "Irony and Civility: Notes on the Convergence of Genre and Portraiture in Seventeenth-Century Dutch Painting." *Art Bulletin* 69 (1987a): 407–30.

——. "Review of Christopher Brown, *Images of a Golden Past*, and Peter C. Sutton *et al.*,

Masters of Seventeenth-Century Dutch Genre Painting." *Art Bulletin* 69 (1987b): 659–61.

——. "'I Janus': Privacy and the Gentlemanly Ideal in Rembrandt's Portraits of Jan Six." *Art History* 11 (1988): 42–63.

——. "Rhetoric and Prose in Dutch Portraiture." *Dutch Crossing* 41 (1990): 72–109.

——. "Privacy, Realism, and the Novelistic in 17th-Century Dutch Painting." *Acts of the 27th International Congress of the History of Art (1989)*, section 3, pp. 35–52. Strasbourg, 1992.

Snelders, H. A. M. "De bekeerde alchimist." *Spiegel Historiael* 7 (1972): 85–91.

Snoep, D. P. "Een 17de eeuws liedboek met tekeningen van Gerard ter Borch de Oude en Pieter en Roeland van Laer." *Simiolus* 3 (1968–9): 77–134.

——. "Adriaen van der Werff (1659–1722)." In Rotterdam 1973, pp. 5–10.

Snoep-Reitsma, Ella. "De *Waterzuchtige vrouw* van Gerard Dou en de betekenis van de lampetkan." In *Album Amicorum J. G. van Gelder*, edited by J. Bruyn *et al.*, pp. 285–92. The Hague, 1973.

Soltow, Lee, and Jan Luiten van Zanden. *Income and Wealth Inequality in the Netherlands 16th–20th Century*. Amsterdam, 1998.

Sonnema, Roy Brian. "Representations of Music in Seventeenth Century Dutch Painting." Ph.D. dissertation, University of California, Berkeley, 1990.

Spicer, Joneath. "Anthony Van Dyck's *Iconography*: An Overview of Its Preparation." In Barnes and Wheelock 1994, pp. 327–64.

Spierenburg, Pieter. *Elites and Etiquette; Mentality and Social Structure in the Early Modern Northern Netherlands*. Rotterdam, 1981.

Spies, Marijke. "Zoals de ouden zongen, lazen de jongen: over de overgang van zang- naar leescultuur in de eerste helft van de zeventiende eeuw." In van den Berg and Stouten 1987, pp. 89–109.

——. "Ongelijke liefde van de 16e tot de 18e eeuw." In Broekhuijsen and Tjoeng 1994, pp. 11–29.

Spies, Marijke, ed. *Historische letterkunde*. Groningen, 1984.

Stanton, Domna C. *The Aristocrat as Art: A Study of the Honnête Homme and the Dandy in Seventeenth- and Nineteenth-Century French Literature*. New York, 1980.

Stapel, Leonore. "Haarlems welvaart: 'de konst van bier te brouwen' of 'excellente stucken lijnwaets?' De beeldvorming rond het economische leven van Hollands tweede stad (1600–1650)." *De Zeventiende Eeuw* 18 (2002): 167–83.

Stavenuiter, Monique *et al.*, eds. *Lange levens, stille getuigen; oudere vrouwen in het verleden*. Zutphen, 1995.

Steadman, Philip. *Vermeer's Camera: Uncovering the Truth Behind the Masterpieces*. Oxford and New York, 2001.

Stechow, Wolfgang, and Christopher Comer. "The History of the Term *Genre.*" *Allen Memorial Art Museum Bulletin* 33 (1975–6): 89–94.

Stewart, Alison G. *Unequal Lovers: A Study of Unequal Couples in Northern Art*. New York, 1977.

Stipriaan, René van. "Vrouwenzaken als motief en thema: over de bruikbaarheid van zeventiende-eeuws komisch toneel als sociaal document." *De Nieuwe Taalgids* 87 (1994): 385–400.

——. "Hollandse botheid in de Spaanschen Brabander." In *Kort tijt-verdrijf; opstellen over Nederlands toneel (vanaf ca 1550) aangeboden aan Mieke B. Smits-Veldt*, edited by W. Abrahamse *et al.*, pp. 95–101. Amsterdam, 1996a.

——. *Leugens en vermaak; Bocaccio's novellen in de kluchtcultuur van de Nederlandse renaissance*. Amsterdam, 1996b.

——. "De Spaanschen Brabander, een kluchtig spel." *Nederlandse Letterkunde* 2 (1997a): 45–66.

——. "Historische distantie in de Spaanschen Brabander." *Nederlandse Letterkunde* 2 (1997b): 103–27.

Stone-Ferrier, Linda A. *Images of Textiles: The Weave of Seventeenth-Century Dutch Art and Society*. Ann Arbor, 1985.

——. "Gabriel Metsu's *Vegetable Market at Amsterdam*: Seventeenth-Century Dutch Market Paintings and Horticulture." *Art Bulletin* 71 (1989): 428–52.

——. "Inclusions and Exclusions: The Selectivity of Adriaen van Ostade's Etchings." In Athens, Ga., 1994, pp. 21–9.

Streng, J. C. *"Stemme in staat"; de bestuurlijke elite in de stadsrepubliek Zwolle 1579–1795*. Hilversum, 1997.

Stridbeck, Carl Gustaf. *Bruegelstudien. Untersuchungen zu den ikonologischen Problemen bei Pieter Bruegel d. Ä. sowie dessen Beziehungen zum niederländischen Romanismus*. Stockholm, 1956.

Strien, Ton van, and Kees van der Leer. *Hofwijck; het gedicht en de buitenplaats van Constantijn Huygens*. Zutphen, 2002.

Stukenbrock, Christiane. *Frans Hals – fröhliche Kinder, Musikanten und Zecher. Eine Studie zu ausgewählten Motivgruppen und deren Rezeptionsgeschichte*. Frankfurt am Main and New York, 1993.

Sullivan, Margaret. *Bruegel's Peasants: Art and Audience in the Northern Renaissance*. Cambridge and New York, 1994.

Sumowski, Werner. *Gemälde der Rembrandt-Schüler*. 6 vols. Landau, 1983–94.

Sutton, Peter C. *Pieter de Hooch*. Ithaca, 1980.

——. "Jan Steen: Comedy and Admonition." *Philadelphia Museum of Art Bulletin* 78 (1982–83): 1–43.

——. "Masters of Dutch Genre Painting." In Philadelphia 1984, pp. xiii–lxvi.

——. "Images of the Interior of the Royal Palace." In Amsterdam 1997b, pp. 18–29.

——. *Gerard ter Borch (Zwolle 1619–1681 Deventer): Woman Sealing a Letter*. New York, N. d.

Sutton, Peter C., and Theodore E. Stebbins, Jr. *Masterpiece Paintings from the Museum of Fine Arts, Boston*. Boston, 1986.

Swillens, P. T. A. *Johannes Vermeer: Painter of Delft 1632–1675*. Translated by C. M. Bruning-Williamson. Utrecht and Brussels, 1950.

Taylor, Paul. "The Concept of *Houding* in Dutch Art Theory." *Journal of the Warburg and Courtauld Institutes* 55 (1992): 210–32.

Temminck, J. J. "Haarlem: Its Social/Political History." In New Brunswick 1983, pp. 17–27.

——(1984a). "De Hout: geschiedenis van het wandelbos van Haarlem." In Temminck 1984b, pp. 9–19.

Temminck, J. J., ed. *Haarlemmerhout 400 jaar: "Mooier is de wereld nergens"*. Haarlem, 1984.

Thiel, Pieter J. J. van. "Review of A. Plokker, *Adriaen Pietersz. van de Venne (1589–1662): de grisailles met spreukbanden*." *Oud Holland* 100 (1986): 66–71.

——. *Cornelis Cornelisz van Haarlem 1562–1638: A Monograph and Catalogue Raisonné*. Doornspijk, 1999.

Thiel, Pieter J. J. van, and C. J. de Bruyn Kops. *Framing in the Golden Age. Picture and Frame in 17th-Century Holland* (English edition of a 1984 Dutch Exhibition Catalogue). Translated by Andrew P. McCormick. Zwolle, 1995.

Thiels, Charles. "Adriaen van der Werff, schilder van kammerstukken." In Rotterdam 1994–5, pp. 153–64.

Thissen, Peter. *Werk, netwerk en letterwerk van de familie Van Hoogstraten in de zeventiende eeuw; sociaal-economische en sociaal-culturele achtergronden van geletterden in de Republiek*. Amsterdam and Maarssen, 1994.

Tóth-Ubbens, Magdi. *Verloren beelden van miserabele bedelaars: leprozen – armen – geuzen*. Ghent, 1987.

Troost, Wout. *Stadhouder-konig Willem III: een politieke bibliografie*. Hilversum, 2001.

Turner, Jane, ed. *The Grove Dictionary of Art*. London, 1996.

Turner, Jane, ed. *From Rembrandt to Vermeer: Seventeenth-Century Dutch Artists (The Grove Dictionary of Art)*. New York, 2000.

Vaeck, Marc van. "Adriaen van de Venne and His Use of Homonymy as a Device in the Emblematical Process of a Bimedial Genre." *Emblematica* 3 (1988): 101–19.

——. *Adriaen van de Venne's "Tafereel van de belacchende werelt" (Den Haag, 1635)*. 3 vols. Ghent, 1994a.

——. "Vonken van hoogdravende wijsheid; over spreekwoordschilderijen." *Kunstschrift* 94 no. 5 (1994b): 17–23.

——. "Adriaen van de Vennes bedelaarsvoorstellingen in grisaille: geschilderde paradoxale encomia?" *De Zeventiende Eeuw* 17 (2001): 164–73.

Vanbergen, J. F. H. H. *Voorstelling en betekenis. Theorie van de kunsthistorische interpretatie*. Assen, 1986.

Vandenbroeck, Paul. "Verbeeck's Peasant Weddings: A Study of Iconography and Social Function." *Simiolus* 14 (1984): 79–121.

——. "Zur Herkunft und Verwurzelung der 'Grillen.' Vom Volksmythos zum kunst- und literaturtheoretischen Begriff, 15.–17. Jahrhundert." *De Zeventiende Eeuw* 3 (1987): 52–84.

Veen, Jaap van der. "The Delft Art Market in the Age of Vermeer." In Haks and van der Sman 1996, pp. 124–35.

Veen, P. A. F. van. *De soeticheydt des buyten-levens, vergheselschapt met de boucken* [1960]. Utrecht, 1985.

Veenstra, Fokke. *Ethiek en moraal bij P. C. Hooft*. Zwolle, 1968.

Vekeman, Hans, and Justus Müller-Hofstede, eds. *Wort und Bild in der niederländischen Kunst und Literatur des 16. und 17. Jahrhunderts*. Erfstadt, 1984.

Veldhorst, Natascha. *De Haarlemse bloempjes: bloemlezing uit een zeventiende-eeuwse liedboekenreeks*. Haarlem, 1999.

Veldman, Ilja. "Goltzius' zintuigen, seizonen, elementen, planeten en vier tijden van de dag: van allegorie naar genre-voorstelling." In Falkenburg 1991–2, pp. 307–36.

——. *Profit and Pleasure: Print Books by Crispijn de Passe*. Translated by Michael Hoyle. Rotterdam, 2001.

Verbaan, Eddy. "Jan Janszoon Orlers schetst Leiden. Illustraties in de vroege stadsbeschrijvingen." In Bostoen 2001, pp. 133–68.

Verberckmoes, Johan. *Laughter, Jestbooks and Society in the Spanish Netherlands*. New York, 1999.

Vergara, Lisa (1998). "*Antiek* and *Modern* in Vermeer's *Lady Writing a Letter with Her Maid*." In Gaskell and Jonker 1998, pp. 235–55.

—— (2001). "Perspectives on Women in the Art of Vermeer." In Franits 2001c, pp. 54–72.

Vermeeren, Carola. "'Opdat de kunst alhier soude mogen floreren': de kunstmarkt in Den Haag in de 17de eeuw." In The Hague 1998–9, pp. 51–78.

Vermet, Bernard. "Bassen, Bartholomeus (Cornelisz.) van." In Turner 2000, pp. 13–14.

Vetter, Andreas W. "Die 'weite Welt' und der umgrenzte Garten–Szenerien vornehmer Feste und Vergnügen." In Braunschweig 2002, pp. 20–28.

Vigarello, Georges. *Concepts of Cleanliness; Changing Attitudes in France since the Middle Ages*. Translated by J. Birrell. Cambridge and New York, 1988.

Vijlbrief, I. *Van anti-aristocratie tot democratie: een bijdrage tot de politieke en sociale geschiedenis der stad Utrecht*. Amsterdam, 1950.

Vlis, Ingrid van der. *Leven in armoede: Delftse bedeelden in de zeventiende eeuw*. Amsterdam, 2001.

Voskuil, J. J. *Van vlechtwerk tot baksteen: geschiedenis en wanden van het boerenhuis in Nederland*. Arnhem, 1979.

Vries, Jan de. *The Dutch Rural Economy in the Golden Age, 1500–1700*. New Haven and London, 1974.

——. "Peasant Demand Patterns and Economic Development: Friesland 1550–1750." In Parker and Jones 1975, pp. 205–66.

——. *Barges & Capitalism: Passenger Transportation in the Dutch Economy (1632–1839)*. Utrecht, 1981.

——. "Art History." In Freedberg and de Vries 1991, pp. 249–82.

——. "Between Purchasing Power and the World of Goods: Understanding the Household Economy in Early Modern Europe," In Brewer and Porter 1993, pp. 85–132.

——. "Searching for a Role: The Economy of Utrecht in the Golden Age of the Dutch Republic." In San Francisco 1997, pp. 49–59.

——. "Luxury and Calvinism/Luxury and Capitalism: Supply and Demand for Luxury Goods in the Seventeenth-Century Dutch Republic." *Journal of the Walters Art Gallery* 57 (1999): 73–85.

Vries, Jan de, and Ad van der Woude. *The First Modern Economy: Stress, Failure, and Perseverance of the Dutch Economy, 1500–1815*. Cambridge and New York, 1997.

Vries, Lyckle de. "Jan Steen, 'de kluchtschilder'." Proefschrift, University of Groningen, 1977.

——. "Jan Steen zwischen Genre- und Historienmalerei." *Niederdeutsche Beiträge zur Kunstgeschichte* 22 (1983): 113–28.

——. "Hat es je eine Delfter Schule gegeben?" In *Probleme und Methoden der Klassifizierung: Akten des XXV. Internationalen Kongresses für Kunstgeschichte, Wien, 4–10 September 1983*, vol. 3, edited by Elisabeth Liskar, pp. 79–88. Vienna and Cologne, 1985.

——. "Dutch Painting." In Washington D.C. 1989, pp. 259–71.

——. *Diamante gedenkzuilen en leerzame voorbeelden; een bespreking van Johan van Gools Nieuwe Schouburg*. Groningen, 1990.

——. "The Changing Face of Realism." In Freedberg and de Vries 1991, pp. 209–44.

——. "Steen's Artistic Evolution in the Context of Dutch Painting." In Washington D.C. 1996, pp. 69–81.

——. *Gerard de Lairesse: An Artist Between Stage and Studio.* Amsterdam, 1998a.

——. "Surveys: Yellow Pages or *Guide bleu?*" *Simiolus* 26 (1998b): 213–24.

——. "'The Felicitous Age of Painting': Eighteenth-Century Views of Dutch Art in the Golden Age." In Grijzenhout and van Veen 1999, pp. 29–43.

——. "Steen, Jan." In Turner 2000, pp. 337–43.

——. "Gerard de Lairesse: The Theorist as an Art Critic." In Pauwels 2002, pp. 291–8.

Vries, Willemien B. de. *Wandeling en verhandeling: de ontwikkeling van het Nederlandse hofdicht in de zeventiende eeuw (1613–1710).* Hilversum, 1998.

Waals, Jan van der. "In het straatje van Montias; Vermeer in historische context." *Theoretische Geschiedenis* 19 (1992): 176–85.

Wadum, Jørgen. "Vermeer's Use of Perspective." In *Historic Painting Techniques, Materials and Studio Practice. Preprints of a Symposium Held at the University of Leiden, The Netherlands, 26–29 June 1995*, pp. 148–54. Santa Monica, 1995.

——. "Vermeer in Perspective." In Washington D.C. 1995–6, pp. 67–79.

—— (1998). "Contours of Vermeer." In Gaskell and Jonker 1998, pp. 201–23.

——. "Dou Doesn't Paint, Oh No, He Juggles with His Brush; Gerrit Dou, a Rembrandtesque *Fijnschilder.*" *Netherlands Technical Studies in Art* 1 (2002): 62–77.

Wagenberg-Ter Hoeven, Anke A. van. "The Celebration of Twelfth Night in Netherlandish Art. *Simiolus* 22 (1993–4): 65–96.

——. *Het driekoningenfeest; de uitbeelding van een populair thema in de beeldende kunst van de zeventiende eeuw.* Amsterdam, 1997.

Wages, Sara M. "Ideaal en werkelijkheid: feit en fictie bij het afbeelden van tuinarchitectuur op zeventiende-eeuwse Hollandse schilderijen." In 's-Hertogenbosch 1996, pp. 125–68.

Walsh, John. *Jan Steen; The Drawing Lesson.* Los Angeles, 1996.

Wasserfuhr, Maria Elisabeth. *Der Zahnarzt in der niederländischen Malerei des 17. Jahrhunderts.* 2nd ed. Cologne, 1977.

Weber, Gregor J. M. "'t lof van den Pekelharingh': von alltäglichen und absonderlichen Heringsstilleben." *Oud Holland* 101 (1987): 126–40.

——. *Der Lobtopos des "lebenden" Bildes; Jan Vos und sein "Zeege der Schilderkunst" von 1654.* Hildesheim and New York, 1991.

——. "Zusammenklang von Tönen, Farben und Herzen: Thema und Variationen niederländischer Musikikonographie." *Barock: Regional-International. Kunsthistorisches Jahrbuch Graz* 25 (1993): 137–52.

——. "'Om te bevestige[n], aen-te-raden, ver-

breeden ende vercieren.' Rhetorische Exempellehre und die Struktur des 'Bildes im Bild.'" *Wallraf-Richartz-Jahrbuch* 55 (1994): 287–314.

——. "Vermeer's Use of the Picture-within-a-Picture: A New Approach." In Gaskell and Jonker 1998, pp. 295–307.

Wee, Herman van der. "Urban Culture as a Factor of Demand in the Economic History of Late Medieval and Early Modern Europe." In *Cities and the Transmission of Cultural Values in the Late Middle Ages and Early Modern Period (Records of the 17th International Colloquium Spa, 16–19.V.1994)*, pp. 7–16. Brussels, 1996.

Weller, Dennis. "Jan Miense Molenaer (c. 1609/10–1668); The Life and Art of a Seventeenth-Century Dutch Painter." Ph.D. dissertation, University of Maryland, 1992.

——. "Jan Miense Molenaer: Painter of the Dutch Golden Age." In Raleigh 2002, pp. 9–25.

Welu, James A. "Vermeer: His Cartographic Sources." *Art Bulletin* 57 (1975): 529–47.

Wesseling, A. "Het beschavingsideaal van Erasmus." In den Boer 2001, pp. 107–29.

Westermann, Mariët. "Steen's Comic Fictions." In Washington D.C. 1996, pp. 53–67.

—— (1997a). "How was Jan Steen Funny? Strategies and Functions of Comic Painting in the Seventeenth Century." In Bremmer and Roodenburg 1997, pp. 134–78.

——. *The Amusements of Jan Steen.* Zwolle, 1997b.

——. "Adriaen van de Venne, Jan Steen, and the Art of Serious Play." *De Zeventiende Eeuw* 15 (1999a): 34–47.

——(1999b). "Farcical Jan, Pier the Droll: Steen and the Memory of Bruegel." In Reinink and Stumpel 1999, pp. 827–36.

—— (1999c). "*Fray en Leelijck*: Adriaen van de Venne's Invention of the Ironic Grisaille." In Falkenburg *et al.* 1999, pp. 221–57.

——. "'Costly and Curious, Full of Pleasure and Home Contentment'; Making a Home in the Dutch Republic." In Newark 2001–2, pp. 15–81.

——. "After Iconography and Iconoclasm: Current Research in Netherlandish Art, 1566–1700." *Art Bulletin* 84 (2002a): 351–72.

——. "Jan Miense Molenaer in the Comic Mode." In Raleigh 2002, pp. 43–61.

Westermann, Mariët *et al.*, eds. *Wooncultuur in de Nederlanden 1500–1800 (Nederlands Kunsthistorisch Jaarboek 51).* Zwolle, 2001.

Wetering, Ernst van der. "Rembrandt's Method – Technique in the Service of Illusion." In London 1992, pp. 12–39.

——. "Het satijn van Gerard ter Borch." *Kunstschrift* 37 no. 6 (1993): 29–35.

Weyl, Martin. *Passion for Reason and Reason of Passion: Seventeenth-Century Art and Theory in France, 1648–1683.* New York and Frankfurt am Main, 1989.

Wheelock, Arthur K., Jr. "Review of Franklin W. Robinson, *Gabriel Metsu (1629–1667); A Study of His Place in Dutch Genre Painting of the Golden Age.*" *Art Bulletin* 58 (1976): 456–9.

——. *Jan Vermeer.* New York, 1981.

——. "Constantijn Huygens and Early Attitudes Towards the Camera Obscura." *History of Photography* 1 (1977a): 93–103.

——. *Perspective, Optics, and Delft Artists Around 1650.* New York, 1977b.

——. *Vermeer & the Art of Painting.* New Haven and London, 1995.

——. "Dou's Reputation." In Washington D.C. 2000, pp. 12–24.

—— (2001). "Vermeer's Craft and Artistry." In Franits 2001c, pp. 41–53.

Wheelock, Arthur K., Jr, and Marguerite Glass (2001). "The Appreciation of Vermeer in Twentieth-Century America." In Franits 2001c, pp. 161–81

Wheelock, Arthur K., Jr, and Adele Seeff, eds. *The Public and Private in Dutch Culture of the Golden Age.* Newark, Del. and London, 2000.

White, Christopher. *The Dutch Pictures in the Collection of Her Majesty the Queen.* Cambridge and New York, 1982.

Wiel, Kees van der. "Delft in the Golden Age." In Haks and van der Sman 1996, pp. 52–67.

Wieseman, Marjorie Elizabeth. "Eglon (Hendrick) van der Neer." In Turner 2000, pp. 232–3.

——. *Caspar Netscher and Late Seventeenth Century Dutch Painting.* Doornspijk, 2002.

Wijngaarden, Hilde van. *Zorg voor de kost: armenzorg, arbeid en onderlinge hulp in Zwolle, 1650–1700.* Amsterdam, 2000.

Wijsenbeek-Olthuis, Thera. "Delft in 18e eeuw, een stad in verval." In Delft 1982–3, pp. 56–64.

——. *Achter de gevels van Delft: bezit en bestaan van rijk en arm in een periode van achteruitgang (1700–1800).* Hilversum, 1987.

——. "Vreemd en eigen: ontwikkelingen in de woon- en leefcultuur binnen de Hollandse steden van de zestiende tot de negentiende eeuw." In Boekhorst 1992, pp. 79–107.

——. "A Matter of Taste. Lifestyle in Holland in the Seventeenth and Eighteenth century." In Schuurman and Walsh 1994, pp. 43–54.

——. "Het Hollandse interieur in beeld en geschrift." *Theoretische Geschiedenis* 23 (1996a): 145–61.

—— (1996b). "Noblesse Oblige; Material Culture of the Nobility in Holland." In Schuurman and Spierenburg 1996b, pp. 112–24.

Wijsenbeek-Olthuis, Thera, and Leo Noordegraaf. "Painting for a Living: The Economic Context of Judith Leyster's Career." In Worcester 1993, pp. 39–54.

Wildt, Annemarie de. "'Wijckt oudt cout vel, al sijt ghij rijcke'. Oude vrouwen en mannen

in taferlen van ongelijke liefde." In Stavenu-
iter 1995, pp. 22–37.

Willems, Gerrit. "Verklaren en ordenen. Over
stijlanalytische benaderingen." In Halbertsma
and Zijlmans 1993, pp. 103–38.

Wind, Barry. "Adriaen Brouwer: Philosopher in
Fool's Cap." *Source* 5 (1985–6): 15–20.

Winkel, Marieke de. "The Interpretation of
Dress in Vermeer's Paintings." In Gaskell and
Jonker 1998, pp. 327–39.

——. "Fashion or Fancy? Some Interpretations
of the Dress of Rembrandt's Women Reeval-
uated." In Edinburgh 2001, pp. 55–63.

Wiskerke, Evert Matthijs. *De waardering voor de
zeventiende-eeuwse literatuur tussen 1780 en 1813.*
Hilversum, 1995.

Wood, Christopher S. "'Curious Pictures' and
the Art of Description," *Word & Image* 11
(1995): 332–52.

Wulp, Bas van der. "A View of Delft in the Age
of Vermeer." In Haks and van der Sman 1996,
pp. 32–51.

Wurf-Bodt, Coby van der. *Van lichte wiven tot
gevallen vrouwen; prostitutie in Utrecht vanaf de
late middeleeuwen tot het eind van de negentiende
eeuw.* Utrecht, 1988.

Ypes, C. *Petrarca in de Nederlandse letterkunde.*
Amsterdam, 1934.

Zandvliet, Kees. *Mapping for Money: Maps, Plans
and Topographic Paintings and Their Role in Dutch
Overseas Expansion during the 16th and 17th
Centuries.* Amsterdam, 1998.

Zijlmans, Jori. *Vriendenkringen in de zeventiende
eeuw: verenigingsvormen van het informele culturele
leven te Rotterdam.* The Hague, 1999.

CATALOGUES OF INSTITUTIONAL
PERMANENT COLLECTIONS

Bourdeaux. *L'or & l'ombre: la peinture hollandaise
du XVIIᵉ en XVIIIᵉ siècles au Musée des Beaux-
Arts de Bourdeaux* (Catalogue by Olivier Le
Bihan). Musée des Beaux-Arts, 1990.

Capetown. *Michaelis Collection. The Old Town
House Cape Town. Catalogue of the Collection of
Paintings and Drawings* (Catalogue by Hans
Fransen). Michaelis Collection, 1997.

Dublin. *Dutch Seventeenth and Eighteenth Century
Paintings in The National Gallery of Ireland: A
Complete Catalogue* (Catalogue by Homan
Potterman). The National Gallery of Ireland,
1986.

Göttingen. *Kunstsammlung der Universität Göt-
tingen; Die niederländischen Gemälde* (Catalogue
by Gerd Unverfehrt). Kunstsammlung der
Universität Göttingen, 1987.

Hamburg. *Die niederländischen Gemälde 1500–1800*
(Catalogue by Thomas Ketelsen *et al.*).
Hamburger Kunsthalle, 2001.

Kassel. *Gemäldegalerie Alte Meister Kassel.
Gesamtkatalog* (Catalogue by Bernhard
Schnackenburg). 2 vols. Mainz, 1996.

London. *Catalogue of Paintings in the Wellington
Museum* (catalogue by C. M. Kauffmann).
Victoria and Albert Museum, 1982.

London. *National Gallery Catalogues: The Dutch
School 1600–1900* (Catalogue by Neil Maclaren
and Christopher Brown). 2 vols. The National
Gallery, 1991.

London. *Dutch & Flemish Seventeenth-Century
Paintings in the Harold Samuel Collection* (Cat-
alogue by Peter C. Sutton). The Corporation
of London, 1992a.

London. *The Wallace Collection; Catalogue of Pic-
tures IV: Dutch and Flemish* (Catalogue by John
Ingamells), The Wallace Collection, 1992b.

Mainz. *Niederländische Gemälde des 16. und 17.
Jahrhunderts* (Catalogue by Christiane Stuken-
brock *et al.*). Landesmuseum, 1997.

Munich. *Alte Pinakothek München; Erläuterungen
zu den ausgestellten Gemälden.* Alte Pinakothek,
1983.

New York. *The Jack and Belle Linsky Collection in
the Metropolitan Museum of Art.* The Metropol-
itan Museum of Art, 1984.

Philadelphia. *Northern European Paintings in the
Philadephia Museum of Art* (Catalogue by Peter
C. Sutton). Philadelphia Museum of Art, 1990.

Rotterdam. *Nederlandse genreschilderijen uit de
zeventiende eeuw. Eigen collectie Museum Boijmans
van Beuningen* (Catalogue by Friso Lammertse).
Museum Boijmans Van Beuningen, 1998.

Springfield. *16th- and 17th-Century Dutch and
Flemish Paintings in the Springfield Museum of
Fine Arts* (Catalogue by Alice I. Davies).
Museum of Fine Arts, 1993.

Vienna. *Die holländische Gemälde des 17. Jahrhun-
derts in der Gemäldegalerie der Akademie der
bildenden Künste in Wien* (Catalogue by Renate
Trnek). Akademie der bildenden Künste, 1992.

Washington D.C. *Dutch Paintings of the Seventeenth
Century* (Catalogue by Arthur K. Wheelock,
Jr.). National Gallery of Art, 1995.

Worms. *Stiftung Kunsthaus Heylshof; Kritischer
Katalog der Gemäldesammlung* (Catalogue by
Wolfgang Schenkluhn *et al.*). Stiftung
Kunsthaus Heylshof, 1992.

EXHIBITION CATALOGUES

Amsterdam. *Arm in de Gouden Eeuw.* Historisch
Museum, 1965–6.

Amsterdam. *Leidse Universiteit 400; stichting en
eerste bloei 1575–ca. 1650.* Rijksmuseum, 1975.

Amsterdam. *Tot lering en vermaak; betekenissen van
Hollandse genrevoorstellingen uit de zeventiende
eeuw* (Catalogue by Eddy de Jongh *et al.*).
Rijksmuseum, 1976.

Amsterdam. *Rembrandt; The Impact of a Genius.*
Waterman Gallery, 1983.

Amsterdam. *Masters of Middelburg* (Catalogue by
Noortje Bakker *et al.*). Waterman Gallery,
1984.

Amsterdam. *Het kunstbedrijf van de familie Ving-
boons.* Koninklijk Paleis op de Dam, 1989.

Amsterdam, *De Hollandse fijnschilders; van Gerard
Dou tot Adriaen van der Werff* (Catalogue by
Peter Hecht). Rijksmuseum, 1989–90.

Amsterdam. *De wereld binnen handbereik;
Nederlandse kunst- en rariteitenverzamelingen,
1585–1735.* Amsterdams Historisch Museum,
1992.

Amsterdam. *Dawn of the Golden Age; Northern
Netherlandish Art 1580–1620.* Rijksmuseum,
1993–4.

Amsterdam. *Mirror of Everyday Life; Genreprints in
the Netherlands 1550–1700* (Catalogue by Eddy
de Jongh and Ger Luijten). Rijksmuseum,
1997a.

Amsterdam. *The Royal Palace of Amsterdam in
Paintings of the Golden Age.* Royal Palace, 1997b.

Amsterdam. *Anthony Van Dyck as a Printmaker.*
Rijksmuseum, 1999–2000a.

Amsterdam. *Rembrandt's Treasures* (Catalogue
by Ben Broos *et al.*). Rembrandt House
Museum, 1999–2000b.

Amsterdam. *Maurits, Prins van Oranje* (Catalogue
by Kees Zandvliet *et al.*). Rijksmuseum, 2000.

Antwerp. *Beeld van de andere, vertoog over het
zelf; over wilden en narren, boeren en bedelaars*
(Catalogue by Paul Vandenbroeck). Koninklijk
Museum voor Schone Kunsten, 1987.

Antwerp. *Jacob Jordaens (1593–1678).* 2 vols.
(Catalogue by R.-A. d'Hulst *et al.*). Koninklijk
Museum voor Schone Kunsten, 1992.

Antwerp. *David Téniers the Younger: Paintings.
Drawings* (Catalogue by Margret Klinge).
Koninklijk Museum voor Schone Kunsten,
1991.

Antwerp. *Elck zijn waerom; vrouwelijke kunstenaars
in België en Nederland 1500–1800.* Koninklijk
Museum voor Schone Kunsten, 1999–2000.

Antwerp. *Venus, vergeten mythe. Voorstellingen van
een godin van Cranach tot Cézanne* (Catalogue
by Ekkehard Mai *et al.*). Koninklijk Museum
voor Schone Kunsten, 2001.

Apeldoorn. *Kent, en versint, eer datje mint; vrijen
en trouwen 1500–1800.* Historisch Museum
Marialust, 1989.

Athens, Ga. *Adriaen van Ostade: Etchings of
Peasant Life in Holland's Golden Age* (Catalogue
by Leonard J. Slatkes *et al.*). Georgia Museum
of Art, 1994.

Basel. *Im Lichte Hollands. Holländische Malerei des
17. Jahrhunderts aus den Sammlungen des Fürsten
von Liechtenstein und aus Schweizer Besitz*
(Catalogue by Petra ten-Doesschate-Chu and
Paul H. Boerlin). Kunstmuseum, 1987.

Berlin. *Götter und Helden für Berlin; Gemälde und Zeichnungen von Augustin und Matthäus Terwesten.* Schloss Charlottenburg, 1995–6.

Boston. *Prized Possessions: European Paintings from Private Collections of Friends of the Museum of Fine Arts, Boston* (Catalogue by Peter C. Sutton et al.). Museum of Fine Arts, 1992.

Boston. *The Age of Rubens* (Catalogue by Peter C. Sutton et al.). Museum of Fine Arts, 1993–4.

Braunschweig. *Die Sprache der Bilder.* Herzog Anton Ulrich-Museum, 1978.

Braunschweig. *Niederländische Malerei aus der Kunstsammlung der Universität Göttingen* (Catalogue by Rüdiger Klessmann et al.). Herzog Anton Ulrich-Museum, 1983.

Braunschweig. *Europäische Malerei des Barock aus dem Nationalmuseum Warschau.* Herzog Anton Ulrich-Museum, 1988–9.

Braunschweig. *Bilder vom alten Menschen in der niederländischen und deutschen Kunst 1550–1750* (Catalogue by Thomas Döring et al.). Herzog Anton Ulrich-Museum, 1993–4.

Braunschweig. *Kein Tag wie jeder andere; Fest und Vergnügen in der niederländischen Kunst* (Catalogue by Andreas W. Vetter and Silke Gatenbröcker). Herzog Anton Ulrich-Museum, 2002.

Brescia. *Da Caravaggio a Ceruti: la scena di genere e l'immagine dei pittochi nella pittura italiana.* Museo di Santa Giulia, 1998.

Copenhagen. *Illusions: Gijsbrechts, Royal Master of Deception.* Statens Museum for Konst, 1999.

Cremona. *Dopo Caravaggio. Bartolomeo Manfredi e la Manfrediana Methodus.* Santa Maria della Pietá, 1987.

Dayton. *Hendrick Terbrugghen in America* (Catalogue by Leonard J Slatkes). Dayton Art Institute, 1965.

Delft. *De Stad Delft: cultuur en maatschappij van 1572 tot 1667,* 2 vols. Stedelijk Museum Het Prinsenhof, 1981.

Delft. *De Stad Delft: cultuur en maatschappij van 1667 tot 1813,* 2 vols. Stedelijk Museum Het Prinsenhof, 1982–3.

Delft. *Leonaert Bramer 1596–1674; Ingenious Painter and Draughtsman in Rome and Delft* (Catalogue by Jane ten Brink Goldsmith et al.). Stedelijk Museum Het Prinsenhof, 1994.

Delft. *Delft Masters; Vermeer's Contemporaries.* Stedelijk Museum Het Prinsenhof, 1996.

Delft. *Een handdruk van de tijd; de almanak en het dagelijks leven in de Nederlanden 1500–1700* (Catalogue by Jeroen Salman). Stedelijk Museum Het Prinsenhof, 1997–8.

Delft. *Beelden van een strijd; oorlog en kunst vóór de Vrede van Munster 1621–1648.* Stedelijk Museum Het Prinsenhof, 1998.

Dordrecht. *De zichtbare wereld; schilderkunst uit de Gouden Eeuw in Hollands oudste stad* (Catalogue by Celeste Brusati et al.). Dordrechts Museum, 1992–3.

Dordrecht. *Jacob Gerritsz. Cuyp (1594–1652)* (Catalogue by Sander Paarlberg et al.). Dordrechts Museum, 2002.

Dresden. *"Der himmelnde Blick." Zur Geschichte eines Bildmotivs von Raffael bis Rotari.* Gemäldegalerie Alte Meister, 1998–9.

Edinburgh. *Rembrandt's Women.* National Gallery of Scotland, 2001.

Frankfurt. *Leselust; Niederländische Malerei von Rembrandt bis Vermeer* (Catalogue by Sabine Schulze et al.). Schirn Kunsthalle, 1993.

Ghent. *Joachim Beuckelaer: het markt- en keukenstuk in de Nederlanden 1550–1650.* Museum voor Schone Kunsten, 1986–7.

Haarlem. *Op zoek naar de Gouden Eeuw; Nederlandse schilderkunst 1800–1850.* Frans Halsmuseum, 1986a.

Haarlem. *Portretten van echt en trouw; huwelijk en gezin in de Nederlandse kunst van de zeventiende eeuw* (Catalogue by Eddy de Jongh). Frans Halsmuseum, 1986b.

Haarlem. *Schutters in Holland; kracht en zenuwen van de stad.* Frans Halsmuseum, 1988.

Haarlem. *Haarlem en Hals.* Frans Halsmuseum, 1990.

Hannover. *Künstler-Händler-Sammler. Zum Kunstbetrieb in den Niederlanden im 17. Jahrhundert* (Catalogue by Ulrike Wegener). Niedersächsisches Landesmuseum, 1999.

Hartford. *Pieter de Hooch, 1629–1684* (Catalogue by Peter C. Sutton). Wadsworth Atheneum, 1998–9.

Houston. *Gray is the Color: An Exhibition of Grisaille Painting.* Rice University. Institute for the Arts, 1974.

Kassel. *The Mystery of the Young Rembrandt.* Staatliche Museen, 2001–2.

Leiden. *Geschildert tot Leyden anno 1626.* Stedelijk Museum De Lakenhal, 1976–7.

Leiden. *Leidse fijnschilders; van Gerrit Dou tot Frans van Mieris de Jonge 1630–1760* (Catalogue by Eric Jan Sluijter et al.). Stedelijk Museum De Lakenhal, 1988.

Leiden. *Van piskijkers en heelmeesters; genezen in de Gouden Eeuw.* Museum Boerhaave, 1993–4.

Leiden. *The Leiden Fijnschilders from Dresden* (Catalogue by Annegret Laabs). Stedelijk Museum de Lakenhal, 2001.

Lemgo. *Hans Vredeman de Vries und die Renaissance im Norden* (Catalogue by Heiner Borggrefe et al.). Weserrenaissance-Museum, 2002.

Lille. *Trésors des musées du Nord de la France I: peinture hollandaise* (Catalogue by Jacques Foucart et al.). Musée des Beaux-Arts, 1972.

London. *Frans Hals* (Catalogue by Seymour Slive et al.). Royal Academy of Arts, 1990.

London. *Rembrandt: The Master & His Workshop, Paintings.* The National Gallery, 1992.

London. *The Cabinet Picture: Dutch and Flemish Masters of the Seventeenth Century* (Catalogue by Christopher Wright). Richard Green Galleries, 1999.

London. *The Genius of Rome, 1592–1623* (Catalogue by Beverly Louise Brown et al.). Royal Academy of Arts, 2001.

Minneapolis. *Dutch and Flemish Masters: Paintings from the Vienna Academy of Fine Arts.* The Minneapolis Institute of Arts, 1985.

Munich. *Adriaen Brouwer und das niederländische Bauerngenre 1600–1660* (Catalogue by Konrad Renger). Alte Pinakothek, 1986.

Munich. *Die Nacht.* Haus der Kunst, 1998–9.

Munich. *Wettstreit der Künste: Malerei und Skulptur von Dürer bis Daumier.* Haus der Kunst, 2002.

Naarden. *De Hollandse kortegaard: geschilderde wachtlokalen uit de Gouden Eeuw* (Catalogue by Ellen Borger). Nederlands Vestingmuseum, 1996.

Newark. *Art & Home: Dutch Interiors in the Age of Rembrandt* (Catalogue by Mariët Westermann et al.). The Newark Museum, 2001–2.

New Brunswick. *Haarlem: The Seventeenth Century.* The Jane Voorhees Zimmerli Art Museum, 1983.

New York. *Adriaen Brouwer; David Teniers the Younger: A Loan Exhibition of Paintings* (Catalogue by Margret Klinge). Noortman & Brod, 1982.

New York. *Liechtenstein: The Princely Collections.* The Metropolitan Museum of Art, 1985a.

New York. *The Age of Caravaggio.* The Metropolitan Museum of Art, 1985b.

New York. *Dutch and Flemish Paintings from New York Private Collections* (Catalogue by Ann Jensen Adams). National Academy of Design, 1988.

New York, *Pieter Bruegel: Drawings and Prints* (Catalogue by Nadine Orenstein et al.). The Metropolitan Museum of Art, 2001a.

New York. *Vermeer and the Delft School* (Catalogue by Walter Liedtke et al.). The Metropolitan Museum of Art, 2001b.

Osaka. *The Public and the Private in the Age of Vermeer* (Catalogue by Arthur K. Wheelock, Jr. et al.). Osaka Municipal Museum of Art, 2000.

Paris. *Le siècle de Rembrandt: tableaux hollandais des collections publiques françaises,* Musée du Petit Palais, 1970–71.

Paris. *Willem Buytewech 1591–1624* (Catalogue by Egbert Haverkamp-Begemann). Institut Neérlandais, 1975.

Paris. *De Rembrandt à Vermeer; les peintres hollandais au Mauritshuis de La Haye.* Grand Palais, 1986.

Paris. *Tableaux flamands et hollandais du Musée des Beaux-Arts de Lyon.* Institut Neérlandais, 1991.

Philadelphia. *Masters of Seventeenth-Century Dutch Genre Painting* (Catalogue by Peter C. Sutton et al.). Philadelphia Museum of Art, 1984.

Pittsburgh. *Gardens of Earthly Delight: Sixteenth and Seventeenth-Century Netherlandish Love Gardens* (Catalogue by Kahren Jones Hellerstedt). Frick Art Museum, 1986.

Raleigh. *Sinners & Saints; Darkness and Light; Caravaggio and His Dutch and Flemish Followers* (Catalogue by Dennis Weller *et al.*). North Carolina Museum of Art, 1998.

Raleigh, *Jan Miense Molenaer: Painter of the Dutch Golden Age* (Catalogue by Dennis Weller *et al.*). North Carolina Museum of Art, 2002.

Rotterdam. *Adriaen van der Werff* (Catalogue by D. P. Snoep and Ch. Thiels). Historisch Museum Rotterdam, 1973.

Rotterdam. *Rubens en zijn tijd/ Rubens and His Age* (Catalogue by Nora de Poorter *et al.*). Museum Boymans Van Beuningen, 1990.

Rotterdam. *French Paintings from Dutch Collections, 1600–1800.* Museum Boymans-van Beuningen, 1993.

Rotterdam. *Rotterdamse meesters uit de Gouden Eeuw* (Catalogue by Nora Schadee *et al.*). Historisch Museum Rotterdam, 1994–5.

Rotterdam. *Dutch Classicism in Seventeenth-Century Painting* (Catalogue by Albert Blankert *et al.*). Museum Boijmans Van Beuningen, 1999–2000.

San Francisco. *Masters of Light: Dutch Painters in Utrecht During the Golden Age* (Catalogue by Joneath A. Spicer, Lynn Federle Orr *et al.*). Fine Arts Museums of San Francisco, 1997.

Southampton. *The National Gallery Lends Dutch Genre Painting* (Catalogue by Christopher Brown). Southampton City Art Gallery, 1978.

's-Hertogenbosch. *Vastenavond-Carnival; feesten van de omgekeerde wereld.* Noordbrabants Museum, 1992.

's-Hertogenbosch. *Aardse paradijzen; de tuin in de Nederlandse kunst I, 15de tot 18de eeuw.* Noordbrabants Museum, 1996.

The Hague. *Gerard ter Borch.* Mauritshuis, 1974.

The Hague. *Great Dutch Paintings from America* (Catalogue by Ben Broos *et al.*). Mauritshuis, 1990–91.

The Hague. *Music & Painting in the Golden Age* (Catalogue by Edwin Buijsen *et al.*). Hoogsteder & Hoogsteder, 1994.

The Hague. *Princely Display. The Court of Frederik Hendrik of Orange and Amalia van Solms in The Hague.* Historisch Museum, 1997–8a.

The Hague. *Princely Patrons. The Collection of Frederick Henry of Orange and Amalia of Solms in The Hague* (Catalogue by Peter van der Ploeg *et al.*). Mauritshuis, 1997–8b.

The Hague. *Gerard ter Borch and the Treaty of Münster* (Catalogue by Alison McNeil Kettering). Mauritshuis, 1998.

The Hague. *Haagse schilders in de Gouden Eeuw.* Historisch Museum, 1998–9.

Tokyo. *The Prints of Pieter Bruegel the Elder* (catalogue by David Freedberg *et al.*). Bridgestone Museum of Art, 1989.

Toronto. *The Dutch Cityscape in the 17th Century and Its Sources.* Art Gallery of Ontario, 1977.

Utrecht. *Nieuw licht op de Gouden Eeuw; Hendrick ter Brugghen en tijdgenoten* (Catalogue Albert Blankert, Leonard J. Slatkes *et al.*). Centraal Museum, 1986–7.

Utrecht. *Nederlandse 17de eeuwse schilderijen uit Boedapest.* Centraal Museum, 1987.

Utrecht. *Rekkelijk of precies; remonstranten en contraremonstranten ten tijde van Maurits en Oldenbarnevelt.* Rijksmuseum Het Catherijneconvent, 1994.

Utrecht. *Pieter Saenredam, het Utrechtse werk; schilderijen en tekeningen van de 17de-eeuwse grootmeester van het perspectief* (Catalogue by Liesbeth M. Helmus *et al.*). Centraal Museum, 2000–01.

Washington D.C. *Gods, Saints & Heroes; Dutch Painting in the Age of Rembrandt* National Gallery of Art, 1980.

Washington D.C. *Dutch Figure Drawings from the Seventeenth Century* (Catalogue by Peter Schatborn). National Gallery of Art, 1982.

Washington D.C. *The Age of William III & Mary II; Power, Politics and Patronage 1688–1702* (Catalogue by Robert P. Maccubbin *et al.*). The Folger Shakespeare Library, 1989.

Washington D.C. *Johannes Vermeer* (Catalogue by Arthur K. Wheelock, Jr. *et al.*). National Gallery of Art, 1995–6.

Washington D.C. *Jan Steen: Painter and Storyteller* (Catalogue by Arthur K. Wheelock, Jr. *et al.*). National Gallery of Art, 1996.

Washington D.C. *Gerrit Dou 1613–1675; Master Painter in the Age of Rembrandt* (Catalogue by Ronni Baer *et al.*). National Gallery of Art, 2000.

Worcester. *Judith Leyster: A Dutch Master and Her World* (Catalogue by James Welu *et al.*). Worcester Art Museum, 1993.

Zwolle. *Zwolle in de Gouden Eeuw; cultuur en schilderkunst* (Catalogue by Jean Streng and Lydie van Dijk). Stedelijk Museum Zwolle, 1997.

PHOTOGRAPH CREDITS

INDEX